Wisdom With Understanding is Better Than Rubies

Lurine Karon Greenberg
Fine Arts Collection

Ordinary Images

Ordinary Images

Stanley K. Abe

THE UNIVERSITY OF CHICAGO PRESS

CHICAGO AND LONDON

STANLEY K. ABE is associate
professor of art history at
Duke University.

The University of Chicago Press, Chicago 60637
The University of Chicago Press, Ltd., London
© 2002 by The University of Chicago
All rights reserved. Published 2002
Printed in China

11 10 09 08 07 06 05 04 03 02 1 2 3 4 5
ISBN: 0-226-00044-3 (cloth)

The University of Chicago Press gratefully acknowledges the support of the
Chiang Ching-kuo Foundation in the publication of this volume.

Library of Congress Cataloging-in-Publication Data

Abe, Stanley K.
 Ordinary images / Stanley K. Abe.
 p. cm.
Includes bibliographical references and index.
 ISBN 0-226-00044-3 (alk. paper)
 1. Art, Buddhist—China. 2. Art, Taoist—China. 3. Art,
Chinese—Three Kingdoms–Sui dynasty, 220–618. 4. Popular
culture—China. I. Title.
 N8193.C6 A24 2002
 704.9'48943'0951—dc21
 2002005007

For the archaeological workers of
New China, without whose dedication
and sacrifices this study would not
have been possible

Contents

Maps

Illustrations

Acknowledgments

THINKING ABOUT THIS BOOK BEGAN IN 1989 as a proposal to the Chinese Popular Culture Project, Institute of East Asian Studies, University of California, Berkeley. Although I was unable to accept a fellowship in the project, the encouragement provided by David Johnson was invaluable. Many fortuitous encounters and acts of kindness have facilitated the study and for these I thank Margaret Hattori, Sunkyung Kim, Dave Hattorimanabe, Joanna Williams, Martin Powers, James Cahill, Wu Hung, Marsha Weidner, Amy McNair, Charles Lachman, Jennifer Holmgren, Paul Harrison, Stephen Bokenkamp, Gil Raz, Peter Nickerson, Daniel Boucher, Keith Wilson, Lee Yumin, Liu Shufen, Ishimatsu Hinako, Okada Ken, Kuno Miki, and Chang Qing.

Two months of archival research at the Fusinian Library, Institute of History and Philology, Academia Sinica, Taiwan, in 1992 allowed me to incorporate rubbings of sculpture and inscriptions into my research. I am very grateful to Lin Dengzan and his staff for their kindness and support. This was followed by extended research in China in 1993 and shorter trips to Chinese museums and sites in 1994, 1997, and 1998. The scholars and archaeological staff in China who offered valuable advice and assistance are far too numerous to list here, but I must mention Su Bai, Ma Shichang, Pei Jianping, Shui Tao, Yin Guangming, and Qin Dashu. The most important sponsor for research in China was the Chinese Museum of History, Beijing, and the Committee for Scholarly Communication with China. With the adept guidance of Shao Wenliang, I was able to conduct research and document works across northern China at too many sites and museums to name. Special thanks to Yu Weichao for introducing me to such a wonderful *peitong* and friend. In 1995, 1996, and 1997, I was able to study works of Chinese sculpture in Japan with the assistance of my friends at the Tokyo National Research Institute of Cultural Properties, past director-general Nishikawa Kyotaro and president Watanabe Akiyoshi,

and past director of the Department of Fine Arts Tsuruta Takeyoshi, and director Nakano Teruo. In Japan, I must acknowledge the exceptional kindness of Mino Yutaka and Fujioka Yutaka of the Osaka City Museum, Takahashi Noriko, Masaki Museum, and Matsumoto Nobuyuki, Koizumi Yoshihide, and Kashima Masaru, Tokyo National Museum.

The writing of the book would not have been possible without the assistance of the Duke University Library system. I am especially grateful to Dr. Kristina Troost, Zhaohui Xue, Lee Sorensen, Yunyi Wang, and all of the wonderful staff at Lilly Library. Also, Edward Martinique and Hsi-chu Bolick of Davis Library at the University of North Carolina, Chapel Hill, provided invaluable assistance and special favors. The library of the Freer Gallery of Art and Arthur M. Sackler Gallery has been a crucial resource. Special thanks to Lily Kecskes and her hardworking staff. And my gratitude goes to the indispensable aid provided by Agnes Wen and the Gateway Service Center of Chinese Academic Journal Publications, East Asian Library, University of Pittsburgh.

Research and writing were supported by a National Endowment for the Humanities Fellowship for University Teachers, a Chiang Ching–kuo Foundation Post-Doctoral Research Grant, an Asian Cultural Council Asian Art Fellowship, a J. Paul Getty Fellowship in Art History and the Humanities, a National Endowment for the Humanities Summer Stipend, a National Endowment for the Humanities Travel to Collections Grant, and numerous research grants and a Junior Leave from Duke University. The publication of the book was supported by a grant from the Chiang Ching-kuo Foundation.

There would be no book without the enthusiasm of Susan Bielstein, who saw the merit of the project when others did not and guided it (and the author) through the rigors of the review process. My deepest gratitude and respect to Susan and all of the professional staff of the University of Chicago Press for their wisdom, guidance, good humor, and support.

Conventions

Texts in the extant Chinese Buddhist canon are cited according to the printed edition *Taishō shinshū daizōkyō,* edited by Takakusu Junjirō and Watanabe Kaikyoku (Tokyo: Taishō Issaikyō Kankōkai, 1924–1935). Citations are provided as follows: *T[aishō]; Taishō* serial number; *Taishō* volume number; page, register (a, b, or c), line number(s): e.g., *T.*784.17.722a:21–22.

Texts in the standard Daoist canon are cited by their number in the *Combined Indices to the Authors and Titles of Books in Two Collections of Taoist Literature,* Harvard–Yenching Institute Sinological Series, no. 25, edited by Weng Dujie (Peking: Yenching University Library, 1935), preceded by the abbreviation *HY*—e.g. *HY* 767.

Squares such as these □ in the text indicate the presence of damaged, erased, or otherwise unreadable Chinese characters. Transliteration of Chinese follows the pinyin system; and of Japanese, the revised Hepburn system. All terms that appear in *Webster's Third New International Dictionary* are considered to have entered the English language and are not italicized.

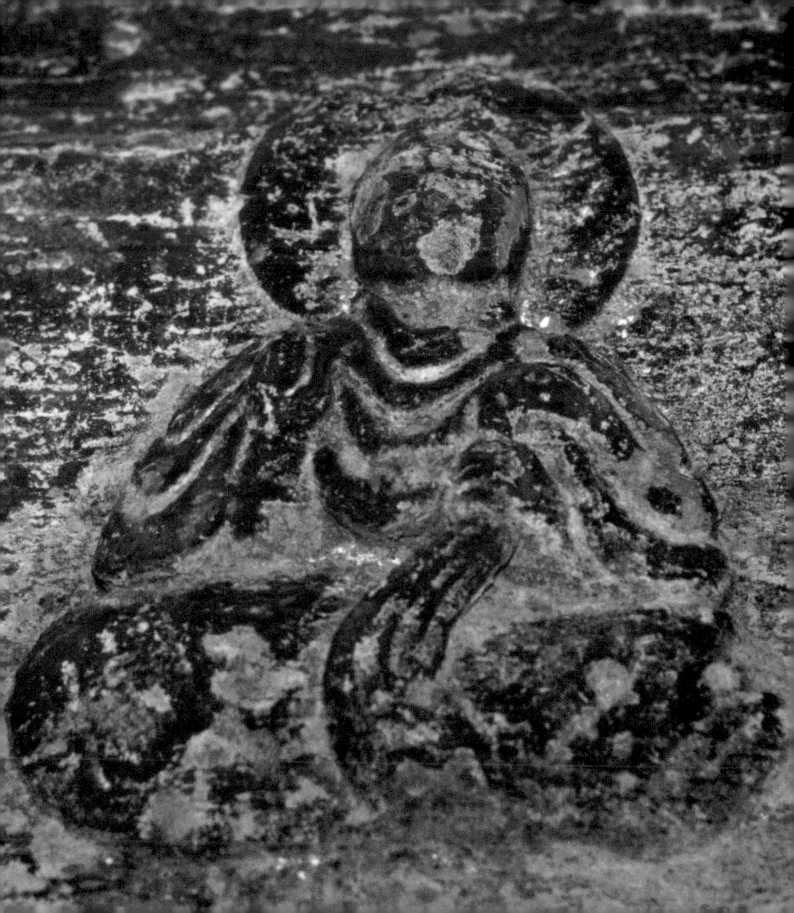

Chapter One

Ordinary: applied to various things of the more or most usual class or type, to distinguish them from others of some special sort.[1]

ORDINARY IMAGES

 THE TITLE OF THE BOOK refers to a large body of visual imagery "of the usual class," not, in other words, considered distinguished in their original context. In contrast to the oft-celebrated works made for imperial patrons, high-ranking officials, illustrious monastics, or literati luminaries, ordinary images—modest in scale, mass-produced, at times incomplete—were created for those of a lesser social, political, and economic standing. Such ordinary images have been considered a largely nebulous mass of undistinguished works because, again in contrast to works of the most elite classes, ordinary images cannot be related to known historical personages or well-defined social groups. To compound the difficulties in explicating the context of ordinary images, the available historical evidence for this period, roughly the third to the sixth centuries C.E., consists of texts written by and for educated elites: official histories and other texts related to the imperial court; poetry, prose, and texts of commentary and criticism by literati elites; canonical texts of Buddhism, often translated or written with official sponsorship, as well as hagiographies of eminent Buddhist monastics aimed at the conversion of the elite classes; and finally canonical Daoist texts "received" by their literati authors. In a time and place where the great majority of inhabitants were not literate, the textual evidence provides us with a remarkable view of China through the eyes of a small and privileged educated class representing perspectives dominated by the interests of the most politically powerful elites: aristocrats, high-level officials, and prominent members of leading local families.[2] This is not to suggest that political elites or the literati class were monolithic or to disregard the variety of the textual oeuvre in this period. Nor do I wish to ignore the ways in which elite texts, most often in the negative, comment on the behavior and mentality of the lower classes. Yet against this significant body of elite testi-

mony there is precious little else with which to balance the historical record and gain a glimpse of the concerns of those of a lesser standing in their own words.

The consequences of the above for the study of ordinary images are profound. To begin, we have a significant body of visual material that was produced not by elite-class patrons but by anonymous donors either unnamed or named but otherwise unidentifiable in the extant historical record. These works and their inscriptions are evidence of what those of a lesser standing did; but to explicate them on the basis of the elite textual tradition would be obviously problematic.[3] This is not to draw too distinct a line between elite and nonelite; despite what must have been a profound distance between those of elite rank and the rest, there can be little doubt that there were many commonalities. The study of ordinary images must then probe zones of difference as well as commonality, shifting between various permutations of the extraordinary and the rest, the elite and the lesser. The issues for such an endeavor are many and some will prove intractable, but the distinguished work of many scholars in recent years, especially those in Chinese social history and religion, provide vital guideposts for the project.

In fact, my interest in ordinary images was originally sparked by the work of two historians of Chinese religion, Erik Zürcher and Anna Seidel. Both have contributed greatly toward the understanding of Chinese beliefs and practices beyond the organized Buddhism and Daoism of the elite and literate classes. I initially believed that among the many extant works of Chinese Buddhist imagery not made for elite-class patrons one might discern the visual corollaries to the noncanonical beliefs discussed by scholars of popular Chinese religion. It soon became clear, however, that access to the images and beliefs of common people in this period was not so straightforward. The ability to sponsor images in stone or other durable materials—the types of works that have survived as evidence of past religious beliefs and practices—was beyond the means of most commoners. In cases where groups of individuals banded together for the purpose of donating an image, many such groups were led by clerics and laity of the elite classes. In addition, all patrons were involved in an activity that was dominated by the impressive visual and textual exemplars of the elite classes. In short, there is much that works against the specification of a distinctly common-class imagery and there is much in what follows that demonstrates the limitations of such an endeavor.

As a result, the study is focused on ordinary images even as it recognizes the difficulties of locating works patronized by the most common social classes. The emphasis on ordinary images is also meant to counter the venerable "fine arts" orientation of art history, which by definition privileges the most costly, rare, and aestheticized objects and their elite-class owners. No less true in China than in the West, the stress on masterworks and individual genius is here opposed by a class of common objects produced by nameless artisans. These works represent the majority of extant images and, in contrast to images of special distinction, most are unremarkable and ordinary in form. The patrons of such imagery were not of the lowest classes but were what I call "subelites":

modest landowners, merchants, lower officials, and others of some means but with no claim to significant political office or aristocratic standing. Works of these patrons will be contrasted to those of high-ranking officials and upper-class elites. The identification of an "ordinary" level of patronage cannot in most cases and by definition be precise; that is, subelites, even when named, are otherwise anonymous.

In the spirit of Zürcher and Seidel, this study attempts to operate in the interstices of conventional categories such as Buddhism, Daoism, and Chinese popular religion.[4] Yet such terms are themselves problematic. What, for example, is the relationship of the term "popular" to the "conventional" categories of secular, Daoist, and Buddhist art?[5] Zürcher has pointed out the way in which the maintenance of clear distinctions between Buddhism and Daoism were of primary interest to clerical elites and their patrons but apparently much less so for the common classes. It follows that works of art that fall between the categories of secular, Daoist, or Buddhist may constitute a "popular" form; yet, as we will find, some examples of such in-between art were produced for privileged elites. Seidel has noted the way in which popular beliefs outside of canonical Buddhism and Daoism were embraced by all classes in Chinese society.[6] The issue was not social class as much as the opposition of members of the most learned classes to popular religious practices.[7] The fundamental tension between the literati and the illiterate (or the approved cults and the so-called superstitious) will be kept foremost in mind in what follows, especially in the utilization of literati and canonical religious texts to explain ordinary images.

This book is a work of conventional art historical practice. Its primary task is to explain and interpret images (*xiang* 像). Here the reader should note the shift from "art" to "image," which marks a tension between the subject of the discipline and a disavowal of "art" as a category appropriate for the images under consideration. The purpose of raising issue with the term "art" is not simply to identify an obvious anachronism, but to highlight the disjunction between the modern understanding of an art object — exemplified by the beautifully lit work in a museum display case — and the way in which these images were known and used in their original contexts.[8] Furthermore, works such as these were rarely if ever considered aesthetic objects by Chinese scholars or collectors. Extant (elite) Chinese writings make clear that sculpture is the work of artisans, a lowly trade not to be confused with the refined talents of painters or calligraphers, whose work might be appreciated in a manner familiar to a modern art collector or museum-goer. This is not simply literati prejudice, but a result of both class difference and the distinct meaning of Chinese religious sculpture — objects of devotion, efficacy, and even superstition — as opposed to the refined aesthetic expression or artistic creativity of the cultivated gentleman. The term "image" therefore registers several important differences from "art," but should not be construed as an attempt to capture the "true" meaning of the image in the past. Sensitivity to the terminology of the period under study is de-

sirable, but words do not grant a privileged access to the past. Rather, the choice of terminology is strategic and meant to underscore the distance between the current language of art and the visual images that will be considered in this study.

In fact, terminological issues pale in the face of a number of more serious problems. To begin, the examples available to us are truly chance finds—accidental survivals of a much larger body of imagery. The way in which new archaeological discoveries, even of a minor sort, can significantly transform our understanding of works such as these is testimony to our ephemeral base of evidence. There is, of course, no alternative but to utilize the available materials, but the act of explanation should be mindful of the fragmentary and misleading nature of the works that we study. In addition, the original contexts of many works are unknown; others may only be imaginatively reconstructed. In those cases where an image may be found in context, the effects of theft and vandalism are often also visible. Documentary evidence of who produced these images and under what conditions is almost nonexistent. No contracts, memoirs, or other records survive; none may have been originally kept. Inferences from tangential literature have often substituted for the lack of specific documentation; the limitations of such evidence will be evident in what follows. We are left with the testimony of the images themselves, what we can infer from the visual evidence and the inscribed texts. But, as the reader will see, in many cases extant images survive in an altered state: some as fragments or damaged wholes, others worn by the elements, many lacking original gilding or paint, still others reworked or added to in later times.

None of the above should rest easily with the task at hand—the explanation of ordinary images—and the narrative that follows will oscillate between the desire to produce a convincing history of images and a recognition of the limitations of such a task. The image that is before us offers a direct, visceral experience of that past; yet there is no transparent view into the time and place from which it came.

The book can be understood to operate on three levels: first, at a microlevel, a focus on detailed evidence, what one might term a "close reading;" second, at a midlevel, a critique of explanatory schemes by which evidence is organized; and third, at a macrolevel, a concern with the operations of art history as a discipline. The levels are, of course, artificial, and the work of art historians continuously and simultaneously involves all three levels, each enabling the others, although it may appear at any moment that there is a concern with one rather than the others. Such an appearance is the basis for the truism that the work of art history can be divided into empirical research on one hand and theoretical (or methodological) inquiry on the other. In what follows, it should become apparent that such a divide is itself theoretical, that is to say, all work in our discipline has proceeded from a theoretical basis since its inception. Art history is also an interpretative discipline that, in the subfield of Chinese art with which this book is concerned, is most

often based on a language of empiricism—that is, a textual strategy in which interpretation is made to sound like a discovery of fact. The propensity to couch our scholarship in empirical-sounding language is one of the normative strategies of the discipline.

The study that follows must necessarily utilize the language of empiricism, but my interest will be to delineate the contradictions and limits of the available data rather than the errors of past scholarship or a set of new conclusions. My view is that the more we know, the less we are able to formulate convincing generalizations or overarching themes. Therefore, the large amount of detailed information on objects and their contexts is central to the argument of the book. In addition, because these works are almost wholly known from archaeological reports and scholarly publications in Chinese—many relatively obscure and difficult to access—there is value for future scholarship in making available as much of the descriptive material as possible. The approach adopted for this study may strike some as unduly pessimistic or negative regarding our access to the past and the ability of a discipline such as art history to progressively improve our factual understanding of past imagery and its contexts. Why I find contradictions where others find conclusions is a question that turns on a difference in theory. It seems to me that the task of the art historian in every period has been the production of a different version of history, not necessarily a better one. Whether a specific historical narrative sounds coherent and convincing to the reader is a factor of the circumstances of its audience; that is, we are captives of our own time and place. In examining past scholarship, the force of past historical contexts may be obvious. Our situation is no different, although a cogent view of our own historical circumstances may be impossible to discern.

History is the production of a narrative that claims a truth-effect—that is, the appearance of reconstructing the facticity of the past. The most crucial techniques for history are rhetorical strategies—the conscious selection, arrangement, and interpretation of certain data as well as the omission of other "facts" in order to construct a compelling argument. The study that follows attempts an alternative to this process through an emphasis on the heterogeneity of the extant evidence. The visual images, physical contexts, inscriptions, and texts that are available to us are fragmentary and chance remnants of a much larger body of material. Even when we investigate instances of relatively well preserved and documented groups of works such as those in the case studies here, the evidence fails to present us with a coherent self-explanation. Any attempt to produce an orderly narrative out of such an inchoate body of data must do significant violence to the historical remains, shaping each bit of evidence to the argument by effacing or ignoring contradictory aspects of the material. Therefore, I attempt to present the works in a manner that allows for more rather than less contradiction, less rather than more certainty, that resists easy incorporation into paradigms of cultural adaptation or formal development. Instead, the alternative is something like an antiparadigm, an insistence that the materials before us are not easily assimilable to logical explanatory schemes. The works considered in this book are treated not as types but as fragments, some less whole

than others. Such works elicit speculation, and much of the past scholarship on these objects is little more than that. The reader will find similar imaginative reconstructions below—this work cannot completely escape the desire for explanations—but presented, I hope, with less credulity than usually encountered.

This is not to say that past and current scholars have not been aware of these issues. But conventional wisdom has suggested that the limits of our evidence are not problematical because we can always construct a plausible story about the past, a type of narrative that satisfies us as probabilistic if not imaginative.[9] This book offers a different kind of narrative, one that does not wish to present itself as empirical, factual, or whole but instead transparent to the fragmentary and limited nature of the evidence as well as the techniques and strategies of our storytelling.

Chapters 2 through 5 each present a case study organized around a group of closely related dated works of known provenance (see map 1). Chapter 2 considers the most geographically dispersed group of images in the book, the earliest known examples of unambiguously Buddha-like images in China. These are found among money trees in Sichuan and southwest China and on ceramicware from the area south of the Yangzi River in the provinces of Hubei, Jiangsu, and Zhejiang; all date to a short period from the end of the second to the beginning of the fourth century C.E. Early examples of the Buddha-like image represent the incorporation of the image into existing Chinese mortuary practices—the images are found almost exclusively in tombs among objects interred with the deceased or as part of the visual decoration of the tomb. These works were made by and for a range of relatively wealthy individuals, some extravagant in their expenditure of resources, but most modest in the scale and furnishings of their tombs. Although the patrons are local elites, what is ordinary about these works is the Buddha-like figure itself—small, inelegant images produced from molds. In addition, tombs and their contents are indicative of a well-developed set of beliefs and practices that were and would remain largely outside the domain of organized Daoism and Buddhism even after the development of these religions as powerful institutional entities. It is in this type of ordinary mortuary practice that the first Buddha images were utilized.

What is striking is the manner in which the Buddha image was appropriated in only a few specific ways in a small number of extant tombs and tomb objects. Previous studies have understood the early Buddha-like figure as a kind of purposeful appropriation of the Buddha as the equivalent of Chinese deities such as the Queen Mother of the West; yet an analysis of tombs with and without the Buddha image indicates that there was little equivalency between the Buddha-like figure and the Queen Mother or other Chinese deities. Rather, the Buddha image had no singular fixed meaning, but was most often used in positions otherwise occupied by animals or motifs that were apotropaic or auspicious. Instead of the equivalent of a specific deity, the Buddha-like figure was a mo-

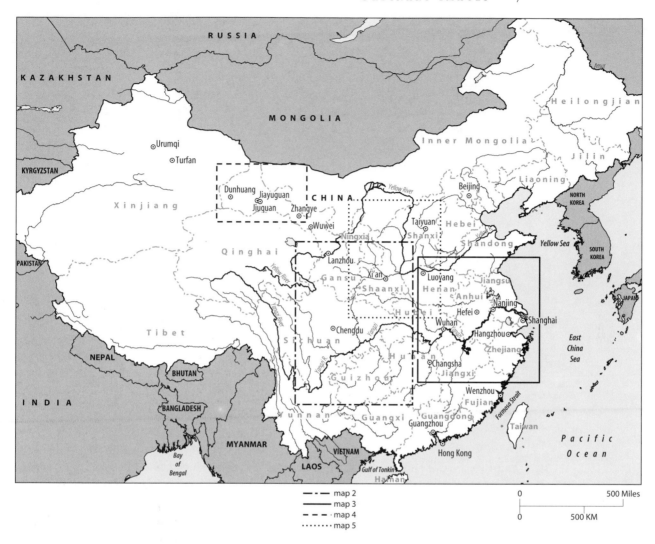

1 China orientation map. By Linda Huff.

tif unsystematically inserted in a variety of mortuary contexts with relatively mundane functions. An important stimulus for the tendency in earlier scholarship to interpret the Buddha image as a substitute for a Chinese deity was the model of the textual transmission of Buddhism into China. The initial translation of Buddhist sutras into Chinese was indeed characterized by the imperfect matching of the foreign language of Buddhism with known Chinese concepts and terminology. In its most technical and limited form, the matching of meanings was called *geyi* 格義. Chapter 2, however, demonstrates that the linguistic strategy of the early translation teams and their literate, elite-class patrons was a specialized activity with little parallel in Chinese mortuary practice. The widespread acceptance of a theory of matching—the Buddha for the Queen Mother—owes

as much to the appeal of the translation paradigm as to a lack of attention to the archaeo-logical record.

Chapter 3 takes up a group of thirteen nearly identical votive stupa discovered in northern Gansu Province. The works, premade for patrons of no special distinction, are inscribed with dates between 426 and 436 and constitute a form of imagery particular to this region. They are also inscribed with nearly identical passages from a Chinese Buddhist sutra along with conventional Buddhist imagery, such as relief carvings of seated Buddhas, as well as the eight trigrams from the *Book of Changes* (*Yijing* 易經). The votive stupa thus represent another form of interaction between Buddhism and indig-enous Chinese practices. In addition, some of the imagery on the votive stupa can be related to motifs used in the tombs of subelites near Jiuquan 酒泉 and Dunhuang 敦煌. Northern Gansu has long been considered a frontier region between China proper and the non-Chinese lands to the west, and the visual imagery from the area has been ex-plained as a mixture of Han and non-Han forms or influences. Chapter 3 attempts to counter the influence paradigm, a model based on the diffusion of forms from distant cultural centers, by considering the votive stupa as unique, local products not copied from distant prototypes and themselves having little influence on later images, east or west. These works were not made to order for individual patrons—the votive stupa were completely carved before the patrons had their dedications added to them. But the works display significant variations among themselves. In such a case, it is not likely that the social positions or aspirations of individual patrons resulted in the choice of differ-ent visual elements. The explication of these works thus revolves around a series of less than direct relationships with local history, mortuary practice, and Buddhism. Although the votive stupa may be placed in a local context, there are crucial elements of that con-text that are currently beyond the reach of our scholarship. How one handles the limi-tations of our evidence is a central concern in this chapter.

The fourth chapter involves similar issues in a different setting. Here, the focus is on the donation of some two dozen niches dated from 495 to 504 in the Guyang Cave at the Longmen Cave temple site located just outside Luoyang. In contrast to the votive stupa, this group of works offers us a variety of classes of patrons in the metropolitan heart of the Northern Wei 北魏 empire. The niches, arranged on the ceiling and upper walls of the cave, represent a full spectrum of patron groups of the period: members of the imperial family, including wives and mothers; court officials; local officials; monks and nuns; and common-class individuals as well as groups organized as *yiyi* 邑義, a type of Buddhist religious association made up of lay patrons and clergy. The niches and their inscriptions serve as a public space in which various patrons affiliated themselves with each other through the subtle manipulation of a circumscribed set of visual and textual rhetorical conventions. Class, however, is not simply reflected in the scale or style of the imagery; neither does the oft-cited sinicization of the non-Han Northern Wei dynasty provide an adequate explanatory scheme for the visual style of the niches. Sinicization

is, of course, another instance of the work of influence, in this case the inevitable acculturation of the non-Han Northern Wei leadership. The niches in the Guyang Cave, however, can be neither easily categorized into Han versus non-Han styles nor organized into the linear progression of sinicization. The chapter demonstrates that the theory of sinicization is just that. A close inspection of the Guyang Cave imagery demonstrates something of the complex and uneven interaction between Han and non-Han cultural forms, a situation that is substantiated by the extant historical record. The explanatory model of sinicization is a powerful and old trope of Han cultural centrality, which makes its invocation doubly problematic, both in terms of the original context of the Northern Wei and the modern one of Orientalism and ethnocentrism. As in the case of the votive stupa in the previous chapter, the Guyang Cave images are not reducible to a straightforward political reading based on social class, and again we are left to ponder the role of the workshop and artisan, how they interacted with the donors and/or possible go-betweens, as well as the actual level of participation by various patrons.

A group of Buddhist and Daoist sculptures from Shaanxi Province dated to the fifth and early sixth centuries is the subject of chapter 5. Chang'an, the most important city in Shaanxi, was a vibrant center of Buddhist translation and monastic activity throughout the fifth century. The chapter begins with a consideration of the extant dated Buddhist images from the city as representative of a canonical Buddhist imagery most closely aligned with the interests and presence of the metropolitan clerical elite. The focus then moves outside the city to juxtapose "provincial" works from sites such as Yaowangshan to the metropolitan sculpture of Chang'an. In contrast to conventional Buddhist imagery, many of the works from the countryside are Daoist in orientation; others combine or conflate elements of Buddhist and Daoist iconography to produce complex and visually distinct dedications. Such an admixture of Buddhism and Daoism in the textual tradition has been identified as a possible clue to popular beliefs and practices. Although these images represent the visual expression of beliefs that are not easily bracketed into categories such as Buddhist or Daoist, they are more than simple expressions of popular religious beliefs. Among the patrons are examples of high and low social backgrounds as well as *yiyi* donations, family donations, and individual sponsorship, including that of Daoist officiants, an indication of the complex ways in which Buddhist, Daoist, and popular beliefs were shared across class lines. The evidence of Lingbao Daoist concepts, in which Buddhism is appropriated as a form of Daoism, further complicates a reading of the imagery into religious categories. The richly varied iconographic forms and complex inscriptions provide us with a body of evidence that demands something more than explanatory models such as synthesis or provincialism.

Past histories of early Chinese Buddhist art have traced broad visual propensities and stylistic development. The alternative presented here, which seeks to particularize and atomize such an overview, does not seek to offer an alternative model. Rather, it dwells on the fragmentation and discontinuities that mark our evidence of the past.

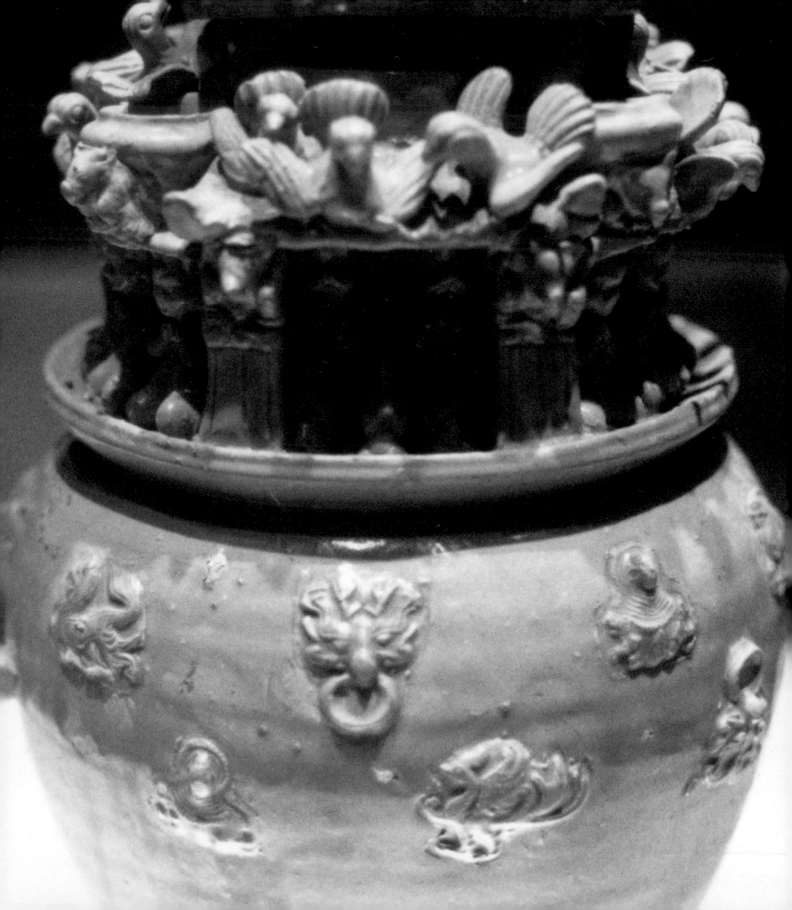

Chapter Two

Although (and *because*) popular religion is the most ancient, most vigorous and most pervasive Chinese religion, it has always had the full weight of the Chinese literati against it.[1]

SMALL BEGINNINGS

OVER A DECADE AGO, a joint Chinese-Japanese research project was organized to study the early transmission of Buddhist imagery into China via southern routes. Culminating in two symposiums held in late 1991 in Chengdu and Nanjing, the project produced an impressive body of publications on the textual and archaeological evidence for the southern transmission of Buddhism into Yunnan, Sichuan, and Guangxi by land, and by sea to the coastal areas of Guangdong, Fujian, Zhejiang, and Jiangsu.[2] This burst of research on the southern route of Buddhism is the second round of recent interest on the earliest period of Buddhist imagery in China, the first being the work of Chinese scholars some ten years earlier, which stimulated Wu Hung's important 1986 essay on the subject.[3] The crucial point of his essay was to clarify how Buddhist elements in second- and third-century Chinese visual imagery did not function in orthodox Buddhist contexts but were adapted in several different ways: in the Eastern Han as a random borrowing of Buddhist elements into Han popular art; in the Three Kingdoms period as something of popular Buddhist beliefs in *hunping* 魂瓶 jars; and at the site of Kongwangshan 孔望山, Jiangsu Province, as the incorporation of Buddhist visual elements into an early Daoist site.[4]

This chapter will take up the subject of the earliest Buddhist elements in China with the advantage of the considerable archaeological findings published since 1986 as well as the scholarship devoted to the southern route in the early 1990s. There is one major problem, however, that has plagued all discussions of early Buddhist imagery in China: the very definition of what constitutes a Buddhist visual element. In 1980, Yu Weichao considered an assortment of imagery as "Buddhist," including a white elephant and rider from Helin'geer, two standing figures with halos from Yi'nan (fig. 2.1), and a six-tusked elephant from Tengxian as well as images of Buddha-like figures from Sichuan.[5] To these

11

2.1 Drawing, carvings on
the four cardinal sides of the
octagonal central column in
the middle chamber, Yi'nan
Tomb. From Wu Hung,
Monumentality, fig. 2.57.

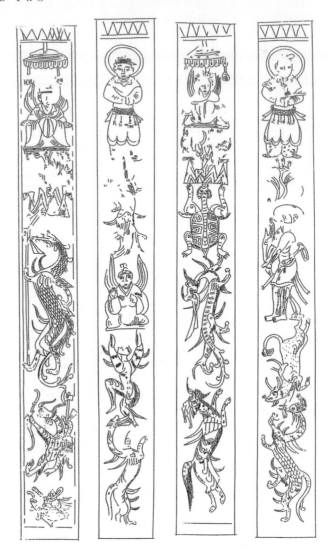

Wu Hung added motifs such as the lotus flower and stupa from the Wu Liang shrine at
Jiaxiang.[6] Recent scholarship on the southern route has extended the range of Buddhist
elements even further to include tomb figures that appear to be non–Han Chinese (*huren*
胡人), labeled as foreign Buddhists or monks, or any figures with their right hands raised,
the familiar *abhaya* mudra of the Buddha.[7] The awareness that Buddhist visual elements
may have been adopted in an unsystematic manner appears to have encouraged scholars
to discover an ever-increasing number of "Buddhist" motifs in early Chinese imagery.
The situation necessitates a reconsideration of what it means to find motifs, postures, or
figural types known in early Indian Buddhist imagery in China. Are all similarities the
result of borrowing? How can it be proven whether a particular motif, the halo behind
the head of a deity, for example, was derived from Buddhist imagery or was invented

without the need of a foreign model? If the halo was originally derived from Buddhist imagery, subsequent uses of the motif may have been inspired not by any knowledge of Buddhist works but by the halo now depicted behind the head of a Chinese deity. Is this still an example of Buddhist imagery? If so, at what point does the halo become an "indigenous" Chinese motif?

The appearance of such isolated Buddhist motifs is prominent in northern China (Helin'geer) and especially Shandong Province (Yi'nan, Tengxian, and Jiaxiang). Yet the North has yielded no examples of the Buddha figure with all of the conventional iconographical traits: an *uṣṇīṣa* atop the head, the halo, monastic dress, and standard forms of posture and hand gestures. What is suggested is a regional pattern in which isolated Buddhist motifs were adopted but the conventional Buddha image played no role. The large scale and ambitious decorative programs of the northern tombs indicate that the use of Buddhist motifs was limited to a few elite families with prominent official-class and literati members, although the small number of examples among a large number of excavated tombs should remind us of the exceptional nature of the motifs. Compared to the Buddha image, which has the advantage of being unambiguously Buddhist in origin, the use of such isolated motifs are especially problematic to interpret. Therefore, it is the conventional image of the Buddha as adopted in other parts of China during the third century that will be the focus of this chapter.

Previous scholarship on the Buddha figure in this period has been understandably concerned with details of their form and origin. Aside from the work of Wu Hung, the issues of function and social context have been given less attention. In what follows, the discussion of the earliest Buddha-like figures will be placed in the greatest detail possible within their archaeological context with emphasis on regional variations in patterns of use.

EARLY BUDDHISM

Erik Zürcher has succinctly termed Buddhism in the Han dynasty a "composite phenomenon, consisting of at least three well-defined sectors: first, a hybrid cult centered upon the court and the imperial family; secondly, the first nucleus of 'canonical' monastic Buddhism; and, in the third place, the diffuse and unsystematic adoption of Buddhist elements in indigenous beliefs and cults."[8] Most of the anecdotal information on the introduction of Buddhism into China comes from dynastic histories and records of court life. These describe a "hybrid court Buddhism" featuring sacrifices to the Yellow Emperor, Laozi, and the Buddha, for example in a memorial by Xiang Kai presented to Emperor Huan at court in 166 C.E. Other texts indicate that the Buddha was perceived to be a combination of immortal (*shenxian* 神仙) and sage with supernatural powers, an understanding that is consistent with the incorporation of the Buddha into the Huang-Lao cult of the court.[9] In addition, the *Scripture in Forty-two Sections* (*Sishi'er zhang jing* 四十二章經), a short collection of aphorisms that appears to have been known at court in

the second century, states that Buddhist practitioners may become an *aluohan* 阿羅漢 *(arhat)* with the ability to fly, transmute their forms, live long lives, and affect heaven and earth.[10] This strongly suggests that the practice of Buddhism was understood to lead to powers similar to those of a Daoist adept.[11]

It was also in the Eastern Han that organized monastic Buddhism in China was established, beginning with the arrival of the Parthian monk-translator An Shigao 安世高 in Luoyang around 148 C.E. Small groups of foreign monks and Han Chinese assistants supported by lay devotees translated and explicated texts in a monastic context in Luoyang into the early third century.[12] What is striking about most of these early translations is that they were not written in "literary sinitic or *wenyan* 文言," the language of scholars and officialdom, but in a formalized vernacular that includes many colloquialisms. Victor Mair suggests a number of reasons why these texts were not written in literary sinitic, including the oral tradition of transmitting Buddhist sutras, the unfamiliarity of the foreign monks with the intricacies of literary sinitic, and the marginal social position of many early Buddhist converts.[13] Zürcher believes the language reflects the vernacular spoken at the capital, evidence that the texts were orally presented to an audience, many of whom may have been illiterate.[14] He has elsewhere suggested that the earliest texts were translated for a lay audience, literate but not of the scholar-official class, possibly a "sub-elite of clerks and copyists, the lowest fringe of the bureaucracy, and traders and artisans."[15] Interestingly, the predominant technical and scholastic orientation of these texts, appropriate for a monastic setting, appears to have attracted interest among some lay practitioners. Zürcher also identifies four texts of a different nature written in a more direct and readable literary style with an emphasis on simple morality and edifying anecdotes. These works appear to be written for a more popular level of lay devotee attracted to the less abstruse aspects of Buddhism.[16] In light of Christopher Connery's compelling argument that the creation of literary sinitic in the Han dynasty should be understood in the context of an imposition of textual authority inextricable from the political consolidation of the imperial realm, one might discern in the absence of literary sinitic something of the marginal status of early Buddhism.[17]

The activities of the first foreign translators and their followers are completely absent from the official historical record and there is no evidence of any close connections between the monastic/translation sector of Han Buddhism and what was going on simultaneously at court. Outside of Luoyang, there is information regarding only one other center of Han Buddhism. This is Pengcheng 彭城, the capital of the Chu 楚 Kingdom and an important commercial center in northern Jiangsu Province near current-day Xuzhou 徐州. An edict by Emperor Ming in 65 C.E. cites the devotion of Prince Ying 英 of Chu to Huang-Lao and the Buddha.[18] Anecdotal evidence indicates that Buddhism continued to be known in this region in the second century—for example, the first known Chinese monk, Yan Fotiao 嚴佛調, who worked with the foreign translator An Xuan 安玄 in Luoyang in 181, was from nearby Linhuai, Anhui Province.[19] The most

important record of Buddhism at Pengcheng, however, is a departure from what we have seen at court or in monastic translation projects. This is the institution established by Ze Rong 筜融, a local official with a short-lived career of violence and betrayal at the end of the second century (c. 190):

> Then he built a great Buddha shrine with a bronze [figure] of a man with gold smeared on the body and clothed with elegant colorful garments. [It had] nine layers of hanging copper (?) plates. Below was a storied pavilion, with a capacity of 3,000 some persons, all of whom examined and read the Buddhist scriptures. People within the region and in the adjacent prefectures who were good Buddhists [devotees] listened and received [accepted] the Way [doctrine]. As an alternative he employed others as servants in order to bring this about. Those who because of this came from far and near at different times reached to more than 5,000 persons. Each time the Buddha was bathed, much wine and food was arranged and mats were spread out on the road for several ten's of *li* [one *li* is one-third of a mile]. People who came to see and to partake of the food moreover were 10,000 persons. The expenditures ran into the hundred millions.[20]

While Zürcher and Tsukamoto find the study of Buddhist scriptures evidence that Ze Rong's institution was a monastery, Leon Hurvitz doubts the likelihood of such a large number of literate commoners reading Buddhist texts at such an early date. His suggestion that the passage refers to the reading of scriptures to an audience seems plausible.[21] In any case, Ze Rong's institution bears less resemblance to the monastic establishments of Luoyang than to a popular cult center with its emphasis on images, spectacle, food, and wine. It is also not insignificant that those who studied here were probably recruited with the promise of exemption from the requirement to provide corvée labor and were thus to some extent personally bound to Ze Rong. They were likely among the thousands of followers who fled with Ze Rong southward when the region was invaded by the armies of Wei Cao Cao in 193.[22]

The description of an image as the focus of popular practices such as the ceremonial bathing of the Buddha indicates that icons of the Buddha were utilized as early as the end of the second century. Additional textual evidence for the making of icons of the Buddha by the end of the second century is found in early Chinese translations of Buddhist sutras where the existence of images is indicated.[23] The oldest iconic image of the Buddha dated by inscription (fig. 2.2), however, is a gilt bronze statue with a regnal date equivalent to 338 C.E.[24] Although various scholars have suggested early dates for some extant undated icons, there is no consensus that any were produced as early as the second century.[25] Rather, the earliest images of the Buddha in China, dating from the late second and third centuries C.E., all come from tombs, which suggests not Buddhist beliefs or the practice of making Buddhist icons but the incorporation of a new and foreign element into established Chinese mortuary practices. This is Zürcher's third sector of "indigenous beliefs and cults." But it is important to note that of the thousands of

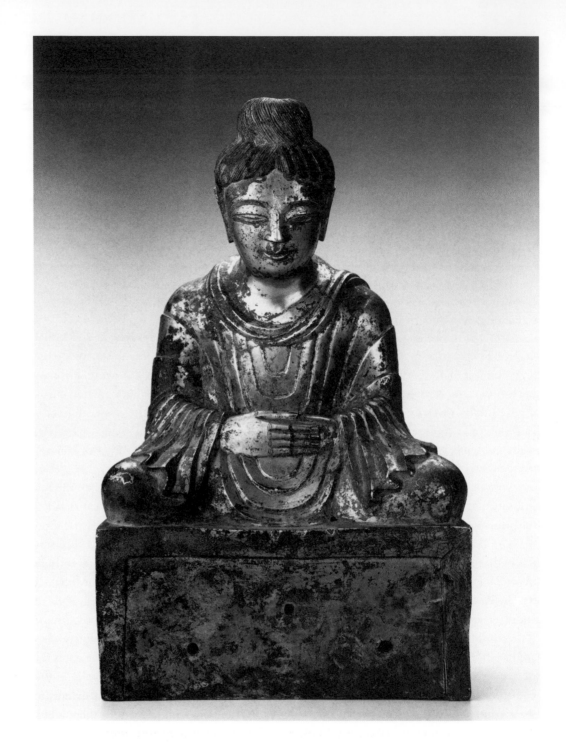

Han dynasty tombs that are known, only a small number contain any evidence of Buddhist imagery.[26] As we will see, the Buddha image was not systematically diffused and adopted; rather, it appears in distinct regions in identifiably local forms. It is also striking that no archaeological evidence for Han dynasty Buddhist visual imagery has been found in the many tombs excavated in the vicinity of Luoyang, which suggests that we are dealing with a phenomenon very different from either the Huang-Lao cult of the court or the translation projects of foreign monks and their lay supporters.[27] The extant historical record is a rich resource for understanding court Buddhism and the beginnings of textual translation and exegesis. These texts, however, are describing very specific sites of Buddhist activity that are unique and involve, for the most part, a tiny elite whose activities are known to us only because later elites, for reasons of their own, chose to record (and probably embellish) their stories.[28] The archaeological material to which we turn in this chapter is of a very different nature, one that has been preserved for us by chance, far removed from the narratives of elite historiography.

Tombs are also a very special kind of repository for visual images. Those with pictorial decoration and/or significant amounts of *mingqi* 明器, burial goods expressly produced for the tomb, were perquisites of the monied classes. Given that artifacts from tombs survive at a much higher rate than those above ground, we have in this material a body of evidence that is as skewed to the values of relatively privileged social groups as are the texts that describe court and monastic Buddhist activities. At the same time, the following discussion will include a variety of tomb types, from the largest multiroom structures to simple single chambers. It is clear from the size and contents of the tombs that the social class of the occupants and patrons ranges from a small number of identifiable members of ruling elite families to a few local high officials to many families of sufficient means to have tombs constructed but whose position in society is otherwise unspecified. A few of the latter tombs may have been the work of highly placed families, but the archaeological record does not permit us to confirm their status; some were probably the burials of lower-level bureaucrats and subbureaucrats as suggested by the Eastern Han patronage pattern.[29] The majority, whether they were officeholders or not, were most likely members of local landowning families of moderate means. It also seems possible that sufficiently wealthy individuals such as merchants would have emulated local landed elites in the practice of constructing tombs. Although the scale of tombs or the amount and type of objects provide some indication of wealth, we know from Han dynasty examples that officials with the same rank could have different size tombs, an indication that income from nonofficial sources such as landholdings were a significant factor in the wealth of any individual or family.[30] In addition, some families are said to have exhausted their resources to provide sumptuous tombs beyond their means; conversely, there is evidence that some elites insisted on a simple burial as a statement against ostentatious mortuary practices.[31] Such variables mean that a comparison of tombs and their contents will produce a measure of wealth as well as class modulated by the attitude of the patrons

toward burial practices. In terms of overall social class, then, we can say that early examples of the Buddha-like figure appear in the tombs of local elites of various kinds, some identifiably of the uppermost classes, others of a somewhat lower social standing.

Concepts of death and the afterlife are fundamental to the construction and decoration of tombs that were the contexts into which Buddhist imagery was first incorporated in China. Mortuary beliefs in the third century were closely related to a range of popular Chinese beliefs—distinct from orthodox Buddhism—that were widely shared across social classes. What we will find in various tombs is the expression of beliefs differentiated not by social class but modulated by wealth and status. We have ample evidence of the simple burials of the lowest classes in which few if any burial goods are found. For others who were able and willing to construct and furnish tombs, the archaeological record provides a glimpse of the concepts within which the image of the Buddha had resonance. Although it may seem at first glance that the use of the Buddha image was a very special case, it will become clear that the image functioned for the most part as quite an ordinary image.

SICHUAN TOMBS

Unambiguously Buddha-like figures have been found in tombs from the late second through the third century C.E. in two regions of China, the Southwest and the Southeast. The earliest extant examples of such figures are from Sichuan and adjacent areas of southwest China. Although none are dated by inscription, these works have been discovered in tombs placed by archaeologists in the latter part of the Eastern Han (25–220) dynasty or the Shu-Han (221–263) Kingdom. These early Buddha-like figures are an interesting contrast to the lack of historical documentation for organized Buddhism in southwest China during this period.[32] Thousands of tombs from this period have been excavated in Sichuan, and the small number of Buddha-like figures published to date makes it clear that the use of the Buddha image was not widespread.[33] I will begin with Buddha-like figures in the decorative carving of tombs and then discuss similar figures that were part of a mortuary object known as a money tree.

Only three examples of a Buddha-like figure used in the decoration of a tomb from this period are known, two in Shiziwan 柿子灣 Tomb 1 and one in Mahao 麻浩 Tomb 1.[34] Both tombs are located across the Min 岷 River from the city of Leshan 樂山 in western Sichuan. The Leshan area has long been known for the thousands of early tombs excavated tunnel-like deep into the mountainsides (map 2).[35] The majority of tombs here and throughout Sichuan are small and undecorated.[36] The larger excavations, with impressively long tunnels and small niches or side rooms, held pottery figures, animals, small architectural structures, bowls, and other objects along with stone coffins often carved in relief on the sides. Shiziwan Tomb 1 (fig. 2.3) is an elaboration on the basic type that adds a large antechamber, 14.6 m wide and 4.6 m deep (fig. 2.4) in front of a group of tombs.[37] From the exterior, three entrances open into the antechamber, each

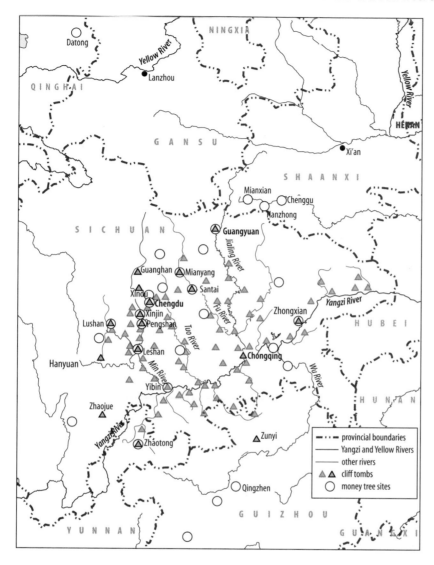

2 Sichuan cliff tombs
and money tree sites. By
Linda Huff after Tang Chang-
shou, "Shiziwan," 72, fig. 1;
and Erickson, "Money
Trees," 41.

aligned with the door of a tomb shaft in the back wall. Only two tombs, the middle
and right, were actually excavated.[38] A faintly incised outline indicates the position of
the third tomb door on the left. The rectangular antechamber is decorated with carving
on the back and side walls (fig. 2.5): a continuous motif of roof eaves and brackets along
the top, narrative scenes with themes of loyalty and filial piety below, and large guard-
ian figures to the sides of the middle and right tombs. Above the middle doorway there
is a small figure that appears to possess the standard iconographical traits of a Buddha
(fig. 2.6): the seated, crossed-legged meditative pose, the right hand raised in the mudra
of reassurance, the left hand holding the end of the monastic robes, a halo behind its
head, and the protuberance atop the head.[39] Although badly worn, this is an unambig-

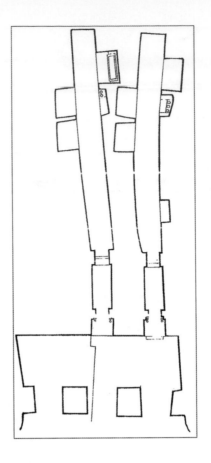

2.3 Plan, Shiziwan Tomb 1. From Tang Changshou, "Shiziwan," 73, fig. 2.

uous version of an Indian Buddha image (fig. 2.7) in contrast to other similar contemporary haloed figures, often with flames or wings rising from the shoulders, that some scholars have identified as Buddha images (fig. 2.1, second column from the left). A second Buddha-like figure, less well preserved, has been set in the center of the lintel above the right tomb entrance.[40]

A third Buddha-like figure is similarly positioned in the antechamber of nearby Mahao Tomb 1, a set of three shaft tombs with a common antechamber.[41] In all, eight similar entryways have been opened at the same level in the cliff face (fig. 2.8). The shared architectural motifs along much of the upper facade and the similar extent of weathering throughout suggests that the whole group was probably excavated in the same period at the end of the Eastern Han or early Shu-Han period. The orderly layout of the tombs further suggests a sequence of construction from left to right when facing the cliff.[42]

Beginning at the far left, the first two tombs, Tombs 4 and 3, are both short shafts into the cliff with an undecorated, common facade. The next pair of openings are entryways not of tomb shafts but into an antechamber, Tomb 2. The facade of the antechamber, with simulated eaves and beams carved as a decorative motif across the top, is

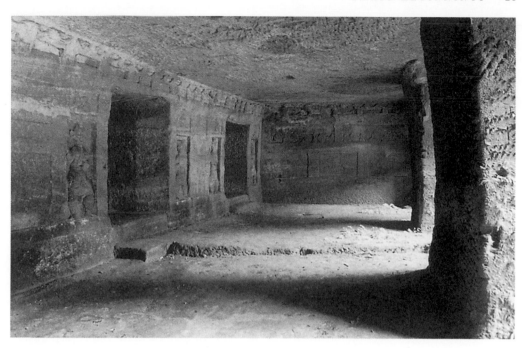

2.4 Antechamber, Shizi-wan Tomb 1, rear and right walls. From Tang Changshou, "Shiziwan," 74, fig. 6.

2.5 Walls of the ante-chamber, Shiziwan Tomb 1. By Linda Huff after Tang Changshou, "Shiziwan," 75, fig. 7.

cut several feet deeper into the cliff face than Tombs 4 and 3. The recession of the fa-cade and addition of the decoration may be understood as formal devices to differenti-ate Tomb 2 from the two tombs to the left. At the back of the antechamber are two shafts; the left is aligned with the left antechamber entryway but the right shaft does not correspond with the right entryway. It is possible that the left shaft was originally con-structed as a single tomb similar to the adjacent Tomb 3 with a shaft that extended to the cliff face—that is, the former entrance of the tomb corresponded with the current left entryway to the antechamber. In contrast, the lack of correspondence between the right shaft and antechamber entryway suggests that the right shaft never extended to the cliff face—that is, the antechamber was excavated before the shaft was opened. The ante-chamber may thus have been a modification which served to produce a pair of shafts that would link the occupant of the left shaft with a spouse or other family member interred

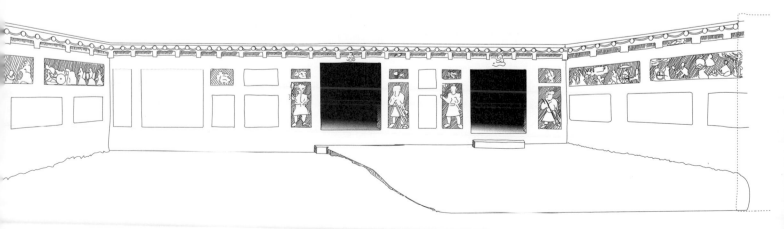

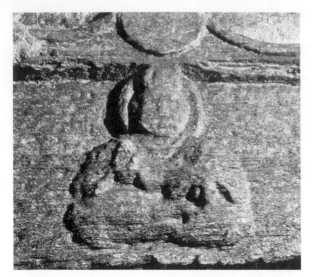

2.6 Seated Buddha-like figure, Shiziwan Tomb 1. From Tang Changshou, "Shiziwan," 77, fig. 15.

2.7 The adoration of the Buddha, Swât. As of 1962 in the collection of H. H. Major General Miângul Jahânzeb, H. Pak., H.Q.A., Wâli of Swât. Photo courtesy of the Istituto Italiano per l'Africa e l'Oriente, Neg. Dep R 4957. Originally published in Faccenna, *Sculptures from the Sacred Area*, vol. 2, part 3: pl. DXXXVI b.

in the right. In order to construct the antechamber as we find it today, the front section of the original left shaft would have been cut away and the original tomb entrance transformed into the left entryway of the antechamber, now aligned with the new entrance to the shaft at the back of the room. The rectangular antechamber is unfinished except for the relief carving across the top of the back wall that simulates the architectural motifs of tile and beam ends. A monster figure was carved above the entrance of the right shaft but no corresponding figure was carved above the left shaft opening. The lack of symmetry in the design suggests, as does the lack of finish on the side walls and the lower part of the back wall, that the antechamber was never completed. The addition of the monster above the right shaft may also signal a new practice, one that was not a part of the decorative scheme of earlier tombs but will be found in subsequent excavations.

The next three entryways open into the antechamber that is Tomb 1. This antechamber is separated from the one to the left by a jutting pier of stone and is further distinguished by the slightly projecting surface of the facade. The ground plan of the antechamber is asymmetrical and, unlike the relatively uniform shafts of Tombs 2–4, the three shafts in Tomb 1 differ significantly from the others in length and shape. In addition, the shafts are not perpendicular to the plane of the facade nor are they properly aligned to the corresponding antechamber entryways. This suggests that none of the shafts originally extended to the cliff face, making it likely that at least part of the current antechamber was planned before the first shaft was opened.

2.8 Plan, Mahao Tombs
1–4. By Margaret Hattori
after Leshan shi wenhuaju,
"Sichuan Leshan Mahao,"
112, fig. 1.

Tomb 4 Tomb 3 Tomb 2

Tomb 1

If the Mahao tombs were opened in sequence from left to right, we can discern a development from single to multiple shaft tombs: Tombs 4 and 3 are single shafts with no antechamber as was the adjacent third shaft; this single shaft was later joined to a fourth by an antechamber to form Tomb 2; then Tomb 1, which contains the Buddha-like figure, was opened as an antechamber. The area in front of the left shaft, which would have been the first to be opened, appears to be the space demarcated by the left and back walls of the original antechamber. The mystery is why the original back wall does not extend straight across the antechamber from left to right (fig. 2.9) and why the right wall is curved in contrast to what we find in Shiziwan Tomb 1 (fig. 2.3). One possibility is that the middle shaft was originally a pair with the left with both shaft entrances placed at the original back wall of the antechamber—that is, the current position of the left shaft entrance. As one would expect if this was the case, these two shaft entrances are in general correspondence with the exterior entryways into the antechamber. In addition, the unusually short length of the middle shaft would have been partially offset if this was the case. Such a scenario would be consistent with the pattern of the paired shafts of Tomb 2. When a third shaft was added, it appears that the left and middle pair was deliberately split. The new shaft was opened as closely as possible to the middle shaft—so close that the shaft could not be continued back in a straight line without breaking into the adjacent space—with the effect of producing the pair as found today. In addition, the rear

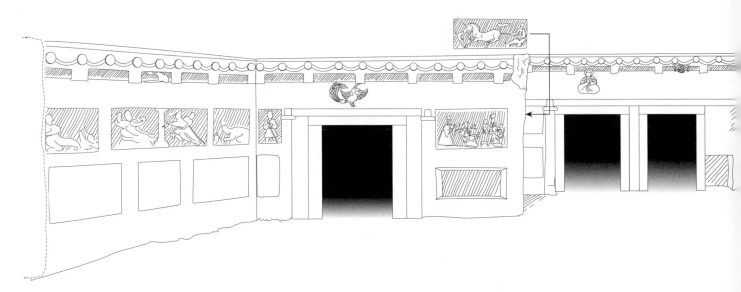

2.9 Antechamber, Mahao
Tomb 1, left and rear walls.
From Leshan shi wenhuaju,
"Sichuan Leshan Mahao,"
pl. 2: 1.

2.10 Walls of the ante-
chamber, Mahao Tomb 1. By
Linda Huff after Leshan shi
wenhuaju, "Sichuan Leshan
Mahao," 113, fig. 2.

2.11 Left wall, antecham-
ber, Mahao Tomb 1. From
Lim, *Stories from China's Past*,
197.

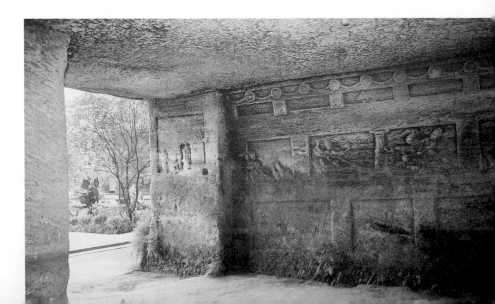

wall of the antechamber was cut back, possibly to further emphasize the new pairing of
the middle and right shafts in contrast to the left. The original right wall of the ante-
chamber was necessarily destroyed in the process of opening the right shaft and the new
right wall was left rounded and largely unfinished, possibly in anticipation of plans to add
still another shaft and widen the antechamber even further at a later date. This was never
accomplished, however, and today there is only a single shaft tomb with a low en-
tranceway, probably excavated at a slightly later date, to the right of the antechamber.

The above hypothetical sequence of construction in Tomb 1 is consistent with a lack
of a single program in the decoration of the antechamber (fig. 2.10).[43] Although the ar-
chitectural motif of simulated tile and beam ends running around the upper part of the
antechamber walls serves to unify the interior, the tile and beam ends are aligned one above
the other in the left wall but misaligned along the back walls. The scale, subject matter, and
form of the relief carving is quite disparate and positioned with little regard for symmetry.

The largest composition, which depicts Jing
Ke's attempted assassination of the King of
Qin, occurs on the left wall (fig. 2.11). A
smaller unidentified narrative scene is carved
at the same level on the rear wall to the right
of the left shaft entrance (fig. 2.12). The for-
mer is a long composition with isolated re-
lief figures arranged on a single ground plane.
In contrast, the latter scene features over-
lapping figures arranged on a tilted ground
plane. The other relief carvings, as one con-
tinues to move around the room to the right,
are even more varied: a horse held with a rope
by an attendant to the left of the center shaft
entrance (fig. 2.13); a scene of a house and
several figures adjacent to the right shaft en-
trance (fig. 2.14); then, facing the horse and at-
tendant across the opening of the center and right-hand shafts, a large standing figure in
high relief (fig. 2.15); this is followed along the right wall by a scene involving a man pulling
a cart. The lack of symmetry and order argues against a singular plan of conception espe-
cially when we compare this antechamber to that of Shiziwan Tomb 1 (fig. 2.5). It is prob-
able that the relief carvings were added at different times by different carvers.

The placement of motifs along the upper part of the walls similarly suggests the lack
of an overall program. Starting again on the left wall, a badly worn creature, possibly
four-legged, has been placed between the simulated beams above the Jing Ke scene
(fig. 2.11). Directly above the opening to the left shaft is a relief carving of a bird
(fig. 2.16), feet perched on the lower edge of the lintel, facing toward the viewer's right

2.12 Rubbing, unidentified scene, antechamber, rear wall, Mahao Tomb 1. From Rudolph, *Han Tomb Art of West China,* pl. 4.

2.13 Rubbing, horse held by rope, antechamber, rear wall, Mahao Tomb 1. From Rudolph, *Han Tomb Art of West China,* pl. 18.

2.14 Rubbing, house and figures, antechamber, rear wall, Mahao Tomb 1. From Rudolph, *Han Tomb Art of West China,* pl. 26.

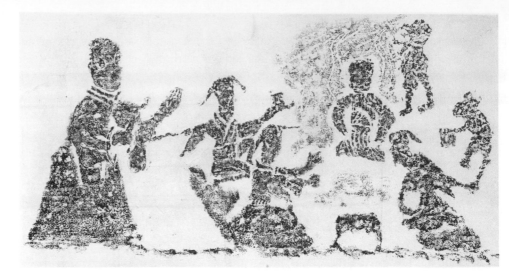

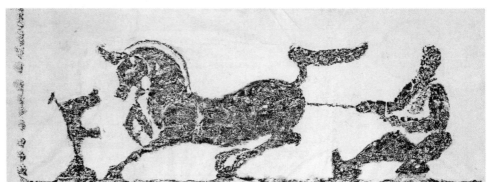

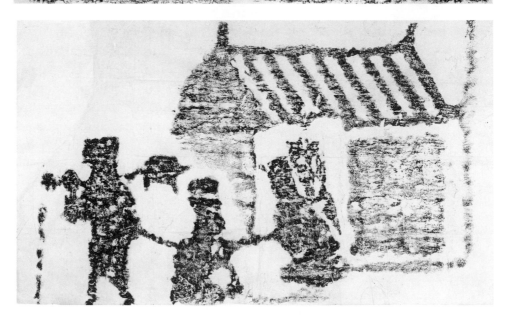

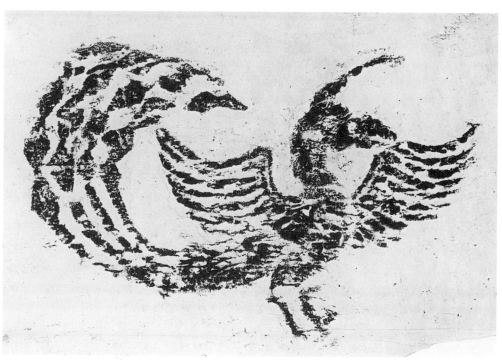

2.15 Standing figure and man pulling a cart, right rear corner, antechamber, Mahao Tomb 1. From Edwards, "Cave Reliefs," fig. 22.

2.16 Rubbing, Red Bird of the South, above left shaft, rear wall, Mahao Tomb 1. From Rudolph, *Han Tomb Art of West China*, pl. 24.

2.17 Center and right
shafts, rear wall, Mahao
Tomb 1. Photo by author.

with opened wings.[44] The bird has been identified as a phoenix or the Red Bird of the
South.[45] At the corner where the rear wall turns back there is another worn relief carv-
ing, possibly the image of a horse and rider. Next, above the opening to the center shaft
(fig. 2.17), is the seated Buddha-like figure, aligned, as was the bird, on the bottom edge
of the lintel. Between the simulated beams above the entrance to the right shaft is the
image of a large-headed monster (fig. 2.18), referred to as a monster-mask (*taotie* 饕餮)
by Rudolph.[46] Further along at the far corner is a kneeling fisherman and large fish.[47]
There are no corresponding figures on the unfinished upper right wall.

The Buddha-like figure (fig. 2.19) was placed in a position parallel to that of the
monster figure above the adjacent shaft and both were likely carved at the time the rear
wall of the antechamber was cut back and the right shaft added. To the extent that the
monster figure may be understood as apotropaic, a protector of the tomb and its occu-
pants, the Buddha-like figure may also be understood as having the same function over-
seeing the entrance to the middle shaft. The monster figure, to be differentiated from
the *pushou* 鋪首, a similar figure holding a ring, is rare in Han dynasty Sichuan tombs,
although it appears twice above shaft entrances at Mahao.[48] The bird above the left tomb
entrance is a more familiar motif in Sichuan.[49] In its position above the doorway, the
bird can be understood as either the auspicious *fenghuang* or the Red Bird of the South,
in the latter case having an additional apotropaic function as one of the *sishen* 四神, or
four directional animals.[50] Although it is not possible to determine whether the bird,

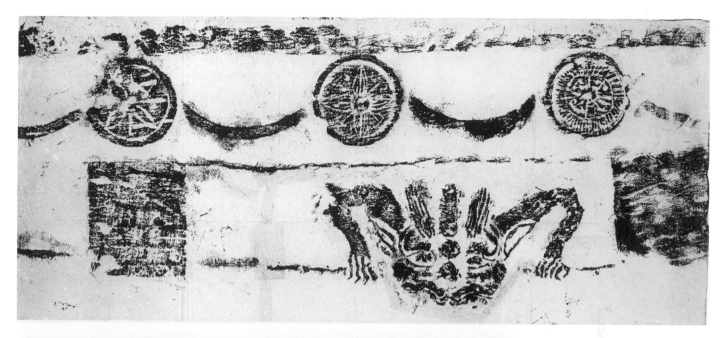

2.18 Rubbing, monster, above right shaft, rear wall, Mahao Tomb 1. From Rudolph, *Han Tomb Art of West China*, pl. 33.

2.19 Seated Buddha-like figure, above central shaft, rear wall, Mahao Tomb 1. Photo by author.

the Buddha, and monster figure were carved at the same time, the three images appear
to function as different but equivalent apotropaic figures. Beyond this limited conclu-
sion, there is little evidence for any larger iconographic program in which to situate the
Buddha-like figure in the Mahao tomb. In addition, the irregular form of the ante
chamber strongly suggests at least two phases of excavation, further rendering unlikely
a single, unified program for the relief carving on the walls.

A few conclusions can be drawn from the Buddha-like figures in the Shiziwan and
Mahao tombs. First, although the features of the figures accord with Indian Buddha im-
ages of the period, the function and meaning of the Buddha-like figure in these tombs
is anything but Buddhist. All three examples of Buddha-like figures are found in the
same position in the lintel above a tomb entrance, a position that is consistently occu-
pied by images with an apotropaic function. Second, there is little evidence to support
the theory that the function of the Buddha-like figure was related to the goal of im-
mortality or the widespread cult of the Queen Mother of the West (Xiwangmu 西王母).[51]
Richard Rudolph has implied that the unidentified narrative scene to the right of the left
shaft entrance in Mahao Tomb 1 (fig. 2.12) might relate to the Queen Mother in that
some of the smaller attendant figures are "reminiscent" of donors in Queen Mother
scenes from Sichuan.[52] But there are significant differences from other Sichuan depic-
tions of the Queen Mother, especially the presence of the large standing figure to the
left and the lack of the ubiquitous tiger/dragon throne (fig. 2.20). Wu Hung has argued
for a visual parallel between the Buddha image in Mahao Tomb 1 and the Queen
Mother of the West and King Father of the East (Dongwanggong 東王公) images in the
gables of the Wu Liang shrine in Shandong province.[53] But there are no images of the
Queen Mother of the West, the King Father of the East, or immortals (shenxian 神仙)
carved above tomb entrances in Sichuan or, for that matter, in the upper part of Sichuan
tombs. This does not deny that images of the Queen Mother and shenxian are found in
Sichuan mortuary contexts; rather, these are found in other forms such as large pottery
tiles (fig. 2.20), relief carving on the exterior of stone coffins, freestanding sculpture,
and, as will be discussed below, figural imagery on money trees and pottery bases.[54]

Finally, the use of the Buddha-like figure in the decorative scheme of Sichuan tombs
is a rarity among the thousands of tombs known from this period. These three examples
appear in tombs very near to each other, are almost identical images, and are carved in
identical positions above a tomb entrance in the back wall of an antechamber. The ap-
pearance of the three Buddha-like figures thus seems to represent a specific, isolated
instance of the insertion of a foreign motif into the vocabulary of Chinese tomb deco-
ration. Nothing in the archaeological record to date suggests that the innovation was
popular or influential locally or in other parts of Sichuan Province. Rather than repre-
senting a practice widespread in Sichuan, these Buddha-like figures are an example of
how an idiosyncratic choice of motif can have little impact on the normative practices
of tomb decoration.

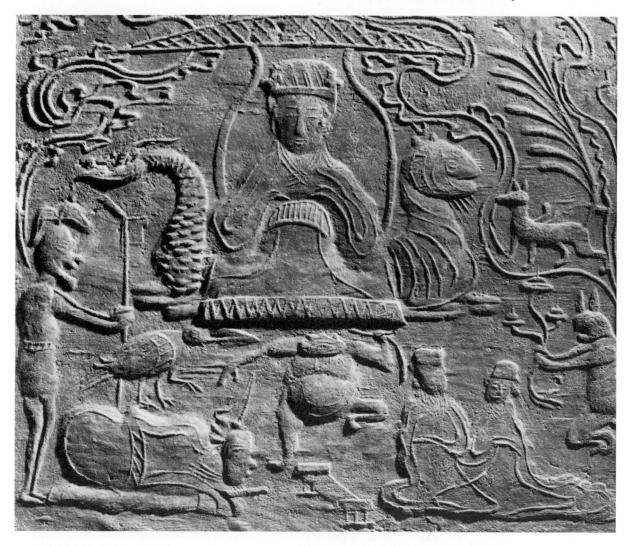

MONEY TREES

The Buddha-like figure is found on one other type of work in southwest China, an elaborate mortuary object found in Eastern Han or Shu-Han tombs known as a money tree (*yaoqianshu* 搖錢樹), so named because of the recurring motif of coins hanging from the branches (fig. 2.21).[55] As of the early 1990s, the ceramic or stone bases and/or the bronze fragments of the superstructure of some seventy money trees had been excavated and published.[56] Their find spots (map 2) are concentrated in Sichuan Province and neighboring sites in Shaanxi to the north and Yunnan and Guizhou to the south.[57] Only a handful of excavated and completely reconstructed money trees have been published: (1) Sichuan Pengshan Shuangjiang 彭山雙江, 135 cm high;[58] (2) Sichuan Mianyang Hejiashan 綿陽何家山 Tomb 2, 198 cm high;[59] (3) Sichuan Guanghan Lianshan 廣漢連山, 153

2.20 Queen Mother of the West, pottery tomb tile, from Chengdu, 40 x 46.5 cm. Photograph from the Sichuan Provincial Museum.

2.21 Money tree with base, from Pengshan, Sichuan. From Rawson, *Mysteries of Ancient China,* 177, no. 87.

cm high;[60] and (4) Sichuan Santai Hujiabian 三台胡家堖, 141 cm high.[61] In addition, a number of reconstructed works have appeared outside China in recent years;[62] and other similar works are known but unpublished.[63]

The reason for the relatively few assembled trees is that the bronze superstructure of excavated works has in every case collapsed and most often only fragments of the fragile branches have been recovered. Even among the reconstructed trees, some are incomplete and others are composites, made up of parts from one or more trees, and at times completed with the addition of recently manufactured sections.[64] These circumstances limit our ability to be certain about the original iconographic program of the assembled trees.[65] The one money tree that is said to have been found intact is the tree from Pengshan (fig. 2.21), not far from Leshan in central Sichuan, although there is no excavation report to confirm its condition in the tomb.[66] The superstructure consists of a thin, hollow bronze trunk inserted into a pottery base; attached are five rows of branches aligned to the four cardinal directions and at the apex is a large bird, often found atop reconstructed money trees and commonly identified as a *zhuque* or rose finch, the Red Bird of the South.[67] The branches of the topmost row (fig. 2.22) have a different design from the four lower rows, each of which is made up of identical branch sections. The delicate, openwork branches are cast in a two-piece mold, front and back. Coins with radiating forms suggestive of vegetation or rays of light extend from the branches. Each branch features the Queen Mother on her tiger and dragon throne along with a variety of small figures and animals. This range of subject matter is typical of money trees, which may also have *bi* 璧 disks, various kinds of celestial figures, and auspicious animals and birds, as well as plants related to the production of elixirs of immortality such as the *lingzhi* 靈芝.[68] Although the theme of immortality in the afterlife is consistent, the range and combination of motifs vary from tree to tree.

Money tree bases were similarly diverse. The base of the Pengshan tree (fig. 2.21), with a winged quadruped beast atop a ram-like creature, represents one of the most often excavated types; others include bases with a rider on a pair of winged ram-like animals, one atop the other, or bases formed as representations of mountain landscapes with small figures. In order to provide support for the tall trunk and extended branches of the bronze superstructure, bases have significant girth and typically extend 35 to 60 cm in height.

The best-known example of a Buddha-like figure from the Southwest is carved on a small pottery base (fig. 2.23), 21 cm high, from Pengshan.[69] On the front half, which is all that survives of the base, the Buddha-like figure is depicted in a heavy robe with deep, parallel folds; its hair is piled atop the head in an approximation of a Buddha's *uṣṇīṣa*. The right hand is raised, possibly in *abhaya* mudra, while the left appears to grasp an end of drapery, all of the above being consistent with the Buddha-like figures from Shiziwan and Mahao. Two smaller figures, one in trousers and the other wearing a long

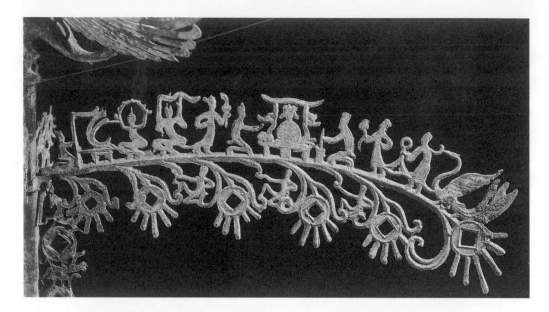

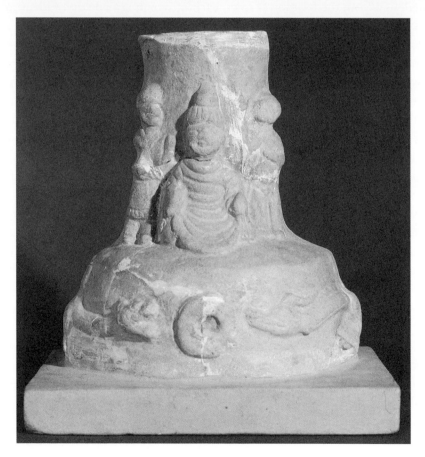

coat, stand to each side, while below the seated figure is carved a *bi* disk between a pair of adorsed dragons. The seated image with small, standing attendant figures is reminiscent of the Buddha flanked by adoring figures in figure 2.7, but the pose of the figure on the right with its back to the viewer is atypical. Although the high collar and the motif of a *bi* framed by adorsed dragons recalls forms found on money tree bases, the small scale makes apparent the impracticality of such a base supporting a tall money tree superstructure with overhanging branches.[70] In fact, no bronze sections of a money tree were recovered from the tomb that yielded the base.[71]

The figure on the Pengshan base was identified as a Buddha as early as the mid-1950s.[72] Soon after, Yang Hong cited the base as an example of one of the earliest works of Buddhist art in China.[73] Yang Hong appears to have been the first to identify the work as the base of a money tree and to suggest that the Buddha image was placed in a position often occupied by immortals *(shenxian)* such as the Queen Mother. As support, the author cited a 1961 essay in which Yu Haoliang states that the Queen Mother is found on money tree bases along with other *shenxian*-related imagery set among three peaks, which indicates that the bases are a depiction of a spirit mountain *(shenshan* 神山), the mountain abode of an immortal.[74] Yu Weichao in 1980 also referred to Yu Haoliang's essay to again identify the Pengshan work as a money tree base and to claim that images of the King Father (which Yu Haoliang does not mention), the Queen Mother, and other *shenxian* were to be found on other money tree bases. All of this indicates to Yu Weichao how Buddhism was first introduced into Daoist and other Chinese belief systems.[75] More recently, Wu Hung cited the Yu Haoliang essay as the basis for stating that "most of the Han money tree stands discovered so far are decorated with images of the Queen Mother of the West."[76] Despite his claim for the importance of the Queen Mother on money tree bases, however, Yu Haoliang failed to provide a single image of the Queen Mother among the six bases illustrated in his essay. The lack of documentation may have been a result of the difficulties of archaeological publishing at that time; but today, among the several dozen published bases, none depict the King Father and only five include the Queen Mother.[77] Although the money tree bases that remain unpublished could significantly alter our understanding, at present it does not appear that the Queen Mother was as ubiquitous on money tree bases as previously thought.

Images of the Queen Mother, however, are found on other kinds of bases. Some are large but clearly not made to support a money tree such as the 60 cm tall turtle and toad base from Chengdu.[78] Others are similar in scale to the Pengshan base with the Buddha-like figure, for example the square base, 14 cm high, from Xindu Majiashan 新都馬家山 Tomb 3.[79] The base was one of two discovered in the tomb; the other, carved with a ram-like animal in the upper register around the collar and standing 45 cm high, appears to be a money tree base. The smaller base likely served a different function, possibly as a stand for a lamp. Another modest base with an image of the Queen Mother is from Guanghan and stands 28 cm high (fig. 2.24). Chen Xiandan identifies the work as a base

2.24 Money tree base,
from Guanghan, Sichuan.
From Chen Xiandan, "On
the Designation," 71, fig. 8.

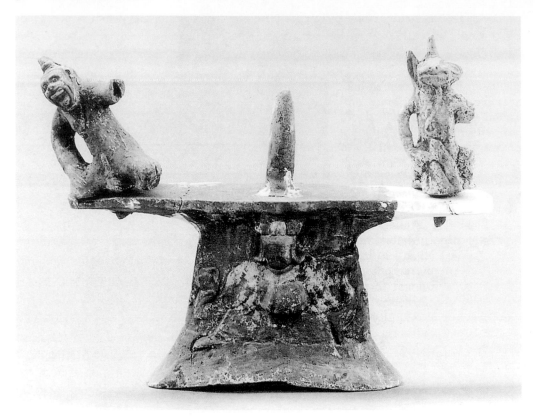

for a money tree, but also inexplicably states that the projecting member in the center is the representation of a phallus.[80] Since reconstructed money trees in all cases have trunks inserted into the base, the projection indicates that this base was not made to hold a money tree trunk. Equivocation over the function of the pottery bases from Sichuan has been the norm. For example, Erickson lists six bases from Pengshan with heights ranging from 15 to 64 cm as money tree bases.[81] Yet the bases are described in the 1991 report on the Pengshan tombs simply as *chazuo* 插座, or generic bases, literally a base for something to be inserted into.[82] Three of these appear to be typical money tree bases, large (between 42 and 64 cm tall) and carved with winged ram-like figures in the upper section and branches with coins in the lower. Two other bases (16 and 39 cm tall) are shaped in the form of a toad, while the last is the 21 cm high base with the Buddha-like figure. Although toad bases have been identified in some publications as money tree bases, they have not been discovered in conjunction with bronze money tree parts and have not been used in reconstructed trees.[83] As for the Pengshan base with the Buddha-like figure, several recent publications have followed the 1991 publication in describing it simply as a *chazuo*.[84]

Several observations can be made from the above. First, the Queen Mother is an important figure on various kinds of pottery bases in the Southwest, but in relation to the total number of examples, she is represented in a surprisingly small number of cases. It might therefore be prudent to consider the depiction of the Queen Mother as one among many alternatives for the decoration of bases and remember that in the great majority of cases her image was eschewed. Second, there is only one, solitary example of a Buddha-like figure on a base from the Southwest and it is found on a work that in all probability was not from a money tree. Although the visual parallel between the Pengshan Buddha-like figure and the Queen Mother remains suggestive, the use of the Buddha-like figure was a singular exception and one might be cautious in accepting the relationship of the two images as evidence for a larger *pattern* of equivalency or interchangeability. Third, in terms of form, the Pengshan base is idiosyncratic, and in scale more closely comparable to the small base in figure 2.24 than money tree bases. The emphasis of much past scholarship on the relationship between the money tree bases and the Queen Mother of the West as well as on the Pengshan base Buddha image and the Queen Mother appears to have been greatly overstated. The crucial role of Yu Haoliang's 1961 essay for the dissemination of certain concepts about the Queen Mother and money tree bases helps to remind us of the sometimes uncritical manner in which our scholarly practices create knowledge through citation and assumption.

If we turn to the superstructure of the money tree, we find a larger number of examples of the Buddha-like figures on the bronze trunk sections. The Buddha-like figures are nearly identical, each with a large *uṣṇīṣa,* right hand raised in *abhaya* mudra, left hand grasping the end of the robe, and a distinctive U-shaped loop to the drapery between the two hands (fig. 2.25). All were cast from a pair of molds, front and back, with small representations of coins forming an aura around the seated images.[85] The figures have been discovered at four scattered sites in central Sichuan (Mianyang), eastern Sichuan (Zhongxian 忠縣), Guizhou 貴州 (Qingzhen 清鎮), and Shaanxi (Hanzhong 漢中). Several similar trunk fragments with Buddha-like figures in collections outside of China are thought to be from bronze trees of this period.[86]

Near Mianyang, two adjacent tombs, Hejiashan Tombs 1 and 2, contained money trees. Tomb 2, a modest single chamber of 5.35 m in length, was filled with over ninety items, including a large bronze horse and two money tree bases plus assorted fragments of the bronze superstructure. One large tree with no Buddha-like or other figures on the trunk has been reconstructed and published from the fragments.[87] The tree (fig. 2.26) is topped by a large bird above an image of the Queen Mother of the West on her dragon/tiger throne; on the lower branches are a dragon's head and elephant as well as images of deer, birds, and feathered immortals (*xianren* 仙人). The slightly larger Heji-

2.25 Drawing and rub-
bing, Buddha-like figures on
money tree trunk, Mianyang
Hejiashan Tomb 1. From
Mianyang bowuguan and He
Zhiguo, "Sichuan Mianyang
Hejiashan yihao," 6, figs.
19–20.

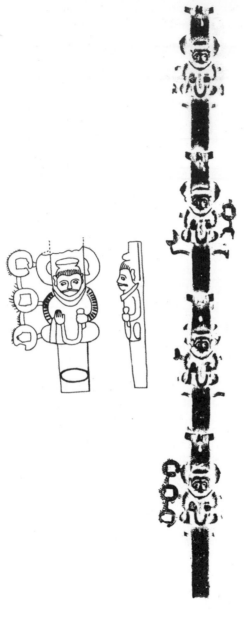

ashan Tomb 1 had front and rear chambers (fig. 2.27), 5.3 and 2.5 m long respectively, which, although partially collapsed, were not disturbed by tomb robbers. In addition to four coffins, two in each room, the tomb contained some thirty-five objects, including attendant figures, a small bronze *pushou*, a *shenshou* 神獸 (deities with mythical animals) mirror, and a money tree. The *pushou* recalls the apotropaic monster figure in the Mahao tomb, while the mirror contains images of a pair of seated winged figures that are named in the mirror inscription as Ximu Dong-wang 西母東王 (the Queen Mother of the West and the King Father of the East).[88] Surprisingly little of the money tree was found: a trunk, 76 cm long, consisting of four segments, each with a Buddha-like figure; a single section of the trunk with a Buddha-like figure (fig. 2.25); and three fragments of the superstructure, two branches with *xian-ren* and a dragon respectively and a *bi* disk surmounted by a rider on a horse. Even more puzzling for an undisturbed tomb, the money tree base, only 22 cm high and described as incomplete, was discovered at the head of one coffin while the fragments of the tree lay at the foot of the same coffin (fig. 2.27). This suggests that the tree was not complete or assembled when it was placed in the tomb. Even so, it is significant that in these two nearby and contemporary examples of money trees, we find the Queen Mother and the Buddha-like figure situated in very different parts of the tree.

In eastern Sichuan, Zhongxian Tujing 涂井 Tombs 5, 7, and 14, dated to the early Shu-Han period, contained the remains of four money trees.[89] Tomb 7 had only a few fragments of a tree that have not been published. Tombs 5 and 14, however, yielded a total of fourteen trunk segments with Buddha-like figures. Tomb 5, a large, intact, and undisturbed double-chambered excavation over 12 m in length, contained some 140 items. Among the rich and varied tomb goods was one money tree (1.26 m tall) in the

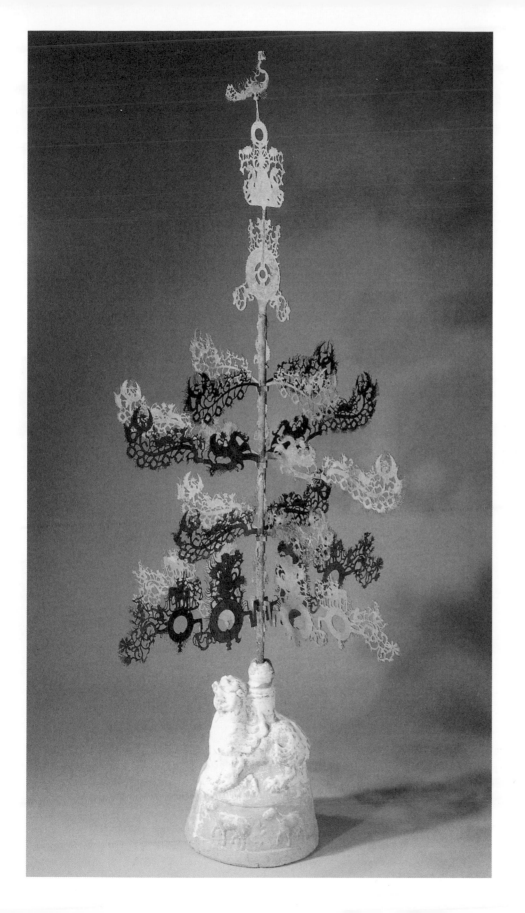

2.26 Bronze money tree
with pottery base, from
Mianyang Hejiashan Tomb 2,
Sichuan. From Zhongguo
wenwu jinghua bianji
weiyuanhui, *Zhongguo wenwu
jinghua,* no. 82.

16 15 14 13 12 11 10 9 8 7 6 5 4 3 2 1

17 18 19 20 21 22 23
 24
 25

 26 34 32
 33
35 27 28 31
 30 29

2.27 Plan, Mianyang Heji-
ashan Tomb 1, Sichuan (*26:*
money tree base; *31: pushou;
32:* money tree trunk). From
Mianyang bowuguan and He
Zhiguo, "Sichuan Mianyang
Hejiashan erhao," fig. 2.

front room with a trunk composed of six segments, each with a Buddha-like figure in the center (fig. 2.28). Fragments of the superstructure were also preserved but are said to lack the familiar motifs of the Queen Mother, immortals, and beasts found on other money trees.[90] Two money trees were found in Tomb 14, a modest single-room tomb, one with three trunk segments and the other with five. All eight pieces featured Buddha-like figures almost identical to those found in Tomb 5 with the exception of two segments in which the Buddha-like figure was flanked by a pair of cicadas (fig. 2.29).[91] Although the archaeological reports sometimes lack crucial details and none of the

2.28 *Below left:* Trunk
segment with Buddha-like
figure, bronze money tree,
from Zhongxian Tujing
Tomb 5, Sichuan. From
He Yun'ao, *Fojiao chuchuan,*
fig. 12.

2.29 *Below right:* Trunk
segment with Buddha-like
figure flanked by cicadas,
bronze money tree, from
Zhongxian Tujing Tomb 14,
Sichuan. After He Yun'ao,
Fojiao chuchuan, fig. 11.

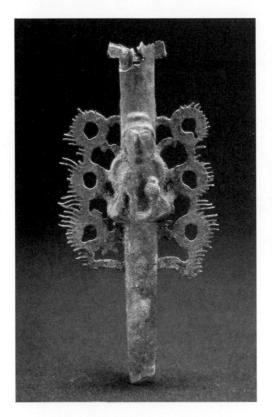

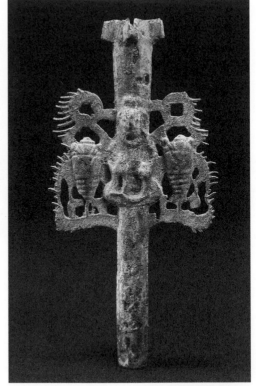

Zhongxian money trees have been reconstructed, it is notable that images of the Queen Mother appear to have been absent from works that contained a Buddha-like figure.

To the south in Guizhou, remains of money trees were discovered in Qingzhen Pingba 平壩 Tombs 1 and 11.[92] The published fragments from Tomb 11 include a bronze tree fragment with a phoenix and a single section of a money tree trunk with a Buddha-like figure (fig. 2.30). Tomb 1 contained part of a tree branch and a segment of a trunk with a relief image of a bear inside a circle (fig. 2.31). A similar example of the bear motif can be found on the Royal Ontario Museum money tree (fig. 2.32), where a series of five bears seated within circles decorates the trunk of the incomplete superstructure.[93] The placement of the bear and the Buddha-like figure in corresponding positions on the trunk suggests a parallel understanding of the two motifs in Guizhou. The bear is also prominent on a base from Yunnan Zhaotong 雲南昭通 Tomb 1. Here, in an unusual design, one large bear straddles three others, each fiercely aligned in one of the four cardinal directions. This unusual base, only 28 cm tall, further indicates the important role of the bear as an apotropaic figure in the far south. Although reconstructed as a money tree, the relationship between the base and the money tree fragments is quite awkward, leaving open the possibility that the base and the tree were not originally made for each other.[94]

2.30 *Below left:* Drawing, Buddha-like figure on money tree trunk, Qingzhen, Pingba Tomb 11. From Guizhou sheng bowuguan, "Guizhou Qingzhen Pingba Hanmu fajue baogao," fig. 10, no. 5.

2.31 *Below center:* Drawing, bear on money tree trunk, Qingzhen Pingba Tomb 1. Guizhou sheng bowuguan, "Guizhou Qingzhen Pingba Hanmu fajue baogao," fig. 12 right.

2.32 *Below right:* Bronze Money Tree, detail, Royal Ontario Museum 994.62.1.1–14. Photo by author.

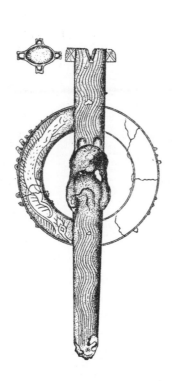
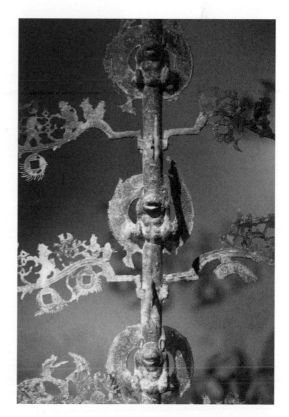

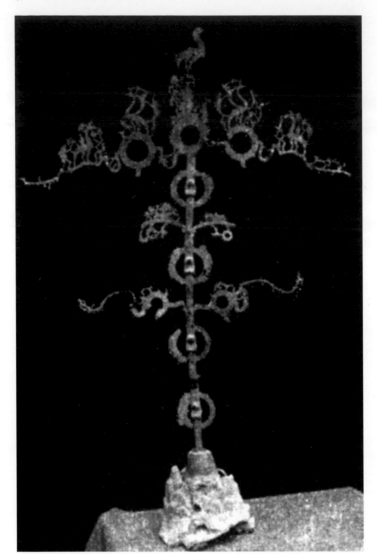

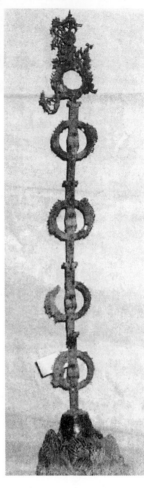

To the north of Sichuan, tombs in the area of southern Shaanxi Province around Hanzhong have yielded parts of five money trees. In one, Hanzhong Puzhen 鋪鎮 Tomb 85M5, the money tree appears to have three Buddha-like figures on the trunk (although they are described in the excavation report simply as images of a seated person).[95] The tomb, one of a group of seven, consists of a short passageway and single room, 6.75 m long, with some small pottery *mingqi,* a bronze mirror, and the money tree. The assembled fragments of the superstructure, according to the single small photo, have been reconstructed haphazardly around the trunk segments with the Buddha-like figures to a length of 50 cm. The base, not illustrated, is described as being in the shape of pointed mountains with figures of a dog and a bear; it is quite small (21 cm high, 23 cm in di-

ameter), an indication that it may be a fragment. The adjacent Tomb 85M4 is reported to have contained parts of a money tree but no base; the tomb also contained a small, uninscribed jar (85M4:19) that held ten lead men. In nearby Mianxian Hongmiao 勉縣紅廟, a tomb with many bronze objects, including four mirrors, also contained a money tree, partially reconstructed to a height of 89.5 cm.[96] The four trunk segments each feature a small figure which, although identified as a monkey in the excavation report, appears in the small photograph to be a bear.

As the vagaries of the often poorly illustrated excavation reports demonstrate, archaeological publications vary in accuracy and quality. Plans and descriptions, as Chinese scholars themselves point out, cannot always be accepted at face value. The publication of another money tree from Shaanxi, near Chenggu 城固 in Hanzhong, is a case in point. The work was published in 1987 as a *taodu* 桃都, a kind of celestial tree (fig. 2.33), with a bird finial atop an incised female figure.[97] The four figures seated within large circles on the trunk segments were described as monkeys. A similar money tree from Chenggu surmounted by a Buddha-like figure with four bears on the trunk segments was recently published (fig. 2.34).[98] Although the latter essay does not acknowledge the earlier publication, a comparison of the illustrations strongly suggests that the components in both cases are the same. The later reconstruction has no branches or bird finial, which are separately described, but the same four figures on the trunk segments—identifiable here as bears, not monkeys—are present. The incised depiction of the top-

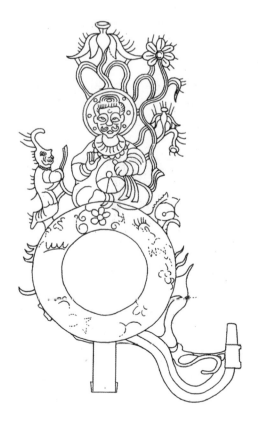

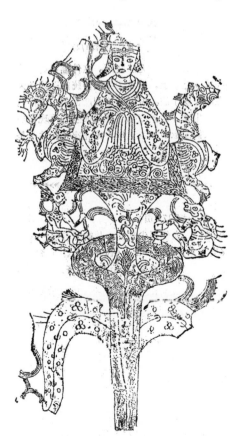

2.35 *Below left:* Drawing, Buddha-like figure, bronze money tree segment, Chenggu, Shaanxi. From Luo Erhu, "Shaanxi Chenggu chutu," 65, fig. 3.

2.36 *Below right:* Drawing, Queen Mother of the West, bronze money tree segment, Xichang, Sichuan. After Liu Shixu, "Sichuan Xichang Gaocao chutu," 279, fig. 1.

2.37 Bear flanked by two
rams, lintel, unidentified
tomb, Pengshan. From a
photograph displayed at the
Leshan Museum.

most seated figure, however, is now described as a Buddha-like figure, albeit one that is
hardly convincing in the hand-drawn illustration (fig. 2.35). Since neither the earlier nor
the later photographs of the figure disclose anything of the form, we are left to take the
word of the author.

Judging from other examples, however, the seated figure on the Chenggu money
tree should be a female figure usually identified as the Queen Mother (see figs. 2.26 and
2.36). If it is indeed a Buddha-like figure, the Chenggu work would represent the sole
example of a Buddha-like figure placed in a position usually occupied by an image of
the Queen Mother. In all other examples, the Buddha-like figure is found only on the
trunk segment while images of the Queen Mother are depicted only in the branches and
tops of money trees. In those few occasions in which the Buddha-like figure was de-
picted, in other words, it was placed not in the position of the Queen Mother but in a
part of the tree decorated with images of bears.[99] The depiction of a squatting bear
flanked by a pair of rams above a tomb entrance at Pengshan (fig. 2.37) indicates that
one understanding of the bear was as an apotropaic figure similar to the Buddha image
in Mahao Tomb 1.[100]

The apotropaic function of the bear is reminiscent of the description in an early text,
the *Zhouli* 周禮, of the exorcist (*fangxiangshi* 方相氏) who dons a bearskin before con-
ducting rituals that include driving demons from a tomb. The *Zhouli,* however, is con-
cerned with state and royal rituals; the description of the tomb exorcism specifically
refers to great funerals and it should not be assumed that such practices were wide-
spread.[101] We are therefore fortunate to have a comment on the *Zhouli* passage in a late
Eastern Han text, the *Fengsu tongyi* 風俗通義, by Ying Shao 應劭 (c. 140–before 204), an
official who once held the post of governor (*taishou* 太守) of a commandery in Shandong

Province.[102] Although Ying Shao lived far from the Southwest, the text is contemporary with money trees and the author is commenting on the ordinary cult practices of his time. The passage states that although the *fangxiangshi* exorcises demons in the tomb as described in the *Zhouli,* the exorcist cannot constantly guard the tomb. Therefore, one plants a thuja tree over the tomb and places a stone tiger in front of it in order to ward off demons.[103] While the text suggests that the practice of tomb exorcism was common, it is striking that the apotropaic measures are positioned outside, not inside, the tomb. If we return to the visual evidence of the money trees, which are always found inside the tomb, it seems clear that the bears are bears and not exorcists wearing bearskins. Alternatively, Erickson has identified a rotund figure on the branches of the money tree from Mianyang Hejiashan Tomb 2 (fig. 2.38) as a *fangxiangshi* based on the energetic posture which is similar to that of a "demon expeller" in the Western Han tomb of Bu Qianqiu 卜千秋 in Luoyang.[104]

What is suggested then is not so much a literal equivalency between bear and exorcist, but a semiotic relationship in which the bearskin visually signifies an apotropaic meaning for the bear. There is, however, no lack of other possibilities for the meaning

2.38 Rubbing, *Fangxiangshi* (?), bronze money tree segment, Mianyang Hejiashan Tomb 2, Sichuan. From Mianyang bowuguan and He Zhiguo, "Sichuan Mianyang Hejiashan yihao," 17, fig. 29, no. 5.

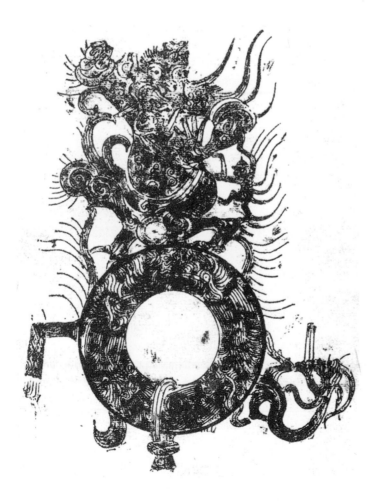

of the bear based on other early Chinese texts. Erickson follows Zhong Jian, who draws on the *Shanhai jing* 山海經, *Zuozhuan* 左傳, and *Guoyu* 國語 to suggest that the bear represents Gun 鯀, the father of Yu 禹 the Great, who was transformed into a bear.[105] She also mentions the "bear ramble" (*xiong jing* 熊經), an exercise for longevity-seekers mentioned in *Zhuangzi* 莊子.[106] Kominami maintains that, based on the correlative system of five phases (*wuxing* 五行) as presented in *Huainanzi* 淮南子, the bear should be regarded as the yellow bear symbolic of the earth (*dadi* 大地).[107] Yu Haoliang, as part of his argument that the money tree is related to a spirit mountain *(shenshan),* quotes from the *Yiwen leiju* 藝文類聚, which states that a bear is among the animals that inhabit a spirit mountain.[108] Chen Xiandan declares that "the bear is inseparably linked to the Dongwanggong [King Father of the East], and they are mentioned together in the *Shenyi jing.*"[109] Still another possibility is that bears served as an animal "helper" in the passage from earth to the heavens. An eloquent proposal for such an understanding of animal motifs on Shang bronze vessels has been made by K. C. Chang based on passages from the *Zuozhuan, Guoyu,* and *Shanhai jing.*[110] Alternatively, if the bear were considered in the context of the scheme of good omens (*xiangrui* 祥瑞) popular during the Han dynasty, it could be identified as the red bear, which is known from the Wu Liang shrine in Shandong.[111]

Most readers will probably find these explanations suggestive to varying degrees. The principal issue, however, is the extent to which such evidence correlates with the imagery. Extant ancient texts—whether historical, anecdotal, hagiographical, or religious in nature—were produced by and for the intellectual elite and were inevitably engaged in political and philosophical debates with specific historic configurations that were not necessarily resonant with popular mortuary practice. When texts are applied with care and skill to visual imagery of the same social class, time, and place, their value can be immense, particularly in relation to the production of visual imagery for literati elites.[112] If, as is too often the case, textual passages are cited as generic expressions of a Chinese "mentality" with little attention to their historic relationship to the images, the result may be less than useful. Even in the case of Ying Shao's *Fengsu tongyi*—where the text is describing ordinary beliefs contemporary with the visual imagery, and the social position of the author may have been close to that of the patrons of the imagery—one cannot assume that the text answers questions posed by specific imagery from a tomb. In fact, the relationship between the two kinds of evidence, textual and artifactual, remains oblique. This should not be a surprise, considering the obvious but usually unacknowledged reality that the extant texts as well as the archaeological record, while extraordinarily rich, are not comprehensive or balanced but the fragmentary and incomplete *chance* remains of the past. Although we have little choice but to draw on the available textual and archaeological evidence, we should beware thinking that these provide us with a complete account of the wide variety of beliefs about death and the afterlife held during this period. They cannot, and thus many crucial questions must remain unclear,

for example, the simultaneous holding of seemingly (from a certain point of view) contradictory beliefs about the afterlife, a characteristic of Chinese popular religion.

Despite the plethora of references to the bear in extant Chinese texts, there is no obvious textual explanation for the function or meaning of the bear motif on money tree trunks. Nor is there evidence of any special relationship between the bear and Buddhism in Sichuan during the second and third centuries. Yet the bear and the Buddha-like figure appear to have been interchangeable motifs on money trees. Their striking visual affinity (compare figs. 2.25, 2.28–2.31) suggests this possibility not only because of a related function or meaning but because their forms were so similar that each could be easily mistaken or substituted for the other. Thus the Buddha-like figure may have been adopted in this context as much for its visual affinity with the bear as for its significance as a deity of foreign origin or its correlation with a Chinese deity.

This is not to say that the visual and archaeological evidence does not have its own special problems. We have seen that in all except one case (and, without an excavation report, it would probably be prudent to remain skeptical about this exception), the extant money trees are fragments or reconstructions, at times combining pieces from more than one tree and/or including modern reproductions of sections. So perhaps extant "complete" trees do not represent the original arrangement of the imagery. For example, the money tree recently acquired by the Asian Art Museum features a single trunk segment with a Buddha-like figure near the top of the tree just below a large section featuring the Queen Mother.[113] The trunks of money trees excavated in China, however, are of two distinct types: either a series of plain trunk segments or a set of five or six identical segments each with a bear or Buddha-like figure. There are no examples of a single segment with a figure as part of an otherwise plain trunk, which strongly indicates that the Buddha-like figure is a segment from a different money tree. The position of the Buddha-like figure on the Asian Art Museum tree can be understood as one example of the manner in which the theory that the Queen Mother and the Buddha-like figure were closely related produces visual evidence for itself. It is, of course, the fragmentary and incomplete nature of extant money trees on one hand and our desire to exhibit whole works of art on the other that prompts such problematic reconstructions. It is also important to remember that in Mianyang Hejiashan Tomb 1, in which the grave goods appear to be for the most part in their original position, the base and the tree fragments—five segments of the trunk each with a Buddha-like figure and a few other branch pieces—were completely separated (fig. 2.27). This indicates that incomplete money trees were sometimes interred, which raises further questions as to the meaning and use of such fragments as well as the relevance of completely reconstructed trees for the original function of the money tree in the tomb.

While the problematic nature of the evidence as well as the unreliability of excavation reports suggest caution, there appear to be at least two iconographical types of money tree: one that featured the Queen Mother in the branches and upper section, and

one with bears or Buddha-like figures molded on the trunk segments. These seem at present to be mutually exclusive—that is, distinct alternatives that were not combined. In addition, the geographic distribution of the types suggests that trees with the Queen Mother were favored in central Sichuan while trees with the bear/Buddha-like figure were favored in areas to the east (Zhongxian), south (Guizhou), and north (Hanzhong). In only a single case, namely the cicadas flanking two of the Buddha-like trunk figures from Zhongxian Tomb 14, do we find a motif indicating that the Buddha-like figure shared connotations of longevity and immortality with the Queen Mother of the West. Yet the logical conclusion, that the Buddha was understood as a deity equivalent to the Queen Mother or King Father, is not supported by the full range of visual evidence. With the exception of the questionable Chenggu money tree discussed above and the small Pengshan base with Buddha-like figure, there is little evidence for a visual parallel between the Buddha figure for the Queen Mother. Rather, the Buddha-like figure appears to have had a role that was related to common apotropaic motifs, in particular the bear, in contrast to the deified Queen Mother.

The large Mahao and Shiziwan tombs were the substantial undertakings of wealthy, local elites.[114] Some of the tombs containing evidence of money trees are similarly impressive; others are more modest, but the expense of having a bronze tree created, even from molds that could be reused, was substantial. The early use of the Buddha-like figure thus appears to have been limited to wealthy local elites. It has also been suggested that money trees may be related to the merchant class. Irisawa argues that the Buddha image was introduced into the Southwest region not by monks but by merchants who had a lay knowledge of the religion and may have carried examples of small-scale images as talismans. In such a context, the motif of coins arrayed around the Buddha-like figure on money tree trunks might be understood as a visual reference to the commercial context of early Buddhist-derived imagery in the Southwest.[115] Even if one were to accept his hypothesis, however, there is no evidence that the tombs containing money trees were those of merchants.

Recently, Wu Hung has followed Xian Ming in linking works such as the money tree to the development of Celestial Master Daoism (Tianshi Dao 天師道), also known as Five Pecks of Rice Daoism (Wudoumi Dao 五斗米道).[116] Traditionally, Celestial Master Daoism is said to have been founded in 142 C.E. when Laozi appeared to Zhang Ling 張陵 in Sichuan. There is scant evidence for the activities of the Celestial Masters, however, until the end of the Eastern Han dynasty when the grandson of Zhang Ling, Zhang Lu 張魯, established an autonomous Celestial Master community in Hanzhong in southern Shaanxi province.[117] Xian Ming argues that excavated money trees and bases are distributed in the same area as the twenty-four official centers (zhi 治) of Celestial Master Daoism, contain Daoist imagery such as the Queen Mother of the West, and should therefore be considered works of Celestial Master Daoism. Wu Hung goes further to include images and inscriptions from cliff tombs, decorated stone sarcophagi, a distinc-

tive type of mirror with a three-level decorative scheme, and money trees.[118] Wu Hung believes that a *sheng* 勝 (fig. 2.20), the characteristic headdress of the Queen Mother of the West, along with "dragon-and-tiger images carved above the entrance to a Sichuan cliff tomb may signify the religious identity of the tomb occupant."[119] But it has been noted by Wu Hung himself that such imagery was not particular to Celestial Master Daoism.[120] Rather, the development of early Daoism as a religion was an uneven process of absorbing, rejecting, and reorganizing extant popular beliefs and practices including those concerned with immortality and immortals.[121] In Sichuan, images of immortals such as the Queen Mother of the West were produced for mortuary contexts well before the advent of Celestial Master Daoism.[122] If we consult the textual evidence, it appears that the Queen Mother of the West was established as a major Daoist deity only in the fifth to sixth centuries and then by the Shangqing 上清 tradition in eastern China.[123] In fact, there is little in early Celestial Master texts to suggest the importance of the Queen Mother or image worship. The archaeological evidence presented by Xiang Ming and Wu Hung similarly lacks unambiguous evidence of a direct relationship to Celestial Master Daoism.

The thesis that works such as money trees are Daoist in function primarily rests on a circumstantial relationship between the location of the Sichuan archaeological material and the twenty-four Celestial Master centers. Zhou Kelin, however, has noted the wide dispersion of excavated money trees beyond the twenty-four Celestial Master centers.[124] In addition, Zhou points out the late date of the textual sources for the twenty-four centers, which raises the question of whether the centers were in fact operative during the second and early third centuries and if so, whether the texts accurately reflect the names and locations of the centers.[125] Zhou also observes that there is no concentration of archaeological evidence of Daoist imagery in Hanzhong, the region in which hundreds of thousands of Celestial Master adherents lived at the end of the Han dynasty—that is, exactly the period when cliff tombs, decorated sarcophagi, the three register mirrors, and money trees were being produced.[126]

We have returned conceptually to the problem of how to understand the function of images in mortuary contexts. Does the carving of a Buddha-like figure in a tomb indicate that the occupant was a Buddhist?[127] Are images of immortality on mortuary objects evidence that the deceased was an adherent of Celestial Master Daoism? Both the case of the Buddha-like figure and the Queen Mother suggest caution in any attempt to coordinate imagery and religious affiliation or function in Sichuan during this period. Consider the discernible pattern in both this and the following chapter indicating that the realms of mortuary imagery and Buddhist imagery were distinct and separate. Even in those regions and time periods when Buddhism was widely practiced, we find remarkably few if any examples of Buddhist religious imagery in Chinese mortuary contexts. There is, in other words, no reason to believe that early Daoists any more than Buddhists expressed their religious affiliation in mortuary imagery. Therefore, it seems

prudent to understand imagery related to immortality from Sichuan as part of a well-established set of local mortuary beliefs with a yet to be determined relationship to the development of Celestial Master Daoism.

As for the Buddha-like figure in Sichuan, Wu Hung has abandoned his former position that the Buddha-like figure was considered an immortal such as the Queen Mother of the West and now states that "an image of the Buddha could have been thought of as an image of Laozi."[128] The argument is based on the well-known story of Laozi traveling to the West and converting the barbarians in the guise of the Buddha.[129] The Buddha-like figure may have thus been recognized by Daoists as Laozi returned to China in the form of the Buddha. Yet we have found the Buddha-like figure in places typically occupied by apotropaic images such as the monster or the bear. The position and function of the Buddha-like figure seems hardly appropriate for the exalted status of Laozi in Celestial Master Daoism. Wu Hung's observation on the use of early Buddhist imagery, however, still stands: "A central characteristic of the early introduction of Buddhism to China [is that] this foreign religion could be accepted because it was largely and willingly misinterpreted."[130] Far from the Huang-Lao cult of the court and organized forms of Buddhist textual transmission and exegesis, the image of the Buddha appears to have been unsystematically adopted into local elite mortuary practices. Furthermore, the archaeological evidence indicates no widespread use of the Buddha-like figure in the Eastern Han or Shu-Han period in the Southwest—just the opposite. The small number of extant examples suggests that the use of the Buddha image, whatever its function, represents the exception, not the rule. Yet the Buddha image in the Southwest was "misinterpreted" in a surprisingly ordinary and unspectacular way.

In retrospect, the relationship of the Buddha image to concepts of immortality and the Queen Mother of the West now appears rather more complicated than previously thought. On one hand, there is little evidence that the Buddha-like figure in the Mahao or Shiziwan tombs can still be considered the equivalent of the Queen Mother or the King Father of the East; on the other, the Buddha-like figure in money trees functioned in the overall context of a work that was undoubtedly concerned with immortality issues. At the same time, the Buddha-like figure and the Queen Mother have yet to be found on the same money tree, which suggests some level of discrimination between the two. Finally, we might reflect on how the fascination with the legendary Queen Mother in past scholarship, piqued by abundant references in early texts and her long career in Chinese popular culture, dictated the special attention that her image has attracted. That is to say, the Queen Mother for a variety of reasons has a purchase for us as modern scholars that is lacking in more ordinary motifs such as the bear.[131] It comes as no surprise then that a major deity such as the Buddha would be understood as the equivalent of the equally important Queen Mother. As we have seen, such a commonsensical theory has the power to generate its own evidence. A small number of examples are extracted from a larger body of archaeological materials and representative works. The

transformation of singular if not idiosyncratic works into exemplars is accomplished by overlooking contradictory evidence in the larger body of material. Earlier scholarship is reiterated, sometimes with a loss of precision, to the point where a theory moves forward on its own momentum regardless of the facts. This is a lesson that might be kept in mind in what follows.

SOUTHEAST

The other examples of the early Buddha-like figure are found in southeast China, primarily the middle and lower Yangzi River region (map 3) when it was under the control of the Wu 吳 Kingdom (222–280) and the Western Jin (265–316) dynasty.[132] This region is not far to the south of the aforementioned Buddhist cult center of Ze Rong at Pengcheng and, unlike the situation in the Southwest, there is textual documentation of

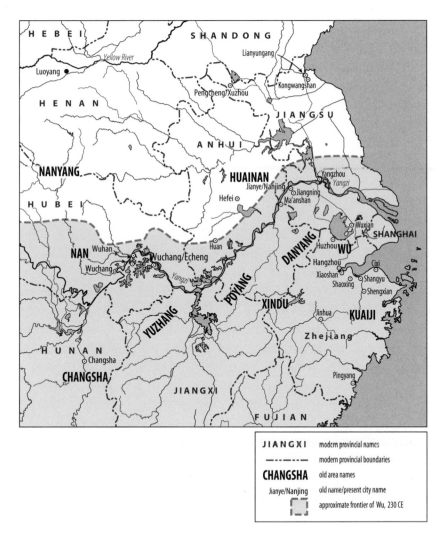

3 Middle and lower Yangzi River region, c. 230 C.E. By Linda Huff after de Crespigny, *Generals of the South*, 426.

JIANGXI	modern provincial names
- - - - - -	modern provincial boundaries
CHANGSHA	old area names
Jianye/Nanjing	old name/present city name
☐	approximate frontier of Wu, 230 CE

early Buddhist activity in the area. The two individuals for whom we have the most detail are Zhi Qian 支謙 and Kang Senghui 康僧會. Zhi Qian, a lay disciple from Luoyang who traveled to Wuchang 武昌 in 220 and then to Jianye 建業 in 229, was the most important translator of Buddhist texts in the Southeast until the late fourth century. His language and approach to translation indicate an interest in popularizing Buddhist thought among the literate population.[133] Kang Senghui, on the other hand, was a monk known more for his miracles than his translation activities. He reached the Wu Kingdom court in 247 and was said to have produced a relic of the Buddha for the emperor. It is also recorded in his biography that he set up an image for ritual circumambulation.[134] The activities of Zhi Qian and Kang Senghui indicate that Buddhism and its texts, clergy, and images were known in the Wu realm, although it is unclear what was known of Buddhism beyond the court.

In terms of visual imagery, the situation in the Southeast is more complex than that of the Southwest because, in addition to the Buddha-like figure, an array of other images and motifs have been identified by various scholars as Buddhist or Buddhist-inspired. For example, at the site of Kongwangshan in northern Jiangsu Province, over one hundred figures are carved in relief on an uneven cliff face some 17 m across.[135] Several Kongwangshan images are Buddha-like with halo, proper mudra, and monastic dress. Others incorporate motifs such as the halo from the Indian Buddha image into conventional representations of Chinese deities. The latter works are clearly hybrids in which the Buddhist visual element, while undeniable, does not represent the adoption of the Buddha image into Chinese art per se but a borrowing that reflects a less direct relationship that is difficult to specify. The periodization of these images remains controversial, with many scholars accepting a late Eastern Han or Wu Kingdom date, while some argue for a period as late as the Tang.[136] Owing to the uncertainty surrounding the date of the works as well as their original context and function, the Kongwangshan images will not be taken up here.

Examples of hybrid figures with possible borrowings from Buddhist imagery are also found on bronze mirrors of the third and fourth centuries from the Southeast. The issue has been complicated by a well-known group of *shenshou* mirrors, all discovered in Japan, that feature unambiguous images of seated and standing Buddha figures.[137] The consensus among scholars, however, is that these works date to the fourth or fifth centuries, later than the works considered in this chapter.[138] A single example of a similar *shenshou* mirror excavated in China, dated to the early third century by Wu Hung, is of questionable value because the form of the reputed Buddha image is badly damaged, making it impossible to ascertain its iconographic details from photographs.[139] The lack of mirrors with unambiguous Buddha images excavated in China—and hundreds of mirrors from Chinese tombs of the Three Kingdoms and Western Jin period are known—raises the question of the extent to which the Japanese examples actually represent earlier practice in China.[140] For this reason, the mirrors discovered in Japan will

2.39 Bronze mirror, from Echeng, Hubei. From Ruan Rongchun, *Bukkyō denrai*, 202, pl. 132.

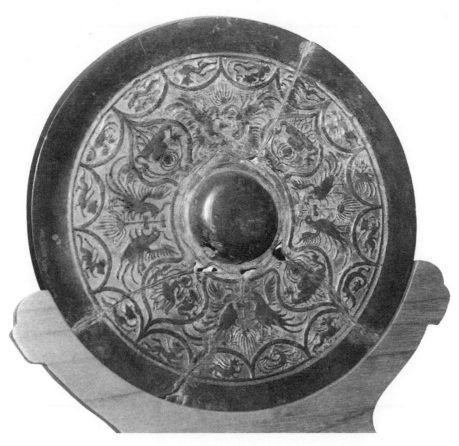

not be considered here. Hybrid images reminiscent of those from the Yi'nan Tomb (fig. 2.1) are found on *kuifeng* 夔鳳 mirrors from China, for example the one excavated at Echeng 鄂城 (fig. 2.39) in northern Hubei Province and thought to be from the period of the Wu Kingdom. Because the figures have halos and their thrones are supported by lotus petals, they have often been identified as Buddha images.[141] It is possible, however, that the throne of three of the figures is the dragon/tiger throne of the Queen Mother (fig. 2.20), which would make these a hybrid of Chinese and Buddhist elements. Such a possibility then opens the question of what is represented by the fourth image, which is a haloed figure with one lowered leg, leaning toward a kneeling supplicant. Of the four images, the last is the most likely candidate to be a Buddha image. Yet the posture and gesture are not conventional in this period, leaving open the possibility that the image was meant to represent something other than the Buddha figure. The Echeng mirror illustrates the difficulty in determining the meaning of hybrid images of this type even if one were able to disentangle the Buddhist and non-Buddhist motifs.[142] Therefore, in what follows, the focus will be on the unambiguous Buddha-like figure similar to those previously discussed from the Southwest.

HUBEI PROVINCE

Some of the earliest Buddha-like figures in the Southeast have been excavated from the
area around Wuchang (present Echeng Hubei), the capital of the Wu Kingdom from
221 until 229 and a strategic city throughout the rule of the Wu.[143] The largest is a
20.6 cm high seated Buddha-like figure made of glazed pottery (fig. 2.40) from Tang-
jiaotou 塘角頭 Tomb 4, just south of Ezhou city, dated by the excavators to sometime
before 261.[144] The tomb was 8.72 m long with a rectangular rear coffin room, a short
corridor, and a square front room (fig. 2.41); mortuary objects inside included model
stoves, model farm buildings such as a granary, an assortment of glazed pottery animals,
standing attendant figures (15.5 to 18.2 cm high), and two smaller unglazed pottery
standing figures (10.6 and 11.6 cm high), reminiscent of lead men from Han dynasty

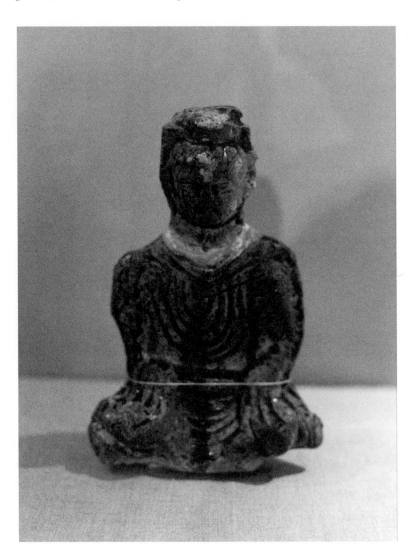

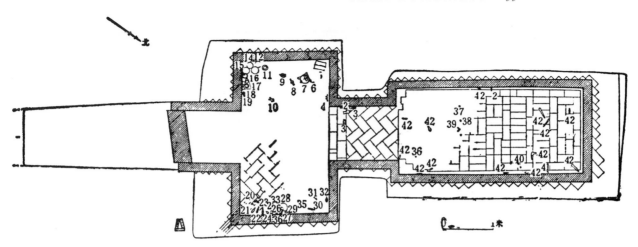

tombs, including the previously discussed Sichuan Hanzhong Puzhen Tomb 85M4. The seated Buddha-like figure is significantly larger in scale than the standing figures from the tomb. The face and the top of the head are damaged although the lower part of a squarish *uṣṇīṣa* is discernible. The hands are not visible and the figure's lower right arm has been lost. If the right arm and hand were in the same position as those of the left side, they would form a version of dhyana mudra but with no hands depicted in the lap.[145] It is also possible, though less likely, that the right hand was originally held up in *abhaya* mudra. The drapery style is similar to that of Buddha-like figures from the Southwest: thick folds that cover the torso with symmetrical loops across the chest and lap. The upper torso is pitched forward, an indication that the figure was originally made to be placed in an elevated position; the bottom of the piece is uneven and not flush with the drapery, which suggests that the work was designed to be set on or attached to a base or additional member.

Porcelain and pottery works appear to have been restricted to the front room of the tomb; only coffin nails, coins, and a gold ring were found in the rear room, the latter objects possibly inside the coffins.[146] The seated Buddha-like figure was found in two pieces in the short corridor between the front and back rooms along with one of the pottery standing attendant figures. No other objects were found in the corridor. The conspicuous position of the image suggests that it served a special function, possibly to guard the deceased in the back room. At the same time, it was found broken, unlike any of the other pottery figures, which raises the possibility that it was moved and broken by tomb robbers. Alternatively, although the ceiling of the rear room has collapsed, the burial objects appear to be undisturbed, which suggests that the figure was already broken when placed in the tomb. There is no evidence to support Yang Hong's suggestion that the seated figure and a pair of the smaller standing pottery figures were a group intended to represent the conventional Buddha image with two attendants, or his speculation that the image was used by the deceased as an object of religious devotion.[147]

2.41 Plan, Ezhou Tang-jiaotou Tomb 4, Hubei (*2:* standing attendant figure; *3:* Buddha-like figure in two pieces). From Hubei sheng wenwu kaogu yanjiusuo and Ezhou bowuguan, "Hubei Ezhou," 5, fig. 6.

2.42 Gold ornament, Wuchang Lianxisi Tomb 475, Hubei. From Ruan Rong-chun, *Bukkyō denrai*, 143, pl. 19.

Rather, the find-spot in the corridor is consistent with an apotropaic function, a role for the Buddha-like figure previously attested to in examples from southwest China.

A second example of a figure described as a Buddha was discovered not far to the west in present-day Wuchang near Wuhan.[148] Tomb 475, dated by inscription to 262, is 8.46 m long and 5.60 m wide with a front room, two small rooms to each side, and a rectangular rear room.[149] Although disturbed at an early date, fifty-six tomb objects were recovered including a 5 cm high gold ornament (fig. 2.42) with the incised image of a standing figure described by Chinese scholars as a Buddha figure.[150] The tiny image, however, is not a Buddha but a bodhisattva, bare-chested with halo and headdress, standing with a slight sway on a lotus base.[151] It is by far the most detailed representation of a bodhisattva figure in this period of Chinese art.[152] The ornament appears to have been broken rather cleanly (on purpose?) across the figure's face and was found just inside the front door of the tomb. It is possible the ornament was a belt buckle, which would make it an object of daily use rather than *mingqi*. It is in any case unique, a sharp contrast to the seated Buddha-like images we have considered so far, and stylistically distinctive in its animated posture and curvilinear lines. Because of its small scale, there is the possibility that the object was not made locally but transported to Hubei from some distance. The find-spot of the object near the door suggests still another possibility—

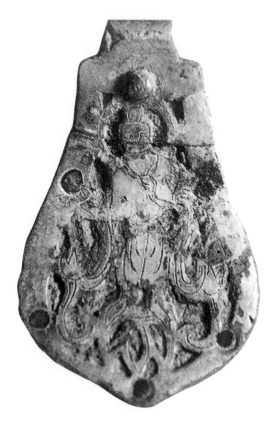

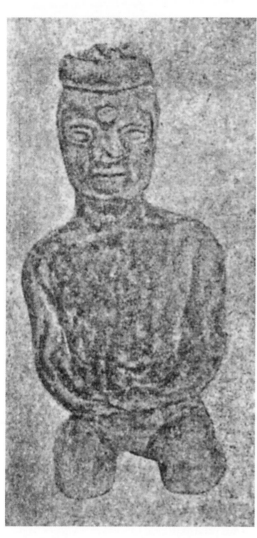

that the ornament was not originally from the tomb or contemporary in date but was dropped or placed at the doorway by a later intruder.

Also found inside the tomb were several kneeling figures, hands in their laps, palms facing up, with small but prominent circles incised on the foreheads (fig. 2.43). Because of the circles, which have been understood as the *ūrṇā* (one of the special marks of the Buddha), these and other similar pottery figures have been identified as Buddhist images by a number of scholars.[153] The round or pointed caps rather than an *uṣṇīṣa* and the lack of the monk's robes as well as the position of the legs, not crossed as is usual for a Buddha image, but tucked back, strongly argue against accepting these figures as Buddhist. Rather, similar standing and seated attendant figures both with and without the circle on the forehead appear as attendants in other tombs from the Southeast, including Tangjiaotou Tomb 4, where neither the attendants nor the Buddha-like figure had the circle displayed on the forehead.[154] Again, the question arises as to how to interpret the appearance of a single attribute of the Indian Buddha image. Is there a conscious intent of making a figure "Buddhist" by including the *ūrṇā* -like circle? How does an iconographical element from Buddhist art relate to the function of otherwise common mortuary figures?

One other important discovery in Tomb 475 was a lengthy inscription on a strip of lead, a *diquan* 地券, or land contract, dated to 262.[155] The text identifies the tomb occupant, Peng Lu 彭盧, his background, age at death, and the extent of the land purchased for his tomb and the price. The inscription ends with the phrase: "the guarantors and witnesses are the King Father of the East and the Queen Mother of the West, in accordance with the statutes and ordinances 知者東王公西王母如律令."[156] Here the pair of deities are adjuncts to a pseudolegal document meant to demonstrate ownership of the land utilized for the tomb.[157] In a similar land contract excavated in Jiangxi and dated to 225, the King Father and Queen Mother are named as the *sellers* of the land.[158] Such

2.43 Kneeling figure, Wuchang Lianxisi Tomb 475, Hubei. From Hubei sheng wenwu guanli weiyuanhui, "Wuchang Lianxisi," pl. 7: 3.

contracts allow us to discern something of the way in which the tomb was understood as a dwelling place parallel to that of the living but in the world of the dead. It is also significant that the King Father and Queen Mother play roles in these contracts that are rather more mundane than that of the glorified rulers of immortal lands found in some texts and imagery of the period.

Seidel suggested that land contracts such as these "afford us a privileged peep-hole into the uncharted realms of common religious beliefs outside court and literati circles."[159] Indeed, most land contracts and related grave-quelling texts appear in relatively simple tombs with few mortuary objects. In this case, however, the tomb occupant holds an official title: *xiaowei* 校尉, or local commandant, a significant position under the Eastern Han.[160] Although it is difficult to determine the relative status of this position under the Wu, the tomb, while not lavish, is of good size, an indication of some status. The unexpected presence of the land contract in such a tomb suggests that certain mortuary practices may have been shared across social classes. We may indeed be glimpsing a commonly held, sober understanding of the requirements of tomb construction that contrasts sharply with the realm of esoteric practices, elixirs, or dreams of longevity indicated in the textual tradition and the tombs of the educated elite.[161] Most significant, there is little correlation between the land contract, the attendant figures with the *ūrṇā*-like circle on the forehead, and the ornament with the image of a Buddhist bodhisattva. Insofar as these objects cannot be easily subsumed under what extant texts tell us about early Chinese beliefs, we may have a unique view of the heterogeneity of mortuary beliefs.

A third example of a Buddha-like figure, from Echeng near the old Wu capital, is not dated by inscription but comes from a tomb of the late Wu or early Western Jin period according to the excavators—that is, the 270s–280s.[162] The large tomb, 9.03 m long, consists of a front room with two small side wings and a long, rectangular rear room. Although it was robbed early on, seventy-nine objects still remained to be excavated. Among these was a pottery model of a courtyard with a scrawled inscription: "the gate/tower of the General Sun 孫將軍門樓也," Sun being the family name of the Wu Kingdom rulers. The excavation report speculates that the tomb occupant is a Sun Shu 孫述, who is mentioned in the Wu dynastic history and would have died at the end of the Wu or the beginning of the Western Jin period.[163] Among the tomb objects was a small kneeling figure, 16 cm high, wearing a cap and holding a blank tablet to its chest, similar to the attendant figures in Wuchang Tomb 475.[164] Also discovered was an incense burner (fig. 2.44) with three small Buddha-like figures seated on the edge of the base.[165] The upper section, a dome with small triangular openings, is topped by a single bird. The seated figures in these works are depicted with their hands folded together in the lap in a position of meditation. This suggests that they represent a different stylistic lineage from those in the Southwest where the Buddha-like figure was consistently shown with the right hand raised in *abhaya* mudra.

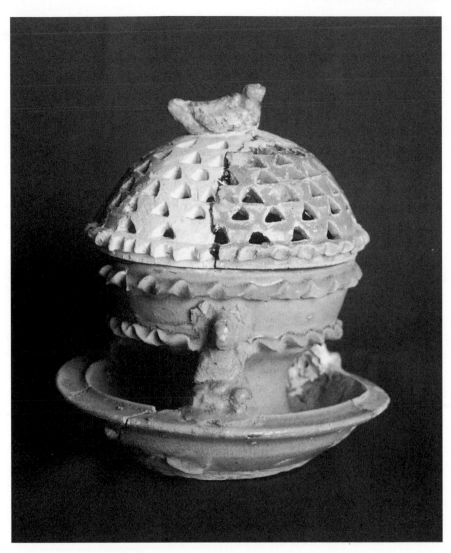

2.44 Incense burner, tomb of General Sun, Echeng, Hubei. From He Yun'ao, *Fojiao chuchuan*, no. 37.

The inscription establishes the occupant of the tomb as, if not Sun Shu, a member of the ruling family of the Wu. In structure and scale, this tomb is similar to Tangjiaotou Tomb 4 and to Wuchang Tomb 475, whose occupant was a high-ranking local official. These three can be compared to a much larger tomb, nearly 15 m in length, from Ezhou that contained an inscription with the name of Sun Lin 孫鄰, the father of Sun Shu, who died in 249.[166] The tomb plan is identical to that of Tangjiaotou Tomb 4, only larger, and despite being robbed twice, still held several hundred objects. Figural imagery included a lamp with dragons on the stem, a bowl decorated with a monster mask, a tiny gold *pushou* near the entrance to the rear room, and a number of small, capped attendant figures (none with circles on the forehead), but no Buddha-like figures. Many

smaller Wu Kingdom tombs have also been excavated in this region, for example Tang-jiaotou Tombs 8, 9, and 10, simple single-room chambers from 3.84 to 4.76 m in length.[167] None of these have yielded objects with Buddhist imagery.

The three examples of Buddha- and bodhisattva-like figures were found in tombs of relatively well placed individuals near Wuchang. In the context of the many other tombs in the immediate vicinity, they represent an unusual choice of imagery. In contrast to the Southwest, there is no consistent context for the images. The small bodhisattva-like figure is especially problematic because, unlike the other two examples, there is no precedent for such a figure at such an early date, and its presence on such a small object leaves open the possibility that it was of a later date or from a distant locale or both. The Buddha-like figure incorporated into ceramicware, however, is relatively common in the Southeast. The seated figures supporting the incense burner can be compared to a group of different but related incense burners from Jiangsu tombs dated to 297, 299, and 305 in which bears occupy similar positions.[168] As we found in the Southwest, there is a certain level of interchangeability between the bear and the Buddha-like figure. In contrast, the seated, ceramic image from Tangjiaotou Tomb 4 is singularly unusual in its large scale and the fact that it was discovered as an independent object. As we will see, all other examples of the early Buddha-like figure are in one way or another attached, decorative motifs. The Tangjiaotou work, although its position in the tomb indicates an apotropaic function consistent with other Buddha-like figures, is a very different class of image and will be discussed in relation to the Buddha icon at the end of the chapter.

ZHEJIANG PROVINCE

At about the same time that Buddha-like figures were used in tombs near the Wu Kingdom city of Wuchang, similar figures were incorporated into the decoration of ceramicware from the lower Yangzi river valley, a region rich in tombs of the mid-third to early fourth centuries. The most numerous examples of the figure are found on the decoration of a jar-like tomb object topped by an elaborate composition of pavilions and human and animal forms (fig. 2.45) known variously as a *gucangguan* 穀倉罐 (granary jar), *duisuguan* 堆塑罐 (relief-sculpted jars), *shenting* 神亭 (spirit pavilions), or *hunping* 魂瓶 (soul urn). *Hunping,* the term long used in English-language studies, has now emerged as the most commonly used term and will be used here.[169] The *hunping* does not function as a vessel: many examples have no conventional mouth or opening at the top and there is often nothing stored inside. As the different names for these works indicate, there is conflicting opinion among scholars about how they should be described and what they represent. Some consider them to be nothing more than *mingqi,* a model of a granary or a storage vessel, while others have suggested that the *hunping* was meant to house the *hun* soul of the deceased. We will return to the issue of their function at the end of this section.

As of the early 1990s, it was reported that some 130 examples of *hunping* were ex-

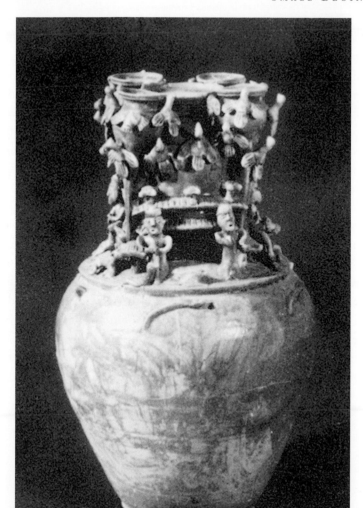

2.45 *Hunping,* Datangling Tomb 101, Shengxian, Zhejiang. From He Yun'ao, *Fojiao chuchuan,* 172, no. 58.

tant.[170] Of these, some fifty or more contain a Buddha-like figure. There are undoubtedly a significant number of *hunping* in local Chinese museums and cultural relics bureaus that have yet to be published. The popularity of such works in a limited area, basically from Nanjing south and east into Zhejiang Province, and over a limited period of time, from roughly 250 to the beginning of the fourth century, provides an excellent opportunity to investigate the incorporation of the Buddha-like figure into existing mortuary practices. Yet there are major obstacles to reconstructing the context of the *hunping,* the most serious being the disturbance and robbing of most tombs and the lack of excavation reports for the majority of the works. In what follows, several clusters of *hunping,* their imagery, and their mortuary contexts will be discussed. The examples will include

excavated works from Zhejiang Province, the area in and around Nanjing, the site of the Wu and Eastern Jin capital of Jianye, and a group of tombs from Wuxi in southern Jiangsu Province. These works from dated tombs have been selected in order to demonstrate something of the complexity of forms found in a variety of synchronic contexts. Some provisional observations on mortuary practice, *hunping,* and the Buddha-like image in Zhejiang and Jiangsu Provinces will follow.

The earliest dated *hunping* and the earliest dated example of the Buddha-like figure in Zhejiang occur in a group of four Wu Kingdom tombs excavated at Datangling 大塘岭 village, 7 km west of Shengxian 嵊縣 in northern Zhejiang.[171] Inscribed bricks in Tombs 101 and 95 date these to 257 and 263 respectively; a pair of nearby tombs, 104 and 105, are not dated by inscription but are, according to the excavation report, contemporary with Tomb 101 or slightly earlier. The double-room Tomb 95 is the largest of the four, 9.56 m long, and, although robbed at an early date, it yielded twenty-nine items, including a covered jar (*lian* 奩) decorated with three Buddha-like figures (fig. 2.46).[172] The images are depicted as seated Buddhas with a small halo, protuberance atop the head, wide parallel lines to indicate the robes, with the mudra of the hands indistinctly rendered but not in *abhaya* mudra. The figure is seated on what appears to be a schematically delineated lotus throne with the heads of two lions projecting out to each side. Compared to the Buddha-like figures from Wuchang, these are rendered more crudely as a small decorative motif produced from a mold and applied to the surface of the ves-

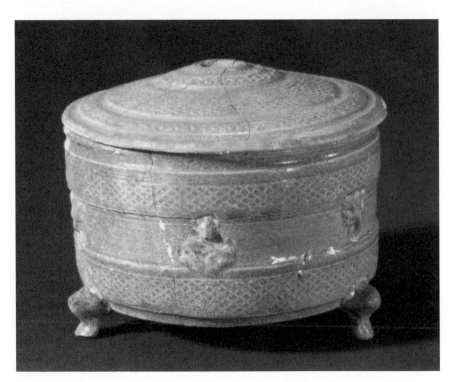

sel. Alternating around the diameter of the jar with the Buddha-like figures are three *pushou* of similar scale, an indication that the function of the Buddha was equivalent to that of the apotropaic *pushou*.

Also found in Tomb 95 were two fragments of pottery identified as coming from a *hunping*.[173] The two fragments from Tomb 95 are consistent with the birds and seated figures of complete *hunping* such as the one in Tomb 101 (fig. 2.45).[174] This work is 45 cm high and divided into two sections: a lower body with full, rounded shoulders, largely plain except for a long, slender creature, a loach (*niqiu* 泥鰍 according to the excavation report) with its head placed at the opening of a small hole. The upper section (fig. 2.47) has five pots surrounded by birds, and below these, arranged along the rim, are figures of musicians, jugglers, and acrobats wearing caps similar to those found on

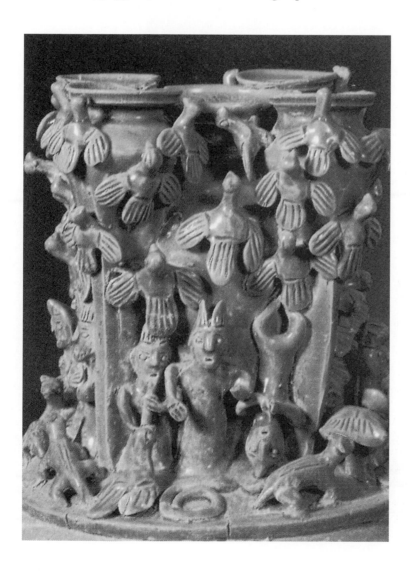

2.47 Upper section, *hunping*, Datangling Tomb 101, Shengxian, Zhejiang. From He Yun'ao, *Fojiao chuchuan*, no. 58.

2.48 Vase with animals and figures, Yinxian, Zhejiang. From Zhejiang sheng bowu-guan, *Zhejiang qiqian*, pl. 108.

the *huren* tomb figures from Hubei; in front of them are arranged bears, dogs, turtles, and snakes. Zhang Heng identifies six of the figures with hands raised in front of them as monks (*sengren* 僧人). This seems doubtful, in that these figures are not differentiated in dress from the musicians and other attendant figures on the jar—they wear the same pointed or round caps and there is no hint of monastic robes.[175] The front of the jar is marked by a gateway.

Some of the visual elements of the *hunping* have precedents in earlier types of Eastern Han mortuary pottery from nearby areas, for example a vase from Yinxian (fig. 2.48), a bear lamp stand from Shangyu 上虞 (fig. 2.49), or a jar (fig. 2.50) surmounted by a set of five pots or tubes and variously decorated with bears, birds, lizards, and turtles known as *wuguanping* 五管瓶 (literally, five linked bottles), or *wulianguan* 五聯罐 (five connected jars).[176] Works such as these date from the Eastern Han period and were the precedents

2.49 *Below left:* Bear lamp stand, Shangyu, Zhejiang. From Zhejiang sheng bowuguan, *Zhejiang qiqian,* pl. 107.

2.50 *Below right: Wuguanping,* Zhejiang Provincial Museum. Zhejiang sheng bowuguan, *Zhejiang qiqian,* pl. 109.

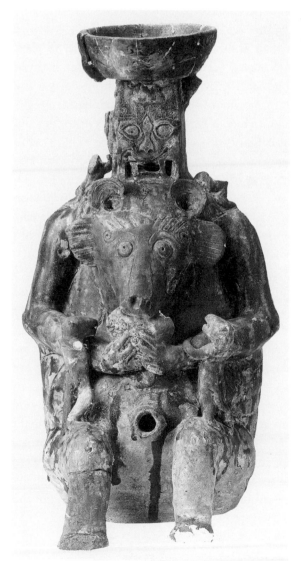

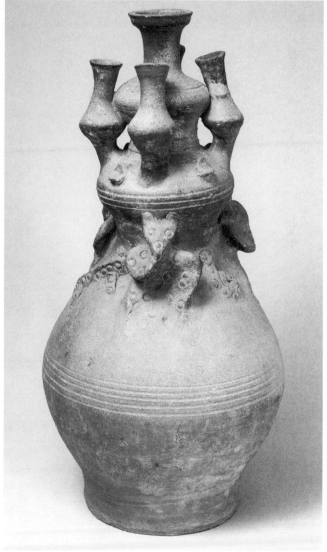

for the distinctive arrangement of five pots in the *hunping* from Tomb 101 (fig. 2.45) and the depiction of animated figures, bears, birds, and other animals. Some earlier works also featured the loach entering or exiting holes in the body, as seen here and on many early *hunping*. The key structural change between the earlier forms and the *hunping* is the appearance of a lip that demarcates the upper zone as a circular platform resting on top of the jar-like lower body.[177] The animated figures on early *hunping* (fig. 2.47) are reminiscent of textual descriptions of shamans (*wu* 巫), well documented in the Southeast region during this time, who were specialists in spirit possession and ecstatic rituals that included music and dance. Although criticized by literati elites and opposed by representatives of organized Daoism and Buddhism, shamans, who were often female and typically lower-class, were employed by emperors as well as commoners as diviners, exorcists, and communicants with the spirit world.[178] Something of the ecstatic practice of shamans is suggested in the imagery of early *hunping,* especially the animated, bulbous-nosed *huren,* some playing musical instruments, others in acrobatic poses. At the same time, it is striking that images of female figures are eschewed.

Tomb 101 was 7.72 m long, smaller than Tomb 95, and said to be similar in plan. The excavation report states that the tomb objects were in place and the tomb had not been robbed; no plan or position of the goods is provided, however. It is said that the *hunping* (fig. 2.45) was found in the southeast corner of the front room alongside a two-lobed bowl.[179] Inscriptions on tomb bricks include a regnal date equivalent to 257 and identify the maker of the tomb, in all probability the occupant, as a Pan Yi 番億, who had the title of a military commander (*jianzhong xiaowei* 建中校尉). The inscription also mentions the determination of the tomb's *tu* 圖 (that is, its position and orientation) by the tombmaster (*zhongshi* 冢師) Zhu Guang 朱珖.[180] The names Pan and Zhu were also found in brick inscriptions from Tomb 95, an indication that the two tombs were part of the cemetery of a prominent local family.[181] The relatively large size of both tombs would be appropriate for individuals of such a background.

Another complete *hunping* was discovered in Tomb 104. This work (fig. 2.51) has a body much like the *hunping* in Tomb 101 (fig. 2.45), including the three small holes and loaches.[182] The upper section, however, is truncated and the five equal-size pots are here transformed into a single large central pot surrounded by four tiny ones. The three-story gate is flanked by a pair of *que* 闕 towers, and along the edge of the upper zone are arranged musicians, some bearded, and naked acrobats. Dogs, turtles, bears, and birds are clustered around the pots. The tomb was a single room (fig. 2.52) in a knife shape, 5.4 m in length, and contained the remains of one coffin, head oriented to the north as one would expect.[183] A hairpin was recovered at this end, an indication that the occupant was female. The *hunping* lies near the head of the coffin amongst a typical range of ceramic and pottery jars, bowls, and *mingqi,* such as a model well and stove. Coins were placed in the coffin along with a mirror; a second mirror appears to have been originally under the coffin. One mirror (no. 12) has an inscription that includes the name of the

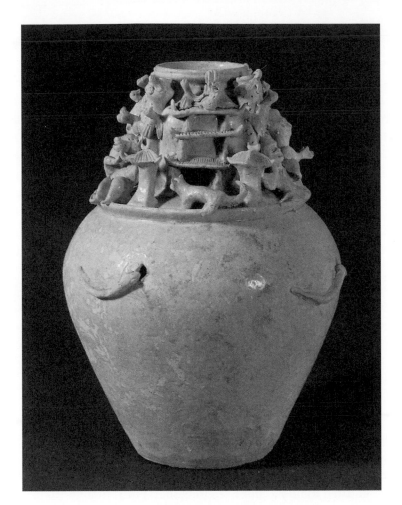

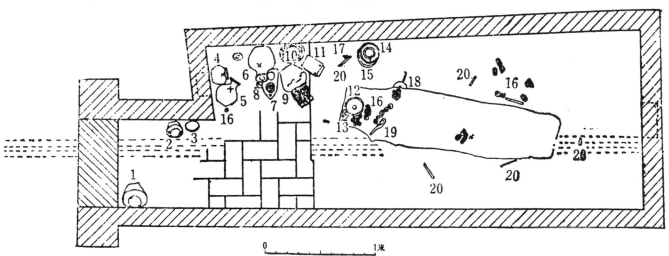

2.51 *Hunping*, Datangling
Tomb 104, Shengxian, Zhe-
jiang. From He Yun'ao, *Fojiao
chuchuan*, no. 57.

2.52 Plan, Datangling
Tomb 104, Shengxian, Zhe-
jiang (*9: hunping; 13:* hairpin;
12: mirror; *18:* mirror). From
Shengxian wenguanhui,
"Zhejiang Shengxian
Datangling," 210, fig. 5.

0 1米

King Father, Dongwanggong, and the character "Xi" of Xiwangmu, the Queen Mother, which identifies the seated figures on the mirror as these two deities. The other mirror is also of the *shenshou* type, as was a mirror found in the adjacent Tomb 105.[184]

Although the disturbed condition of Tomb 104 should be a caution, several observations can be made from the excavation report. The *hunping* in Tombs 95, 101, and 104 were discovered not in a position of special importance but in the corners of the tombs together with other common types of *mingqi*. No tomb figures were found in these tombs, which suggests that the imagery of figures and animals on the *hunping* may have taken over the role of attendant figures such as those in Hubei. In contrast, images of the Queen Mother and King Father, restricted to mirrors in the Southeast, are found alongside *hunping* in Tombs 104 and 105. We can discern here two parallel alternatives for visual imagery in the tomb, one centered on the Queen Mother/King Father and the other focused on *hunping* and other ceramicware with images including the Buddha-like figure. The Buddha is absent from Shengxian tombs dated to the 250s and appears only in the slightly later Tomb 95, dated to 263. Together with the dated examples from Hubei, this suggests that it was about 260 at the earliest that the Buddha-like figure was first depicted on objects in Wu Kingdom tombs. But the Buddha-like figure does not appear on *hunping* in Zhejiang until 280.[185] For earlier examples of the Buddha motif on *hunping,* we must turn to the area around Jianye (present-day Nanjing), the capital of the Wu Kingdom and the Western Jin dynasty.

NANJING AND VICINITY

The tombs around Nanjing have yielded a number of important examples of the use of the Buddha-like figure in the third century. Arguably the most spectacular find was a glazed ewer (fig. 2.53), 32 cm high, from Nanjing Yuhuatai Changgang 雨花台長崗 Tomb 5. The undated tomb has not been published but is thought to be from the end of the Wu Kingdom or the early Western Jin dynasty (roughly 280).[186] Both the shape and the elaborate decoration of the vessel are unusual and suggest that it was made for a patron of significant status. The vessel is divided into three parts: (1) the lid with a bird handle and bird-like creatures, some with human heads, painted in dark ink under the glaze; (2) a neck painted with seven feline beasts; and (3) the body (fig. 2.54) with appliqué decoration on the shoulder and two registers of winged human figures in profile, eleven above and ten below. They each hold a long staff or stem with three round pods and are placed in a setting of intricate, ethereal grasses. The figures are immortals (*xianren*), the lightness of their bodies suggested by the thin limbs and wings, who hold a plant from which an elixir of immortality is produced.[187] Applied to opposite ends of the shoulder of the ewer are two Buddha-like figures, each with *uṣṇīṣa* and halo, seated with hands together in the lap on a lotus-petal throne flanked by small lions, heads turned inward. At the other sides are a pair of lugs that have been transformed into birds depicted as one would see them from above—head, wings, and body symmetrically splayed to

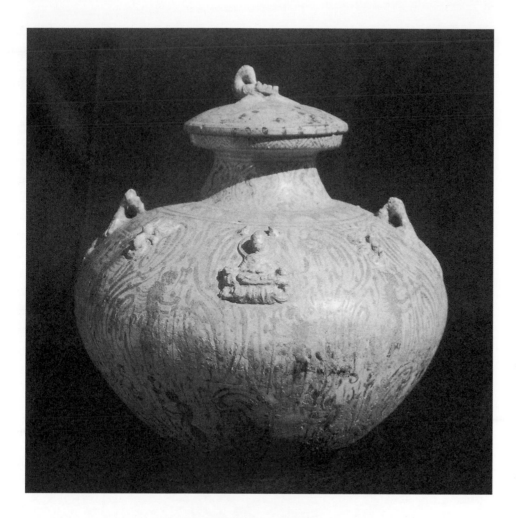

2.53 Glazed ewer, Nanjing
Yuhuatai Changgang Tomb 5.
From He Yun'ao, *Fojiao
chuchuan,* no. 38.

2.54 Drawing of neck and
body, glazed ewer, Nanjing
Yuhuatai Changgang Tomb 5.
From Yi Jiasheng, "Nanjing
chutu," 74, fig. 3.

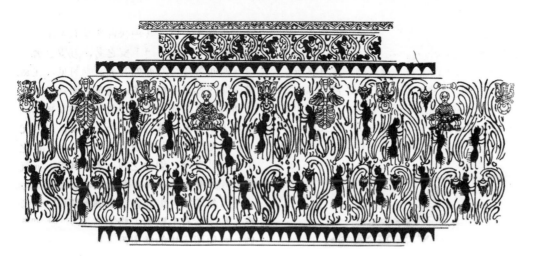

the sides. A *pushou* has been affixed between each Buddha-like figure and bird. The Buddha-like figure is here placed in a position equivalent to the unusual bird, possibly the Red Bird of the South, which is also found on some *hunping*. The *pushou*, which will sometimes be found in a position equivalent to the Buddha-like figure, is in this case smaller than the birds and Buddha-like figures.

A second example of a work with imagery comparable to that on the ewer has been recovered from a tomb at Ma'anshan 馬鞍山, Anhui Province, some 50 km southwest of Nanjing. The tomb has been identified by inscription as that of Zhu Ran 朱然, an important military figure of the Wu Kingdom, who died in 249. Although modest in scale (8.7 m long) and previously broken into, the tomb still contained over 140 items, including ceramics, bronze vessels, and many lacquer objects, an indication of the types of objects and imagery preferred by those of high status. A square lacquered cover was decorated with the four directional animals, various birds and beasts, and, among a design of clouds and vapor, three elegantly dressed standing figures, one of whom holds a plant with three circular nodes (fig. 2.55).[188] The three figures appear to represent seekers of immortality, not yet winged and emaciated as we see on the Nanjing ewer, but depicted on their journey through an ethereal world. The design of the cover, which contains no Buddhist imagery, might, when compared to the Nanjing ewer, be understood as a slightly earlier variation of the realm of immortality.

The Ma'anshan lacquer cover and the Nanjing ewer are exceptional, finely crafted articles distinct from ordinary mortuary objects such as bronze mirrors or ceramicware.

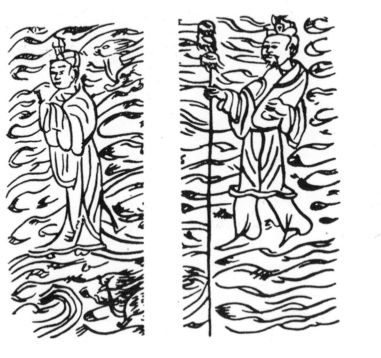

The sumptuous materials are enhanced by an especially fluid visual style accented by the swirling lines of delicate grasses and ethers. Here we can discern one manner in which immortality was visually represented for the elite classes under the Wu Kingdom. Although delicately delineated depictions of immortals and *xianren* would be favored in the later tombs of elites in this region, it should be noted that such a visual style was not widespread under the Wu.[189] As for the Buddha image, all that can be concluded at this point is that its incorporation into the decoration of the ewer is consistent with themes of immortality suggested by money trees in the Southwest. The Buddha-like figure, however, is not part of the swirling, ethereal realm of *xianren* depicted in the under-painting, but an appliqué on the shoulder of the vessel along with the splayed bird and *pushou*. In other words, we find the Buddha image among apotropaic motifs rather than in the realm of immortals, a conclusion supported by the lack of any Buddha-like figure among the immortality seekers in the Ma'anshan lacquer cover. It should be noted that the Queen Mother is not represented in either scene.

The earliest dated *hunping* (figs. 2.56 and 2.57) from Nanjing—coarsely decorated with a profusion of forms—shares some motifs with the previous two works.[190] Discovered in a tomb with bricks dated to 265, this work, rather different in character from the Zhejiang Shengxian *hunping,* has a roof with birds over the main pot balanced on the heads of seated *huren.* Four small pots mark the corners of the upper story and are supported by a large beast head atop a squatting bear. The rim of the upper section is lined with seated *huren,* hands clasped in front of their chests. A pair of *que* towers rather than a storied gate denotes the front of the jar, and a large recumbent ram has been conspicuously positioned between the towers. The lower body is decorated with small *pushou* around the upper shoulder and alternating standing figures and *bixie* 避邪, a winged apotropaic beast, below. The figures are depicted in profile and grasp with both hands a thin stem with three large nodes, reminiscent of the *xianren* figures on the Nanjing ewer. There is only one hole, placed rather low on the body, with three loaches. The roof is removable and the visual impression of the work is significantly altered without it, a reminder that the top section of *hunping* were sometimes misplaced or destroyed.

The work dated to 265 has no Buddha-like figures, but in the 270s such figures would become popular decorative motifs on *hunping,* especially from tombs in the area around Jiangning 江寧, just south of Nanjing city. The earliest example (fig. 2.58), inscribed with a date of 272, is a good contrast to the work dated to 265.[191] The former has an unusually smooth, even, lustrous green glaze; the architectural elements are clearly articulated and emphasized, for example in the transformation of the large central pot into a roofed building with small towers at the corners of the round roof, a shape unusual in *hunping.* The roof and structure are not removable, which underscores the sense of architectural integrity in the central structure. Furthermore, the dominant role of the large figures crowded around the superstructure is here reversed: the figures are few, small, and unobtrusive in relation to the architecture. On the body, the holes have been

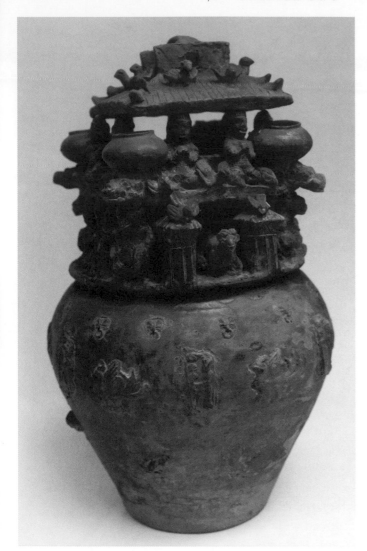

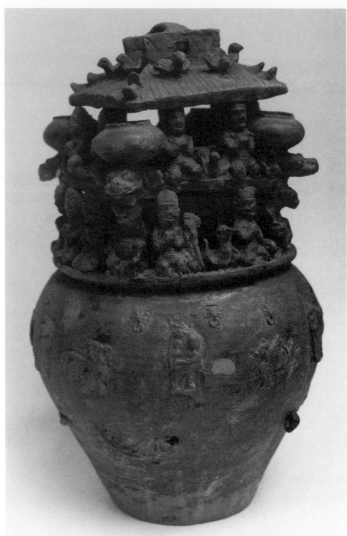

2.56 *Above left: Hunping,*
front, Nanjing Caochangmen
wai Dianli xuejiao nei, Nan-
jing, tomb dated to 265.
Nanjing City Museum.
Photo by author.

2.57 *Above right: Hunping,*
rear, Nanjing Caochangmen
wai Dianli xuejiao nei, Nan-
jing, tomb dated to 265.
Nanjing City Museum.
Photo by author.

enlarged and multiplied; the applied figures are more sharply and carefully delineated. Between the front and rear gates is a miniature commemorative stele (*bei* 碑) set on the back of a turtle (fig. 2.59). The stele is inscribed with the date, identifies the person who had the *bei* erected (the *taishou* or governor of Changsha 長沙), and records the wish that the *hunping* benefit his descendants. The named party, apparently the deceased, was a man of some significance and the inscribed stele here appears to function in much the same manner as full-size stele erected in front of the tombs of officials and other members of the social elite—that is, as memorials and markers of status (fig. 2.60). The stele, combined with the superior quality and distinctive formal features of the *hunping,* distinguishes the deceased as a person of importance.[192]

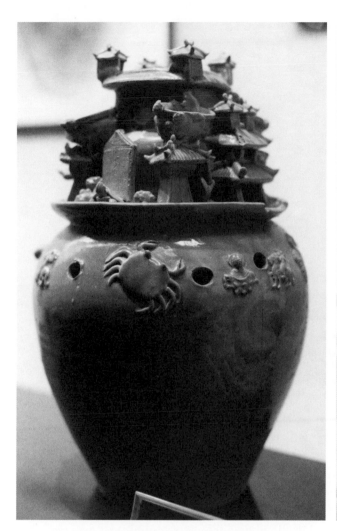 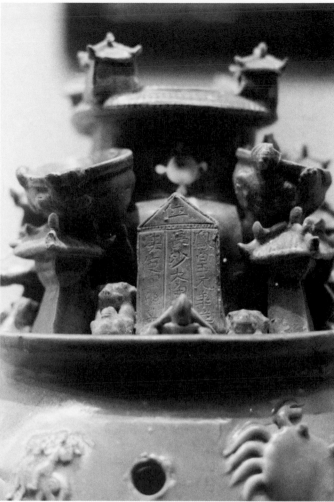

The Buddha-like figure has been placed on the shoulder of the body along with a series of motifs (clockwise from the front): a *huren* riding a quadruped beast (possibly the *bixie* found on the body of the work dated to 265), the Buddha-like figure, a large crab, the rider on a beast again, the head of a snake emerging from the jar, and then (the order of these is not confirmed) a *qilin* 麒麟 or unicorn, a fish, a turtle, another crab, the Red Bird, and a phoenix. The Buddha-like figure is not inserted into a position that would indicate any special importance, for example under the front gate or the stele. Rather, the Buddha is one among a series of motifs that appear to be auspicious, as in the case of the *qilin,* or apotropaic, as in the Red Bird. One other Buddha-like figure appears on this work, attached to one of the four small pots (fig. 2.59). There are no other figural images on the pots, and the addition of the small figure seems like an afterthought. Although it faces the rear of the stele, the figure was not placed on the pot nearest to the

2.58 *Above left: Hunping,* Jiangning Xiafang, Jiangsu, tomb dated to 272. Nanjing City Museum. Photo by author.

2.59 *Above right: Hunping,* detail, Jiangning Xiafang, Jiangsu, tomb dated to 272. Nanjing City Museum. Photo by author.

stele, which suggests that no special relationship between the two was intended.

Another example of a *hunping* with Buddha-like figures comes from a Jiangning tomb with a lead tomb deed dated to 273.[193] The tomb is a small, single room, 4.84 m long, with a small alcove into which most of the nearly fifty objects recovered, including a *hunping,* were placed (fig. 2.61). There were two coffins, both with mirrors at one end, probably near the head. A bracelet was found in one coffin, an indication that one of the deceased was female. The lead deed, whose text was not published, was placed in the open near the head of the other coffin, most likely the spouse of the female. The *hunping* (figs. 2.62–64) is distinguished by a round dish above the large central pot, a double-lipped rim, and an especially orderly arrangement of decorative motifs: four small pots and clusters of birds in the register nearest the round top, a large and clearly articulated pair of *que* towers flanking a large two-story front gate, and identical rows of six capped *huren* arranged to each side. Note the manner in which the lip, which is grooved, has been cut away at the base of the gate, a very distinctive feature. The body is decorated with a series of images on the shoulder, starting from the front and moving clockwise: a standing figure with the elixir plant, a bird seen from above similar to that in the Nanjing ewer, a Buddha-like figure, the Red Bird, a damaged image, another bird from above, a *bixie* with a rider, and the Red Bird again. Below this register is a row of eight identical *pushou.* The holes in the body and the accompanying loaches have dis-

appeared and are not typically found on works from this period and later. As previously mentioned, *hunping* sometimes have detachable parts, a fact that may have a significant effect on the appearance of a work. In this example the round dish can be removed, as in figure 2.63, and in another photograph, two birds have been placed inside the dish (fig. 2.64). This reminds us that, as in the case of money trees, *hunping* were not always discovered intact and their reconstruction may at times be conjectural or even arbitrary.

To summarize, the earliest *hunping* from Nanjing can be divided into two zones. The upper consists of a platform with gates, *que* towers, and pots populated by *huren* and birds. The lower features various animal motifs, some auspicious (*qilin*), some apotropoaic (*pushou*), others difficult to understand in context. The animated figures of the Sheng-xian *hunping* are here replaced by orderly rows of identical *huren* figures in the works dated to 265 and 273. In the two works dated to 272 and 273, a single Buddha-like figure is incorporated into the series of motifs on the body. In the former work, a tiny Buddha-like figure was also added to one of the small pots in the upper zone, but this is a singularly unusual placement of the figure, very much an aberration. In the latter, the place-

2.61 Plan, Jiangning Zhaoshigang Tomb 7, Jiangsu, dated to 273 (*3:* mirror; *9:* bracelet; *10:* mirror; *24: hunping; 38:* lead deed). From Jiangsu sheng wenwu guanli weiyuanhui, "Nanjing jinjiao," 188, fig. 2.

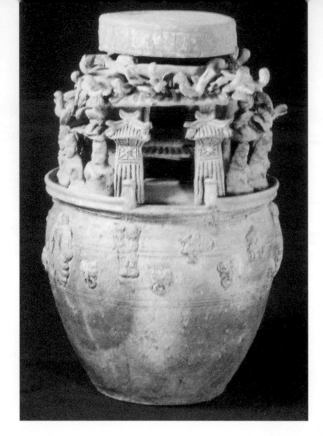

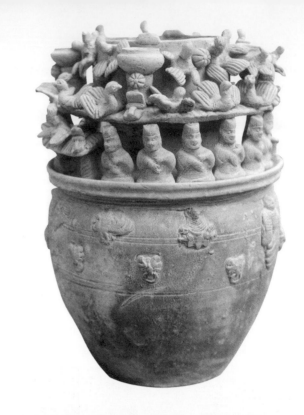

2.62 *Above left: Hunping,*
front, Jiangning Zhaoshigang
Tomb 7, Jiangsu. From He
Yun'ao, *Fojiao chuchuan,*
no. 62.

2.63 *Above right: Hunping,*
side without top, Jiangning
Zhaoshigang Tomb 7,
Jiangsu. From Ruan Rong-
chun, *Bukkyō denrai,* 192,
pl. 114.

2.64 *Right: Hunping,* front
with birds in top, Jiangning
Zhaoshigang Tomb 7,
Jiangsu. From Nankin
hakubutsuin, *Nankin haku-
butsuin ten,* no. 48.

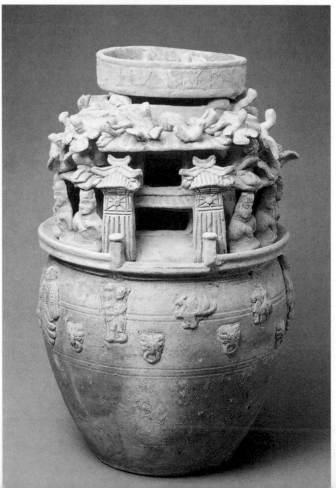

ment of the Buddha-like figure among the splayed bird and *pushou* is reminiscent of the composition of the Nanjing ewer. The minor role of the small Buddha-like figure is consistent in these works and we can at best say that it appears to function as an auspicious or apotropaic motif. Beyond the broad iconographic similarities, however, these three early works are distinct from each other in coloring and in design, an indication of the range of alternatives available for the makers and patrons of such works.

If we organize *hunping* according to visual affinities, however, a different kind of pattern emerges. Take, for example, the following group of works, beginning with a *hunping* (fig. 2.65) from a Jiangning double-chambered tomb some 9.5 m long with bricks dated to 275.[194] The size suggests that the tomb was constructed for a person of some means and, although robbed, it yielded many ceramic and bronze objects, including the *hunping,* which was found in the small alcove off the front room. The upper section of the work has the usual front and rear gates, but in this case small seated figures of *huren* are positioned in the openings, one in the front and five in the rear (fig. 2.66). Along

2.65 *Below left: Hunping,* front, Jiangning Shangfang Tomb 79M1, Jiangsu, tomb dated to 275. From He Yun'ao, *Fojiao chuchuan,* no. 63.

2.66 *Below right: Hunping,* rear, Jiangning Shangfang Tomb 79M1, Jiangsu, tomb dated to 275. Nanjing City Museum. Photo by author.

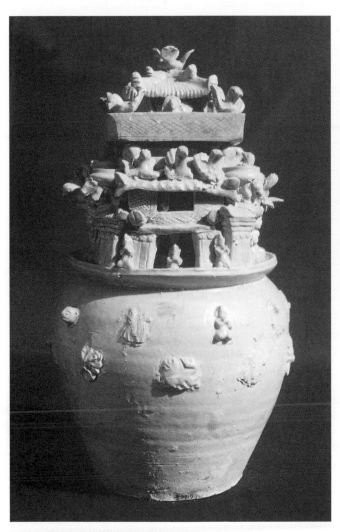

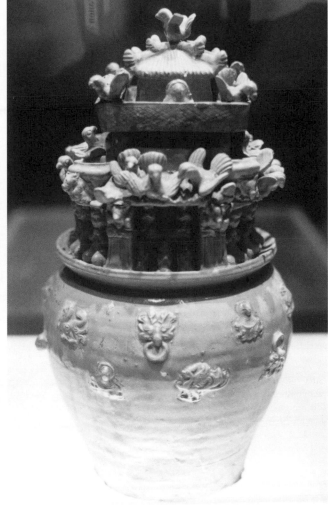

each side between the two gates are arranged five larger *huren*. Note the grooved lip of the body. The lid of the *hunping* is a platform in the shape of a square dish with a small roofed structure in the center. At each of the four corners is a bird facing outward and in between, peering over the edge of each side of the lid, is a small haloed Buddha-like figure.[195] The sides of the lid as well as the upper story of the main gate are enlivened with a pattern of cross-hatched lines. The lower body is decorated with two registers of images: the upper has, clockwise from the front, a *xianren* on a horse, a bear head emerging from the jar, a winged ram, a seated Buddha-like figure, a *pushou*, a *qilin*, a phoenix, a seated Buddha-like figure, and a *huren,* nine figures in all; the lower register also has nine figures: a *qilin*, a *pushou*, a seated Buddha-like figure, another *pushou* but placed upside down (fig. 2.66, far right side), a phoenix, another Buddha-like figure, a bear head emerging from the jar, a *pushou*, and a *xianren* on a horse. Here we find the Buddha-like figure not only included in the now familiar set of motifs on the body of the *hunping,* but also as a set of four images facing the four directions in the square top.

A second Jiangning tomb with bricks dated to 272 and 274 yielded a *hunping* similar in structure (fig. 2.67): two registers of relief figures on the body, a gateway framed by *que* towers flanked by seated *huren,* birds and four small pots above, and a square dish platform with a small roofed building.[196] The identical cross-hatched design on the platform strengthens the impression of visual affinity with the *hunping* dated to 275. At the same time, there are subtle differences—only one gateway on the second work and, rather than *huren,* a large squatting bear has been placed in the opening. No Buddha-like figures are to be found in the upper platform or on the body, which is decorated with two rows of identical birds in relief. The double groove on the lip is not found in the second work and the round platform with birds does not extend as far out over the heads of the *huren* below. Qi Haining 祁海宁, one of the excavators, confirms that the tomb, a modest double-chambered structure 6.65 m in length, had not been robbed, although it had filled with mud (fig. 2.68). The square top of the *hunping* was found neatly placed next to the body among the majority of twenty-two pieces of pottery and greenware in the front room. It is reported that the *hunping* contained grain, although the material has yet to be scientifically analyzed.[197] Only two items were discovered in the rear room—a small greenware oil lamp and a bronze *shenshou* mirror, the only item of metal found in the tomb. The mirror was inscribed with a Wu Kingdom regnal date of 244. The distribution of the tomb objects confirms a general pattern in which the *hunping* is one of a group of ceramic and pottery works of both everyday use and *mingqi* that is placed in one part of the front room while the rear room is largely empty except for the coffin and metal objects, especially bronze mirrors. The lamp left in the rear room in this case is a poignant reminder of the darkness to which the beloved family member was consigned.

Another visually related work comes from a Jiangning tomb (fig. 2.69) with bricks dated to 280.[198] The rear room was destroyed, leaving only the entryway and front room

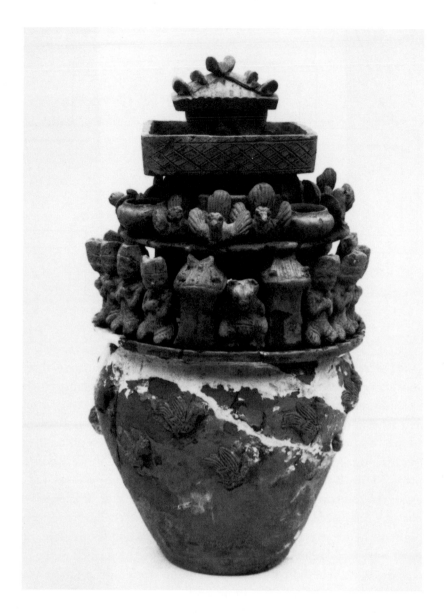

2.67 *Hunping*, front, Dong-
shanqiao, Nanjing, tomb
dated to 272. Photograph
courtesy of Qi Haining.

2.68 Plan, tomb, Dong-
shanqiao, Nanjing, dated
to 272. From Nanjing shi
bowuguan and Jiangning xian
bowuguan, "Nanjing shi
Dongshanqiao," 33, fig. 2.

Top

北

Body

2.69 Plan, Jiangning Suo-shu Tomb 85JSM1, dated to 280 (*2:* bowl; *7:* stone block; *23: hunping*). From Nanjing shi bowuguan, "Nanjing Shizishan," 612, fig. 2.

intact. The scale of the front room, less than 2 m long, suggests that this was originally another relatively small double-chambered tomb. A low platform (described in the excavation report as a *jitai* 祭臺, or ritual altar) was raised against one wall; a ceramic bowl and a stone slab were found on it. Altars such as these are not uncommon in the front rooms of double-chambered tombs and appear to have been used to place offerings at the time of the burial rites.[199] Bricks had been placed in each corner; a small cup was placed on each of the front two. The *hunping* (fig. 2.70) was located among the majority of the tomb objects along the wall opposite the altar. It is noteworthy that the *hunping* was not placed on any of the specially elevated settings for objects in the tomb. The body of the *hunping* is much simplified in comparison to previous examples, with only eight large birds, represented as if seen from above (described in the report as a phoenix, *luanfeng* 鸞鳳). The lid placed above a round opening is a square plate decorated with cross-hatching similar to that found on the two previously discussed *hunping* (figs. 2.65 and 2.67); at one corner is a small Buddha-like figure and it is probable that such an image originally decorated each of the corners rather than the birds found on the *hunping* of 275. Below the lid is a platform with a distinctive pinched edge on which are arranged four small pots with seated bears, *huren,* and birds. Along the rim below are a pair of *que* towers and a total of nine identical Buddha-like figures.

One other related *hunping* (fig. 2.71) was excavated from an undated tomb in Nanjing.[200] This tomb is a single room, only 4 m long, dated on stylistic grounds to the middle Western Jin dynasty by the excavators. It appears to have been intact and contained twenty-three objects, mostly greenware; only a few coins and a fragment of a mir-

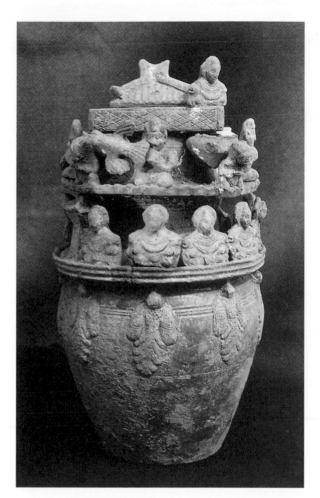

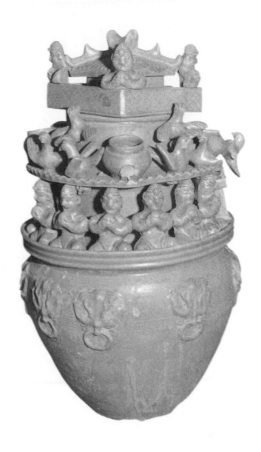

ror were made of metal. This *hunping* is very similar to the one dated to 280 (fig. 2.70). Both have a three-level superstructure with a square platform lid as well as an identical pinched (wavy) decorative pattern around the outer edge of the second register and the same tripartite molding on the rim. The differences are that six *pushou* replace the large birds on the body, eight seated *huren* replace the Buddha-like figures along the rim, there are only birds and pots on the next register, and four *huren* replace the Buddha-like figure at the corners of the lid. A two-lug bowl (fig. 2.72) with a single Buddha-like figure was recovered along with the *hunping*.[201] This is the second time we have encountered the combination of a bowl with a Buddha-like figure and a *hunping* with no similar figure, the previous example being in Zhejiang Shengxian Tomb 95, dated to 263.

As pointed out by Ruan Rongchun, the latter two *hunping* from the Nanjing area are very close in style to a work from a tomb dated to 277 at Shangyu, northern Zhejiang.[202] The tomb is a small, single-room chamber (fig. 2.73), and the *hunping* was found among ceramicware objects in the front corner.[203] According to the plan, the *hunping* and other

2.70 *Left: Hunping,* Jiangning Suoshu Tomb 85JSM1, tomb dated to 280. From He Yun'ao, *Fojiao chuchuan,* no. 79.

2.71 *Right: Hunping,* Nanjing Shizishan Tomb 84XSM1. From Ruan Rongchun, *Bukkyō denrai,* 198, pl. 126.

2.72 Bowl with Buddha-like figure, Nanjing Shizishan Tomb 84XSM1. From He Yun'ao, *Fojiao chuchuan,* no. 50.

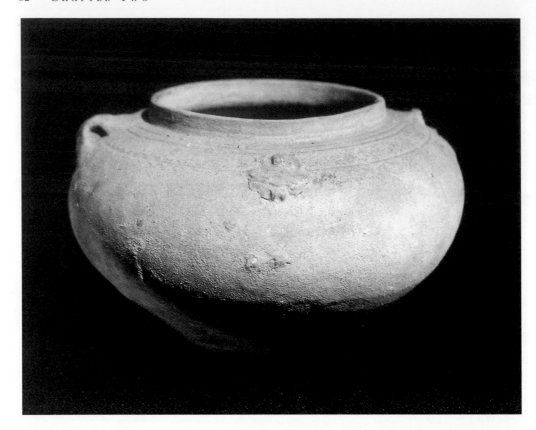

works were discovered upright, a strong suggestion that they were not disturbed by tomb robbers. This work (fig. 2.74) does not appear to have Buddha-like figures, although the archaeological report identifies the seated *huren* along the rim as Buddha images. The lower body is decorated with a single band of densely packed relief carving made up of *pushou,* riding figures, *qilin,* and birds, but no Buddha figures, although the report states that they are represented. Squatting bears have been placed in two of the corners of the square lid—that is, in the same position as the *huren* in figure 2.71 and the Buddha-like figure in figure 2.70. What is again indicated is the interchangeability of the Buddha-like figure with the bear, as we found in the money trees, and a similar equivalency with the seated *huren.* The relationship is most striking in a comparison between the series of Buddha-like figures on one *hunping* (fig. 2.70) with the row of *huren* on the others (figs. 2.71 and 2.74). There is a strong sense that a limited range of stock motifs are being deployed on the *hunping* in differing combinations primarily for the sake of visual diversity.

The similarities among the five works, especially the latter three, suggest that they were produced in the same locale, if not the same kiln. Since all except one were excavated in the Nanjing area, it would be reasonable to consider Nanjing to be the place of

production, with a single *hunping* from Nanjing having found its way to distant Shangyu. In fact, no kiln sites of this period have been reported in the vicinity of Nanjing. Rather, evidence of kilns has been found at Yixing in southern Jiangsu Province and at Shaoxing and nearby Shangyu in Zhejiang; the latter site had more than sixty kilns during the Western Jin period.[204] This suggests that the *hunping* found in Nanjing were more likely manufactured in Shangyu. Further evidence for the wide distribution of works from Shangyu kilns can be found in a number of *hunping* that have a place-name (taken by scholars to indicate their place of production) identified in their *bei* inscriptions (fig. 2.75) as Kuaiji 會稽 or Shining 始寧, the former being the third-century name of the *jun* 郡, or prefecture, that included Shaoxing and Shangyu, while the latter was a *xian* 縣, or county, just to the south of Shangyu. Although many of these works were excavated from nearby tombs, four such *hunping* were found at Wuxian 吳縣 in southern Jiangsu and one made it as far as Pingyang 平陽 in far southern Zhejiang.[205] At the same time, the works self-identified as coming from Kuaiji or Shining are far from uniform in color or style. In this period, a kiln might produce a visually diverse range of wares, and kilns in different areas of Jiangnan 江南 (literally south of the Yangzi River) made very similar types of works, a situation that has thwarted attempts to establish stylistic distinctions among contemporary kilns.[206] The visual affinities among our five *hunping*—one excavated in Shangyu and the others from the Nanjing area—are suggestive of a common kiln or locality of manufacture, but little else can be determined from the visual evidence.

The visual relationships among *hunping* from tombs of a later date are no less complex. For example, five *hunping* have been excavated from tombs of the 290s at Shizishan 獅子山 in the above mentioned Wuxian.[207] Tomb 2, a double room just over 9 m in length, contained bricks with an inscription dated to 293 that identifies the occupant as a *taishou,* or governor. The *hunping* (fig. 2.76), which has a small *bei* mounted on a tortoise stating that it was from Kuaiji and made in 292 (fig. 2.75, 3), is topped by a four-

2.73 Plan, Shangyu Jiang-shan Tomb M84, Zhejiang, dated to 277. From Shangyu xian wenwu guanlisuo, "Zhejiang Shangyu Jiangshan," 135, fig. 1.

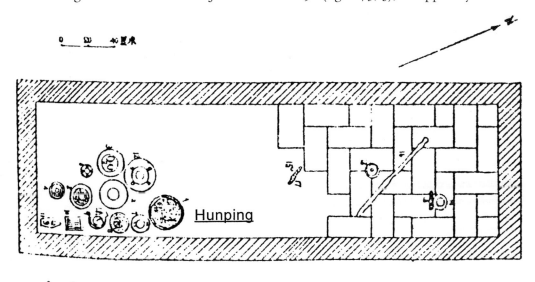

Hunping

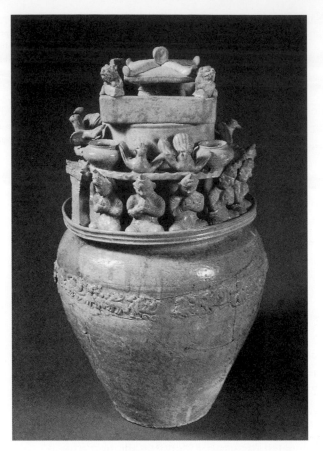

2.74　*Hunping,* Shangyu Jiangshan Tomb M84, Zhejiang, tomb dated to 277. From He Yun'ao, *Fojiao chuchuan,* no. 65.

sided, walled compound. Below are two registers crowded with images of *huren,* birds, and bears; the body features large figures each holding a staff, monkeys, birds, crabs, and *qilin* in relief. Although one publication lists a Buddha-like figure and bear among the uppermost register of birds, there appear to be two bears and no Buddha in published photographs of the work.[208] Only 10 m away from Tomb 2 is the undated Tomb 4, nearly identical in scale and shape.[209] Based on the correspondence in tomb type and grave goods, the excavation report suggests a similar date for Tomb 4. A *hunping* (fig. 2.77) was found in the left side of the front room on a raised platform along with a greenware pot and model stove. This work also includes a small *bei* on a tortoise (fig. 2.75, 4) with Kuaiji in the top or "head" of the stele followed by the phrase "from Shining 出始寧." The architectural form, a large, central roofed structure with four smaller pavilions below, is, however, different from the work in Tomb 2. The body, which has one prominent hole, is decorated with two registers of relief motifs, including *pushou* and Buddha-like figures. Tomb 3 was not intact and yielded only five items, including a hunping (fig. 2.78) with a small *bei* atop a tortoise. The inscription contains the regnal name *Yuankang* 元康, which lasted from 291 to 299, but no specific year, and also states that it was from Shining. The form of the *hunping* is quite similar to that of Tomb 4, but there is no hole in the body and small Buddha-like figures are placed in both the upper and lower zones. Interestingly, a *pushou,* a motif usually restricted to the body of *hunping,* has been applied to the pillars of the three-story gate in the upper section along with a Buddha-like figure. Note that in each of these *hunping,* the arrangement of figures around the lower edge of the upper section recalls the composition of animated, capped figures and small animals found on *hunping* of thirty years earlier from Shengxian (figs. 2.47 and 2.51).

Some 80 m to the other side of Tomb 2 is the undisturbed Tomb 1, a slightly smaller (7.9 m long) two-chamber excavation with a small alcove and rounded side walls in the rear room.[210] Inscriptions on bricks date Tomb 1 to 295. Two *hunping* were discovered

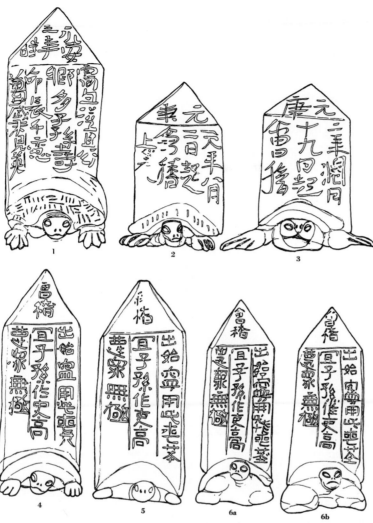

2.75 Drawing of stele inscriptions from *hunping*.
1. Shaoxing, 2. Pingyang,
3. Shizishan Tomb 2
(fig. 2.76), 4. Shizishan Tomb
4 (fig. 2.77), 5. Shanghai Museum, 6. Shaoxing Longshan.
From Okauchi Mitsuzane.
"Go-renkan to sōshoku tsuke
tsubo," 692.

in the tomb: one in the front right corner of the rear room among other grave goods, and a second by itself in the front room. The former has not been published; from the description, however, it also appears to be similar to the *hunping* from Tomb 4. The upper section is said to feature a walled enclosure with a three-story structure rising from the center; on the corners below are four pavilions flanked by birds and *huren;* a pair of *que* towers form a gate with more *huren,* dogs, bears, sheep, and tigers. On the body assorted figures and animals are described: dragons, *qilin,* and *pushou* as well as two snakes, one entering and the other emerging from a hole. No Buddha-like figures are mentioned, and this work seems to be consistent with the first three *hunping* from the site. The other *hunping* from Tomb 1 (fig. 2.79) has eight prominent Buddha-like figures along the upper rim and an absolutely plain body. Also distinctive are the upturned,

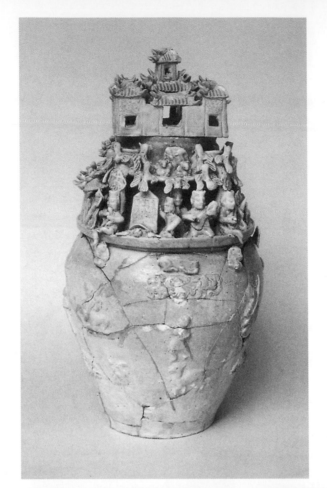

2.76 *Above: Hunping,*
Wuxian Shizishan Tomb
M2, dated to 292. From
He Yun'ao, *Fojiao chuchuan,*
no. 90.

2.77 *Below left and right:*
Hunping, front and rear,
Wuxian Shizishan Tomb
M4. Wuxian wenwu guanli
weiyuanhui, "Jiangsu Wuxian
Shizishan sihao," pl. 8: 1–2.

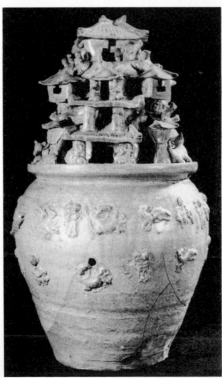
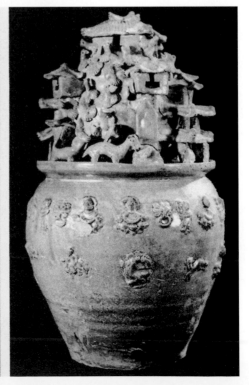

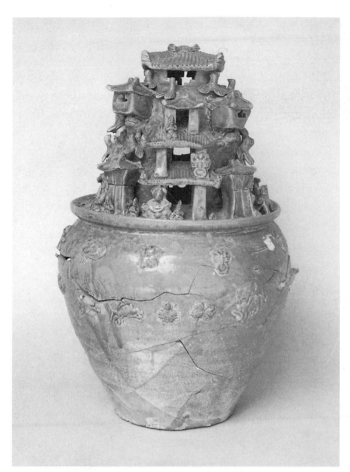

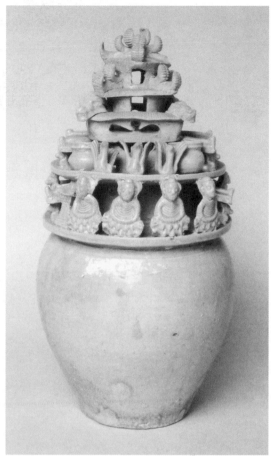

2.78 *Left: Hunping,* Wuxian Shizishan Tomb M3, dated to 291–299. From He Yun'ao, *Fojiao chuchuan,* no. 96.

2.79 *Right: Hunping,* Wuxian Shizishan Tomb M1, dated to 295. From He Yun'ao, *Fojiao chuchuan,* no. 100.

curved forms on the roof, the uniformly outward-facing birds, and the use of small crouching bears as supports for the three-storied gate.[211] Compared to the jumble of architecture and images in the first four *hunping* from Shizishan, the plain body and neatly distinguished motifs contribute to a very different and simplified impression.

The formal treatment of the Buddha-like figures in the second Tomb 1 *hunping* is also distinctive in that they are now presented as separate serial images. The Tomb 1 work, however, is not an anomaly. Three nearly identical works, all found in Zhejiang Province, have been published: one, undated, from Huzhou 湖州, not far to the south of Wuxi; a second, also undated, from a small single-chamber tomb in distant Wuyi 武義, near Jinhua 金華 in central Zhejiang; and a third from another small single-chamber tomb near Hangzhou with bricks dated to 298.[212] In addition, there are several other examples of *hunping* from Jiangsu Province in which rows of similar large figures were utilized. One is from a small, double-chambered undated tomb in the Jiangning area south of Nanjing, said to be of the Wu period.[213] In this work (fig. 2.80), the squat shape and reduced emphasis on architecture further emphasize the registers of serial birds and

Buddha-like figures. The body is not plain, although the reported images (two *pushou*,
six coiled dragons, and two dancing monkeys) are difficult to discern. Another *hunping*
comes from a very small (only 3.9 m long), single-chamber undated tomb near Nanjing
also said to be of the Wu period. This work eliminates the birds altogether and fills both
upper registers with rows of similar haloed figures, one of which is placed in each door-
way of the central architectural structure (fig. 2.81).[214] Although the figures are often
published as Buddha-like, closer inspection reveals that the usual lotus seats are not de-
picted and the hands are placed together at the chest, a gesture not consistent with
Buddha-like figures but typical for images of *huren* on *hunping.*[215] There appears to have
been a fusion of motifs in this work: the head and body halo as found on the Jiangning
Buddha-like figures combined with the seated *huren* figure with hands raised to the
chest. Such a hybrid image is unique; the two types of figures were clearly differentiated
on other *hunping,* which suggests an informed choice in this case rather than any mis-

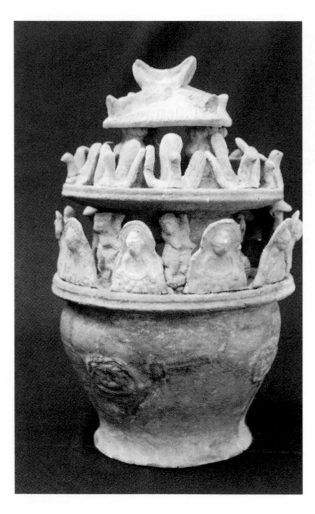
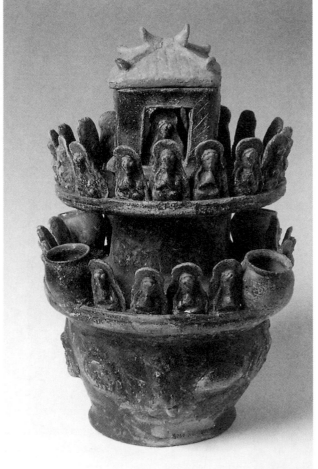

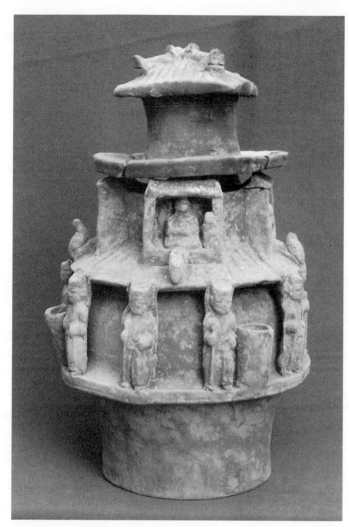

understanding.[216] It should be noted that this work also has a squat body with large re-
lief motifs difficult to discern but said to be a Buddha-like figure, a *pushou,* and a fish.[217]

In contrast, a third example (fig. 2.82), the most unusual of all, was found in a very
large four-room tomb with bricks dated to 297 near Yangzhou 揚州, just north of Nan-
jing.[218] Here the rounded lower body of earlier *hunping,* deemphasized in scale in the two
previously discussed works, has been completely abandoned. Rather, a short cylindrical
base supports a roofed platform with four tall pots, six standing capped figures, each
holding a staff, and a pair of *que* towers forming a gateway. The capped figures appear to
be three-dimensional versions of those found in relief on the body of the *hunping* from
Jiangning dated to 273 (fig. 2.62). In the next register, a single seated figure with an at-
tendant is installed in each of four niches, one to a side. A single bird is seated facing the
niche in an attitude of veneration. It is not clear whether the seated figure should be

identified as a Buddha-like figure. Although the hands in the lap indicate the meditative posture found in other Buddha-like figures, there is no halo or lotus or lion pedestal. An image such as this is reminiscent of a conventional Buddha image in posture and its setting within a niche-like space and might be best understood as a hybrid image akin to those found in the Han dynasty Yi'nan Tomb (fig. 2.1), in which visual motifs inspired by Buddhist imagery are used for the depiction of non-Buddhist deities.[219]

FUNCTION OF THE *HUNPING*

In his perspicacious and still influential essay of 1961, Wai-kam Ho noted that compared to the large number of objects found in tombs, *hunping* were relatively few in number, an indication that they were part of a special kind of interment (*zang* 葬) of *zhaohun* 招魂 or summoned souls.[220] He goes on to argue that this type of ritual was important for those northerners who were forced to leave family members without proper burial during their flight from the fallen Western Jin capital of Luoyang to the lower Yangzi valley in 311. Information about this practice is contained in a number of documents from the beginning of the Eastern Jin, including a petition in 318 to officially prohibit the practice.[221] The large scale and elaborate decorative motifs of the upper zones of *hunping* make them likely candidates for the works referred to in the Eastern Jin debate over the burial of the summoned soul, called *lingzuo* 靈座 (seat of the soul) or *huntang* 魂堂 (hall of the soul) in the texts. Yet it is now clear that by 311 the use of *hunping* in Jiangnan tombs had all but ceased, and the great majority of extant works must have been produced independently of the specific problem faced by Jin dynasty elites from the North.[222] This does not rule out the possibility that Eastern Jin émigrés adopted the earlier *hunping* for their own purposes, but what remains unclear is the extent to which the fourth-century debate reflected the function of *hunping* in earlier tombs. The relationship between the earlier archaeological finds and the later Eastern Jin debates is suggestive but conjectural.

Since Ho's essay, the practice of *zhaohun* as well as the related issue of the dualism of the *hun* 魂 and *po* 魄 souls have received considerable scholarly attention.[223] Recently, the case has been made that the division of the soul between a *hun* and *po* after death—that the former was ethereal and rose to heaven while the latter was heavy and sank to the earth—was fundamentally a scholastic concept and not a widespread belief. Rather, as Brashier puts it, most "non-literati and some literati sources tend to use these terms generically and interchangeably and usually refer to a single entity distinct from the body . . . [E]fforts were made to keep this entity housed in the tomb with the body at death."[224] Although the concept of a single entity that survived separately from the body after death was widely acknowledged, the terminology for such an entity, its destination, and its relationship to the tomb did not cohere in a consistent system of beliefs. Instead, the issue for most seems to have been entirely practical and mundane: how to insure the comfort and happiness of the deceased in order to prevent any harm befalling the living.

To this end, as archaeological materials amply demonstrate, the deceased was provided with documents addressed to the rulers of the afterworld such as land contracts, celestial ordinances, and official inventories. Larger tombs were essentially underground dwellings furnished with utilitarian objects of everyday life, models of familiar objects, and special mortuary objects such as mirrors, money trees, or *hunping*. In general, there appears to be an understanding that the afterlife would be a parallel to the present. For example, small lead men placed in jars with inscriptions which declare that the figures will perform the labor demanded by the gods of the underworld are typically found in small, lower-class tombs, most likely the burial places of those who were required to perform corvée labor in their lifetime.[225] Documents such as land contracts were used in tombs of middling size, presumably for those whose claim to the land may have been open to challenge. Conversely, the largest tombs typically lack such semilegal contracts, testament to the status of the deceased in this world as well as in the afterlife.

Although *hunping* are extraordinary objects in comparison to other forms of *mingqi,* it is striking that they were not typically positioned adjacent to the corpse or given special pride of place in the tomb. Rather, *hunping,* which are almost always found among the usual sets of ceramic and pottery goods clustered together at some remove from the coffin, appear to have been treated in a remarkably undistinguished manner. What is suggested is that the *hunping* was a rather ordinary object among a common range of types produced for burials in the Southeast. This is in contrast to bronze mirrors, which are consistently found near the corpse, often inside the coffin. The evidence of third-century tombs thus indicates a continuation of Han dynasty practices in which bronze mirrors were understood to be the most important symbols of longevity in the tomb, especially in terms of their durability as metal objects.[226] Mirrors were also the *only* mortuary objects in the Southeast containing images of the Queen Mother, often paired with the King Father, unlike in the Southwest, where the Queen Mother alone was an important visual motif, not only on money trees, but on pottery tomb reliefs, stone sarcophagi, and even on occasion as free-standing sculpture.[227]

It is also notable that only a single *hunping* is found in a tomb regardless of the number of coffins. Even in the cases of multiple burials over time—for example three couples and one female interred in a tomb near Nanjing dated to the period between 265–280—only one *hunping* was excavated.[228] A rare exception is the previously discussed Wuxian Shizishan Tomb 1, in which one work (fig. 2.79) was found by itself on a raised platform of bricks used as a ritual altar *(jitai)* in the front room. Such platforms are not unusual in tombs of this period (see fig. 2.69), but to find a *hunping* in this position rather than the typical assortment of cups and dishes used for offerings is unexpected. The style of the work is also distinct from the other *hunping* at the site, including the second *hunping* in Tomb 1, which suggests the possibility that the work was added to the tomb some time after the original interment. One might be tempted to suggest that the special position of the work was related to the emphasis on serial Bud-

2.83 Plan, tomb at Jiangsu
Jiangning Zhangjiashan, dated
to 297. From Nanjing bowu-
yuan, "Jiangsu Jiangning xian
Zhangjiashan," 908, fig. 1.

dha images found in the upper zone. But the only other example of an isolated *hun-ping*—also on an elevated section of bricks—suggests otherwise. The tomb, at Jiangsu Jiangning Zhangjiashan 江蘇江寧張家山 (fig. 2.83), contained bricks dated to 297.[229] The report states that the *hunping* included twenty-five Buddha-like figures in the upper section, twelve figures each 5.6 cm in height, and thirteen smaller figures (each 2.5 cm in height). Later, while continuing to refer to the figures as *foxiang* or Buddha images, the report states that the figures look like *huren* and may represent Western monks. Although the illustrations are too few and poor in quality to allow for a definitive statement, the identifiable figures are all of *huren,* not Buddha-like figures. Therefore, although suggestive, neither the multiple *hunping* in a single tomb nor the two tombs with *hunping* on an altar indicate a special function for *hunping* related to the depiction of serial Buddha images.

The fact that a *hunping* was not given a special place within the tomb, particularly the absence of a close physical relationship to the coffin, mitigates against the hypothesis that *hunping* were meant to house the soul *(hunpo)* or spirit (*shen* 神) of the deceased in the tomb. In one case (fig. 2.68), the top was found neatly placed on the floor next to the *hunping,* which tells us that it was not even necessary for the *hunping* to be assembled in the tomb. The example of Wuxian Shizishan Tomb 2, in which the *bei* of the *hunping* is dated to 292 and the tomb bricks to 293, is evidence that *hunping* were in some cases made before the tomb had been completed. If the date on the *bei* was the date of death, as proposed by one scholar, the few such dated works extant were special objects made to order for the funerals of specific individuals after their deaths. In contrast, the great majority of *hunping* were probably ready-made works purchased when needed.[230] These observations are merely suggestive, but they point toward the importance of the *hunping* prior to their burial with the deceased, possibly relating to funer-

ary rituals rather than the afterlife in the tomb. Some of the *bei* inscriptions specifically refer to the funerary function of *hunping,* as pointed out by Wu Hung, who translated one such text (fig. 2.75, 6a–6b) as follows: "(The ware is made in) Shining, Kuaiji, and is to be used for funerary purposes. It will bring good fortune to the descendants (of the departed)—help them to win promotion to high official rank—and will benefit people infinitely 會稽出始寧用此喪葬宜子孫作吏高遷眾無極."[231] A number of *bei* on *hunping* repeat the text verbatim (fig. 2.75, 4–5) while others express similar sentiments (fig. 2.75, 1).[232] Besides the funerary purpose, we find in the *bei* inscriptions an emphasis not on the deceased, but on how the *hunping* will bring good fortune to the surviving descendants. The *hunping* inscriptions express the common understanding that filial piety would be repaid in terms of future success for the descendents of the dead.[233] Rather than an abode for the soul of the dead, the inscriptions suggest that the *hunping* was a votive offering for the benefit of the living. The many contemporary tombs from this region without *hunping* (although the numerous jars in museum collections must have originally come from some of these tombs) are a reminder that it was the tomb, filled with items used by the deceased as well as *mingqi,* that was considered to be the primary abode of the soul, not the *hunping.*

 While such an argument clarifies the function of the *hunping* as a funerary object, the elaborate ensemble of motifs arranged on *hunping* distinguishes them from the straightforward models of architecture or various forms of ceramicware among which *hunping* were placed in the tomb. Early *hunping* (fig. 2.47) featured figures and animals around the upper edge reminiscent of shamans and their ecstatic ritual practices. Textual accounts of shamans and their variety of roles in mediating the relationship between the spirit and human world shed light on some of the popular beliefs that appear to be represented on the *hunping.* It was shamans, for example, who were known to have a special relationship with the animal world, for example the ability to identify and placate malignant animals such as foxes, water lizards, turtles, and snakes.[234] The latter three often occur as motifs on the bodies of *hunping.* Shamans were also known for their ability to see and communicate with the otherwise invisible forms of the dead, for example in incidents involving the Wu Kingdom emperors Sun Xiu 孫休 (r. 258–264) and Sun Hao 孫皓 (r. 264–280) as recorded in the *Soushenji* 搜神記.[235] Such shamanic powers might have been thought to be appropriate for a work used in a funerary context and then buried with the deceased. The rows of seated *huren* found on many *hunping,* inexplicably described as Buddhist monks *(sengren)* in a number of publications, may be better understood as shamans also, albeit in strikingly formal and iconic postures. In some instances, such seated figures were depicted holding a gourd or melon-like object (figs. 2.71 and 2.74), possibly a ritual implement or musical instrument.[236]

 In the upper zone, all but the earliest *hunping* feature a narrow range of architectural motifs (roofs, platforms, gates, and *que* towers), sets of bowls and birds. The gates flanked by *que* towers, well known from Eastern Han tomb sites, served to mark the point of

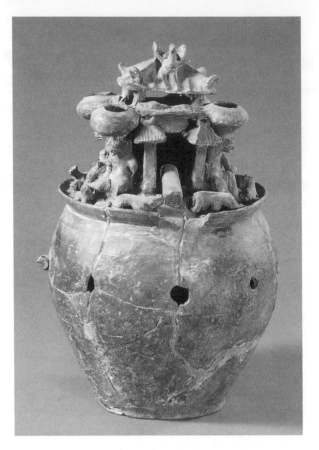

transition between the world of the living and that of the dead.[237] One undated work
(fig. 2.84) from Dengfushan on the outskirts of Nanjing has a casket prominently placed
directly across the threshold of the gateway.[238] Accordingly, one could understand the
gateway on *hunping* to be the entrance to the world to which the deceased was consigned
and the interior of the architectural structure as that world, a parallel to the tomb. Al-
ternatively, Kominami has argued that the paired *que* towers symbolize the gate of heaven
(*tianmen* 天門) based on examples of *que* labeled as such on mirrors and stone sarcophagi
from Sichuan.[239] This is consistent with Wu Hung's suggestion that the upper section of
the *hunping* was a luxurious wonderland and a paradise of the soul.[240] The Sichuan
examples feature welcoming figures in the gateway, and the *que* towers are topped
with auspicious *fenghuang* or, in one case, the Queen Mother and the King Father. One
further example can be added, a winged female figure at a half-open doorway on the end
of a sarcophagus, a position often decorated with *que* tower gateways; above the door-
way is depicted a *pushou*.[241] In contrast, the gateways of *hunping* are typically empty.
When filled, we find a recumbent ram (fig. 2.56), *huren* (figs. 2.65 and 2.66), or a bear
(fig. 2.67). The same birds that cluster on the roof and around the bowls of the super-

structure are usually placed above the *que* towers. Only at one site, Wuxian Shizishan, do we find the application of small animal motifs (fig. 2.77), a *pushou,* or a Buddha-like figure (fig. 2.78) to the uprights of the gateway. The contrast between the heavenly associations of the Sichuan *tianmen* and the largely mundane presentation of *hunping* gateways, surely a subtle regional difference in emphasis, indicates that the superstructure of *hunping* may represent less a heavenly realm than the shadowy, unknown world of the dead. It then follows that the pavilion may be understood to represent a safe dwelling place with ample sustenance symbolized by the ubiquitous pots and birds. These are expressions of the desire of the living that the deceased be fed and cared for and function as the counterparts of the ritual offerings of food to the ancestors either at their tombs or lineage shrines.

As for the body of the *hunping,* the hole and loach on early works suggested to most scholars the way in which the *hunpo* entered the lower realm of the work. Wu Hung related the holes and loaches on the body of *hunping* to the underground Yellow Spring (*huangquan* 黃泉), a destination for the *po* soul.[242] Kominami, with reference to classical texts such as *Mengzi* 孟子 and *Chunqiu zuoshi zhuan* 春秋左氏傳, believed that the latter imagery equates the body with an old concept of a watery world in the bowels of the earth.[243] There is also a record in *Shiji* 史記 of Han Emperor Gaozu summoning the *hun* of his mother, which took the form of a snake.[244] The previously mentioned *hunping* with the coffin across its gate entrance (fig. 2.84), dated to the Wu Kingdom period based on style, also has holes on its body with the head of a loach emerging from one and a tail entering another. This would seem to indicate that the deceased was located in the upper section in the coffin even as the loach moved in and out of the holes. Such a situation suggests an example of *hunpo* dualism except for the odd juxtaposition of the heavier *po* in the upper zone while the lighter *hun* represented by the loach is apparently consigned to the lower body. Another explanation is that the loach represents the *po* in the dark underworld; the *que* towers, coffin, and animal and human figures around the rim indicate the tomb and this world; and the birds on the roof represent the *hun* flying off to a heavenly realm.[245] The latter thesis has the advantage of a neat vertical scheme of three registers which generates a sense of clarity and organization to the work. The problem is that the holes and loaches were an early feature of *hunping* completely abandoned in later works and replaced on the body with a wide array of motifs in different combinations: *pushou, qilin, bixie,* dragons, crabs, turtles, lizards, phoenixes, splayed birds, winged rams, riders on horses, running figures with staffs, and the seated Buddha-like figures. Most of these motifs cannot be easily related to a watery underworld, and some have no easy explanation at all, for example the oft-found rider and the prominent standing or running figure holding a staff (fig. 2.85). The latter are sometimes identified as warriors (*wushi* 武士). Although there are no precedents for the latter figure in the Southeast, there is a distant visual relationship to a type of guardian figure holding a halberd from Sichuan tombs, called *dazongbo* 大宗伯 by Wu Hung and *daxingbo* 大行伯 in

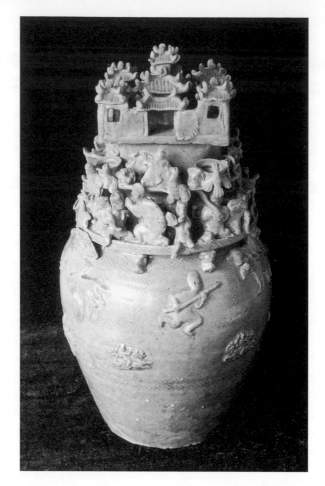

the *Shanhai jing.*[246] Yet the context of the *hunping* has little parallel in the Sichuan works, and one is reminded again of the limitations of our extant sources for the explanation of such figures. The motifs on the body are not consistent among the works, and the varied combinations of motifs suggest to me that there is no single concept behind their deployment on *hunping.*

More than one explanatory theory might be proposed. For example, since the pavilions become more elaborate in some works as the holes disappear, we might postulate a shift in emphasis to the upper zone, possibly a change in concepts of the afterlife. Still a further shift might be indicated by the *hunping* that have plain bodies. Or it could be argued that the meaning of the body—a dark, watery, lower world—remains the same whether one finds holes and loaches or the later wide range of auspicious and apotropaic motifs applied to the body. The later sets of motifs then might be understood as primarily apotropaic—that is, protecting the upper zone from what was inside the lower body of the jar. There are other possibilities and, in fact, some evidence for a certain random-

ness to the placement and selection of the later motifs. One work (fig. 2.65) exhibits the sole example of a small *huren* on the body of any extant *hunping*. Interestingly, the same vessel has a *pushou* attached upside down (fig. 2.66) in contrast to all of the other correctly oriented *pushou* on this work. In both cases, it seems possible that the appliqué motifs were slapped on in a less than thoughtful manner. This naturally raises the question of the extent to which the selection of motifs and their arrangement—both within acceptable patterns, of course—were left to the individual artisan. Are these intentional choices that would yield insight with the proper interpretation, or have we reached the limit of what one could discover about belief systems through the analysis of visual imagery?

THE ORDINARY BUDDHA

Based on eleven dated examples available to him in the early 1980s, Wu Hung observed that the Buddha-like figure on *hunping* seemed to shift over time from the lower body to the upper zone.[247] This led him to suggest that the Buddha image was transformed from a secondary to a primary decorative motif in later works. While the pattern in the position of the Buddha-like figure is generally upheld, the larger number of dated works now available suggests a more complicated situation. Indeed, the earliest dated works with the Buddha-like figure tend to limit the figure to the body, but works from the 270s utilize the Buddha-like figure in both lower and upper zones (fig. 2.66). Most important, it appears that *hunping* dated to the 280s were made with the complete range of possibilities: the Buddha-like figures only in the lower zone, only in the upper, in both lower and upper, or no figure at all.[248] A similar pattern was found in the 290s at the site of Wuxian Shizishan, in which the five excavated *hunping* exhibit all of the above options for the Buddha-like figure: only in the lower zone (fig. 2.77), only in the upper zone (fig. 2.79), in both (fig. 2.78), and no figure (fig. 2.76 and the unpublished work from Tomb 1). While *hunping* with no Buddha-like figures continue to be used into the fourth century—we have examples from tombs dated to 302 and 313—*hunping* with the Buddha-like figure actually seem to fall out of favor at the end of the third century.[249] Only one work from a tomb dated after 299 contains a Buddha-like figure. This *hunping* (fig. 2.86), from a tomb with bricks dated to 322, has a single Buddha-like figure on the shoulder. Its form—the wide central opening with no top, the four large adjacent jars on stem-like supports—as well as the prominent bearded musicians and snakes (one emerging from a hole) recalls *hunping* of the 260s or 270s. The work is wholly anomalous for the early fourth century. It has been suggested that this was an early work reused in a later tomb; if so, we have no dated *hunping* with a Buddha image of any kind after the end of the third century.[250]

The not insignificant issue raised by this example is that the date of a tomb may in fact not coincide with that of the *hunping* excavated inside it. Tombs from this area are most often dated from a single inscription on one of their bricks. We have seen, however, examples of tombs for which more than one date has been discovered—on bricks

2.86 *Hunping,* Zhejiang
Xioshan, tomb dated to 322.
From He Yun'ao, *Fojiao
chuchuan,* no. 106.

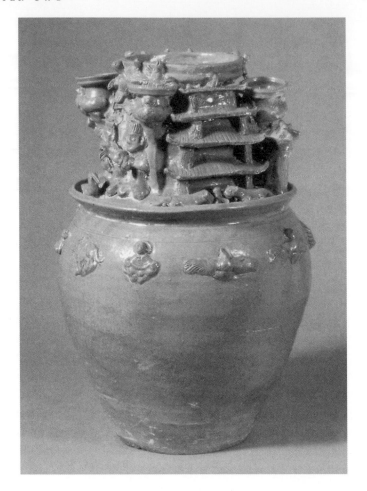

stamped with different dates, a lead deed, or a *hunping bei* inscription. Typically these
dates are only a few years apart, often a reflection of the discrepancy between the date
of death and that of interment or the separate date of the construction of the tomb as
well as differing dates of manufacture for the bricks.[251] The possibility, however, that a
dated tomb and the style of a *hunping* could be fifty to sixty years apart is sobering for
the above analysis, which has placed considerable weight on the date of tomb bricks or
other documents discovered inside a tomb for providing the date of a *hunping.* It is prob-
able that on some occasions *hunping* manufactured at a significantly earlier date were
used in later tombs; but, except in those few cases in which a work contains a dated *bei*
inscription, it is nearly impossible to be certain.

It now seems that the linear, evolutionary development of the Buddha-like figure
from a relief image on the body to a three-dimensional image in the upper zone, as pre-
viously suggested by Wu Hung, is not so clear-cut. The emphasis on serial Buddha-like
figures in the upper zone occurred in a notably small number of works and did not re-

place other, long-established ways of using the Buddha image in the decorative program of *hunping*. Rather, all types of *hunping* were used concurrently (although we must be less certain about exact dates of production), with the type featuring large, serial Buddha-like figures in use as early as the Wu period but at least by 280. Wu Hung understood the prominence of the Buddha-like figure in the upper zone of *hunping* as a change in orientation away from established conceptions of a paradise to a new paradise of the Buddha, possibly reflecting knowledge of the paradises described in translations of Buddhist sutras made in the Wu Kingdom. He went so far as to declare that such *hunping* were placed in tombs of early Buddhists and are evidence of a "popular Buddhism" distinct from the orthodox religion being developed among the literate clergy and their court patrons.[252] The possible inspiration from paradise texts translated at court or the development of a popular mortuary Buddhism cannot be totally rejected, but many questions still remain regarding the function of the *hunping* before as well as after the introduction of the Buddha image.

CONCLUSION

For most art historians, myself included, the visual emphasis on the Buddha image suggests a development toward iconic forms of conventional Buddhist imagery. It does not seem to be a coincidence that at the beginning of the fourth century when the Buddha-like figure disappeared from *hunping,* we find small bronze figures, the earliest extant Buddhist icons. At the same time, an explanation of the Buddha-like figures on *hunping* as linear and progressive—the figure develops in stages from a small motif among others to an independent icon—is surely influenced by what we *know* follows these figures: the full-fledged blossoming of a Buddhist iconic tradition in China. This is an example of the way in which a teleological formulation (from our point of view in the present back into history), with all of the component stages of development unfolding in reverse, can overdetermine the analysis of a complex historical phenomenon. In fact, the most significant piece of evidence for the nonlinear development of the early Buddha image is the large ceramic Buddha-like figure from Tangjiaotou Tomb 4 in Hubei, which in retrospect we can appreciate as a singularly unique example of an independent Buddha image in a tomb from the Southeast and one that most closely approximates the independent form of the conventional Buddha icon. Yet this work was found in a tomb dated to before 261 by the excavators, a period, even if the date is not absolutely precise, that places it at the beginning rather than the end of the tradition of the Buddha image in Jiangnan tombs. Until and unless further archaeological finds alter the picture, we must conclude that the earliest adoption and use of the Buddha image in the Southeast was not a process of linear development but a phenomenon that occurred simultaneously in different and unsystematic forms.

Zürcher has stated that the Buddha-like images in early Chinese art "were 'up-to-date' borrowings, roughly synchronous with the date of the Indian originals."[253] While

absolute dating of Indian works of this period is controversial, we know that there were three distinctive and overlapping types of seated Buddha images produced under the Kushan dynasty in the first to third centuries C.E.[254] The earliest was the Kapardin type, in which the chest was covered by thin material and the right shoulder was left bare.[255] The second type, both shoulders covered and drapery arranged in symmetrical rounded folds, was followed by an asymmetrical type in which flat folds were pulled to one side. While it is impossible to confirm how up-to-date the Chinese images were, it is interesting that of these three types, all available as models, only one, the symmetrical type with both shoulders covered (fig. 2.7), appears in early Chinese Buddha-like figures.

It may not be coincidental that the symmetrical drapery style, rendered in a simple, schematic fashion, was utilized in images on a number of Indian coins of the Kushan period as well as on small reliquaries.[256] The abbreviated style of the earliest Buddha-like images in China accords well with the style of the small Indian images—both may represent the effect of producing the image via a small-scale mold, for example in the bronze tree or *hunping* figures. This supports the oft-repeated belief that portable, small-scale works rather than large Indian icons were the prototype for the earliest Buddha-like images in China.[257] Not incidentally, visual motifs from such objects would be most susceptible to being utilized without regard to or knowledge of their original Buddhist meaning. Yet not a single example of an object of this type from the second or third century has been discovered within China.[258] It thus seems likely that few examples of Indian Buddhist imagery were actually in circulation in China and that a single example, rough sketch, or even verbal description of an image could serve as the basis of an early Chinese Buddha-like figure, which might then have been a model for other images produced in the locality. This means that there was little need of extensive or repeated contact with foreign models for many small early images to be made. The clearly delimited areas in which the Buddha image was produced and the narrow range of works in which it was incorporated indicate the regional and localized nature of the earliest adaptation of the Buddha image in China.

There is still the question of why a Buddha-like image from a small foreign object would be attractive to Chinese of the period. We have seen that Buddha-like images were not widely diffused but were anomalous and regionally specific. Such a limited interest in Buddhist visual elements accords with Zürcher's observation on early Chinese Buddhist texts: "Some elements in a scripture could—for a variety of reasons—'catch on' and become productive factors in Chinese Buddhism, whereas other notions figuring in the same text would remain alien and undigested."[259] Why something "catches on" is, of course, the key question. In terms of the visual arts, one might assume that not every Indian or Buddhist-derived motif in circulation was appropriated; some were utilized, others were ignored; some had a limited impact, others continued to be important over longer periods of time. Yet the tendency to understand Buddhist texts and art as parallel classes of evidence that were apprehended and translated in similar ways may

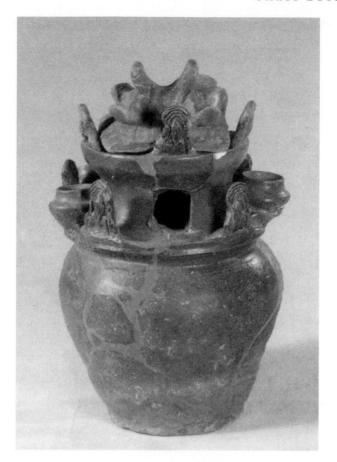

2.87 *Hunping,* Nanjing Zhonghuamenwai Langjia-shan, tomb dated to 293. From He Yun'ao, *Fojiao chuchuan,* no. 91.

be misleading: an entire text was presented for translation, but there is no evidence that complete sets of Buddhist images or narrative cycles were known in China during this period. Not surprisingly, the Buddha-like image and textual transmission have little correlation in the extant historical record of Buddhism in China.

The Buddha-like figure was introduced into Chinese funerary and mortuary practices in various guises. In most cases the figure was one among many apotropaic motifs used in tombs, on money trees, and on ceramicware such as *hunping.* Very little in the archaeological remains suggests a conventional Buddhist understanding of the figure or a status for the Buddha equivalent to that of other extant Chinese deities such as the Queen Mother of the West. As the *hunping* (fig. 2.87) from a Nanjing tomb dated to 293 indicates, what we see in an image may or may not be what was intended. I am at a loss to explain these ghostly shapes, clearly intended to form the Buddha images that we have been studying, but strangely unrealized.[260] Many questions remain concerning the earliest Buddha-like figures in China; the questions as well as the works represent something of the ambiguities and subtleties of early Chinese mortuary practices that we as modern scholars are only beginning to appreciate.

Chapter Three

Like practically all works of medieval Chinese literature, the early sources were written by and for *literati,* and deal only with one *niveau,* one segment of the immensely complex phenomenon which was early Chinese Buddhism . . . It is a discouraging fact that hardly anything is known about other, equally important, manifestations of Buddhism on Chinese soil . . . The earliest development of popular Buddhism in the various regions of the empire, the growth of locally differentiated popular beliefs and cults . . . are hardly ever mentioned.[1]

LOCAL CONTEXT

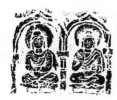

AS WE SAW IN THE PREVIOUS CHAPTER, images of the Buddha would largely disappear from Chinese mortuary contexts in the fourth century while becoming ubiquitous as conventional religious icons. The earliest extant works are bronze figures, usually very small and often crudely cast, occasionally larger and skillfully attended to (fig. 2.2). One would expect some remains of contemporary sculptures in stone—they are recorded in a number of textual sources—but there are none until the fifth century.[2] The earliest is a type of ordinary sculpture (fig. 3.1) produced in northwest China under the rule of the Northern Liang 北凉 dynasty (397–441).[3] Seven of the group are inscribed with dates corresponding to the years between 426 and 436. From the inscribed dedications—in which a number of the works are described as stupa or pagoda (*ta* 塔)—it is clear that these were votive works made for the benefit of the patron's parents and others. The Northern Liang votive stupa vary in size from 17 cm to nearly a meter in height and although the majority are only partially preserved, they form a closely related set of thirteen extant examples: six discovered in the immediate vicinity of Jiuquan, four from the area of Dunhuang, two found in Khocho near Turfan, and one whose provenance is unknown (map 4). The two works from Turfan, neither of which has an inscribed date, may be placed slightly later than the rest, between 443–460 when survivors of the Northern Liang ruling family controlled the oasis.

As the earliest group of dated and provenanced works of Chinese Buddhist imagery, the Northern Liang votive stupa provide us with a unique opportunity to examine the production of Buddhist images at a specific locale and time. These works appear to have been stock objects, made in workshops and purchased by donors after they had been carved. These aspects of the votive stupa have not been prominent in earlier discussions;

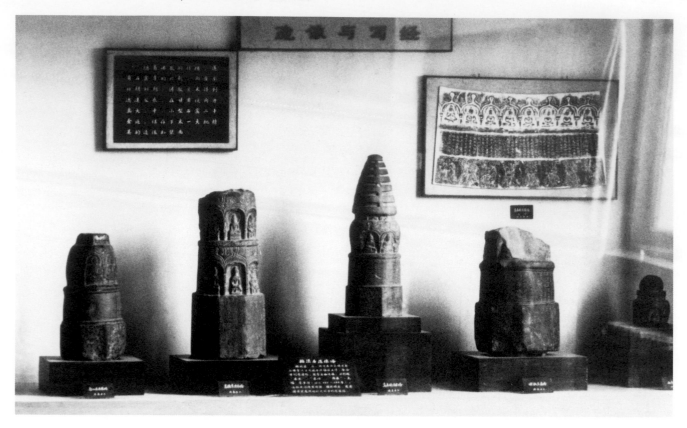

经文与造像

3.1 Northern Liang votive stupa. Gansu Provincial Museum. Photo by R. Vandenbossche, courtesy of Krishna Riboud.

rather, there has been a tendency to consider the component parts of the works separately and attempt to trace the sources of particular motifs or stylistic traits. An especially clear example of such an approach can be found in Alexander Soper's 1958 discussion of the "ultimate sources" of the features found on the votive stupa.[4] The effect is to explain the object as a mélange of discrete components from distant points, little more than a receptacle of multiple vectors of influence. At a later point in the same essay, however, Soper notes the consistent local character of the visual styles found in the early Mogao Caves at Dunhuang, "distinguishable at first sight both from the more purely Chinese remains to the east and from the more purely Central Asian ones to the west."[5] The tension between the two explanatory models, distant influence versus local choice, is a familiar theme in the study of visual imagery from the Dunhuang region.

These works are unique local products that demand to be related to their immediate conditions and contexts, hence the extended review of the historical and archaeological record of the region. Yet the extant evidence is not without problems. We are, for example, dependent upon historical texts such as dynastic histories and biographies of Buddhist monastics that are, each in its own way, partial and distorted windows into

the past. The salient "facts" recorded in these texts, despite their impressive breadth, emphasize the actions of a relatively small and privileged element of Chinese society. The dynastic histories were imperial projects intended to establish an official version of the history of the former dynasty; Buddhist biographies such as the *Lives of Eminent Monks* (*Gaoseng zhuan* 高僧傳) were hagiographies intended for the propagation of Buddhism among the elite classes.[6] In such texts, political exigencies and didactic purposes determined how events were described and who would be depicted in what kind of light. Such texts were never meant to be impartial, objective records of the past, and to accept them as such would be a grave error, especially in the investigation of ordinary images. The corrective offered by archaeological remains, as we found in chapter 2, is not without its own limitations. The relationship between local archaeological evidence, for example from mortuary contexts, and the Northern Liang votive stupa is not self-evident but oblique, a relationship of not completely commensurable materials. In other words, the task of explaining these works in their local context is not as straightforward as it may seem and in fact may be ultimately impossible. Such an acknowledgment is crucial if one is to resist the understandable disciplinary demand for definitive conclusions— that is, closure, regardless of the intractable difficulties of joining odd remnants of textual and archaeological evidence to chance remains of visual imagery. The discussion

4 Dunhuang and Jiuquan area. By Linda Huff after Dunhuang Institute for Cultural Relics, *Art Treasures of Dunhuang,* 9.

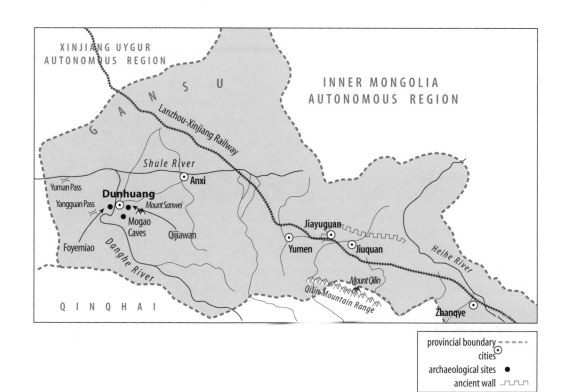

that follows thus endeavors to tread the border between explication and conjecture, history and desire.

HISTORY

It is well known that northern Gansu, at one end of the Hexi 河西 corridor, served as a major gateway between China and the western regions beginning as early as the second century C.E.[7] While important as sites for the introduction of non-Han cultural formations into central China, Dunhuang and nearby Jiuquan also had a long history of settlement by Han Chinese dating back to the Western (Former) Han dynasty when the area of northern Gansu Province was first organized into Chinese administrative units. Beginning with Jiuquan sometime between 121 and 104 B.C.E., a total of four military commanderies, or *jun,* were established.[8] Besides the westernmost *jun* of Dunhuang and Jiuquan, the other commanderies were Zhangye 張掖 and Wuwei 武威 to the southeast. The establishment of these administrative units was part of an effort to open and colonize a large area stretching from northern Gansu deep into Mongolia following the victories of Han armies over the Xiongnu 匈奴 in 121 and 119 B.C.E.[9] The relocation of both civilians and military personnel into the region was the primary strategy utilized by the central government.[10] It should be noted that at the time of the Western Han colonization the region was most likely inhabited by Xiongnu and other non-Han peoples. Many of these non-Han residents were recruited by the government into military service.[11] The early population of Dunhuang and Jiuquan would thus have included Han Chinese colonists, both from the Gansu region and from Central China, and local non-Han peoples, many of whom appear to have adopted Han Chinese names and customs to a certain extent even at this early date.[12]

Census records as of 9 C.E. indicate that colonization was successful. A total of 11,200 families and 33,035 individuals was recorded for Dunhuang *jun* 郡 and 18,137 families and 76,726 individuals for Jiuquan.[13] More important, evidence for the existence of elite Han Chinese families in Dunhuang appears as early as the Eastern Han dynasty (25–220).[14] Historical records from the period include many *rencai* 人才, or "men of talent," from Dunhuang families such as the Zhang 張, Ge 蓋, Cao 曹, Suo 索 and Fan 氾.[15] In addition, a genealogy of the Fan lineage, which first settled in Dunhuang in 28 B.C.E., lists the notable accomplishments of lineage members as government officials from the Han into the Former Liang dynasty.[16] Something of the position of local elites such as the Fan can be gauged from the report of the Wei appointed governor who arrived at Dunhuang in 227 and found that "the old powerful families had excessive land, and the humble folk not soil enough on which to stick an awl; he ordered it all to be divided up and allocated on a per person basis."[17]

Despite such efforts, the elite families of Dunhuang and Jiuquan appear to have flourished under the Wei and Western Jin dynasties. The relative weakness of the central government allowed local families in the region to monopolize profits from trade

between central China and the western regions.[18] New irrigation techniques and an improved plough introduced between 249 and 254 no doubt increased productivity on the lands owned by the local elite.[19] Dunhuang continued to produce "men of talent" during this time. For example, between 280 and 289 five members of the Dunhuang elite—Zhang Han 張魁, Suo Jing 索靖, Suo Zhen 索紾, Suo Yong 索永, and Fan Zhong 氾衷—were honored for their scholarly abilities as the "Five Dragons of Dunhuang."[20]

The fourth and early fifth centuries saw the rise and fall of a number of dynasties and small kingdoms that ruled the area around Dunhuang and Jiuquan. One of the most important would be the Northern Liang dynasty, established by the Xiongnu lineage of Juqu 沮渠 in 397. All of the northwestern area of Liangzhou 涼州, the provincial designation of Hexi including Dunhuang and Jiuquan, soon came under Northern Liang control. But in 400 Li Gao 李暠, who was the Northern Liang governor of Dunhuang, proclaimed his independence and with the support of the leading families of Gaochang and Dunhuang established the Western Liang dynasty based at Dunhuang.[21] Court officials and governors under Li were drawn solely from Han Chinese families; Dunhuang was represented by members of the Suo, Song 宋, Fan, Zhang, Liu 劉, and Linghu 令狐 lineages.[22]

Meanwhile, the Northern Liang were gradually expanding control of territory to the south under the leadership of Juqu Mengxun 沮渠蒙遜 (r. 401–433), occupying Zhangye in 401 and finally gaining the traditional seat of power in Liangzhou, Guzang 姑臧, in 412.[23] With the capture of Dunhuang in 421, the Western Liang was brought to an end.[24] Juqu Mengxun died in 433, leaving all of Hexi under the rule of the Northern Liang. His son, Juqu Mujian 沮渠牧犍, succeeded to the throne, and in 437 he and the Northern Wei emperor Shizu 世祖 (r. 423–452) consolidated their relationship by exchanging sisters as consorts.[25] Nonetheless, in 439 Juqu Mujian was charged with twelve crimes by the Northern Wei and an invasion of the Northern Liang was initiated.[26] Guzang fell to the Northern Wei in the same year and a large portion of the population was transferred to the Northern Wei capital of Pingcheng 平城.[27] Juqu Mujian's sons fled westward: Wuhui 無諱, Governor of Jiuquan, and Yide 宜得, Governor of Zhangye, escaped to Dunhuang, while Anzhou 安周, Governor of Ledu 樂都, eventually found his way to the Central Asian kingdom of Shanshan.[28] At this time, the governor of Dunhuang was Juqu Wuhui's cousin, Tang'er 唐兒. The following year, Wuhui and Yide mounted an offensive and recaptured Jiuquan, but when faced with a Northern Wei army at Zhangye, Wuhui offered to return Jiuquan to the Northern Wei. This offer was accepted and Wuhui was given titles and allowed to keep the city as his base. Upon this turn of events, Tang'er rebelled against his uncles and they responded by marching on Dunhuang, allowing the Northern Wei to recapture Jiuquan in 441.[29] Faced with an advancing Northern Wei army from Jiuquan, Wuhui abandoned Dunhuang and joined his brother Anzhou in Shanshan.[30] Soon thereafter, in 443, they took control of Turfan, where they continued to rule as the Northern Liang dynasty until 460.[31] Meanwhile, the

grandson of Li Gao, Li Bao 李寶, moved into Dunhuang in 442 and promptly offered up the city to the Northern Wei.[32]

The historical texts indicate that the area around Dunhuang and Jiuquan was removed from central Chinese political authority for most of the period after the fall of the Eastern Han dynasty. During this period, members of the local Han Chinese elite played a principal role in the regional administration of Hexi.[33] The same sources indicate that the Han Chinese elite families of the region were interested in upholding traditional Han Chinese culture.[34] For example, in 372 the Dunhuang scholar Guo Yu 郭瑀 is said to have attracted a thousand followers when he discoursed on the Confucian classics from his cave dwelling outside Zhangye.[35] And a Confucian revival marked the emergence of Li Gao's Western Liang state in 400 at Dunhuang. Temples were erected and decorated with paintings of Confucian themes; one center of Confucian learning served as a school for the children of the local elite, with some five hundred pupils in attendance.[36] Interest in traditional Han Chinese culture also continued under the rule of the Xiongnu Northern Liang dynasty. Juqu Mengxun in 426 requested from the Song court at Nanjing copies of the works of early philosophers, and a total of 475 chapters (*juan* 卷) were received. In 437 a return gift to the Song, which included Confucian texts dating back to the Han dynasty, gives some indication of the canonical treasures known in Liangzhou.[37] The Northern Liang rulers also involved Han Chinese scholars from Dunhuang such as Song You 宋繇 and Liu Bing 劉昞 in literati activities for the court during the early part of the fifth century.[38]

This is to say that, according to the official histories, by the 420s and 430s Liangzhou had been long known for its distinguished Han families and exemplary in its preservation of Han culture. Even accounting for the bias in the historical records, Hexi appears to have had a well-established, local Han elite with a relatively strong Han cultural tradition. Without diminishing the importance of its role as an entrepôt, the recognition of the Han historical context is an important counter to the usual understanding of the region as little more than a frontier settlement, as much a Central Asian oasis as an established part of China. At the same time, it comes as no surprise that the historical record repeatedly highlights the propagation of Confucian virtues and traditional learning, which were also central concerns for the eminent scholars commissioned to draw up such histories. Conversely, we are provided little information about the heterodox beliefs or practices that may have been common among the less learned residents of Liangzhou.

BUDDHISM

According to the information provided by Buddhist texts, monastic forms of Buddhism appear to have been well established in Liangzhou by the third century. For example, the earliest record of a monk from Dunhuang states that Dharmarakṣa, or Fahu 法護 (c. 230–308), commenced his Buddhist training at the age of eight. Dharmarakṣa's biography states that his family of Yuezhi 月支 origin had already lived in Dunhuang for

several generations and that he was "broadly read in the six classics and widely versed in the sayings of the hundred schools."[39] Zürcher identifies this as an example of "the thorough acculturation of non-Chinese individuals living in the border regions of the Chinese empire."[40] Dharmarakṣa, however, utilized Han Chinese collaborators in most of his translations, and the level of his own ability in Chinese was certainly overstated in the biographical sources.[41] This is, of course, not surprising in Buddhist hagiographical literature produced to defend and propagate the religion among educated Han literati. The extent to which other non-Han Chinese in Dunhuang were acculturated, even after several generations of residence, also remains open to question. In 284 Dharmarakṣa, who traveled extensively, translated a text at Dunhuang with the support of a group of lay sponsors whose names included both Han and non-Han names.[42] This is an indication of the multiethnic patronage of textual translations at Dunhuang where Dharmarakṣa was assisted by Fasheng 法乘, a Han disciple who had established a monastery there.[43] Dharmarakṣa was again in the region in early 295 when he translated a work at Jiuquan.[44]

The earliest recorded activity at the famous Mogao cave site just to the south of Dunhuang is from the same period. According to the "Mogaoku ji 莫高窟記" (Record of the Mogao Grottoes), Suo Jing (238–303), one of the "Five Dragons of Dunhuang," inscribed a wall at the site with the name of the temple, Xianyansi 仙巖寺. This probably took place sometime before 290 while Suo was governor of Jiuquan.[45] The anecdote indicates the early involvement of laypeople with Buddhism at the Mogao site and, more significantly, the involvement of a member of an elite Dunhuang family. The "Mogaoku ji" also recounts the opening of the first Mogao Caves in 366. In that year a monk named Lezun 樂僔 arrived at the Mogao site and was struck by the golden light reflected from the cliff face. This vision, which resembled a "thousand Buddhas," inspired him to excavate a cave. Later, a second monk, Faliang 法良, built a cave next to that of Lezun.[46] Neither monk was from Dunhuang; Faliang is said to have come from the east, although there is no indication of either of their specific origins or activities before reaching Dunhuang. These texts underscore the central role of monks and monastic institutions for the development of cave temples.

The Mogao site was flourishing with some 280 images erected by the time of Juqu Mengxun's reign in the 420s and 430s.[47] The caves were only one of a number of Buddhist cave sites stretching along the Hexi corridor from Dunhuang to the southern parts of Liangzhou. A colophon from a manuscript dated to 406 discovered at the Mogao site provides some insight into the activities of the monastic community at Dunhuang:

> The bhiksu Te-yu, who received the full disciplinary vows from the spiritual teacher (upādhyāya) Fa-hsing, the master of discipline Pao-hui, and the master of doctrine Hui-ying, south of the city of Tun-huang, and subsequently went into retreat during the summer with his companions in the ceremony, Tao-fu, Huyi-yü, and others, twelve in all, has written out the commandments for recitation . . .[48]

Other colophons refer to monks donating, compiling, and copying various texts.[49] According to the *Shilaozhi* 釋老志 (Treatise on Buddhism and Daoism) of the *Weishu* 魏書:

> Liang-chou had from Chang Kuei onward for generations believed in Buddhism. Tun-huang touches upon the Western Regions, and the clergy and laity both acquired the old fashions. The villages, one after the other, had many reliquaries [*ta* 塔 stupa/ pagoda] and temples.[50]

Chang Kuei (Zhang Gui 張軌) was founder of the Former Liang dynasty at the beginning of the fourth century. This entry indicates the thriving state of Buddhism in Dunhuang just before the Northern Wei invasion in 439.[51]

The best documented Liangzhou monk of the early fifth century was Dharmakṣema (Tanwuchen 曇無讖, 385–433), who arrived at the Northern Liang capital of Guzang in 412 and translated texts under the sponsorship of Juqu Mengxun until 433.[52] Most important, Dharmakṣema emphasized the mystical efficacy of Buddhism—he was renowned for the power of his *dhāraṇī* (*tuoluoni* 陀羅尼), a Buddhist spell or incantation. Such occult skills served to impress not only rulers and patrons such as Juqu Mengxun but the common people among whom Dharmakṣema was said to have worked. A strong concern with thaumaturgy should not be surprising in this region where "the desert was animate, the Silk Road alive with phantoms, and protective spiritual power was no idle, abstruse notion."[53]

The *Gaoseng zhuan* indicates that many Buddhist monks in the first half of the fifth century came from old, established elite Dunhuang families such as the Meng, Cao, Zhang, Suo, and Fan.[54] The correlation between famous monks and elite families is not surprising, considering that the compilers of standard dynastic histories such as the *Weishu* and Buddhist biographies such as the *Gaoseng zhuan* were primarily writing for and about the educated Chinese elite. At the same time, the close relationship between Buddhist clergy and powerful local families no doubt had a basis. Throughout China, large landowners often provided land and workers to establish monasteries.[55] This was no doubt the case in 422 when the monk Dharmamitra (Faxiu 法秀) constructed a monastery at Dunhuang "on a spacious site, planting a thousand trees and opening cultivation on a garden of a hundred *mu,* until with its chambers, pavilions, and pools [the whole] was extremely majestic."[56] These landholdings, even accounting for hyperbole, appear impressively large for Dunhuang, where the limited water supply must have restricted the amount of land under cultivation and available to monastic establishments.[57] The support of local elite families was undoubtedly vital for the monastic establishments of Dunhuang and nearby Jiuquan.

TOMBS

An important supplement to the above historical outline of Liangzhou is provided by the many tombs excavated in the area. For example, near Jiayuguan 嘉峪關, just to the

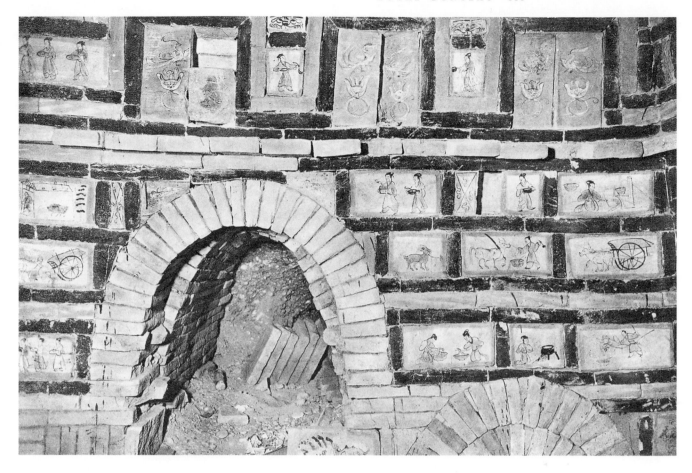

northwest of Jiuquan, large brick-lined tombs with double or triple chambers and high domed or truncated pyramid shaped ceilings were constructed by wealthy local families in the third to early fourth centuries. The largest tombs were typically decorated with painted bricks that depict scenes of everyday life, such as ploughing, harvesting, herding, cooking, and eating, and portray local architecture, social customs, and dress (fig. 3.2).[58] Scenes such as these are comparable in subject matter to those from contemporary tombs in Henan or Sichuan.[59] Distinctive to Jiayuguan, however, are the placement of the pictorial bricks, their casual, almost cursory painting style, and the design of the tombs themselves. Although there is precious little inscriptional evidence to document the social class of the tomb occupants, the many different kinds of farming, herding, and domestic scenes on the painted bricks suggest relatively large-scale landholdings. Other subject matter—horse- and ox-drawn carriages, horseback riders, and large military processions—suggests individuals who served in official capacities.[60] At the same time, the possibility that the imagery represents aspirations rather than actual position should be kept in mind.

3.2 Painted tomb bricks, front room, west wall, Jiayuguan Tomb 5. From Gansu sheng wenwudui, Gansu sheng bowuguan, and Jiayuguan shi wenwu guanlisuo, *Jiayuguan bihuamu,* pl. 29.

Imagery similar to works of local elite classes discussed in the previous chapter are scant but do exist in painted brick tombs. One example is from a large three-chambered tomb from Gaotai 高台, south of Jiuquan, which contained bricks painted with figures identified as those of the Queen Mother of the West (fig. 3.3) and King Father of the East (fig. 3.4) as well as the legendary pair of Fuxi 伏羲 and Nüwa 女媧.[61] By the East-

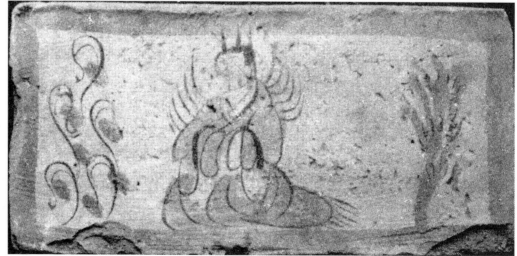

3.3 Queen Mother of the West (?), painted brick from a tomb at Gaotai Luotuocheng, Gansu. From Zhangye diqu wenwu guanli bangongshi and Gaotaixian bowuguan, "Gansu Gaotai Luotuocheng," inside front cover, no. 2.

3.4 King Father of the East (?), painted brick from a tomb at Gaotai Luotuocheng, Gansu. From Zhangye diqu wenwu guanli bangongshi and Gaotaixian bowuguan, "Gansu Gaotai Luotuocheng," 48, fig. 12.

ern Han, both pairs of deities had come to be identified in visual imagery with the cosmic forces of *yin* and *yang,* dark and light, male and female.[62] Although the identification of the painted female figure as the Queen Mother is without a clear basis—there are no distinctive attributes such as the flames rising from the King Father's shoulders—images of paired male and female deities appear with regularity in the tombs of local elites. Two coffins contained in Jiayuguan Tomb 1 had lids painted with Fuxi and Nüwa (fig. 3.5), their tails extending toward each other among swirling ethers and cloud-scrolls.[63] In this case, the style of painting, which recalls the elegance of Western Han painting in the well-known Mawangdui Tomb 1 banner or the Bu Qianqiu tomb ceiling painting from Luoyang, is especially important to note.[64] The delicate, ethereal pictorial style conveyed a sense of wealth and aristocratic privilege in the third century as well, for example in contemporary works from the Nanjing area (figs. 2.53 and 2.55).[65] One other Jiayuguan painted brick tomb also yielded a pair of painted coffins. According to the report, the male's coffin was decorated with a painting of the King Father on the front and the Queen Mother on the rear; the female's coffin had the figures of Fuxi and Nüwa among floating clouds. The interior of the latter was decorated with a diagram (fig. 3.6) described by the excavators as an illustration of the eight trigrams (*bagua* 八卦), although the trigrams themselves are absent.[66] In addition, the coffin contained a two-part, purple-red banner called a summoning banner (*zhaofan* 招幡) in the report: the upper was decorated with the depiction of a monster figure; the lower had an inscription: "the dead go to darkness *(yin),* the living go to light *(yang)* 死人之陰生人之陽."[67] Unfortunately, neither the coffin paintings nor the banner have been published.

By far the most impressive tomb in the region is the slightly later Jiuquan Dingjiazha 丁家閘 Tomb 5, a large double-chambered tomb (fig. 3.7) dated by excavators to the

3.5 Fuxi and Nüwa, male's coffin (top) and female's coffin (bottom), Jiayuguan Tomb 1, drawing. From Gansu sheng wenwudui, Gansu sheng bowuguan, and Jiayuguan shi wenwu guanlisuo, *Jiayuguan bihuamu,* figs. 19: 1 and 2.

0 5 10 20厘米

3.6 Illustration of eight trigrams, interior of female's coffin lid, Jiayuguan Tomb 13. From Jiayuguan shi wenwu guanlisuo, "Jiayuguan xincheng shi'er, shisan hao," 8: 12, fig. 6.

Later Liang to Northern Liang period (386–441).[68] The tomb was plundered but retains well-preserved paintings in the front room; they cover all surfaces from just above the floor to the gently sloping ceiling. Instead of painted bricks lining the interior, the walls of Dingjiazha Tomb 5 were plastered and prepared for painting in a manner similar to the Mogao cave temples. The painting is divided into two registers and depicts ploughing, harvesting, cooking, and architecture similar to the scenes found on the earlier painted bricks. Several aspects of the subject matter, however, are distinctive. One scene on the lower register of the south wall (fig. 3.8) depicts a nude woman placing an offering under a large tree on a raised platform; a small animal-monster inhabits one of the lower branches. The tree is identifiable as that of the local earth deity (*she* 社), whose veneration as a tutelary god of local communities has a long history.[69] The prominent depiction of the *she* tree in the tomb of a highly placed individual suggests a prominent role for local elite families in a communitywide expression of popular belief. Above the opening into the rear burial chamber was painted a scene of music, dancing, and entertainment observed by a large-scale male figure, most likely the tomb occupant himself. Other imagery such as a large fortified dwelling (north wall) and multiple covered carriages (west wall) are testimony to the high status of the deceased. The excavators surmise that the occupant was a local official of some rank. In contrast to the earthly existence recorded on the walls, the sloping ceilings are covered with representations of a heavenly realm of mountain peaks and swirling clouds. The north and south sides feature a dashing horse and deer respectively; the regal figures of the King Father (fig. 3.9)

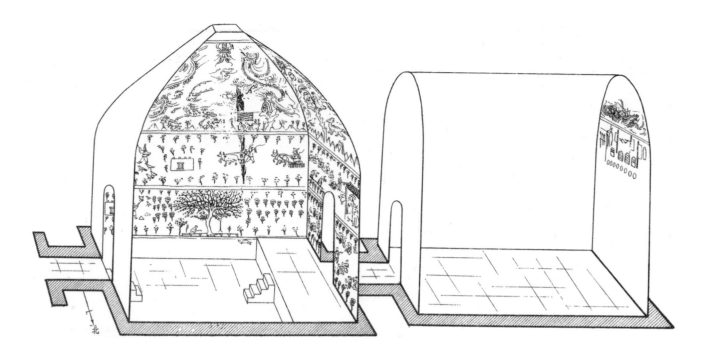

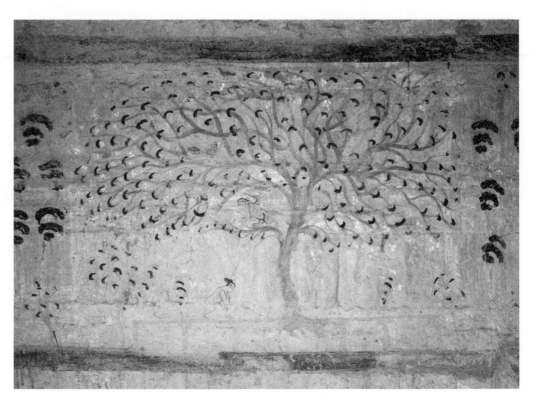

3.7　Schematic drawing,
Dingjiazha Tomb 5, Jiuquan.
From Gansu sheng wenwu
kaogu yanjiusuo, *Jiuquan shiliu-
guo mu,* 5.

3.8　Wall painting, south
wall, Dingjiazha Tomb 5, Jiu-
quan. From Gansu sheng
wenwu kaogu yanjiusuo, *Jiu-
quan shiliuguo mu,* no page
number.

3.9 King Father of the East, east wall, Dingjiazha Tomb 5, Jiuquan. From Gansu sheng wenwu kaogu yanjiusuo, *Jiuquan shiliuguo mu,* no page number.

3.10 Queen Mother of the West, west wall, Dingjiazha Tomb 5, Jiuquan. Gansu sheng wenwu kaogu yan-jiusuo, *Jiuquan shiliuguo mu*, no page number.

and Queen Mother (fig. 3.10) rule over the east and west slopes. The execution of the imagery is confident and the animated lines of the ceiling painting in particular convey a strong sense of aristocratic splendor.

Many tombs of the third to fifth centuries have been excavated around Dunhuang. Four tombs at Foyemiao 佛爺廟, to the south of the present Dunhuang city, are contemporary with the brick-lined tombs at Jiayuguan and similar in structure but smaller.[70] The main rooms are about three meters in depth with small alcoves to the side or rear. One tomb is double-chambered while the other three are single rooms. As in the Jiayuguan tombs, painted bricks were arranged on the exterior screen wall above the entrance as well as the interior, which was well furnished with ceramic vessels, cooking utensils, lamps, lacquered objects, and mirrors. Although none of the tombs contained written documentation of the occupants or the date of interment, the scale, brick construction, decoration, and plentiful tomb goods suggest patrons of significant means.

Among tombs at Foyemiao dated to the fourth century, one of the largest is Tomb 60M1, a single room, 4.2 m in length, with a truncated pyramid ceiling neither lined with bricks nor decorated with painting.[71] The tomb contained a single coffin, a quantity of pottery, and a few other interesting mortuary objects—including a small gold ornament with an engraved cicada inside the coffin near the head.[72] Such an object— the precious metal as well as a symbol of immortality utilized in Sichuan money trees— suggests an elite background for the deceased. This is a notable exception in Dunhuang tombs, where favored elite-class subject matter related to immortality (such as the Queen Mother) is completely absent. An inscription dated to 369 identifies the tomb occupant as Fan Xinrong 氾心容, wife of a Zhang Hong 張弘. The authors of the excavation report point out that the Fan lineage was well-known in Dunhuang and a reference in the *Jinshu* 晉書 biography of Zhang Gui states that a Zhang Hong died in battle in 351.[73] The tomb, even if it is not the wife of the Zhang Hong referred to in the *Jinshu,* is large for Dunhuang and probably belongs to a local elite family. Similar tombs between three and four meters square were grouped in walled family compounds at Foyemiao and provide us with a view of the normative burial practices of local elite lineages.[74] In contrast to the tombs at Jiayuguan and Jiuquan, the tombs of elite Dunhuang families were smaller and less elaborately decorated. What is consistent among the local elite-class tombs is the use of a domed or truncated pyramid ceiling.

The dated inscription in Tomb 60M1 was part of a "grave-quelling text (*zhenmuwen* 鎮墓文)" written on a pair of small unglazed jars (fig. 3.11).[75] The use of such texts is well attested to in the Eastern Han but they do not appear in post–Han dynasty Chinese tombs except in the region around Dunhuang and Jiuquan.[76] Two *zhenmuwen* have been excavated from large painted brick Wei-Jin period tombs, one from the previously mentioned Jiayuguan Tomb 1 and one from Jiuquan, but neither text is well preserved.[77] All other examples are from Dunhuang, although none of the four painted brick tombs at Foyemiao contained *zhenmuwen*. The *zhenmuwen* in this region were roughly inscribed

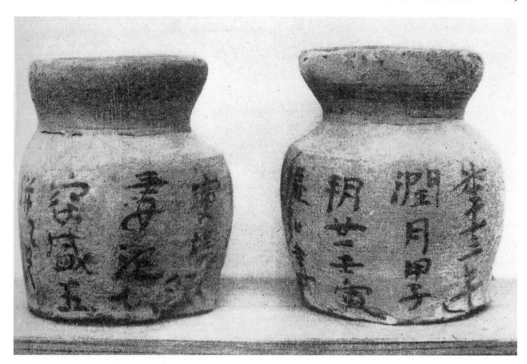

3.11 Dated jars, Tomb 60M1, Foyemiao, Dunhuang. From Dunhuang wenwu yan-jiusuo kaoguzu, "Dunhuang Jinmu," 3: pl. 7: 1

in vermilion or black ink on unglazed pottery, most often jars variously termed grain bottles (*wuguping* 五穀瓶), grave-quelling jars (*zhenmuguan* 鎮墓罐), or grave-quelling "dipper" bottles (*zhenmu douping* 鎮墓斗瓶). In a few cases, similar texts were also written on round bowls (*bo* 鉢). A fragment of such a bowl, broken and with only a part of the text preserved, and two jars with nearly identical inscriptions were found in Tomb 60M1.[78] The text on the jars was atypically brief, only listing the date, the name of the deceased, and a self-identification as a *wuguping*.

Most *zhenmuwen* from Dunhuang, however, are more effusive. Foyemiao Tomb 80M1, a single chamber 3.4 by 3.5 m with a truncated pyramid ceiling, contained the burial of a couple identified in their respective inscriptions as the husband, Zhang Fu (courtesy name Dezheng) 張輔字德政, who died in 405, and his wife Fa Jing 法靜, deceased in 421.[79] Five *zhenmuwen* were inscribed on pottery objects: two jars (M1:32 and M1:33), one near the head of Zhang Fu and the other at the foot of his coffin, a broken round bowl (M1:34) inside his coffin, a jar (M1:6) below the feet of Fa Jing, and a broken round bowl (M1:8) probably inside her coffin. The distribution of jars with *zhenmuwen* text at the head and feet or the placement of an inscribed broken bowl in the coffin of the deceased is a common pattern. Besides the *zhenmuwen* and the usual assortment of potteryware, Zhang Fu's coffin contained fragments of silk brocade and next to his head an inscribed stone block with only traces of black ink remaining. This suggests to the excavators a person of some status, possibly a scholar.[80] Certainly the

inclusion of a courtesy name (*zi* 字) in the inscription is consistent with such a background, as is the elite surname of Zhang.

In his study of sixteen *zhenmuwen* from Foyemiao (including the 60M1 and 80M1 examples mentioned here), Machida Ryūkichi identified two basic modes of texts. One (Type A) is exemplified by 80M1:6, which states that a *douping* along with grain (*wugu* 五穀) and lead men (*qianren* 鉛人) were placed below to exonerate the living above (probably from any blame for the violation of the earth in digging a tomb); the Master Green Bird (*qingniaozi* 青鳥子) and the North Star (*beichen* 北晨) decree that the dead themselves should accept the blame without recourse to the living and that the dead and the living should be separate. The text ends with the often seen phrase: "quickly, quickly, in accordance with the statutes and ordinances." The second mode (Type B), as in 80M1:34, employs a different set of terms. There is no mention of grain, lead men, Master Green Bird, or North Star; instead, the deceased is said to encounter *bakui* 八魁 and *jiukan* 九坎, probably celestial bodies (to be discussed below). There follows a list of infusions (*zhu* 注), pathogenic influences related to death pollution, presumably to be expelled. Finally, there is the phrase "let the living go forward, the dead shrink back" (生人前行死人卻步). In this example, the *douping* is also mentioned, but this is an anomaly in Type B texts as well as an inaccurate self-description—the vessel is in fact a bowl. Overall, the two modes represent distinct, alternative formulas for *zhenmuwen*.[81] In Tomb 80M1, all *douping* had Type A inscriptions while the broken bowls were inscribed with Type B texts.

Another mortuary precinct, Qijiawan 祁家灣, just to the west of the present Dunhuang city, offers evidence that the use of *zhenmuwen* was not limited to the tombs of local elites. The site yielded 88 small *douping,* the majority inscribed with *zhenmuwen,* from 117 tombs; of these, 21 pairs of *douping* were dated with inscriptions as early as 276 and as late as 420.[82] Most of the excavated tombs are modest, if not tiny, single rooms with flat ceilings and plain walls; double-chambered tombs with truncated pyramid ceilings are few and assigned to a relatively early period—the late third or early fourth centuries. The excavators state that these must have been the tombs of high-ranking officials, but there are no official titles in the published inscriptions. The report further suggests that rooms with side alcoves were tombs of small landowners, small single rooms were for commoners.[83] There are no surnames of Dunhuang elite lineages such as Fan or Zhang preserved in the inscriptions. Despite the claims of the excavators, there is a strong impression that Qijiawan, in contrast to the local elite tomb groups at Foyemiao, was a precinct for those of lesser status and wealth.

In the nine tombs placed in the latest period at Qijiawan, roughly 398–420, seven contained *douping*.[84] The most interesting is the domed ceiling, single-chambered Tomb 310, just large enough (2.2 by 2 m) to hold two corpses, a male and female, interred in coffins on platforms.[85] Although it had been disturbed, the tomb still contained some two dozen burial objects, including fragments of silk clothing. An unusual find was a square brick painted with three well-dressed seated figures (fig. 3.12) set on the floor

3.12 Painted tomb brick, Qijiawan Tomb 310, Dunhuang, dated to 398. From Gansu sheng wenwu kaogu yanjiusuo et al., *Dunhuang Qijiawan*, pl. 41.

against the rear wall. The excavators speculate that the painting includes an image of the interred male.[86] The image might be understood as an alternative to the scenes on painted brick tombs and is the only visual indication of a claim of social status for the occupants. The male corpse was buried with two *douping* (M310:15 and 22) inscribed with identical *zhenmuwen* dated to 398 (both of Type A). One was set outside the foot of the coffin; the other, in a departure from the usual custom, was placed inside an earthenware pillow, inside of which were found remains of food.[87] Only one *douping*, set just outside the head of the coffin, was found near the female corpse. The short inscription has been largely lost but a date some two and a half months later than that of the male is detectable. Pieces of an inscribed bowl—deliberately broken according to the report—were also found scattered over the corpse of the female. The character for the Buddha (*fo* 佛) is used twice in the bowl's otherwise indecipherable inscription.[88]

The above is the only example of a Buddhist presence—in word or image—in the mortuary culture of the region. It is significant that the Buddha is mentioned on a broken bowl similar to those found in 60M1 and 80M1, which were inscribed with a *zhenmuwen* of Type B. These texts are distinguished by the list of pathogenic infusions *(zhu)* to be expelled. One could infer that the text on the Tomb 310 bowl, although different from either of the *zhenmuwen* types, had a similar function to those on the other bowls—that is, as a formulaic incantation for the protection of the living. The fact that the bowls in all cases were broken corroborates the possibility that the object was part of a ritual in which the vessel was shattered and scattered over the corpse. Such a use for the inscribed bowl as well as the inclusion of the name of the Buddha in the text is intriguing and otherwise unattested to in the historical record, but it is consistent with Buddhist involvement in thaumaturgic practices.

Two enigmatic passages in the *zhenmuwen* also suggest a ritual function, related in this instance to astrology and divination. One is the reference in Type B texts to *bakui* and *jiukan* (literally "Eight Chiefs" and "Nine Canals") as a destination or meeting place for the deceased. Each is the name of a set of stars according to one of the astronomical chapters of the *Jinshu,* but there is nothing in the text that provides a hint as to why these two groups, hardly distinguishable from the hundreds of other star groups named in the *Jinshu* chapters, were singled out for use in *zhenmuwen.*[89] In addition, the character *kui* in *bakui* is the name of the second of twelve menstrual spirits arranged on cosmic boards (*shi* 式) from the Later Han period in this region;[90] and the character *kan* in *jiukan* is the trigram *(gua)* of the North in the set of eight trigrams, which may have been represented in the coffin from Jiayuguan (fig. 3.6).

The other passage is the reference to Master Green Bird (*qingniaozi*) and the North Star *(beichen)* in Type A texts as the entities that speak or give authority to the decrees in the *zhenmuwen.* It has been suggested that the North Star was understood in this period to govern the fate of humans.[91] The phrase *qingniaozi* is known only as part of the title of an anonymous early text, the *Qingniaozi xiangzhongshu* 青鳥子相冢書, as quoted in the *Shishuo xinyu* 世說新語.[92] It may be more than coincidental that the passage referred to discusses the geomantic divination of tombs. The reference to Master Green Bird might also be related to the green bird *(qingniao)* or three green birds mentioned in the *Shanhai jing* as attending the Queen Mother of the West. In a poem based on the *Shanhai jing,* the renowned Eastern Jin poet Tao Qian 陶潛 (365–427) describes them as messengers that return to the Queen Mother's realm each evening.[93] There is, however, nothing else in *zhenmuwen* of this type to corroborate a relationship between Master Green Bird and the Queen Mother. It is possible that Master Green Bird represents the transformation of the green bird into an independent deity with or without an implicit understanding of the bird's role as messenger of the Queen Mother. In either case, the lack of references to Master Green Bird in elite texts may be an indication that the deity was part of a set of popular beliefs not embraced by literati such as Tao Qian. Alternatively, this may be

a local belief specific to the Liangzhou region. Keeping in mind that most extant tombs have been disturbed, there still remains the fact that there are no references to the Queen Mother in burials with *zhenmuwen,* which strongly suggests that Master Green Bird represents a popular alternative to the elite-class fascination with the Queen Mother and King Father. What is consistent in these obscure references is their relationship to astronomical formations and deities, astrology and divination—interests that were certainly widespread in other parts of China but appear to be especially intense in Liangzhou.

Overall, *zhenmuwen* appear to operate among a cluster of related popular beliefs and imagery—with a strong astrological orientation—regarding the fate of the deceased. In contrast to the representation of well-known figures of immortality such as the Queen Mother of the West in the tombs of the elite classes, *zhenmuwen* were roughly inscribed on inexpensive potteryware and represent a range of mortuary beliefs embraced by many of a lesser social standing. Most important for the contemporary votive stupa from Jiuquan and Dunhuang, *zhenmuwen* provide us with a glimpse of religious beliefs beyond canonical Buddhism and, in the example of the bowl inscribed with the character *fo,* we have a hint of the way in which the Buddha was incorporated into local mortuary practices. To a degree, we will find that the Northern Liang votive stupa, to which we now turn, represent the flip side of such practices—that is, the integration of local interests in astrology and divination into an ostensibly Buddhist form of sculpture. We are again reminded that the testimony of extant early texts often bear less than a direct relationship to the archaeological evidence; and in some cases the available texts provide no hint of the ordinary beliefs and practices expressed in works such as *zhenmuwen.*

NORTHERN LIANG VOTIVE STUPA

The extant votive stupa have been discovered in only two areas of Liangzhou—Jiuquan and Dunhuang, ruled by the Northern Liang dynasty up to 441—and in Turfan, the Central Asian kingdom where the remnants of the Liang ruling family arrived in 443. Northern Liang votive stupa are small enough to be transported (one dedication states as much) and works found at Jiuquan or nearby Dunhuang were not necessarily the products of that locality. In addition, some votive stupa were never dedicated, and there is evidence that a number were completed without specific patrons. The inscribed dates, in other words, record the date of dedication, which could be many years after the work was made. It is therefore unsurprising that the formal features of the works are not consistent in terms of their place of discovery; nor is there a clear stylistic progression in dated works from early to late.[94] In what follows, the majority of the votive stupa will be organized into two distinct stylistic groups of five and three works respectively. Two later works from Turfan form a third group; and three remaining works, each in their own way anomalous, will be treated separately.

Group A consists of five works, the earliest in date being that of Gao Bao 高寶, his wife, and their children (or Gao Shanmu 高善穆), dated to 428 and discovered in Jiuquan

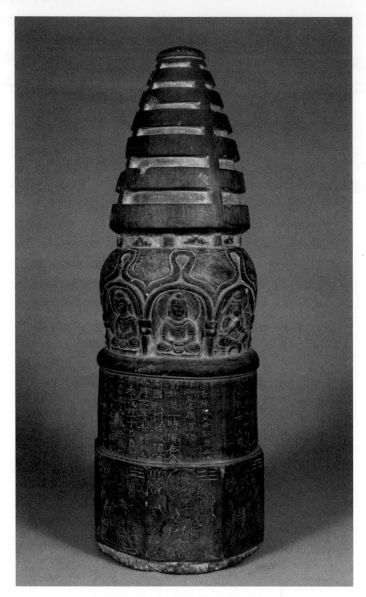

(fig. 3.13).[95] The typical morphology of the Northern Liang votive stupa can be seen in this complete and well-preserved work, which stands 45 cm high with four clearly defined registers, each corresponding in a very general way with the architectural form of a stupa (fig. 3.14). Starting from the bottom, there is an octagonal base, a round drum, a dome with image niches, and a projecting crown with seven tapering stories that abstractly indicate the series of parasols that typically surmount stupa. The architectural parallel is underscored by the depiction of brackets between the third and fourth registers. The third register is lined with a series of eight image niches (fig. 3.15), each of

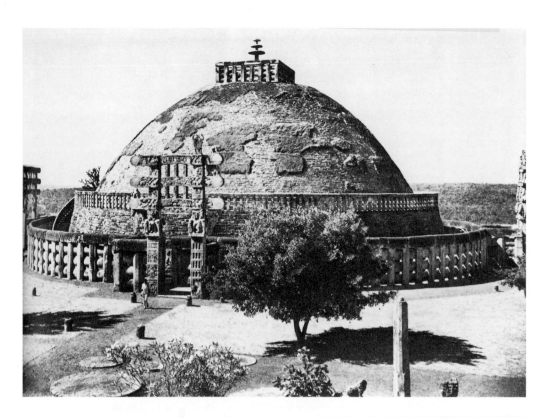

3.14 Stupa 1, Sanchi. From Craven, *Indian Art,* pl. 37.

3.15 Gao Bao votive stupa, rubbing. From Durt, Riboud, and Lai, "A propos de «stûpa miniatures» votifs," fig 9.

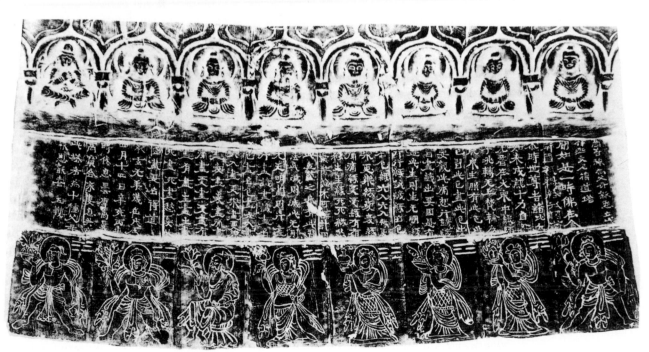

3.16 Gao Bao votive stupa, detail, cross-ankled bodhisattva. Photo by author.

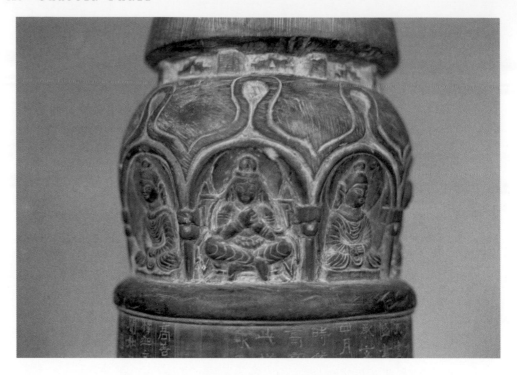

which corresponds to one of the eight sides of the octagonal base. These comprise seven identical Buddha images, robes covering both shoulders and falling in symmetrical loops over the chest, legs tucked under the robes, and hands placed together in the lap in a meditative position (dhyana mudra). The eighth figure is a crowned and bejeweled bodhisattva (fig. 3.16) with long, flowing hair, hands clasped together at the chest and sitting with ankles crossed on a raised throne with a distinctive triangular back. In the crown is a small seated Buddha image. The set of seven Buddhas and one bodhisattva almost certainly represents the six Buddhas of the Past, Sakyamuni, and Maitreya bodhisattva (the future Buddha). The series of images, if read in a clockwise direction consistent with the circumambulation of a stupa, begins with the first Buddha to the left of the bodhisattva figure, and ends with the future Buddha as the eighth and last image.

The round drum below the images is solely devoted to text divided into two portions: a section of a Buddhist sutra text that is consistent in all of the works followed by the dedication of the donation, which typically includes the name of the donors, the date, and a statement as to the circumstances and wishes of the donors. While many works of early Chinese Buddhist art were inscribed with dedications, these are the only extant examples of works from this period that contain a sutra passage—much less one preserved in the extant canon. The text commences under the first Buddha image (fig. 3.13) and is followed, as will be the usual pattern, by the dated dedication. Note that the dedication by Gao Bao did not take up all of the available space, and an anomalous

second dedication (without a date) carved in a smaller and lighter hand immediately precedes the beginning of the sutra text. This appears to be a case of a second individual, Gao Shanmu, taking advantage of the available uncarved surface to add his inscription.

The bottom register is octagonal and each of the eight sides is incised with a haloed figure, four male and four female. The halos indicate that the figures are meant to be understood as divinities as opposed to mortals. The four female figures, all standing, are dressed in full-length skirts with scarves that swing behind their halos. Each holds a different offering: a flaming jewel, a dish with a plant, a vessel with a flower, and a long-stemmed lotus flower. Three of the four male figures stand in an energetic pose with legs apart and hold floral arrangements similar to those seen in the female figures. They are bare-chested and nude except for a kind of *dhoti* and long swinging scarves. The costume of these figures is not Han Chinese but points to a Central Asian or Indian origin. In the case of the fourth male figure (fig. 3.17), who is shown seated, elderly, and bearded, holding a lotus flower,

3.17 Gao Bao votive stupa, detail, seated figure. Photo by author.

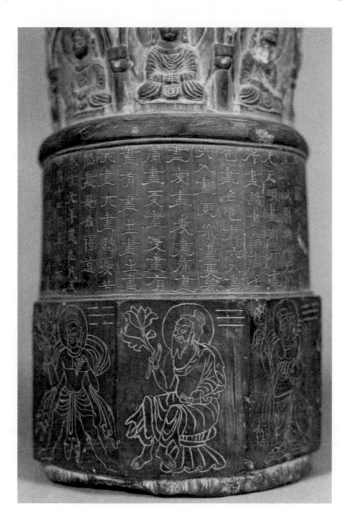

3.18 Comparative drawings of celestial figures, bottom register, Northern Liang votive stupa. From Kuno Miki, "Hokuryō-tō," 266–67.

there is less certainty regarding the appropriate cultural referent. In most cases, he has been taken as one of the eight non-Han figures; he certainly bears similarity to images of bearded brahmans known from Central Asian sites such as Kizil.[96] But here his dress appears to be more like that of a Han Chinese sage or gentleman.[97]

In the upper right corner of each side is one of the eight trigrams (*bagua* 八卦), unprecedented in any known work of early Chinese Buddhist art. The set of eight trigrams, central to early systems of philosophical and cosmological correlation, follow the arrangement known as the Later Heaven (*houtian*) or King Wen sequence.[98] Although the antiquity of trigrams has been extensively discussed, there is only one example of a possible King Wen sequence that predates the Northern Liang votive stupa: on a reconstructed fragment of a cosmic board (*shi* 式 or *shipan* 式盤) of the Eastern Han dynasty.[99] Later examples, on bronze mirrors especially from the Tang dynasty onward, are numerous. The appearance of the trigram on the majority of votive stupa thus represents an unusual, early instance of traditional cosmological symbolism adopted for Buddhist imagery. On the Gao stupa, the trigram *zhen* ☳, which correlates with the east, is aligned with the beginning of the sutra text and the first Buddha in the sequence of eight images above. Traditionally, the trigrams are also correlated with members of a family: mother, father, three sons, and three daughters, each of the children designated as eldest, middle, and youngest. On the eight sides of the votive stupa, each trigram is indeed matched with the appropriate incised image of a male or female celestial (fig. 3.18),

		☶ 艮 Gen Northeast Youngest Son	☵ 坎 Kan North Middle Son
Gao Shanmu	高善穆		
Tian Hong	田弘		
Cheng Duan'er	程段兒		
Wang Zhaojian	王曌堅		
Shashan	沙山		
Ma Dehui	馬德惠		
Song Qing	宋慶		

乾 Qian Northwest Father	兌 Dui West Youngest Daughter	坤 Kun Southwest Mother	離 Li South Middle Daughter	巽 Xun Southeast Eldest Daughter	震 Zhen East Eldest Son		
						高善穆	Gao Shanmu
						田弘	Tian Hong
						程段児	Cheng Duan'er
						王翼堅	Wang Zhaojian
						沙山	Shashan
						馬德惠	Ma Dehui
						宋慶	Song Qing

3.19 Tian Hong votive
stupa, Jiuquan, dated to 429.
Photo by R. Vandenbossche,
courtesy of Krishna Riboud.

although only the seated and bearded elder and the mother figure to his right are clearly differentiated from the others.[100] The top or crown of the Gao Bao stupa is engraved with a representation of the constellation Ursa Major (Great Bear), which contains the Big Dipper. The Dipper was the principal celestial body for early Chinese astronomical as well as divinatory practices and was often inscribed as a celestial pointer on the central plate of Han dynasty cosmic boards.[101] The handle of the Dipper on the Gao stupa is directed to the north.[102]

A second work in Group A is the Tian Hong 天弘 votive stupa from Jiuquan dated to 429 (fig. 3.19). The upper section of this work has been broken off, leaving nothing of the superstructure and only parts of three seated Buddhas in dhyana mudra in the third register. The remains of the Buddha figures closely approximate those of the Gao votive stupa, as do the standing figures on the octagonal base. It is considerably larger, however, standing 41 cm in its present state and probably once over 60 cm at its full and original height. The short dedication reads, following the date, as follows: "Tian Hong, in order to requite the concern of his father and mother, and of his monarch, set up this stupa 天弘爲父母君王報恩立此塔."[103] A third Group A work is the Cheng Duan'er 程段兒 votive stupa, also from Jiuquan and dated to 436 (fig. 3.20). The Cheng votive stupa is

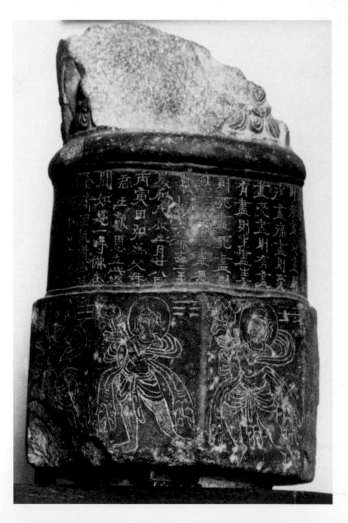

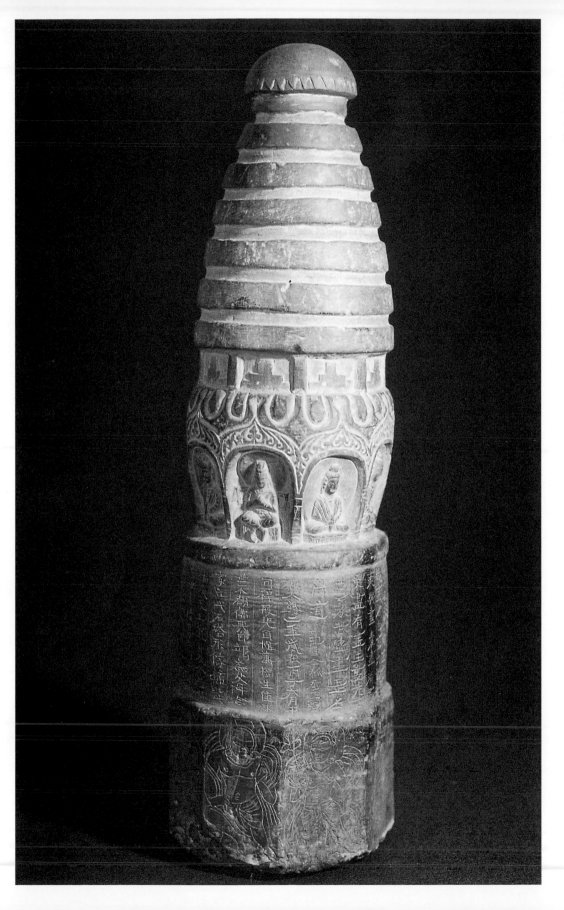

3.20 Cheng Duan'er votive stupa, Jiuquan, dated to 436. From Zhongguo meishu quanji bianji weiyuanhui, ed., *Wei Jin Nanbeichao diaosu*, no. 31.

very close in scale (43 cm high) and form to the Gao. The major difference is in the lowest register, where the trigrams are omitted, and the top, which does not have the engraved Dipper. In addition, there are several small variations in the handling of the image register: the arch enclosing each seated figure on the Cheng votive stupa is enlivened with an animated flame motif; the simple plinths of the seated Buddha figures are replaced by lotus thrones; and the dress of the Cheng Buddha figures alternate between having their outer robe draped high across the chest, as all of the Gao Buddha figures are depicted, or having the garment open and pulled down in a V toward the lap. A small fragment—only the image register and top of a votive stupa made from a dark stone—was also found at Jiuquan and should be included in Group A.[104]

The last work in Group A and the only one from Dunhuang is the undated votive stupa of Wang Zhaojian 王翼堅, his wife Wei 韋, and their family (fig. 3.21). The work was originally known only through a description and transcription of a rubbing published in 1963 by Jue Ming, who stated that the stupa had been discovered about 1928–29 in the Sanwei Mountains (Sanweishan 三危山) south of the Mogao Caves in a Daoist temple called the Laojun tang 老君堂.[105] The stupa was recovered from another Daoist temple, the Wangmugong, in 1981 and was displayed in the Dunhuang City Museum as being from Sanweishan. Most recently, the discovery of an early rubbing of the dedication, apparently made before this section of the stupa was damaged, has revealed the name of the donors.[106] This work is complete and, although slightly smaller (36 cm high), is similar to the Gao and Cheng votive stupa. The Buddha figures are draped in the alternating styles of robes as in the Cheng votive stupa. The execution overall is crisper, deeper, and more detailed, most notably in the carving of the base figures, framed and raised in low relief rather than the flat incised lines in the examples above. In contrast to the other works, the trigrams are placed in the uppermost left corner of the panels.

Group B is distinguished by a different approach toward the surface of the works. Instead of the three-dimensional forms emphasized in Group A, these works consistently employ carving in shallow relief. In addition, the series of Buddha images in Group B works alternate dhyana and *abhaya* mudra; and a third mode of drapery is used in which the right shoulder and the upper chest is exposed. The earliest is that of Ma Dehui 馬德惠 from Jiuquan and dated to 426 (fig. 3.22). This work, dated only two years before the Gao votive stupa, is similar in scale (34 cm high without the uppermost register) and design. The image niches (fig. 3.23) depict the seated Buddha figures in two alternating modes: one has the outer robe high across the chest and hands in the lap in dhyana mudra; the other depicts the robe pulled down to expose the upper chest with the right hand raised in *abhaya* mudra. The arrangement of the robes follows that of the Cheng and Wang works. But in the Ma stupa three Buddhas and a cross-ankled bodhisattva in *abhaya* mudra alternate with four Buddhas in dhyana mudra.

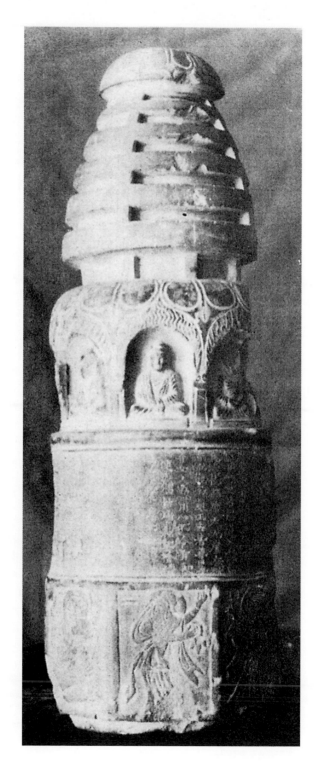

3.21 Wang Zhaojian votive stupa, from Dunhuang. From Yin Guangming, "Dunhuang shi bowuguan zang sanjian Bei-Liang shita," pl. 3: 2.

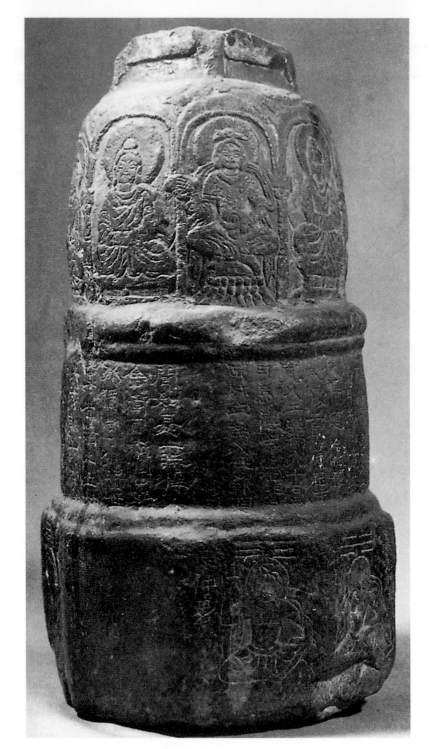

3.22 Ma Dehui votive
stupa, Jiuquan, dated to 426.
From Zhongguo meishu
quanji bianji weiyuanhui, ed.,
Wei Jin Nanbeichao diaosu, 6.

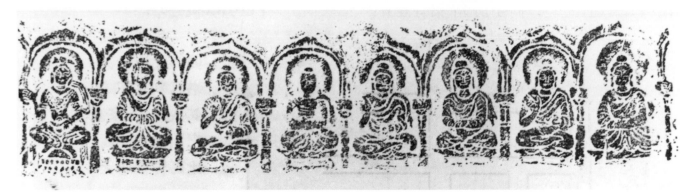

The bottommost register is not complete: the side under the beginning of the sutra text (fig. 3.22) that should display the trigram *zhen* was left blank—no figure or corresponding trigram was ever carved. The trigrams on the remaining sides have been placed above the heads of the figures rather than to the side. Wang Yi records partially preserved colophons on the base. On the left of each side are the names of the trigrams and their familial affiliations, all correctly matched. On the right of six sides (excluding the *zhen* and *gen* trigram sides) are colophons referring to members of Ma Dehui's family (Hui's father, mother, and two daughters) and two others, one a monk (*shamen* 沙門) named Tanzhi 曇智 and the other a leader or teacher (□ *shi* □師), the male Bao'er 男保兒.[107] The two sets of colophons, which are not found on any other votive stupa, are curious in that the eight family names of the trigrams are applied to an incomplete set of male and female figures, while the set of six other names fail to correspond with the gender of the seven incised figures. The father's name is placed next to the figure of the eldest daughter *(li)*, the monk Tanzhi next to the youngest daughter *(dui)*, and one of Hui's daughters is aligned with the father *(qian)*. Very little of this suggests an overall program or plan, rather just the opposite. Furthermore, these faintly incised and incomplete colophons are a sharp contrast to the neatly inscribed dedication and sutra text. Although it is impossible to be certain, there is the possibility that the colophons were not part of the initial design of the Ma votive stupa but were added to the work at a later date by someone other than the original patron or designer.

The work most similar to the Ma stupa is the undated work known as the Shashan 沙山 votive stupa (fig. 3.24), discovered not at Jiuquan but to the south of Dunhuang.[108] Not only is the technique of carving the image niches in shallow relief the same, the Shashan work also has seated Buddha figures in both dhyana and *abhaya* mudra (fig. 3.25), although the strictly alternating pattern is not followed. The bodhisattva figure is also similar—jewelry, bare chest, scarves sweeping around the back of the head, and right hand held up in *abhaya* mudra. But rather than being seated on the usual elevated throne with legs down and ankles crossed, the bodhisattva is depicted on the same lotus seat and

3.23 Ma Dehui votive stupa, rubbing of image register. From Wang Yi, "Bei-Liang shita," 1: 181, fig. 7, photo courtesy of Krishna Riboud.

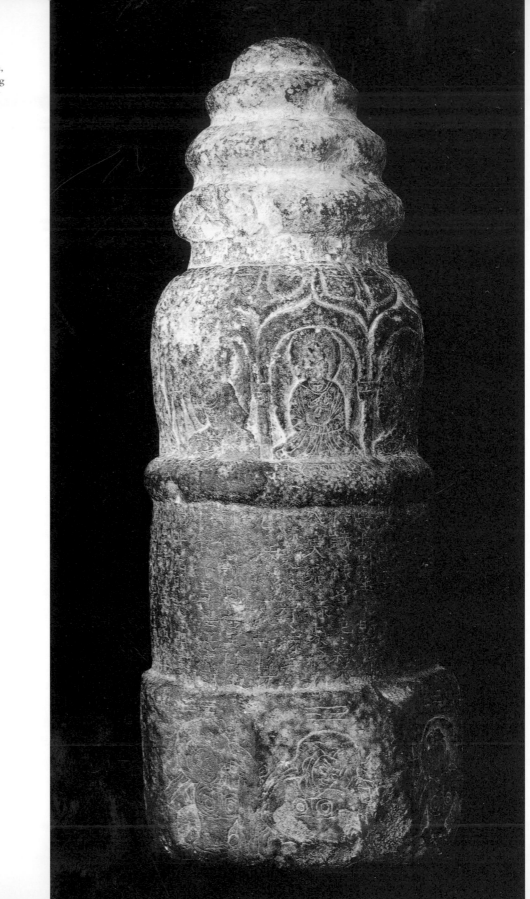

3.24 Shashan votive stupa,
Dunhuang. From Dunhuang
yanjiuyuan, *Dunhuang*, 220.

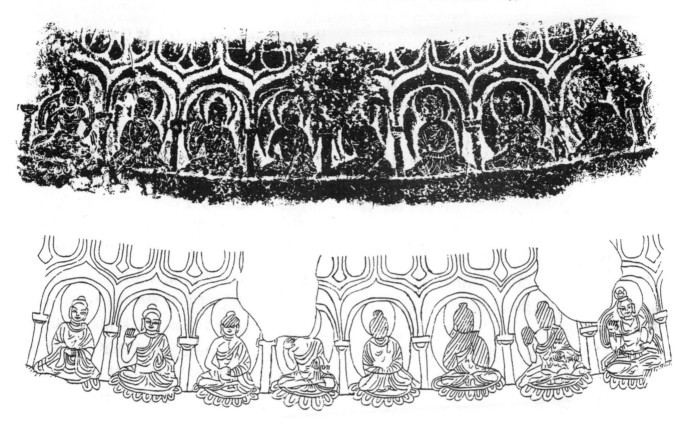

in the same cross-legged position as the Buddha figures. The position of the legs is a curious iconographic departure without precedent in early Chinese Buddhist art. The use of the lotus thrones throughout is also distinctive among the votive stupa. Another significant feature is the large uncarved area that has been left between the end and beginning of the sutra text on the second register, a space that might hold some nine rows of a dedication that was never inscribed on the work. This is clear evidence that the Northern Liang votive stupa, at least in some cases, would be completely carved and decorated without a dedication (that is, before one or more donors had come forward).

The third work in Group B is the donation of □ Jide □吉德, also from Dunhuang and dated to 426 (fig. 3.26).[109] Although badly worn, a rubbing and drawing (fig. 3.27) indicate that the eight images had the same arrangement of dhyana and *abhaya* mudra seated Buddhas; but in this case the bodhisattva is standing—the only standing figure among extant votive stupa. This is not the only anomalous feature of the □ Jide work. For example, four of the five Buddhas and the standing bodhisattva are identified by name in colophons to the right of each figure. Yin Guangming has found that this series of names matches those in an extant Buddhist sutra text.[110] One of the Buddhas

3.25 Rubbing and drawing of image register, Shashan votive stupa. From Yin Guangming, "Dunhuang shi bowuguan zang sanjian Bei-Liang shita," 78, figs. 5 and 6.

3.26 □ Jide Votive Stupa, from Dunhuang. From Yin Guangming, "Dunhuang shi bowuguan zang," pl. 3: 3.

(fourth from the right in fig. 3.27), however, has no colophon, apparently because there was no room to write one—an indication that these two Buddha images were carved adjacent to each other *before* the idea of inserting colophons was conceived. The uneven spacing between the images and the resultant difference in the scale of the written characters further suggests that the inscribed names were not part of an original plan for the register. These are not indisputable bits of evidence—one could always suggest inattention or error as a cause—but the fact that none of the other extant votive stupa include similar colophons in the image register lends credence to the possibility that the names of the deities were not original to the carving of the images.

Another anomaly is the insertion of an image in the second register between the beginning and end of the sutra text.[111] To follow the evidence provided by the Sha-shan votive stupa, the area occupied by the image may have been meant for the donor's dedication and initially left blank. No dedication was ever carved, however, and the standing image was probably added at a later time. Finally, the octagonal base of the work has no images or trigrams. Rather, five sides have been carved with a dedicatory inscription of twenty-one lines; one side has traces of writing, one has been ground down, and one has been otherwise effaced.[112] The condition of the base suggests that it was originally unfinished, either uncarved or with only a few of the eight sides decorated. The dedication was written here probably because the image had already been inserted into the empty space next to the sutra text above. Thus the original work was probably limited to the typical set of eight images in the third register and the sutra text in the second. The significant departures from the conventions of the Northern Liang votive stupa seen in the other ele-

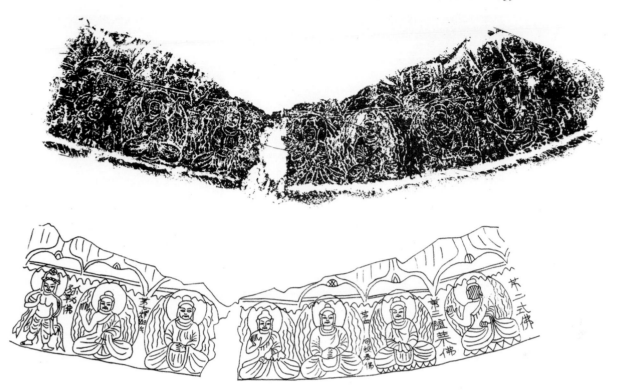

3.27 Rubbing and drawing of image register, □ Jide votive stupa. From Yin Guangming, "Dunhuang shi bowuguan zang," 81, figs. 13–14.

ments indicate that they were later additions, although how much later is impossible to determine.

Group C consists of the two undated votive stupa from Turfan, that of Song Qing 宋慶 et al. (fig. 3.28) and a second work (fig. 3.29).[113] Although stylistically quite different, the sutra texts carved on the two works are virtually identical (with small but consistent variations) to the texts on the Group A and B votive stupa. The work of Song Qing is a large (66 cm high), handsome piece carved from a distinctive red sandstone, damaged but preserved up to the bottom of the superstructure.[114] This is the only votive stupa with a title for the sutra: *foshuo shi'er yinyuan jing* 佛說十二因緣經. The title, however, is not found in the extant Chinese Buddhist canon and is otherwise unknown. The sutra text occupies most of the narrow drum, leaving space for only two lines of six or seven characters each for the dedication. Most of the characters have been effaced except for one donor's name, Song Qing, and a reference on the next line to a wife named Zhang 妻張. Judging from the spacing of the characters, it is possible that other names were listed between these two and the individuals were not related.

Soper has argued on stylistic grounds that this work belongs to the period when Northern Liang rule continued briefly from 443–460 in Turfan.[115] He believed that the

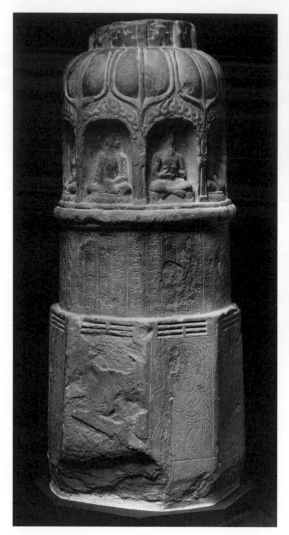

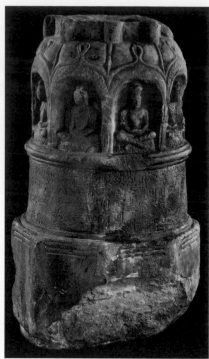

3.28 *Left:* Song Qing votive stupa, Khocho. Museum für Indische Kunst, Berlin, MIK III 6838. Photograph by Iris Papadopoulos, courtesy of the Museum für Indische Kunst.

3.29 *Right:* Khocho votive stupa, probably from Turfan. Museum für Indische Kunst, Berlin, MIK III 610. Photograph by Iris Papadopoulos, courtesy of the Museum für Indische Kunst.

Song Qing figures exhibit a change of style from the Gansu votive stupa—for example the manner in which the scarves of the Song Qing attendant figures sweep between the head and the halo. In addition the Turfan figures are slimmer and wear prominent crowns with rosette designs.[116] These changes were for Soper indicative of a later stylistic development resulting from Sassanian influences. Other differences between the Gansu votive stupa and the one from Turfan noted by Soper include a wider arch over the image niches in the Song Qing votive stupa, with the flames filling the arch; the attenuated peak of the arch point in the Turfan work; and the fact that the trigrams in the Song Qing stupa are set on an axis above each of the attendant figures incised on the lower register. The additional votive stupa discovered in Gansu since Soper's article, however, are considerably closer in style to the Song Qing work. The Cheng Duan'er

votive stupa (fig. 3.20), for example, has similar wide arches with flames; and the work of Ma Dehui (fig. 3.22) and the Shashan work from Dunhuang (fig. 3.24) feature the trigrams centered above the head of the figures in the lower register. The most distinctive feature of the Song Qing votive stupa not duplicated in any of the works from Gansu is the manner in which the loop at the peak of the arches over the image niches is pulled up between the lotus petals of the upper register. And in fact, a second votive stupa recovered by the Germans from Turfan was not known to Soper. This work (fig. 3.29), to be discussed below, is even closer in style to those from Gansu than the first Turfan votive stupa—for example, the peak of the arch is the simple loop typically found in the Gansu votive stupa. All this suggests that a significant period of time did not necessarily divide the works from the two areas.

The second votive stupa from Turfan is small, only 28 cm high, and made from a light grayish stone.[117] Despite the obvious differences in scale and color of stone, it is generally consistent in style with the Song Qing stupa—with several anomalies: the flame pattern is carved only on alternating niche arches; no figures have been added to the octagonal base although it has wide, deeply carved trigrams as in the other Turfan work; and the sutra text does not commence below the first Buddha image in the cycle but rather between the second and third Buddhas. Most notably, in the space where the dedication would be typically inserted, there is a short exegesis on the sutra text.[118] The additional exegesis—four lines of four characters each in contrast to the consistent six characters per line of the sutra section—is further distinguished by the addition of incised horizontal guidelines. In contrast to the typical dedication (which may or may not take up the allotted space) or the lightly carved additions to blank areas of some votive stupa, these four lines were carefully planned and executed. The blank sides of the base indicate that this work was not completed; if this is so, the space for the dedication may have also originally been blank. The filling in of this space with the additional (and redundant) text suggests not only that this was a later addition but that the act itself was consciously meant to avoid dedicating and claiming the merit for the incomplete work.

The remaining three works are anomalous, each in different ways, and cannot be incorporated into any of the above groups. The first is the Bai Shuangju 白雙且 votive stupa from Jiuquan dated to 434 (fig. 3.30). The uppermost section has been lost, but below we find the image register doubled (fig. 3.31), the text shifted down to the octagonal base, and the figures and trigrams eliminated.[119] All of the seated Buddha images are identical, with hands together in front of their laps and symmetrical loops of drapery over the chest—except for one in the niche to the right of the cross-ankled bodhisattva in the upper register. The hands of this Buddha are hidden under its robes and the outer garment is pulled down in a V to reveal the cross-hatched vestment below. In addition, a second bodhisattva with one leg over the other (fig. 3.32) replaces a Buddha figure in the lower register in the niche to the left of the cross-ankled bodhisattva. The manner in which the lower torso has been cut away, the shriveled left leg, and the smallish throne

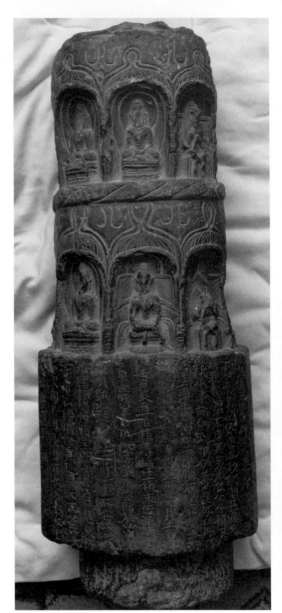

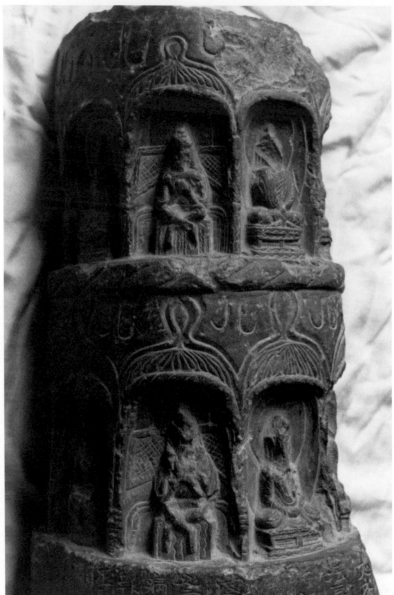

3.30 *Left:* Bai Shuangju votive stupa, Jiuquan, dated to 434. Photo by author.

3.31 *Right:* Bai Shuangju votive stupa, detail, image registers. Photo by author.

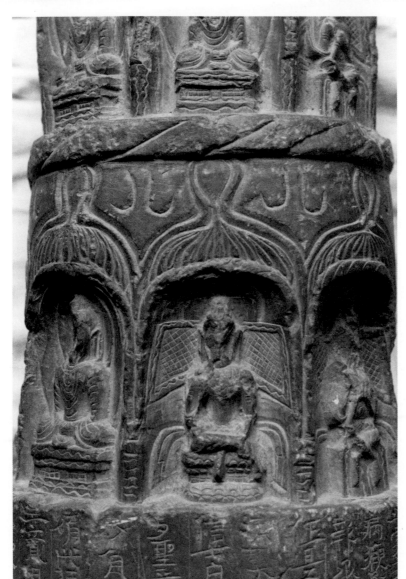

3.32 Bai Shuangju votive stupa, detail, cross-legged bodhisattva. Photo by author.

indicate that the figure was recut. Because a second bodhisattva within a set of eight images is anomalous, one is tempted to regard this as an error in which a Buddha figure similar to the one above or to the left was originally intended. Possibly the distinctive cross-hatched throne-back used only with the bodhisattva images was mistakenly carved into the background and, not wishing to place a Buddha image in an iconographically inappropriate niche, the figure was awkwardly reworked without a good sense of an alternative form. The cross-ankled bodhisattva type was not possible to fashion out of the Buddha figure because of the problem of representing the usual two arms rising together

3.33 Bai Shuangju votive
stupa, detail, lowest register,
end of text and blank face.
Photo by author.

to the chest. The result is a kind of mess, with the stump of the left leg appearing espe-
cially odd.[120]

The base contained no images but was used to inscribe the sutra text and dedica-
tion. A section equivalent to two of the eight sides of the base has been smashed. The
textual remains indicate that a significant portion of the sutra text was originally carved
here. The dedication has survived essentially intact and is followed by a largely blank side
(fig. 3.33) adjacent to the destroyed section. Interestingly, the first five characters of the
sutra text have been lightly scratched at the top right of the blank side. This is where
one would expect the sutra text to begin; these characters may have been preliminary
marks to guide the actual cutting of the characters that start the sutra passage. It is puz-
zling, however, that the beginning of the text was never actually carved while later por-
tions of the sutra are found on the sides following the destroyed section. It is possible

that the lightly incised characters were added at a later date by someone who recognized where the opening phrase of the sutra text should have been, but never was, carved.

Although missing characters in various parts, the dedication is the longest among the extant votive stupa. It begins: "In Liang, under the late great Juqu, in the third year of Yanhe, the year being *jiaxu,* in the seventh month, in the first third of the month 涼故大沮渠緣禾三年歲次甲戌七月上旬, the gentleman of pure faith, Bai Shuangju, aware of the insignificance of his own merit, (that) he has been born, as by chance into *mofa* (the age of the eclipse of the Dharma) 〔清〕信士白雙〔且?〕惟簿福生值末法波流 . . ."[121] The use of the term *mofa* is striking in such an early work and will be discussed below. The inscription continues: "Then, on mount and crag, walking with this stone on his back, he erected a holy stupa . . . 即於山巖步負斯石起靈塔 . . ." This may indicate an original location for the work on a mountain or the participation of the donor in transporting the stone out of the hills. Alternatively, the flowery, euphemistic language of the dedication as a whole suggests the possibility that the passage was more concerned with a poetic mood than a statement about actual practice. The dedication ends with a sentiment that the patron's meritorious act will be beneficial to the "Lord of the realm and his august younger brother (*guozhu yuandi* 國主元弟)" and allow his fathers and mothers for the past seven generations, as well as his brothers, both elder and younger, his ancestors, and his other kin to have a future encounter with Maitreya.

A second anomalous work is that of Chunyu Guo 淳于國 and others from Dunhuang (fig. 3.34). This undated work is by far the largest extant votive stupa, 96 cm high in its present damaged condition—the upper half of the image niches and all of the superstructure missing. It appears to have followed the usual structure of the Northern Liang votive stupa: there are remnants of a deeply carved standing figure on one side of the base and the lower parts of five image niches remain on the dome. Although the surface of the drum is largely destroyed, two sections of text can still be identified. On one side (fig. 3.35) are parts of eleven lines of the sutra text in Chinese, written as usual top to bottom in lines from right to left. On the other side (fig. 3.36) is a Brāhmī version of the sutra text written left to right across the upper part of the register in ten full lines, with an eleventh partial line of text. The Brāhmī text corresponds with a portion of a complete version of the *Pratītyasamutpādasūtra* preserved on a brick at Nālandā of the sixth century. Based on the Nālandā text, it is estimated that the Brāhmī version of the sutra would have originally filled the eleven lines encircling the votive stupa.[122] The Chinese sutra based on *T.*125, however, is different from the version of the sutra preserved at Nālandā—that is, the Chinese and Brāhmī versions are not translations of each other.[123] An epigraphic comparison of the Brāhmī script with that of the Nālandā brick reveals that the style of writing on the votive stupa is a different and earlier cursive style suggestive of a date to the second half of the fifth century.[124] Immediately below the Brāhmī is a second section of text in Chinese—the remains of the dedication that was written from left to right in a series of horizontal lines mimicking the direction of the Brāhmī

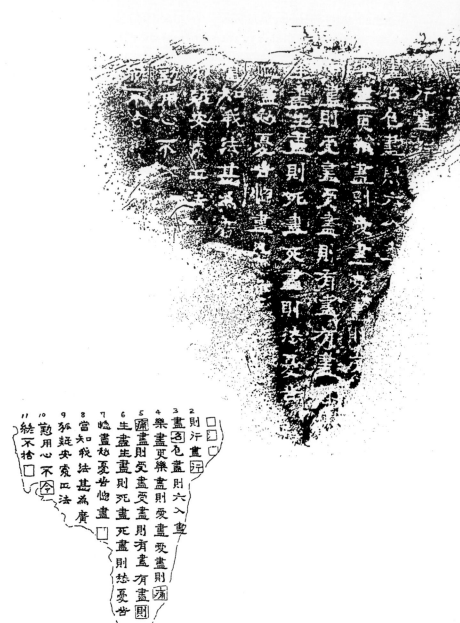

3.34 *Left:* Chunyu Guo votive stupa, Dunhuang. Photo by author.

3.35 *Right:* Rubbing and transcription of text, Chunyu Guo votive stupa. From Jue Ming, "Ji Dunhuang," 12, figs. 3 and 5.

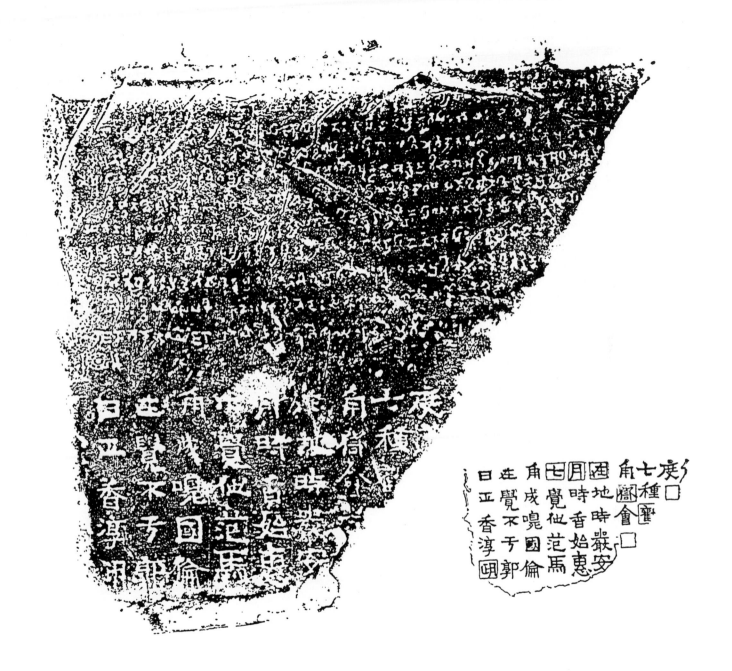

script. This is the only example of a bilingual work from this early period of Chinese Buddhist art.

Four donor names are recorded in the dedication (fig. 3.36): Chunyu Guo 淳于國 and Fan Shiyan 氾始嚴 on the fourth line, Guo Lun 郭倫 and Ma Hui'an 馬惠安 on the line below. Both lines are cut off by the damaged area to the right, which indicates that there were probably many more donors originally listed. Just above, in the space between each of the image niches, the remains of three incised figures can be discerned. These are devotees, possibly generic images of donors, that include a monk (fig. 3.37) and what appear to be two female figures in full dress with their hands together under long sleeves. These are the only donor figures found on any Northern Liang votive stupa. Compared to the other works, the Chunyu Guo votive stupa in its complete form must have been a large, impressively elaborate and ambitious work.

The final anomalous work, that of Suo E 索阿 et al. and dated to 435 (fig. 3.38), is the sole votive stupa whose provenance is not known. The work was purchased by the Cleveland Museum of Art in 1990 and is significantly different from the other votive stupa in scale (it is the smallest at 16.9 cm in height), material (a dark gray stone unlike any of the other Northern Liang works), and surface condition (traces of gilding and red pigment as well as an oily resinous material).[125] The text on this work is the only one

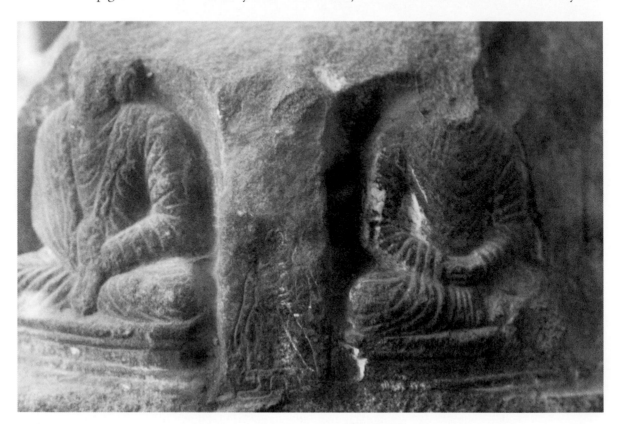

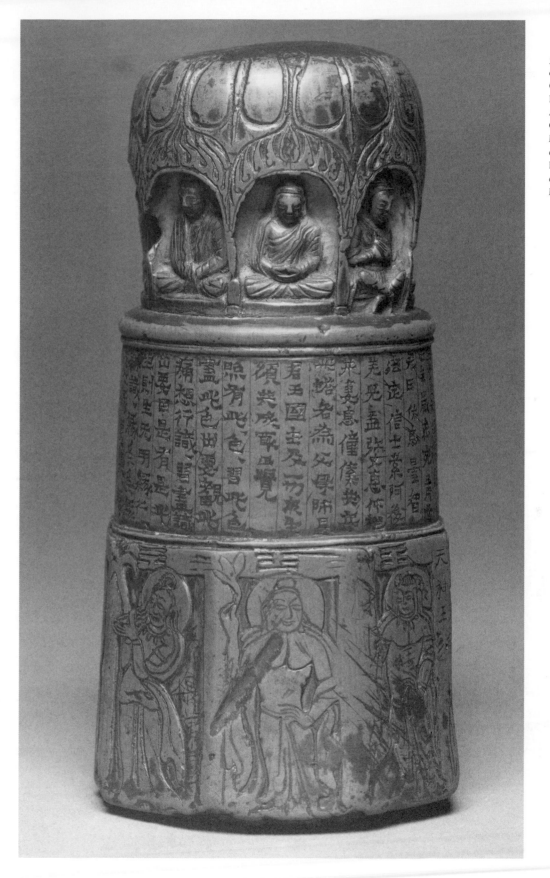

3.38 Miniature votive stupa of Suo E and others. China, Gansu Province, dated to 435, Northern Liang dynasty, 397–439. Steatite, height 16.9 cm. Copyright © The Cleveland Museum of Art, 2000. Purchase from the J. H. Wade Fund, 1990.84. Photograph courtesy of The Cleveland Museum of Art.

that does not begin with the opening phrase "thus have I heard" (*wen ru shi* 聞如是) followed by a description of the setting in which the Buddha's sermon was presented. Rather, the Suo text jumps directly to the topic of the five aggregates and continues past the point where the other stupa inscriptions stop to include a large part of the Buddha's exhortation to the monastics. Only the Wang Zhaojian stupa includes this portion of the sutra. Another similarity with the Wang Zhaojian stupa is the manner in which the eight figures on the base are each set within a rectangular frame. In the Suo stupa, however, the trigrams are set directly above the figures. Oddly, a second set of trigrams has been lightly incised in the upper right corner of seven of the sides. These smaller trigrams do not always correspond with the central trigram and their distracting presence suggests the possibility that they were a later addition. On the eighth side, the characters *tian shen wang* 天神王 (far right of fig. 3.38) have been written just to the right of the standing figure, and the same figure appears to have the character *wang* 王 roughly sketched on its abdomen. Along with the lightly etched second set of trigrams, these anomalous characters may not have been part of the original decoration of the work.

As for its provenance, the small scale and grayish material of the Suo votive stupa positions it closest to the second stupa from Turfan. At the same time, the flame pattern in the arch as well as the handling of the loop extending up from the peak of the arch is similar to that of the Song Qing Turfan stupa. But the small, centered trigrams are very different from the distinctively deep and wide trigrams in both Turfan works, and the standing figures in the base are carved in a simple style found on Gansu stupa. In addition, the segment of sutra text on the Suo stupa is very different from that of the two Turfan works. There are, in other words, no consistent stylistic affinities to indicate a possible provenance for the Suo stupa. It is clear from the numerous small works from private collections, however, that some objects from the early Central Asian expeditions were kept in private hands. The small Turfan stupa was surprisingly never accessioned in Berlin while the Suo stupa was apparently held in European private collections for some time.[126] Both may have originally been retained by one of the German explorers; alternatively, the Suo piece may have been collected by someone like Paul Pelliot, who was in Central Asia and Dunhuang from 1906 to 1909. In any case, smaller pieces such as the Suo votive stupa or the second stupa from Turfan were easily portable; it is also possible that they were carved in a region distant from their place of discovery.

DEFINITION AND FORM

Although six of the Northern Liang votive stupa are identified in their inscriptions as a *ta* 塔 or *shita* 石塔, literally a stone stupa or pagoda, this has not settled the question of how to define or name them. Besides *shita*, scholars have called them a sutra reliquary (*jingta* 經塔), a sutra pillar (*jingchuang* 經幢), and a miniature stupa—a range of terms that is indicative of the difficulty of matching these works with established categories of Buddhist imagery.[127] The terms *jingta* and *jingchuan* have the advantage of acknowledg-

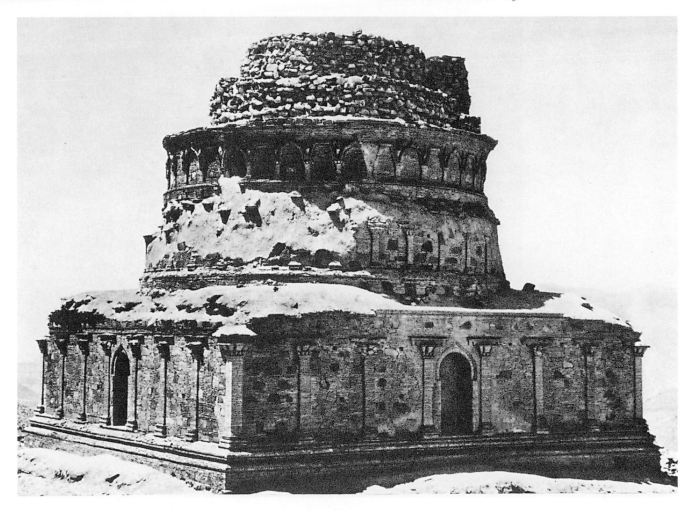

ing the textual (*jing* or sutra) component of the work, but both expressions are anachronistic, applied to sutra pillars of a type known only in later periods.[128] The use of the term "miniature stupa" was based on a perceived link between the form of the Northern Liang work and the Indian stupa.[129] Yet a comparison with the remains of Indian stupa from central India (fig. 3.14) or Gandhara (fig. 3.39) demonstrates that the votive stupa, while generally related in form, is far from a miniaturized version of the stupa. Rather, these works allude to the architectural elements of the stupa without literally depicting its architectural form. The Northern Liang votive stupa are also quite different in form from early Chinese pagoda architecture, known from textual evidence and suggested in votive works of the latter part of the fifth century—for example, a work (fig. 3.40) dated by inscription to 466 or a smaller pagoda fragment (fig. 3.41) from Jiuquan.[130] Interestingly, the votive stupa do have a visual affinity to the earliest extant Chinese pagoda (fig. 3.42), the brick structure at Song Shan, central Henan Province, dated

3.39 Stupa, Guldara. From Craven, *Indian Art,* pl. 56.

3.40 Votive pagoda, dated to 466. National Museum of History, Taibei. From Guoli shi bowuguan, *Fotiao zhi mei*, no. 004.

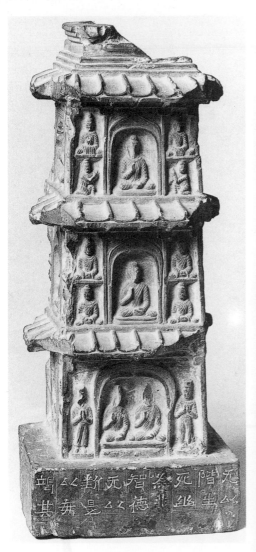

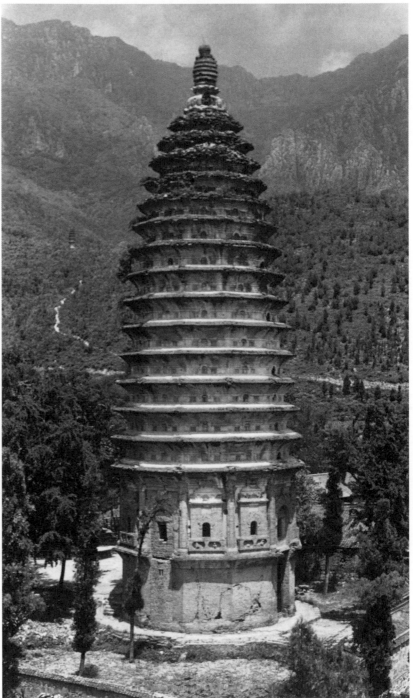

3.41 *Left:* Votive pagoda, Jiuquan. From Matsubara Saburō, *Chūgoku bukkyō chōkokushi ron,* pl. 95c.

3.42 *Right:* Pagoda, Song Shan, Henan, c. 523. From Liang Ssu-ch'eng, *Pictorial History,* 57.

3.43 *Left:* Reliquary stupa, Taxila. From Kurita Isao, *Gandara bijutsu,* 2: no. 807.

3.44 *Right:* Votive stupa, Tumshuk. Museum für Indische Kunst, Berlin, MIK III 8080. Photograph courtesy of the Museum für Indische Kunst.

to circa 523. The twelve-sided pagoda, however, is unique for the time period and there is no evidence that the votive stupa and pagoda are historically related or derive from a shared architectural precedent.[131]

Not surprisingly, the form of the Northern Liang votive stupa has more of an affinity with other stupalike works from India and Central Asia, some of which were reliquaries placed inside larger stupa and others which were votive without a specifically reliquary function. One is an unusual type of Indian reliquary known from a single ex-

ample (fig. 3.43) discovered at Jaulian, Taxila. The slender work, 3 feet 8 inches high, was fashioned to fit exactly into the relic chamber of a secondary stupa near the main stupa.[132] Made of plaster, and painted and bejeweled around the dome, the reliquary consists of a high, square base, two square stories surmounted by three round stories, and a small dome; each story is delineated by projecting eaves. A cubelike *harmika* supports a thick mast from which rises a series of eleven tapering parasols; at the top sits an additional finial that appears to be a second set of parasols. There is nothing comparable in Indian stupa to this strange, elongated form, although a small undated wooden votive stupa from Tumshuk in Central Asia (fig. 3.44) features the same exaggerated mast and parasols. In neither of these cases, however, do we find the eight-sided base or round drum of the votive stupa; nor is there anything approaching the elaborate figural imagery of the Northern Liang works.

For these features, the most closely related work is a stone votive stupa from Mathura (fig. 3.45), 55 cm high, with a square base and octagonal second register topped

3.45 Votive stupa, Mathura, c. 420–440. Lucknow Museum B 116. Photograph courtesy of Joanna Williams.

by a plain round dome.[133] The stupa, undated but assigned on stylistic grounds to circa 420–440, has four large panels on the lower register, each featuring a standing Buddha—three in *abhaya* mudra and one with its hand down in *varada* mudra. Small supplicants kneel to each side of the standing Buddhas. Eight seated Buddha images in niches are arrayed around the middle register, five in dhyana mudra, two in *abhaya* mudra, and one in *dharmacakra* mudra. All have symmetrically draped robes falling from both shoulders, unlike the Northern Liang stupa in which Buddha figures in *abhaya* mudra are consistently depicted with asymmetrical drapery with the right shoulder exposed. There is a round dome, but whether a staff and umbrellas originally extended from the crown is unknown. Although clearly different in major ways, the Mathura votive stupa is quite suggestive in scale and overall form of the Northern Liang works.[134]

These examples indicate that the Northern Liang votive stupa have visual relationships to works from India and Central Asia, where at Khotan in 400 the Chinese monk-pilgrim Faxian 法顯 noted that residents erected small stupa (*xiaota* 小塔) in front of the doors to their houses.[135] No details of their form are provided, although the smallest are said to be twenty feet in height. The scale hardly matches their description as small—there may have been a scribal error here—but the observation supports the visual evidence of not only a widespread stupa cult but its popularity among ordinary people. The Northern Liang stupa are undoubtedly part of pan-Asian practices involving votive stupa. Yet such an observation fails to explicate where within a range of stupa-related practices and beliefs the Northern Liang works might be situated. We are thus fortunate to have more than the usual evidence of a local context for the votive stupa as well as the testimony of their inscriptions, with which it is possible to balance comparisons to distant motifs and styles.

PATRONS AND DEDICATIONS

All or part of the dedication on ten of the votive stupa have been preserved. Five list only a single donor (Tian, Cheng, Ma, □ Jide, and Bai), presumably all male because inscriptions from this period typically identify females as such. Three (Gao, Wang, possibly Song) identify a husband, wife, and family; one (Suo) lists four unrelated individuals and their wives, children, and servants. The last (Chunyu) also includes a number of unrelated surnames, but most of the dedication has been lost. Three figures of devotees, however, are preserved on this work—two women and a monk—which suggests the patrons were a group of individuals including women and monastics. The surnames of donors on works from Jiuquan are Gao, Tian, Cheng, Ma, and Bai; from Dunhuang, they are Wang, Chunyu, Fan, Guo, and Ma; from Turfan we have Song and Zhang; and the unprovenanced Cleveland work has the names Suo, Hou, Meng 孟, and Wen.[136] Several names—Fan, Song, Zhang, Suo, and Meng—are well attested to as names of elite families from Dunhuang. But Song and Zhang appear only on the work from Tur-

fan; while Fan, Suo, and Meng are each found among a list of donors with other family names—hardly a special setting for a distinguished member of a local lineage. Most important, none of the extant donors are identified as holders of an official title or position, a designation often found on inscriptions of this type.[137] The usual practice, as we saw in various inscriptions in the previous chapter, is that any individual holding such a title would include it in his inscription. The absence of titles in the votive stupa is, of course, evidence *ex nihilo,* but it further suggests that these were not officeholders but individuals of a lesser standing.

At the same time, the emphasis on the long textual passages and the high quality of the calligraphy on most of the works belies an appreciation for if not expression of literati values. This is underscored in one case (Cheng) where the calligrapher is identified, a rarity in early Chinese sculpture. The reference in the Suo dedication to servants is also noteworthy, a reminder that the patrons of votive stupa were of sufficient means to hire domestic help. It seems likely that we are dealing here with a patronage group similar to that of the small Qijiawan tombs, certainly to be differentiated from the local elite lineages buried at Foyemiao, but not without some education, wealth, or claim to status. It might be inferred from the above that the patrons of the votive stupa were most likely from a class of small local landowners or merchants. This is a far cry from the men of celebrated local families whose learning and cultural achievements dot the extant historical record.

With the exception of the image of a monk on the work of Chunyu Guo et al., the lay orientation of the patrons of votive stupa is quite consistent and a contrast to what we find at the Dunhuang Mogao cave temple site.[138] Buddhist monks and nuns are well attested to as donors in fifth-century manuscript colophons found at the site; and painted images of monks leading lay Buddhist worshipers decorate the Northern Liang Caves 268 and 275.[139] Moreover, Cave 268 was constructed with small meditation cells, most certainly for the use of individual monks. The image of monks leading lay patrons can be understood as a visual metaphor for the pattern of patronage at the Mogao Caves in which the monastic community, following well-established patterns in India and Central Asia, was the primary user and developer of the site. The construction of a cave, even one of the small Northern Liang dynasty caves, must have been an extensive undertaking, probably including some of the wealthy and prominent local families from whom the monastic leadership was most likely composed.[140] By comparison, votive stupa would have been a more affordable type of work for those of lesser means.

The dedications also provide us with a clue as to the manner in which the votive stupa were produced. As noted above, the Shashan stupa from Dunhuang has no dedication. But at the end of the sutra text, where the dedication is typically placed, there is a blank area that would hold some nine rows of characters. This is clearly the place for the dedicatory inscription, which was never inscribed. Other votive stupa with a com-

plete dedication also have a blank row or uninscribed area that was available for inscription but which was apparently not needed. For example, on the Gao stupa there is a blank area between the end of the main dedication and a short second dedication placed just before the beginning of the sutra text (fig. 3.13).[141] The Cheng stupa is an example of the opposite problem—not enough room for the dedication—and the record of the donation (beginning in the fifth line from the right, ending with line eleven) is noticeably cramped (fig. 3.46) in comparison to the sutra text. In contrast to the standardized form of the votive stupa, the dedications vary in length and form. This suggests that the works were completely carved, including the sutra text, except for the dedication. Only after a donor paid for a work would the dedication be inscribed onto the blank area left for it. One can imagine workshops in which votive stupa were carved and set aside to await a donor. Such a donor did not seem to mind the fact that the object was not made to his or her order. In contrast to the ostentation of painted cave temples, the votive stupa suggests something of a more ordinary work reflective of not only the modest social position of the patrons but a different set of concerns.

Although the dedications follow a predictable formula, they are by no means identical and include variations in personal detail that indicate the patrons either directed the composition of the texts or at least expected texts produced for them to be individualized. One striking feature of the texts, seen only in two of the dedications, is the use of the nearly identical statements: "born by chance 生值 into the Final Age" (*moshi* 末世) in the Cheng stupa, and the same phrase in the Bai stupa except that *mofa* 末法 replaces *moshi*.[142] *Moshi*, a term known from at least the second century B.C.E., was popularized in Buddhist texts through the third-century translations of the previously mentioned

3.46 Rubbing, inscription, Cheng Duan'er votive stupa. Photo by R. Vandenbossche, courtesy of Krishna Riboud.

Dunhuang monk Dharmarakṣa. The term is used to connote in general the period following the passing of the historical Buddha Sakyamuni.[143] The concept is a melancholy one for Buddhists like Cheng, who underscores his unlucky predicament by following the above statement with the phrase: "unable to contemplate the Buddha 不觀佛."[144] Nattier has demonstrated that *mofa* was a neologism coined as an equivalent to *moshi,* but not attested in Buddhist canonical sutras until the beginning of the fifth century. The use of *mofa* in the Bai stupa is thus an unexpected and important early example of the term.

Yin Guangming maintains that the use of *moshi* and *mofa* on the votive stupa is evidence of a belief in the well-known tripartite historical framework for the decline of the dharma, the true teachings of the historical Buddha, after Sakyamuni's passing from earth—that is, the periods of True Dharma (*zhengfa* 正法), Semblence Dharma (*xiangfa* 像法), and Final Dharma (*mofa*).[145] He goes so far as to argue that the commencement of the period of *mofa* was understood to be the year 434 following the periodization scheme articulated by the monk Huisi 慧思 (515–577) in a commentary traditionally dated to 558.[146] This is especially germane to the inscribed dates of 434 and 436 on the Cheng and Bai stupa. It is clear, however, that the three-part system in which *mofa* plays such an important role was a creation of the mid–sixth century—Huisi's text is the earliest extant written exposition—at which time the neologism *mofa* was given new meaning as the end of the dharma, an extended period during which the true teachings of the Buddha would be extremely difficult if not impossible to access. The use of *moshi* and *mofa* on the two votive stupa, therefore, should not be confused with the later understanding of *mofa* within the tripartite framework that was to become so popular in China, Korea, and Japan. This is not to say that the strongly negative sense of *mofa* in

the later system was completely absent from the fifth-century understanding of a term such as *moshi,* which was used in the Han dynasty to denote an evil and decadent time.[147] But the sense of *moshi/mofa* in the votive stupa dedications is limited to a rather simple and understandable lament of one so unfortunate as to have been born into an age without a living Buddha.[148]

SUTRA TEXT

The Northern Liang votive stupa are unique in having virtually identical transcriptions of a canonical sutra text inscribed on them. There are no similar examples of images inscribed with text copied from canonical Buddhist sutras in the fifth or early sixth centuries. The sutra is an exposition on *pratītyasamutpāda,* the doctrine of dependent origination, upon which Sakyamuni meditated on the night of his enlightenment.[149] The subject—the linked causes of human suffering and their cessation—is the most fundamental teaching of Buddhism. The passage closely parallels a section of a sutra preserved in the *Zeng yi a han jing* 增一阿含經, a translation of the *Ekottarārikagama* (commonly known as the *Ekottarāgama* sutra) by Gautama Saṅghadeva, a Kashimiri monk in Nanjing in the years 397–398.[150] There are a number of small differences between the printed sutra and the stupa version that indicate that the latter is likely an older version of the Saṅghadeva translation and closer to the original.[151] The *Ekottarārikagama* is a collection of canonical texts known in the Pali canon as the *Aṅguttarara-nikāya;* the *Zeng yi a han jing* translation is the only complete extant version. The *pratītyasamutpāda* formula exists in a number of versions and, as is characteristic of texts in the *Zeng yi a han jing,* this version appears to have been assembled from portions of other canonical sutras.[152] Interestingly, several fragments of the *Zeng yi a han jing* were among the Stein manuscripts discovered at Dunhuang. One is thought to date from the early fifth century, but none include this particular sutra.[153]

The printed version of the sutra has four sections: (1) a description of the setting in which the sermon was presented; (2) a short exposition on the five aggregates (*skandha, yin* 陰) and their destruction; (3) a listing of thirteen (rather than the usual twelve) causes (*nidāna, yinyuan* 因緣) followed by a listing of the cessation of the thirteen causes; and (4) an exhortation for monks to practice mindfulness and charity. The stupa versions are in no cases the complete sutra: six include all sections except the last; three include part but not all of the fourth section; one of these eliminates the opening section. The section addressed to the monastic community appears to have been dispensable and only included when space was available. What seems clear is that the core of the text as copied onto the votive stupa comprises sections two and three—that is, the passages in which the aggregates are discussed and the links of dependent origination are listed. The centrality of the *yinyuan* or causes is underscored by the otherwise unknown title provided

for the sutra on the Song stupa: "Sutra on the Twelve Causes Spoken by the Buddha" (*Fo shuo shi'er yinyuan jing* 佛說十二因緣經).

In India, the *pratītyasamutpāda* was understood as not only the essence of the *dharma* but as a counterpart to the Buddha himself: "He, monks, who sees the *pratītyasamutpāda* sees the *dharma;* he who sees the *dharma* sees the Buddha." [154] In practice, this understanding manifested itself in depositing the *pratītyasamutpāda* verse inside stupa. An early example is the Kharoṣṭhī inscription of possibly the second century C.E. punched onto a small copper votive stupa from Kurram in northwest India. [155] The main part of the inscription is a recitation of the twelve links, an "attempt to appropriate the enlightenment experience of the Buddha—his cognizance of the chain of causation—into the stupa cult that venerated his corporeal remains." [156] The archaeological context of the Kurram votive stupa is not known, but it is the type of work that has been found deposited in or near stupa. [157] Another example is the *pratītyasamutpāda* verse, written on a piece of birch bark, discovered inside a small copper vessel near a small stupa at Lauriyā–Nandangarh. [158] In these cases, the verse appears to be as appropriate for deposit in a stupa context as relics of the Buddha—that is, the dharma as preserved in the *pratītyasamutpāda* was understood as the equivalent of the bodily relics of the Buddha.

The Indian practices are suggestive of a similar function for the sutra on the Northern Liang votive stupa. A number of the stupa were said to have been discovered in cave temples or at former Buddhist temple sites, but none of the works were excavated as stupa or pagoda deposits and there is nothing in the dedications that indicates such a purpose. The Bai inscription indicates that the stupa may have been carried to or set up in the mountains, which reminds us that these were portable objects that have probably been used over the centuries in various contexts not necessarily consistent with their original function. A good example is the discovery of the Wang votive stupa at the Laojun tang 老君堂 earlier in this century and its subsequent reburial in the Wangmugong 王母宮, both of which are Daoist, not Buddhist, institutions. [159] One cannot rule out the possibility that the Northern Liang works functioned as stupa deposits, but it seems unlikely especially in light of their elaborate decorative program—a strong contrast to the small, plain vessels with which the Indian texts were associated. It seems plausible, however, that the *pratītyasamutpāda* verse on the Northern Liang votive stupa functioned in a manner similar to the Indian examples—that is, as a literal substitute for the *dharma* and thus the Buddha. Rather than a relic-equivalent placed inside a stupa, however, the verse represented the presence of the Buddha on the exterior of the votive work. [160]

In later periods, the *pratītyasamutpāda* in abbreviated form was used as a *dhāraṇī*, found for example inscribed on the interior bricks of a pagoda in Yunnan. [161] Pillars carved with *dhāraṇī* are well-known from the Tang dynasty. [162] One late Buddhist sutra recommends that an amulet be made with a relic wrapped in a piece of birch bark inscribed with the abbreviated *pratītyasamutpāda* verse. [163] Examples of the efficacy of the

verse as *dhāraṇī* are all late in date, but there is something to the formulaic structure of the listing of the causes (A gives rise to B, B gives rise to C, etc., followed by A terminates B, B terminates C, etc.) that lends itself to what Durt calls the "catechistic" or "magical" character of the text.[164] Although there is no evidence for the use of the *pratītyasamutpāda* as a *dhāraṇī* in the fifth century, one is reminded of stories in which Buddhist sutras functioned in this period as talismans or protective amulets.[165] In addition, compilations of *dhāraṇī* sutras were beginning to circulate in China by this time, and we have fragments from Dunhuang as evidence that some such texts were known in the region.[166] Five separate fragments of one *dhāraṇī* text said to have been translated at nearby Zhangye between 402–413 are preserved in the Stein Collection.[167] Another Dunhuang manuscript, a composite text with a Northern Liang regnal date of 422, includes *dhāraṇī* and a list of twelve days, one per month, suitable for the remission of sin.[168] Such interests fall within the realm of popular beliefs as much as Buddhist doctrine, more closely aligned with *zhenmuwen* than canonical sutra texts or abstruse exegesis on the *Yi Jing*. To the extent that the Northern Liang votive stupa are products of this milieu, it seems possible that the function of a repetitive formula such as the links in the *pratītyasamutpāda* was primarily understood as magical and efficacious. Ironically, then, an exceedingly rare example of a canonical sutra text copied onto an early Chinese image may reflect not the learned interests of the elite clerics who so assiduously guarded the purity of the textual tradition, but the "superstitious" practices of many ordinary Buddhists.

CELESTIALS AND TRIGRAMS

Although the celestial figures on the base of the votive stupa in figure 3.18 appear at first glance to have a direct relationship to Indian or Central Asian precedents, their identity is by no means clear. Yin Guangming has argued that the figures represent a version of the set of spirit kings (*shenwang* 神王), following the characters inscribed on the Suo E work and a listing of eight *shenwang* in the *Daban niepan jing* 大般涅槃經 (*Mahāparinir-vāṇasūtra*).[169] The characters for *shenwang* along with the character *wang* on the torso of the adjacent celestial figure, however, are roughly scratched onto the surface of the stupa. It is not clear that these were part of the original design and the identifying characters might be better understood as an anachronism—that is, the ingenuous work of someone in the sixth century or later who interpreted the eight deities as being the set of later spirit kings. In addition, the spirit kings in visual representations, as Yin's own illustrations demonstrate, are consistently depicted as a set of ten figures—and only then in the sixth century.[170] The spirit kings also have a recognizable iconographic form—dragon or animal heads and distinctive attributes—none of which are to be found in the figures on the votive stupa bases.[171] And the gender of the celestial figures, four males and four females, is not easily rationalized with the set of spirit kings.

Another scholar, Kuno Miki, has suggested that the eight figures on the Northern Liang votive stupa represent the Indian deities known as the eight *devalokas* (*batian* 八天).[172] The problems in this case parallel what we found in Yin Guangming's argument: the typical attributes of the *devalokas*—riding atop animals such as bulls or elephants, for example—are not to be found on the votive stupa and the male and female figures have no correlation with the set of *devalokas*. There is no question that various sets of spirit kings and *devalokas* are to be found in translations of Buddhist sutras from as early as the Eastern Han dynasty, but neither Yin nor Kuno make a convincing case for a visual relationship between these and the eight figures on the base of the Northern Liang votive stupa.[173] To compound the problem, the celestial figures are not consistent among themselves in the attributes that they hold, and in the Ma and Shashan works the figures abandon the usual flowers, water bottles, and so on to take up tridents, an attribute that is often held by images of Shiva on Kushan dynasty coins.[174] This could be interpreted to mean that the figures with tridents are manifestations of Shiva and, by analogy, all of the votive stupa figures are to be understood as Shiva. But it also seems possible that the trident was a motif applied to the figures without a clear understanding of its relationship to Shiva (or the meaning of Shiva) in the Indian context. Finally, it is important to recognize that the trident appears on only the Ma and Shashan stupa and may have been specific to Type B works. Whether the tridents were intended to indicate that these celestial figures were different deities from the celestials on other stupa bases is not clear.

The most convincing explanation for the figures on the base of the votive stupa remains that of Wang Yi, who early on identified the four male and four female celestials as the personifications of the adjacent trigrams. Interestingly, there is evidence for popular rituals involving the trigrams and the Big Dipper in which the trigrams were reified as the *bashi* 八史 or Eight Archivists, the spirits of the eight trigrams.[175] The *bashi* are known in several Han dynasty texts; and by the time of Ge Hong in the early fourth century there was a divinatory practice of summoning the Eight Archivists in order "to know in advance about things that have not yet formed."[176] The rituals involving the Archivists were popular enough to be appropriated into two Daoist texts: the *Taishang tongling bashi shengwen zhenxingtu* 太上通靈八史聖文眞形圖 (hereafter *Bashitu*) and the *Taishang wuji dadao ziran zhenyi wuchengfu shangjing* 太上無極大道自然眞一五稱符上經 (hereafter *Wuchengfu*), both probably dated to the latter fourth or early fifth centuries at the latest.[177] The *Bashitu* describes the Eight Archivists as pairs of male and female couples (paired trigrams) who descend to one's house and may be consulted, men addressing the male deity and women the female. Part of the necessary ritual is the setting out of eight talismans in the eight directions and making offerings at the left door pillar of the main hall. A second section of the text describes the talismans as being received by the Yellow Emperor from Laozi, who "saw them in the Big Dipper and is said also to have brought

them to the barbarians (*hu* 胡) of India."[178] According to the text, the Eight Archivists reside in the Big Dipper as well as the pillar of the main hall of one's home, and when asked questions, they return to the Dipper to consult the registers of fate. Each Archivist is also matched with a specific star in the Dipper.

The *Wuchengfu* presents a different version of the Eight Archivist ritual, emphasizing sets of five as well as eight talismans, the use of special plants, including the carving of the plants into effigies of the deities, meditations on the names of the Eight Archivists as well as visualizing them, and combinations of the trigrams with the chronogram directions (based on the earthly branches, *dizhi* 地支). Here, the trigrams serve as "abstract symbols for the constituents of all phenomena . . . in constant flux, dynamically transforming into each other in an eternal process of actualization, whereby the things of the world are made and remade."[179] Most interestingly, the *Wuchengfu* adds a scheme of ten directions, taken directly from a known Buddhist sutra, to which the eight trigrams and directions augmented by the zenith and nadir are correlated.[180] Raz makes the important point that the differences in approach are indicative of the way in which an earlier ritual is being appropriated into two competing Daoist traditions: the *Bashitu* 八史圖 related to Shangqing and the *Wuchengfu* 五稱符 to Lingbao.[181] Such rituals in their original form were explicitly proscribed according to one Celestial Master text: "You should not possess the prognosticatory writings of the lay people or the Chart of the Eight Spirits. Also, you should not practice any of them."[182] The *Bashitu* and *Wuchengfu* can thus be understood as reflecting the transformation of previously improper rituals into those appropriate for organized forms of Daoist practice in the Shangqing and Lingbao traditions.

If the eight celestial deities on the votive stupa are manifestations of the trigrams, these figures may represent the Eight Archivists. Some details gleaned from the texts further support such a hypothesis. For example, the *Bashitu* specifically identifies the Archivists as four male and four female deities; pairs of the Archivists descend on a door pivot or pillar in a main hall, which is suggestive of the pillar shape of the votive stupa; and the Big Dipper carved atop the crown of the Gao work is considered the residence of the Eight Archivists. In contrast, there appears to be less of a direct correlation with the *Wuchengfu,* primarily because of the insertion of the ten Buddhas in the text with which there is no correlation on the votive stupa. At the same time, the emphasis in this text on the meditation and visualization of the Archivists resonates with not only the celestials on the base but Buddhist meditation and visualization practices suggested by the set of eight Buddhist images in the niches above.[183] Yet the trigram names and figures on the votive stupa fail to match the couples described in the *Bashitu,* and the Big Dipper is found on only one stupa. The relationship of the figures and trigrams to either text is thus suggestive but hardly direct, not surprising if the two texts extrapolate and modify an original set of rituals. The "source" of the set of eight images on the votive

stupa, then, is possibly the same set of popular rituals that were the basis of the two Daoist texts. If so, this is rare evidence of the adoption of motifs and deities from a largely unknown strata of ordinary belief and practice into early Buddhist images.

SEVEN BUDDHAS AND MAITREYA

The final major component of the votive stupa is the set of Buddha and bodhisattva figures. The images of the Buddha are depicted in two basic modes of dress: first and most common is with both shoulders covered similar to the Buddha-like images discussed in chapter 2 and the earliest extant Buddhist icons of the fourth century (fig. 2.2). In this mode, the drapery can fall from the shoulders in either a symmetrical or asymmetrical pattern. (Another variation pulls the outer robe down to reveal a V-shaped section of the undergarment over the torso.) The second mode has the robe pulled back to expose the right shoulder and upper chest. Type A works and the Bai stupa depict the Buddha only in the first mode, while both modes are used in all of the other works. While the figural style among the works is closely related, the images are not identical and there are subtle variations in the handling of proportions, volume, and line in the figures as well as the niche and its decoration. For example, compare the patterns of drapery and figural proportions on two Type A works, the Gao and Cheng stupa (figs. 3.13 and 3.20 respectively). Scholars have often noted an Indian prototype for the style of the figures in Kushan period (first and second centuries C.E.) works from Mathura and Gandhara.[184] But a more relevant comparison might be the gilt bronze icon of 338 (fig. 2.2), especially the distinctive manner in which the hands are placed together in a vertical position, which can also be found on the Gao stupa seated Buddhas. Although the bronze statue is usually considered a Gandharan-derived work, it seems clear that even such an early Chinese image possesses visual attributes, such as the hand position, which are not copied from Indian prototypes. In chapter 2 it was suggested that once early Buddha-like images were produced in a local region, these images themselves became the most likely models for new images. For the Northern Liang votive stupa—works created at a time when Buddhist icons were common in China—it seems even more likely that various local traditions of image-making were the primary inspiration for the figural style.

In contrast, there is no Western nor Chinese iconographic prototype for the set of seven seated Buddhas and a cross-ankled bodhisattva arrayed on the stupa. The set of eight figures certainly represents the seven Buddhas of the Past, including Sakyamuni as the last, and the Buddha of the Future, Maitreya, in bodhisattva form.[185] But in India, extant sets are few and typically consist of eight standing figures or eight seated figures all with legs tucked under them (for example, fig. 3.45). Although the cross-ankled bodhisattva was a relatively popular image, cases in which a cross-ankled bodhisattva was combined in a set with seven seated Buddhas are rare.[186] In fact, it is not clear when and

where the seven Buddhas of the Past was first combined with Maitreya; we only know that the set of eight as carved on the Northern Liang works is the principal early example of this iconographic type extant in India, Central Asia, and China. It is also important to note that this set of eight seated images is not found in later fifth- or sixth-century works of Chinese Buddhist art where seven small Buddhas are typically arrayed around a large central image of Maitreya.[187] This again underscores the important unique aspects of local image production that have been obscured by the preoccupation in much past scholarship with identifying distant sources of influence.

Scholars have noted a special relationship between the Northern Liang ruling family and Maitreya, indicated in both the inscription for an image of Maitreya erected by Juqu Anzhou in Turfan dated to 445 and a Maitreya text that was translated by a member of the Northern Liang ruling family.[188] The cross-ankled bodhisattva, usually thought to represent Maitreya, is prominent in the Northern Liang Mogao Cave 275 as well as the votive stupa. Furthermore, dedications on two votive stupa (Bai and Suo) include the secular ruler as one of the beneficiaries of the donation.[189] An alternative reading of the seated cross-ankled figure has been suggested by Gu Zhengmei, who argues that this image type represented the bodhisattva as a *cakravartin* (*zhuanlunwang* 轉輪王), a world ruler.[190] The reasoning is complex, but in essence Gu understands the cross-ankled bodhisattva as linking political authority with not only the future Buddha Maitreya but the figure of a *pratyeka* Buddha (*bizhifo* 辟支佛), one who individually strives for Buddhahood. The multivalence of the image is thus quite powerful in its flexibility, capable of correlating the ruler with concepts of a present Buddha as well as a bodhisattva, the Buddha-to-be of the future. In the case of the Northern Liang votive stupa, the position of the cross-ankled figure at the end of the series of past Buddhas is suggestive of just such a meaning.

The interpretative possibilities raised by scholars such as Gu remind us of the potential multivalency of Buddhist imagery.[191] Their explanations of iconography, although advanced with the intention of establishing the basis of the imagery, only demonstrate the wide range of texts that might relate to the Northern Liang votive stupa. Such textual scholarship reminds us that there was a plethora of sources for visual imagery; no single text was necessarily the sole or primary source of works such as the votive stupa. In addition, the makers of the image, the patrons, and a range of different viewers need not have shared—and may not have felt compelled to share—a common understanding of the imagery. Rather, it is likely that a complex series of overlapping readings—some elements shared by some viewers, others shared by others, still others unique to specific individuals—was a normative condition for the understanding of complex works such as the Northern Liang votive stupa. That the full complexity of sources or readings is unavailable to us today should not prevent us from an appreciation of the multivalency inherent in our field of study.

FUNCTION AND THE LOCAL

In addition to the distinctive qualities of its component parts, the three main registers of the votive stupa are in most cases clearly coordinated. The series of Buddha and bodhisattva figures, the sutra text, the trigrams and celestials, read in a clockwise direction, can be seen to begin and end together. From a Buddhist perspective, the works can be understood as a tripartite presentation of the Buddha: first, as part of a lineage of past and future Buddhas in the set of images; second, as the presence of the Buddha in the dharma represented by the *pratītyasamutpāda* verse; and third, as a metonym for the physical remains of the Buddha in the abstracted architectural form of the votive stupa that is imbued not with relics but with the verse as relic. The bottom register of deities and trigrams, however, reflect a more complex situation. On one hand, these motifs serve to represent the incorporation of the trigrams and their deified forms into Buddhism; on the other, the popular ritual that lies behind the deified trigrams remains transparent—a visual remainder that suggests an opposite function for the work: the marshalling of Buddhist texts and images in service of the ordinary beliefs of lay patrons. The common theme is a widely held concern with good fortune in the present as well as the future. Visual elements such as the trigrams draw together threads of beliefs and ritual involving mortuary practices, divination, and popular deities such as the *bashi* with Buddhist concepts. The Northern Liang votive stupa thus appear to unify Buddhist and non-Buddhist elements through an imagery of circularity and continuity coordinated among three hierarchically arranged levels of ritual practice: one focused on conventional Buddhist images, one on a central Buddhist text, and one on the trigrams and their personification.

The clear alignment of the registers has encouraged some scholars to go further in the correlation of meaning between the registers. For example, Yin Guangming has aligned the set of Buddha and bodhisattva figures to the compass directions conventionally assigned to the trigrams below. The most recent Buddha, Sakyamuni, is located above the trigram *kan,* which is associated with the north, the direction of *yin,* darkness, and death. North is also the direction of the Dipper and it may be no coincidence that the handle of the Dipper atop the Gao stupa points to the north. The trigram's orientation and the position of the Dipper together reiterate the negative sense of the present age without a Buddha. On the other hand, the cross-ankled bodhisattva, the future Buddha Maitreya, is positioned above the trigram *gen* in the northeast position associated with spring and morning.[192] While intriguing, the limits of such correlations are demonstrated here as well: what is the logic, for example, that would match the remaining six Buddhas of the Past with the remaining trigrams, especially in the case of the Buddhas that would need to correspond with the four female divinities?

Recently, Eugene Wang has extended Yin Guangming's correlative approach to propose a unified, comprehensive reading of the Northern Liang votive stupa. The com-

plex and astute argument understands the votive stupa as a hybrid Buddhist-Chinese form in which every element is intricately related across the spatial and temporal symbolism of the two cultural systems.[193] The celestial figures as personifications of the trigrams, the trigrams (along with the Big Dipper) as directional and cosmological symbols, the symbolism of the theme of causality and ending in the sutra text, the cycle of seven Buddhas of the Past and the future Buddha Maitreya, even the mismatched distribution of the six inscriptions on the base of the Ma Dehui stupa—all can be correlated and explained through references to classical texts, philosophical treatises, cosmological manuals, and Buddhist sutras. It is not surprising then that Wang follows Soper in highlighting Juqu Mengxun's interest in the Chinese classics or the scholarship of Northern Liang literati such as Kan Yin 闞駰 and Zhang Zhan 張湛 on the *Book of Changes*.[194] Only the most gifted and erudite Chinese scholars would have possessed the breadth of knowledge necessary to conceive of the kind of sophisticated symbolism that Wang ascribes to the program of the votive stupa.

There are two problems, however, to such a formulation. One is the relationship between the abstruse concepts and symbolism of the texts cited by Wang and the votive stupa, which were mass-produced objects for relatively undistinguished donors. While the lengthy sutra text suggests a learned audience, the class of patrons suggested by the stupa dedications may have been less interested in philosophical discourse than in practical, even magical, results. Wang states that the trigrams on the stupa "are symptomatic of the culture steeped in the learning of the *Book of Changes* and the Yin-Yang occult derived from it."[195] But as we found in our review of the mortuary evidence, there is no significant usage of the trigrams in the area around Dunhuang and Jiuquan; rather, local elites as well as those of a lesser standing utilized a rather different set of auspicious and efficacious motifs and objects in their tombs. There are no examples of trigrams in religious imagery from the region, including the Mogao Buddhist cave site south of Dunhuang. What is suggested is that the literati scholars of the *Book of Changes* were exactly that—their textual exegesis operated in an intellectual and social milieu far removed from the pragmatic concerns of those involved in the Northern Liang votive stupa. Furthermore, the prominence of such scholars in the dynastic histories is very much a factor of the orthodox values necessarily promoted in such documents.

A second problem is the straightforward relationship between the votive stupa and the cosmic board proposed by Wang: "On the basis of the symbolic functions of the cosmic board, we can infer certain uses of the stupas, since the latter is all but a displaced form of the former, and the trigram scheme provides a conceptual continuity."[196] Indeed, the trigrams are a link between the cosmic board and the votive stupa, but a review of the extant Han dynasty cosmic boards shows that motifs such as the Big Dipper, the twenty-eight lodges (*xiu* 宿), the twelve months, the ten heavenly stems and twelve earthly branches (*ganzhi* 干支), and the four nodal points (*siwei* 四維) are by far the

most common if not essential imagery.[197] None except the Dipper (and then only in one example) appear on any votive stupa. In addition, the sole Han dynasty cosmic board said to have trigrams was a badly damaged work discovered at Lelang in Korea with only one trigram preserved; the oft-reproduced drawing of the board with the full set of trigrams was published by Japanese scholars in 1930. Their reconstruction was based on texts, some from a later period when the set of eight trigrams was more widely utilized.[198] There is, of course, still the possibility that all eight trigrams were originally represented on the Lelang board, but this is not at all certain. It has been noted that the reconstruction of the Big Dipper on the upper section of the board is in error.[199] The Lelang cosmic board, however, continues to be widely published, a small example of the manner in which an understandable desire to have evidence of the early use of the eight trigrams prompts uncritical reproduction and citation.[200]

The only other extant cosmic board with trigrams contains only four and is dated to the latter half of the sixth century, more than a century after the Northern Liang works.[201] The trigrams represent the four directional gates, which is a different emphasis from the set of eight trigrams on the stupa; in addition, this board has no Dipper on its upper section. In contrast, the Dipper motif is regularly inscribed on the upper section of the Han dynasty boards. Yet it is noteworthy that the Dipper is only combined with the trigrams in one instance—the reconstructed cosmic board from Korea—and the board found at Wuwei in Gansu Province has the Dipper but no trigrams. Conversely, the Big Dipper is found on only one out of three votive stupa that retain their crowns, which indicates that the Dipper was not an essential motif on the stupa. In sum, the sole example of a cosmic board with the eight trigrams that predates the votive stupa is the reconstruction from Korea; the Six Dynasties board does not utilize the set of eight trigrams nor the Big Dipper; and the one board found in the region of the votive stupa has no trigrams.

While the visual correlations may be shaky, Wang's argument is still compelling as a conceptual and theoretical formulation. After all, the combination of visual motifs from Buddhist and Chinese sources on the votive stupa is undeniable. It is interesting, however, that he comes to the conclusion that "the hybridization of two symbolic systems on the stupas is a physical and architectural equivalent to the exegetic practice known as *geyi* 格義 ('matching of meanings')."[202] The term *geyi* is commonly understood to denote the practice of presenting Buddhist teachings through terms from Chinese classics such as *The Book of Changes* to literati audiences during the third and fourth centuries. But strictly speaking, it appears to have been a highly technical procedure, little more than the matching of Buddhist and Chinese numerical categories.[203] As such, the term is specific to the introduction of Buddhism among an educated audience who would appreciate the erudition of Buddhist adherents in arcane classical references. It seems unlikely that individuals of such a class would find the trigrams or partially nude celestials

on the base of the Northern Liang stupa attractive. This is not to say that there is no re-
lationship between classical texts, the trigrams, and Buddhism, but rather to suggest the
possibility that the technique of *geyi* may be rather far removed from the makers and pa-
trons of the votive stupa, whose social and educational backgrounds appear to be rela-
tively undistinguished. It should also be noted that by the fifth century, *geyi* was widely
rejected as an imperfect, failed method of translation and exegesis.[204]

Although clearly related, none of the Northern Liang votive stupa are identical. The
extant remains suggest a surprisingly varied set of improvisations on a basic concept—
that is, visual evidence that offers us a notion of the heterogeneity possible in what ap-
pears to have been a relatively large-scale production of stone images. Here we have a
unique opportunity to consider the way in which a set of images of the same place and
time—typically understood as representative of a unified regional or period visual style
—also provide evidence of significant stylistic individualization that was obvious to the
makers and noticed by viewers. What does it mean that a completely preserved work,
the Cheng stupa, has no trigrams and no Dipper? Or that the Bai stupa doubles the reg-
ister of Buddhist images and eliminates the deities and trigrams from the base? Such de-
viations may have been motivated by theoretical concepts of space and time. They may
also have been the result of little more than a desire to elaborate or differentiate one's
work from those of others. The specific reasons for such variations are beyond our reach.
While the votive stupa responded to the interests and needs of a relatively ordinary pa-
tron group, there is no evidence beyond the dedicatory inscription that specific works
were customized for individual patrons. This indicates that workshop organization and
practice—of which we know little—was crucial for the form of these works. It should
also be recalled that there is a pattern of irregular textual emendations to four of the stupa
(Ma, 格 Jide, Bai, and Suo), all except the Suo being unfinished in some aspect. These
along with works that were never dedicated remind us that the extant body of votive
stupa do not necessarily represent what the works were meant to be in their whole and
completed state.

Past studies of the visual imagery of Liangzhou have been guided by a fundamental
distinction of ethnicity, between Han Chinese and non-Han Chinese; as well as one of
geography, between the metropolitan center and the provincial periphery. Scholarship
on the Northern Liang votive stupa has been exemplary in this regard, carefully delin-
eating, for example, the visual features that are derived from the West versus those that
emanate from central China. Such a description replicates the commonly held view that
this frontier region was always a space in which Han and non-Han cultures mixed, but
somehow had little identity itself—a place eternally suspended between the solidly Han
zhongyuan and the barbarian non-Han cultures of the West.[205] Although self-designated
as a *ta,* the Northern Liang works were not conventional reliquaries nor were they de-
posited in larger pagodas, the most commonly seen practices involving votive stupa in

India. Neither was their form taken up in China. Rather, these stupa are products of a complex local cultural milieu, a type of sculptural production that combined Buddhist and non-Buddhist elements to satisfy the needs of local patrons. Out of a myriad range of possible models, local workshops created a form of imagery that spoke directly to an audience in Dunhuang and Jiuquan. It was to be an ordinary form that was particular to its own time and place.

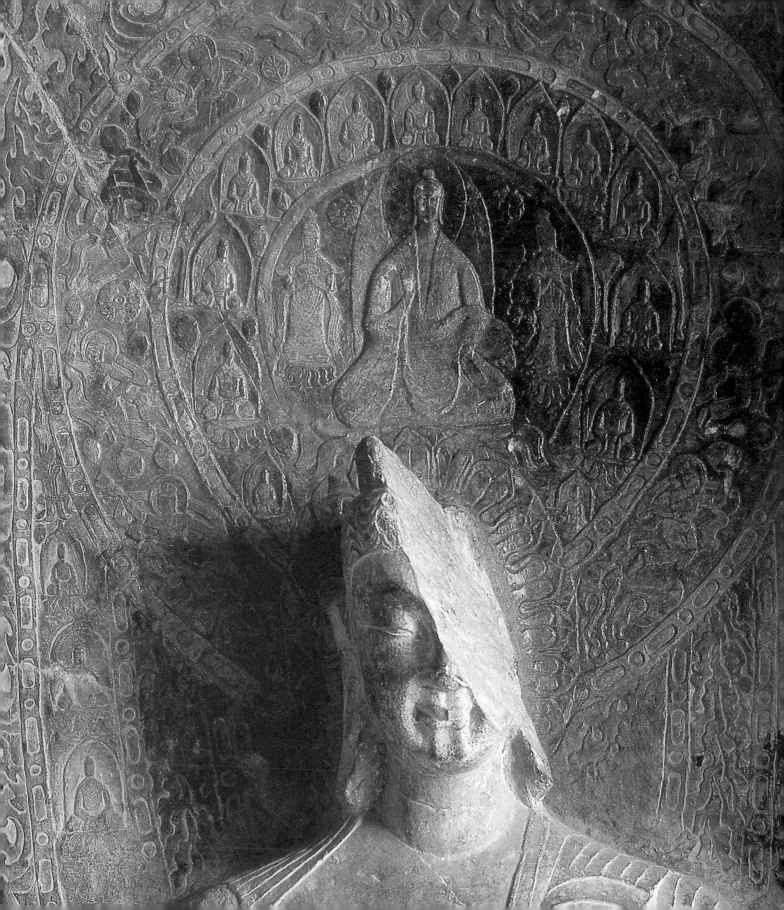

Chapter Four

The reforms [of the late fifth century] made the Northern Wei fit more closely into the mold of the traditional Chinese state. . . . They were designed to overhaul the antiquated structure of government and build the dynastic power upon firmer foundations. It was not, as the name "sinification" might imply, the simple love of Chinese ways which begot the reform.[1]

SINICIZATION

 AS WE HAVE SEEN in the two previous chapters, the typical early Chinese Buddha image was depicted in a type of monastic dress that is consistent with models of a Western—that is, Indian or Central Asian—type. Two modes of monastic dress are found on the Buddha figure in early Indian sculpture: one with a high neckline and both shoulders covered (closed mode) and one in which the right shoulder and upper chest of the figure are left exposed (open mode). The closed mode was exclusively used for the Buddha figure in China until the first half of the fifth century, when a variation of the open mode is first seen.[2] The alternative rendering of the open mode (fig. 4.1) brings the robe up over the top of the right shoulder and down over the arm. This mode, which we encountered on a few of the Northern Liang *shita,* was unknown in India and must have been developed in either Central Asia or Liangzhou.[3] Whatever its origin, the open mode would soon become the preferred manner of representing the Buddha image.

This was the case at the Yungang cave temple site near the Northern Wei capital of Pingcheng 平城 (present-day Datong 大同 in northern Shanxi Province), begun with a monumental set of imperially sponsored caves in the 460s. Only variations of images in the closed or open modes of dress were utilized on Buddha figures until the appearance of a completely new mode of dress in the 480s. Found most prominently in Cave 6 (fig. 4.2), this version of the closed mode has the drapery falling evenly over both shoulders, but the material from the right side of the torso is draped not over the left shoulder but across the left forearm. The result is that the high neckline of the closed mode is loosened and the undergarments, especially the vest often held in place by a sash with a large bowknot and streamers, are exposed to view. In addition, the new mode is often

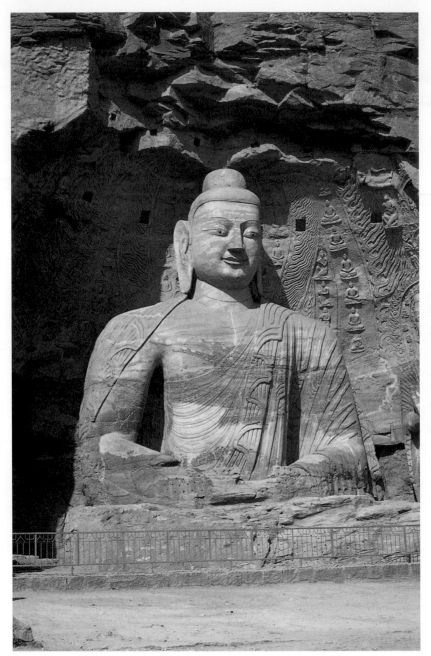

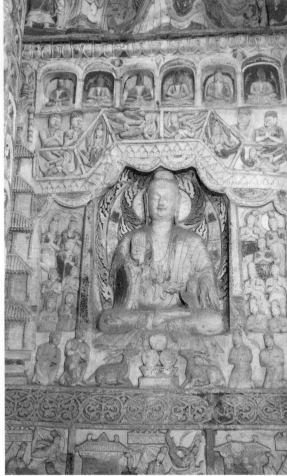

4.1 *Left:* Seated Buddha, Yungang Cave 20, c. 465. Photo by author.

4.2 *Right:* Seated Buddha, Yungang Cave 6, east wall. From Unkō sekkutsu bun–butsu hokanjo, *Unkō sekkutsu,* 1: pl. 104.

accompanied by stiffly splayed and fishtailed ends to the drapery, spread to the sides of standing images and in front of seated images. Such decorative elements as well as the thick, broad pleats of the drapery suggest Han Chinese dress and will be referred to here as the Han mode.

There is a parallel development in the dress of the standing and cross-ankled bodhisattva figures. In contrast to the earlier mode of dress (fig. 4.3) with close-fitting drapery and flowing scarves to the sides, the Cave 6 bodhisattva in the Han mode (fig. 4.4) features scarves that cover the shoulders in wide, flat pleats and cross in an X-pattern over the legs; a flaring skirt is similar to that found on standing Buddha figures in the Han mode. Laurence Sickman eloquently describes the transformation of the earlier Western styles:

> The linear, geometric style, inherent in Han art, soon began to modify the forms, reducing still more any naturalism that Central Asia had retained from the modified Hel-

4.3 *Left:* Standing bodhisattva, Yungang Cave 7, south wall. From Unkō sekkutsu bunbutsu hokanjo, *Unkō sekkutsu,* 1: pl. 152.

4.4 *Right:* Standing bodhisattva, Yungang Cave 6, east wall. From Unkō sekkutsu bunbutsu hokanjo, *Unkō sekkutsu,* 1: pl. 117.

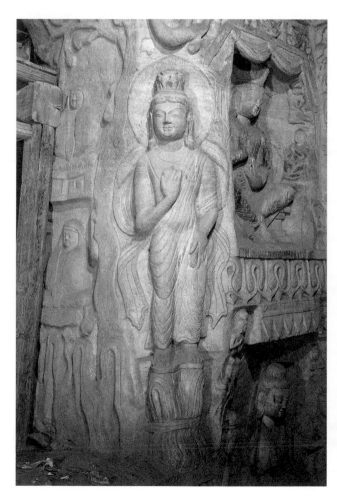

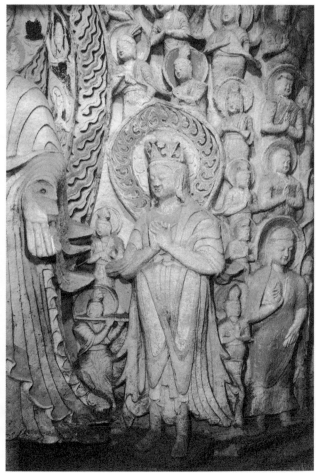

lenism of Gandhara and the sensuousness of Indian sculpture. . . . Specifically the Chinese modified the forms away from any lingering naturalism and towards a formal stylization, forced the fluttering scarves and ribbons into sweeping curves of controlled tension, reduced the rounded drapery forms to flat planes interrelated in patterns of linear rhythms which successfully concealed any indications of the body underneath. By the end of the fifth century, in the best caves of Yün-kang, all of the polyglot languages of Buddhism as it reached China . . . were beginning to be fused into a consistent Chinese declaration of faith and zeal.[4]

The process of sinicization, according to Sickman, was completed only after the capital was moved to Luoyang 洛陽 in 494–95. There, at the cave temple site of Longmen just south of the city, "the style of Buddhist sculpture becomes thoroughly consistent and Chinese in character. . . . Spiritual content deepens and becomes more compelling through a greater attenuation of the figures of Buddhas and Bodhisattvas."[5] The new mode of dress, in other words, is only part of a larger shift in form to a Chinese rather than Western visual style.

For most scholars, the new Han mode of dress appears to be a radical change from a well-known type of monastic dress to one based on Han secular costumes. In one of the most influential early discussions of the issue, Mizuno Seiichi and Nagahiro Toshio, in their study of the Yungang Caves, argued that the change in the dress of the deities (Buddhas, bodhisattvas, and celestial attendants) moved from "an imagined exotic to a realistic Chinese style," while the dress of secular worshipers "changed from a Northern to a Chinese style."[6] The assumption is that the earlier mode was "familiar only to Western Buddhist monks and both strange and unacceptable to the Northern Wei peoples." An alternative mode for depicting the Buddha was provided with the imperial edict of 486 that ordered a change in official court costume from non-Han dress to that of traditional aristocratic Han attire. As a result, according to Mizuno and Nagahiro, the dress of the emperor became the model for the Buddha image; presumably those artists who were "accustomed to represent Western type dress gradually fell out of favour."[7] Most important, the authors were clear about how the style of sculpture at Yungang and Longmen was derived: "The earlier style of Yün-kang was created out of a harmony of Western influences, Northern vitality and Han culture. . . . As opposed to this, the later Yün-kang style sprang from a decline in the influences of Western culture and Northern vitality combined with a remarkable recovery of native Han civilization."[8]

Several issues are raised by Mizuno and Nagahiro's argument. First, as James Caswell has argued, the style of the Cave 6 figures—especially the fleshiness and the proportions—is consistent with the earlier-style Yungang images, despite the dramatically different mode of dress.[9] The introduction of the Han mode of dress is little more than a surface innovation and the many stylistic variations in Cave 6 strongly suggest a period of experimentation in which styles and modes were mixed. Although Mizuno and Nagahiro acknowledge the tentative nature of the Cave 6 innovations, their analysis fails to

make the important distinction between mode of dress and visual style.[10] Second, as Mizuno and Nagahiro recognize, the Han mode of dress did not immediately replace the earlier mode; both were simultaneously utilized in late fifth-century sculpture at Yungang. There was no inevitability to the choice of a style of image—patrons and sculptors had a range of possibilities available to them. We may not be able to discern the basis for these choices or the intention of those involved, but we can recognize the volition that was a necessary element of the work. Third, the conception of how visual styles are formed, in this case a combination of "Western influence," "Northern vitality," and "Han culture or civilization," betrays an essentialist and hierarchical understanding in which Han culture is given a privileged position. These essentialist abstractions are then deployed in a mechanistic formula to explain certain kinds of visual effects. This is not to pillory extraordinary scholars but to discern something of the theoretical basis of earlier scholarship.

Mizuno and Nagahiro's argument was countered by Alexander Soper in his remarkable essay of 1960.[11] Soper suggested that the adoption of Han ceremonial dress at the Northern Wei court was not enough of a reason for the invention of such an extraordinary garment: "a strange medley of new Chinese and old Indian elements, combined in a way impossible to explain in terms of functional clothing."[12] Furthermore, Soper saw the change of dress as an innovation in the iconography of the Buddha too radical for the "barbarian" Northern Wei to initiate. Rather, the sinicized image could only have been developed by the more culturally sophisticated and confident Han Chinese in the Southern dynasties and later copied by the Northern Wei. Soper painstakingly maps a complex web of historical and visual inferences to suggest how the southern sinicized image might have been introduced into the North in the Yungang Caves. The compelling argument for Soper's case, however, was not historical or visual—evidence of the former is largely conjectural, albeit of the highest level, while remains of the latter is meager—but the fundamental superiority of Han culture to that of the barbarians.[13] In such a situation, the historical trajectory of any non-Han regime was preordained. In the words of Soper:

> The Chinese possessed, finally, resources far beyond the reach of any nomad, first in their ability to draw on the experience of the past through books, and second, by their insistence on guarding and transmitting their knowledge and mental discipline through organized study. In time, as everyone knows, such cultural assets proved so essential to the maintenance of the Wei empire, and promised a way of life so much more rewarding than the barbarian one, that they came close to stifling the non-Chinese tradition entirely. In the metropolitan society that grew up at Lo-yang in the first quarter of the sixth century, as all the visible riches of the Chinese way of life came once again into fruit—scholarship, literature, the arts, music, fine garments, elaborate ceremonies, the pleasures of careless luxury—specific T'o-pa traits must have almost completely disappeared.[14]

The alteration of the dress of the Buddha image, from the robes of barbarians to that of the Han sage, was only one instance in the process of acculturation.

There is yet another complicating factor. Soper believed that the sinicized dress of the Buddha image was a radical innovation that was conceptual in nature, not descriptive of actual dress.[15] This is important for his argument that the sinicized mode of dress could only have been developed in the culturally sophisticated Han Chinese dynasties of the South. A. B. Griswold, while avoiding any direct disagreement with Soper, has placed the issue on a rather different footing in an essay published only three years after Soper's.[16] Griswold makes a convincing case for the overall "reality" of both the Western and Han mode of the Buddha figure's dress in terms of Chinese monastic practice. He is able to identify the basic garments as stipulated in the Pali *vinaya* texts—an undercloth, a robe, a shawl, and a vest—in both modes. Griswold explains the sinicized dress of the Buddha as simply a rearrangement of the monastic garments seen in the Western mode (compare 4.1 and 4.2): the outer shawl is draped evenly over both shoulders, the "backthrow" is allowed to slip off the left shoulder and drape over the left forearm rather than being held in the left hand, the vest is brought up across the chest and the sash and bow are added. Furthermore, the splayed and artificial looking folds of the drapery are understood to be a stylized rendition of stiff, newly pleated silk.

Griswold also makes the compelling suggestion that the mode of dress of an image reflects local monastic attitudes toward proper monastic attire, a totally different approach from that taken by either Mizuno and Nagahiro or Soper. Griswold cites the seventh-century monk Yijing, who, upon his return from south Asia, criticized certain Chinese monastic practices of his time: the loosening of the neckline; the form of the vest, especially the long streamers; and the manner in which the robe lies across the left arm rather than being thrown over the left shoulder. Significantly, all of these violations, based on Yijing's understanding of the *vinaya* in India, are seen in examples of the Han mode of dress in Yungang Cave 6. This strongly suggests that the Han mode was based on monastic attire as much as the earlier mode. Rather than a radical innovation, the change in mode of dress appears to literally reflect a change in the practice of Chinese Buddhist monks. To what extent this new mode of monastic dress was understood to be unorthodox in fifth-century northern China is unclear; we only know that Yijing absolutely rejected it in the seventh century.

What is implied is that the different modes of dress for images in the Yungang Caves had a correlation with actual practice in local Buddhist monastic establishments. Representations of monastics (fig. 4.5) in Cave 6, however, depict them in the Western open or closed modes of dress, which suggests that if the Han mode was utilized in the fifth century, it was not taken up by all clergy. One possibility is that the Han mode of monastic dress, related as it was to the visual appearance of upper-class Han Chinese and the new dress code at court, was favored by if not limited to those from elite backgrounds or in monasteries with the highest class of patrons. This would mean that the Han

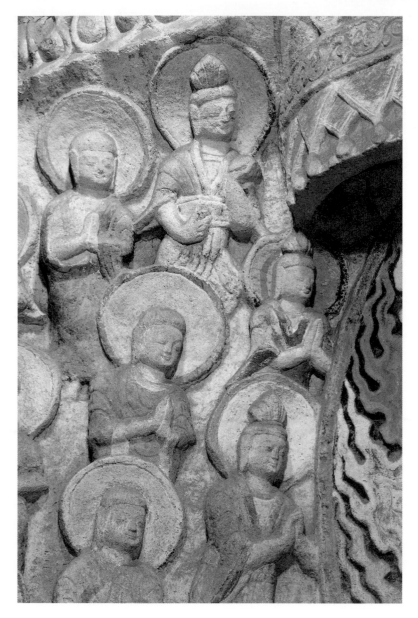

4.5 Monks and other attendant figures, Yungang Cave 6, south wall. From Unkō sekkutsu bunbutsu hokanjo, *Unkō sekkutsu,* 1: pl. 131.

mode—at least in the early period of its introduction—was a prerogative of social class. When utilized on the Buddha figure, the Han mode of dress differentiated the Buddha from the ordinary monastic and related him to the most ostentatious visual signs of power and elite status.

It should be noted that several fundamental assumptions frame the issue for Mizuno and Nagahiro as well as Soper. First is the clear division of the various cultures—Western, Northern, and Han—into distinctive vectors of influence. Each culture has essen-

tial qualities, immutable and consistent, that can be confidently ascribed to individuals and visual styles. Second is the inevitability of sinicization and the value of acculturation—that is, Han culture as a higher and more civilized way of life. That such a perspective is patently chauvinistic is, of course, quite obvious today; yet it continues to be a potent force in scholarship to the present. Third is the only faintly obscured biologism of the stylistic analysis in which visual types arise, mature, spread, and decay as if driven by natural processes largely independent of human volition. Cultural essentialism, barbarian sinicization, biologism—these have been the foundation on which our knowledge of Northern Wei Buddhist sculpture has been constructed. Fortunately, recent scholarship on the social history of the Northern Wei period offers some alternative perspectives from which a different kind of interpretation might be attempted.

PINGCHENG TO LUOYANG

The people who would eventually rule as the Northern Wei were a confederacy, the Xianbei 鮮卑, under the leadership of the Tabgatch (Tuoba 拓拔 in Chinese) tribe since the fourth century.[17] The Tuoba were one of a number of pastoralist peoples who occupied the northern steppes from northwest Heilongjiang to eastern Qinghai Province. When they came to power in northern China, the Tuoba and other Xianbei tribes comprised the ruling elite (*guoren* 國人 or compatriots); other steppe tribes in the confederacy, many previously conquered by the Xianbei, were ranked in positions of descending privilege.[18] Toward the end of the fifth century, the term *guoren* came to be replaced by a more inclusive term, *beiren* 北人 or Northerner, an indication that the differentiation between *guoren* and others of northern descent had lessened. At the same time, tribal organization and the distinctions between tribes were never erased even after the Northern Wei assumed complete control of northern China in 439. It would be an error to treat the Northern Wei dynasty as a monolithic barbarian entity.[19]

In the telling of Northern Wei history, the relocation of the capital from Pingcheng to Luoyang punctuates a series of sinicizing "reforms," measures instituted by the empress dowager Wenming 文明 (442–490), who served as the regent of the child emperor Gaozu Xiaowen 高祖孝文 from 476 to her death, and continued by the still young emperor from 490 to his early demise in 499. The term "reform" serves as a trope for the transformation of the non-Han, "barbarian" dynasty into a properly sinicized regime; the term signifies development, acculturation, civilization, and progress. Most historians give much credit for the sinicization of the Northern Wei court to the Han Chinese empress dowager Wenming, whose tutelage is said to have instilled in Gaozu a "reverence for traditional Han culture."[20] It is far from clear, however, whether Wenming was of the Han ethnic background that her family claimed. The question, which bears on Soper's thesis that Wenming was the logical patron of the many sinicized Buddha images in Yungang Cave 6, is illustrative of the complexities of ethnicity in northern China during the fifth century.

Wenming was a member of the Feng 馮 lineage, a family that ruled the Northern Yan 北燕 Kingdom in the Northeast from 408–437. Her father together with his mother and two brothers defected to the Northern Wei in 433, and he was given an official position in Chang'an. The Northern Yan was soon conquered by the Wei and some years later Wenming's father was convicted of an offense and executed, giving Wenming "the best reasons for hostility to T'o-pa tradition."[21] According to Soper, the Feng was a Han Chinese lineage; consequently, the Northern Yan was praised in the Jin dynastic history while the Northern Wei history dismissed the Yan "much more curtly."[22] The implication is that the racial background of the Feng was the basis for the contrasting tone of the dynastic histories, positive from the Han Chinese Jin point of view and negative from the non-Han Northern Wei.[23] Soper believed that the harsh treatment of the Han Chinese family at the hands of the Northern Wei was motivation for Wenming to seek retribution as she rose from the imperial harem to consort of Emperor Gaozong Wencheng 高宗文成 (r. 453–465) and regent for Emperors Xianzu 顯祖 (r. 465–471) and Gaozu. The magnificent Yungang Cave 6, brimming with images in sinicized robes, is understood by Soper to be Wenming's personal revenge on the imperial family, a donation to give her "malicious pleasure in outdoing the grandeur of the T'o-pa memorial temples at their own chosen site."[24] In this analysis, ethnicity and racial antagonism are fundamental motivating factors for the utilization of the sinicized mode.

Scholarship on the Feng, however, raises a number of challenges to Soper's argument.[25] First, the claim of an ethnic Han lineage for the Feng is suspect—the dynastic history references to the Feng are inconsistent and implausible in too many ways. In contrast to Soper, who declared that the Northern Wei history omitted "everything that presented the enemy's [i.e., the Feng's] case in too favorable a light," the omissions in the Northern Wei account of the Feng could be read as a deliberate attempt by the author, Wei Shou 魏收, to obscure the real origins of the Feng and thereby protect their claim to a Han lineage.[26] Second, from the personal names of the Feng, it appears likely that at the beginning of the fifth century the first language of the family was a Xianbei dialect. Further evidence for the non-Han background of the lineage is provided by the excavation near Beipiao 北票, Liaoning 遼寧 Province, of the tombs of Feng Sufu 馮素弗, brother of the Northern Yan ruler Feng Ba 馮跋, and Sufu's wife.[27] The style of burial—two pits under one mound, the paintings of dogs and their interment, as well as the burial of a male child inside Feng Sufu's coffin—do not reflect typical Han mortuary customs. Based on tomb objects similar to those found in the burial of Han ruling elites, Su Bai concluded that the tomb indicates the way in which Han elites like the Feng were influenced by the non-Han cultures of this region. But the strikingly non-Han character of the mortuary practices suggests equally that the Feng were a Xianbei lineage beginning to adopt elite-class culture. Third, the Feng intermarried with Han Chinese families only after they established themselves as the rulers of the Northern Yan Kingdom. Wenming's mother came from the Wang 王 of Lelang 樂浪, a distinguished Han lineage

in Liaodong 遼東 that appears to have provided marriage partners to the Feng as part of their alliance with the ruling house. The Feng thus appear to have been sinicized barbarians who rose to power in the early fifth century, were taken as marriage partners for the Tuoba household and other non-Han elite lineages after the fall of the Northern Yan, and were integrated into the lesser "Chinese" gentry of the northeastern plain only in the sixth century. By 551, when the Northern Wei history was commissioned under the Northern Qi 北齊 (550–577) dynasty, the Feng had developed a close relationship with the ruling Gao 高 family, a similarly sinicized non-Han lineage, which helps to explain the largely circumspect treatment given the Feng by Wei Shou.

There are several crucial, interrelated issues here. One is that patterns of intermarriage in northern China during the first half of the fifth century indicate that purity of blood was not an issue for many of the Han and non-Han ruling families. What was paramount was political advancement. This does not mean that social origins or family status was not important under the Northern Wei, but rather that lineage obfuscation if not falsification was common among low-status Han and non-Han families alike. The issue of ethnicity is thus far more complex than what the usual Han/non-Han dichotomy indicates. For example, the placement of Wenming in the Northern Wei harem was no chance occurrence—she was one of a number of women from similar non-Han, sinicized families that had fallen to the Wei. Her chief patron was the foster-mother of Emperor Gaozong, Lady Chang 常, whose Liaodong family had close ties with the Feng and who was also captured during the Northern Wei campaigns against the Yan. Lady Chang would soon engineer the suicide of the heir-apparent's mother, Lady Li 李—a Han Chinese woman whose family served the southern Liu-Song dynasty (420–477)—and the appointment of Wenming as empress. There is no indication that the two women were hesitant to eliminate the Han mother from the South; but rather than racial hostility, it seems likely the women from related Liaodong families acted with an eye toward increasing the influence of families such as their own.[28]

As regent for Gaozu, Wenming is portrayed as representing ethnic Han interests in her promotion of Han Chinese officials as well as reform measures meant to bring Northern Wei policies in line with the practices of past Han dynasties.[29] But there is evidence that Wenming was more concerned with her own political position and that of her blood relatives than any program of racial solidarity. She placed the daughters of her brother Feng Xi 馮熙 into key positions in the harem and had his sons married to Tuoba princesses. She was not adverse to policies unpopular with Han elite lineages, such as the failed attempt at land-distribution and taxation reform in 483, which challenged the privileged position of powerful families in the provinces and increased tensions with the old Han Chinese families of the Northeast.[30] In this light, reform measures initiated under Wenming, such as the change of court dress, appear to have less to do with the promotion of Han culture and more with the building of her own power base through her

chosen allies, Han and non-Han alike, in conjunction with the consolidation of imperial family power.

Lineages such as the Feng played an important role in Northern Wei politics because they were both well connected to other non-Han northern families and accepted in Han Chinese circles. It was quite clear who they were to their contemporaries under the Northern Wei as well as the Northern Qi sponsors of the *Weishu*. The family's claim to a Han lineage begins with later histories such as the *Weishu* as well as the *Beishi* 北史 and *Jinshu*, both written in the seventh century.[31] For many recent scholars, the distinguished Han background concocted for Wenming, the person most responsible for the sinicization of Gaozu, was all too easy to accept. This is the point where lineage falsification and the modern belief in the sinicization of barbarians meet. For Soper and others, whether a patron was Han Chinese or not was crucial as an explanation for Han visual elements in Buddhist imagery. Such racial essentialism effectively blinds one to the complexities of ambition, status, and power with which someone like the empress dowager was forced to negotiate.

The situation after Wenming's death in 490 was no less complicated. Gaozu quickly moved forward with his own vision of reforms. His plan to transfer the capital to Luoyang, however, was not embraced by his advisers and even senior Han officials such as Li Zhong 李沖 spoke out against the move. Only when a plot to depose the emperor involving almost all of the leading non-Han families was discovered and quashed did opposition yield.[32] Still, it was necessary for Gaozu to hatch a secret plan for the move in 493, shared with only a few of his most trusted confidants and conducted under the pretext of a military campaign against the South.[33] Although there has been much debate among historians as to the motivation for his decision, the foremost reason for Gaozu's insistence on the move to Luoyang against consistent opposition at court appears to have been his single-minded conceit that he would soon reunify China. Pingcheng was too far to the north to serve as a base for campaigns against the South; if the Northern Wei was to proclaim itself the legitimate ruler of China, a suitable capital such as Luoyang, with direct links to previous Han dynasties, was a necessity.

Unhappily for Gaozu, those northerners with the strongest ties to the area around Pingcheng continued to oppose the move, resulting in a serious rebellion of leading northerner families in 496. Opposition to Gaozu's sinicization policies were expressed at the highest levels, the most dramatic protest being registered by the emperor's son and heir apparent, Xun 恂, who attempted to leave Luoyang and return to the North. Xun was stripped of his titles and forced to commit suicide in 497. Approval of the move was secured only with much political maneuvering, including handsome bribes to supporters and the dismissal of noncompliant officials.[34] Further sinicizing reforms at Luoyang met with mixed results. Those having to do with transforming state ritual, largely under the control of the emperor, were the most successful. Other changes were impos-

sible to enforce. For example, the edict that only Chinese would be used at court was soon modified to exempt northerners over the age of thirty. The banning of Northern-style clothing in 494 appears to have been widely ignored; Gaozu is recorded to have been angered at finding out more than two years later that many women in Luoyang still wore traditional dress.[35] Xianbei and other non-Han elites seem to have retained more of their northern culture in Luoyang than Soper supposed:

> Most of our evidence from the *Weishu* suggests that although the T'o-pa aristocracy had accepted—in principal [*sic*] and in practice—the Chinese institution of a royal dynastic line with its concomitant principles of primogeniture and female regencies, their behaviour during the early sixth century was in many respects more "nomadic" than Chinese. At the beginning of the sixth century, certain non-Chinese cultural habits, religious practices and marriage customs were still quite prevalent among the aristocracy in Loyang where the degree of sinicization had far outstripped that among non-Chinese leaders in the provinces. In addition some Chinese families like the Hu of An-ting seem to have adapted well to non-Chinese habits of the period. . . . [They] seem to have been status oriented rather than obsessed with racial or cultural purity.[36]

Holmgren further notes: "the historical evidence indicates that racial intermarriage was both acceptable and common within the imperial family well before the Emperor Kao-tsu's accession to the throne in 471 A.D. Indeed, by his time, it would be difficult to compile a list of 'pure-blood' T'o-pa."[37] Contrary to much scholarly opinion, however, the offspring of these mixed marriages were far from sinicized; there are examples of members of elite Han families in Luoyang who accepted non-Han social customs such as levirate as late as 525.[38] This is not to say that some members of the Northern Wei ruling elite were not as enthusiastic about Han Chinese customs and values as the emperor. But, as one might expect, significant numbers of northerners refused to follow the path of sinicization—and most significantly, there is evidence that some Han Chinese families adopted and practiced "barbarian" customs even in Luoyang.

The range of choices available to Han and northerner in the late fifth and early sixth centuries strongly suggests that visual styles or modes of dress for a Buddhist donation were not a matter of cultural or ethnic allegiance, nor acculturation or sinicization, but practical issues of status, affiliation, and promotion. Such an understanding raises questions as to the broad application of the model of sinicization to explain Buddhist art of this period, a model that still informs much scholarship on non-Han, conquest dynasties such as the Northern Wei.[39] A case in point is the set of Gaozu's edicts of 495 on the ranking of leading families and the restriction of marriage partners for imperial family members to a select list of primarily Han lineages. This reform has often been considered to be a sinicizing policy, an acknowledgment of traditional Chinese notions of social hierarchy and the transfer of administrative power to officials of Han elite back-

grounds.[40] In fact, the edict appears to have been an attempt to emphasize status rather than ability as the criteria for high position, a calculated move to benefit the imperial family and its closest allies rather than Han Chinese in general. The result was that the most distinguished old Han families of the Northeast were granted special status by the emperor to the exclusion of all others; the attainment of promotion to high office was made much more difficult for the majority of Han and non-Han officials alike.[41] The emperor was "primarily concerned to enhance the status of two distinct categories of men—those whose families had a history of service to the Wei, and those with a history of personal ties to the throne. His goal was to merge these two categories so that political privilege would accord directly with social status . . . loyalty, past service and high social standing of the family were all important; race was irrelevant."[42]

The above analysis suggests that the mode of dress for a Buddha image was not simply a reflection of a patron's Han or non-Han racial background; nor was it a straightforward matter of the Northern Wei adopting Han cultural forms from southern China. Issues of politics and status crossed racial as well as class and gender boundaries for the patrons of Buddhist imagery. These interests would in turn have necessarily interacted with the no less complex set of motivations involving tradition, training, and creativity emanating from the makers of those image. With issues such as these in mind, let us turn to the Longmen Cave site and consider the patterns of patronage, intention, and style in the earliest period of work in the Guyang Cave.[43]

LONGMEN GUYANG CAVE

The Buddhist cave temple site of Longmen 龍門, located just south of the Northern Wei dynasty (386–535) capital of Luoyang in north central China, consists of large excavations and thousands of smaller image niches carved from the cliff face for approximately half a mile along the Yi 伊 River (fig. 4.6).[44] The earliest extant dated images at the site are located in the Guyang 古陽 Cave, a large rectangular space roughly 13.5 m deep, 7 m wide, and 11 m high.[45] The rounded ceiling (fig. 4.7) as well as the long, sloping walls on the rear, north, and south sides are now almost completely covered with some thirteen hundred image niches carved out of a hard, gray limestone.[46] At the rear center is a large main image (fig. 4.8), a seated Buddha raised on a high throne flanked by a pair of standing bodhisattvas to each side; at the base of the throne remains one of what was originally a pair of attendant lions.[47] The side walls (fig. 4.9) each feature three rows of major image niches. In this study, the rows are numbered I to III from bottom to top; the niches are numbered 1 to 4 from the back of the cave to the front.[48]

The niches with which we will be concerned, dated between 495 and 504, are located in the upper half of the cave that is, the level of Row III and above. During this time, the Guyang Cave was the main if not sole cave being worked on at the site.[49] Although the process by which the cave was excavated and the niches installed is not absolutely clear, there appears to have been three main stages of work. The initial stage

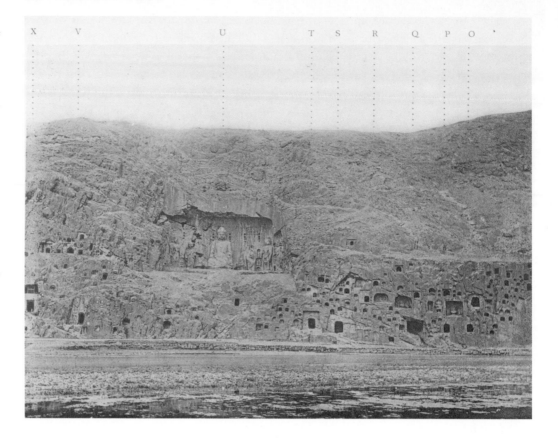

began in a natural cavern with a series of scattered dedications in the curved ceiling when the floor was 3.1 m higher or just below the level of Row III.[50] The earliest dated niche in Row III was dedicated in 498; meanwhile, smaller niches continued to be opened in the ceiling and between the Row III niches. The earliest inscription from the level of Row II is dated to 505; the floor must have been lowered to accommodate Row II by that date. Inscriptions dated to 505 and 506 around the main image and attendant bodhisattvas indicate that these figures were in place before the floor was lowered.[51] Meanwhile, even after the lowering of the floor, most dated dedications are found in the ceiling and the level of Row III. The floor was lowered for a second time around 518—the earliest dated inscription found in Row I—and this was the third and final stage of excavation. Miscellaneous donations continued to be made in the cave through the Tang dynasty at the lowest level, which was never completed. The current floor partially covers niches in Row I.

While the Guyang Cave appears to have fallen into disuse after the Tang dynasty, it would not be forgotten. Rubbings of inscriptions from Longmen were known and admired by Chinese scholars as early as the Northern Song dynasty (960–1126), but their

4.8 Main image and interior, Guyang Cave. From Liu Jinglong, *Longmen ershipin,* 18.

interest was largely limited to the examples of ancient calligraphy from the site. These were similar to important texts or works of calligraphy carved in commemorative stone stele from as early as the Han dynasty.[52] The stele form, which is adapted for many inscriptions in the Guyang Cave, belongs to an elite tradition of public discourse that was well established by the end of the fifth century.[53] Only at the end of the nineteenth century did the caves themselves as well as their sculptural decoration attract scholarly attention—and most of that attention came from abroad. The Japanese scholar Okakura Kakuzo traveled to Longmen on his first trip to China in 1893 and lectured about the site with lantern slides upon his return to Japan.[54] These were the first photographs of Longmen seen in Japan. Other Japanese visitors included Ito Tuta in 1902, Tsukamoto Yasushi and Hirako Takurei in 1906, and Sekino Tadashi in 1906 and again in 1918. The earliest European visitors were French: a mining engineer, Leprince-Ringuet, in 1899, Philippe Berthelot in 1905, and Édouard Chavannes in 1907.[55] Chavannes' subsequent publication of the site in *Mission archéologique dans la Chine septentrionale* introduced a

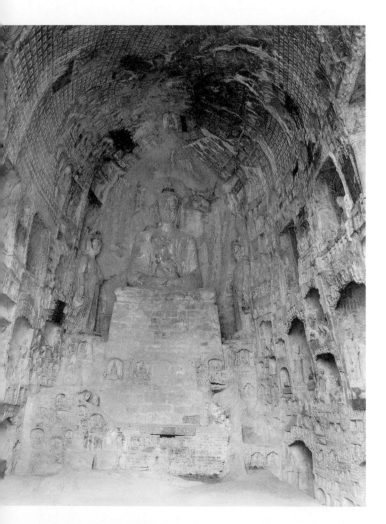

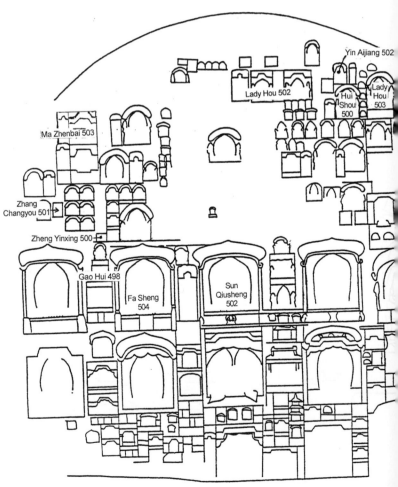

wide range of early sculpture and inscriptions from the cave temples (see fig. 4.6, the most important caves identified by letter) to Europe.[56] Chavannes was followed by Charles Freer in 1910, who also had photographs of the caves taken, and then the Swedish art historian Osvald Sirén visited Longmen in 1918 and 1921.[57] The most important early work on Longmen after Chavannes' publication was carried out by Mizuno Seiichi and Nagahiro Toshio, who surveyed the site with a photographer for six days in April 1936 and produced a volume in 1941 that included extensive descriptions with photos and the publication of many inscriptions.[58] The site was declared a protected cultural property in 1961 and has been extensively studied and published by Chinese scholars.[59]

The reader may have noticed that almost all of the image niches in the Guyang Cave have been heavily damaged, most often by the removal of the heads. The majority of the thorough looting of sculpture from the cave was conducted between the time of the earliest visits by European and Japanese travelers at the turn of the century and the 1930s. Some pieces had already been removed when Chavannes studied and photographed the

4.9 Drawing, walls, Guyang Cave. After Ishimatsu Hinako, "Ryūmon sekkutsu Koyōdō zōzō kō," fig. 6.

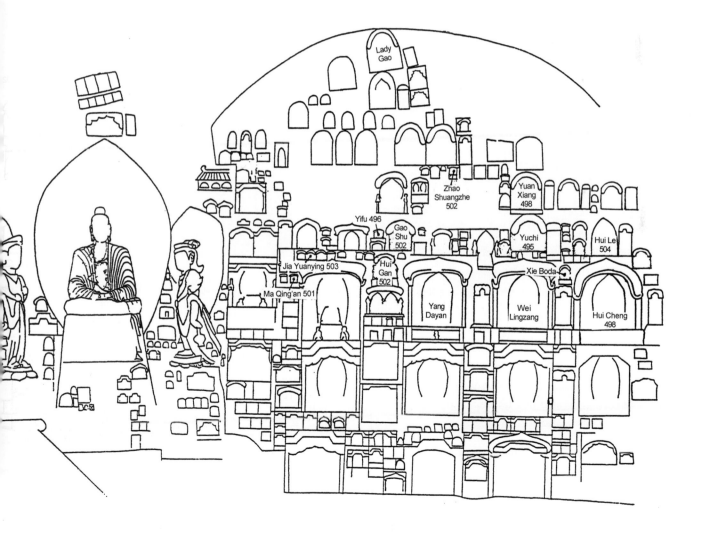

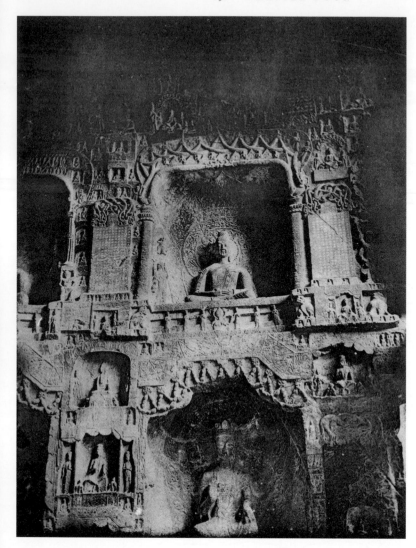

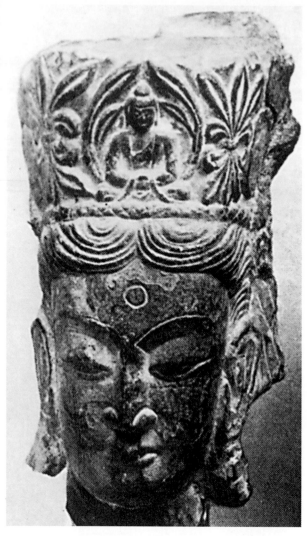

4.10 *Left:* North wall, Guyang Cave in 1907. From Chavannes, *Mission archéologique,* 2, 1: pl. 244, no. 376.

4.11 *Right:* Head of bodhisattva, possibly from Guyang Cave, C. T. Loo Collection. From Chen Zhejing, Wen Yucheng, and Wang Zhenguo, *Longmen liusan,* fig. 16.

cave in 1907 (fig. 4.10). By 1925, Sirén wrote that many of the works that Chavannes had published had been partially or wholly destroyed and that many heads and figures had disappeared in the three years between his two visits in April 1918 and December 1921.[60] The head in figure 4.11 was formerly in the collection of C. T. Loo, one of the most important dealers in Chinese Buddhist sculpture during this period, and it is typical of many that now reside in museums and private collections in Japan, Europe, and the United States.[61] Loo, who began by dealing in Chinese ceramics, has written about how he became interested in the field of Buddhist sculpture:

I remember one day in the spring of 1909 I called at the Museé [*sic*] Cernuschi in Paris to inquire for the Director. . . . During our conversation he showed me a pic-

ture of a stone head and this fine stone immediately awakened in me a desire to de-
velop a new line in Chinese Art. . . . I immediately mailed a photograph of the stone
head to my partner in China and soon received word telling me that one of his buy-
ers was traveling as interpreter in Sian for Mr. Marcel Bing, a French dealer. While
they were talking to a local dealer Mr. Bing kicked something hard under a table at
which he was sitting. This was the head in which we had been interested and
Mr. Bing buying it for ten Chinese dollars eventually sold it to the Stoclet Collection
in Bruxelles.[62]

Loo's anecdote gives us a sense of the unremarkable manner in which such objects
circulated in China as well as the operation of the art market early in the twentieth
century. Ironically, it was the publication of the Buddhist sculpture in the Guyang
Cave that contributed to what must have been a lucrative enterprise involving local
"agents" who would supply sculpture to middlemen for sale to art dealers in Beijing,
Xi'an, and other cities—who in turn found buyers in foreign collectors, dealers, and
museum representatives. The scholarly work of sinologists such as Chavannes, Sirén,
and others inadvertently provided photographic catalogs from which foreign buyers
could choose works to pursue on the open market or in some cases "special order"—
that is, indicate to their agents in China which pieces in situ they were interested in
acquiring.[63] We are reminded of the way in which the most idealistic goals of study
and preservation are easily incorporated into less admirable schemes for profit. Not sur-
prisingly, the circulation of images continues to this day. A figure was advertised as
from Longmen in a 1993 London Sotheby's catalog (fig. 4.12) and suggestively com-
pared with similar works thought to be from the Guyang Cave, including one in the
Reitberg Museum, Zurich, and another in the Asian Art Museum, San Francisco.[64]
The piece was sold at auction for approximately US$12,000. Note that as part of the
argument for the authenticity of the image, the catalog entry states that a section of
the Guyang Cave, showing similar figures in situ, is illustrated in an early publication
by Osvald Sirén.[65]

Although the removal of sculpture from the Guyang Cave occurred very early in
this century, the Sotheby piece and others like it remind us of the continuing presence
of missing fragments from the cave in the art market. The early scholarly discovery, pub-
lication, and wholesale removal and sale of sculpture from the cave was a single pro-
cess—the scholarly activities being necessary for establishing and stimulating the mar-
ket for Chinese Buddhist sculpture, and the subsequent removal of works to museums
and private collections making sculpture available for study and publication. But even as
the looted fragments of sculpture from the Guyang Cave pique our interest in the orig-
inal state of the cave, their permanent removal makes impossible a reconstruction of the
whole. The discussion of the Guyang Cave that follows turns on such contradictions and
the still-intimate relationship between the goals of preservation, collecting, scholarship,
and academic publishing.

4.12 Cross-ankled bodhi-sattva, possibly from Guyang Cave. From Sotheby's London, *Fine Chinese Ceramics, Bronzes and Works of Art*, no. 32.

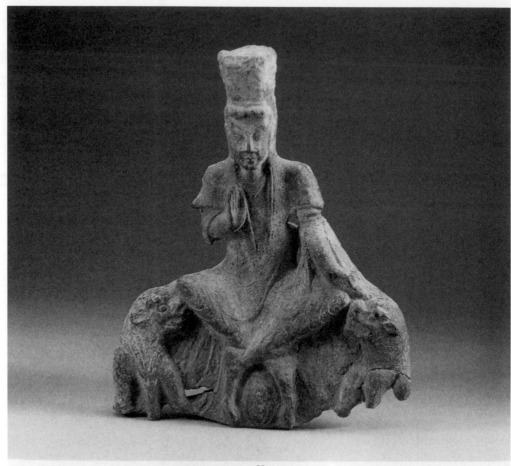

32

SCULPTURE

32
**A RARE LONGMEN RELIEF LIMESTONE
CARVING OF MAITREYA**
Northern Wei Dynasty (386–532 A.D.)
seated with legs crossed at the ankles, the right arm
raised in an attitude of blessing and the left resting
on his knee, the long robes draped over the legs and
falling in characteristic even folds, the face with
crisply carved high arched brows beneath the tall
flat-sided crown, a pair of recumbent lions flanking
the figure's knees, each with the head turned and
gazing upwards, the stone of grey colour rough hewn
on the reverse
34 cm., 13⅜ in high, repaired breaks

Several other Maitreya figures carved in this classic late Northern
Wei style and believed to come from the Guyang cave at Longmen,
Henan province, are recorded, some larger, some smaller in size
than the present example; compare, in particular, figures in the
Rietberg Museum, Zürich, illustrated in *Chinese Sculptures in the von
der Heydt Collection*, pl. 11; in the Avery Brundage Collection,
illustrated in *Chinese, Korean and Japanese Sculpture*, pl. 38; and two
others illustrated in *Rokucho no Bijutsu*, pls. 203 and 205
A section of this cave, showing similar figures *in situ*, is illustrated
by Siren, *Kinas Konst Under Tre Artusenden*, vol. I, fig. 234

£6,000–8,000

北魏　龍門石灰石佛像

FIRST PERIOD

The earliest activity in the cave can be divided into two main periods: the first, concentrated on the north wall, consists of niches dedicated between 495 and 498; after a short interregnum with only a few small donations, the second period is comprised of niches opened between 502 and 504 on both the north and south walls. In the first group we find large images that represent patronage from the Northern Wei ruling elite mixed with smaller niches donated by individuals of a lower, but still official, standing; in the second, we see a wider mix of sponsors including the development of group patronage through associations known as *yiyi*.

The first dated image niche in the cave is by Lady Yuchi 尉遲 (454−519), wife of the prince of Changle 長樂王 Qiumuling Liang 丘穆陵亮, dated to the eleventh month of 495.[66] The Mu, a Xianbei lineage, were particularly favored for high office and intermarriage by the ruling Tuoba Wei throughout the fifth century; this prince, known after 496 by his sinicized name of Mu Liang (451−502), was a very important court official who had the responsibility of overseeing the construction of the new capital at Luoyang.[67] In the 470s he was married to a member of the imperial family, the elder princess of Zhongshan.[68] Lady Yuchi must have been a later wife, possibly of northerner background.[69] The dedication states that a stone image of Maitreya (*mile* 彌勒) was made for the mother's deceased son, Niujue 牛橛. The image (fig. 4.13) is a cross-ankled bodhisattva flanked by attendant lions and bodhisattvas in a rounded, garland-festooned niche. Just outside and behind the attendant bodhisattvas are the remains of several donor figures, a female on the left and two males on the right, all dressed in northerner costume (fig. 4.14). The Maitreya is represented in a Western mode of dress, scarves looping behind the shoulders with a broad band of material, pleats highlighted by a distinctive s-curve, descending down the chest from the left shoulder. The standing attendant bodhisattva to the right is also presented in a Western mode. In contrast, the inscription (fig. 4.15) is carved in a simple style made elegant by its placement on an elaborate one-sided version of a traditional Han memorial stele, topped by the usual pair of entangled dragons and supported on a large monster mask with a pair of muscular attendants to each side.

Although it is not possible to be certain, it is not likely that Lady Yuchi's niche was preceded by many other donations in the Guyang Cave. Luoyang was a devastated and largely abandoned city after the fall of the Western Jin in 311. After its capture by Northern Wei forces in 423, the *Weishu* reports that the former capital "had long been on the borders; city walls and ceremonial gateways were in ruins, and there was no sign of life in the countryside around."[70] From 430, when Luoyang was captured by Song forces and then quickly recaptured by the Wei, the city continued to be an important Northern Wei military base but little else. When Emperor Gaozu visited the city in 493, he toured a series of ruins. It is not surprising then that some time elapsed between his announcement in late 493 that Luoyang would be the new capital and when the first palace building was completed and palace officials arrived in Luoyang in the autumn of 495.

4.13 Niche dedicated by Yuchi, dated to 495, Guyang Cave. From Liu Jinglong, *Longmen ershipin*, 34.

4.14 Drawing of niche dedicated by Yuchi. From Liu Jinglong, *Longmen ershipin*, 36.

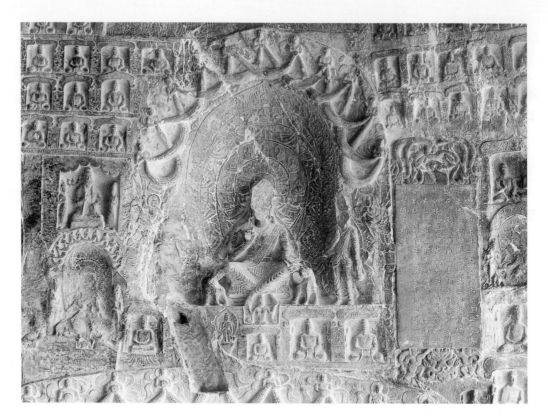

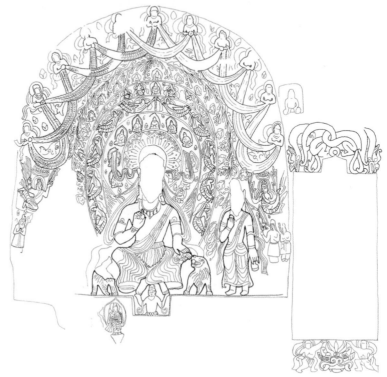

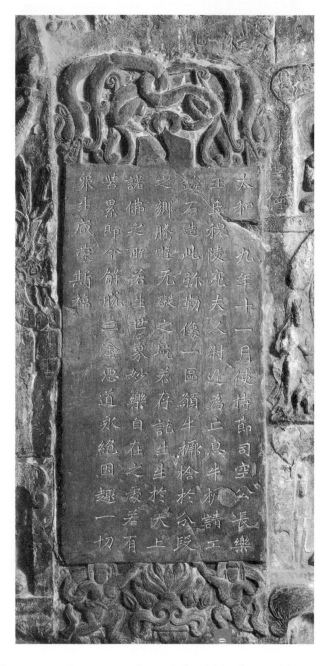

The move south seems to have created much hardship for wealthy as well as common people: there are complaints recorded in 495 that proper living quarters were still not available for officials and stocks of food had yet to be established. Only a few official buildings appear to have been completed before Gaozu's death in 499; and it was only in 502, when the system of wards in the city was constructed, that the city could be

understood to have taken reasonable shape.[71] As one of the officials responsible for the construction of the new capital, Mu Liang was probably among the first to move to Luoyang. There is no evidence, but the early demise of Lady Yuchi's son may have been a result of the hardships of the move. Considering the difficult conditions in Luoyang, workshops for producing sculpture or inscriptions could not have been a high priority, and those that carried out Lady Yuchi's work must have been only recently organized. In any case, the touching dedication by the wife of such an important Northern Wei official for their deceased son indicates that the Longmen site and the Guyang Cave were known early on to the most powerful officials in the capital.

While more patrons with court connections would soon dedicate images in the cave, the next two dated niches are unexpectedly modest: one (fig. 4.16), dedicated by Yifu 一弗 for the benefit of her deceased husband, the minor official (buyulang 步輦郎) Zhang Yuanzu 張元祖 in 496, is some distance down the north wall from the image of Lady Yuchi; while the other, facing Lady Yuchi's from the opposite wall, is the small niche (fig. 4.17) of Gao Hui 高慧 dated to the second month of 498.[72] Yifu's image, like that of Lady Yuchi, was dedicated to a deceased family member, but the imagery is completely different. Rather than a seated bodhisattva, the main image is that of a meditating Buddha in Western style, the robe pulled over the top of the right shoulder leaving part of the chest exposed (open mode); the hands are placed together with palms facing in; drapery folds flow over the arms and are gathered in front of the legs. The niche is of the pointed arch type with a honeysuckle decorative pattern. The Gao Hui image, on the other hand, is a cross-ankled bodhisattva in a rounded arch niche similar to that of Lady Yuchi but with a vine scroll pattern rather than the distinctive looping garlands. Neither inscription is in the stele form, an indication that the stele used for Lady Yuchi's dedication was understood to be a prerogative of the most elite classes. While both inscriptions are relatively short, there are significant and instructive differences between them. The style of the calligraphy is nearly identical, but the careful placement and balance of each character in the Yifu dedication is for the most part lost in that of Gao Hui (fig. 4.18), which appears hurried, a jumble of large and small characters. The latter is not dedicated to an individual but to the parents of the past seven generations, individuals of the present and those who are deceased, as well as all sentient beings. Most interestingly, additional names are scrawled in the blank area after the end of the text, with a final honorific title (qingxinshi 清信士) at the far left apparently never completed with a devotee's name. It is difficult to tell whether these were part of the original dedication or added at a later date. The comparative size of the two niches, however, is not consistent with the quality of the calligraphy or the status of their patrons—that of Gao Hui, the individual without any official title, being twice the size of that of the minor official's wife.[73] This will not be the first instance in which scale and social position fail to correlate in the Guyang Cave niches. At the same time, both the Yifu and Gao Hui niches are much smaller and at some distance from the niche of Lady Yuchi; it is not clear

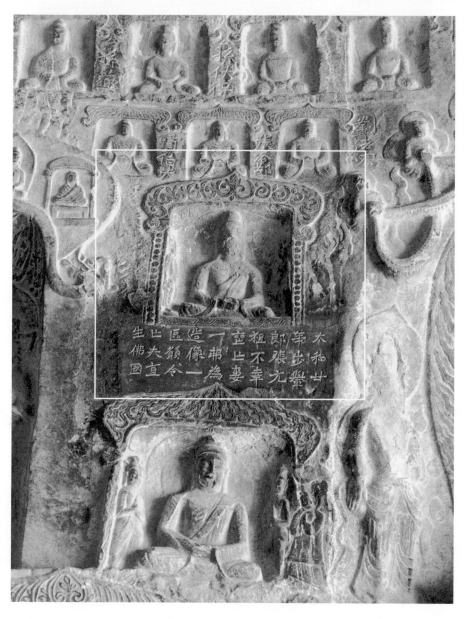

4.16 Niche dedicated by
Yifu, dated to 496, Guyang
Cave. From Liu Jinglong,
Ryūmon nijuppin, 46.

whether their smaller scale was the result of economic necessity or a conscious decision
not to rival the donation of Lady Yuchi, or a combination of both.

Next is the dedication by the monk Hui Cheng 慧成 for his deceased father, the
duke of Shiping 始平公, in the ninth month of 498.[74] Positioned at the entrance to the
cave and nearly adjacent to the Lady Yuchi niche, Hui Cheng's is the first dated dedica-
tion among the eight major niches in Row III (fig. 4.19, far right). The form of the niche
(fig. 4.20), a rounded arch with garlands, mimics that of Lady Yuchi, but in a larger scale

4.17　Niche dedicated
by Gao Hui, dated to 498,
Guyang Cave. Photograph
by Chen Zhi'an.

4.18　Rubbing, inscription
for the niche dedicated by
Gao Hui. From Beijing
tushuguan, *Beijing tushuguan-
zang,* 3: 32.

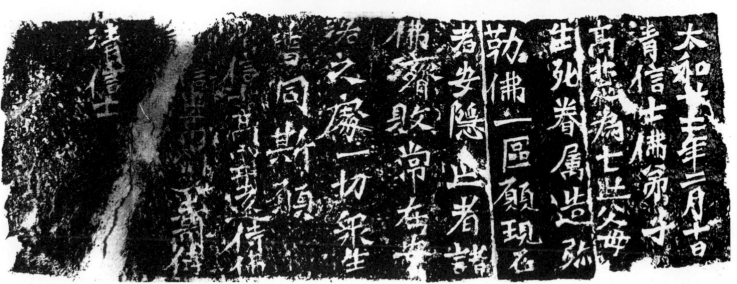

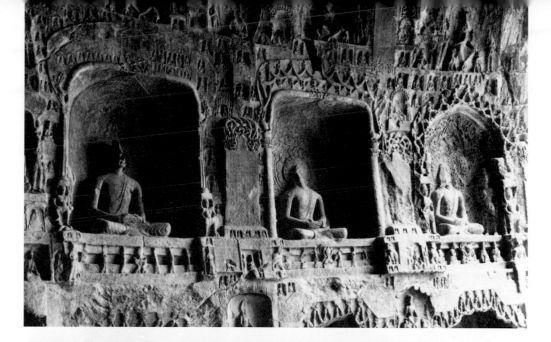

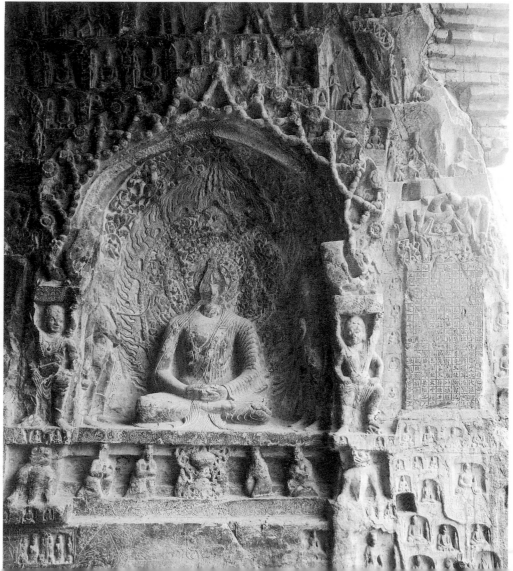

4.19 North wall, Guyang
Cave, niches dedicated by
Yang Dayan, Wei Lingzang
and Xue Fashao, and Hui
Cheng (left to right). Photo-
graph by the author.

4.20 Niche dedicated by
Hui Cheng, dated to 498,
Guyang Cave. From Liu Jing-
long, *Longmen ershipin*, 48.

and with several important differences. The ends of the arch terminate in upturned dragon heads, typical of the pointed arch type of niche (for example, see the adjacent niches to the left in fig. 4.19) but not usually combined with the rounded arch niche. The bodies of the dragons originally formed a molding along the lower edge of the arch beneath the garlands, but these have been cut away for unknown reasons. The four-armed figures that uphold the dragons are singularly unique in the large Row III niches. The main image is a meditating Buddha rather than the cross-ankled bodhisattva that is typically enshrined in the rounded arch niche; the seated Buddha figures in the cave are most often placed in a pointed arch niche, as in the small image dedicated by Yifu. The seated Buddha, dressed in a Western mode similar to the Yifu image, is flanked by a pair of attendant bodhisattvas in Han style with broad, flat scarves crossed over the body. As we will see, the usual pattern in Guyang Cave seated Buddha niches will be the Western-style Buddha combined with Han-style bodhisattvas. The background, carved in high relief, is alive with small adoring figures and leaping flames. Below the Buddha, four worshipers in northerner costume kneel before an elaborate *boshanlu* 博山爐, or incense burner in the shape of a mountain.

The inscription is a lengthy text carved on a large Han stele (fig. 4.21).[75] The archaic, highly stylized language and allusions to traditional Han imagery, brimming with erudition, is meant to produce a self-representation appropriate for a member of an elite Han family. The status accorded the form of the stele on which the elaborate text is written is enhanced here by the ruled squares for each of the characters, a feature of large funerary stele of upper-class individuals, and the highly unusual technique of carving the characters in relief. In addition, the calligrapher (Zhu Yizhang 朱義章) and composer (Meng Da 孟達) of the text are named at the very end, an unusual occurrence in Buddhist inscriptions from this period, an indication of the special pride taken in the work.[76] What is powerfully evoked in the Hui Cheng dedication are the formal visual codes of traditional Han elite discursive practices displayed on commemorative funerary stele. The combination of a Western-style Buddha and donors in northerner costume with the Han-style bodhisattvas, stele, and inscription is indicative of the heterogeneity of visual styles in the Hui Cheng niche.

Several fundamental questions related to the inscription remain unresolved. One is the date, which is unclear because the two numerical characters following the Taihe regnal era have been obliterated, leaving open the possibility that the inscription reads either the twelfth year (488), the seventeenth year (493), or the twenty-second year (498) of the era. The latter is the most widely accepted although alternative readings still have their proponents.[77] One problem with a date of 493 or earlier is how one would envision the production of Hui Cheng's large niche and inscription in the Guyang Cave before Luoyang had been repopulated. Such an endeavor is a complex production requiring the participation of one or more workshops. How would these be sustained at a time when there were few if any nearby centers of population from which workshops might

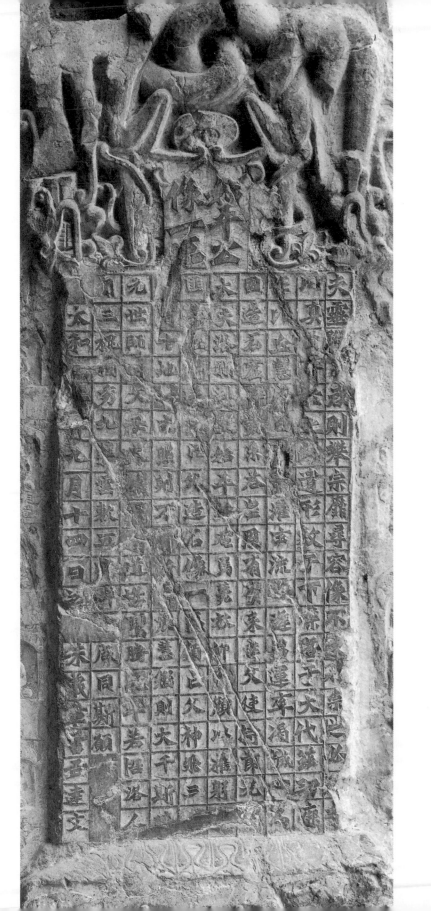

4.21 Inscription for the
niche dedicated by Hui
Cheng. From Liu Jinglong,
Ryūmon nijuppin, 56.

4.22 *Left:* Niche dedicated by Yuan Xiang, dated to 498, Guyang Cave. From Ryūmon bunbutsu hokanjo and Peking daigaku kōkokei, *Ryūmon sekkutsu,* 1: pl. 155.

4.23 *Right:* Inscription for the niche dedicated by Yuan Xiang. From Liu Jinglong, *Ryūmon nijuppin,* 66.

draw patrons? Another question is the identity of the duke of Shiping and his son. The title is not to be found in the extant historical records of the period connected with any figure who might have died just before 498. Much speculation has gone into this question but with no convincing solution.[78] Still another question is raised by the fact that the inscription mentions two donations by Hui Cheng: the making of a stone cave for the state 爲國造石窟 as well as a stone image for the recently deceased duke. The donation of the cave has been taken by some to indicate that Hui Cheng was claiming credit for the Guyang Cave as a whole.[79] Alternatively, the mention of a cave could simply refer to a previous donation separate from that of the adjacent image niche. I will return to this issue at the end of the chapter.

Only nine days after Hui Cheng's work of 498, the youngest half-brother of the emperor, the prince of Beihai, Yuan Xiang 元詳 (476–504), donated a niche (fig. 4.22) just above Lady Yuchi's.[80] The inscription (fig. 4.23) states that in early 495, when Yuan Xiang accompanied Gaozu on a military expedition south, it was at the Longmen site that Yuan Xiang parted company with his mother, Lady Gao.[81] At that time, they made a vow to have an image of Maitreya made in order that they might together enjoy peace. This vow was fulfilled with the completion of this image niche in 498. The description of their vow suggests that the Longmen site and possibly the Guyang Cave were already

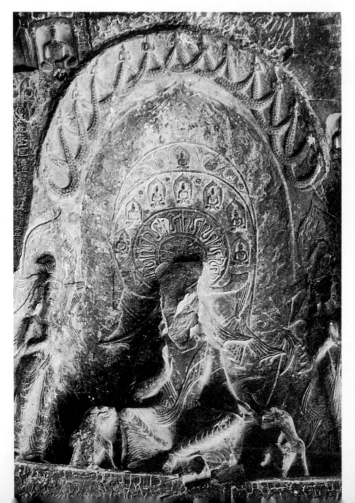

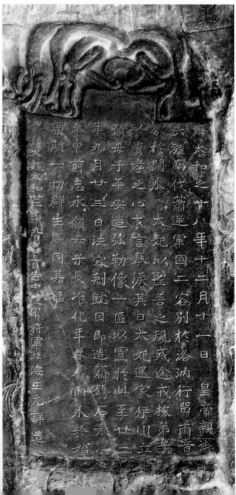

known as an appropriate place for such an image niche some eleven months before the date of Lady Yuchi's dedication. The inscription also demonstrates that it was possible for some time to elapse, nearly four years in this case, between the decision to donate an image and the actual date of the dedication.

Interestingly, Yuan Xiang did not follow the lead of Hui Cheng and dedicate a major niche in Row III, although the prince certainly had the means as well as significant social and political status. Rather, he placed his dedication just above the 495 niche of Lady Yuchi (fig. 4.24), and the form of his offering closely echoes the latter. Nearly identical in scale and composition, both works have inscriptions carved in stele-like formats and feature a cross-ankled bodhisattva image in a rounded niche decorated with garlands. Considering the range of alternatives available to Yuan Xiang, this work appears to be a deliberate statement of affiliation with the Lady Yuchi and her husband Mu Liang.[82] At the same time, in contrast to the northerner dress of the donors and the Western mode of the bodhisattva in the earlier niche, Yuan Xiang's niche depicts rows of

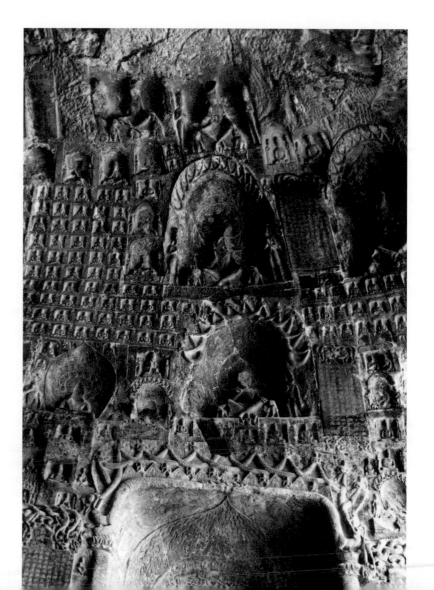

4.24 Niches dedicated by Yuan Xiang (above) and Yuchi (below), north wall, Guyang Cave. Photo by author.

donors in Han costume just below the main image and the cross-ankled bodhisattva, as well as attendants depicted in the sinicized style. The main characteristics of the Han style in the early bodhisattva images are the distinctive scarves that cross in an X-pattern over the body; the ribbons from the crown depicted as stiff, pointed, and flattened abstract, concave shapes; and the slimmer and lighter overall proportions of the figures. This is the earliest dated niche in the Guyang Cave with both the main and attendant figures in the sinicized style.[83]

The only other donation that can be firmly assigned to the first period is that of Xie Boda 解伯達, a local military commandant, whose inscription is dated to the Taihe 太和 regnal period but with no indication of year, and must therefore be no later than 499.[84] The niche (fig. 4.25), near in scale to the small works of Yifu and Gao Hui, is tucked into the space to the left of the arch of Hui Cheng's donation on the north wall and below Yuchi's. The placement mirrors that of Gao Hui's niche on the opposite wall and the contents—a cross-ankled bodhisattva flanked by two attendants with a round, garlanded arch—duplicates the earlier donation of Lady Yuchi. The text is quite elegantly carved (fig. 4.26), the calligraphy a bit looser and less formal than what one finds in the previous inscriptions. The language is distinguished by a notably abstract, literary quality; for example, Chavannes notes an allusion to the *Yijing* 易經.[85] All of this is unexpected considering the small scale of the donation and the relatively modest rank of the sponsor. The standing attendant figures are in Western style and it appears from the handling of drapery to the sides of the central figure that it too was in the same style. This niche, more than any we have discussed, illustrates the difficulties caused by the loss of images for the study of the Guyang Cave. The inscription was smashed in 1935 by a local farmer, probably long after the image of the cross-ankled bodhisattva was removed (see upper right of fig. 4.10 for the image in place), presumably to increase the value of rubbings taken before the inscription was damaged.[86] The circuit of destruction and preservation illustrated here, the former necessary for the value of what is preserved, is a crucial element for the collecting and appreciation of Chinese Buddhist art. This is not to say that rarity is only produced through willful human destruction but to point out one ordinary instance of value enhancement.

The most noteworthy feature of the first period of niche construction is the heterogeneity of the patronage, which encompasses nearly the complete range of sponsors of Northern Wei Buddhist sculpture from those connected to the imperial family and high court officials to lesser officials and commoners (those with no official rank or title), monks and laity, men and women. The expectation that the location and scale of a donation would be indicative of the class standing of the patrons is generally upheld: the three largest niches, associated with members of the court (Lady Yuchi and Yuan Xiang) or high officials (Hui Cheng's father), were clustered together at the front of the north wall. One small niche by a local military officer (Xie Boda) was opened between that of Lady Yuchi and Hui Cheng's dedications and appears to have been a statement of affiliation with these

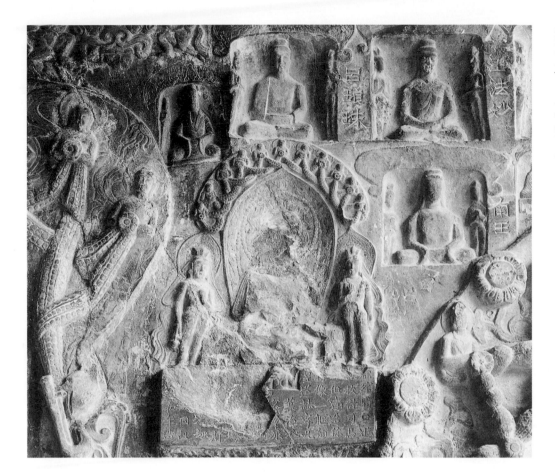

4.25 Niche dedicated by Xie Boda, before 499, north wall, Guyang Cave. From Liu Jinglong, *Longmen ershipin,* 68.

4.26 Rubbing and transcription, inscription for the niche dedicated by Xie Boda. From Liu Jinglong, *Longmen ershipin,* 73.

elite donors. The two small dedications by lesser patrons were placed at some distance from the others, one on the north wall (Yifu) and one on the south (Gao Hui).

The relationship of social class to the visual style of a donation is not as straightforward or determinant. For example, the first dated dedication in the cave is by a person with very powerful political connections, Lady Yuchi; but her political position did not result in visual emulation. Rather, the next dated niche, that of the wife of a very minor official, Yifu, takes a completely different form from that of Lady Yuchi's. Some elements of Lady Yuchi's donation were duplicated in three other niches of the first period, but each relates to her work in a different way. Gao Hui's donation utilizes the cross-ankled bodhisattva in the round arch but eschews the garland motif in the arch; Hui Cheng's appropriates the round arch and garland motif but for a seated Buddha image, which is anomalous both in terms of the normative form of arch used with a Buddha image and for the arch types found in the major niches of Row III; and Yuan Xiang's niche is physically the closest to Lady Yuchi's and the most similar in scale, yet all figures are represented in the Han rather than Western style. Only in the donation of the local military commandant, Xie Boda, do we find a near literal reiteration of the visual style of Lady Yuchi's niche. Outside of the Han stele framework for the inscription, which is restricted to the elite-class donations (Lady Yuchi, Hui Cheng, Yuan Xiang), there are no formal attributes of the first-period niches that consistently differentiate them according to patronage group. Rather, we have a surprisingly varied range of visual elements in different combinations.

It has been usual for scholars to understand the early Longmen Caves in relation to the Yungang Caves that preceded it; after all, both were located near a Northern Wei capital from which patronage was drawn. A number have gone so far as to conclude that it was sculptors from Yungang that were responsible for the early niches in the Guyang Cave.[87] Yet many important elements of style and mode of dress were not carried over to the Guyang Cave from Yungang. For example, a Yungang niche dated to 489 (fig. 4.27) has many similarities with Lady Yuchi's niche of 495 (fig. 4.13) in terms of subject matter, composition, posture, and the Western mode of dress. But the Guyang Cave figure is carved in a leaner style—not so much elongated as more firm with a harder surface and crisper angles—and a similar contrast can be found in the pair of lions to the sides of each bodhisattva. Part of the difference might be attributed to the limestone in the Guyang Cave compared to the softer sandstone of Yungang. Yet there is more than just a different kind of material reflected in the approaches. The usual visual conventions at Yungang—the trabeated arch niche for cross-ankled bodhisattva figures or the consistent placement of the right foot in front of the left—are abandoned in the earliest Guyang Cave works, which adopt the round niche unknown at Yungang and reverse the usual foot position of the cross-ankled figure.[88] In the Han mode of dress, the differences between the niche dedicated by Yuan Xiang (fig. 4.22) and a niche from Yungang Cave 6 (fig. 4.28) are even more striking: for example, note the distinctive two-dimensional quality of the Guyang

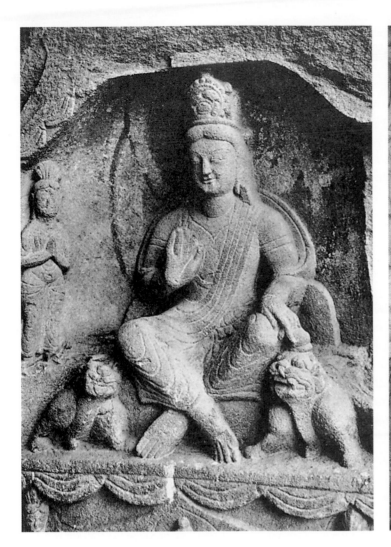

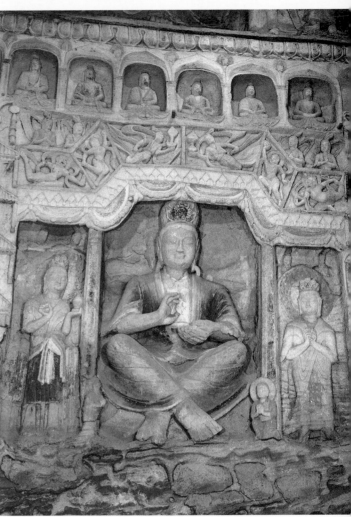

work with emphasis on flat, crossing scarves as well as the ribbons and scarves with exaggerated flaring, pointed arcs extending out from the head and shoulders. Similar contrasts can be found between the standing attendant bodhisattva figures and those from Yungang Cave 6.[89] Although the modes of dress are identical in these comparisons, the full, expansive shapes emphasized at Yungang are a very different expression of visual style.

The significant disjuncture between the style of the two sites indicates that the initial work in the Guyang Cave was neither an extension of the Yungang style nor the work of the sculptors who worked at Yungang. There is no evidence in the historical or archaeological record of any significant population near Luoyang that was supporting stone carving of religious images, tombs, or other monuments during the period leading up to the end of the fifth century. Therefore, the question remains open as to who worked on

4.27 *Left:* Cross-ankled bodhisattva, Yungang Cave 17, dated to 489. From Mizuno Seiichi, *Chūgoku no chōkoku,* fig. 56.

4.28 *Right:* Cross-ankled bodhisattva, Yungang Cave 6. From Unkō sekkutsu bunbutsu hokanjo, *Unkō sekkutsu* 1: pl. 108.

the first-period niches in the Guyang Cave. One possibility was suggested by Ishimatsu Hinako, who notes that the distinctive round niche over a cross-ankled bodhisattva can be found on two fifth-century works of sculpture from Chang'an.[90] Chang'an, where we know sculpture workshops were active in the fifth century, remains a likely locale to supply artisans for the new capital. The larger of the early Guyang Cave niches feature detailed, ornate relief carving, particularly inside the image niches, arches, and along decorative border areas in the cave. This confident and elegant style suggests that the sculptors had experience with other Buddhist or mortuary sculpture such as tomb decorations and sarcophagi.[91] The popularity of the Han stele form in the Guyang Cave also suggests a relationship to workshops that produced commemorative stele for tombs. The demand for mortuary and religious sculpture was no doubt present in any significantly populated area in northern China, and it is possible to envision experienced carvers drawn to Longmen and Luoyang from not-too-distant areas of northern Henan or Hebei.[92]

INTERREGNUM

After the dedication of 498 by the emperor's younger brother, Yuan Xiang, interest in the Guyang Cave among court patrons appears to have waned. An important reason must have been the death of Emperor Gaozu in the fourth month of 499 while on a military campaign south of Luoyang. The unexpected demise of the young emperor focused the attention of court officials and members of the imperial family on the problems of the succession of Gaozu's young son, Shizong Xuanwu 世宗宣武 (r. 499–515). On his death bed, Gaozu named a council of regents that included the prince of Beihai, Yuan Xiang. Organized to assure a smooth transfer of authority and to protect the new emperor, the members of the council were soon engaged in rival plots, including a plan by another of Gaozu's half-brothers, Yuan Xi 元禧, to assassinate Shizong in 501. Lesser power plays appear to have been continually unfolding at court; and Yuan Xiang, a major player in these intrigues, was himself brought down by rivals and killed in 504. Meanwhile, Mu Liang remained among the highest-ranking court advisers until his death in 502.[93]

There are no dated inscriptions from 499 and only two works from 500. One is that of Zheng Yinxing et al. 鄭胤興等, only the second donation on the south wall.[94] The tiny niche (fig. 4.29), opened just above Gao Hui's dedication of 498, contains an image of a cross-ankled bodhisattva under a trabeated arch—the earliest dated example of this type of niche in the cave—with a pair of contemplating (siwei 思惟) bodhisattvas to each side, which are unknown in any early Guyang Cave niches. The inscription consists of seven short lines squeezed rather crookedly in the space below the images and comprises little more than a date, a line now totally lost, and five names. The trabeated arch niche and the siwei bodhisattvas are very unusual for the early date, which suggests that one accept the 500 date with caution. The other inscription of 500 is incomplete, placed in the upper part of a good-size Han stele (fig. 4.30) in the west (rear) part of the ceiling. The short text (fig. 4.31), which ends abruptly about halfway across the width

4.29 Niche dedicated by Zheng Yinxing et al., dated to 500, south wall, Guyang Cave. Photograph by Chen Zhi'an.

4.30 Niche dedicated by Hui Shou, dated to 500, ceiling, Guyang Cave. Photograph by Chen Zhi'an.

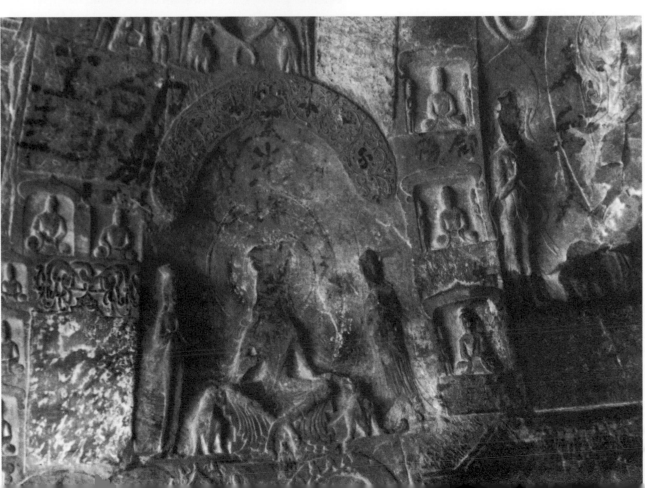

4.31 Rubbing, inscription for the niche dedicated by Hui Shou, dated to 500. Rubbing no. 21021, Fusinian Library, Institute of History and Philology, 8 Academia Sinica, Nangang, Taiwan. Photograph courtesy of the Institute of History and Philology, Academia Sinica.

of the space, was left inexplicably unfinished and provides us with little information regarding the dedication.[95] The title *yixiang* 邑像 was placed in the head and the first donor is identified as *yishi* Hui Shou 邑師惠壽. The niche contains a cross-ankled bodhisattva and two standing attendants in a round niche decorated with a vine scroll. Some details appear to have not been finished—for example, the drapery of the left bodhisattva—and it appears that all of the figures were meant to be in a sinicized style. The unfinished text indicates that Hui Shou and possibly other organizers either abandoned their large dedication or were unable to raise the resources necessary to have it completed.

The use of the terms *yixiang* and *yishi* in the inscription indicates that the niche was sponsored by an *yiyi*, an association of lay believers with monastic leadership that was active during the Northern Wei period.[96] *Yiyi* have precedents in local associations known as *she*, some of which erected stele inscribed with the names of the participants. In the fifth century, the organizational structure of the *she* as well as their patronage of monuments was adopted for Buddhist purposes.[97] There is evidence that Buddhist monks organized *yiyi* as an alternative to the traditional *she* that performed bloody sacrifices to the land god.[98] Although the *yishi* Hui Shou's niche of 500 is the earliest dated example of an *yiyi* in the Guyang Cave, a few extant rubbings of inscriptions provide evidence of the activities of *yiyi* during the fifth century. The earliest (fig. 4.32), dated to 440, records the making of a Buddha image by a group that describes itself as a *heyiyi daosu* 合邑儀道俗, an association of monks and lay believers, led by Wang Shenhu 王神虎, the director of the (making of the) image (*xiangzhu* 像主).[99] Another early inscription (fig. 4.33) records the donation of a pagoda at the Lingshan temple 靈山寺 in Shandong Prov-

ince by some two hundred donors in 477.[100] Three leaders of the group are named at the end of the text: a *duyizhu* 都邑主, or metropolitan director of the association; a *weina* 唯那, or monastic overseer; and a *tazhu* 塔主, or director of the (making of the) pagoda. This is a case in which the group did not designate itself as an *yiyi*. Rather, it is the presence of a term such as *duyizhu* in the context of a group donation that gives us an indication that this was a religious association that functioned as an *yiyi*. A third inscription records the dedication of an image of Maitreya by seventy-eight donors in Eastern Hebei Province in 489.[101] In this case the group identified itself as an *yiyi daosu* 邑儀道俗. The leadership of the *yiyi* consisted of three *duweina* 都唯那, or metropolitan monastic overseers, and eight *weina*. Interestingly, one of the *duweina*, Zhu Siyuan 朱思淵, is also identified by several minor official titles and is apparently a local official.[102] This association included eleven monks among its members.

There is also evidence that *yiyi* sponsored image niches at the Yungang cave site. One inscription for a niche on the south wall of Cave 13, only bits of which can be read,

4.32 *Left:* Rubbing, inscription of Wang Shenhu, dated to 440. From Beijing tushuguan, *Beijing tushuguanzang,* 3: 6.

4.33 *Right:* Rubbing, inscription of the Lingshan temple pagoda, dated to 477. From Beijing tushuguan, *Beijing tushuguanzang,* 3: 13.

includes reference to an *yizi* 邑子.[103] The best known Northern Wei dedication by an *yiyi* is located on the upper east wall of Cave 11 (fig. 4.34) and dated in the inscription to 483.[104] Close to 10 feet in height, the elaborate donation is an image niche consisting of a large number of Buddha and bodhisattva figures in different combinations as well as images of lay worshipers. The association, which in this case did call itself an *yiyi* 邑義, was composed of fifty-four men and women. To the right of the inscription (fig. 4.35) are three large figures of monks with colophons that identify each as an *yishi* 邑師, or teacher of the association. From the prominence given the three monks and their position in front of rows of lay devotees, they appear to have been the leaders of the *yiyi*. A fourth monk, also identified as an *yishi,* leads a group of smaller laymen two rows above the three monks. The total number of figures including the monks comes to fifty-four.

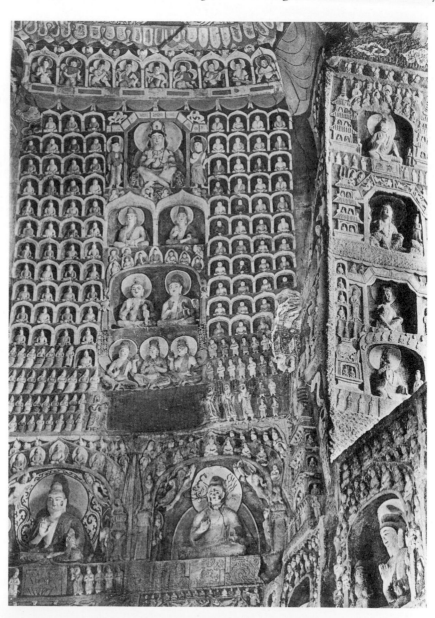

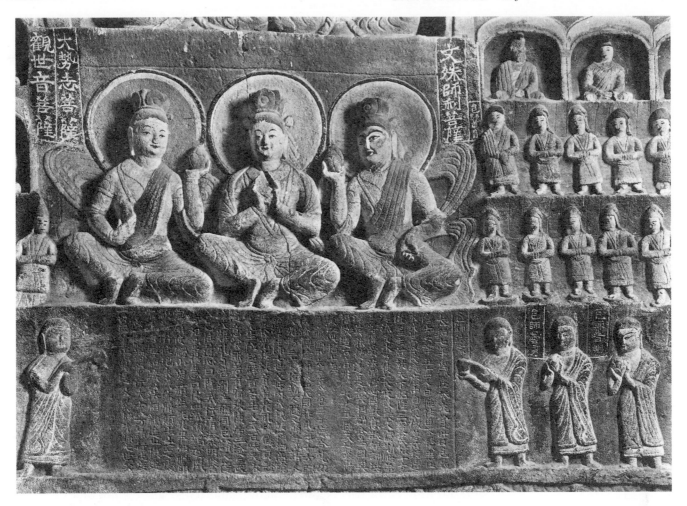

In contrast to the *yishi,* the names of the lay devotees were apparently never carved onto the blank cartouches next to each figure.

The inscription describes the *yiyi* as an association of men and women believers who realized that they have been born in a "degenerated period" (*modai* 末代) and have no means of self-enlightenment:

> Accordingly, by banding together in order to bring good fortune to the country, we reverently made a stone shrine (*shimiao* 石廟) with ninety-five images and several Bo-dhisattvas, wishing by this means, first that the virtue of the Emperor, the Empress Dowager and the Prince shall be identical with heaven and earth [and that their] power shall surpass that of Cakravartins, that [their] spiritual power shall cover the four quar-ters of the world and that they shall bring lasting peace to the country, that they shall bring all peoples of the ten directions into submission and make glorious the Three Jew-els which shall not disappear for ever. We also wish that the souls of [our] fathers and

4.35 Inscription for the niche, east wall, Yungang Cave 11, dated to 483. From Mizuno Seiichi and Nagahiro Toshio, *Yün-kang,* 8, pt. 2 (plates): pl. 30.

mothers of seven generations and of [our] paternal and maternal relations shall reside in a high place, be peacefully nourished and splendidly received.[105]

The inscription continues for some length to describe various good wishes hoped for the beneficiaries of the donation. As Mizuno and Nagahiro point out, the text oddly ends in midsentence. It appears that the dedicatory panel, bordered by a vertical incised line on the right, originally extended the complete width of the image niche above it. At some point after the whole text was incised onto the panel, the left portion was re-cut, leaving the surface of this section at a lower level and eliminating something like four lines plus the original vertical border. The motivation for such an unusual alteration may have been that additional space was required for the donor figures on the left, al-though there appears to be room to the right of the inscription for more figures if these were needed to match the exact size of the *yiyi*. Yet there are many examples of North-ern Wei works in which the number of figures is fewer than the total number of donors indicated in an inscription. It remains a mystery why in this case the text was so arbi-trarily truncated for the sake of a few donor figures, none of which were important enough to have their names recorded in the colophons. An example such as this leads one to question the usual assumption that the inscription was crucial for any votive im-age, especially in light of the fact that a great majority of dedications at the Yungang site are without inscriptions of any kind.

The texts of *yiyi* provide us with some sense of the structure and interests of such associations prior to the Guyang Cave inscription of 500. The 440 dedication begins its list of beneficiaries with the emperor; those dated to 483 and 489 add the empress dowa-ger and in the former case the crown prince. The making of donations for the benefit of the emperor, imperial family, or the realm as a whole has been much noted in past scholarship on Northern Wei Buddhism, but a survey of the extant image inscriptions suggests those with such a reference were in the minority.[106] These kinds of loyal senti-ments were likely little more than a politic element of public discourse, a prudent mea-sure in a Buddhist dedication.[107] At the same time, the frequent occurrence of references to the imperial family or the empire in *yiyi* inscriptions suggests a special relationship to political authority, which is further indicated in the inscription of 489 where a *weina* is also a local governmental official. Several Northern Wei imperial edicts indicate the of-ficial role of *weina* during this period. For example, an edict of 472 orders the investi-gation of unregistered, drifting monks; those legitimate clergy allowed to travel are or-dered to have an official document from a *weina* or a *duweina*. Similar edicts of 486 and 509 suggest that the role of *weina* as overseers of the Buddhist clergy continued well into the sixth century.[108] It thus appears that *yiyi,* insofar as they were associations with *weina* in leadership positions, were a form of organization endorsed by and under the supervi-sion of Northern Wei governmental authorities. Evidence of the intimate relationship between *yiyi* and officialdom can also be found in the Guyang Cave, although there are examples of small, anonymous *yiyi* such as the one led by the *yishi* Hui Shou.

The two inscribed images dated to 500 are followed in 501 by the small dedication of an individual commoner, Ma Qing'an 馬慶安, on the north wall to the left of the arch of niche III–1 (fig. 4.36).[109] Ma's niche appears to be part of a set of four nearly identical niches carved here and, if the irregular manner in which the adjacent inscriptions are arranged is any clue, these may have been completed as a set before individual patrons had been secured. As in the other small niche on the north wall, Yifu's of 496, this work (fig. 4.37) features a seated Buddha with hands together in the lap flanked by two standing bodhisattva attendants. The Ma Buddha is draped in the closed mode, however, and has a narrower, more upright contour. The dedication is arranged in six short lines below the image. No doubt because of the presence of the carving to the right, the first line of text noticeably slants to the left. Subsequent lines are straight but the final line of the text, which is the regnal date and year, has been written in characters significantly smaller than the balance of the inscription. Possibly the small line is part of the inscription directly above it, although the slightly compressed characters in the next to last line

4.36 North wall and niches dedicated by (1) Ma Qing'an, dated to 501, and (2) Jia Yuanying, dated to 503, Guyang Cave. Photo by author.

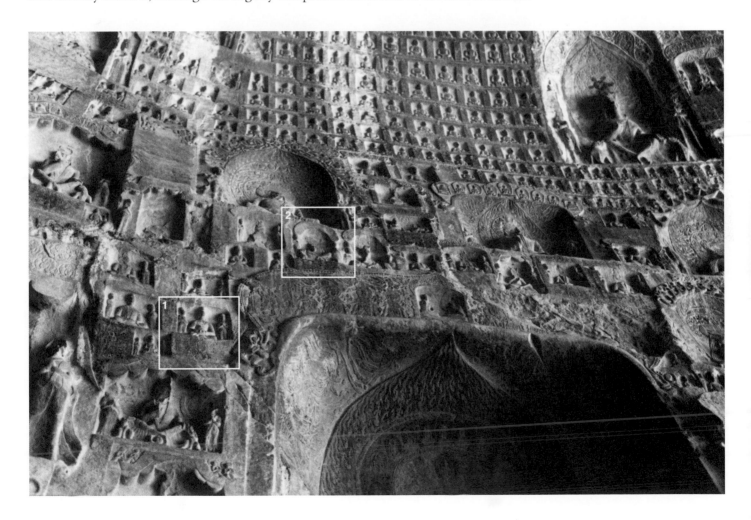

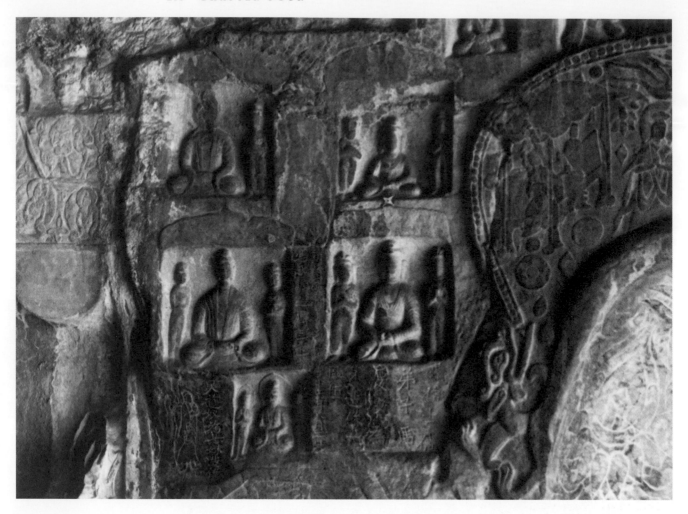

4.37 Niche dedicated by Ma Qing'an *(lower right),* dated to 501, north wall, Guyang Cave. Photograph by Chen Zhi'an.

suggest that the carver of Ma's inscription had realized at that point that he was running out of space for the intended text.

The inscription is also notable in that the donor directs the benefit accrued from making the image to the body 為身, presumably his own. Buddhist teachings extol the virtue of making sacrifices for others, and this is reflected in wishes for the benefit of parents and past teachers often encountered in Buddhist inscriptions. It is thus very unusual to find a patron naming himself as the beneficiary of a donation—much less specifying the corporeal body, generally understood by Buddhists to be transient and something one should not be attached to.[110] Such a dedication by a lay believer of common background suggests that the goals of some patrons were more self-centered (and less enlightened) than what is usually expressed in Buddhist dedications. That Ma Qing'an's dedication might indicate something of the beliefs of common-class believers is a possibility, but one that is not presently confirmed by collaborating evidence.[111]

In contrast, the dedication of the earl of Yunyang, Zheng Changyou, 雲陽伯鄭長猷, dated to the ninth month of 501, represents the return of elite-class patronage to the cave (fig. 4.38).[112] This is the first dated inscription by a Northern Wei official since 498. Zheng (died 512), who held numerous titles under both Emperors Gaozu and Shizong, had his work placed in the upper part of the south front wall above the niches of Gao Hui and Zheng Yinxing et al. The choice of position is significant—removed from the donations of Lady Yuchi and Hui Cheng yet fully confronting them. The niche is also

4.38 Niche dedicated by Zhang Changyou and wife, south wall, Guyang Cave. From Liu Jinglong, *Longmen ershipin,* 74.

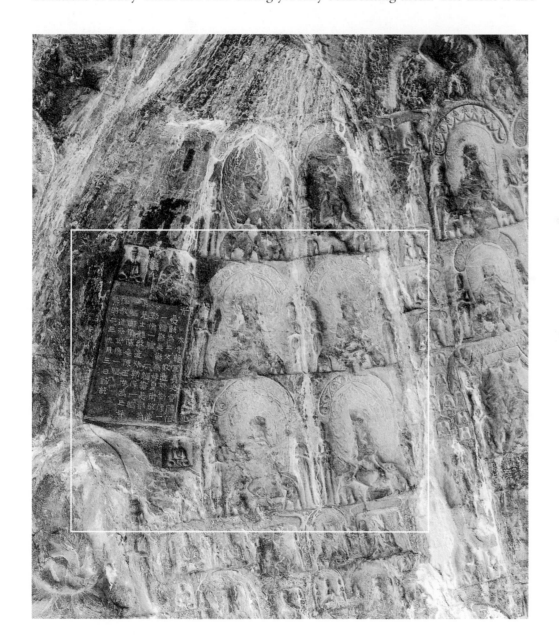

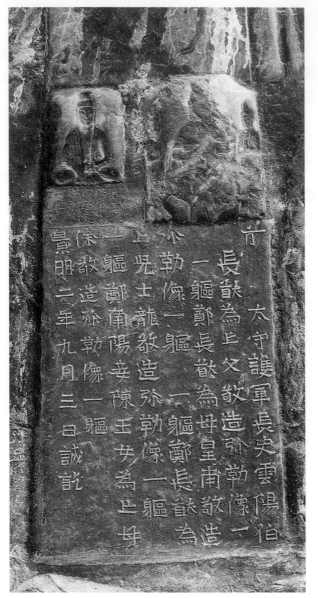

in a very different form—thereby under-scoring its visual distance from the earlier elite-class works—an unprecedented set of four separate dedications of a single Maitreya bodhisattva image each, three by Zheng and one by his wife. In addition, the style of the work departs from that seen on the north wall, presenting the cross-ankled bodhisattva and attendants in the sinicized style as initiated in Yuan Xiang's niche but with rounded arches decorated with the vine scroll pattern as found in the Gao Hui donation a few feet below. Each image is dedicated to a deceased family member: the father, mother, and son of Zheng plus the mother of the wife. The inscription (fig. 4.39) contains numerous anomalies—for example, the first character *qian* 前 is not completed; the character *yi* 一 is repeated for no reason at the bottom of line two and the top of line three; and there are numerous blank spots in the text, the most intriguing being at the top of the second line where Zheng's family name would be expected to appear but was never carved. The text is strikingly truncated, almost cryptic, with nothing of the flow and elegance of earlier inscriptions such as Hui Cheng's or even the simple clarity of the dedication by Yifu.

The shape and arrangement of the four niches are also puzzling. They are part of a set of six nearly identical niches and two tablets, the upper tablet originally blank, stacked within a tapered space at the front-south corner of the cave. It is difficult to determine whether the space, which narrows up to a point, was a natural formation or the rough outline of a boat-shaped mandorla meant for a large single image that was never carved. In any case, the image niches follow the right edge of the space, each row narrowing as they ascend. According to the placement of the tablets, Zheng and his wife sponsored the bottom four while the upper two were never dedicated—reminiscent of the Northern Liang *shita* without dedications—which suggests that some Guyang Cave

4.39 Inscription for niche dedicated by Zhang Chang-you and wife. From Liu Jing-long, *Longmen ershipin,* 81.

image niches were similarly completed before a patron had claimed the work. In addition, the Zheng inscription is not particularly well aligned to the donation. It is the usual practice in the cave, as in the upper blank tablet (now defaced with later graffiti), to set the bottom of the dedicatory panel at or very near the level of the lower edge of the image niche. The odd placement of the Zheng tablet suggests that the space directly below was already taken up at the time that the tablet was carved. If, in addition, the set of six image niches was already in place, there would be no alternative but to position the Zheng tablet as we see it today. After the bottom four images were claimed, it would make sense to block out the second tablet above for the eventual donation of the upper pair of images. It thus appears probable that both dedicatory panels were added after the six niches were carved. If the patron and the number of niches to be donated had been known from the beginning, there would have been the opportunity to properly align the inscription and the niches—but clearly this was not the case. This example of constructing niches without blocking out a space for the inscription would explain the lack of a consistent spatial relationship between image and text in the cave—that is, the way inscriptions are variously positioned to the left, right, or below the image niche. Such a practice would also help to explain why many niches have no tablet for a dedication. While some images were no doubt inserted into a space with no room for an inscription, it is likely that in other cases the space around the image niche was taken over by other carving before the niche was claimed by a sponsor and a space for the dedication blocked out. It should be noted that this problem in the alignment of inscription panel to image niche is not found in any of the first-period donations, a strong indication that each of those works was commissioned and executed as a planned ensemble of image and text.

SECOND PERIOD

The four donations of 500–501—anomalous, fragmentary, and incomplete—appear to reflect the uncertain period immediately following the death of Emperor Gaozu and the ascension to the throne of his young son. By 502 the political situation had begun to stabilize; with the city's ward walls completed, construction of the elaborate residences and temples for which Luoyang would become famous could begin; patronage of Buddhist temples in the city was intense from this time forward. For example, the emperor Xuanwu established the Jingming temple 景明寺 before the end of 503. The prince of Beihai, most likely the Yuan Xiang who dedicated the Guyang Cave niche of 498, established a temple, the Zhuishengsi 追聖寺, in the southern suburbs of Luoyang before his death in 504.[113] Another temple, the Zhengshisi 正始寺, was founded in 504 by a group of highly placed officials. The donors were headed by Cui Guang 崔光, a member of the well-known Boling 博陵 Han lineage and a prominent court adviser, who alone contributed 400,000 coins.[114] Clearly the imperial family and the political elites of Luoyang had ample opportunity to lavish support on Buddhist institutions close at hand.

The distant Longmen site was not forgotten—early in the Jingming 景明 era (500–503), Shizong ordered caves constructed on the model of those at Yungang for the memory of Gaozu and his mother, usually thought to be two of the Binyang Caves.[115] Shizong would visit the site in the twelfth month of 504, but the imperial commission of caves would not be completed during his lifetime, an indication of the limited interest the site elicited from the court during the early sixth century.[116]

Others, however, were attracted to the Guyang Cave, especially commoners and *yiyi*. The second period of niche construction in the Guyang Cave, far more intense than the first, commences in 502 with six dated works dedicated between the fifth and eighth months. The earliest is that of an *yiyi* in Row III of the south wall, a niche (fig. 4.40) commonly referred to as that of Sun Qiusheng et al.[117] This is the second dated niche in Row III and, like the first (Hui Cheng's) on the opposite wall, the dedication is written on a version of a traditional Han stele topped with entwined dragons (fig. 4.41). The inscription, titled *yizixiang* 邑子像 in the head, records the donation of four local officials and some two hundred others, although there was only space for the names of 140 of the donors. Prominently listed to each side of the title are two governors of local commanderies (*taishou* 太守): Sun Daowu 孫道務 and Wei Baidu 衛白犢, each of whom holds a court title (*zhongsan dafu* 中散大夫), and one of whom is identified as the *yizhu* of the association.[118] At the beginning of the text is listed two more officials: Sun Qiusheng 孫秋生 and Liu Qizu 劉起祖, both identified as the *gongcao* of Xincheng 新城縣功曹, an important local office in a nearby district.[119] Fifteen *weina* are arranged across the top of a long list of names. The text, which states that the donation is a *shixiang* 石像 or stone image, is carved in a blunt but refined style similar to that of the Hui Cheng inscription. Although by far the longest inscription by an *yiyi* in the Guyang Cave, most of the text is taken up by the list of names, and the flowery dedication itself is shorter than Hui Cheng's. As we found in the Hui Cheng dedication, the composer and calligrapher of the text are identified by name.

The image is an upright Buddha seated in a meditative pose inside a pointed arch niche. The work is very similar in scale and composition to the Hui Cheng image in the opposite wall, down to the set of four kneeling worshipers and *boshanlu* entwined with dragons below the Buddha. The Sun Qiusheng figures are badly damaged, however, and it is not possible to determine whether they were dressed in northerner costume as in the Hui Cheng niche or in Han dress. Both Buddha images are presented in a Western mode of dress with nearly identical handling of the decorative pattern of the drapery; the attendant bodhisattvas in the Han mode are also nearly identical. It seems likely that the carvers of the later image were looking directly across the cave to the Hui Cheng niche as a model rather than to an adjacent niche such as the undated one directly to the right. The torso of the Buddha figure in the Sun Qiusheng niche is more squared, most noticeably in the shape of the shoulders, a little more sharply angled at the bend of the arms, and with a bit of stiffness in the feel of the drapery. Other differences are in the

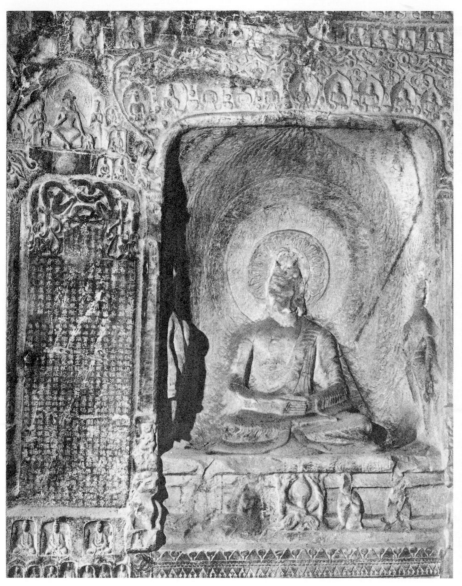

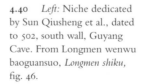

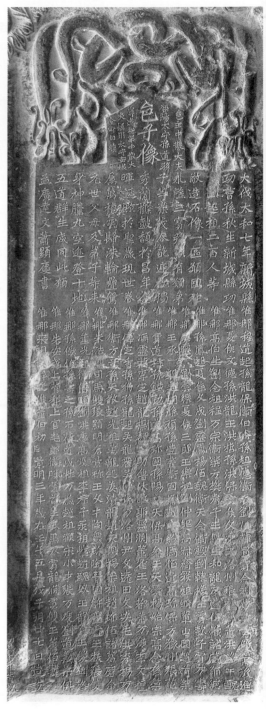

4.40 *Left:* Niche dedicated
by Sun Qiusheng et al., dated
to 502, south wall, Guyang
Cave. From Longmen wenwu
baoguansuo, *Longmen shiku,*
fig. 46.

4.41 *Right:* Inscription for
the niche dedicated by Sun
Qiusheng et al. From Liu
Jinglong, *Longmen ershipin,* 33.

type of niche—the rounded type of the earlier work is replaced by the pointed arch niche filled with seated Buddhas and flying attendant figures—and the handling of the relief carving of the halo behind the Buddha figure, incised and more delicate compared to the deeper three-dimensional forms in the Hui Cheng niche.[120]

The two-hundred member *yiyi* led by prominent Northern Wei officials and fifteen *weina* appear to have possessed sufficient political status and economic wherewithal to construct a very impressive monument. Rather than another individual elite donor, it was an *yiyi* that was the first to dedicate a large Row III niche on the south wall and to match the scale of the Hui Cheng niche, the largest dated donation in the cave up to that time. That the work of an *yiyi* was far grander than that of members of the imperial family and high court officials is significant; there was apparently no concern that the politically powerful would be offended. This is a further indication that *yiyi* such as this one functioned with the official approval of the state. The deliberate choice of location and scale, as well as the conscious stylistic correlations with the earlier Hui Cheng image, are part of a visual rhetoric that serves to both affiliate the *yiyi* with the court and declare the loyal and upstanding nature of the members of the association. In this regard, it should be noted that the first wish in the dedication is that the empire be blessed 國祚, but there is nothing else of an overtly political nature among the long list of wishes and beneficiaries.

The Sun Qiusheng inscription contains two dates, as was the case in the Yuan Xiang work. The one at the end of the text states that work was completed in 502 (景明三年五月二十七日). The other date begins the dedication and indicates that the association had a stone image made in 483 (seventh year of *taihe* 太和七年). If both apply to the same image niche—and there is nothing to indicate otherwise—there is a discrepancy of nineteen years in the date of the work. It is always possible that an image made in 483 was dedicated in 502, but the 483 date is too early in terms of the style of the carving. Following the precedent in the Yuan Xiang inscription, we might take the earlier date to refer to the time when the donors vowed to have an image made; intervening circumstances delayed the completion of the work until 502. Nearly two decades seems far too long, however, to fulfill such a pledge, even considering the scale of the elaborate niche and inscription.[121] Also, the Yuan Xiang text was explicit about the vow and its circumstances, while the Sun Qiusheng clearly states that in 483 the patrons had an image constructed. Some scholars have suggested that the date should have been the seventeenth year (太和十七年 or 493) and the character for ten (十) was inadvertently omitted.[122] Examples of an omitted character in a regnal date and miswritten characters in Guyang Cave inscriptions are cited as support, but in fact there is no method of proving the omission of the ten. The two widely separated dates continue to stimulate a fascinating body of speculation even as they resist a convincing explanation.

The end of the fifth month of 502 was a busy time in the Guyang Cave. In addition to the dedication of the Sun Qiusheng niche on the twenty-seventh day, three small

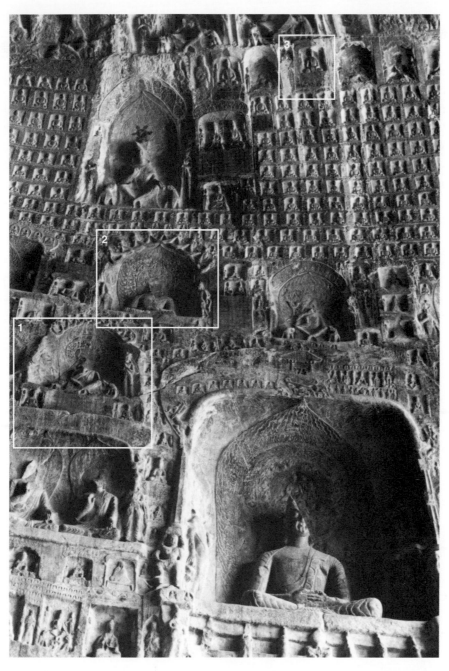

4.42 Niches dedicated by *(1)* Hui Gan, *(2)* Gao Shu et al., and *(3)* Zhao Shuangzhe, dated to 502, north wall, Guyang Cave. Photo by author.

niches (fig. 4.42) were dedicated on the opposite (north) wall on the thirtieth day. These works, in close proximity to one another, were sponsored by a monk, an *yiyi,* and a commoner. The niche by the monk, Hui Gan 惠感 (fig. 4.43), is located prominently in Row III between the rear and adjacent major niches and just below Yifu's donation of

496.[123] The main figure is a cross-ankled bodhisattva flanked by bodhisattvas and a pair
of lions. The niche is of the round type with the familiar looping garlands; the nimbus
and background is carved in high relief. All of this is reminiscent of Lady Yuchi's niche
(fig. 4.13) of 495. The handling of the drapery, particularly the long, curling fall of
scarves from behind the heads of all three figures, is in the Western mode (fig. 4.25),
while the scarves crossing over the front of the body and through a *bi* disk is a hallmark
of the Han mode. In this case, however, the scarves are not depicted as flat, broad rib-
bons of drapery, as one expects in the Han mode, but as a series of raised and linked oval
segments. This is not so much the modification of the Han mode by a Western one but
the unexpected appearance of a style blending aspects of both. The handling of the nim-
bus, far bolder than the incised work in the Sun Qiusheng niche, also suggests an earlier
approach of deeper relief carving best seen in Hui Cheng's niche (fig. 4.20) of 498. A
comparison with Yuan Xiang's niche (fig. 4.22) indicates how the nearby sinicized mode
was *not* taken up as a model. One is tempted to understand this work as archaistic, a con-
scious recuperation of the early Western styles into forms otherwise contemporary with
its 502 dating. But what is suggested is something else again, a creation beyond the sys-

tem of modes and styles, Western or Han, that continues to inform our analysis. The Hui Gan niche belies any straightforward narrative of the sinicization of Buddhist art, yet it also reminds us of the seemingly inescapable necessity of descriptive categories such as Han/non-Han.

Hui Gan's niche represents the rearticulation of a series of earlier works on the north wall featuring a basically Western style of figuration in a round, garlanded niche. The inscription states that he had an image of Maitreya made for his deceased parents; the first in a series of wishes is that the empire prosper and be forever lofty 國祚永隆. Hui Gan's text is arranged in neat columns of five characters each; but at the end, in a blank space, an undated dedication by a second monk, the *biqiu* 比丘 Fa Ning 法寧, has been added in two columns of seven and six characters respectively. The latter inscription was probably meant to refer to the small niche containing a seated Buddha to its immediate left. This is a good illustration of the way in which the length of texts did not always fill the available space and remaining uninscribed areas could be utilized by other donors for their own purposes.

The second dedication (fig. 4.44) of the same day was sponsored by an *yiyi* and opened just above Hui Gan's niche. The inscription (fig. 4.45), carved on a panel to the right of the niche, records the names of the *yizhu,* Gao Shu 高樹, and the *weina,* Xie Bodu 解伯都, as well as thirty other members of the association.[124] In contrast to the donation of the *yiyi* led by Sun Qiusheng, there are no official titles listed for any of the patrons. Not surprisingly, the Gao Shu niche is smaller in scale with a less prominent location; the shorter text is carved on a simple rectangular tablet without allusions to the Han stele form. Part of the reason may have been the lack of room adjacent to the niche; the carvers were not able to align the tablet with the lower edge of the niche. It is noteworthy that three members of the Gao family listed on the Gao Shu dedication are also included among the sponsors of the Sun Qiusheng work.[125] This indicates that individuals were not restricted to any single *yiyi* and that such associations may have had a range of different functions, some more or less like a village association, others specially formed to make a one-time donation. But despite overlapping membership as well as the use of common phrases in both *yiyi* dedications, there seems to have been no interest in duplicating the visual form of the larger *yiyi* niche dedicated only three days earlier.[126] Rather, the Gao Shu–led *yiyi* sponsored a meditating Buddha in a round, garlanded niche, a combination found in the Row III niche of Hui Cheng dated to 498. While the Hui Cheng niche combined a Western-style Buddha with Han-style attendant bodhisattvas, all of the Gao Shu figures are in the Western style. The interior of the Gao Shu niche is carved in deep relief as was the Hui Cheng, but there are no dragons at the end of the arch here—that is, the Gao Shu rounded arch is of the type consistently used for cross-ankled bodhisattva figures, beginning with that of Lady Yuchi. The swelling chest and rounded upper arms of the Gao Shu Buddha create a softer, less angular form than either the Hui Cheng or Sun Qiusheng Buddhas. The general direction of development

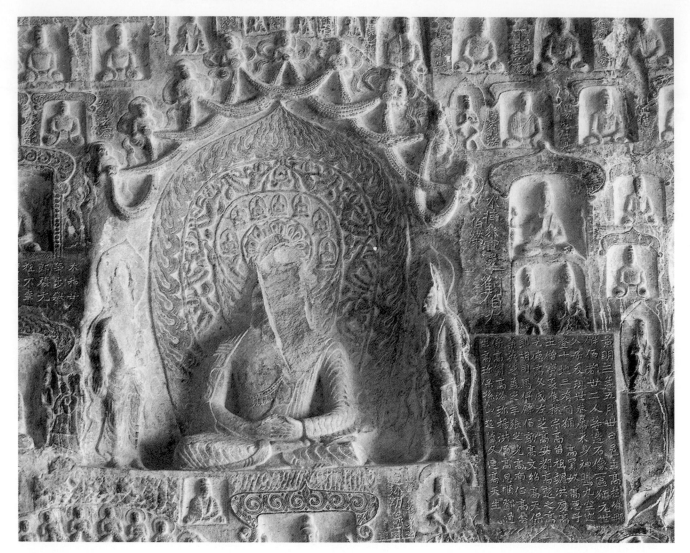

4.44 Niche dedicated by
Gao Shu et al., dated to 502,
north wall, Guyang Cave.
From Liu Jinglong, *Longmen
ershipin*, 82.

in the figural style of the Buddha image in the cave—toward increased angularity and
elongation—is reversed in this niche.

The sharp break in the stone caused by the removal of the head is a particularly harsh
reminder of the fate of many of the images under discussion. In this case, however, we
have an opportunity to view the image in its original state, albeit only through a photo
montage. A private collector, C. K. Chan, purchased a stone head (fig. 4.46) with the
thought that it might have come from a site such as Longmen. It was subsequently
verified that the head was originally from the Gao Shu image, and a composite photo
(fig. 4.47) of the reconstituted image was published.[127] This is another example of the
fluidity of sculpture from the cave: their circulation through an international art market
and the possibility that they might be repatriated—not through the mechanisms of in-

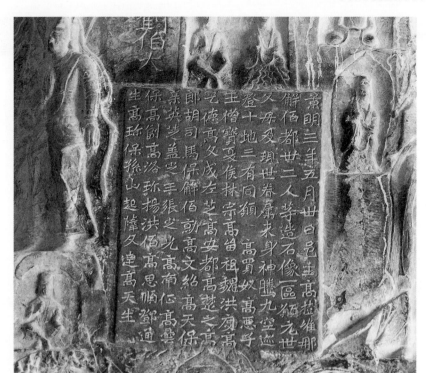

ternational relations but, ironically, through the workings of the same commodity system that was fundamental for the initial removal. Mr. Chan has not returned the head to the Longmen Caves, although he has expressed an interest in supporting the creation of a museum to house works that are returned to the site, and so the closest we can come to restitution is through the truth effect of the photographic image. The Gao Shu Buddha figure with head is quite similar to a work like the Yifu image (fig. 4.16) of 496, a further indication of the possibilities of adopting a conservative approach toward the Buddha image in the early sixth century.

The third dedication of the thirtieth day, by the commoner, Zhao Shuangzhe 趙雙哲, is small and placed in a spot high above the Gao Shu niche (upper section, fig. 4.42).[128] The image is a Buddha seated in a pointed arch niche in a Western mode of dress with both shoulders covered (fig. 4.48). The style of the figure is comparable to that of Yifu's niche below, the most noticeable difference being the closed mode of dress, the more elongated outline of the arms, and the torso that tapers to a slightly narrower face. The arch is undecorated, the attendant bodhisattvas lack details, and the two standing devotees in northerner dress to the left of the niche are mere outlines. All of this indicates that the niche was roughed out but not completed. Zhao's inscription (fig. 4.49) was neatly executed although a significant portion has been damaged. The surface appears

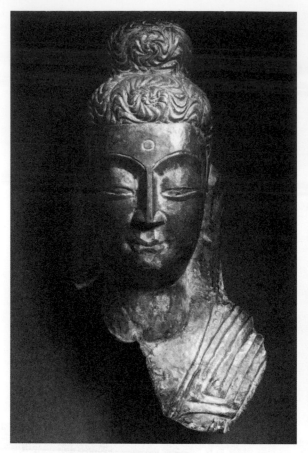

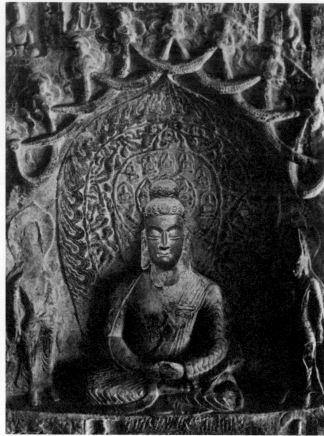

4.46 *Left:* Head of a Buddha, from the niche dedicated by Gao Shu et al., C. K. Chan Collection. Photo courtesy of the Longmen shiku yanjiusuo.

4.47 *Right:* Composite photo, restored seated Buddha, niche dedicated by Gao Shu et al. Photo courtesy of the Longmen shiku yanjiusuo.

to be abraded as if the text was erased, but it is unclear why this would have been done in such a remote section of the cave.

In the second period, the prominent role of donations by court-related or official class sponsors has been displaced by a more diversified range of patrons, including *yiyi* and individual commoners. The range of styles utilized in the niches has similarly grown more eclectic. We have seen a pattern in which the earliest niches were concentrated on the north wall with subsequent donations moving increasingly outward to the opposite (south) wall and both the rear and front sections of the ceiling. This expansion of work culminates with the earliest dated dedication of a major niche in Row III of the south wall by the *yiyi* led by Sun Qiusheng and others in 502. But only three days later a trio of smaller niches was dedicated in close proximity to one another on the north wall. The return to the north wall signals a renewal in the use of the round garlanded niche and various elements of the Western style. This is a reversal of the trend of adopting Han figural styles in works in the ceiling and south wall. One clue as to why there was a return to the earlier style of imagery is the possible familial relationship between Xie

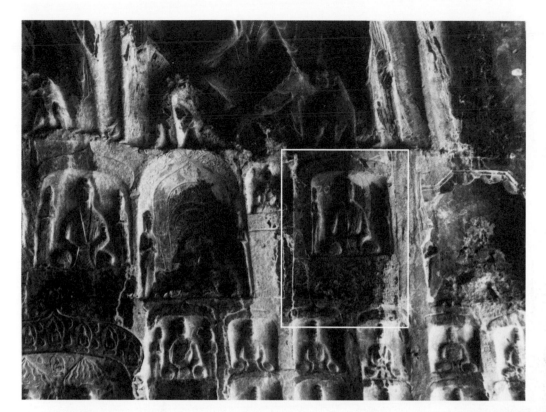

4.48 Niche dedicated by Zhao Shuangzhe, dated to 502, north wall, Guyang Cave. Photograph by Chen Zhi'an.

4.49 Rubbing, inscription for niche dedicated by Zhao Shuangzhe. From Beijing tushuguan, *Beijing tushuguanzang*, 3: 56.

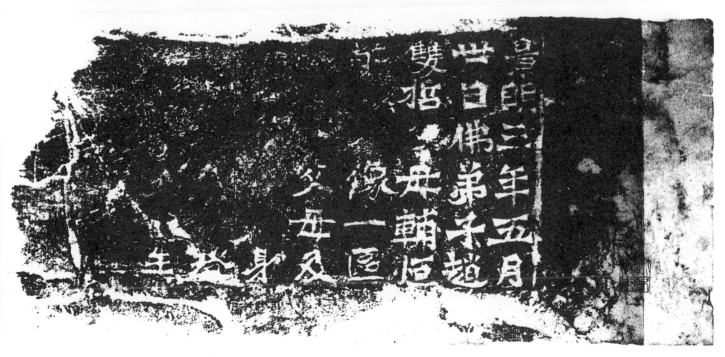

Bodu, the *weina* in the Gao Shu dedication, and the military commandant Xie Boda, whose niche so closely reiterated the early style of Lady Yuchi's.[129] In any case, the deliberate choice of the older style cannot be explained as ignorance or provincialism. Rather, with a range of possible stylistic choices, it was the Western mode—abandoned on the south wall and ceiling—that was the most meaningful for a later group of patrons.

WOMEN SPONSORS

The next group of dated niches in the Guyang Cave is a cluster of donations by female patrons at the very top of the rear ceiling (fig. 4.50), near the niche dated to 500 and sponsored by *yishi* Hui Shou. The earliest in the group (fig. 4.51), dated to the sixth month of 502 and also the work of an *yiyi,* was opened just above the *yishi* Hui Shou

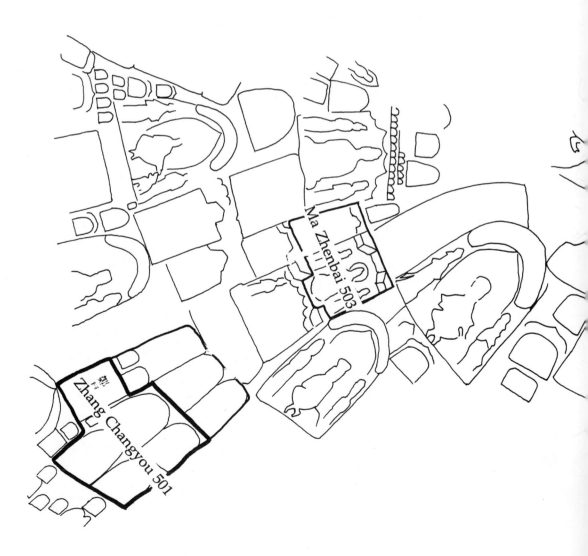

niche. The badly worn inscription (fig. 4.52) is primarily a list of the names of an association of twenty-one women, beginning with the nun Su □zi 比丘尼蘇□子, the *weina* Yin Aijiang 尹愛姜, and the *weina* Zhang Zhi□ 張隻□.[130] This is the oldest dated example of a woman's association as sponsor of Buddhist imagery in China. No *yizhu* or *yizi* is included in the inscription and the work is dedicated for the benefit of the parents of the donors going back seven generations. The inscription is placed in the familiar Han stele format topped with the dragon design and a small head with the title *dinü* 娣女, or female disciples. Because the Han stele format has been associated with the elegant compositions of elite-class donations, the rough and uneven calligraphy here is unexpected. It is as if, with the passing of time, common-class patrons such as these were able to appropriate the form of elite inscriptions without the associated calligraphic

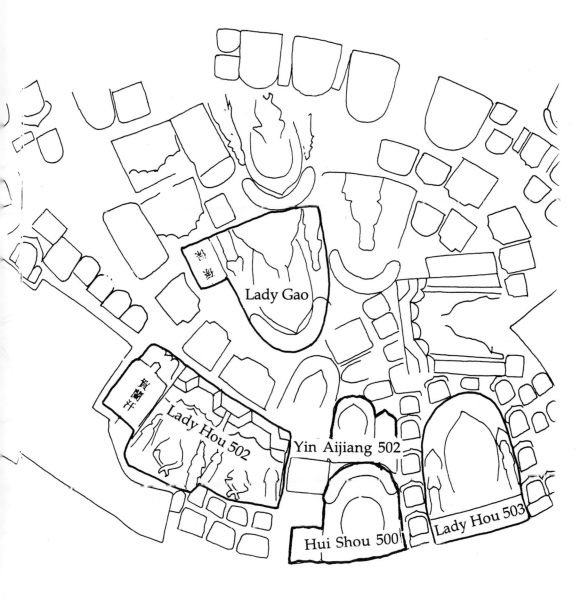

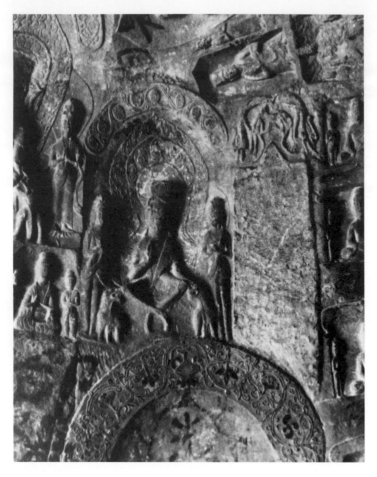

4.51 *Left:* Niche dedicated
by Yin Aijing et al., dated to
502, ceiling, Guyang Cave.
Photograph by Chen Zhi'an.

4.52 *Right:* Rubbing, in-
scription for niche dedicated
by Yin Aijing et al. From
Beijing tushuguan, *Beijing
tushuguanzang,* 3: 57.

skills. The image dedicated was a cross-ankled bodhisattva, identified as Maitreya in the text, with a pair of standing attendant figures. The sculpture, in contrast to the calligraphy, is crisply and simply rendered, the figures rather attenuated in the sinicized style inside a rounded niche decorated with a vine scroll. Stylistically, the niche is reminiscent of the four dated to 501 sponsored by Zheng Changyou and his wife in the front part of the south wall (fig. 4.38).

Two months later a niche (fig. 4.53) just to the front (east) of the women's *yiyi* niche was dedicated by Lady Hou, grandmother of the prince of Guangchuan 廣川王祖母太妃侯.[131] Lady Hou was the wife of the first prince of Guangchuan, Tuoba Lüe 略 (died 480), the son of Emperor Gaozong (r. 452−465). She was the mother of the second prince, Yuan Xie 元諧 (died 495), and the grandmother of the then-current prince, Yuan Lingdao 元靈道.[132] The dedication to her deceased husband utilizes the format of the Han stele (fig. 4.54), following the precedent of the similarly highly placed Lady Yuchi. The text is beautifully carved in enlarged characters, 4 cm high, a logical strategy to offset the distance from which they must be viewed, but an example that was not followed in other inscriptions in the ceiling. The image niche to the right (fig. 4.53) is very unusual: two connected niches with trabeated arches, each with a cross-ankled bodhisattva and flanking attendants, all in the Han style. The most recent publications of the cave consider both niches to be the work sponsored by Lady Hou, a reasonable conclusion considering the fact that there is no border between the two niches. Other visual evidence, however, indicates that the initial donation was the left niche adjacent to the inscription and that the right niche was a later addition. The concave shape of the nimbus inside the left niche as well as the roughly cut round outline of the upper edge of the niche are consistent with earlier examples of the round arch type (fig. 4.43), which suggests that Lady Hou's niche originally may have been quite conventional—a single round arch with garlands enclosing the cross-ankled bodhisattva. Such a work would be similar to what we find in a second dedication by the same Lady Hou in 503 (fig. 4.55), placed only a meter to the west (or rear) of these niches.

At some later date, a second donor (someone with a close relationship to Lady Hou such as the prince of Guangchuan himself) may have wished to have an image that was not just adjacent but physically joined with the work of Lady Hou. Unfortunately, the area to the right was not completely open: the row of four seated Buddhas below the second niche was already in place. Therefore, the bottom of the right niche could not be aligned to that of the left. Rather, it was the upper border of the niches that was redesigned to unify the pair. The trabeated arch was adopted, possibly because its angular form was visually well suited for a pair of arches, and the original decorative motif of garlands in the left arch and the area above the rounded arch were recarved into the trabeated arch we now see. The prominent fall of drapery between the niches, often found on the outer upper edges of trabeated arches, marks the original border between the two niches, which was recarved and completely removed between the backs of the two

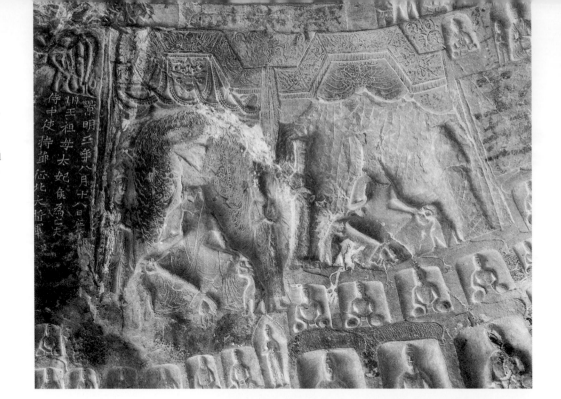

4.53 Niche dedicated by
Lady Hou, dated to 502, ceil-
ing, Guyang Cave. From Liu
Jinglong, *Longmen ershipin,* 98.

4.54 Inscription for niche
dedicated by Lady Hou, dated
to 502, ceiling, Guyang Cave.
From Liu Jinglong, *Longmen
ershipin,* 104.

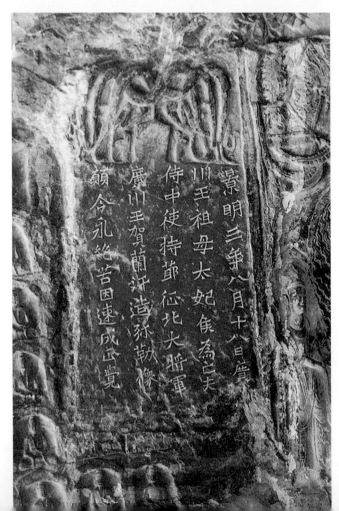

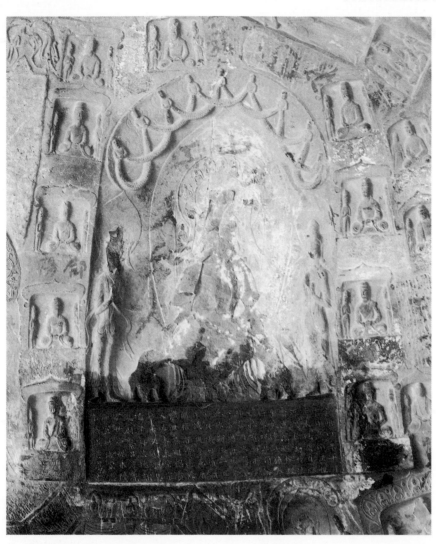

4.55 Niche dedicated by
Lady Hou, dated to 503, ceil-
ing, Guyang Cave. From Liu
Jinglong, *Longmen ershipin*,
112.

standing attendant figures. The space between the arches was filled with the haloed heads and torsos of adoring figures. The garland motif, in contrast to the usual motif of curtains below a trabeated arch (as in the right arch), may have been inspired by the garland loops that they replaced in the new design. The narrow shape of the left niche retains the proportions of the round arch niche, while the wider rectangular shape of the right niche is consistent with other examples of the trabeated arch type in the cave (fig. 4.60). The seated bodhisattva and lions nearly protrude from the left niche, further suggesting the possibility that the original niche around them was cut away.

Finally, it is clear that the right niche was never completed: the pattern of drapery on the main figure has yet to be carved, the background inside the niche is only roughed out, the figure of the left attendant is unfinished, and the right attendant is barely a shape.

4.56 *This page:* Inscription
for the niche dedicated by
Lady Hou, dated to 503,
ceiling, Guyang Cave. From
Liu Jinglong, *Ryūmon nijup-
pin,* 172.

4.57 *Opposite:* Niche dedi-
cated by Lady Gao, ceiling,
Guyang Cave. From Liu Jing-
long, *Longmen ershipin,* 180.

The contrast between the completed left niche and the condition of the right indicates that the right niche was indeed a later addition and most likely the unfinished attempt to augment and redesign Lady Hou's original dedication. It should also be mentioned that the round arch and cross-ankled bodhisattva is the normative type among dated works in this section of the ceiling, which further supports the hypothesis that the left niche was originally of the rounded arch type.

In contrast to the earlier donation, the inscription for Lady Hou's dedication of the tenth month of 503 is placed not on a stele but in a wide rectangular panel under the image (fig. 4.55).[133] The text (fig. 4.56), not carved in enlarged characters, is an extended and flowery dedication for the benefit of Lady Hou's family and her grandson, the prince of Guangchuan Yuan Lingdao. The niche is of the rounded arch type with garlands above a cross-ankled bodhisattva with standing attendants, all in the Han style; the form is a simplified version of Yuan Xiang's niche of 498. Note that her niche is flanked by a series of small, virtually identical pointed arch niches, each containing a seated Buddha. The lowest on the left (left of fig. 4.56) is inscribed with a short dedication by an official stating that an image of Sakyamuni was made for the benefit of Lady Hou and the prince of Guangchuan. A second niche, third from the bottom on the right, was similarly dedicated by another official.[134] Although the officials are not named and there are no dates, the small works demonstrate the manner in which patrons had works placed next to those of status with the intent of demonstrating their loyalty and support. The extant inscriptions suggest that each of the flanking niches was the votive work of minor officials who were in a close relationship with the family of Lady Hou and the prince of Guangchuan.[135] We can see in this ensemble of niches the manner in which a major donation and a series of related votive works may have been planned and coordinated.

One other work in this section of the cave should be mentioned: the niche (fig. 4.57)

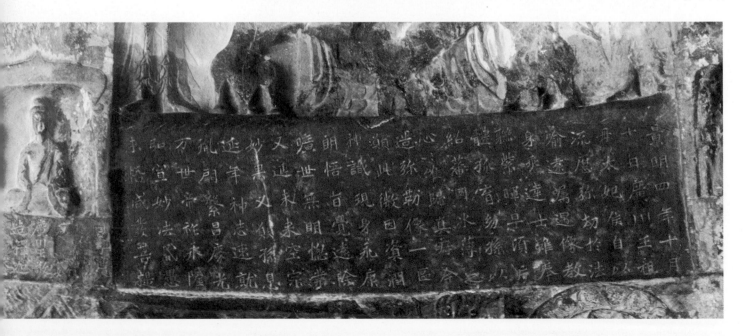

4.58 Rubbing, inscription
for the niche dedicated by
Lady Gao. From Liu Jing-
long, *Longmen ershipin,* 183.

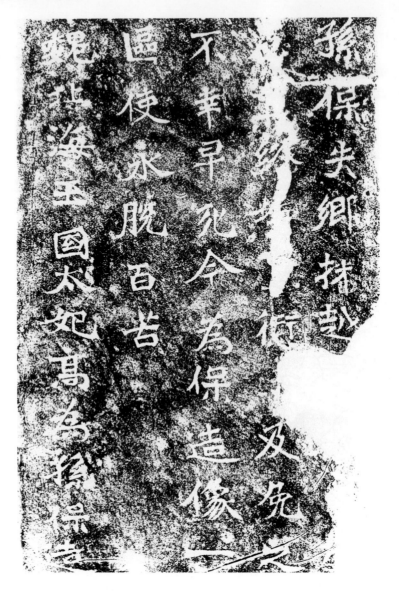

sponsored by Lady Gao, mother of the prince of Beihai 北海王太妃高, Yuan Xiang, who
made the donation of 498 on the north wall.[136] The undated dedication (fig. 4.58) is for
the benefit of Lady Gao's grandson, who passed away at a young age, and is carved on a
stele-like slab as was the prince of Beihai's inscription. In scale and content, Lady Gao's
niche is similar to that of Lady Hou's, only some 60 cm removed, and the others with
rounded arches in the adjacent area. The cross-ankled bodhisattva and attendant figures
are all in a sinicized style. The niche is not completely finished, the details of the figures
and the decorative motifs in the niche and arch having never been applied. The smooth

surface of the arch indicates that a relatively shallow incised pattern, probably of vine scrolls rather than the deeply carved garland motif, was intended.

It is possible that Lady Gao's was the earliest niche in this part of the ceiling, which would mean that work here was initiated by a donation from an imperial family member. Another possibility is that the location of Lady Gao's niche—far removed from that of her son Yuan Xiang—as well as its unfinished state was related to Northern Wei court politics. In 504 Yuan Xiang was found guilty of greed and other charges, including having an affair with the wife of Yuan Xie 元燮, the prince of Anding 安定王. Lady Gao was said to have been furious with Yuan Xiang after he was arrested and reduced to the status of commoner. Yuan Xiang would die in custody in the middle of 504, leaving his family in disgrace.[137] This might explain why Lady Gao did not open a niche near her son's and why her donation was never completed. In this case, her niche should date to the latter part of 504.

There is one more niche from 503 by a female patron, in this case a commoner: Jia Yuanying 賈元嬰, who dedicated her work in the north wall (fig. 4.36), near that of Ma Qing'an, on the second day of the eleventh month.[138] The small niche (fig. 4.59) was quite plain with an unembellished round arch containing a cross-ankled bodhisattva flanked by lions, but no sign of attendant figures. The brief dedication states that the image of Maitreya was for the benefit of a deceased husband and younger brother as well as a daughter. The donor was apparently unworthy to have her niche placed in the

4.59 Niche dedicated by Jia Yuanying, dated to 503, north wall, Guyang Cave. Photograph by Chen Zhi'an.

ceiling with those of elite female patrons such as Lady Gao. The simple form of the niche indicates the kind of work—profuse throughout the cave—that may be considered that of commoners.

The four other donations by women, one by the female *yiyi* flanked by the two of Lady Hou and joined by the nearby work of Lady Gao, suggests that gender affiliation was a consideration in sponsoring niches at the top of the ceiling. It is striking that the *yiyi* of relatively lower social standing found it necessary to emulate the Han-style stele commonly found in the donations of elite patrons. The cluster of works sponsored by women underscores the central role of female patrons in the Guyang Cave from its inception and suggests something of the manner in which class divisions might be ameliorated through gender identification. The simple niche of Jia Yuanying, on the other hand, reminds us that many male and female donors were left with whatever insignificant spaces might be available to the more common classes.

LOYALISTS

The last group of dated niches to be discussed emphasizes to varying degrees a concern with expressing loyalty to either past or present emperors or imperial family members. The first such dedication, dated to the eighth month of 503, is on the front section of the ceiling (fig. 4.50), at some remove from the cluster of women's donations at the rear.[139] Located a short distance above the four niches of Zheng Changyou and his wife, this was the project of an *yiyi* of thirty-four patrons under the leadership of an *yizhu,* Ma Zhenbai 馬振拜, and two *weina,* Zhang □cheng 張□成 and Xu Xingzu 許興族 (fig. 4.60). There are no official titles attached to any names, again an indication that the members were all commoners. The inscription, which also utilized the Han stele form with the title *yizixiang* squeezed in two lines into a small head, is the first in the cave to specifically designate the Northern Wei emperor as a beneficiary, and in this case the *only* beneficiary, of the donation. This is striking considering the fact that we have reviewed a significant number of earlier donations from highly placed individuals, court officials, and members of the imperial family, as well as a number of *yiyi*. There is the occasional patriotic mention of the empire but nothing like this reference; the fact that the patrons are organized in an *yiyi* should alert us again to the special relationship of this form of Buddhist association with the state.

The main image has been removed and scholars disagree on whether the original form of the figure was a cross-ankled bodhisattva or a seated Buddha.[140] Cross-ankled bodhisattvas in a Han style feature stiff ends of drapery and ribbons carved on the inner surface of the niche behind the head and shoulders (fig. 4.53), much as one sees here around the standing attendant bodhisattvas. But none are to be found behind the main figure here; nor is there evidence of the small lions that usually flank the bodhisattva image. Furthermore, the beautifully scalloped ends of drapery visible below the lower edge of the niche is a characteristic of Han-style seated Buddha images rather than bodhisattva

4.60 Niche dedicated by
Ma Zhenbai et al., dated to
503, ceiling, Guyang Cave.
From Liu Jinglong, *Longmen
ershipin,* 106.

figures. The remains of drapery well match the "waterfall" drapery pattern found on
some sixth-century works—for example, on a Buddha image, possibly from the Guyang
Cave, now in the Asian Art Museum, San Francisco (fig. 4.61).[141] The comparison
strongly indicates that the main image in the Ma Zhenbai niche was a similar type of
Buddha and the earliest dated niche in the cave to incorporate the "waterfall" pattern.
Other undated examples of a seated Buddha in the trabeated arch type of niche in the
ceiling suggest that the combination of the trabeated arch with the seated Buddha im-
age was common in the upper part of the cave. At a later point, however, the trabeated
arch will become strongly associated with the cross-ankled bodhisattva image—for ex-
ample, in the major niches of Row II (fig. 4.73).

 The next two dated works were dedicated by individual monks on the same day at
the beginning of 504.[142] One was opened in the upper part of the north wall (fig. 4.19)
directly above Hui Cheng's Row III niche by the monk Hui Le 慧樂.[143] The round arch
niche, the background left largely plain as we saw in Lady Gao's work, encloses the fig-
ure of a cross-ankled bodhisattva badly mutilated when the head was removed (fig. 4.62).
As might be expected for the relatively late date, the slender main image and flanking

4.61 Seated Buddha, possibly from Guyang Cave. Asian Art Museum, San Francisco, B60 S499. Photo courtesy of the Asian Art Museum of San Francisco.

bodhisattvas are depicted in the Han style. To the right is the inscription (fig. 4.63) carved on a Han stele with *mile foxiang* 彌勒佛像 (Maitreya Buddha image) as the title—which may strike some as odd because the image is clearly that of a bodhisattva, not a Buddha. The text dedicates the work to the prince of Beihai, Yuan Xiang, at this point a powerful confidant of the emperor Shizong. The encomium to the prince conveys a strong political flavor to the monk's work, which is reinforced by the location of the donation just above the niche made by the monk Hui Cheng for the duke of Shiping and near Yuan Xiang's own dedication. At the same time, Hui Le does not choose to underscore his relationship to the older works with visual quotations, as we have seen in some other niches on the north wall (fig. 4.42).

On the very same day, another monk, Fa Sheng 法生, dedicated a major niche (fig. 4.64) in Row III of the south wall next to the *yiyi* niche of Sun Qiusheng.[144] The arch is a similar pointed type and, as in the Sun Qiusheng work, the seated, meditating Buddha is depicted in a Western style with Han-style attendant bodhisattvas. The work

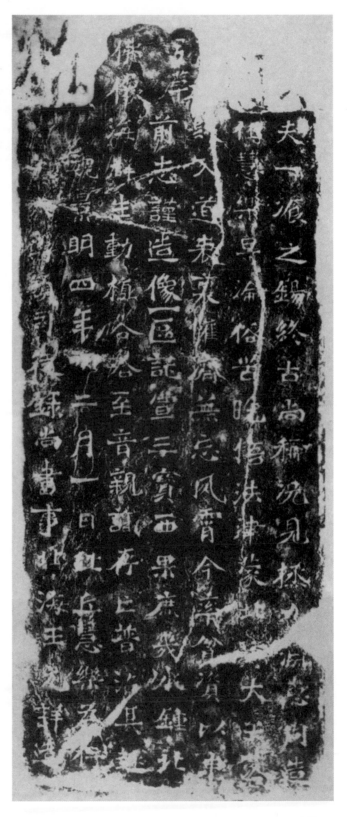

4.62 *Left:* Niche dedicated by Hui Le, dated to 504, north wall, Guyang Cave. Photograph by Chen Zhi'an.

4.63 *Right:* Rubbing of the inscription for the niche dedicated by Hui Le. From Liu Jinglong and Li Yukun, *Longmen shiku beike*, 2: no. 1850.

4.64 Niche dedicated by
Fa Sheng, dated to 504, south
wall, Guyang Cave. From
Ryūmon bunbutsu hokanjo
and *Peking daigaku kōkokei*,
Ryūmon sekkutsu, 1: pl. 140.

is less finished, however, with abrupt, hard edges along the drapery over and down both
shoulders. The same effect is found in the sharply broken-off edges of the drapery in
front of the legs. The kneeling worshipers of the *yiyi* niche, also found in Hui Cheng's
early Row III donation, are here replaced by a pair of groups in procession (fig. 4.65):
monks on the left leading a row of laymen, and possibly tonsured nuns on the right lead-
ing sumptuously dressed female followers. Considering the class of patrons indicated by
these figures, one would expect the inscription to be set on a large Han stele to the side
of the niche as was done for the Sun Qiusheng *yiyi* donation; but quite unexpectedly,
the text is limited to a small squarish panel between the pair of processions. The com-
position is reminiscent of the later pair of imperial processions carved in the Binyang
賓陽 Cave.[145] In fact, the names of the prince of Beihai, his son, and another member of
the imperial family are recorded in small characters among the figures (along with those
of five of the clergy). But the names are lightly scratched onto the stone and not placed
in the usual colophon frames, which suggests that these were not part of the original
design of the niche.[146] This is not to say that the names provided may not be accurate.
The visual representation of a relationship between Buddhist clergy and the highest lev-
els of patronage is echoed in the inscription, which expresses Fa Sheng's devotion to
Xiaowen, the posthumous name of the deceased emperor Gaozu, the previously en-
countered prince of Beihai, Yuan Xiang, and the prince's mother. Along with Hui
Cheng and Hui Le, Fa Sheng is the third monk who has mentioned highly placed indi-
viduals in his dedication, testimony to the close—possibly even familial—ties between

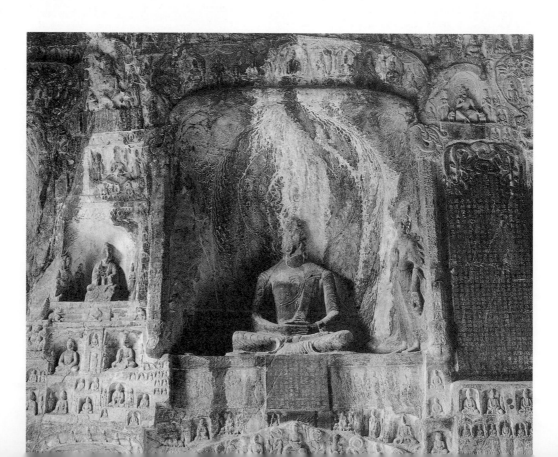

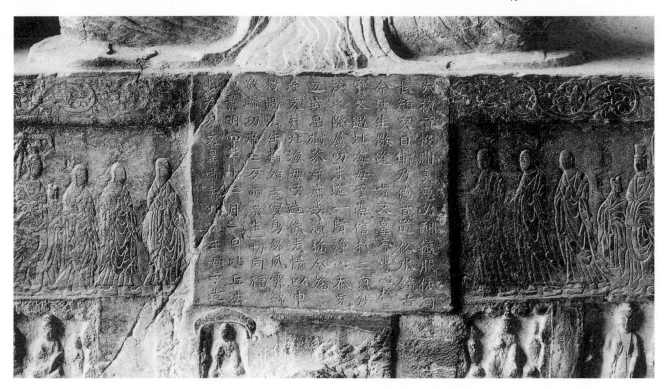

4.65 Inscription flanked by donors, niche dedicated by Fa Sheng. From Liu Jinglong, *Longmen ershipin,* 127.

certain elite-class monks and the imperial family. In addition, the fact that two works for the prince of Beihai were dedicated on the same day by two monks underscores the manner in which the prince's earlier niche served as inspiration for his supporters.

Two other major undated niches in the north wall of Row III need to be mentioned because they are probably of this period or just after. The first is that of two individuals, Wei Lingzang 魏靈藏 and Xue Fashao 薛法紹, whose niche (fig. 4.66) is adjacent to that of Hui Cheng's.[147] Wei is identified at the end of the dedication as an important local official, the *gongcao* 功曹 of Luhun 陸渾, a county (*xian*) located some 50 km southwest of Longmen.[148] The Han stele form, with the title *shijiaxiang* 釋迦像 (Sakyamuni image) in the head, is used for the inscription. The tablet, which was broken some time after good rubbings (fig. 4.67) of the whole had been made, contains a florid, abstract text with only a broad reference to the empire. The main image has something of the angular quality of Fa Sheng's, the same sharply delineated drapery over the right arm, and similar abrupt cutting of the stone in front of the legs, all of which contributes to a similar sense that the work was not finished. The convention of kneeling worshipers below the main image has been modified to represent the donors in standing positions. The niche is an interesting hybrid in that the pointed arch shape, standard for seated Buddha images, is decorated with the prominent looping garlands that are found in round arches, initially on Lady Yuchi's donation of 495 just above and for a Buddha im-

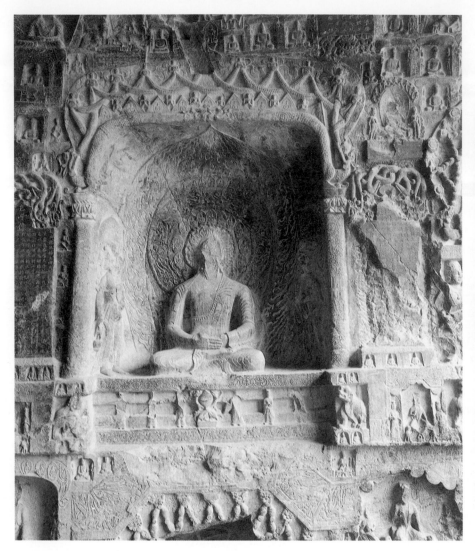

4.66 *Left:* Niche dedicated by Wei Lingzang and Xue Fashao, dated 504, north wall, Guyang Cave. From Liu Jinglong, *Longmen ershipin,* 144.

4.67 *Right:* Rubbing, inscription for the niche dedicated by Wei Lingzang and Xue Fashao. From Liu Jinglong, *Longmen ershipin,* 157.

age in Hui Cheng's niche just to the right (fig. 4.19). The latter two and the Wei Lingzang arch can be understood as a series of linked variations on the garland motif in the north wall.

The other undated major niche is to the left of Wei Lingzang's (fig. 4.68). The inscription placed on a Han stele tablet is titled *yizixiang* or *yiyi* image. But there is only one sponsor listed in the text (fig. 4.69): the *yizhu* Yang Dayan 楊大眼, a prominent Wei military leader who made this donation upon his return from a campaign in the South.[149] Based on the *Weishu* records of Yang's involvement in such campaigns, dates for the niche from 500 to 506 have been suggested by various scholars, but circa 504 appears most plausible.[150] The work is clearly that of an individual sponsor, which makes

the references to *yizixiang* or *yizhu* inexplicable. Possibly Yang and others originally meant to lead an *yiyi* in the sponsorship of the niche but the association failed to materialize and the work was completed as the donation of Yang. What is underscored by this odd juxtaposition of the powerful elite sponsor and a nonexistent *yiyi* is that the project was primarily Yang's; if there was participation from unmentioned members of an *yiyi*, it appears to have been little more than the obligatory support of those beholden to him. This is not to say that all *yiyi* dedications were necessarily of this type, but to discern something of the possible individual nature of some group donations as well as the relationship of elite and common patrons. Yang's dedication is directed at beginning and end toward the benefit of the deceased emperor Xiaowen, the posthumous name of Gaozu. The tone is decidedly nostalgic and if the work was dedicated after the sudden

4.68 *Left:* Niche dedicated by Yang Dayan, dated to 504, north wall, Guyang Cave. From Liu Jinglong, *Longmen ershipin*, 158.

4.69 *Right:* Inscription for the niche dedicated by Yang Dayan. From Liu Jinglong, *Ryūmon nijuppin*, 96.

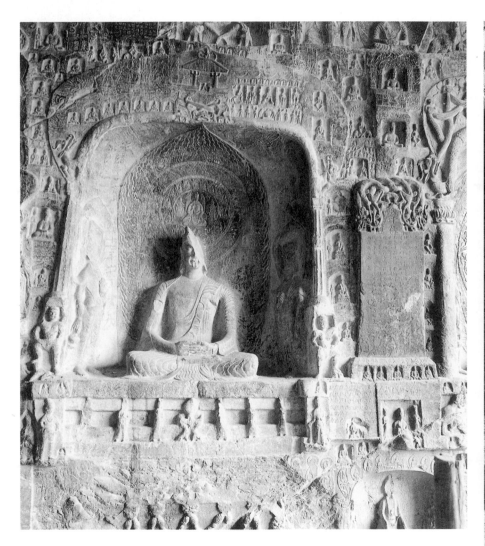

demise of Gaozu's brother, Yuan Xiang, in mid-504, one might read the text as a covert paean to the memory of Yuan Xing, whose presence in the cave would have been so recently palpable.

Yang's image is very close in style to that of Wei Lingzang but was more completely finished—for example, in the reasonably convincing rendition of drapery over and around the feet. As was the case in each of the major Row III niches, the Buddha is in the Western mode of dress while the attendant bodhisattvas to each side are in the Han mode. Interestingly, the style of the seated Buddhas in the halo (fig. 4.70) is a contrast to the main Buddha figure. Draped in the closed mode, the fullness of the lower robes, the sloping shoulders, and the relatively small head lend a very different sensibility to the small images. It should be noted that the ends of the robe that would typically pass over the left shoulder are allowed to slide down—exactly the same practice found in the Han mode in Yungang Cave 6, but without any of the other elements of the Han type of dress. The two standing attendants on lotus bases, the left figure rather more fully garbed in the Han mode than the right, are also a contrast to the standing bodhisattvas in the niche. The small seated Buddha figures in the first ring are in yet another version of the closed mode. We are again reminded of the range of contemporary modes and styles available to the patrons of the Guyang Cave. Despite the distinctive stylistic characteristics and carving in the most shallow relief yet encountered in any of the Row III niches, the decoration of the niche appears internally consistent and contemporary with the main Buddha image and attendants. The crown of the pointed arch, on the other hand, was inexplicably left unfinished, allowing an unorganized jumble of small carvings to be added at a later date.

PATRONAGE AND PROCESS

Several levels of social class may be distinguished in the patrons of dated niches in the Guyang Cave: imperial family members, court or other high officials, lower officeholders, individual monks, individual commoners, and *yiyi*. As previously noted, while patronage was mixed from the inception of niche construction, the prominent early dedications by highly placed individuals such as Lady Yuchi or the son of the duke of Shiping, Hui Cheng, remained exemplary of certain goals and visual themes for niches in the cave. The foremost was the commemoration of deceased family members in eulogies inscribed on a form of the Han memorial stele.[151] But exceptions occur from early on—Gao Hui's generalized dedication of 498, for example. Later dedications of a commemorative nature were concentrated among elite patrons such as Zhang Chengyou and wife, Lady Hou, and Lady Gao. The appropriation of the Han stele form has often been cited as evidence of sinicization; however, the persistence of Western modes of imagery in the accompanying sculpture belies a more complex situation. Ethnicity, while an important factor in the selection of visual styles, was not determinative. Rather, elite-class patrons as a whole preferred Han modes of dress and, predictably, the Han mode

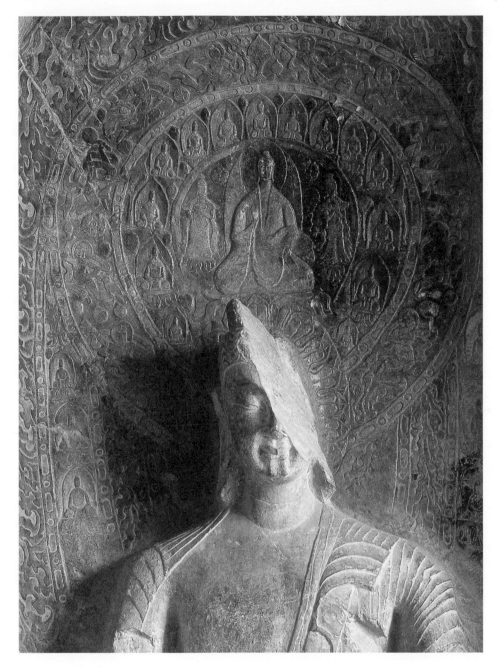

4.70 Detail, seated Buddha and halo, niche dedicated by Yang Dayan. From Liu Jing-long, *Longmen ershipin,* 167.

was increasingly favored as time passed. Yet there were moments when it was appropri-ate to revert to older styles as in the three niches simultaneously dedicated in 502 (Hui Gan, Gao Shu, and Zhao Shuangzhe). An important lesson is that new modes or styles do not automatically replace older ones: various permutations of multiple styles may co-exist at the same time and place. Evolutionary schemes of linear development may be

pertinent if the view is from a sufficiently distant point; individual works in a single site such as the Guyang Cave, however, allow us to delineate a far more complex conjunction of interests and visual choices.

The number of dedications in the Guyang Cave by patrons of a common social standing, individual monks, and *yiyi* increased after the death of Emperor Gaozu in 499. The correlation in the earlier period, however, between the class of the patron and the size of an image niche—the higher the class, the larger the niche—was for the most part erased in the second period. Other visual marks of status in the first period—for example the Han stele form for the inscription—continued to be almost completely a prerogative of elite donors (Lady Hou, Lady Gao, Sun Qiusheng, Yang Dayan, Wei Lingzang). A monk, Hui Le, who used the stele form to extol the virtues of the prince of Beihai, may have been from an elite-class family. The elite monopoly of the Han stele form is broken only in the dedication by the women's *yiyi* (Yin Aijing et al.) in the ceiling. Notably, the calligraphy of their inscription is far below the level set in other dedications using the Han stele format, an indication that this *yiyi* was not of the same class as the other elite patrons. This is not to say, however, that only elite-class patrons were capable of securing a high level of calligraphic skill for their inscriptions—there are examples of excellent calligraphy among the dedications of common-class donors.

The five dedications by *yiyi* in the Guyang Cave are surprisingly varied in scale, subject matter, and social composition. What they indicate is that the characteristics of group donations by religious associations could vary to a considerable degree and are not easily fitted into a category of nonelite patronage. The use of the Han form of stele in the *yiyi* dedication of Sun Qiusheng illustrates the manner in which *yiyi* led by local officials appropriated elite forms. It was even possible, although not typical, for an *yiyi* with no special social status such as that of Yin Aijiang et al. to sponsor a niche not only adjacent to the dedications of elite-class women such as Lady Hou and Lady Gao but also reproducing their use of the Han stele form. The other examples include the modest images of *yiyi* led by Gao Shu and Ma Zhenbai plus the unfinished dedication of Hui Shou.

If *yiyi* served as a vehicle through which commoners were able to participate in the donation of works comparable in scale or refinement to those of the elite classes, the benefits of banding together is underscored by a glance at the donations of individuals such as Gao Hui or Zhao Shuangzhe. With short, hastily written texts that fail to fill the available space, their niches are all but indistinguishable from the myriad other small works crammed into the walls. They are haphazard and inchoate in a manner that would suggest their marginal social position in the Guyang Cave. The modest scale and visual quality of such niches strongly argue for their common-class patronage.

The complex mix of patronage in the Guyang Cave was recognized by Soper, who suggested that the cave was opened and developed by a loose association of individual donors.[152] At the same time, the two symmetrical rows of large image niches along the walls and the imposing main image at the rear are evidence that someone had a plan for

the cave. The most likely candidate is the monk Hui Cheng, who claimed to have made a cave temple for the benefit of the nation. Since the Guyang Cave was a natural cavern and did not need to be excavated, this probably means that he was taking credit for the installation of the main image and the set of eight large niches, which he might reasonably be expected to coordinate and direct. Yet Hui Cheng was not nearly the first to complete a dedication in the cave, that of Lady Yuchi's being nearly three years earlier. Furthermore, Lady Yuchi's dedication is relatively small and placed high up on the north wall. A nearly identical niche would be opened above hers by Yuan Xiang, the prince of Beihai and half-brother of the emperor, in 498. This is notable because patrons of such status would be expected to command a more central and significant donation, namely one of the eight large Row III niches. Apparently, claiming one of the large image niches was not an option for Lady Yuchi or Yuan Xiang, which suggests to some that the eight niches were already spoken for. Alternatively, their small niches may have been planned before the set of eight niches had been conceived. Although a definite conclusion is not possible, it seems possible that work in the Guyang Cave commenced in the upper walls of the natural cavern before Hui Cheng claimed the cave and conceived of the symmetrical set of large niches.

In addition, we know that the prince of Beihai and his mother vowed to make their image niche in early 495 and dedicated the work in 498. It therefore seems reasonable to assume that the dedication by Lady Yuchi of 495 was planned some time before its completion. It is thus probable that work on the Guyang Cave commenced some time in the latter part of 494 or early 495, at a time when the new capital had hardly taken shape. Lady Yuchi's donation for her deceased son may have been the act that established the natural cave as a site of commemorative dedications. Her dedication was soon followed by Yifu's small niche for her deceased husband, setting a pattern in which women would continue to have significant patronage in the cave. The plan for the set of eight niches and main image might therefore be understood as the reorientation of the cave from a site open to a wide range of patrons to one ordered around the symmetrical works of elite male donors. Hui Cheng's political and social status—the son of a highly placed Northern Wei official—was the necessary basis for him to take over a cave that already had the highest levels of patronage, albeit only for small niches.

If Hui Cheng planned the major images in the cave, it is difficult to determine what he was able to complete beyond the image niche of 498 for his father. Some scholars have suggested that the undated large niche at the rear of the south wall (fig. 4.71) was the earliest in the set of eight based on style, specifically the Western style of all of the figures and the robust, deep carving of the niche interior. Although one should be cautious about relying on stylistic features to periodize niches in the Guyang Cave, a compelling argument has been made that the carving in this niche—less hardened and stylized than that of the others—indicates that it should be at the beginning of the series of eight niches.[153] If this work was the first to be completed, it is very odd that there is no

4.71　Niche III–1, south
wall, Guyang Cave. From
Ryūmon bunbutsu hokanjo
and Peking daigaku kōkokei,
Ryūmon sekkutsu, 1: pl. 144.

adjacent Han stele as in Hui Cheng's donation nor any inscription at all despite the ample room that should have been available. One possible explanation is that this niche is also the work of Hui Cheng, who would have had no need to erect a stele for each of his niches. The opposite niche, the rearmost on the north wall (fig. 4.72), also lacks a dedication or a stele and might have originally also been a work of Hui Cheng. This niche, however, appears to have been recarved in a style contemporary with the main images on the back wall, dated to 505 or a little before. In contrast to the other seven large niches in this row, the surface across the front of the base is cut conspicuously deeper (fig. 4.73). Also note the scored diagonals across the front of the throne, which are reminiscent of the crossed legs of bodhisattva figures in the cave, as well as the small

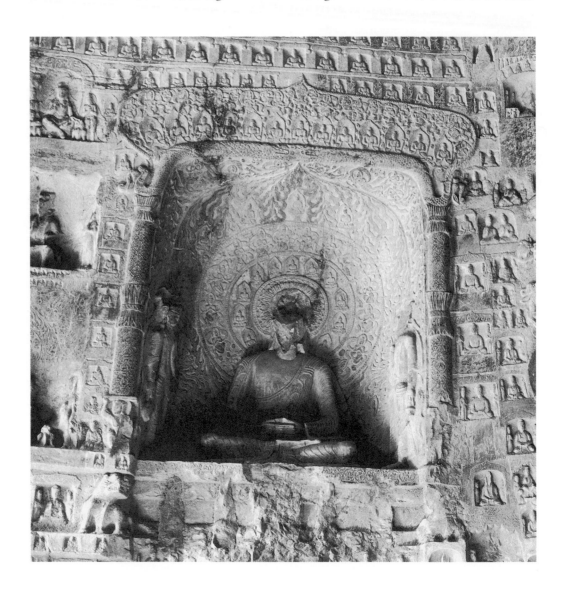

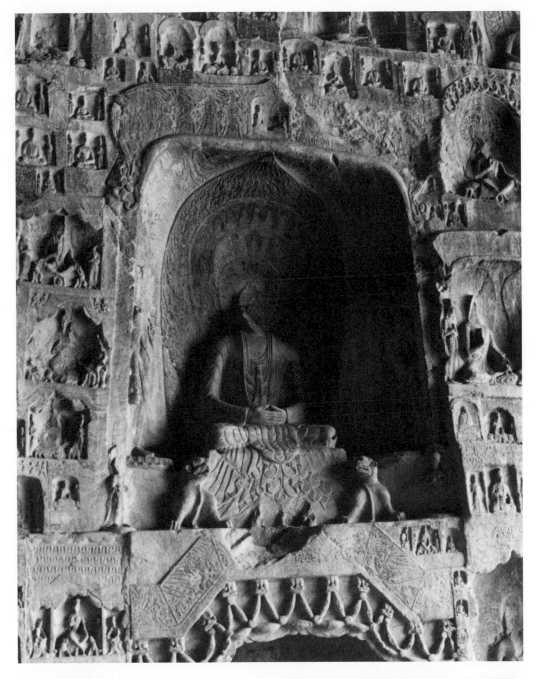

lions to each side. The latter are ubiquitous as attendant figures to the cross-ankled bodhisattva and are rarely if ever found with a seated Buddha as we have here. Katherine Tsiang argues that the original image was a cross-ankled bodhisattva, which would complete the original set of eight niches as a set of the seven Buddhas of the Past and

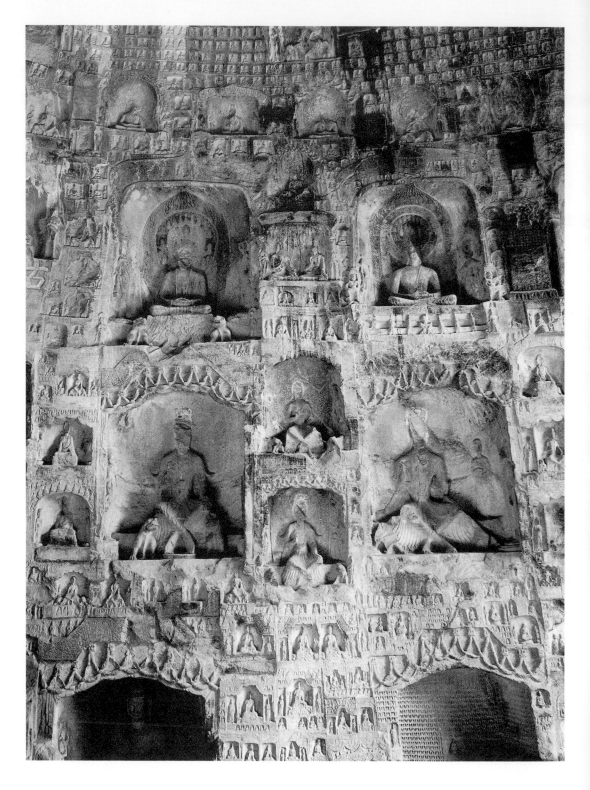

4.73 North wall, west section, Guyang Cave. From *Ryūmon bunbutsu hokanjo* and Peking daigaku kōkokei, *Ryūmon sekkutsu,* 1: pl. 150.

Maitreya.[154] Such a set would further indicate the involvement of a single patron or co-ordinator. The recutting of the bodhisattva figure, however, tells us that the original plan was abandoned before 505, which further suggests that Hui Cheng was not involved in the cave by this date.

Only one other large niche, the first on the south wall facing Hui Cheng's donation, lacks a dedication, although an adjacent inscription on a stele could have been destroyed by damage to the front wall. If the last niche without an inscription was also sponsored by Hui Cheng, we have a neat symmetrical arrangement of two facing pairs of niches at the very front and rear of the cave for his works. The other four large niches are accounted for and each was dedicated relatively late in the period under consideration, which raises the possibility that these patrons were not part of the original plan but stepped forward after it was clear the monk would not himself complete the set of eight images. The first patrons to dedicate a niche in this group was the *yiyi* led by the local official Sun Qiusheng and others of similar rank; followed by a monk, Fa Sheng, who appears to have had a close relationship to members of the imperial family; and two undated works. One of the latter is that of the military officer Yang Dayan; the other is that of a prominent local official, Wei Lingzang. Monks and laymen alike, these patrons are distinguished, at least in their rhetoric, by their service to the Northern Wei and their loyalty to the imperial family. If Hui Cheng planned the set of eight niches for the benefit of the nation, those individuals who completed his work appear to have very much shared his loyalist sentiments.

The main image group in the cave, the large-scale seated Buddha and attendant bodhisattvas at the rear, was completed by 505. It has been suggested that the paean to the former and current emperors in Yang Dayan's dedication of circa 504 was inspired by gazing at the main image of the Guyang Cave: "seeing the brilliant tracks of the former emperor(s) and gazing at the beautiful traces of the flourishing sage(s) 覽先皇之明蹤, 睹盛聖之麗跡." This could mean that Yang was relating the main image specifically to the former emperor, Gaozu, either as the patron or the beneficiary of the work, and the current emperor Shizong as the one responsible for its completion.[155] Imperial patronage for the main image would be consistent with the scale of the work as well as the numerous imperial connections in the cave and the elevated status of Hui Cheng's father. It is therefore tempting to construe the purpose of Shizong's visit to Longmen in 504 as being for the dedication of the Guyang Cave main image in the memory of Gaozu. The language of texts such as Yang's, however, is characterized by grand metaphoric allusions and one is hesitant to too quickly interpret his flowery imagery as a reference to specific imperial patrons.

Similarly, it should be remembered that the version of Hui Cheng's role in the Guyang Cave as related over the past few paragraphs is far from proven fact. Despite the surfeit of dated inscriptions and niches there is much that is elusive if not paradoxical in the extant evidence. The difficulties in explaining the development of the cave in rela-

tion to the pattern of patronage is compounded by the fact that we have no evidence for the process of planning and executing niches in the Guyang Cave. A sponsor would have had to engage someone to plan and carry out her or his work. In contrast to the Mogao Caves outside Dunhuang, which almost certainly had a resident community of monastics and laypeople to design the cave temples, there is nothing to indicate that a similar situation existed at Longmen.[156] Even if the monk Hui Cheng was the individual responsible for the Guyang Cave, he seems not to have been particularly attentive to the myriad small donations appearing almost at random from an early date. Alternatively, Hui Cheng may have intended that the cave was available to a wide range of donors. Yet the marked disorganization and heterogeneous patronage belies the vision or supervision of any single overseer.

In contrast to calligraphic quality, the level of the carving of the figures and niches appears relatively even throughout both periods, although the mutilation of so many figures and the small scale or location of some works make close stylistic comparison difficult. It seems probable that one or more organized workshops of designers and carvers were available to work in the cave with a relatively low level of state or monastic supervision. In such a situation, several alternative scenarios for the planning and production of the niches are possible. One is that the sponsors specified the type of work to be done and where the donation should be placed. A second is that the donors had nothing to say about either the visual content or placement of a niche, which probably means that they did not necessarily visit the site before the work was completed. A third would be some combination of input from the sponsors and independent decisions by the workshop. Although the texts of the inscriptions have been described as formulaic and predictable, and indeed some phrases are repeated in more than one text, the differences in the overall rendition of the dedications—no two are exactly alike—indicate that the donors wished their texts to be individualized. In some cases the length of a text did not match the size of the tablet; in others, the text appears incomplete. Some niches were never completed. Such visual anomalies suggest that some—maybe most—of the sponsors never saw their finished donations in the Guyang Cave.[157] Such a possibility is supported by inscriptions that identify donors who are from places located some distance from the Longmen site. If it was common for some time to pass between the commissioning of a niche and its completion, one could imagine patrons who visited the Guyang Cave and made arrangements for the opening of a niche, but did not necessarily expect to ever return to see it.

As we have seen, the Guyang Cave presents the art historian with an especially messy set of problems: no clear overall design or sequence of works, many dated niches but also many obviously important dedications lacking inscriptions and/or dates, and a heterogeneous range of patronage. For one in search of a stable history of patronage, function, and meaning in the cave, it is most disconcerting to gaze up at the sloping walls and domed ceiling of the Guyang Cave (fig. 4.7), writhing with hundreds of barely legible

image niches and dedications. In that vertiginous moment, the surface of the Guyang Cave provides too much data, an overload of sensory information that is not only an aporia in the linear narrative of Buddhist sculpture but an unruly, unmanageable site that, if dwelled upon too long, threatens to overwhelm the present with the inchoate vision and voices of the past.

Chapter Five

Perhaps we are—as so often happens—handicapped by the fact that we can only observe Buddhism and Taoism at the very highest level, that of the religious "professionals" and their written texts—the tops of two pyramids. We may consider the possibility that at a lower level the bodies of the pyramids merged into a much less differentiated lay religion, and that at the very base both systems largely dissolved into an indistinct mass of popular beliefs and practices.[1]

ALTERNATIVES

 IN THE PREVIOUS CHAPTER, the focus was on works of sculpture produced just outside the capital of the Northern Wei dynasty. In the earliest cave at the Longmen site we found votive niches dated from 495–504 that operated within a narrow range of visual types and ostensible religious goals. Although the patrons in the cave reflected a wide range of Northern Wei society, works of elites as well as the common classes were uniformly limited to conventional forms of Buddhist imagery with no evidence of popular beliefs as we found in the Northern Liang pillars. The Guyang Cave niches were products of a metropolitan milieu—the most conventional politically as well as religiously—that was most closely aligned with clerical and elite-class Buddhism. This chapter moves westward from Luoyang to consider contemporary works from Shaanxi Province (map 5) where we find a far greater variety of imagery, including Daoist and Buddhist-Daoist works. Although a number of scholars have followed Zürcher's suggestion that popular beliefs and practices are to be located at the intersection of Buddhism and Daoism, we will find that sculpture from Shaanxi reflects a rather more complex range of imagery and beliefs that defy any easy categorization.[2]

The fall of Luoyang to the Xiongnu 匈奴 in 311 marked the end of the Western Jin dynasty and the beginning of the Sixteen Kingdom Period in northern China. Chang'an, captured by another Xiongnu leader in 316, was to be the capital of several non-Han kingdoms during the fourth and early fifth centuries, including the Former Qin (351–394) and Later Qin (384–417) dynasties. These were respectively established by members of the Di 氏 and Qiang 羌 peoples who, along with other non-Han groups such as the Jie 羯, were settled in and around Chang'an well before the Northern Wei captured the city in 426 from the Xiongnu Xia Kingdom. Buddhism flourished among and with

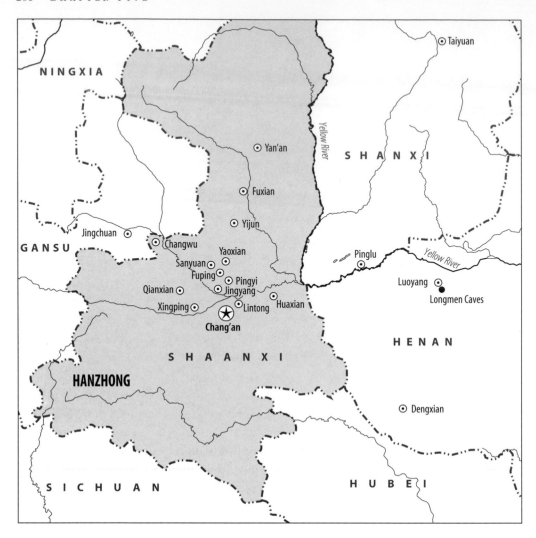

the support of many non-Han rulers during the fourth and early fifth centuries. Chang'an was an important center of Buddhist translation—two of the most famous early propagators of Buddhism, Daoan and Kumarajiva, worked here despite the political turmoil. Monastic institutions continued to flourish after the Northern Wei takeover; it was one of these monasteries that drew the attention and ire of Emperor Shizu, who initiated a proscription of Buddhism in 445. Buddhism would soon recover and, if extant works of sculpture are any indication, the religion was a powerful presence in the region in the latter half of the fifth and early sixth centuries.[3]

It was to the southwest of Chang'an in Hanzhong 漢中 that the followers of Celestial Master 天師 Daoism maintained a semiautonomous state from the early third cen-

tury until they were overrun by armies of the Former Qin in 373.[4] It is probable that many Daoist families were moved to Chang'an after the defeat. The most important figure for organized Daoism in the North, Kou Qianzhi 寇謙之 (365–448), was a member of a high-ranking family from Pingyi 馮翊, near Chang'an. When Chang'an was taken by the Eastern Jin general Liu Yu 劉裕, Kou's older brother led a large number of families to Northern Wei territory and was rewarded with an appointment as their governor at Luoyang.[5] This was no doubt helpful when Kou traveled to the Northern Wei capital in 424 with newly revealed texts and, with the support of the court official Cui Hao 崔浩 (381–450), gained for his teachings the official approbation of the Northern Wei court. In addition, the site of Louguan 樓觀, some 60 km southwest of Chang'an, was an important Daoist site that was considered in later periods to be the home of Yin Xi 尹喜, the first recipient of the *Daode jing* 道德經 and Laozi's 老子 interlocutor.[6]

By the latter part of the fifth and early sixth centuries, the area around Chang'an— with its long history of racial, cultural, and religious heterogeneity—was a fertile site for the production of a wide range of visual imagery. Osvald Sirén and others recognized from early on the distinctiveness of Northern Wei sculpture from Shaanxi as well as the variety of visual styles to be found within the sculptural production of the province.[7] For the most part, the diversity of styles in Shaanxi has been understood in terms of provincialism in local visual traditions.[8] But the various approaches and themes reflect more than subregional styles; they are also related to different kinds of patronage—factors of social class and ethnicity, a range of individual, family, and group donations including *yiyi*—as well as a more complicated mixture of religious goals and beliefs. Among this web of complex factors, my interest will be to locate and identify examples of both elite and "ordinary" works. I will begin with a discussion of dated sculpture from Chang'an, the most important urban center in the province, then move to contemporary works from outlying areas, including Lintong 臨潼 and Yaoxian 耀縣.

METROPOLITAN PRODUCTION: CHANG'AN

The earliest dated work of Buddhist sculpture from Chang'an is a cross-ankled Buddha (fig. 5.1) from Xingpingxian 興平縣, just west of the city, dated by inscription to 471.[9] There are a number of slightly later works, contemporary with the Guyang Cave, that have been excavated from the immediate vicinity of the city. These establish something of the range of stylistic approaches found in the metropolitan area at the end of the fifth and beginning of the sixth centuries. The first is a rectangular niche (fig. 5.2) dated by inscription to 496 discovered in a southern suburb of Xi'an.[10] The main image is a seated Buddha dressed in monastic robes with symmetrical folds delineated in parallel lines over the arms, down the chest, and splayed below the hands. The enlarged proportions of the head and hands in contrast to the pipelike limbs, the simple lines of the drapery, and the almost childlike facial features lend an air of naive charm to the work. To the sides are a

5.1 Cross-ankled Buddha,
dated to 471. Beilin Museum,
Xi'an. From Matsubara
Saburō, *Chūgoku bukkyō
chōkokushi ron,* 1: pl. 42.

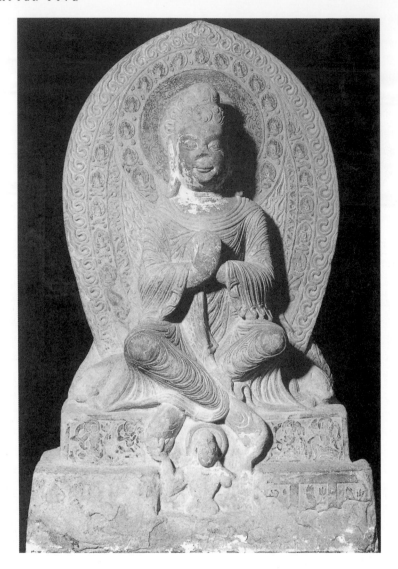

pair of figures that should be bodhisattvas, but these slim attendants appear to be dressed in feminine long gowns with their hair piled high atop their enlarged heads. This is a decidedly odd depiction of the usual standing attendants—for example, those from Yungang (figs. 4.3 and 4.4).

The dedication, carved in a crabby, inelegant hand on the right front, identifies the work as a Sakyamuni (*shijiawen* 釋迦文) image made by the Buddhist disciple (*fodizi* 佛弟子) Tian Yu 天郁, represented by the small donor figure in relief. Above a pair of similar figures to the left side are the names of two more patrons identified as a "Woman of Pure Faith" (*qingxinnü* 清信女) and a "Man of Pure Faith" (*qingxinshi* 清信士). Arrayed

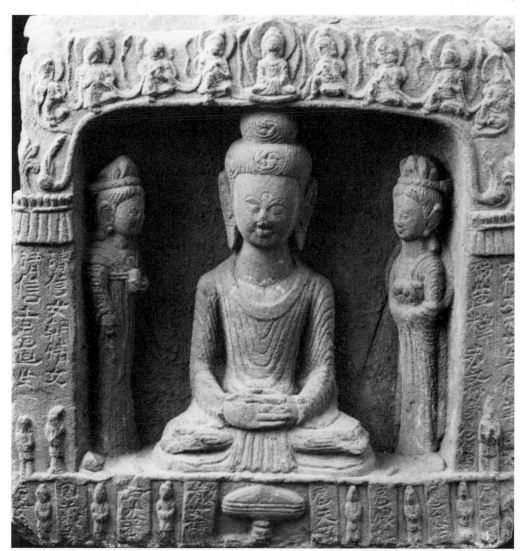

5.2 Rectangular niche, dated to 496. Beilin Museum, Xi'an. Photo courtesy of Pei Jianping.

along the bottom of the niche are a series of standing donor figures with adjacent colophons. The right side has a vertical series of four small seated Buddhas in niches above two registers of donors and colophons. On the left side, the four Buddhas are replaced by a single image at the top, with a short dedication by another *qingxinshi* and a scene with two figures facing a *boshanlu* below. There are no official titles among the named patrons and, combined with the noticeably inattentive calligraphy, it seems unlikely that the patrons were aristocrats or of the scholar official class. The lack of symmetry in the composition of the two sides and certain oddities such as the large mushroom-like shape of the *boshanlu* in the front, as well as the aforementioned feminine attendant figures,

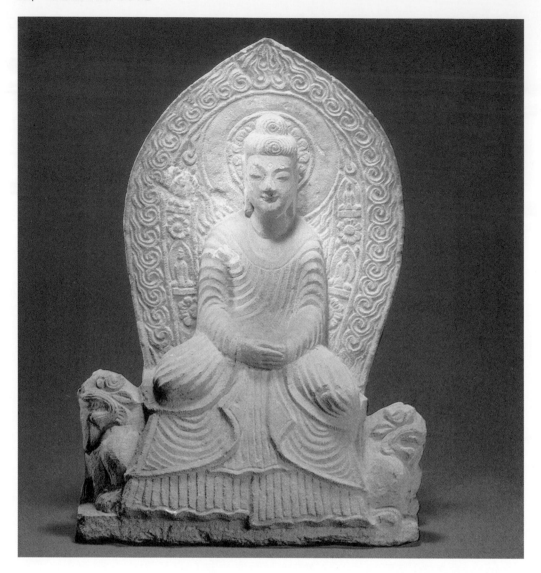

further suggest a work not especially well planned or concerned with orthodox visual forms. All of the donor figures appear to be in non-Han dress.

In comparison, a work (fig. 5.3) dedicated some six years later in 502 follows the convention of displaying the drapery in bold, parallel folds but is otherwise rather different.[11] The face, while still youthful, is rectangular and more mature; the body is fuller beneath the robes and the outline of the image is softer with a better sense of proportion. The drapery is delineated with deep, scalloped edges enlivened by the asymmetry of the folds across the chest. The figure is slightly off-center, leaning to the right, and the lower legs are oddly undefined in favor of a curtain of drapery between the thighs.

5.4 Cross-ankled Buddha, stone. Beilin Museum, Xi'an. From Matsubara Saburō, *Chūgoku bukkyō chōkokushi ron,* 1: pl. 128.

There is little attempt to indicate the layers of material in a naturalistic fashion; rather the stone is rendered into a flat, stiff pattern of overlapping pleats. The dedication on the otherwise undecorated back of the mandorla names Liu Baosheng 劉保生 as the donor of the work. Interestingly, a second work (fig. 5.4) lists the same Liu Baosheng and his wife, depicted to each side of the *boshanlu,* as donors.[12] The pair are elegantly portrayed, the wife on the left in a long skirt and tunic typical of non-Han dress found in depictions of donors. The other figure, which should be the husband, wears a very similar outfit rather than the expected non-Han pants and tunic (for an example of non-Han dress, see the Yungang Cave 11 donor figures, females to the left and males to the right,

5.5 Rear, square stele, dated to 501. Beilin Museum, Xi'an. From Matsubara Saburō, *Chūgoku bukkyō chōkokushi ron,* 1: pl. 104a.

in figs. 4.34 and 4.35). This undated stele features a cross-ankled Buddha and is generally similar in style to the previous work, although there are a number of differences such as the more simply rendered, flatter parallel lines of the drapery and the prominent oversized hands and feet. The peculiarities of the work dated to 502 raise questions about its authenticity as does the fact that neither of these two works was excavated, both having been donations to the Beilin Museum, Xi'an, in 1952.[13] It is not impossible that the 502 work was copied from the undated piece, which would explain the mishandling of the legs and the unusual scalloped folds of drapery, these being a modern elaboration of the stiff, linear lines of the Northern Wei work. The cross-ankled Buddha, in any case, raises no similar questions and serves to demonstrate another distinctive visual style current at the beginning of the sixth century.

A third example of sculpture from Chang'an is a large square stele (fig. 5.5) dated to 501.[14] Each of the sides contains a niche with a seated Buddha and two attendant bodhisattvas. Below the rear niche is the dedication; although damaged, it indicates that the work was donated by a single *qingxinshi,* the name now lost, for his deceased wife with the hope that she have a heavenly rebirth. The text is written in lightly incised

squares as we saw in a number of elite-class inscriptions in the Guyang Cave, although the calligraphy here is rather blunt and not especially distinguished. No official titles are provided for the donor and it is primarily the impressive scale and elegant workmanship that manifests the work of a single patron of some means and probably of elite social status. This example, however, underscores the problems of translating the apparent cost of a votive work into evidence of social class: we in fact have no clue as to the actual social or political status of the patron.

While the four images share some general traits with the two earlier works, there are significant differences in style. Beginning with the niche above the inscription, we find another version of the seated Buddha image with hands held together in the lap. Compared to the 496 stele (fig. 5.2), the face of this work is fuller and the neck thicker; the shoulders drop off sharply to emphasize the large head and the torso is more rounded. The fall of drapery below the hands is similarly modest although elaborated in the form of a pair of curtains framing a central pattern, reminiscent of how the drapery was handled in the 502 image (fig. 5.3). The pattern of the robes, however, is different from either of the first two works, here represented by repeated but varied, swelling folds accented by an incised line across the ridge, a technique that was utilized in the work of 471 (fig. 5.1). There is a rhythm in the swirling, curvilinear pattern of the alternatively thick and thin folds that is lacking in the three later works (figs. 5.2, 5.3, and 5.4). The niche on the opposite side or front of the stele (fig. 5.6) takes still another approach. The Buddha is seated on a wide Mount Sumeru–type throne and is even broader than the first, with a plump face and a full fall of drapery over the front of the throne that recalls in its flat, wide pleats and rectilinear contours that of the 502 work. The characteristics of the third image (fig. 5.7) recalls the first in the proportions of the head and torso, but the style of throne is different from either of the previous niches. The drapery style is also distinctive, in this case taking the thick and thin folds of the first niche image and drawing them down in a lively pattern of parallel lines. The fourth niche (fig. 5.8) is very close to the third in approach, with the difference being still another variation in the fall of drapery in which repeated V-shaped loops accent the flow of material from the chest downward. The variation in style among the four images might suggest to some that they were not created at the same time or that different hands were involved. Yet there is only one dedication and an overall unified approach to the stele that indicates to me that the work should be considered to have been conceived and completed as a single whole.

The square stele of 501 is especially instructive in demonstrating the way a relatively older style, exemplified by the first image above the dedication (fig. 5.5), might be deployed side by side with other styles of imagery. If we take these images (figs. 5.2–5.8) as a whole, it is possible to discern something of the range of styles that were available in Chang'an just before and after the year 500. As we found in the Guyang Cave, changes in style may not always be consistent with a scheme of diachronic progression—that is, even in a specific locale, we should expect various stylistic approaches to commingle and

5.6 Front, square stele, dated to 501. From Matsubara Saburō, *Chūgoku bukkyō chōkokushi ron,* 1: pl. 103a.

5.7 Right side, square stele, dated to 501. From Matsubara Saburō, *Chūgoku bukkyō chōkokushi ron,* 1: pl. 104b.

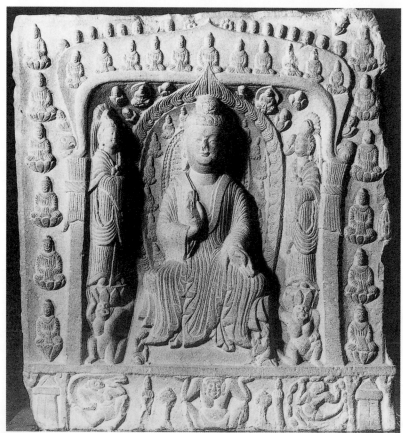

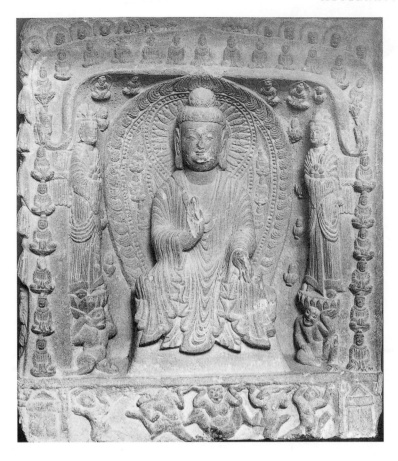

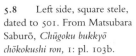

5.8 Left side, square stele, dated to 501. From Matsubara Saburō, *Chūgoku bukkyō chōkokushi ron,* 1: pl. 103b.

overlap. If these works are considered in terms of the sinicization issue discussed in the previous chapter, we again discover a distinctive and unexpected local pattern. None of the Buddha images are represented in the Han modes of dress found at Yungang and Longmen; and only in the attendant figures of the four-sided stele (figs. 5.5–5.8) do we find something like the looped, crossing scarves of the Han mode. In terms of the attenuated figural style seen in early sixth-century Longmen works, there appears to have been little influence on Chang'an where the large-headed, fleshy, full-bodied form is consistently popular. On the whole, there is a penchant toward draping the figures rather fully; most of the Buddha images are in the closed mode with both shoulders covered and the standing attendants wearing full-length gowns. Nowhere is there any interest in key characteristics of the Han mode such as the prominent undergarment tied at the chest with a large ribbon (fig. 4.2). Only in the four-sided stele dated to 501 do we have something like the characteristic thick layers of Han mode drapery, the elaborate patterns, and the sharply defined angular edges. It is probably not coincidental that the 501 stele is the work most likely to have been a product of elite patronage; donors of lesser status as in the 496 work appear satisfied with a less ambitious approach.

The two readable family names of patrons among these works, Tian and Liu, are Han, although there are well-known non-Han Liu lineages.[15] As we found in the previous chapter, the determination of ethnicity from family names, at best tricky, is particularly vexed when Han and non-Han peoples, elites as well as those of lesser stature, have had intimate social interaction for many centuries. There is no reason to believe, in other words, that there were many pure-blooded Qiang or Di lineages in and around Chang'an by the late fifth century; conversely, many Han people were no doubt deeply affected by the mixed cultural milieu. This does not mean that some families, in order to claim prestige and status, would not present themselves as direct descendents of a pure-blooded elite lineage, whether Han or non-Han. But there is little in the extant works or archaeological record that supports a direct correlation between ethnicity and the type, mode, or style of Buddhist imagery from Chang'an. Depictions of donor figures offer little assistance in this regard. The small, slender figures on the base of the square stele of 501 are difficult to identify in terms of gender much less their style of dress. The presumably male figure on the base of the undated Liu Baosheng image is especially intriguing in the ambiguity of its costume, a near mirror image of the female figure to the left but also vaguely recalling the long Han-style robes of elite-class male patrons—for example, on the Fa Sheng niche in the Guyang Cave (fig. 4.65). The Liu Baosheng examples remind us that images of donors during this period were not meant to be portraits but were generalized, often serial representations of the patrons as they would like to be seen. The elegance and refinement of their portrayal appears to have been more central than the ethnic identity of their costume.

DAOIST IMAGES

Despite stylistic differences, the dated works from Chang'an are uniform in terms of their subject—single Buddha images with or without a pair of standing attendants—their iconography, and their postures. These are conventional Buddhist images with relatively narrow parameters of types generally consistent in content with contemporary works from the Guyang Cave. Outside of Chang'an, a more varied range of forms were produced, including Daoist images such as the stone shrine of *nanguan* Fu □ 男官傅□ dated to 499 in the Field Museum of Natural History (fig. 5.9).[16] Yao Weiyuan does not identify the family name Fu as a non-Han lineage; yet all of the donor figures are male and wear typical northerner headgear, pants, and long overcoats. The inscription provides a place-name for the donor: Xianyang jun Shi'an xian 咸陽君石安縣, which is north of Chang'an in current Jingyang xian 涇陽縣.[17] Museum records, however, state that the work was uncovered at the site of a temple, Liangjingsi 晾經寺, some 5 km southwest of Chang'an. This serves to remind us that works of sculpture were portable and neither find-spots nor place-names in the inscription, which only indicate where the donor came from, are absolute evidence of the place of manufacture. The title *nanguan,* which is found on other examples of Daoist sculpture from this period, is that of a Daoist

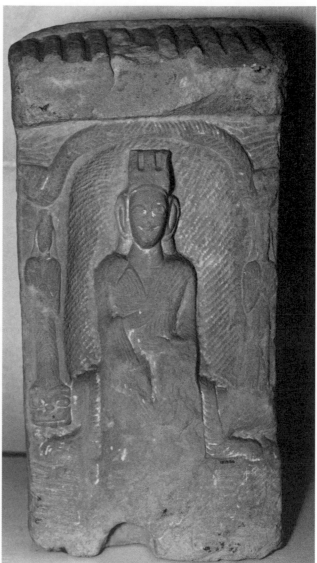

officiant and alerts us to the Daoist rather than Buddhist orientation of the image.[18] At the same time, the structure of the inscription is consistent with contemporary Buddhist dedications, including the familiar statement of wishes for the beneficiaries. As we will see below, the image itself also has parallels with Buddhist sculpture.

The rectangular stone, 65 cm high, 33 cm wide, and 21 cm deep, was carved as a roofed shrine with two large image niches on the front and back, a smaller niche on one narrow side, and the inscription on the other. The front and back (fig. 5.10) images are nearly identical: a seated, cross-ankled figure with large, distended ears; dressed in a gar-

5.9 *Left:* Front, shrine dedicated by *nanguan* Fu □, dated to 499, sandstone. Field Museum of Natural History FMNH 121396. Photo by author.

5.10 *Right:* Rear, shrine dedicated by *nanguan* Fu □. Photo by author.

ment secured by a high belt across the chest; and wearing a distinctive headgear, square ish in outline with two deep grooves. The costume is similar to that of Han secular dress, an example of which can be found in a tomb at Dengxian 鄧縣, southern Henan 河南 Province (fig. 5.11), and was probably related to the dress of leading Daoists of the period.[19] The hands of the figures are held up in a gesture unknown in Buddhist iconography. With the exception of the feet, which protrude from below the scalloped edges of the robes in the familiar cross-ankled position of Buddhist images (figs. 5.1 and 5.4), little else in the seated figures is consistent with orthodox Buddhist imagery. The standing attendant figures, however, are very similar to those found in the 496 work from Chang'an (fig. 5.2), and the seated figure in the small left-side niche (fig. 5.12) could be a Buddha image—draped in monastic robes, legs crossed, and hands in the lap in meditation—except for the tall hat. The parallels with Buddhist imagery are closer in some examples than others, but in seated icons the distinguishing features of Daoist deities are the hat, which replaces the *uṣṇīṣa* or cranial protuberance of the Buddha; the type of dress, which follows Han secular costume rather than monastic robes; and the hand gestures, which depart from conventional Buddhist mudras.

The style of the image is quite distinct from any of the Chang'an Buddhist sculpture. The extended neck and slightly overlarge heads as well as the general naïveté of the decorative forms is reminiscent of the 496 Buddhist image from Chang'an. But in the Fu shrine the carving is more simplified, even coarse—for example, in the bold parallel folds of the drapery or the long, diagonal lines that serve to decorate the interior of the niche. The lack of proportional balance can be seen in the tiny hands and the huge ears of the figures. On the lower sections of the work, the outlines of the *boshanlu* on the front and donor figures to the sides are hardly more than sketched in. Although the niches of the front and rear have similar arches formed by the long body of a pair of linked dragons, there appears to be uncertainty in how to relate the arch to the pair of dragon heads that appear to each side of the figures. The body of the dragons extends down to the head only on the left side of the front niche; the right side as well as both sides of the rear niche are occupied by standing attendant figures. Alternatively, the arrangement on the rear might be understood as a dragon arch similar to that in the Guyang Cave (fig. 4.66) unrelated to the lion throne below. Yet the asymmetry of the front niche is a puzzle—testimony to a less than assured concept for the shrine.

In past scholarship, such anomalies have been considered the errors, misunderstandings, or ignorance of provincial artisans.[20] The assumption is that "correct" works from metropolitan ateliers are by definition normative and deviations are failures. Anomalous imagery is thus understood to be unacceptable to knowledgeable metropolitan elites, but good enough for provincial bumpkins. The dated niches of the Guyang Cave, however, are evidence of the varied imagery produced for different kinds of patrons at a single metropolitan site. For certain lesser donors, the imagery made for pa-

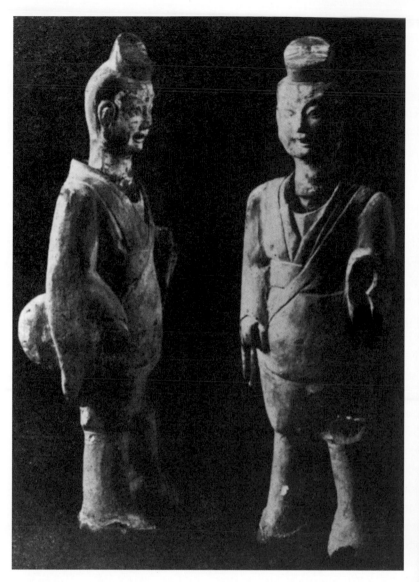

5.11 *Left:* Pottery figurines,
early sixth century, Dengxian
Tomb. From Henan sheng
wenhuaju wenwu gongzuo-
dui, *Dengxian,* 38: no. 52.

5.12 *Right:* Left side, shrine
dedicated by *nanguan* Fu □,
dated to 499. Photo by
author.

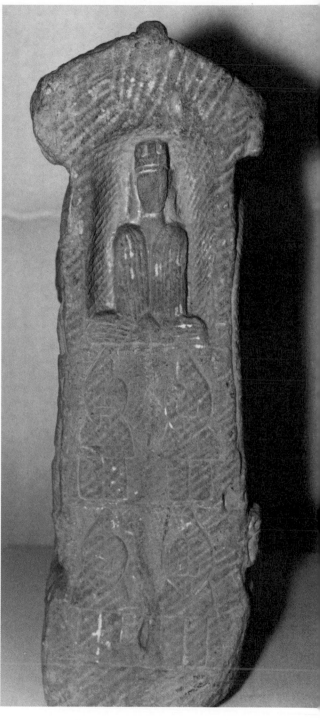

trons of the highest social standing was understood as exemplary and emulated. But some works consciously deviated from normative models, while others were simply poorly executed or inexplicably unfinished, all of which suggests that metropolitan production was hardly uniform. The Buddhist works from Chang'an, although far fewer in number, also suggest variations in metropolitan styles within orthodox Buddhist iconographical types. The Fu stele is the first of a number of works from outside Chang'an that will be anomalous in terms of metropolitan norms; yet different levels of patronage and contrasting religious motivations will complicate any easy categorization based on a metropolitan/provincial dichotomy.

FENG SHENYU STELE, LINTONG

Still further variations of Buddhist and Daoist imagery can be found in other parts of Shaanxi. Around Lintong 臨潼, a short distance east of Chang'an, a small group of sculpture from the early sixth century has been discovered.[21] These works are tall, rectangular stele *(bei)* with image niches, relief carving, and inscriptions—a type of sculpture based on the earlier form of commemorative stele. Such large stele, which will be a popular form of religious donation in northern China in the sixth century, are found most often not in cities such as Chang'an but in outlying areas and were made to be displayed along roadways or other conspicuous public places.[22] As one stele from Lintong states: "To execute the stone and expose a true form [of the divinity], the stele is erected by the roadside. It shall stand for thousands of years without any erosion, the longer it stands the harder it becomes."[23] Stele were thus public monuments with a function and audience more broadly cast than pieces such as the Fu stele, whose smaller scale suggests a personal, votive work.

The oldest stele from Lintong (figs. 5.13–5.17), dated to 505, is 154 cm high, 66 cm wide, and 32 cm deep.[24] As is typical in Northern Wei stele from Shaanxi, all four surfaces are finished and carved, the front and rear with a large image niche each, the sides with smaller niches. On the left side (fig. 5.15, left) is an inscription stating that the *daomin* 道民 Feng Shenyu 馮神育 and an *yi* 邑 of some two hundred people had this image made. Interestingly, the association is described as a *heyi* of 220 members in a later section of the text. Zhang Yan's transcription yields a total of 198 names and my count indicates 140 donor images, 60 female figures—all carved on the rear face—and 80 male figures on the other three sides of the stele.[25] The title *daomin* for the main sponsor is used here in a manner parallel to *yizhu* in the Sun Qiusheng et al. *yiyi* Guyang Cave inscription—that is, to designate the leader of the *yiyi* responsible for the dedication. The many other titles inscribed on the Fan Shenyu stele offer us a glimpse of the hierarchy of a Daoist *yiyi*. Beginning to the right of the front niche (fig. 5.13) are four *sandong fashi* 三洞法師 or masters of the Three Caverns, as the collection of the teachings of the three main schools of Daoism were called. One of them, Fu Yongluo 傅永洛, is identified as a resident of Pingding Niyang xian 平定泥陽縣, located at current-day Fuping 富平, north

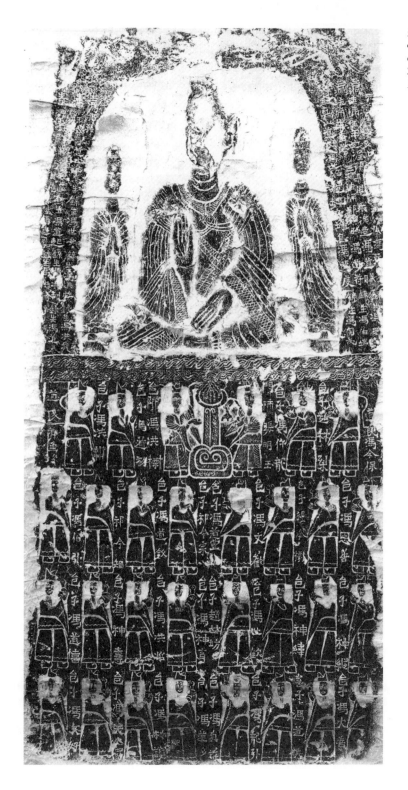

5.13 Rubbing, front, stele dedicated by Feng Shenyu et al., dated to 505. From Zhang Yan and Zhao Chao, *Beichao fodao*, 50.

of Chang'an.[26] After the *fashi* are listed three *lusheng* 錄生, a term that is found together with *nanguan/nüguan* and *daomin* in several Daoist texts and appears to designate an officiant.[27] All were members of the Feng clan, one with the longer title of *lusheng zhen-shan daomin* 錄生眞山道民. To the left of the front niche a dozen or more *lusheng* plus one *daoshi* 道士 and a *daomin* are recorded, almost all with the surname Feng. Below the front niche is an array of male figures in four registers. Flanking the *boshanlu* at the top center are two figures differentiated from the others by the detailed lines of their drapery. One figure is identified as an *yishi* 邑師, the other as a *menshi* 門師. With the exception of two colophons of *daomin* on the outer edges of the top register, all of the remaining donor figures are labeled as *yizi*.

Other titles are similarly arranged on the rear face of the stele (fig. 5.14). To the right of the image niche are the names of two *dianlu* 典錄, two *shizhe* 侍者, three *daoshi*, one *daomin*, and one *yizheng* 邑正; to the left are listed two *yizheng*, a *weina*, an *yilao* 邑老, a *daoshi*, and a ⬜*shimu* ⬜師母. Below the niche are six rows of female donor figures with colophons. These are smaller in scale than the male figures on the front, and all are simply listed by name with the exception of two *yizi* in the center of the topmost register. The sides of the niche (fig. 5.15) are treated in a similar fashion: two *lusheng*, a *qingxin-shi* 清信士, and a ⬜*shi* ⬜士 to the sides of the left-hand niche, and several *daoshi* to the side of the niche on the upper right side. The lower registers of both sides are decorated with male figures with the title of *yizi*. All of the donor figures are dressed in northerner costume.

The titles on the Feng stele indicate something of the organizational form of a Daoist *yiyi*. It appears that groups of officials were listed on the stele in hierarchical order beginning with the upper part of the front followed by the upper part of the rear and sides. The highest ranked—those with the most elaborate titles and descriptions—were the *sandong fashi* and the *lusheng,* probably officiants. The *dianlu* and *shizhe* on the rear upper section appear to be assistants to the officiants; they are followed by a group of lesser officials: the *yizheng* and *weina*. Two titles, *yilao* and ⬜*shimu,* suggest a patriarch and matriarch of the association. The relatively more numerous *daoshi* and *daomin* may be considered a still lower level of membership, and the single *qingxinshi* was a lay disciple. This term is often found as the honorific for Buddhist patrons; in a Daoist context, it indicates a disciple who has taken the initial precepts in the Lingbao 靈寶 tradition.[28] All of the above titled individuals were listed on the upper part of the stele but lacked an accompanying donor image. In contrast, the 80 male donor figures in the lower sections are all given the title of *yizi*—with the exception of a pair of officials, an *yishi* 邑師 and a *menshi* 門師, clearly differentiated by their distinctive visual treatment next to the *boshanlu* on the front face (fig. 5.13). And on the rear, the 60 female figures with no titles are led by two *yizi* in the center of the upper register. From the above, it is possible to identify three categories of patrons: a large group of officials and advanced lay followers, who were not given visual form on the stele; a group of lay male sponsors,

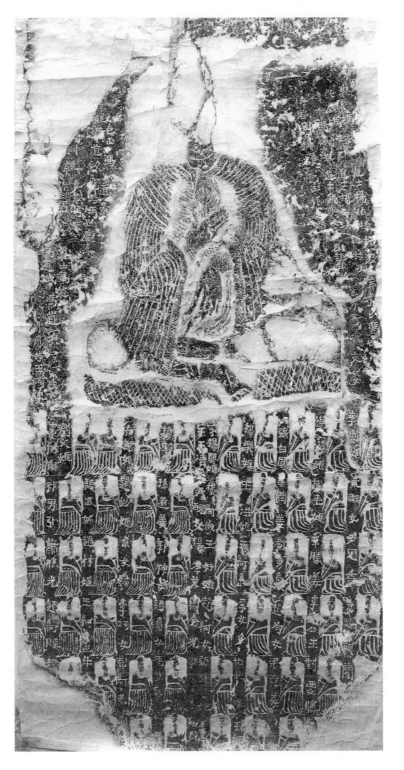

5.14 Rubbing, rear, stele dedicated by Feng Shenyu et al. From Zhang Yan and Zhao Chao, *Beichao fodao*, 51.

5.15 Rubbing, sides, stele
dedicated by Feng Shenyu
et al. From Zhang Yan and
Zhao Chao, *Beichao fodao*, 52.

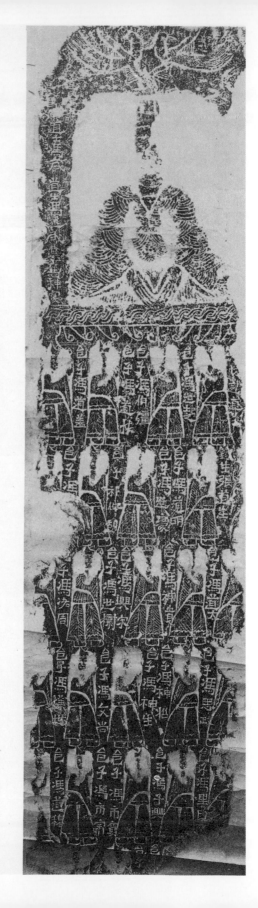

yizi, led by an *yishi* and a *menshi;* and a group of female lay sponsors, who have no titles and are led by two *yizi*. The *daomin* Feng Shenyu might thus be understood as an official of the *yiyi* who was responsible for this particular group donation. Although those listed in the upper sections of the stele are given prominence, their inclusion appears to have been primarily honorific; the actual sponsors of the stele were most likely the common lay members of the *yiyi* portrayed in the lower registers.

One might observe that although the titles *yishi, weina,* and *yizi* are well-known in Buddhist *yiyi* inscriptions, the other titles clearly identify the Feng stele as Daoist in orientation. The image in the front niche (figs. 5.13 and 5.16), however, is a seated Buddha figure in meditative pose, right hand in *abhaya* mudra, dressed in monastic robes and flanked by two similarly dressed standing attendants (bodhisattvas?). The square-shouldered main figure as well as the attendants have long faces and extended, conical necks. Most distinctively, sections of the robes are delineated by contrasting patterns of intersecting parallel lines, and a fine cross-hatching is used to indicate the trim. The inside of the niche is carved with a simple pattern of parallel striations as we saw in the Fu shrine; a decorative pattern of interlocking loops has been incised across the lower border of the niche. The rear figure (figs. 5.14 and 5.17) is seated in a similar posture but with the right hand holding a small fanlike object that is an iconographic feature of Daoist deities.[29] With neither attendants nor a clearly delineated niche, the image is significantly larger than the Buddha figure and is carved in high relief, which produces the striking effect of a deity emerging from the surface of the stone. Although close in style to the front figure, the fan is the key iconographic feature that differentiates the Daoist from the Buddhist images. In addition, both feet of the rear figure are exposed, and the treatment of the surface decoration—particularly the combination of curvilinear lines on the drapery and the rough cross-hatching on the front of the platform below the figure—distinguishes the rear image from the Buddha on the front. The side images (fig. 5.15) are both seated figures differentiated by their robes and hand positions—the left in monk's robes, hands together in a familiar mudra of meditation; and the right in the high belted robe of a Daoist deity with both hands extended down, palms facing in. Their drapery is delineated by repeated chevron patterns and variations on the interlocking decorative pattern along the front of the bases. If the principal image on the front face and the left side figure are taken as Buddhist, these would form a symmetrical group with the two Daoist images on the rear and right side. Previously, I had suggested that the Feng stele represented a conscious hybrid donation by a Buddhist-Daoist association.[30] The balance in the visual imagery between Buddhist and Daoist iconography is clear; but it now seems certain that the leadership of the *yiyi* was completely Daoist, and there is nothing in the text of the inscription to indicate any Buddhist orientation.

The Fu and Feng family stele provide us with a glimpse of Daoist image production in the countryside around Chang'an at the beginning of the sixth century. Although

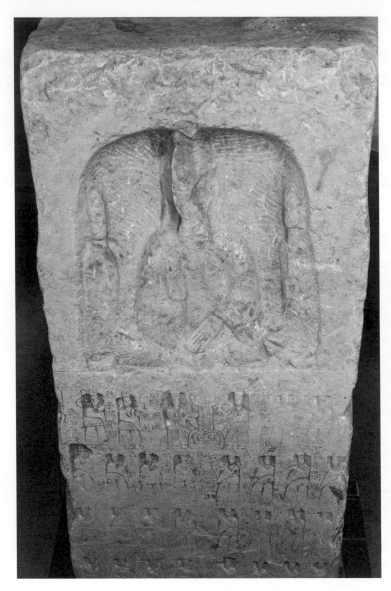

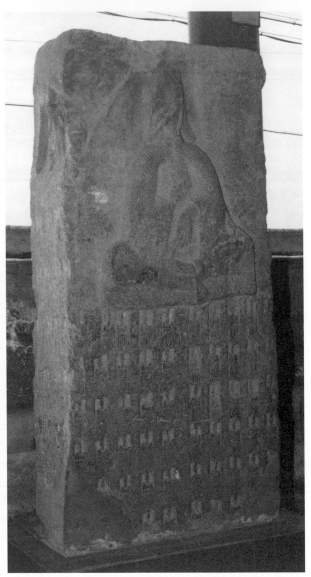

5.16 *Left:* Front, stele dedicated by Feng Shenyu et al., dated to 505. Lintong Museum. Photo by author.

5.17 *Right:* Rear, stele dedicated by Feng Shenyu et al., dated to 505. Lintong Museum. Photo by author.

similar in basic approach, the Fu stele is far simpler, even crude, in comparison to the carving of the Feng family work. The patronage of an individual *nanguan* for the former and the Daoist *yiyi* with many high-ranking officiants for the latter certainly had a role in the relative size of the stele and quality of the carving. But in addition to differences in social class (and the evidence does not allow us to specify with certainty what that difference might exactly be), the relatively grander Feng stele can be understood as the result of the greater resources of a group in contrast to an individual. If the dress of the donor figures is indicative of ethnic background, the patrons in both cases were non-

Han; yet the family names do not indicate anything but a Han lineage. It is possible that the Fu and Feng were non-Han lineages that adopted Han names; or they may have been Han families that intermarried with non-Han peoples settled in Shaanxi Province for many generations. Another possibility, suggested by the fact that donor figures in non-Han dress are ubiquitous in Buddhist sculpture throughout the fifth century, is that patrons were customarily depicted in non-Han costume as a visual convention—that is, without regard to their ethnic background. All this is speculation without solid evidence: the combination of Han family names and Daoist images in Han-style robes with the non-Han attire of the donor figures cannot be reconciled through a simple correlation of ethnicity and visual imagery.

YAOWANGSHAN

The largest extant body of sculpture from the Northern Wei period in Shaanxi Province comes from Yaowangshan 藥王山, just outside of Yaoxian 耀縣, some 100 km north of Xi'an (Chang'an). Close to thirty stele are assignable to the Northern Wei; sixteen of these are inscribed with dates ranging from 424 to 533.[31] There is a variety of visual styles, levels of patronage, and religious motives—Buddhist and Daoist, as well as mixtures of the two—among these works. The earliest dated Daoist stele from Yaowangshan is that of Yao Boduo 姚伯多 and his family (fig. 5.18) dated to 496.[32] While the top section has been lost, what remains of the front face has one large niche at the top and the first part of a long inscription below. The primary icon is a seated figure, hands together on the lap in a meditating pose, flanked by two standing attendants (fig. 5.19). As we have seen, such a triad is common in Buddhist art of the period, but in this case the figures are distinguished as Daoist by their distinctive squarish hats (cut off on the right attendant), which replace the conventional uṣṇīṣa of the central seated Buddha figure and crowns of the standing attendant bodhisattvas. The Daoist orientation of the stele is confirmed by the inscription stating that the donation is a stone image of Huang Lao-jun 皇老君 or the deified Laozi. This is the earliest dated work in which a specific Daoist deity is named.

The rear face of the stele (fig. 5.20) has two niches: the upper contains a single figure, seated with crossed ankles, hands together at the chest; the lower niche contains another cross-ankled figure with two standing attendants. All appear to wear the square hats seen in the front niche. The cross-ankled posture is shared in Buddhist and Daoist images, the hat again being the key differentiating attribute. The sides of the stele (fig. 5.21) are concerned not with the depictions of deities but with persons associated with the donation. At the top of the left side are two registers of male donor figures. The single figure above has a colophon that identifies him as the donor *daomin* Yao Wenqian 道民姚文遷供養; the row of five figures below have colophons that also identify them as donors, beginning on the right with Yao Boduo. The other side appears to have origi-

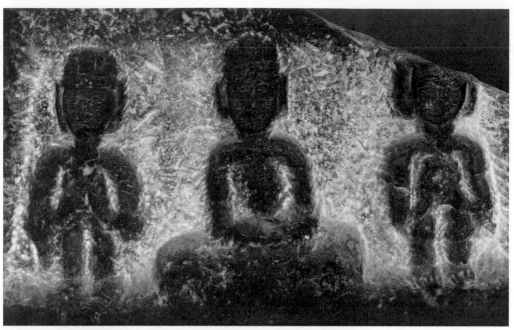

5.19 Detail, image niche, front, stele dedicated by Yao Boduo et al. Photo by author.

5.20 Rear, stele dedicated by Yao Boduo et al. Photo by author.

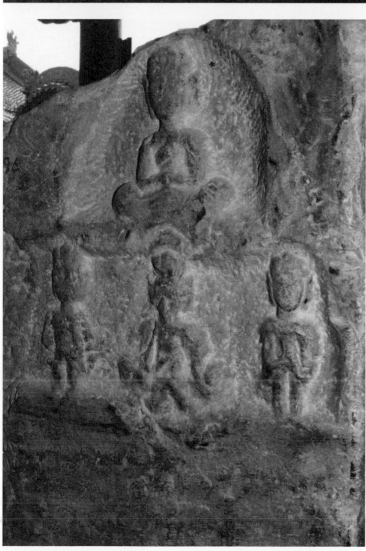

5.21 Rubbing, sides, stele dedicated by Yao Boduo et al. From Zhang Yan and Zhao Chao, *Beichao fodao*, 11.

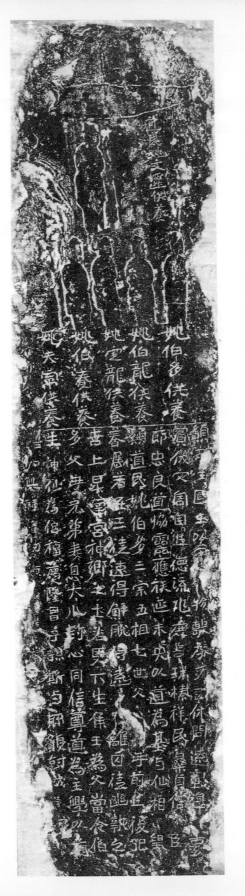

nally mirrored the left with two registers of donors, female in this case, at the top. The upper figure has been lost but the row of five female figures below remain. Each is identified as a *qingxin* 清信 or "pure disciple," which in Lingbao texts designates "those adherents who are to undergo refinement in the Southern Palace for rebirth."[33] The figures represent the male donors and possibly their respective wives, who are given equal visual status on the stele if not within the text of the dedication. The *daomin* Yao Wenqian and the now lost but probable female figure on the other side are depicted as donors, although they are not mentioned in the inscription. They appear to hold a position parallel to the Daoist officials on the upper section of the Feng stele—that is, family members of a rank higher than the actual donors—in this case, Yao Boduo and the other male and female patrons depicted below Yao Wenqian.

The inscription lists Yao Boduo and his brothers as the lead donors of an image made for the benefit of the emperor and for seven generations of ancestors and relatives. The Yao identify themselves as descendants of the Qiang founders of the Later Qin Kingdom; and the lengthy, erudite inscription carved onto all four sides of the stele is an example of the manner in which text and calligraphy manifest the elevated class background of the patrons.[34] The expression of loyalty to the Northern Wei emperor from such an elite family is not a surprise. There is also the wish that the stele not be moved from its location in the mountains where it was to provide "easy contact with the divine immortals 往來神仙."[35] As we saw in chapter 2, there was a special relationship between the most elite classes and the cult of immortals that appears to have continued into later periods. The inscription is also by far the most elaborate exposition of Daoist thought in any early image, and Bokenkamp has identified a number of instances in which the inscription draws on language and imagery found in the Lingbao textual tradition. At the same time, there is no special emphasis on Laozi—who is deified as Huang Laojun on the Yao Boduo stele—in the Lingbao texts.[36] In a recent study, Bokenkamp argues that the surprising choice of the deified Laozi as the focus of a Lingbao-inspired stele was part of a larger strategy to demonstrate to followers of Celestial Master Daoism, for whom Laozi is quite central, that Laozi as well as the Celestial Master tradition was subsumed within the more comprehensive Lingbao teachings. In addition, the length and elegance of the text suggests to Bokenkamp the way in which "veneration for the *Laozi* text above worship of Laozi himself is a feature both of the Lingbao scriptures and of the Yao Boduo stele."[37]

The main characteristic of the Lingbao tradition, as Bokenkamp has amply demonstrated, is a conscious syncretism "employed first to synthesize from various systems a single, comprehensive account of the cosmos and the life of man within it. This synthesis was clearly intended to attract adherents of rival beliefs."[38] The strategy was to assimilate Buddhist and rival Daoist texts and practices as not incorrect but simply lower and less developed forms of Lingbao doctrine. Works such as the Feng Shenyu stele with its matched Buddhist and Daoist deities or the Yao Boduo stele with its emphasis on

Laozi may thus be understood as synthetic Lingbao works calculated to attract adherents from Buddhism and Celestial Master Daoism. At the same time, some sentiments found in the Yao Boduo stele are also reminiscent of the "new" Celestial Master Daoism promulgated by the prominent local elite family member, Kou Qiangzhi, at the Northern Wei court.[39] Kou advocated the rectification of impure practices, such as sexual rites, and the elimination of "false" practices employed by Daoist rebels.[40] These goals were no doubt welcomed by the court as well as those in local positions of power such as the Yao. The latter's stele inscription states that "in the present age the teachings of the Dao are scattered and the myriad deceptions become more intense as a result. Borrowed ways make chaos of perfection, [yet] the masses of people are enticed by them."[41] Sentiments like these and the dedication of the stele to the benefit of the emperor is evidence of the way in which loyalist elite families found the Daoism of Kou amenable to their political needs.

The erudite, beautifully carved inscription stands in sharp contrast to the relatively crude craftsmanship and odd figural style (note the tubular arms and legs of the figures as well as the overly large heads) of the images of the deities. Why would patrons with at least pretensions of significant social position tolerate such an odd and seemingly unrefined style for their otherwise costly and beautiful donation? The glowing praise showered on the image in the dedication provides some important clues:

> Its construction and decoration exhausted the marvelous carving of artisans who brought out in relief and painted the bejeweled image, so that it is as if [the deity's] true face were revealed in the present age. In its carving they fully exploited their utmost skill to bring the pure visage into view, so that it is as if one were face to face with the Perfected. Had not the Dao aided [them] in its role as hidden ancestor and had we not comprehended his superior words, how would this have been possible? At the time [when the images were completed], those coming to do reverence [to the image] paid homage to the Grand Ultimate through their joyous viewing of it; while guests coming in faith gazed at the Mystic Portals and were brought into companionship with the Sage. All these arrived, unable to overcome their joy.[42]

First, the text reminds us that the images on the stele were embellished with polychrome. The original effect of the stele must have been very different from that of the present, in which the front surface has been blackened by the taking of multiple rubbings and the figures are cast in a distorted, harsh relief. At the same time, the figures are undeniably squat and awkwardly proportioned, and there is no evidence of the elaborate decorative relief carving that we will find on other stele. The hyperbolic text might be taken as an example of a rhetorical strategy both flattering to the sponsors of the stele and familiar to the audience. The description of an image on an image is a rare occurrence in this period and resonates with the manner in which actual images often fail to match the hyperbole of literary descriptions of images. The disjunction between text

and image suggests again the problems inherent in too easily applying statements from extant texts to an explanation of images.[43] Despite the crude appearance of the imagery today, the Yao Boduo stele is an excellent example of the manner in which sophisticated text and fine calligraphy are deployed to lend prestige and status to the donation of elite-class patrons.

In contrast to the Yao Boduo stele, three contemporary works from Yaowangshan appear to represent patronage of a lesser sort. The first (fig. 5.22) is dated to the same year, 496, and is the donation of Wei Wenlang 魏文朗, a native of Beidi jun 北地郡, just southeast of Yaoxian.[44] The work is badly worn all around and the short inscription on the lower front face (fig. 5.23) is now very difficult to read. Sketched out in uneven lines, the text states that Wei has had a stone image made for the benefit of the parents of seven (past) generations.[45] No donor figures were represented on the work and it appears that Wei, who has no titles attached to his name, was an ordinary patron of no special distinction. The upper section of the front face contains the main niche with a seated figure (fig. 5.24) flanked by two small attendants. The large *uṣṇīṣa,* monastic robes, and hands in the lap in a mudra of meditation indicate that this is a Buddha figure. The features of the image are simply outlined, drapery delineated by parallel incised lines, and the background decorated with radiating carved lines similar to that in the Fu shrine (fig. 5.9). Below the niche are arranged three squatting figures (figs. 5.22) with arms raised to support the niche, a motif often used in Buddhist images (see fig. 5.1). Below the main niche is a row of five small niches, each of which appears to hold a seated Buddha figure identical to the main image.

The rear face (fig. 5.25) contains two niches of equal size, one above the other, both again featuring a seated Buddha image with small attendants similar to the main niche. Sets of three niches, each with a seated figure and flanking attendants, one above the other, are arranged on the two sides. The group on the right is better preserved (fig. 5.26) and we can see that the figures are differentiated by the position of their hands: in the lap in the lowest and together at the chest in the two above. On the other (left) side, the middle figure clearly has hands in the lap, while the other two appear to be similar to the two figures on the right with hands raised at the chest. The raised position of the hands is not unknown in early Buddhist imagery from Chang'an (fig. 5.1) but is not a common gesture in Buddhist works. How to interpret its appearance here is far from clear, especially since the number and arrangement of the niches—the three to each side as well as the row of five small Buddhas across the front—is highly unusual for a Buddhist stele. Previously I speculated on the possible combination of the three images on each side and the two on the rear forming a set of eight Buddhas, possibly the seven Buddhas of the past plus Maitreya as a Buddha.[46] But such an iconographic reading fails to account for the main image and the unusual row of five Buddhas on the front. The idiosyncratic set of niches and the odd hand positions of the side images suggest that, while the majority of figures on the Wei Wenlang stele exhibit the standard visual traits of

5.22 Front, stele dedicated
by Wei Wenlang, dated to
496. Yaowangshan Museum,
Yaoxian. Photo by author.

5.23 Detail, inscription,
front, stele dedicated by Wei
Wenlang, dated to 496. Photo
by author.

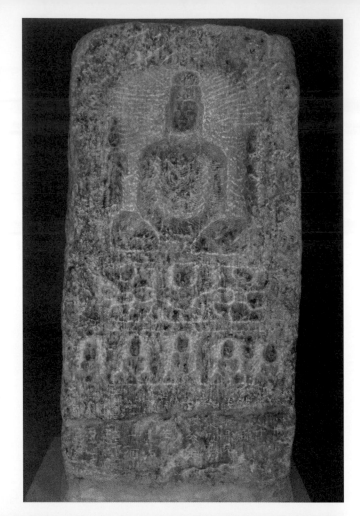

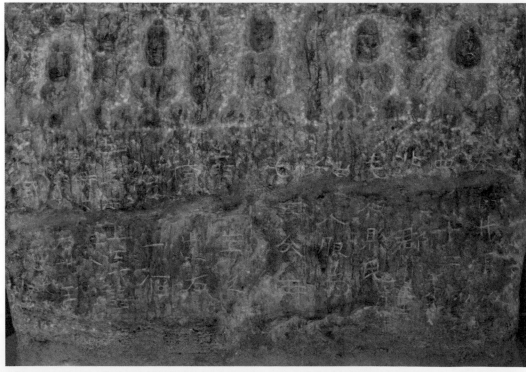

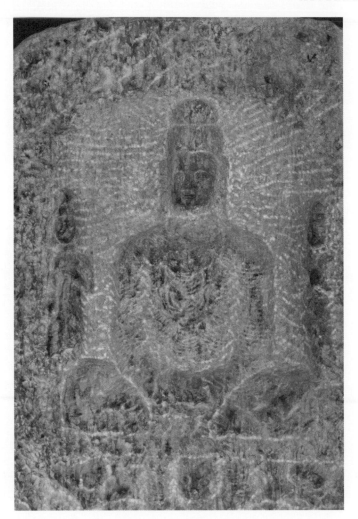

5.24 Detail, main image, front, stele dedicated by Wei Wenlang, dated to 496. Photo by author.

Buddha images, there is some ambiguity in the iconography. In the past, such an unconventional work might be described as a product of provincial misunderstanding; in the context of other unusual images from Yaowangshan, however, it seems advisable to consider this stele as another example of the variations in iconography and approach selected by the local makers of the works.

 Although the less than ideal condition of the stele makes one cautious, it seems unlikely that the surface of the Wei Wenlang stele was ever finished to the extent of the Yao Boduo or Feng stele. Such a rough or even cursory treatment of the stone suggests less attention, skill, or time devoted to the work—that is, minimal cost for a patron of limited means. Two other works from the site were treated in a similar manner. One, dedicated by Yang Eshao 楊阿紹 and his family, is a rectangular stone (fig. 5.27) slightly

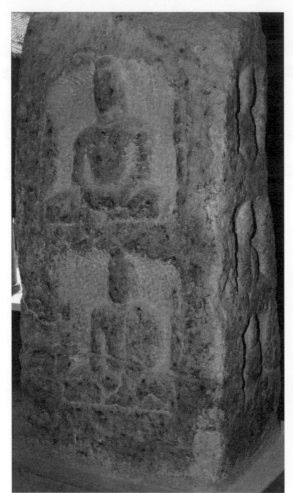 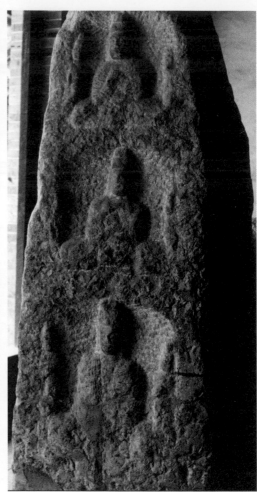

5.25 *Left:* Rear, stele dedicated by Wei Wenlang, dated to 496. Photo by author.

5.26 *Right:* Right side, stele dedicated by Wei Wenlang, dated to 496. Photo by author.

smaller than that of Wei Wenlang.[47] The work, which is finished only on the front, has one large image niche housing a seated figure depicted in Han-style robes with a belt across the midsection. This main icon, flanked by two standing attendant figures, wears a large square hat and holds its right hand in the familiar Buddhist gesture of *abhaya* mudra. As we found in the Yao Boduo stele, the main seated figure and its two attendants are distinguished as Daoist by their dress, while the meditative pose and mudra follow Buddhist iconographic conventions. At the same time, the style of the work is reminiscent of the Wei Wenlang stele—full, blocky figures, large rectangular heads, and drapery as well as background surfaces embellished by summary, parallel lines.

The inscription, which is neatly written, states that the donor was from Beidi jun 北地郡, Fuping 富平 and contains the wish that "all family members will gather for the three meetings under the dragon-flower tree, their path will be orderly and their ma-

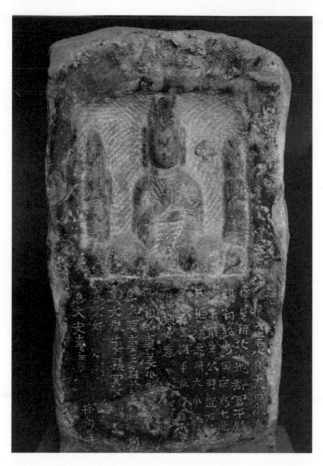

5.27 Front, stele dedicated by Yang Eshao, dated to 500. Yaowangshan Museum, Yaoxian. Photo by author.

terial goods plentiful, that they will be fed and clothed naturally, 願眷屬大小, 龍化三會, 道整物丰, 衣食自然."[48] The phrase 衣食自然 is an "oft-repeated Lingbao promise that the dead will be 'fed and clothed naturally' by the otherworldly agents of the Dao as a response to Lingbao ritual. In the scriptures this represents an abrogation of the familial responsibility to 'feed' the dead bloody offerings through ancestral sacrifices."[49] The "three meetings under the dragon-flower tree 龍花三會" is a common phrase in Buddhist texts that refers to the sermons that Maitreya will give upon his return to earth as the next Buddha.[50] The text combined with the visual imagery suggests a Lingbao-inspired assimilation of Buddhist forms similar to what we found in the Yao Boduo stele. Yang, who is joined in the dedication by the family members listed to the left of the dedication, is not identified with an official title and there is no visual indication—well-dressed donor figures, for example—that would suggest some social status for the Yang family. The fact that three sides of the stele were left unfinished may be an indication that the Yang family could only afford the decoration of the front face.

The second stele of 500 (fig. 5.28), dedicated according to the inscription just twelve

5.28 Front, stele dedicated
by Yang Manhei, dated to
500. Yaowangshan Museum,
Yaoxian. Photo by author.

5.29 Main images, front,
stele dedicated by Yang Man-
hei. Photo by author.

days after the first, was the work of Yang Manhei 楊縵黑 and his family.[51] As in the Yang Eshao work, only the front face of the stone has been finished; but in this case there are a pair of seated images (fig. 5.29), each, along with its two attendants, placed within separate side-by-side niches. The left figure wears a squarish hat and holds a small object in its right hand; in contrast, the right figure has an *uṣṇīṣa* and its right hand is in *abhaya* mudra. They would thus represent a Daoist deity on the left and a Buddha on the right, the first example of such a pairing that we have encountered.[52] Such paired figures are common in Buddhist art of the fifth century and are understood to represent Sakyamuni and Prabhūtaratna seated side by side as described in the *Lotus Sutra*.[53] The pairing of a Daoist and Buddhist deity, however, may be an expression of *huahu* theory, the widespread Daoist teaching that Laozi, under the guise of Sakyamuni, traveled west to instruct the barbarians about the Dao. Essentially, this means that Buddhism is nothing more than a version of Daoism that has returned to China ostensibly as a foreign teaching, "two paths that return to the One," according to a Lingbao text.[54]

Interestingly, the right niche and image is slightly larger than that of the left, a departure from the balance that governs paired images generally, whether Buddhist or Daoist. In this case, however, what is suggested is less a priority on the right-hand deity than a lack of concern or attention to the relationship of scale between the paired figures. The inscription (fig. 5.30) below the paired images—written in haphazard, uneven characters and lines—also suggests a lack of care or refinement in the work. Despite the remarkably indifferent handling of the inscription, the Yang Manhei work is so closely related to the Yang Eshao stele in the type of stone, scale, and style of carving that it appears to have come from the same workshop. In addition, the texts on the two stele are very similar in structure and identical in some parts—for example, both donors are described as being from Beidi jun, Fuping; and both texts include the identically worded wish that "all family members will gather for the three meetings under the dragon-flower tree, their path will be orderly and their material goods plentiful, that they will be fed and clothed naturally." This indicates that the dedication of the paired images was considered in the same light as that of the single Daoist deity of Yang Eshao. Although Buddhist and Daoist inscriptions draw on a stock set of wishes, the use of such a lengthy identical passage in these two dedications is highly unusual. This may be evidence of a conscious act of imitation. All of the above indicates that the two Yang families, probably members of the same clan or lineage from Fuping, dedicated works with an intended close formal relationship probably produced by the same local workshop.

The Wei Wenlang stele, while larger than that of the two Yangs, is similar enough in style that it may also have been a product of this workshop some four years earlier. This indicates that the stele carvers were not organized according to religious affiliation but were available to create stele with iconographic and textual variations that matched the interests of Buddhist as well as Daoist patrons. In none of the three stele do we find

5.30 Rubbing, front, stele dedicated by Yang Manhei. From Zhang Yan and Zhao Chao, *Beichao fodao,* 47.

elegantly dressed donor figures as we had in the Yao Boduo stele. The two Yang stele are carved only on the front, leaving three sides of the stone completely unfinished. The lack of any evidence of high status combined with the rough quality of the carving and the relatively short and, in the case of Yang Manhei, poorly executed inscriptions indicate that both Yang stele were created with limited resources, reflecting the comparatively lower social and economic status of their patrons. In comparison, the Wei Wenlang stele appears to be only slightly more ambitious in that all four sides are attended to; otherwise, the coarse handling of the figures and surfaces as well as the roughly sketched inscription also suggest less than elite-class patronage. If the same workshop

produced all three works, it may have been one that specialized in rough sculpture affordable to common-class patrons.

The six images discussed above represent all of the published sculpture from the area outside of Chang'an dated by inscription to before 505. Of these, the Yao Boduo stele represents the type of imagery produced for patrons of elite status. Interestingly, in spite of the testimony of the inscription, the emphasis is not on the images but on the complex, sophisticated text. The class background of the patrons of the Feng stele from Lintong is not clear; there are no official titles although the dress and comportment of the donor images suggest a group with at least a claim to some social status. The Fu shrine was the donation of an individual *nanguan* whose social status was probably similar to that of the *nanguan* in the Feng stele. Of the three remaining works from Yaowangshan, the Wei Wenlang stele is the largest and most ambitious in terms of the number of images carved, while the two works by the Yangs indicate something of what was possible for patrons of lesser standing and resources. These works do not represent a distribution of social class as much as permutations of patronage types modulated by religious roles (clergy versus lay) and group organization. To put it another way, if the Yao Boduo stele represents the upper strata of social class and the Yang stele the lowest at Yaowangshan, works such as the Fu shrine, the Feng stele, and the Wei Wenlang stele provide us with a glimpse of the range of works produced for individuals of less than elite status—in these cases a Daoist officiant, members of a large *yiyi,* or an individual donor. The religious orientation of these works cuts obliquely across social classes with all except the Wei Wenlang stele having passages of unequivocal Daoist orientation in their inscriptions. The imagery, on the other hand, is more or less Daoist (Yao Boduo, Fu, Yang Eshao), a conscious mixture of Daoist and Buddhist figures (Feng, Yang Manhei), or Buddhist with some anomalous mudras as in the Wei Wenlang.

The small sample of dated works from the area outside of Chang'an is evidence that Daoists had a choice of dedicating Daoist or an admixture of Daoist and Buddhist images. The choice was not a reflection of social position. Rather, class appears to correlate with two visual elements: the complexity, length, and calligraphic quality of inscriptions on one hand and the visual representation of the patrons on the other. Those for whom such visual elements were appropriate either held significant social position or wished to claim such a status; conversely, only those with sufficient means could declare their upstanding social standing through the production and display of such works. None of the above necessarily negates Zürcher's compelling suggestion that Buddhist-Daoist admixtures below the level of elite clerical practice would indicate something of a "less differentiated lay religion, and that at the very base both systems largely dissolved into an indistinct mass of popular beliefs and practices." But, at least in this period of time, many lay as well as common-class Daoists appear to have little problem in differentiating Daoism from Buddhism despite appropriating imagery and language from the latter.

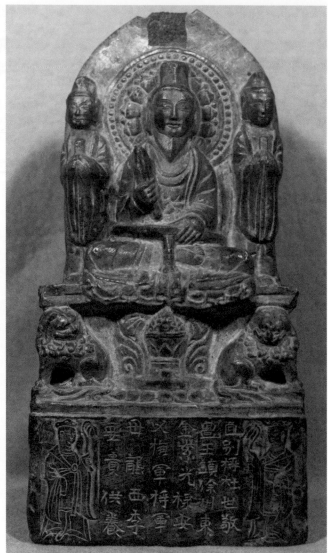

5.31 *Left:* Front, stele dedicated by Liu Wenlang, dated to 499. Yaowangshan Museum, Yaoxian. Photo by author.

5.32 *Right:* Daoist stele, dated to 587. Tokyo geijutsu daigaku. Photo by author.

QUESTIONS

I have not mentioned two dated but problematic works in the Yaowangshan collection. One is the Liu Wenlang 劉文朗 stele (fig. 5.31) from Yaowangshan dated by inscription to 499.[55] The drapery is delineated in broad, symmetrical pleats, different from other works from the site but similar to that found in Daoist figures from later in the sixth century, for example a work (fig. 5.32) dated to 587.[56] The flat implements, a tablet or tally (*hu* 笏), held in both hands by each of the figures is unknown in Northern Wei Daoist images but is often depicted held by the attendants in works of the later sixth century.

The main icon holding the implement with both hands is very unusual even in later periods. In addition, the distinctively angled outline of the top of the stele and the gently rounded niche are characteristic of works from the latter part of the sixth century.[57] These elements of style do not accord with the date provided in the inscription; it seems probable that the work was made in the latter part of the sixth century and for unknown reasons inscribed with the 499 date. The Liu stele is listed as part of the original Yaowangshan collection with no recorded find-spot or date of discovery. Such murky origins raises further questions about the work although the 499 date continues to be accepted by many scholars.[58]

A more difficult case is presented by the four-sided stele of Wei Wenlang 魏文朗 (fig. 5.33) from Yaowangshan with a date of 424 (*Zhengshi* second year 正始二年) in the inscription.[59] As the earliest dated work from the site and one of the earliest dated examples of Northern Wei sculpture, the Wei Wenlang stele has drawn considerable attention and conflicting interpretations. The primary icon in the front face (fig. 5.34) is a pair of seated figures not unlike the paired images in the Yang Manhei stele. In the Wei Wenlang work, however, the two figures are placed within a single niche on a *ta* 榻, a raised platform.[60] The one on the left (fig. 5.35) appears to be bearded, wears a Han Chinese–style robe with a high belt, and holds a small fan or diamond-shaped implement in the right hand. The other figure is dressed in monk's robes with right hand raised in *abhaya* mudra. Curiously, the left hand of both figures extend down in identical displays of *varada* mudra, a common gesture in Buddhist sculpture. While the right figure appears to be consistent with Buddhist images, the dress, beard, and attribute held in the hand of the left figure indicate that it is a Daoist deity.[61] The two figures to each side of the *boshanlu* below the niche echo the affiliations of the paired images in the main niche. On the left is a Daoist officiant wearing a hat and dressed in a long-sleeved garment; on the right is a tonsured figure dressed in what appears to be the robes of a Buddhist monk.

A prominent arch of entwined dragons, a common element in Buddhist sculpture as we saw in the Guyang Cave, defines the upper border of the niche. The flying heavenly attendants to the sides of the dragons as well as the *boshanlu* below the niche are also motifs that we have previously encountered. Beyond these visual elements, however, the designers of the stele have added largely unfamiliar imagery such as the pair of disks to each side of the niche, probably to be interpreted as the sun and moon, or the deer to the left side. There are also architectural structures containing seated figures, a small roofed niche to the right, and a larger pavilion supported by a squatting monster figure on the left, both with distinctive owl-tail ridge ornaments, a traditional Chinese architectural motif. Below the *boshanlu* is a procession of a camel and riding figure followed by an ox-drawn covered carriage. The depiction of the camel is a reminder of the desert regions to the West into which Laozi was said to have disappeared and from which, according to *huahu* theory, his teachings as Buddhism returned to China. The motif of the

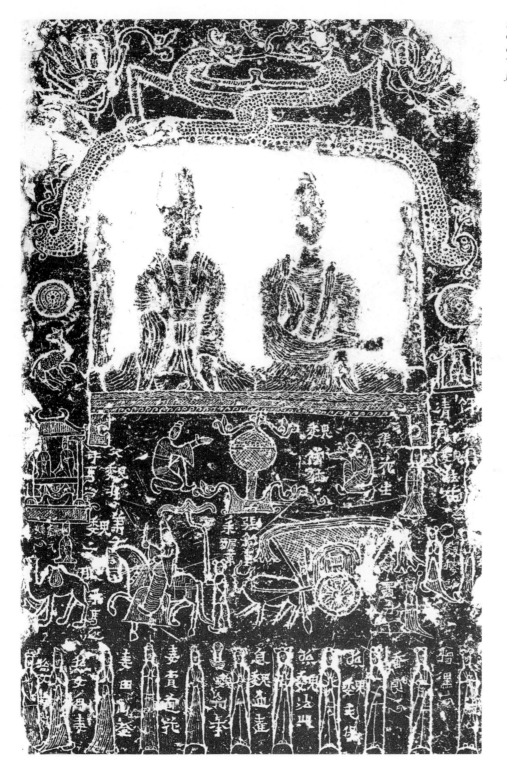

5.34 Rubbing, front, stele dedicated by Wei Wenlang, dated to 424 (?). From Zhang Yan and Zhao Chao, *Beichao fodao*, 1.

5.35 Detail, left deity, im-
age niche, front, stele dedi-
cated by Wei Wenlang, dated
to 424 (?). Photo by author.

rider and ox-drawn carriage is often found in the visual imagery of elite-class individu-
als, for example in the aforementioned tombs at Dengxian.[62] The Han style architec-
tural forms as well as the rider and cart may be understood as rhetorical visual conven-
tions that expressed the way in which members of the Han upper classes wished to
present themselves. The elegantly dressed donor figures along the bottom of the stele
underscore the elevated class position of the images of the patrons or at least their aspi-
ration to a social position appropriate to these images.

In fact, the principal donor, Wei Wenlang, is not named with the official titles that
would be usual for an individual of significant status.[63] Rather, the only indicators of so-

cial position are visual—for example, that Wei Wenlang is identified in a colophon as the rider in the procession, an indication that he may have held a military position. Another colophon names Zhang Ezhong, presumably his wife, riding in the cart, which is followed by several smaller figures with the surname Wei who might be their children. The colophons of the tall donor figures at the bottom indicate that these are meant to represent Wei's sons and their wives and children. The two colophons next to the pavilion name the two occupants as Wei's parents; on the right side, two names, one a Wei and the other a Zhang, identify images of individuals presumably related to the families of the husband and wife.[64] The monk to the right of the *boshanlu* is identified as Wei Sengmeng. The main participants in the donation of the stele are thus presented to us as Wei Wenlang, his wife, and their extended family.

The rear face of the stele (figs. 5.36 and 5.37) contains a large image niche with a paired dragon arch, but in this case the heads form the two ends of the niche and a foliate design emanates from their mouths to be entwined at the apex. Two birds face each other above the niche and are flanked by a pair of flying celestials. Seated within the niche is a single figure, right leg crossed over the knee and cheek resting on its hand, with two lions at its feet. The posture is familiar in early Chinese Buddhist art as that of a bodhisattva, usually bare-chested and bejeweled.[65] But here the figure is dressed in a fashion similar to the Daoist figure on the front and appears to represent a Daoist deity, albeit in a pose derived from Buddhist iconography. Motifs similar to those found on the front are also used on the rear: the *boshanlu,* the pavilions with seated figures, and the deer now joined by a tiger and bear in a landscape setting. The two figures in the pavilions have no identifying colophons but might represent the lay Buddhist Vimala-kīrti and the bodhisattva Mañjuśrī in debate.[66] A single figure flanks each side of the *boshanlu:* a monk to the right and a layman to the left. If the rear figures are read as parallel to the kneeling figures flanking the *boshanlu* in the front side, the left figure should be a Daoist officiant. Two prominent standing figures have been depicted below the pavilion to the right and are identified in colophons as *daonü* 道女 and Changsheng 萇生. It has been suggested that this is the same Changsheng as the husband of one of Wei Wenlang's daughters 女夫蕭萇生, named at the end of the dedication below, and the *daonü* is Wenlang's daughter.[67]

On the left side of the stele (fig. 5.38, left) are a pair of niches, one above the other. Within the upper is a single seated figure holding a small diamond-shaped article in its right hand and wearing a distinctive tall hat and Han-style robes. The lower niche holds a similar figure with its hands placed together at the chest. Each seated figure is flanked by two standing attendants. On the right side (fig. 5.38, right), we find the narrow surface decorated with a single niche containing a seated Buddha, dressed in monastic robes and in a position of meditation with two standing bodhisattvas to each side. Below the single niche is another engraved scene of a rider on a horse and two spear-bearing soldiers, also on horses.

5.36 Rear, stele dedicated
by Wei Wenlang, dated to
424 (?). Photo by author.

To summarize, the stele includes a pair of Daoist and Buddhist figures in the front niche, a Daoist figure in a typically Buddhist pose in the rear niche, Daoist figures one above the other on one side, and a seated Buddha with attendants on the other.[68] The work has been interpreted in a number of ways, typically as an amalgamation of Han and non-Han, Daoist and Buddhist elements.[69] In the dedication on the rear, Wei Wenlang describes himself as a *fodizi* 佛弟子 or Buddhist disciple who has had a *fodaoxiang* 佛道像 made. The latter phrase has been taken by many scholars to indicate that a *fodao* or dual Buddhist-Daoist image was commissioned by a Buddhist disciple. Others have noted that the term *fodao* 佛道, rather than an indication of some combination of Buddhism and Daoism, was used to mean the "Buddhist path," an equivalent to *fofa* 佛法, Buddhist law, or even *fojiao* 佛教, Buddhism.[70] The stele might then be considered a straightforward Buddhist work commissioned by Buddhist adherents if it were not for the icono-

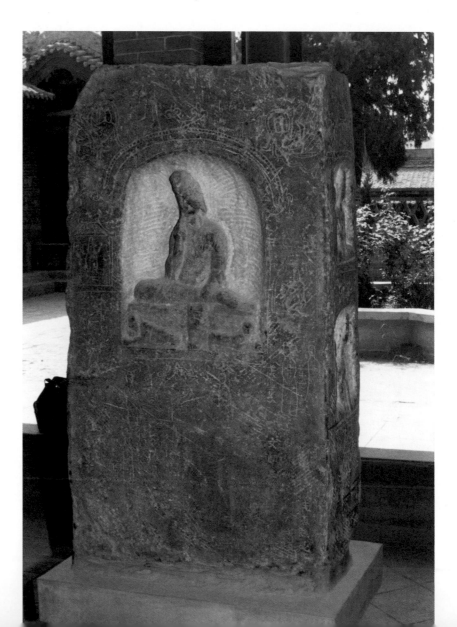

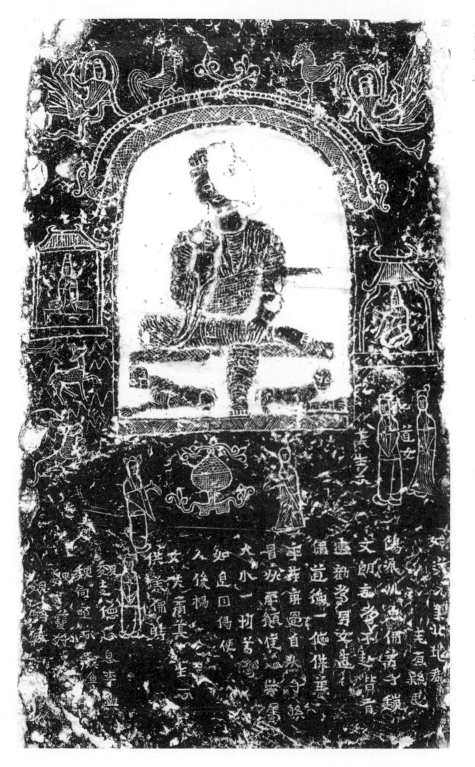

5.37 Rubbing, rear, stele dedicated by Wei Wenlang, dated to 424 (?). From Zhang Yan and Zhao Chao, *Beichao fodao*, 2.

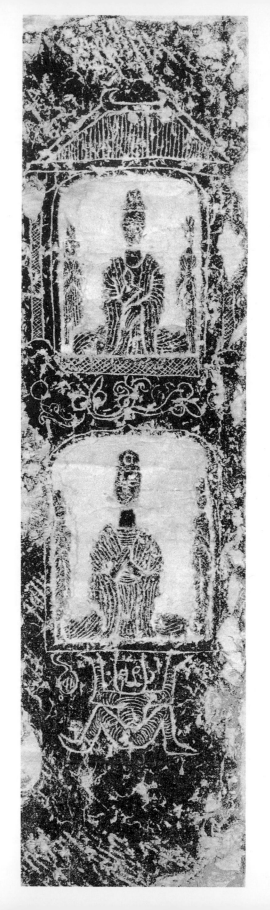
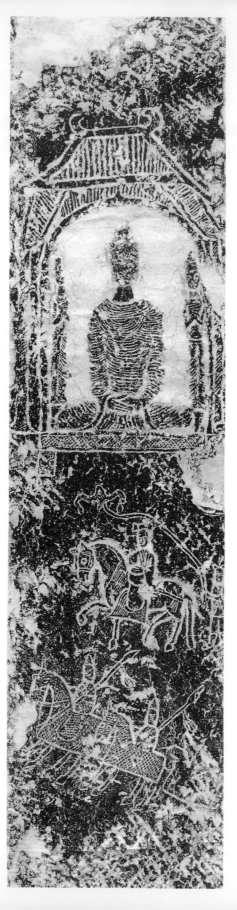

5.38 Rubbing, left and right sides, stele dedicated by Wei Wenlang, dated to 424 (?). From Zhang Yan and Zhao Chao, *Beichao fodao*, 3.

graphic anomalies. One could understand the stele as the Buddhist equivalent to the Daoist appropriation of Buddhist images in the Feng stele, where Buddhist images were made equivalents to Daoist deities in a work sponsored by a Daoist *yiyi*. In this case, a Buddhist, Wei Wenlang, has made a donation in which Daoist images are made the equivalent of Buddhist ones. A Buddhist orientation is supported by the depiction of Buddhist monks with tonsured heads and monastic robes to the side of the *boshanlu* on the front and rear of the work. The monk on the front appears to be a family member, Wei Sengmeng 魏僧猛; it may be significant that the matching figure to the left, a layman or possibly a Daoist officiant, is unnamed.

It remains unclear, however, how one might ascertain the intention of Wei Wenlang and the other patrons. Do they mean to indicate that Buddhism absorbs Daoism—that is, the reverse of the Feng stele? Or is there an understanding that Daoism and Buddhism are true equivalents even for a Buddhist adherent? Or is the stele another example of Daoist rhetorical strategies in which a professed Buddhist is shown to accept something like the Lingbao doctrine that Buddhism is really just Daoism from the West?[71] Another possible reading is that Wei Wenlang donated the Buddha images while other members of his family such as his wife were the donors of the Daoist images. The two figures on the rear labeled *daonü* and Changsheng have been referred to as evidence that, in contrast to Wei Wenlang, some family members were avowed Daoists. Textual evidence of the occurrence of similar divisions of familial religious orientations are also cited to support such an interpretation of the stele.[72] Each interpretation seems possible, as does the alternative that individuals could simultaneously hold beliefs in Buddhism and Daoism without contradiction. Different kinds of beliefs and practices may have been appropriate for different situations and occasions—function would be the determinant factor.

The visual evidence from Shaanxi consistently points toward accommodation rather than rivalry in Buddhist-Daoist relationships. In fact, the notion that the two doctrines were fundamentally competitive and opposed may be somewhat misleading. For example, in northern China the first court debates between Buddhists and Daoists did not occur until 520; the well-known polemical exchanges between the two sides developed toward the end of the sixth century and later.[73] It should also be remembered that such debates involved clergy at the highest levels of organized Buddhism and Daoism with stakes such as imperial patronage that were of consequence primarily to court elites. In the earlier period, it appears that Daoists looked upon Buddhism with some tolerance as a generally respectable religion. After all, it was Laozi who had produced that teaching, and the conversion of the barbarians, from the Daoist point of view, was a civilizing process.[74] This is not to say that there was no sense of competition between the two, but works such as the Wei Wenlang stele provide us with a corrective to an often overly generalized understanding of antagonisms as fundamental to Buddhist-Daoist relationships.

An even more basic question, however, has been recently raised about the Wei Wenlang stele. The second character of the Northern Wei regnal era, *shiguang* 始光, which begins the inscription at the far right (fig. 5.37), is damaged, but the fact that this is the only known fifth- or sixth-century regnal era commencing with the character *shi* has convinced most scholars that the intended era was *shiguang*. Ishimatsu Hinako has challenged this assumption, beginning with an analysis of the damaged character that attempts to demonstrate that it could not be *guang*.[75] It is, however, possible that the *guang* character was simply miswritten, an error on the part of the composer or a misunderstanding by the carver. This would not alter the intention of recording a date of 424 for the stele. But Ishimatsu supports her case with the argument that the area around Yaowangshan was under the control of the Xia 夏 Kingdom (407–431) until 426, when the Northern Wei captured Chang'an, making the use of the Northern Wei regnal era of *shiguang* in 424 highly unlikely. In addition, the place-name for Wei Wenlang, Beidi jun 北地郡 Sanyuan xian 三原縣, is problematic in that the *Weishu* chapter on place-names does not include Sanyuan as one of the seven *xian* under the *jun* of Beidi. A Tang dynasty record indicates that Sanyuan xian was not established until 427–430 at the earliest and possibly as late as 446.[76]

Ishimatsu's most persuasive argument, however, is visual: the Wei Wenlang stele has many stylistic affinities with Yaowangshan stele of circa 514–520 and few with the works of circa 499–500 that we have discussed. The earliest dated stele from Yaowangshan can be divided into three groups: those dated between 424–500, a second group from 514–515, and a third from 519–524. Ishimatsu first points out a number of similarities in motif between the Wei Wenlang stele and an undated Yaowangshan work, the Wu Biaoxiong 吳標兄 stele (fig. 5.39). These include the entwined dragons above the front niche, the flying attendant figures, the circular sun and moon motifs, the pavilion to the left of the niche, the distinctive *ta* platform for the image, the *boshanlu,* the deer above, lions below the *ta,* and equestrian images scattered around the lower half of the surface. None of these motifs are found in the first group of Yaowangshan stele. The Wu stele is closely related in style to the Zhang Luanguo 張亂國 stele dated to 514 (fig. 5.40), which also features entwined dragons and an enclosed cart as we found on the Wei Wenlang work. In addition, the Zhang stele has donor figures that are very similar to those on the Wei work. To Ishimatsu's observations, we can add the close visual relationship of the main icon of the Wu Biaoxiong (fig. 5.41) to the Wei Wenlang stele. I would also add another comparable work, the Fumeng Wenqing 夫蒙文慶 stele from Yaowangshan, dated to 519, in which the thin-necked, elongated seated figures (fig. 5.42) with rigid, closely spaced parallel lines to indicate the drapery are quite similar to the seated figure on the right side of the 424 stele.[77] Also, there are shared motifs with the Wei Wenlang stele in the incised relief carving around the front image niche (fig. 5.43)—for example, the flying attendant figures and pavilions. The comparison with works from 514 to 519 indicates a commonality of motifs and visual styles that is shared by the Wei Wenlang work. Most

important, these works are visually distinct from the sculpture dated between 496 and 500. A date of 424 indeed appears far too early for the style of the Wei Wenlang stele: Ishimatsu suggests a period between 500 and 514, possibly closer to 500, although her own visual comparisons as well as my own indicate a date in the 514–519 range.

While compelling, the argument rests to a large extent on the assumption that period styles are discrete and progressive, a concept that has been questioned in this chapter. Meanwhile, if one is to reject the *shiguang* regnal era, how can we explain the in-

5.39 Rubbing, front, stele dedicated by Wu Biaoxiong. Yaowangshan Museum, Yaoxian. Collection of Shukutoku University, photograph courtesy of Ishimatsu Hinako.

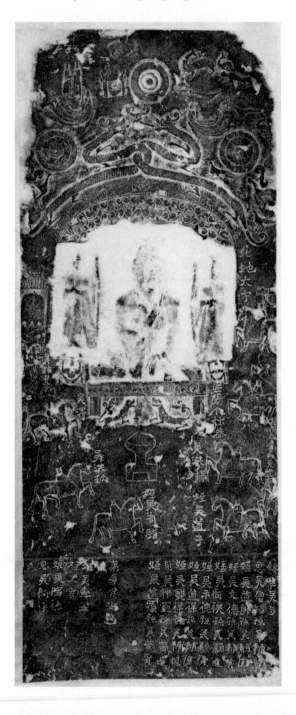

5.40 Rubbing, front, stele dedicated by Zhang Luanguo, dated to 514. From Zhang Yan and Zhao Chao, *Beichao fodao*, 58.

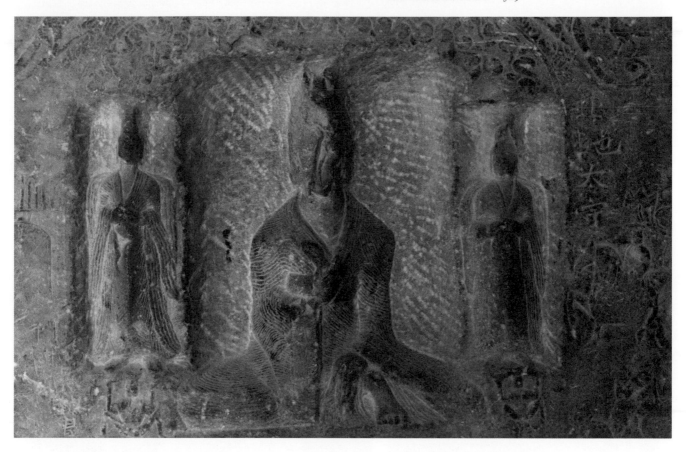

5.41 Detail, main image, front, stele dedicated by Wu Biaoxiong. Yaowangshan Museum, Yaoxian. Photo by author.

scription and its corruption? This is a difficult issue that Ishimatsu understandably avoids. Was the inscription (fig. 5.37) added at another time after the sculpture was carved? Although the names listed to the left side are not carved as deeply as the dedication, an indication that they may not be contemporary with the balance of the text, there is little visual evidence to suggest that the area now occupied by the inscription was originally left undecorated, a necessary condition if the text was added at a later date. There is one significant anomaly in the arrangement of the text: the second line does not continue from the top as it should but only consists of four characters Sanyuan xian min 三原縣民 placed directly to the left of the Beidi jun 北地郡 (plus a blank spot after the *jun*) in the first line as below. This is the only line of text that fails to begin at the top of the inscription and the effect is to separate the first two lines from the balance of the inscription. Is it possible that these two lines (始口元年北地郡/三原縣民) were added to the dedication at a later date? The original text would have then been undated, commencing at the top of the third line with the phrase "yangyuan chuanzhong 陽源川忠" modifying the *fodizi* Wei Wenlang.

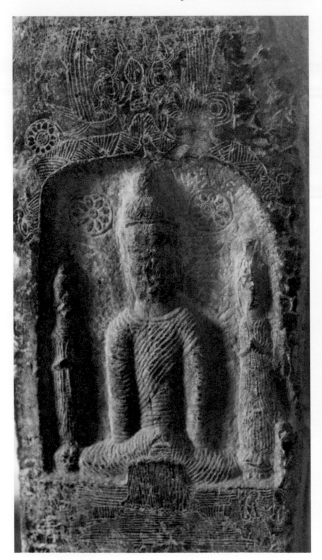

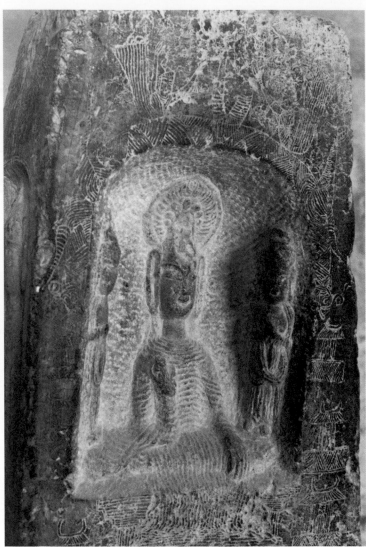

5.42 *Left:* Detail, image niche, right side, stele dedicated by Fumeng Wenqing, dated to 519. Yaowangshan Museum, Yaoxian. Photo by author.

5.43 *Right:* Detail, image niche, front, stele dedicated by Fumeng Wenqing, dated to 519. Yaowangshan Museum, Yaoxian. Photo by author.

Such a hypothetical explanation is not without weaknesses—for example, a blank area to the right of the beginning of the original inscription would have been quite odd; inscriptions at Yaowangshan consistently commence at the far right edge of the stone. If Ishimatsu is correct and the regnal period is not *shiguang,* why would someone add a nonexistent regnal period? Although there are no answers to these questions, it is possible to suggest where the phrase "Beidi jun Sanyuan xian" may have come from. While the *jun* Beidi appears in three Yaowangshan inscriptions (Yao Boduo, Yang Eshao, and Yang Manhei), the combination of "Beidi jun Sanyuan xian" is only found on one other early Yaowangshan work, the Wei Wenlang stele of 496. This raises the possibility that

the place-name was copied from the 496 work, a kind of creative reinscription known in other cases—for example, the copying of portions of a Northern Wei dynasty inscription from the Guyang Cave onto an otherwise uninscribed Ming dynasty stele.[78] But in this case, the situation is different in that only the date and place-names were added. It seems as if someone wished to append information lacking in the extant inscription. The odd position of the second line—only the four characters 三原縣民—aligned next to 北地郡 in fact not only reproduces the text: the two lines replicate the physical arrangement of the two lines on the 496 stele down to the blank spot after *jun* (figs. 5.23 and 5.44). To find the two identical lines of text in exactly the same physical arrangement as we find here is without precedent and suggests something more than coincidence. What is suggested is that the third and fourth lines of text from the Wei Wenlang stele of 496 were abstracted from the balance of the inscription, possibly via a rubbing, which then served as the model from which the characters were replicated on the 424 (?) stele. One can imagine a carver, possibly illiterate, simply copying or tracing the two lines exactly as reproduced in the rubbing.

Ishimatsu notes that the variant character for *lang* 腺 found in the 496 stele is also used in the 424 (?) work—not in the inscription but in Wei Wenlang's colophon on the front, just above the rump of the camel. In other words, his name was written with both versions of *lang*.[79] For Ishimatsu, this is evidence that the two works were donated by the same Wei Wenlang, which further supports her thesis that the 424 (?) stele was actually made circa 500 or after.[80] This indeed may have been the understanding of whoever added the date and place-names to the 424 (?) stele and, if so, the motivation was not forgery—that is, to deceive—but rather to furnish information lacking in the original text by drawing on data from what appeared to be another donation by the same patron. Generally supportive of this interpretation is the fact that both Wei Wenlang stele were discovered by chance in 1934 and that neither found their way into the art market, the only reasonable goal if the inscription was a forgery added to enhance its value in modern times.[81]

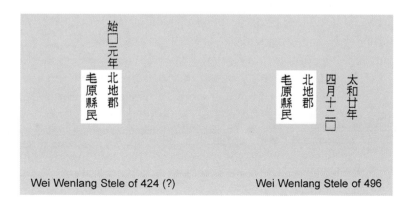

Wei Wenlang Stele of 424 (?) Wei Wenlang Stele of 496

There is a significant problem, however, to assigning both of the stele to the same Wei Wenlang. As previously discussed, the 496 stele belongs to a rough, simple class of works suggestive of a relatively common-class patronage. This is in sharp contrast to the 424 (?) stele, in which the motifs and style not to mention the self-representation of the donors bespeak an elevated class of patronage. It is not that a single patron could not donate dissimilar works, but the quality of the differences in the two stele is a powerful argument against the possibility that both were the work of the same class of patron. To put it another way, it is highly unlikely that the Wei Wenlang who would justifiably take pride in the 424 (?) stele would also wish to be represented by the imagery of a work like the 496 stele.

CONCLUSION

Past studies have understood Daoist sculpture of this period to be little more than poor copies of Buddhist iconography and styles. Recently, Liu Yang has argued the very opposite: that the source of Northern Wei Daoist imagery lies in traditional representations of Chinese deities such as the Queen Mother of the West.[82] For Liu, Buddhist imagery provides little that was new; rather, borrowings from Buddhist works were for the most part familiar Chinese motifs that had previously been incorporated into Buddhist images.[83] Although his study is a valuable corrective to the overly one-sided emphasis of past scholarship, Liu's argument is limited from the onset to reversing the direction of "influence." Such a maneuver leaves the influence paradigm and its related assumptions intact. But even from the handful of dated works discussed above, one can discern various permutations of provenance, class of patronage, and religious orientation being played out in sculpture of considerable variety and complexity. The issue turns not so much on who influenced whom but around the range of available alternatives in any given local tradition and the type of imagery that was most appropriate for patrons of differing backgrounds.

The sculpture from outlying areas of Shaanxi can for the most part be understood in terms of mixtures and variations on conventional Buddhist and Daoist imagery. In contrast to the orthodox Buddhist iconography of works from Chang'an, they are anomalous; and it is likely that more than a few Buddhist ecclesiastical elites in the city found them to be ignorant abominations. From the Daoist side, following the scholarship of Bokenkamp, it is possible to understand works such as the Feng stele as quite well informed—that is, the donation of a group of former Buddhists who accepted the Lingbao teachings that Buddhism was nothing more than a form of Daoism.[84] Yet one is hesitant to consider any mixture of Buddhist and Daoist imagery as Lingbao inspired; there were most likely other iconographical permutations that were equally well informed, and no doubt some of these might represent a thorough amalgamation of Buddhist, Daoist, and popular imagery. Clearly, the complete range of intentions brought to works

of sculpture by their patrons is not easily divisible into the categories of Buddhism, Dao-
ism, or some other set of beliefs; those involved as well as the viewing public were in-
terested less in doctrine than efficacy. The intentions and beliefs of these individuals
come to us not through erudite doctrinal exegesis but in the material evidence of the
images themselves. It remains for future scholarship to find the means to move closer to
that past while understanding that such an endeavor is but a demand of our present.

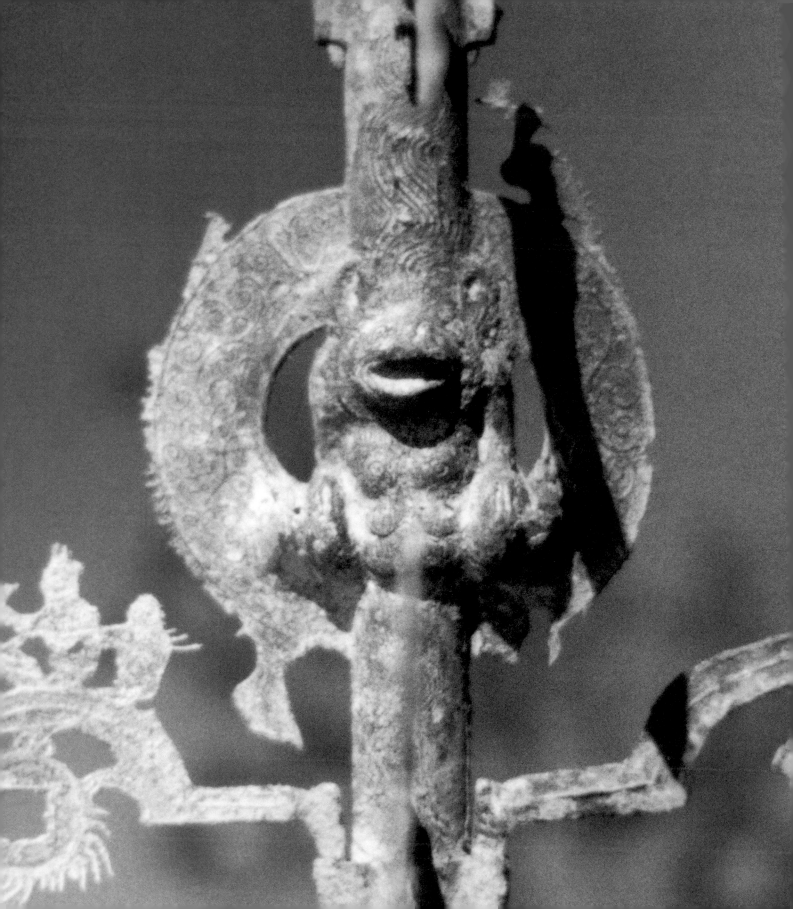

Conclusion

It is the nature of the general public to like strange and marvelous tales and fantastic literature. Why? Because facts do not satisfy the imagination and embellished language [is] stimulating and moving. Therefore scholars of talent and glib essayists exaggerate and embellish the facts with lush, beautiful language. Writers create empty writings, transmitting the fantastic. Those who hear these things consider them real and tirelessly repeat them; those who read them take them as facts and continuously transmit them until they are recorded in books of bamboo and silk.[1]

ORDINARY PRACTICE

 ALL SCHOLARSHIP IS BASED ON ASSUMPTIONS, the most fundamental of which cannot be questioned without threatening the whole of the argument. This study is no exception, and the issues raised by Ishimatsu regarding the date of the Wei Wenlang stele exposes a major assumption underlying the previous analysis, that the inscriptions on extant images are accurate records of the facts of a donation: the background, social class, and goals of the patrons as well as the date of the sculpture. If one inscription can be altered, amended, or supplemented at a later time—whatever the motivation—others can be similarly corrupted. Such an understanding does not even consider the possibility that genuine, contemporary inscriptions might knowingly provide "inaccurate" information about the work. This is, of course, not a new problem and scholars have long recognized the potential misinformation provided in inscriptions. The case of the two Wei Wenlang stele highlights the role of evidence in such a process and the mechanisms by which we select or ignore certain facts in the process of producing a coherent narrative about visual images of the distant past. There are stakes involved and how different scholars react to arguments such as Ishimatsu's depends a great deal on our own investment in the Wei Wenlang stele as a singular example of sculpture from the early fifth century.

The goal of the project was to develop a narrative about ordinary images, their production, and the range of possibilities available to common-class patrons and the image makers they commissioned. What was produced, however, by the matching of specific images with discrete elements of subject position, in this case social class, was a kind of knowledge about the workings of images as well as class that is often awkward and not completely satisfying. Part of the problem has to do with the incommensurability of im-

ages and social facts or—maybe more to the point—the way in which knowledge produced about images and knowledge produced about society, while undoubtedly related, repeatedly slip past each other. The more directly and unambiguously one attempts to fix the relationship between the two, the less nuanced and meaningful the relationship appears to be. In the end, the study has been about visual imagery as evidence of its own creation and the difficulties of seeing and reading the past from the present.[2]

The book has also been a sustained attempt to provide alternatives to the main explanatory models for early Chinese religious imagery—for example, the progression from a Western-influenced style to fully sinicized Buddhist images. In order to pursue this goal, the study sought to understand the extant works as the result of choices made from a multiplicity of possibilities available to patrons and makers at a specific place and time. This is not to say that the well-known narrative of the sinicization of Buddhist art in China is incorrect but to suggest that such a theoretical scheme subsumes an unruly body of evidence into an easily digestible story, one that continues to have wide acceptance. It should be noted here that the approach taken in this book is not meant to simply critique the ethnocentrism of the sinicization paradigm. Any number of scholars have pointed out the manner in which the significant contributions of foreign influences on Chinese culture have been ignored; they would, for example, have us remember the many non-Chinese terms that have been incorporated into the Chinese language.[3] Yet this hardly affects the theoretical underpinnings of sinicization—that is, models of influence and acculturation. Rather, such arguments simply reverse the two poles, Han and non-Han, to insist on a valuation of foreign influence; the reverse, of course, is always possible.

One question that remains is this: at what point does a word or cultural practice stop being a loan from a foreign culture and become Chinese? (Or in our case, when does the foreign form of the Buddha image become a Chinese Buddha image?) This is not inconsequential—such a question can only be answered by recognizing that essentialist categories such as Han or non-Han as well as theories of influence operate as arbitrary and abstract terms through which a construction of Chinese art history is framed. Without an understanding of why certain choices are made and the processes by which some visual or linguistic elements are used and others ignored, the insistence on the priority of foreign influences or native Han forms, even the insistence on developing an analysis based on such a simplistic division, reduces any effort toward understanding the dynamics of cultural interaction to an intuitive if not political choice. At the same time, the reader would have noted the repetitious and predictable utilization of the Han/non-Han construction, at times obliquely, more often obviously, in the previous chapters.

Is it then possible to produce a real alternative? Maybe, although this study has attempted to be vigilant regarding easy claims of "new approaches." Models of cultural influence and sinicization cannot be simply dismissed; they have purchase exactly because of their consonance with conventional, modern modes of understanding and ex-

plaining cultural interaction. That dissatisfaction with the sinicization model has begun to appear now is no less a factor of changes in our understanding of culture in contemporary life. We live in a world that increasingly suggests to us that cultural interaction is complex, political, negotiated, and conscious. It comes as no shock then that older models of influence or acculturation may appear inadequate in the face of new models of hybridity, resistance, and contestation. This may suggest to some that the approach adopted in this study has been faddish, an ephemeral and obvious reading of history from a contemporary framework, but what is being argued is that the making of history is *always* the framing of the past in terms of the present. The situation is no less true today than it was for scholars in the nineteenth century, the 1930s, or the 1950s. If current understandings are eschewed as trendy or fashionable, the alternative is to recycle theories from the past. There is no choice but to recognize that the older model has outlived its usefulness, yet no easy alternative is available and one is hesitant to simply replace one paradigm with another—we face unknown territory.

The images discussed in this study have been related to religious beliefs and practices that as a whole have rather little to do with the Buddhism or Daoism of elite textual traditions. At the same time, we have found few direct visual or inscriptional references to beliefs and practices beyond those cited in canonical Buddhist sutras or Daoist texts. That is, none of the extant imagery appears to have been generated out of an interest in expressing something of the extra-canonical beliefs testified to in extant apocryphal and eschatological texts, ghost stories, or miracle tales.[4] Furthermore, images are often described in Buddhist texts as having miraculous powers. Yet we have found nothing in the inscriptions on images that would indicate the importance of such powers from the viewpoint of the donors. This is a sober reminder that however one might detach the evidence of visual imagery from the elite textual traditions that have informed our understanding of organized Buddhism or Daoism in early China, the images fail for the most part to have a direct relationship with noncanonical beliefs and practices.

Every publication of research and scholarship has the potential for stimulating further ideas and questions in the reader. One of the most intriguing aspects of scholarship is that one never knows precisely what—from the isolated footnote to the most sweeping generalization—might spark or encourage a completely unanticipated creative thought. As outlined in the introduction, this study has been an attempt to frame issues in a manner that will open them to more—rather than fewer—questions. The method is an attempt to remain consonant with the fragmentary and contradictory visual, archaeological, and historical materials at hand. Rather than crafting the evidence into a tightly knit argument with an inevitable consummation, each chapter has been an attempt to push the body of evidence or interpretive strategy to its limit—that is, those peripheral points at which any argument begins to lose its cohesion and momentum. This is not to claim that out of a range of possible interpretations, I have not favored one or the other; but to suggest that the extant material is better served by provisional con-

clusions that are transparent in relation to their theoretical basis. Although some may find this strategy lacking in conviction or courage if not disingenuous, it is hoped that other readers will welcome the potential of such an approach for encouraging multiple avenues of research on the topics touched on here as well as subjects not imagined by the author.

Notes

CHAPTER ONE

1. *Oxford English Dictionary,* 2nd ed. (Oxford: Clarendon Press, 1989), 10: 911.
2. As Rawski has pointed out, the level of literacy in premodern societies is difficult to ascertain. With no widespread educational opportunities in the sixth century C.E. or before, most Chinese were probably able to read or write only a few characters. Others no doubt possessed a limited, specialized vocabulary of characters used in everyday affairs such as business transactions, counting, and record-keeping, or the writing of names. Practically speaking, literati and religious texts were restricted to a very small minority of educated elites. Evelyn Sakakida Rawski, *Education and Popular Literacy in Ch'ing China* (Ann Arbor: University of Michigan Press, 1979), 1–8.
3. The emphasis on inscriptions rather than elite texts is inspired by the work of Gregory Schopen, who has been exemplary in utilizing archaeological and epigraphical evidence (as opposed to canonical Buddhist texts) to understand the practice of early Indian Buddhism. See Gregory Schopen, *Bones, Stones, and Buddhist Monks: Collected Papers on the Archaeology, Epigraphy, and Texts of Monastic Buddhism in India* (Honolulu: University of Hawaii Press, 1997), 1–22.
4. For an exemplary recent model of this approach, see Stephen Teiser, "The Spirits of Chinese Religion," in Donald S. Lopez, Jr., ed., *Religions of China in Practice* (Princeton: Princeton University Press, 1996), 3–37.
5. As noted in Wu Hung, "Buddhist Elements in Early Chinese Art (2nd and 3rd Centuries A.D.)," *Artibus Asiae* 47, 3/4 (1986): 303.
6. An approach emphasized in Mu-chou Poo, *In Search of Personal Welfare: A View of Ancient Chinese Religion* (Albany: State University of New York Press, 1998).
7. Anna Seidel, "Chronicle of Taoist Studies in the West, 1950–1990," *Cahiers d'extrême-asie* 5 (1989–90): 283.

8. Although a similar concern motivates Hans Belting, the history of the religious image in China has few parallels to that of the Christian tradition. See Hans Belting, *Likeness and Presence,* trans. Edmund Jephcott (Chicago: University of Chicago Press, 1994), xxi.
9. For probabilistic constructions, see Martin Powers, *Art and Political Expression in Early China* (New Haven: Yale University Press, 1991), 17–18.

CHAPTER TWO

1. Anna Seidel, "Chronicle of Taoist Studies," 283.
2. For the symposia, see He Zhiguo, "'Zaoqi fojiao zaoxiang nanchuan xitong Zhong-Ri xueshu yantaohui' shuping" (Review of the "Joint Chinese–Japanese scholarly research conference on the southern tradition of early Buddhist imagery"), *Dongnan wenhua* 1991, 6: 61–66. A large number of related essays were published in 1991 in various issues of *Dongnan wenhua.* In addition, the project resulted in two books: He Yun'ao, ed., *Fojiao chuchuan nanfang zhi lu* (The southern route of the early Buddhist tradition) (Beijing: Wenwu chubanshe, 1993); and Ruan Rongchun, *Bukkyō denrai no michi: nanpō rūto* (The path of Buddhist transmission: southern route) (Kyoto: Yūkonsha, 1996). Also see Wu Jialun and Jiang Yuxiang, *Gudai xinan sichou zhi lu yanjiu* (Research on the ancient southwestern Silk Road) (Chengdu: Sichuan daxue chubanshe, 1990); Gu Xuejia, "Nanfang sichou zhi lu zhiyi" (Questioning the validity of the Silk Road in South China), *Shixue yuekan* 1993, 3: 27–30; Gao Dalun, "Guanyu 'Nanfang sichou zhi lu' de jidian sikao" (Some reflections on the southern Silk Road), *Zhongguoshi yanjiu* 1995, 2: 131–38; Wu Tingqiu and Zheng Pengnian, "Fojiao haishang chuanru Zhongguo de yanjiu" (Research on the entry of Buddhism into China via the sea route), *Lishi yanjiu* 1995, 20–39; Tong Enzheng, "Gudai Zhongguo nanfang yu Indu jiaotong de kaoguxue yanjiu" (An archaeo-

logical study of communication between ancient southern China and India), *Kaogu* 1999, 4: 79–87.

3. Wu Hung, "Buddhist Elements in Early Chinese Art (2nd and 3rd Centuries A.D.)," *Artibus Asiae* 47, 3/4 (1986): 263–352. Also see sections of his *The Wu Liang Shrine* (Palo Alto: Stanford University Press, 1989), 136–41; and *Monumentality in Early Chinese Art and Architecture* (Stanford: Stanford University Press, 1995), 135–42.

4. Wu Hung, "Buddhist Elements," 273.

5. Yu Weichao, "Dong-Han fojiao tuxiangkao" (A study of Eastern Han dynasty Buddhist imagery), *Wenwu* 1980, 5: 68–77.

6. Wu Hung, *Monumentality*, figs. 2.49, 2.51, and 2.54.

7. For example, see Ruan Rongchun, *Bukkyō denrai*, 47–50, figs. 17 and 18.

8. Erik Zürcher, "Han Buddhism and the Western Region," in *Thought and Law in Qin and Han China*, ed. W. L. Idema and E. Zürcher (Leiden: E. J. Brill, 1990), 159.

9. Wu Hung, "Buddhist Elements," 265. Huang-Lao thought was established at court well before the introduction of Buddhism to China. See Mark Csikszentmihalyi, "Emulating the Yellow Emperor: The Theory and Practice of Huanglao, 180–141 B.C.E.," Ph.D. diss., Stanford University, 1994.

10. T.784:17.722a:21–22. Translated by Robert H. Sharf, "The Scripture in Forty-two Sections," in Donald S. Lopez, Jr., ed., *Religions of China in Practice* (Princeton: Princeton University Press, 1996), 364–65.

11. Wu Hung, "Buddhist Elements," 266.

12. After An Shigao, there would be the teams organized around An Xuan 安玄, Lokaksema (Zhi Loujiachen 支婁迦讖), Kang Mengxiang 康孟詳, and Zhi Yao 支曜. See Erik Zürcher, "A New Look at the Earliest Chinese Buddhist Texts," in *From Benares to Beijing: Essays on Buddhism and Chinese Religion in Honour of Prof. Jan Yun-Hua*, ed. Koichi Shinohara and Gregory Schopen (Oakville, Ont.: Mosaic Press, 1991), 282–84.

13. Victor H. Mair, "Buddhism and the Rise of the Written Vernacular in East Asia: The Making of National Languages," *Journal of Asian Studies* 53, 3 (August 1994): 709–10.

14. Based on his analysis of twenty-nine extant texts that he regards as genuine Han dynasty productions. Erik Zürcher, "Late Han Vernacular Elements in the Earliest Buddhist Translations," *Journal of the Chinese Language Teachers' Association* 12 (1977): 177–79. The literacy rate in China during the Han dynasty is impossible to ascertain with any accuracy; Bodde has suggested, however, that "probably never more than five per cent or so of the total of the population . . . had educational access to the complex written ideographs." Derk Bodde, *Festivals in Classical China* (Princeton: Princeton University Press, 1975), 2.

15. Zürcher, "A New Look," 289.

16. Ibid., 290.

17. Christopher Leigh Connery, *The Empire of the Text: Writing and Authority in Early Imperial China* (Lanham: Rowman & Littlefield Publishers, 1998), 4–13.

18. Erik Zürcher, *The Buddhist Conquest of China* (Leiden: E. J. Brill, 1972), 27 and 331 n. 86; Tsukamoto Zenryū, *A History of Early Chinese Buddhism*, trans. Leon Hurvitz, 2 vols. (Tokyo: Kodansha International, 1985), 1: 63.

19. Zürcher, *Buddhist Conquest*, 34; Tsukamoto, *Early Chinese Buddhism*, 1: 64–65.

20. Translation in Marylin M. Rhie, *Early Buddhist Art of China and Central Asia* (Leiden: Brill, 1999), 20, based on Chen Shou, *Sanguozhi* (Record of the Three Kingdoms) (Beijing: Zhonghua shuju, 1959), 1185. Rhie also translates a less elaborate version from Fan Ye, *Hou Hanshu* (History of the Later Han) (Beijing: Zhonghua shuju, 1965), 2368, on the previous page.

21. Zürcher, *Buddhist Conquest*, 28; Tsukamoto, *Early Chinese Buddhism*, 1: 73; Hurvitz in Tsukamoto, *Early Chinese Buddhism*, 1: 493–94, note t.

22. Tsukamoto, *Early Chinese Buddhism*, 1: 64–65.

23. Lewis R. Lancaster, "An Early Mahayana Sermon about the Body of the Buddha and the Making of Images," *Artibus Asiae* 36, 4 (1976): 289; and Paul Harrison, "Commemoration and Identification in *Buddhanusmrti*," in *In the Mirror of Memory*, ed. Janet Gyatso (Albany: State University of New York Press, 1992), 220–22.

24. Asian Art Museum of San Francisco, *Chinese, Korean, and Japanese Sculpture: The Avery Brundage Collection, Asian Art Museum of San Francisco* (Tokyo: Kodansha International, 1974), 64–67, no. 19.

25. A recent argument for dating the seated gilt bronze Buddha in the Harvard University Sackler Museum of Art to c. 160 C.E. is made in Rhie, *Early Buddhist Art*, 89.

26. In the early 1980s, it was estimated that over ten thousand Han dynasty tombs had been been discovered since 1949. Wang Zhongshu, *Han Civilization*, trans. K. C. Chang (New Haven: Yale University Press, 1982), 175.

27. Notwithstanding recent claims that archaeological finds in the area contain Buddhist imagery. For example, see the argument that a mirror dated to 93 C.E. features images of the Buddha and Laozi in Shang Chunfang, "Ji Luoyang chutu de Dong-Han shiqi fojiao wenwu ji qi xiangguan wenti" (Notes on the Eastern Han Buddhist cultural relics unearthed in Luoyang and related issues), *Wenwu chunqiu* 1998, 71–72; and Wen Yucheng, "Gongyuan yi zhi san shiji zhongguo de xianfo moshi" (The Immortal-Buddha type in first to third century China), *Dunhuang yanjiu* 1999, 161–63.

28. For the construction of the Chinese Buddhist canon, see Kyoko Tokuno, "The Evaluation of Indigenous Scriptures in Chinese Buddhist Bibliographical Catalogues," in *Chinese Buddhist Apocrypha*, ed. Robert E. Buswell (Honolulu: University of Hawaii Press, 1990), 31–74. For an example related to the biographies of monks, see Arthur F. Wright, "Biography and Hagiography: Hui–chiao's *Lives of Eminent Monks*," in *Silver Jubilee Volume of the Zinbun–Kagaku Kenkyusyo, Kyoto University*, ed. Zinbun Kagaku Kenkyujo Kyoto Daigaku (Kyoto: Kyoto Daigaku Jinbun Kagaku Kenkyujo, 1954), 2: 383–432.

29. Powers, *Political Expression*, 129, drawing on Chai Zhongqing, "Nanyang Han huaxiang shimu muzhu ren shenfen chutan" (A preliminary study of the social status of tomb occupants in decorated stone tombs at Nanyang), in *Handai huaxiang shi yanjiu* (Studies of Han dynasty decorated stones), ed. Nanyang Handai huaxiang shi xueshu taolunhui (Beijing: Wenwu chubanshe, 1987), 45–52.

30. Lydia Dupont Thompson, "The Yi'nan Tomb: Narrative and Ritual in Pictorial Art of the Eastern Han (25–220 C.E.)," Ph.D. diss., New York University, 1998, 112–20.

31. Mu-chou Poo, "Ideas concerning Death and Burial in Pre-Han and Han China," *Asia Major* 3rd ser., 3, 2 (1990): 25–62; for a later example, see Albert E. Dien, "Instructions for the Grave: The Case of Yan Zhitui," *Cahiers d'extrême-asie* 8 (1995): 41–58.

32. For example, the earliest records of a Buddhist monk in the Southwest date from the second half of the fourth century. See Zürcher, *Buddhist Conquest,* 395 n. 154. Also see Tsukamoto, *Early Chinese Buddhism,* 1: 118–19.

33. For a review of cliff tombs in Sichuan, see Luo Erhu, "Sichuan yamu de chubu yanjiu" (A preliminary study of the cliff tombs in Sichuan and adjacent areas), *Kaogu xuebao* 1988, 2: 133–67.

34. For the dating of the figures in the tombs, see Tang Changshou, "Leshan Mahao, Shiziwan yamu foxiang niandai xintan" (New inquiry into the date of the cliff-tomb Buddha images at Leshan Mahao and Shiziwan), *Dongnan wenhua* 1989, 2: 69–74.

35. The study and publication of tombs in the area of Leshan, referred to in earlier Western publications as Chiating (Jiading 嘉定), has a long history. See Wolfgang Franke, "Die Han-zeitlichen Felsengraber bei Chia-Ting (West Ssuchuan)," *Studia Serica* 7 (1948): 19–27; Zhou Junqi, "Lun Leshan shi Dong-Han yamu de yanjiu" (Research on the Eastern Han dynasty cliff tombs at Leshan), *Sichuan wenwu* 1997, 6: 10–17.

36. For examples of small, plain, common-class burials, see Sichuan sheng wenwu guanli weiyuanhui and Baoxing xian wenhuaguan, "Sichuan Baoxing Longdong Dong-Han muqun" (A group of Eastern Han tombs at Baoxing Longdong, Sichuan), *Wenwu* 1987, 10: 34–53.

37. Tang Changshou, "Shiziwan Cliff Tomb no. 1," *Orientations* 28, 8 (September 1997): 72–77.

38. The length of the middle and right tombs is 27.6 and 27.2 m respectively.

39. Illustrated in He Yun'ao, *Fojiao chuchuan,* fig. 2; Ruan Rongchun, *Bukkyō denrai,* fig. 10; Tang Changshou, "Shiziwan," fig. 15.

40. For a comparative rendering of the two images, see Tang Changshou, "Leshan Mahao, Shiziwan yamu," figs. 2–3.

41. The tomb is part of a group of excavations now incorporated into the Leshan Museum. The most complete archaeological survey is Leshan shi wenhuaju, "Sichuan Leshan Mahao yihao yamu" (Mahao Tomb 1, Leshan, Sichuan), *Kaogu* 1990, 2: 111–15, 122.

42. The following is based on a survey of the site in 1998. The assignment of numbers to Tombs 2–4 is my own. I am indebted to Walter Spink's inspired seminar at Ajanta in 1983 for stimulating my interest in such reconstructions.

43. Rhie, *Early Buddhist Art,* 48, states that the middle shaft is unfinished and possibly the last to be carved. Although the middle shaft is shorter than the other two, I have found no evidence that it was unfinished. A general sequence of excavation from the left wall of the antechamber to the rear wall and finally to the right is supported by the archaeological report. Leshan shi wenhuaju, "Sichuan Leshan Mahao," 115.

44. Franke erroneously located the bird on the upper wall between the left and center tomb entrances. The position of the misplaced bird was not corrected in subsequent publications of Franke's diagram by Rudolph or Edwards. The correct position is found in Leshan shi wenhuaju, "Sichuan Leshan Mahao," 114 and fig. 2.

45. Wolfgang Franke, "Die Han-zeitlichen Felsengraber," 37. Edwards calls the bird a phoenix, while Rudolph uses the Red Bird. Rawson notes that the term "phoenix" is used to describe two different, but interchangeable Chinese mythical birds, the Red Bird of the South, the *zhuniao* 朱鳥 or *zhuque* 朱雀, and the *fenghuang* 鳳凰. See Richard Edwards, "The Cave Reliefs at Ma Hao (Part 1), *Artibus Asiae* 17, 1 (1954): 13; Richard C. Rudolph, *Han Tomb Art of West China: A Collection of First- and Second-Century Reliefs* (Berkeley and Los Angeles: University of California Press, 1951), 24; Jessica Rawson, *Chinese Ornament: The Lotus and the Dragon* (London: Holmes & Meier, 1984), 99.

46. Rudolph, *Han Tomb Art of West China,* 25.

47. See ibid., pls. 11 and 12.

48. For two other Sichuan examples, see Käte Finsterbusch, *Verzeichnis und Motivindex der Hans-Darstellungen,* 2 vols. (Wiesbaden: O. Harrassowitz, 1966), 2: figs. 97 and 169. Finsterbusch identifies both as *taotie* (1: 241). For the *pushou,* see Hayashi Minao, "Jūkan hosho no jakkan o megutte" (Demon mask with ring from Eastern Zhou to Tang period), *Tōhō gakuhō* 57 (March 1985): 1–74. Thanks to Audrey Spiro for the latter reference.

49. Twelve examples are listed in Finsterbusch, *Verzeichnis und Motivindex,* 1: 234.

50. For a general overview, see Ni Run'an, "Lun liang Han siling de yuanliu" (A discussion of the origin and development of the four directional animals in the two Han dynasties), *Zhongyuan wenwu* 1999, 1: 83–91. The four directional animals are also depicted on coffins in Sichuan. See Wu Hung's discussion in Lucy Lim, *Stories from China's Past* (San Francisco: Chinese Culture Foundation of San Francisco, 1987), 178–79. Also see William Cohn, "The Deities of the Four Cardinal Points in Chinese Art," *Transactions of the Oriental Ceramic Society* 18 (1940–41): 61–75.

51. For the Queen Mother of the West in this time period, see Michael Loewe, *Ways to Paradise: The Chinese Quest for Immortality* (London: Allen & Unwin, 1979), 86–126; Anna Seidel, "Tokens of Immortality in Han Graves," *Numen* 29, 1 (1982): 79–122; Wu Hung, "Xiwangmu: The Queen Mother of the West," *Orientations* 18, 4 (1987): 24–33; Riccardo Fracasso, "Holy Mothers of Ancient China: A New Approach to the Hsi-wang-mu Problem," *T'oung Pao* 74 (1988): 1–46; Jean M. James, "An Iconographic Study of Xiwangmu During the Han Dynasty," *Artibus Asiae* 55, 1/2 (1995): 17–41.

52. Rudolph, *Han Tomb Art of West China,* 21 (caption to fig. 4).

53. Wu Hung, "Buddhist Elements," 267–69.

54. For an image on a stone coffin, see Leshan shi yamu bowuguan, "Sichuan Leshan shi Tuogouzui Dong-Han yamu qingli jianbao" (Report and inventory on the cliff tomb of the Eastern Han dynasty at Tuogouzui in Leshan City, Sichuan), *Wenwu* 1993, 1: fig. 21. For an example of freestanding sculpture, see Jin Sha, "Sichuan Yibin chutu Xiwangmu taoyong" (Pottery tomb-figure of Xiwangmu excavated from Yibin, Sichuan), *Wenwu* 1981, 9: 43, fig. 1.

55. Although *yaoqianshu* (literally "shaking money tree") is the most oft-used term, many scholars have argued for the term *shenshu* 神樹 or divine tree. See Zhong Jian, "Shitan Handai yaoqianshu de tuxing yu neihan" (Discussion of the significance and form of Han

dynasty money trees), *Sichuan wenwu* 1989, 1: 18–22; Zhao Dianzeng and Yuan Shuguang, "Sichuan Zhongxian Sanguo tongfoxiang ji yanjiu" (Research on the bronze Buddha images of the Three Kingdoms period from Zhongxian, Sichuan), *Dongnan wenhua* 1991, 5: 58; Chen Xiandan, "On the Designation 'Money Tree,'" *Orientations* 28, 8 (September 1997): 67–71.

56. The most comprehensive survey of these works is Susan N. Erickson, "Money Trees of the Eastern Han Dynasty," *Bulletin of the Museum of Far Eastern Antiquities* 66 (1994): 5–115. For more recent discussions, see Wang Yonghong, "Handai 'yaoqianshu' de xingzhuang ji neihan" (Form and significance of Han dynasty "money trees"), *Zhongguo lishi bowuguan guankan* 1996, 2: 42–49; and He Xilin, "Dong-Han qianshu de tuxiang ji yiyi" (The imagery and meaning of Han dynasty money trees), *Gugong bowuyuan yuankan* 1998, 3: 20–31.

57. There are two finds outside this area: one in Qinghai, noted by Erickson, and a fragment from Gansu; see Gansu sheng wenwu guanli weiyuanhui, "Lanxin tielu Wuwei—Yongchang yanxian gongdi gumu qingli gaikuang" (General survey of the ancient tombs at the Yongchang Yanxian construction site, on the new Lanzhou to Wuwei railway), *Wenwu cankao ziliao* 1956, 6: 41, fig. 17.

58. Sichuan sheng bowuguan, *Sichuan sheng bowuguan* (Sichuan provincial museum) (Beijing: Wenwu chubanshe, 1988), pl. 185; Jessica Rawson, *Mysteries of Ancient China: New Discoveries from the Early Dynasties* (New York: G. Braziller, 1996), no. 87, where the height is given as 105 cm.

59. Mianyang bowuguan and He Zhiguo, "Sichuan Mianyang Hejiashan erhao Dong-Han yamu qingli jianbao" (Brief report and inventory of the Eastern Han cliff tomb Hejiashan No. 2, Mianyang, Sichuan), *Wenwu* 1991, 3: 9–19; Zhongguo wenwu jinghua bianji weiyuanhui, *Zhongguo wenwu jinghua* (Gems of China's cultural relics) (Beijing: Wenwu chubanshe, 1997), pl. 82; He Zhiguo, "Zhongguo zuida de yaoqianshu ji qi neihan" (Largest money tree in China and its significance), *Wenwu tiandi* 1998, 2: 45–48.

60. Lim, *Stories from China's Past*, color pls. 8 and 9, pl. 58; Chen Xiandan, "On the Designation," figs. 1 and 3.

61. Zhong Zhi, "Santai Hujiabian yaoqianshu chukao" (Initial study of the money tree from Santai Hujiabian), *Gugong wenwu yuekan* 188 (November 1998): 120–27.

62. Royal Ontario Museum, Toronto, Canada, 994.62.1–14, 139 cm high; Asian Art Museum of San Francisco, the Avery Brundage Collection, 1995.79.a–cc, 175 cm high; Detroit Institute of the Arts, 1996.29.a–kk, 138 cm high; also see trees advertised in *Orientations* 25, 1 (January 1994) by Kaikodo Gallery, 122 cm high, and Christie's South Kensington, Ltd., *Fine Chinese Ceramics, Paintings and Works of Art* (New York: March 22, 1999), no. 200, 159 cm high.

63. Erickson records two such trees, one from Guanghan and one in the Tsui Museum of Art, Hong Kong, in "Money Trees," 18 n. 67. Klaas Ruitenbeek of the Royal Ontario Museum has studied three unpublished money trees in a private collection in Toronto. And in a private communication, Sherman Lee reported seeing as many as ten trees in various states of reconstruction in 1996 at the Sichuan Provincial Museum, Chengdu.

64. See Karen Trentelman, Leon Stodulski, Ray Lints, and Chongmin Kim, "A Comparative Study of the Composition and Corrosion of Branches from Eastern Han Dynasty Money Trees," *Studies in Conservation* 44, 3 (1999): 170–73. Thanks to Karen Trentelman for providing to the author a copy of this essay in manuscript form. The branches of the money tree in the Detroit Institute of the Arts appear, on stylistic grounds, to be from five different works; tests on the trunk and finial determined these to be modern reconstructions. The Asian Art Museum tree has two branches that are composites of fragments; in addition, one bronze section appears to be modern, according to Michael Knight.

65. Among the excavated works, the tree from Sichuan Guanghan is one of the most stylistically consistent, although it too has undergone significant restoration. The reconstructed tree consists of 64 sections compared to the original 32 whole and partial fragments recovered from the tomb. See Yang Xiaowu, "Qiantan Guanghan shi chutu yaoqianshu de xiufu" (Discussion of the restoration of a "money tree" excavated from Guanghan), *Sichuan wenwu* 1989, 6: 76–77, 49.

66. Rawson, in *Mysteries of Ancient China*, 177; Shen Zhongchang and Li Xianwen, "Ji Pengshan chutu de Dong-Han tong yaoqianshu" (On the Eastern Han bronze money tree excavated from Pengshan), *Chengdu wenwu* 1986, 1: 17. Also see Shen Zhongchang and Li Xianwen, "Dong-Han tongzhi taozuo yaoqianshu" (Money trees with bronze branches and pottery bases of the Eastern Han period), *Renmin zhongguo* 1980, 12: 37–38.

67. Chen Xiandan, "On the Designation," 67. An alternate interpretation is that the bird represents the sunbird that perches on the *fusang* tree in the Eastern Sea and each day provides the world with light. See Wu Hung, in Lim, *Stories from China's Past*, 160.

68. Erickson meticulously surveys the variety of subject matter in "Money Trees," 9–27.

69. The excavations of the Pengshan Eastern Han tombs, carried out in 1941–42, were published in Nanjing bowuyuan, *Sichuan Pengshan Han dai yamu* (Han dynasty cliff tombs at Pengshan, Sichuan) (Beijing: Wenwu chubanshe, 1991). See fig. 44 and pl. 1 for the base.

70. For the *bi* and dragons on a money tree base, see Nanjing bowuyuan, *Sichuan Pengshan*, 36, fig. 45.

71. Two very small cast bronze pieces from the tomb may be part of a money tree, but they are too fragmentary to be identified with certainty. See Nanjing bowuyuan, *Sichuan Pengshan*, 90, fig 167: 8 and 10.

72. Zeng Zhaoyu, *Yi'nan guhuaxiang shimu fajue baogao* (Report of the excavation of ancient stone engravings in a tomb near Yi'nan) (Beijing: Wenhuabu wenwu guanliju, 1956), 66–67, figs. 42.

73. Yang Hong, "Guonei xiancun zuigu de jizun fojiao zaoxiang shiwu" (Earliest objects of Buddhist imagery preserved in China today), *Xiandai foxue* 1962, 4: 32–33, fig. 3.

74. Yu Haoliang, "'Qianshu,' 'qianshuzuo' he yulong manyan zhi xi" ("Money trees," "money tree bases," and the performance known as the fish-dragon transformation), *Wenwu* 1961, 11: 43–45.

75. Yu Weichao, "Dong-Han fojiao tuxiangkao," 75–76.

76. Wu Hung, *Wu Liang Shrine*, 139.

77. One each from Santai, Mianyang Hebian, Guanghan, Chengdu, and Yibin 宜賓. For the Santai base, see Santai xian wenhuaguan, "Sichuan Santai xian faxian Dong-Han mu" (Eastern Han tomb discovered at Santai, Sichuan), *Kaogu* 1976, 395, pl. 1: 5 and 6; the Mianyang base is from Hebian Bai Tomb 2, see He Zhiguo, "Sichuan Mianyang Hebian Dong-Han yamu" (Eastern Han cliff tombs at Hebian, Mianyang, Sichuan), *Kaogu* 1988, 3: 222, fig. 5: 5 and 225, fig. 8; for the Guanghan base, see Chen Xiandan, "On the Designation," 68 and fig. 6; for the Chengdu base, see Zhongguo meishu quanji bianji weiyuanhui, ed., *Taoci* (Ceramics) (Shanghai: Shanghai renmin meishu chubanshe, 1988), fig. 153; for the Yibin base in Tomb 3, see Sichuan sheng bowuguan and Yibinshi wenguansuo, "Yibinshi Shanguci Handai yamu qingli jianbao" (Report and inventory of the Han dynasty cliff tombs at Yibin, Shanguci), *Wenwu ziliao congkan* 9 (1985): 135, fig. 9.

78. Object M5: 52 in Chengdu shi wenwu kaogu gongzuodui and Qingbaijiang qu wenwu guanlisuo, "Chengdu shi Qingbaijiang qu Yuejin cun Han mu fajue jianbao" (Report on the excavation of Han dynasty tombs at Yuejin village, Qingbaijiang district, Chengdu city), *Wenwu* 1999, 8: 30 and fig. 33: 2.

79. Sichuan sheng bowuguan and Xinduxian wenguansuo, "Xinduxian Majiashan yamu fajue jianbao" (Report on the excavation of cliff tombs at Xinduxian, Majiashan), *Wenwu ziliao congkan* 9 (1985): 102 and fig. 103.

80. Chen Xiandan, "On the Designation," 70.

81. Erickson, "Money Trees," 39.

82. Nanjing bowuyuan, *Sichuan Pengshan,* 35–38.

83. For a base 21 cm high in the form of a crouching toad from Guangyuan, Sichuan, labeled as a money tree base, see Zhongguo meishu quanji bianji weiyuanhui, ed., *Qin Han diaosu* (Qin and Han dynasty sculpture) (Beijing: Renmin meishu chubanshe, 1985), plate 103.

84. See Nanjing bowuyuan, *Nanjing bowuyuan zang baolu* (Catalogue of the treasures of the Nanjing Museum) (Shanghai: Shanghai wenyi chubanshe, 1992), 117–18; Zhongguo meishu quanji bianji weiyuanhui, ed., *Qin Han diaosu,* pl. 127; and He Jiying, "Xifang yishu dui Wei Jin Nanbeichao Sui Tang taociqi de yingxiang" (Western artistic impact on the ceramics of the Wei, Jin, Northern-Southern, Sui, and Tang dynasties), *Shanghai bowuguan jikan* 7 (1996): 158. At the same time, Erickson is not alone in considering the work to be a money tree base. See He Yun'ao, *Fojiao chuchuan,* 166; Rhie, *Early Buddhist Art,* 56–58.

85. For technical details of manufacture, see Elizabeth Errington and Joe Cribb, with Maggie Claringbull, eds., *The Crossroads of Asia: Transformation in Image and Symbol in the Art of Ancient Afghanistan and Pakistan* (Cambridge: Ancient India and Iran Trust, 1992), 250–51.

86. Three from collections in Japan are illustrated in He Yun'ao, *Fojiao chuchuan,* figs. 13–15; another in England was published in Errington et al., *Crossroads of Asia,* no. 205 and color pl., p. 32; and one in the collection of the Royal Ontario Museum (992.100.1) is unpublished.

87. Although the excavation report divides the parts of the superstructure between two trees, these have been combined to reconstruct a tree of twenty-nine pieces. See Mianyang bowuguan and He Zhiguo, "Sichuan Mianyang Hejiashan erhao," 3: 15–16; and Zhongguo wenwu jinghua bianji weiyuanhui, *Zhongguo wenwu jinghua,* 281.

88. Mianyang bowuguan and He Zhiguo, "Sichuan Mianyang Hejiashan yihao Dong-Han yamu qingli jianbao" (Report and inventory of the Eastern Han cliff tomb Hejiashan No. 1, Mianyang, Sichuan), *Wenwu* 1991, 3: 1–7; for the mirror, see pl. 1: 3.

89. Sichuan sheng wenwu guanli weiyuanhui, "Sichuan Zhongxian Tujing Shu-Han yamu" (Shu-Han cliff tombs at Tujing, Zhongxian, Sichuan), *Wenwu* 1985, 7: 49–95.

90. Zhao Dianzeng and Yuan Shuguang, "Sichuan Zhongxian Sanguo tongfoxiang ji yanjiu," 56. Unfortunately, the Tomb 5 tree had not been fully described or reconstructed at the time of this study.

91. He Yun'ao, *Fojiao chuchuan,* figs. 9 and 11.

92. Guizhou sheng bowuguan, "Guizhou Qingzhen Pingba Han mu fajue baogao" (Report on the excavation of a Han tomb at Pingba, Qingzhen, Guizhou), *Kaogu xuebao* 1959, 1: 85–103.

93. The tree listed in Christie's South Kensington, *Fine Chinese Ceramics,* no. 200, also has five bears molded onto the trunk, although these have no circular halo.

94. Yunnan sheng wenwu gongzuodui, "Yunnan Zhaotong Guijiayuanzi Dong-Han mu fajue" (Excavation of Eastern Han tombs at Guijiayuanzi, Zhaotong, Yunnan), *Kaogu* 1962, 8: 395–99.

95. Hanzhong shi bowuguan and He Xincheng, "Shaanxi Hanzhong shi Puzhen zhuanchang Han mu qingli jianbao" (Inventory report on the Han tombs at the Puzhen brick factory, Hanzhong city, Shaanxi), *Kaogu yu wenwu* 1989, 6: 44 and fig. 14: 12.

96. Tang Jinyu and Guo Qinghua, "Shaanxi Mianxian Hongmiao Dong-Han mu qingli jianbao" (Report and inventory of an Eastern Han tomb at Hongmiao, Mianxian, Shaanxi), *Kaogu yu wenwu* 1983, 4: 30–34 and pl. 1.

97. Wang Shouzhi, "Chenggu chutu de Handai taodu" (Han dynasty *taodu* excavated from Chenggu), *Wenbo* 1987, 6: 91–92.

98. Luo Erhu, "Shaanxi Chenggu chutu de qianshu foxiang jiqi yu Sichuan diqu de guanxi" (A money tree Buddha image excavated at Chenggu Shaanxi and its relationship to those of the Sichuan region), *Wenwu* 1998, 12: 63–70.

99. For the bear motif, see the discussion of the bear-shaped legs on a Western Han *ding* vessel by Jessica Rawson in Yang Xiaoneng, ed., *The Golden Age of Chinese Archaeology* (New Haven: Yale University Press, 1999), no. 131, 396–97.

100. The ram had an auspicious meaning during the Han dynasty reinforced by the use of the character for "ram" (*yang* 羊) within the character for "auspicious" (*xiang* 祥). See Erickson, "Money Tree," 9.

101. For the *fangxiangshi* and a translation of the texts discussed in this paragraph, see Peter S. Nickerson, "Taoism, Death, and Bureaucracy in Early Medieval China" (Ph.D. diss., University of California, Berkeley, 1996), 105–6. For the *Zhouli,* see William G. Boltz, "Chou li," in Michael Loewe, ed., *Early Chinese Texts: A Bibliographical Guide* (Berkeley: Society for the Study of Early China, 1993), 24–32.

102. Michael Nylan, "Feng su t'ung i," in Loewe, *Early Chinese Texts,* 105. For *taishou,* see Charles O. Hucker, *A Dictionary of Official*

Titles in Imperial China (Stanford: Stanford University Press, 1985), entry no. 6221.

103. Translated in Nickerson, "Taoism, Death, and Bureaucracy," 106−7.

104. Erickson, "Money Trees," 24.

105. Erickson, "Money Trees," 9; and Zhong Jian, "Shitan Handai," 19−20.

106. Erickson, "Money Trees," 9−10, who also cites the *xiong jing* illustrated in a diagram from Mawangdui Tomb 3.

107. In his discussion of the bear on *hunping*. See Kominami Ichirō, "Shinteiko to Tōgo no bunka" (Spirit bottles and Eastern Wu culture), *Tōhō gakuhō* 65 (1993): 230−32.

108. Yu Haoliang, "'Qianshu,'" 43.

109. Chen Xiandan, "On the Designation," 70.

110. Kwang-chih Chang, *Art, Myth, and Ritual* (Cambridge: Harvard University Press, 1983), 61−72.

111. For the relationship of *xiangrui* to early Buddhist imagery, see Wu Hung, "Buddhist Elements," 270−73. The red bear is identified in Wu Hung, *Wu Liang Shrine,* 239−40.

112. Exemplary in this regard are Wu Hung, *Wu Liang Shrine;* and Powers, *Art and Political Expression.*

113. Stephen Little, ed., *Taoism and the Arts of China* (Berkeley and Los Angeles: University of California Press, 2000), 154−55, no. 25.

114. Han dynasty tombs of the lower classes are known, but these are plain with few grave goods. See Wang, *Han Civilization,* 212−13, figs. 312−20.

115. Irisawa Takashi, "Yōsenju butsuzō kō" (A consideration of Buddha images on a bronze "money tree"), *Mikkyō zuzō* 12 (December 1993): 44−60. Also see James, "An Iconographic Study," 38; and for the relationship between money trees and trade routes, see Jiang Yuxiang, "Shilun zaoqi daojiao zai Ba-Shu fasheng de wenhua beijing" (A preliminary discussion of the cultural background to the occurrence of early Daoism in Ba-Shu), in *Daojia wenhua yanjiu,* ed. Chen Guying (Shanghai: Shanghai guji chubanshe, 1995), 328−30.

116. Xian Ming, "Lun zaoqi daojiao yiwu yaoqianshu" (Discussion of money trees as early Daoist votive objects), *Sichuan wenwu* 1995, 5: 8−12; Xian Ming, "Zai lun zaoqi daojiao yiwu yaoqianshu" (A further discussion of money trees as early Daoist votive objects), *Sichuan wenwu* 1998, 4: 29−33.

117. For the early history of Celestial Master Daoism, see Stephen R. Bokenkamp, *Early Daoist Scriptures* (Berkeley and Los Angeles: University of California Press, 1997), 1−6 and 32−37; Terry F. Kleeman, *Great Perfection: Religion and Ethnicity in a Chinese Millennial Kingdom* (Honolulu: University of Hawaii Press, 1998), 61−80; David C. Yu, trans., *History of Chinese Daoism* (Lanham, Md.: University Press of America, 2000), 126−72.

118. Wu Hong, "Diyu kaogu yudui 'Wudoumi dao' meishu chuantong de chonggou" (Regional archaeology and the reconstruction of the artistic tradition of Wudoumi daoism), in *Han Tang zhi jian de zongjiao yishu yu kaogu* (Religious art and archaeology of the Han to Tang period), ed. Wu Hong (Beijing: Wenwu chubanshe, 2000), 431−60; Wu Hung, "Mapping Early Taoist Art: The Visual Culture of Wudoumi Dao," in *Taoism and the Arts of China,* ed. Stephen Little (Berkeley and Los Angeles: University of California Press, 2000), 77−93.

119. Wu Hung, "Mapping Early Taoist Art," 82.

120. Ibid., 77.

121. Rolf A. Stein, "Religious Taoism and Popular Religion from the Second to Seventh Centuries," in *Facets of Taoism,* ed. Holmes Welch and Anna Seidel (New Haven: Yale University Press, 1979), 53−82.

122. See, for example, an image of the Queen Mother of the West on a base (M5: 52) from Tomb M5, dated to the late Western Han or early Eastern Han in Chengdu shi wenwu kaogu gongzuodui et al., "Chengdu shi Qingbai jiang qu," 36 and fig. 33, no. 2.

123. Suzanne Cahill, *Transcendence and Divine Passion: The Queen Mother of the West in Medieval China* (Stanford: Stanford University Press, 1993), 32−34.

124. The discrepancy in distribution is actually confirmed in Wu Hung, "Mapping Early Taoist Art," 80−81, figures 1 and 4.

125. The earliest texts documenting the twenty-four Celestial Master centers date to the latter part of the sixth century. See Wang Chunwu, *Tianshi Dao ershisizhi kao* (A study of the twenty-four centers of Tianshi Dao) (Chengdu: Sichuan daxue chubanshe, 1996), 68−70; and Yi Wen, "Daojiao gushi yanjiu de zhongda tupo" (Major breakthrough in the study of Daoist ancient history), *Sichuan wenwu* 1997, 2: 21.

126. Zhou Kelin, "Yaoqianshu wei zaoqi daojiao yiwu shuo zhiyi" (Doubts concerning the hypothesis that "money trees" were early Daoist votive objects), *Sichuan wenwu* 1998, 4: 17.

127. For a discussion based on such an assumption, see Richard Edwards, "The Cave Reliefs at Ma Hao (Part 2)," *Artibus Asiae* 17, 2 (1954): 118−20.

128. Wu Hung, "Mapping Early Taoist Art," 91.

129. For the story, see Zürcher, *Buddhist Conquest,* 290−99.

130. Wu Hung, *Monumentality,* 136.

131. A contemporary example would be the interest in the Queen Mother as a goddess or "mother goddess." See Lee Rainey, "The Queen Mother of the West: An Ancient Chinese Mother Goddess?" in *Sages and Filial Sons,* ed. Julia Ching and R. W. L. Guisso (Hong Kong: Chinese University Press, 1991), 81−100; Cahill, *Transcendence and Divine Passion.*

132. For background on the region, see Yoshio Kawakatsu, "L'aristocratie et la société féodale au début des Six Dynasties," *Zinbun* 17 (1981): 107−60; Liu Shufen, "San zhi liu shiji Zhedong diqu jingqi de fazhan" (The economic development of the Zhe-Dong area from the third to the sixth centuries), *Zhongyang yanjiuyuan lishi yuyan yanjiusuo jikan* 58, 3 (1987): 485−524; Rafe de Crespigny, "The Three Kingdoms and Western Jin: A History of China in the 3rd Century AD: I," *East Asian History* 1 (June 1991): 1−36; Rafe de Crespigny, "The Three Kingdoms and Western Jin: A History of China in the 3rd Century AD: II," *East Asian History* 2 (December 1991): 143−65; Hans Bielenstein, "The Six Dynasties, Vol. 1," *Bulletin of the Museum of Far Eastern Antiquities* 68 (1996): 5−324.

133. Zürcher, *Buddhist Conquest,* 50.

134. Alexander C. Soper, *Literary Evidence for Early Buddhist Art in China* (Ascona: Artibus Asiae, 1959), 5−6.

135. Lianyungang shi bowuguan, "Lianyungang Kongwangshan moya zaoxiang diaocha baogao" (Report on the investigation of the cliff images at Lianyungang, Kongwangshan), *Wenwu* 1981, 7: 1−7.

136. The discussion in Wu Hung, "Buddhist Elements," 292–303, remains germane. For a summary of the Chinese scholarship on periodization and other issues, see Zürcher, "Han Buddhism," 165–66 n. 20. The site is treated as late second to third century in Rhie, *Early Buddhist Art,* 27–47.

137. A recent publication of the Japanese mirrors can be found in Nara kokuritsu hakubutsukan, *Higashi Ajia no hotoketachi* (Buddhist images of East Asia) (Nara: Nara kokuritsu hakubutsukan, 1996).

138. For the fourth century, see Wu Hung, "Buddhist Elements," figs. 29–35. A number of the same works are dated to the fifth century in He Yun'ao, *Fojiao chuchuan,* pls. 26–30. Some scholars, however, continue to support an earlier dating, for example Kawanishi Hiroyuki, "Sankakubuchi butsujūkyō" (Triangular rimmed Buddha–mythical beast mirrors), *Kōkogaku foramu* 5 (September 1994): 1–20. It remains unclear whether the mirrors with the Buddha-like images as well as other related mirrors were imported from China or made by Chinese emigrant craftsmen in Japan. For a recent discussion of the issue, see Wang Zhongshu, "Lun Riben 'fangzhi sanjiao yuan shenshou jing' de xingzhi jiqi yu suowei 'bozai sanjiao yuan shenshou jing' de guanxi" (On the character of "imitative triangular rimmed bronze mirrors with deities and mythical animal designs" in Japan and their relationship with so-called "imported" ones), *Kaogu* 2000, 1: 78–88.

139. Wu Hung, "Buddhist Elements," 278–81 and fig. 35. Wu Hung follows Wang Zhongshu in accepting the seated figure as a Buddha image. See Wang Zhongshu, "Guanyu Riben de sanjiaoyuan foshoujing" (Regarding the Japanese triangular-edged Buddha and mythical animals mirrors), *Kaogu* 1982, 6: 630–39. For a dissenting opinion, see Xiong Shouchang, "'Huawendai foshoujing' zhiyi, yu Wang Zhongshu xiansheng shangque" (Questioning "decorative-band *foshou* mirrors," and the deliberations of Wang Zhongshu), *Dongnan wenhua* 1992, 3–4: 143–47. It may be significant that none of the recent Chinese publications of Buddhist art from the southern route, which include nearly every image with a hint of a Buddhist component, have chosen to illustrate this mirror.

140. For published mirrors from this region, see Kong Xiangxing, *Zhongguo tongjing tudian* (Illustrated dictionary of Chinese bronze mirrors) (Beijing: Wenwu chubanshe, 1992); and Hubei sheng bowuguan and Ezhou shi bowuguan, ed., *Echeng Han Sanguo Liuchao tongjing* (Han, Three Kingdoms, and Six Dynasties bronze mirrors from Echeng) (Beijing: Wenwu chubanshe, 1986).

141. Wu Hung, "Buddhist Elements," 282, fig. 41; Wang Zhongshu, "Lun Wu Jin shiqi de fojiao kuifeng jing" (On the Buddhist phoenix mirrors of the Wu and Jin periods), in *Zhongguo kaoguxue yanjiu: Xia Nai xiansheng kaogu wushi nian jinian lunwenji* (Archaeological research in China: A collection of papers in commemoration of the fiftieth year of Prof. Xia Nai's work in archaeology), ed. Zhongguo kaoguxue yanjiu bianweihui (Beijing: Wenwu chubanshe, 1986), 257–61, fig. 2: 2; Kong Xiangxing, *Zhongguo tongjing tudian,* 397; Ruan Rongchun, *Bukkyō denrai,* 202, fig. 132; Rhie, *Early Buddhist Art,* 123–24.

142. Several other problematic images have been published as Buddhas, but these will also be set aside for similar reasons. See He Yun'ao, *Fojiao chuchuan,* figs. 4 and 5, and Rhie, *Early Buddhist Art,* 130–32.

143. Rafe de Crespigny, *Generals of the South: The Foundation and Early History of the Three Kingdoms State of Wu* (Canberra: Australian National University, Faculty of Asian Studies, 1990), 413. Also referred to as Ezhou 鄂州. For the political history of the Wu dynasty, see Bielenstein, "Six Dynasties," 13–46.

144. Hubei sheng wenwu kaogu yanjiusuo and Ezhou shi bowuguan, "Hubei Ezhou shi Tangjiaotou liuchao mu" (Tombs of the Six Dynasties period at Tangjiaotou, Ezhou, Hubei), *Kaogu* 1996, 11: 1–27.

145. For a very similar ceramic figure in dhyana mudra, 30 cm high, in the collection of the Palace Museum, Beijing, see Ruan Rongchun, *Bukkyō denrai,* 165, fig. 61.

146. For the function of metal in tomb contexts, see K. E. Brashier, "Longevity Like Metal and Stone: The Role of the Mirror in Han Burials," *T'oung Pao* 81, 4–5 (1995): 201–29.

147. Yang Hong, "Ba Ezhou Sun-Wu chutu tao foxiang" (On the pottery Buddha image excavated from a Sun-Wu tomb in Ezhou City), *Kaogu* 1996, 11: 30.

148. Present-day Wuchang should not be confused with the aforementioned Wu Kingdom capital of Wuchang located at Ezhou. See de Crespigny, *Generals of the South,* 265–66 n. 78.

149. Hubei sheng wenwu guanli weiyuanhui, "Wuchang Lianxisi Dong-Wu mu qingli jianbao" (Report and inventory of the Eastern Wu tomb at Lianxisi, Wuchang), *Kaogu* 1959, 4: 189–90.

150. The figure was identified as a Buddha not in the excavation report cited above, but in the following essays: Cheng Xinren, "Woguo xiancun gudai fojiao zhong zuizao de yizun zaoxiang" (The earliest Buddhist image extant in our country to date), *Xiandai foxue* 1964, 11–12; Cheng Xinren, "Wuhan chutu de liangkuai Dong-Wu qianquan shiwen" (Two Eastern Wu dynasty inscribed lead title deeds excavated at Wuhan), *Kaogu* 1965, 10: 529–30. Cheng's opinion is still followed in Zhongguo meishu quanji bianji weiyuanhui, ed., *Qin Han Diaosu,* 2 (text), figure 3.

151. The figure is identified as a bodhisattva in Marylin M. Rhie, "The Earliest Chinese Bronze Bodhisattva Sculptures," *Arts of Asia* 25, 2 (March–April 1995): 87; and also by Ruan Rongchun, *Bukkyō denrai,* 143.

152. Small standing figures on mirrors have been identified as standing bodhisattvas by some scholars, but they are invariably much cruder renditions. See the comparison in Rhie, "Earliest Chinese Bronze Bodhisattva Sculptures," 87, figs. 1 and 2.

153. Yang Hong, "Guonei xiancunzuigu," 33, fig. 4; He Jiying, "Xifang yishu," 158, fig 2. For similar figures, see He Yun'ao, *Fojiao chuchuan,* figs. 114–15.

154. Hubei sheng wenwu kaogu yanjiusuo and Ezhou bowuguan, "Hubei Ezhou shi Tangjiaotou," fig. 16.

155. Incompletely transcribed in Hubei sheng wenwu guanli weiyuanhui, "Wuchang Lianxisi," 189–90; fully transcribed and illustrated in Cheng Xinren, "Wuhan chutu de liangkuai Dong-Wu qianquan shiwen," 529–30; and Ikeda On, "Chūgoku rekidai boken ryakkō" (A brief study of Chinese tomb documents of the past dynasties), *Tōyō bunka kenkyūjo kiyō* 86 (1981): 225, no. 26.

156. The King Father and Queen Mother are referred to in the exact same phrase in a land contract dated to 338. See Terry Kleeman, "Land Contracts and Related Documents," in *Chūgoku no shūkyō shisō to kagaku: Makio Ryōkai hakushi shōju kinen ronshū* (Religion,

thought and science in China: a festschrift in honor of Professor Ryōkai Makio on his seventieth birthday), ed. Makio Ryōkai hakushi shōju kinen ronshū kankōkai (Tokyo: Kokusho kankōkai, 1984), 24.

157. Another example of the King Father and Queen Mother as guarantors and witnesses in a land contract is dated to 227 and was also excavated from Wuhan. Cheng Xinren, "Wuhan chutu," 529; Ikeda On, "Chūgoku rekidai," 225, no. 24.

158. Kleeman, "Land Contracts," 12 (as dated to 226); Ikeda, "Chūgoku rekidai," 224, no. 23.

159. Anna Seidel, "Traces of Han Religion," in *Taoism and Religious Culture,* ed. Akizuki Kan'ei (Tokyo: Hirakawa shuppan, 1987), 28.

160. For *xiaowei,* see Hucker, *A Dictionary of Official Titles,* entry no. 2456. Under the Eastern Han, the position of *xiaowei* was ranked at 2,000 *dan,* a unit of measurement of grain that was employed to indicate official rank. See Thompson, "Yi'nan tomb," 112–14 and 124.

161. Seidel, "Traces," 47–48.

162. Echeng xian bowuguan, "Echeng Dong-Wu Sun jiangjun mu" (Tomb of a General Sun of the Eastern Wu at Echeng), *Kaogu* 1978, 3: 164–67, 163.

163. Ibid., 163; Chen Shou, *Sanguozhi,* 1211.

164. Echeng xian bowuguan, "Echeng Dong-Wu," pl. 7: 1.

165. Ibid., fig. 9: 2; pl. 7: 3; illustrated without the lower section here and in He Yun'ao, *Fojiao chuchuan,* no. 37 and Ruan Rongchun, *Bukkyō denrai,* 169, no. 71. The base of a nearly identical work, also with Buddha-like figures, has been excavated from Yichang 宜昌 in western Hubei Province. See *Bukkyō denrai,* 170, nos. 72–73.

166. Ezhou bowuguan and Hubei sheng wenwu kaogu yanjiusuo, "Hubei Ezhou Egang yinliaochang yi hao mu fajue baogao" (Report on the excavation of tomb no. 1 in the drink factory of the Ezhou municipal steel mill), *Kaogu xuebao* 1998, 1: 103–32.

167. Even smaller Wu Kingdom tombs from the area are known. See Echeng xian bowuguan, "Hubei Echeng sizuo Wu mu fajue baogao" (Report on the excavation of four Wu tombs at Echeng, Hubei), *Kaogu* 1982, 3: 257–69; Ezhou shi bowuguan, "Hubei Echeng Wu Jin mu fajue baogao" (Report on the excavation of Wu and Jin tombs at Echeng, Hubei), *Kaogu* 1991, 7: 608–13.

168. From Yixing Tomb 1 dated 297, see Luo Zongzhen, "Jiangsu Yixing Jin mu fajue baogao" (Report on excavation of Jin tombs at Yixing, Jiangsu), *Kaogu xuebao* 1957, 4: pl. 5: 1; from a tomb excavated at Jiangning dated to 299, see Wu Wenxin, "Jiangsu Jiangning chutu yipi Xi-Jin qingci" (A group of Western Jin ceramics uncovered at Jiangning, Jiangsu), *Wenwu* 1975, 2: 92–94; and from a tomb dated to 305 from Wuxi, see Nanjing bowuyuan, 134–35; for an undated example from Yixing, see Nankin hakubutsuin, *Nankin hakubutsuin ten* (Exhibition from the Nanjing Museum collection) (Nagoya: Nagoya-shi hakubutsukan, 1981), no. 57.

169. As of June 1998, *gucangguan* was used for the labels at the Shaoxing Museum, Zhejiang Province; *duisuguan* was used at the Zhejiang Provincial Museum and the Shanghai Museum; both *duisuguan* and *hunping* were found at the Nanjing City Museum; and *hunping* was the preferred term at the National Museum of Chinese History, Beijing. A current reference work uses *hunping:* Meng

Jun and Gao Guopei, *A Chinese-English Glossary and Illustrations of Antique* (Han-Yingwen wucihui yu tulu) (Hong Kong: Woods Publishing Co., 1991), 6 (illustrations). The most recent books on early Chinese Buddhist images have also adopted *hunping,* for example He Yun'ao, *Fojiao chuchuan* (1993) and Ruan, *Bukkyō denrai* (1996), as have some Japanese scholars; see Irisawa Takashi, "Butsu to rei: Kōnan shutsudo busshoku konpei kō" (Buddhas and spirits, a study of soul vases decorated with Buddha images from Jiangnan), *Ryūkoku daigaku ronshū* 444 (1994): 233–71. For further discussion of terminology, see Yamada Meiji, Kida Tomo-ō and Irisawa Takashi, "'Zaoqi fojiao zaoxiang nanchuan xitong' yanjiu gaikuang ji zhanwang" (Review and prospects for research on "the southern tradition of early Buddhist imagery,") *Dongnan wenhua* 1991, 3: 51–52.

170. Xie Mingliang, "Liuchao gucangguan zongshu" (Summary of Six Dynasties granary vessels), *Gugong wenwu yuekan* 109 (April 1992): 44.

171. Shengxian wenguanhui, "Zhejiang Shengxian Datangling Dong-Wu mu" (Tombs of the Eastern Wu State at Datangling, Sheng County, Zhejiang), *Kaogu* 1991, 3: 206–16.

172. Ibid., pl. 1: 4; He Yun'ao, *Fojiao chuchuan,* no. 34.

173. Zhang Heng, "Zhejiang Shengxian faxian de zaoqi fojiao yishupin ji xiangguan wenti zhi yanjiu" (Research and related questions on early Buddhist works discovered at Shengxian, Zhejiang), *Dongnan wenhua* 1992, 2: 22, fig. 3.

174. Ibid., 22, figs. 1 and 2, and pl. 1: 1 and 2; He Yun'ao, *Fojiao chuchuan,* no. 58.

175. Zhang Heng, "Zhejiang Shengxian," 22.

176. For the vase, see Zhu Boqian, ed., *Yueyao* (Yue ware) (Shanghai: Shanghai renmin meishu chubanshe, 1983), no. 6; for the bear lamp stand, see Zhejiang sheng bowuguan, *Zhejiang qiqian nian* (7000 years in Zhejiang) (Hangzhou: Zhejiang renmin meishu chubanshe, 1994), pl. 107; for the *wuguanping,* pl. 109. A number of similar jars have been excavated from northern Zhejiang, one from a tomb at Shangyu dated to 109 C.E. See Wu Yuxian, "Zhejiang Shangyu Haoba Dong-Han Yongchu sannian mu" (Eastern Han Yongchu third-year tomb at Zhejiang Shangyu Haoba), *Wenwu* 1983, 6: 40–44.

177. The importance of the lip is discussed by Kominami Ichiro, "Shinteiko," 240. However, Kominami does not distinguish *wuguanping* (or *wulianguan,* as he terms the earlier form) from *hunping* based on this characteristic.

178. Wu Hung, "Buddhist Elements," 288, identified these same figures as shamans, but emphasized their role in summoning the soul. For a recent review of literature on shamans, see Fu-shih Lin, "Chinese shamans and shamanism in the Chiang-nan area during the Six Dynasties period (3rd–6th Century A.D.)," Ph.D. diss., Princeton University, 1994, 24–27, 99–104, 137–41.

179. Zhang Heng, "Zhejiang Shengxian," 21.

180. Following Kominami Ichirō, "Shinteiko," 244–45.

181. Zhang Heng, "Zhejiang Shengxian," 22.

182. Shengxian wenguanhui, "Zhejiang Shengxian Datangling," pl. 1: 5.

183. Ibid., 210, fig. 5.

184. Ibid., 213–14, fig. 8. Note that fig. 8: 1 is M104: 12, misidentified as M101: 12.

185. This conclusion is generally supported by two undated and prob-

ably later examples of works with the Buddha-like figure from other sites in Shengxian: a four-loop jar that is almost identical to a jar with no Buddha-like figures from a nearby tomb dated to 259, and the lower half of a *hunping* from Tomb 29 with four embossed Buddha-like figures and four *pushou*. Both works are placed in the Western Jin period by Zhang Heng. For the four-loop jar with the Buddha-like figures, see Zhang Heng, "Zhejiang Shengxian," 23 and pl. 1: 8; He Yun'ao, *Fojiao chuchuan*, no. 48. For the jar dated to 259, see Shengxian wenguanhui, "Zhejiang Shengxian liuchaomu" (Six Dynasties tombs from Shengxian, Zhejiang), *Kaogu* 1988, 801 and pl. 3: 3. Two of the Buddha-like figures are published in Zhang Heng, "Zhejiang Shengxian," 23–24, figs. 9–10; for these as well as a crouching monster figure, see He Yun'ao, *Fojiao chuchuan*, no. 77.

186. Some forty tombs were excavated here from 1983 to 1985. Of these, Tomb 5 was the most completely preserved and over forty objects were recovered. See Yi Jiasheng, "Nanjing chutu de liuchao zaoqi qingci youxiacai pankouhu" (Early Six Dynasties celadon ewer with dish-shaped mouth in underglaze enamel excavated from Nanjing), *Wenwu* 1988, 6: 72–75; Yi Jiasheng, "Wu mo Jin chu qingci youxiacai hua yishu chuyi" (An opinion on the underglaze painting art on the greenware dated to the end of the Wu, beginning of the Jin dynasties), *Dongnan wenhua* 1989, 2: 176–79.

187. Yi Jiasheng suggests a number of possibilities for the plant, including *huanglongzhi* 黃龍芝. Yi Jiasheng, "Wu mo Jin chu," 177. Similar plants with three pods, however, have been identified by some as the elixir *lingzhi* and by others as the "tree of three pearls." For *lingzhi*, see Erickson, *Money Trees*, 19–20; for the tree, see Wu Hung, in Lim, *Stories*, 167.

188. Anhui sheng wenwu kaogu yanjiusuo and Ma'anshan shi wenhuaju, "Anhui Ma'anshan Dong-Wu Zhu Ran mu fajue jianbao" (Report on the excavation of the Eastern Wu tomb of Zhu Ran at Ma'anshan, Anhui), *Wenwu* 1986, 3: 7, fig. 9.

189. For an exploration of elite tastes, including a discussion of the Nanjing ewer, see Audrey Spiro, "Shaping the Wind: Taste and Tradition in Fifth-Century South China," *Ars Orientalis* 21 (1991): 95–117.

190. From a tomb at Nanjing Caochangmenwai Dianli xuexiao 南京草場門外電力學校, the work was unpublished as of the summer of 1998 when examined and photographed by the author at the Nanjing City Museum. Special thanks to Shui Tao 水濤 of the Nanjing University Department of History for introducing me to the staff of the Nanjing City Museum.

191. From Nanjing Jiangning Shangfang 南京江寧上坊 Tomb 93JSXM 采, The tomb was destroyed. See Hua Guorong, "Jiangsu Nanjingshi Jiangningxian Xiafang cun faxian Dong-Wu qingciqi" (Eastern Wu greenware discovered at Xiafang Jiangning Nanjing, Jiangsu), *Kaogu* 1998, 8: 92–93.

192. Also recovered was a pottery stove with a house-like structure added above the base. On the building are birds and a creature with a bird body and a human head. The modification of the typically plain stove is unprecedented and serves as another example of a special interest in distinctive goods on the part of the deceased and/or his survivors. See Nanjing shi bowuguan and Hua Guorong, "Jiangsu Nanjingshi," pl. 7: 5

193. Nanjing Jiangning Zhaoshigang 南京江寧趙士崗 Tomb 7. A lead tomb deed appears on the plan of Tomb 7, although the inscription is not mentioned in the excavation report: Jiangsu sheng wenwu guanli weiyuanhui, "Nanjing jinjiao liuchaomu de qingli" (Inventory of the Six Dynasties tombs in the suburbs of Nanjing), *Kaogu xuebao* 1957, 1: 187–91. The date is listed in Wang Zhimin, "1955 nian Nanjing fujin chutu de Sun Wu liang Jin qingciqi" (Celadon wares of the Wu and two Jin dynasties excavated in 1955 from the vicinity of Nanjing), *Wenwu cankao ziliao* 1956, 11: 8; although the tomb number was not specified by Wang, scholars have subsequently applied the 273 date to Tomb 7.

194. Shangfang Tomb 79M1. See Nanjing shi bowuguan, "Nanjing jiaoxian sizuo Wu mu fajue jianbao" (Report on the excavation of four Wu Kingdom tombs from the outskirts of Nanjing), *Wenwu ziliao congkan* 8 (1983): 9–15.

195. The report, without basis, describes the superstructure as a pagoda (*ta* 塔). Nanjing shi Bowuguan, "Nanjing jiaoxian," 11. Another nearly identical square top (but without the *hunping*) was found in another Nanjing tomb. See Nanjing shi bowuguan, "Nanjing shi Yinxi cun Xi-Jin mu" (A Western Jin tomb in Yinxi village, Nanjing), *Huaxia kaogu* 1998, 2: 29–34.

196. Nanjing shi bowuguan and Jiangning xian bowuguan, "Nanjing shi Dongshanqiao 'Fenghuang san nian' Dong-Wu mu" (Eastern Wu tomb dated "Fenghuang third year" at Dongshanqiao, Nanjing), *Wenwu* 1999, 4: 32–37.

197. The excavation report does not specifically state whether the tomb had been robbed, nor are individual objects identified in the published plan. Special thanks to Qi Haining for his cooperation and to Shui Tao for contacting him and communicating the information to the author.

198. Jiangning Suoshu Tomb 85JSM1. See Nanjing shi Bowuguan, "Nanjing Shizishan, Jiangning Suoshu Xi-Jin mu" (Western Jin tombs at Nanjing Shizishan, Jiangning Suoshu), *Kaogu* 1987, 7: 611–18.

199. Annette Kieser, "Northern Influence in Tombs in Southern China after 317 CE? A Reevaluation," paper presented at the conference "Between Han and Tang: Cultural and Artistic Interaction in a Transformative Period," Beijing University, July 8, 2000, 12.

200. Nanjing Shizishan Tomb 84XSM1. See Nanjing shi Bowuguan, "Nanjing Shizishan," 615–18, pl. 6: 2.

201. Ibid., fig. 8: 15 and pl. 6: 3.

202. Ruan Rongchun, *Bukkyō denrai*, 199.

203. Shangyu Jiangshan Tomb M84. Shangyu xian wenwu guanlisuo, "Zhejiang Shangyu Jiangshan Sanguo Wu mu fajue jianbao" (Report on the excavation of a Three Kingdoms Wu tomb discovered at Jiangshan, Shangyu, Zhejiang), *Dongnan wenhua* 1989, 2: 135–37.

204. For information on relevant kiln sites, see Yutaka Mino and Patricia Wilson, *An Index to Chinese Ceramic Kiln Sites from the Six Dynasties to the Present* (Toronto: Royal Ontario Museum, 1973), 34 (Zhejiang) and 56 (Jiangsu); Yutaka Mino and Katherine R. Tsiang, *Ice and Green Clouds* (Bloomington: Indianapolis Museum of Art, 1986), 17–18; Feng Xianming and Zhongguo guisuan yanxuehui, eds. *Zhongguo taoci shi* (History of Chinese ceramics) (Beijing: Wenwu chubanshe, 1982), 137–41.

205. Nakamura Keiji, "Kōnan rikuchōbo shutsudo tōji no ichikōsatsu" (An inquiry into ceramics excavated from Six Dynasties tombs in Jiangnan), in *Chūgoku chūsei no bunbutsu*, ed. Tonami Mamoru (Kyoto: Kyoto daigaku jinbun kagaku kenkyūjo, 1993), 120–23.

206. Asian Art Museum of San Francisco and He Li, *Chinese Ceramics* (New York: Rizzoli, 1996), 46. For a more optimistic discussion of kiln sites and styles, see Michele Pirazzoli-t'Serstevens, "De l'efficacité plastique à la productivité: les grès porcelaineux du Jiangnan aux IIIe–IVe siècles de notre ère," *T'oung Pao* 84, 1–3 (1998): 29–32.

207. Tombs 1–3 are published in Wuxian wenwu guanli weiyuanhui and Zhang Zhixin, "Jiangsu Wuxian Shizishan Xi-Jin mu qingli jianbao" (Report and inventory of the Western Jin tombs at Shizishan, Wuxian, Jiangsu), *Wenwu ziliao congkan* 3 (1980): 130–38. The group of four tombs is discussed in Kominami, "Shinteiko," 298–99.

208. He Yun'ao, *Fojiao chuchuan*, 181, no. 90.

209. Wuxian wenwu guanli weiyuanhui, "Jiangsu Wuxian Shizishan sihao Xi-Jin mu" (Western Jin tomb 4 at Shizishan, Wuxian, Jiangsu), *Kaogu* 1983, 8: 707–13.

210. For a plan of Tomb 1, see Wuxian wenwu guanli weiyuanhui, "Jiangsu Wuxian Shizishan Xi-Jin mu qingli jianbao," 131, fig. 3.

211. For the bears and the gate, see ibid., pl. 5, no. 1.

212. For the Huzhou work, see He Yun'ao, *Fojiao chuchuan*, no. 83; for the Wuyi work, see ibid., no. 86; and Jinhua diqu wenguanhui and Wuyi xian wenguanhui, "Zhejiang Wuyi taoqichang Sanguo mu" (Three Kingdoms tomb at the Wuyi pottery factory, Zhejiang), *Kaogu* 1981, 4: 376–79; for the Hangzhou work, see He Yun'ao, *Fojiao chuchuan*, no. 93; and Zhejiang sheng wenwu kaogu yanjiusuo, "Hangzhou diqu Han, Liuchao mu fajue jianbao" (Report on the excavation of Han and Six Dynasties tombs in the Hangzhou area), *Dongnan wenhua* 1989, 111–28.

213. Nanjing shi Bowuguan, "Nanjing jiaoxian," 7–8.

214. Jin Qi, "Nanjing Ganjiaxiang he Tongjiashan liuchao mu" (Six Dynasties tombs at Ganjiaxiang and Tongjiashan, Nanjing), *Kaogu* 1963, 6: 303–4; He Yun'ao, *Fojiao chuchuan*, no. 66.

215. For a line drawing that makes the gesture clear, see Okauchi Mitsuzane, "Gorenkan to sōshoku tsuki tsubo" (Five linked pots and decorated votive jars), in *Kodai tansō II: Waseda daigaku kōko gakkai sōritsu 35-shūnen kinen kōkogaku ronshū*, ed. Takiguchi Hiroshi (Tokyo: Waseda daigaku shuppanbu, 1985), 680, fig. 6, no. 49.

216. For an example of haloed Buddha-like figures and *huren* figures with hands to their chests on the same *hunping*, see He Yun'ao, *Fojiao chuchuan*, no. 98.

217. He Yun'ao, *Fojiao chuchuan*, 174.

218. Xupu liuchaomu fajuedui, "Yangzhou Xupu liuchaomu" (Six Dynasties tombs at Xupu, Yangzhou), *Kaogu xuebao* 1988, 2: 236 and 242.

219. Such an interpretation would be consistent with Wu Hung's thesis that the frontal, iconic mode of depicting Chinese deities such as the Queen Mother was inspired by the example of Buddhist imagery. See his discussion in *Wu Liang Shrine*, 134–35.

220. Wai-kam Ho, "Hun-p'ing: The Urn of the Soul," *Bulletin of the Cleveland Museum of Art* 48, 2 (February 1961): 26–34. For examples of recent reiterations of Ho's views, see Kuo Li-ying, "Au-

tour du *Fojiao chuchuan nanfang zhi lu wenwu tulu*," *Arts Asiatiques* 53 (1998): 104–5; Rhie, *Early Buddhist Art*, 18.

221. Most recently discussed in Nickerson, "Taoism, Death, and Bureaucracy," 626–27.

222. Also noted by K. E. Brashier, "Han Thanatology and the Division of 'Souls,'" *Early China* 21 (1996), 138 n. 56.

223. Most notably Ying-shih Yu, "'O Soul, Come Back!' A Study in the Changing Conceptions of the Soul and Afterlife in Pre-Buddhist China," *Harvard Journal of Asiatic Studies* 47 (December 1987): 363–95.

224. Brashier, "Han Thanatology," 138. For similar views, see Nickerson, "Taoism, Death, and Bureaucracy," 619–24; and Mu-chou Poo, *In Search of Personal Welfare*, 62–66, 163–65.

225. For lead men, see Nickerson, "Taoism, Death, and Bureaucracy," 83–85, 150.

226. Brashier, "Longevity Like Metal and Stone," 207.

227. This underscores the importance of the regional variations in the popularity and depiction of the Queen Mother of the West as suggested early on by Wu Hung, "Xiwangmu," 24.

228. Kominami Ichirō, "Shinteiko," 274–75; Nan Bo, "Nanjing Xigang Xi-Jin mu" (Western Jin tomb at Xigang, Nanjing), *Wenwu* 1976, 3: 56, fig. 1.

229. Nanjing bowuyuan, "Jiangsu Jiangning xian Zhangjiashan Xi-Jin mu" (Western Jin tomb at Zhangjiashan, Jiangning, Jiangsu), *Kaogu* 1985, 10: 908–14.

230. Kominami Ichirō, "Shinteiko," 276.

231. Wu Hung, "Buddhist Elements," 286–87; text transcribed in Jiang Xuanyi and Qin Tingyu, *Zhongguo ciqi de faming* (The invention of porcelain in China) (Shanghai: Yiyuan zhenshangshe, 1956), no. 30. An alternative reading—that *sangzang* 喪葬 should be read as the single character *ling*—indicating a type of pottery vessel, seems less probable. See Wuxian wenwu guanli weiyuanhui, "Jiangsu Wuxian Shizishan Xi-Jin mu," 136, discussed by Wu Hung, "Buddhist Elements," 286 n. 54.

232. From a *hunping* dated to 260 in the collection of the Gugong Bowuguan, Beijing, see Zhongguo meishu quanji bianji weiyuanhui, ed., *Taoci* (Shanghai: Shanghai renmin meishu chubanshe, 1988), no. 169; Ruan Rongchun, *Bukkyō denrai*, nos. 109–11. For the inscription, see Chen Wanli, *Zhongguo qingci shilüe* (Shanghai: Shanghai renmin chubanshe, 1957), 4.

233. Kominami Ichirō, "Shinteiko," 276–77.

234. Lin, "Chinese shamans," 139.

235. Ibid., 192–93, translation based on Gan Bao, *Soushenji* (In search of the supernatural, the written record) (Beijing: Zhonghua shuju, 1979), 2: 26–27; cf. J. J. M. de Groot, *The Religious System of China*, 6 vols. (Leiden: E. J. Brill, 1892–1910), 5: 543, 6: 1215–1216. Also, Kenneth J. DeWoskin and J. I. Crump, Jr., *In Search of the Supernatural* (Stanford: Stanford University Press, 1996), 25–26.

236. As suggested by Ruan Rongchun, *Bukkyō denrai*, 199.

237. Wu Hung, "Myths and Legends in Han Funerary Art: Their Pictorial Structure and Symbolic Meanings as Reflected in Carvings on Sichuan Sarcophagi," in Lim, *Stories from China's Past*, 73.

238. Nanjing bowuyuan, *Nanjing fujin kaogu baogao* (Archaeological report on the environs of Nanjing) (Shanghai: Shanghai chuban

gongsi, 1952), pl. 5, nos. 1–4. Also see Kominami Ichirō, "Shinteiko," 283.

239. Kominami Ichirō, "Shinteiko," 283–85, figs. 28–31; Zhao Dianzeng and Yuan Shuguang, "Tianmen" kao (Considering the gate of heaven), *Sichuan wenwu* 1990, 6: 3–11.

240. Wu Hung, "Buddhist Elements," 289.

241. Wu Hung in Lim, *Stories,* 178 and pl. 70A and 70B.

242. Wu Hung, "Buddhist Elements," 289.

243. Kominami Ichirō, "Shinteiko," 279.

244. K. E. Brashier, "Han Thanatology," 137, nn. 54 and 55.

245. Okauchi Mitsuzane, without recourse to *hunpo* dualism, suggests a similar tripartite division. See "Gorenkan," 703.

246. For an example of the figure in Sichuan, see Rudolph, *Han Tomb Art,* fig. 68. For *dazongbo,* see Wu Hung in Lim, *Stories,* 167; for *daxingbo,* see Loewe, *Ways to Paradise;* for a translation, see Guo Po and Hao Yixing, *Shan Hai Ching: Legendary Geography and Wonders of Ancient China,* trans. Hsiao-chieh Cheng, Pai Hui-Chen Cheng, and Kenneth Lawrence Thern (Taipei: Committee for Compilation and Examination of the Series of Chinese Classics, National Institute for Compilation and Translation, Republic of China, 1985), 195.

247. Wu Hung, "Buddhist Elements," 286.

248. Compare He Yun'ao, *Fojiao chuchuan,* nos. 80 (lower only), 79 (same as fig. 2.67, upper only), 87 (lower and upper), and 88 (no Buddha-like figure).

249. For the work dated to 302, see Ruan Rongchun, *Bukkyō denrai,* no. 129; for the work dated to 313, see Shen Zuolin, "Zhejiang Shaoxing Fenghuangshan Xi-Jin Yongjia qinian mu" (Western Jin Yongjia year-seven tomb at Fenghuangshan, Shaoxing, Zhejiang), *Wenwu* 1991, 6: 59–63.

250. Kominami Ichirō, "Shinteiko," 272–73.

251. For a similar situation from the Han dynasty, see Wu Hung, "Myths and Legends," 75.

252. Wu Hung, "Buddhist Elements," 289–91.

253. Zürcher, "Han Buddhism," 167.

254. Summarized in Joanna G. Williams, "The Case of Omitted Hundreds: Stylistic Development in Mathura Sculpture of the Kusana Period," in *Mathura: The Cultural Heritage,* ed. Doris Srinivasan (New Delhi: Manohar Publications for American Institute of Indian Studies, 1989), 326; for examples, see Stanislaw J. Czuma, *Kushan Sculpture: Images from Early India* (Cleveland: Cleveland Museum of Art, 1985), 227–32.

255. For the Kapardin type, see Johanna Engelberta van Lohuizen-de Leeuw, "New Evidence with Regard to the Origin of the Buddha Image," in *South Asian Archaeology 1979,* ed. Herbert Härtel (Berlin: D. Reimer Verlag, 1981), 377–400. For the dating of the Kapardin type, see Ju-hyung Rhi, "From Bodhisattva to Buddha: The Beginning of Iconic Representation in Buddhist Art," *Artibus Asiae* 54, 3/4 (1994): 207–20.

256. For coins, see Joe Cribb, "The Origin of the Buddha Image: the Numismatic Evidence," in *South Asian Archaeology 1981,* ed. Bridget Allchin (Cambridge: Cambridge University Press, 1984), figs. 30.1 and 30.4. The relationship to the Kanishka reliquary has been previously discussed by Wu Hung, "Buddhist Elements," 290–91.

257. For example, Edwards, "The Cave Reliefs at Ma Hao (Part 2)," 112; Zürcher, "Han Buddhism," 166–67.

258. For a recent survey of early numismatic evidence, see Kang Liushuo, "Beichao sichou zhi lu huobi gaishu" (Summary outline of the currency used along the Silk Road in the Northern dynasties), *Zhongguo qianbi* 1998, 4: 32–35.

259. Zürcher, "A New Look," 277.

260. It has been observed that the deformed figures are the result of the poor quality of the molds rather than any problem in firing. The question of why such a poor-quality work would be glazed, fired, and used in a tomb, however, remains unanswered. Thanks to Professor Qin Dashu of the Archaeology Department, Beijing University; and Rose Kerr, Head of the East Asian Collections, Victoria and Albert Museum, London, for their insightful comments on this *hunping.*

CHAPTER THREE

1. Erik Zürcher, *Buddhist Conquest,* 2–3.

2. For a textual reference to early stone statues of Buddhas, see Soper, *Literary Evidence,* 9–10.

3. The earliest publications of these works are Shi Yan, "Jiuquan Wenshushan de shiku siyuan yiji" (Historical remains of the Jiuquan Wenshushan stone cave temples), *Wenwu cankao ziliao* 1956, 7: 53–59; Wang Yi, "Bei-Liang shita" (Stone pagodas of the Northern Liang), *Wenwu ziliao congkan* 1977, 1: 179–88. Some were previously published in Herbert Härtel, *Along the Ancient Silk Routes* (New York: Harry N. Abrams, 1982), pls. 7 and 8. The unprovenanced work was acquired in 1990 by the Cleveland Museum of Art. See J. Keith Wilson, "Miniature Votive Stupa (*Shita*) and Stele with Sakyamuni and Maitreya," *Bulletin of the Cleveland Museum of Art* 81, 8 (October 1994): 313–20. The most recent studies by Yin Guangming will be individually referenced below.

4. Alexander C. Soper, "Northern Liang and Northern Wei in Kansu," *Artibus Asiae* 21, 2 (1958): 144–48.

5. Soper, "Northern Liang," 157.

6. For the Northern Wei dynastic history (*Weishu*) and its author, see Jennifer Holmgren, "Lineage Falsification in the Northern Dynasties: Wei Shou's Ancestry," *Papers on Far Eastern History* 21 (1980): 1–16. For the *Gaoseng zhuan,* see Arthur F. Wright, "Biography and Hagiography: Hui-chiao's *Lives of Eminent Monks,*" in *Silver Jubilee Volume of the Zinbun-Kagaku-Kenkyusyo, Kyoto University,* ed. Zinbun Kagaku Kenkyujo Kyoto Daigaku (Kyoto: Kyoto Daigaku Jinbun Kagaku Kenkyujo, 1954), 2: 383–432.

7. Hexi, literally "west of the [Yellow] river," presently corresponds to Gansu Province from Lanzhou westward and is sometimes referred to as the "Gansu corridor" in Western literature.

8. A *jun* was an administrative territory usually made up of several districts. See Hucker, *Dictionary of Official Titles,* 200. Dates for the founding of these commanderies in Ban Gu, *Hanshu* (History of the Former Han) (Beijing: Zhonghua shuju, 1962) do not agree. The date of 111 B.C.E. is given for the founding of Dunhuang on page 189; for a translation, see Homer H. Dubs, *History of the Former Han Dynasty,* 3 vols. (Baltimore: Waverly Press, 1938), 2: 82–83. But the date of 88/87 B.C.E. can be found on pages 1612–14. For a discussion of these dates, see Enoki Kazuo, "Kan Gi jidai no

Tonkō" (Dunhuang in the Han and Wei periods), in *Tonkō no rekishi,* ed. Enoki Kazuo (Tokyo: Daitō shuppansha, 1980), 21–22; and A. F. P. Hulsewé, *China in Central Asia,* Sinica Leidensia, vol. 14 (Leiden: E. J. Brill, 1979), 75–76 n. 40.

9. Hulsewé, *Central Asia,* 41 and 75.

10. Lao Kan, "Population and Geography in the Two Han Dynasties," in *Chinese Social History,* ed. E-tu Zen Sun and John deFrancis (1956; reprint, New York: Octagon Books, 1966), 91–93.

11. Wolfram Eberhard, "The Origin of the Commoners in Ancient Tun-huang," *Sinologica* 4, 3 (1955), 143–45.

12. Eberhard notes that many non-Han surnames from this period have "perfectly Chinese personal names." See Eberhard, "Origin of the Commoners," 147. In addition, there is evidence that the exchange of tribute and trade between the Xiongnu and Han Chinese had a considerable influence upon the former. See Yu Ying-shih, *Trade and Expansion in Han China: A Study in the Structure of Sino-Barbarian Relations* (Berkeley and Los Angeles: University of California Press, 1967), 36–42. At the same time, cultural borrowings were no doubt two-way, a fact that traditional Chinese historical texts tend to minimize.

13. Ban Gu, *Hanshu,* 1614. Noted in Shi Weixiang, "Bakukokutsu kankei nenpyō" (Chronology related to the Mogao Caves), in *Tonkō Bakukokutsu* (Mogao Caves of Dunhuang), ed. Tonkō bunbutsu kenkyūjo, 5 vols. (Tokyo: Heibonsha, 1980), 1: 262.

14. For a review of Dunhuang elite families as well as those from other areas of Hexi and Gaochang, see Wolfram Eberhard, "The Leading Families of Ancient Tun-huang," *Sinologica,* 4, 4 (1955): 209–32.

15. Shirasu Jōshin, "Zaichi gōzōku, meizoku shakai" (Society of powerful and famous provincial families), in *Tonkō no shakai,* ed. Ikeda On (Tokyo: Daitō shuppansha, 1980), 27–29. See also Cao Shibang, "Lun liang Han qi nanbeichao Hexi zhi kaifa yu ruxue shijiao zhi jinzhan" (Discussion of the development of Hexi from the Han-Wei to the Northern and Southern dynasties and the advancement of Confucianism and Buddhism), *Xinya xuebao* 5, 1 (1960): 93–95.

16. The genealogy is found in a manuscript (S.1889) in the Stein Collection, British Library. For a detailed study, see Ikeda On, "Tonkō Han shi kaden zankan ni tsuite" (On an inherited family history of the Fan lineage of Dunhuang), *Tōhōgaku* 24 (1962): 14–29. Also see Denis Twitchett, "The Composition of the T'ang Ruling Class: New Evidence from Tun-huang," in *Perspectives on the T'ang,* ed. Arthur F. Wright and Denis Twitchett (New Haven: Yale University Press, 1973), 61; and Shirasu, "Zaichi gōzōku," 30–31.

17. *Sanguozhi* (Record of the Three Kingdoms), *Weizhi,* chap. 16, biography of Cang Ci, as quoted in He Changqun, *Han-Tang jian fengjian tudi suoyouzhi xingshi yanjiu* (Research on the forms taken by feudal land tenure systems from Han to Tang times) (Shanghai: Shanghai renmin chubanshe, 1964), 291; translated in Mark Elvin, *The Pattern of the Chinese Past* (Stanford: Stanford University Press, 1973), 36.

18. Shirasu Jōshin, "Zaichi gōzōku," 14.

19. Su Bai, "Liang Han Wei Jin Nanbeichao shiqi de Dunhuang" (Dunhuang in the Han, Wei, Jin, Northern and Southern dynasties period), in *Silu fanggu* (Visiting archaeological sites of the Silk Road), ed. Sichou zhi lu kaochadui (Lanzhou: Gansu renmin chubanshe, 1983), 21; Enoki Kazuo, "Kan Gi jidai," 30; Yang Lien-sheng, "Notes on the Economic History of the Chin Dynasty," *Harvard Journal of Asiatic Studies* 9, 2 (June 1946): 154–55.

20. Fang Xuanling, *Jinshu* (History of the Jin) (Beijing: Zhonghua shuju, 1974), 1648. Noted in Shi Weixiang, "Bakukokutsu kankei nenpyō," 262.

21. Shirasu Jōshin, "Zaichi gōzōku," 38. Li Gao was a member of a distinguished Han Chinese family from Longxi in southeast Gansu Province. See Satō Chisui, "Goko jūroku koku kara nanbokuchō jidai" (From the Sixteen Kingdoms to the Northern and Southern dynasties period), in *Tonkō no rekishi,* ed. Enoki Kazuo (Tokyo: Heibonsha, 1980) 71–78. For details on the Li lineage see Lionel Giles, "Tun-huang Lu: Notes on the District of Tun-huang," *Journal of the Royal Asiatic Society,* July 1914, 713.

22. Shirasu Jōshin, "Zaichi gōzōku," 38; Satō Chisui, "Goko jūroku koku," 71–72.

23. Satō Chisui, "Goko jūroku koku," 75.

24. Ibid., 78.

25. Jennifer Holmgren, "*Wei-shu* Records on the Bestowal of Imperial Princesses during the Northern Wei Dynasty," *Papers on Far Eastern History* 27 (1983): 50–51.

26. Kenneth Douglas Klein, "The Contribution of the Fourth-Century Xianbei States to the Reunification of the Chinese Empire," Ph.D. diss., University of California, Los Angeles, 1980, 121–23.

27. The *Shilaozhi* (Treatise on Buddhism and Daoism) in the *Weishu* records the number of residents relocated as 30,000 families. See Wei Shou, *Treatise on Buddhism and Taoism,* trans. Leon Hurvitz; Japanese annotation by Tsukamoto Zenryū (Kyoto: Jimbunkagaku Kenkyusho, 1956), 61 n. 1.

28. Satō Chisui, "Goko jūroku koku," 85.

29. Ibid., 86; Soper, "Northern Liang," 143.

30. Shi Weixiang, "Bakukokutsu kankei nenpyō," 263.

31. For a discussion of the historical and archaeological evidence for the dynastic rulers of Gaochang from the fourth into the seventh centuries, see Hou Can, "Xi-Jin zhi beichao qianqi Gaochang diqu fengxing nianhao zhi tantao" (Notes on the regnal titles employed in the Gaochang area before and during the Western Jin to Northern Dynasties periods), *Kaogu yu wenwu* 1982, 2: 92–102.

32. Satō Chisui, "Goko jūroku koku," 86.

33. It should be noted that this elite class was based at the local or provincial level and was not necessarily part of a national elite. For a discussion of the local elite, see David G. Johnson, *Medieval Chinese Oligarchy* (Boulder: Westview Press, 1977), 30–31; Twitchett, "T'ang Ruling Class," 82–83; and Patricia Buckley Ebrey, *The Aristocratic Families of Early Imperial China,* Cambridge Studies in Chinese History, Literature, and Institutions (Cambridge: Cambridge University Press, 1978), 26.

34. Again one needs to be aware of the inherent interest of official historiographers in recording and thereby promoting the advancement of traditional Han culture.

35. Shi Weixiang, "Bakukokutsu kankei nenpyō," 262.

36. Satō Chisui, "Goko jūroku koku," 74.

37. According to the history of the Song dynasty as cited by Soper, "Northern Liang," 133–34.

38. Ibid., 134 n. 7.

39. Biography in *Chu sanzang ji ji*, *T*.2145.55.97c–98b; translation in Daniel J. Boucher, "Buddhist Translation Procedures in Third-Century China: A Study of Dharmarakṣa and His Translation Idiom," Ph.D. diss., University of Pennsylvania, 1996, 24. For the problem of identifying the Yuezhi and their origin, see ibid., 44–50.

40. Zürcher, *Buddhist Conquest*, 65.

41. See Boucher's discussion of the translation process in "Buddhist Translation Procedures," 62–102.

42. The text is the *Xiuxing daodi jing*, *T*.606.230, colophon translated in Paul Demiéville, "La *Yogācārabhūmi* de Saṅgharakṣa," *Bulletin de l'École française d'Extrême-Orient* 44, 2 (1954): 348–49. The proper division of the list of names remains controversial, some scholars finding nearly all the names to be non-Han, others a majority to be Han surnames. Boucher, "Buddhist Translation Procedures," 66–67.

43. Tsukamoto Zenryū, *Early Chinese Buddhism*, 1: 229–30.

44. Colophon translated in Boucher, "Buddhist translation procedures," 81–82.

45. The "Mogaoku ji" is an inscription dated to 865 partially preserved on the north wall of the antechamber of Cave 156 and copied in entirety in a Dunhuang manuscript, P.3720. See Su Bai, "'Mogaoku ji' ba" (Postscript on the "Record of the Mogao Grottoes"), *Wenwu cankao ziliao* 1955, 2: 113–19. For the reference to Suo Jing, see He Shizhe, "Cong gongyangren tiji kan Mogaoku bufen tongku de yingjian niandai" (Examining the construction dates of the Mogao Grottoes from donor inscriptions), in *Dunhuang Mogaoku gongyangren tiji*, ed. Dunhuang yanjiuyuan (Beijing: Wenwu chubanshe, 1986), 196. For a summary of all inscriptions related to initial activities at the Mogao site, see Okazaki Takashi, "Shichū no michi to Tonkō Bakukokutsu" (The Silk Road and the Mogao Grottoes of Dunhuang), in *Tonkō Bakukokutsu*, ed. Tonkō bunbutsu kenkyūjo (Tokyo: Heibonsha, 1980), 1: 216–17.

46. The "Mogaoku ji" account agrees with an inscription on a stele dated to 698 found in Cave 332 entitled "Li Huairang chongxiu fokan bei" (The restoration of the Mogao Grottoes by Li Huairang stele). The inscription is translated in Édouard Chavannes, *Dix inscriptions Chinoises de l'Asie centrale d'après les estampages de M. Ch.-E. Bonin* (Paris: Librarie C. Klincksieck, 1902), 58–60. For a more complete transcription of the text, see Wan Gengyu, "Zhengui de lishi ziliao, Mogaoku gongyangren huaxiang tiji" (Precious historical materials, Mogao Grotto donor portrayal inscriptions), in *Dunhuang Mogaoku gongyangren tiji*, ed. Dunhuang yanjiuyuan, (Beijing: Wenwu chubanshe, 1986), 191 n. 1. A variant tradition is preserved in a Dunhuang manuscript in the Pelliot Collection (P. 2691, "Shazhou tujing" composed in 949), which states that construction of the Mogao Caves started in 353. See Su Bai, "Mogaoku ji," 116 n. 10.

47. As recorded by Daoxuan in his *Ji shen zhou san bao gan tong lu*, *T*.2106.52.418a, and quoted by Soper in "Northern Liang," 142.

48. S.797, translated in Lionel Giles, *Descriptive Catalogue of the Chinese Manuscripts from Tun-huang in the British Museum* (London: British Museum, 1957), 132–33.

49. For example, see S.1437, S.2942, S.4010, and S.4494. Translations

of the colophons can be found in Giles, *Descriptive Catalogue*, 109, 17, 113, and 196, respectively.

50. Wei Shou, *Treatise on Buddhism*, 61.

51. Although the entry is undated, it is immediately followed by one describing the attack on the Northern Liang in 439 and the subsequent removal of the population.

52. Biography translated from the *Gaoseng zhuan* in Robert Shih, *Biographies des moines éminents (Kao seng tchouan) de Houei-kiao* (Louvain: Institut Orientaliste, 1968), 98–107.

53. Michel Strickmann, "India in the Chinese Looking-Glass," in *The Silk Road and the Diamond Path*, ed. Deborah E. Klimburg-Salter (Los Angeles: UCLA Art Council, 1982), 53.

54. For the biography of the monk Shan Daokai 單道開, family name Meng, see *T*.2059.50.387b–c. Also see Michel Soymié, "Biographie de Chan Tao-k'ai," *Mélanges publiés par l'Institut des hautes études Chinoises* 1 (1957): 415–422. For Daofa 道法, family name Cao, see *T*.2059.50.399b. For Chaobian 超辯, family name Zhang, see *T*.2059.50.408b. For Faying 法穎, family name Suo, see *T*.2059.50.402a. For Daoshao 道韶, family name Fan, see Bao Chang, *Mingsengzhuan chao* (Biographies of famous monks, copy) (Taibei: Xinwenfeng chuban gongsi, 1975), 10. Completed in 519, this text is only preserved in sections copied by the Japanese monk Shūshō 宗性 in 1235. See Wright, "Biography and Hagiography," 408–410.

55. For an overview with much information gleaned from Dunhuang documents, albeit of a later date, see Jacques Gernet, *Buddhism in Chinese Society: An Economic History from the Fifth to the Tenth Centuries* (New York: Columbia University Press, 1995), 94–141.

56. Soper, *Literary Evidence*, 43.

57. D. C. Twitchett, "The Monasteries and China's Economy in Medieval Times," *Bulletin of the School of Oriental and African Studies* 19, 3 (1957): 528–31.

58. Gansu sheng wenwudui, Gansu sheng bowuguan, and Jiayuguan shi wenwu guanlisuo, *Jiayuguan bihuamu fajue baogao* (Report on the excavation of the Jiayuguan wall painting tombs) (Beijing: Wenwu chubanshe, 1985).

59. For an Eastern Han example from Henan, see Powers, *Art and Political Expression*, fig. 140; for Sichuan, see the many pottery tomb reliefs in Lim, *Stories*.

60. Gansu sheng wenwudui et al., *Jiayuguan bihuamu*, 74–77.

61. Zhangye diqu wenwu guanli bangongshi and Gaotaixian bowuguan, "Gansu Gaotai Luotuocheng huaxiang zhuanmu diaocha (Investigation of the pictorial brick tomb at Luotuocheng, Gaotai, Gansu)," *Wenwu* 1997, 12: 45.

62. Wu Hung, "Xiwangmu," 24.

63. Gansu sheng wenwudui et al., *Jiayuguan bihuamu*, 18.

64. For Mawangdui, see Fu Juyou, *Mawangdui Han mu wenwu* (Han tomb cultural relics from Mawangdui) (Changsha: Hunan chubanshe, 1992). For the tomb of Bu Qianqiu, see Li Houbo, "Han Dynasty Tomb Murals from the Luoyang Museum of Ancient Tomb Relics," *Orientations* 25, 5 (May 1994): 40–50.

65. For the aristocratic associations of this style, see Powers, *Art and Political Expression*, 79–82.

66. Jiayuguan shi wenwu guanlisuo, "Jiayuguan xincheng shi'er, shisan hao huaxiang zhuanmu fajue jianbao" (Report on the ex-

cavation of pictorial brick tombs numbers 12 and 13 at Xincheng, Jiayuguan), *Wenwu* 1982, 8: 12.

67. Ibid., 15.

68. Gansu sheng wenwu kaogu yanjiusuo, ed., *Jiuquan shiliuguo mu bihua* (Wall painting of the Sixteen Kingdoms tomb at Jiuquan) (Beijing: Wenwu chubanshe, 1989).

69. The background of this scene, especially its relationship to female devotees, is treated in Zheng Yan, "Jiuquan Dingjiazha shiliuguo mu sheshu bihua kao" (Investigation of the land god tree in the Sixteen Kingdoms tomb at Dingjiazha, Jiuquan), *Gugong wenwu yuekan* 143 (February 1995): 44–52. For an overview of *she*, see Dorothy C. Wong, "The Beginnings of the Buddhist Stele Tradition in China." (Ph.D. diss., Harvard University, 1995), 158–74.

70. Dai Chunyang and Gansu sheng wenwu kaogu yanjiusuo, ed., *Dunhuang Foyemiaowan Xi-Jin huaxiangzhuan mu* (Western Jin pictorial brick tombs at Foyemiaowan, Dunhuang) (Beijing: Wenwu chubanshe, 1998).

71. Dunhuang wenwu yanjiusuo kaoguzu, "Dunhuang Jin mu" (Jin tombs at Dunhuang), *Kaogu* 1974, 3: 191–99.

72. Ibid., pl. 7: 3.

73. Ibid., 198, referring to Fang Xuanling, *Jinshu*, 2244.

74. For the additional tombs, see Xia Nai, "Dunhuang kaogu manji" (Notes on archaeology at Dunhuang), *Kaogu tongxun* 1955, 1: 2–7; and Gansu sheng Dunhuang xian bowuguan, "Dunhuang Foyemiaowan Wu-Liang shiqi muzang fajue jianbao" (Report on the excavation of Five Liang period tomb groups at Foyemiaowan, Dunhuang)," *Wenwu* 1983, 10: 51–60.

75. Thanks to Peter Nickerson for his assistance with the reading of *zhenmuwen* and many helpful comments for the understanding of these texts.

76. Anna Seidel, "Traces," 25 and 48 note 8. A useful survey of the Han material is Wu Rongceng, "Zhenmuwen zhong suojiandao de Dong-Han dao wu guanxi" (The relationship of Eastern Han Daosim and shamanism seen among grave-quelling texts), *Wenwu* 1981, 3: 56–63. In a manner similar to what we found in chapter 2, many scholars are tempted to consider Han dynasty *zhenmuwen* to be evidence of Daoism. Such an argument has been recently made regarding *zhenmuwen* from Dunhuang in Ning Qiang, "Patrons of the Earliest Dunhuang Caves: A Historical Investigation," in *Between Han and Tang*, ed. Wu Hung (Beijing: Wenwu chubanshe, 2000), 514–17. Both Seidel and Wu Rongzeng rightly conclude, however, that the mortuary beliefs expressed in *zhenmuwen* represent popular concepts that were later appropriated by organized forms of Daoism.

77. Item M1: 9, Gansu sheng wenwudui et al., *Jiayuguan bihuamu*, 25; and item M6: 1 in Gansu sheng wenwu kaogu yanjiusuo, "Gansu Jiuquan Xigoucun Wei Jin mu fajue baogao" (Report on the excavation of the Wei and Jin tombs at Xigou, Jiuquan, Gansu), *Wenwu* 1996, 7: 16, fig. 32, and 20–21.

78. Dunhuang wenwu yanjiusuo kaoguzu, "Dunhuang Jinmu," 196, fig. 13.

79. Gansu sheng Dunhuang xian bowuguan, "Dunhuang Foyemiaowan," 51–60.

80. Ibid., 58–60.

81. The above follows Machida Ryūkichi, "Tonkō shutsudo shi, go seiki tōkan tō meibun ni tsuite" (Regarding the inscriptions on the fourth and fifth century bottles excavated at Dunhuang), *Kenkyū kiyō, Tokyo gakugeidai fukō, Ōizumi kōsha* 10 (1986): 108–9. For the unusual terms *qingwuzi, beichen,* and *bakui jiukan,* see 113–14, nn. 13, 14, 17, and 18.

82. Dai Chunyang, Zhang Long, and Gansu sheng wenwu kaogu yanjiusuo, *Dunhuang Qijiawan, Xi-Jin Shiliuguo muzang fajue baogao* (Dunhuang Qijiawan, Report on the excavation of the tombs of the Western Jin dynasty and Sixteen States period) (Beijing: Wenwu chubanshe, 1994), 100–122, 146–48.

83. Ibid., 171. The excavation report cites *zhongyuan* patterns and a single room tomb (Foyemiao Tomb 60M1) of a well-known Dunhuang elite family member to suggest that double-room tombs were for officials with a rank of 2000 *dan* or more.

84. Ibid., 198–99.

85. Ibid., 44–45, fig. 31.

86. Ibid., 140 and pl. 41. Two other tombs of the same period contained a similarly painted brick.

87. The grain (*wugu*) mentioned in Type A *zhenmuwen* no doubt refers to the food placed in *douping*. The lead men also mentioned in Type A texts, however, are rarely found in tombs from this region. Only three examples are reported at the Qijiawan site, two inside a single *douping* from Tomb 313. Gansu sheng wenwu kaogu yanjiusuo et al., *Dunhuang Qijiawan,* 20, fig. 14, and pl. 45.4.

88. Gansu sheng wenwu kaogu yanjiusuo et al., *Dunhuang Qijiawan,* 86–87.

89. Fang Xuanling, *Jinshu,* 305. Machida, "Tonkō shutsudo," 114, nn. 17 and 18; Ho Peng-yoke, *The Astronomical Chapters of the Chin Shu* (Paris, The Hague: Mouton & Co., 1966), 107 and 109. It should be noted that the *Jinshu* was compiled in the seventh century.

90. Donald Harper, "The Han Cosmic Board: A Response to Christopher Cullen," *Early China* 6 (1980–81): 53. The earliest example is from Gansu Province. See Gansu sheng bowuguan, "Wuwei Mojuzi sanzuo Han mu fajue jianbao" (Report on the excavation of three Han dynasty tombs from Mojuzi, Wuwei), *Wenwu* 1972, 12: 9–21.

91. Machida Ryūkichi, "Tonkō shutsudo," 114 n. 14, with reference to passages in Wei Shou, *Weishu,* and Chen Shou, *Sanguozhi.*

92. Ibid., 113–14 n. 13. For the *Shishuo xinyu* reference, see Richard B. Mather, *A New Account of Tale of the World* (Minneapolis: University of Minnesota Press, 1976), 360.

93. For the reference to the green bird, see Guo Po and Hao Yixing, *Shan Hai Ching,* 195; and Loewe, *Ways to Paradise,* 90. For Tao Qian's poem, see T'ao Ch'ien and James Robert Hightower, *The Poetry of T'ao Ch'ien* (Oxford: Clarendon, 1970), 236; and Cahill, *Transcendence and Divine Passion,* 53. Note that the character *qing* 青 can be translated as green, blue, black, or gray.

94. In contrast to Yin Guangming, who uses the inscribed dates and find-spots to organize the works in "Bei-Liang shita fenqi shilun" (On the periodization of the Northern Liang stone pagodas), *Dunhuang yanjiu* 1997, 3: 84–94.

95. The possibility that the donor was Gao Bao rather than Gao Shanmu is suggested in Hubert Durt, Krishna Riboud, and Lai Tung-Hung, "A propos de «stûpa miniatures» votifs du Vᵉ siècle

découverts à Tourfan et au Gansu," *Arts Asiatiques* 40 (1985): 97. But the donor is consistently identified as Gao Shanmu in their text.

96. See Härtel, *Along the Ancient Silk Routes,* figs. 75–76. Thanks to Marianne Yaldiz and Chhaya Bhattacharya for their comments in this regard.

97. Durt et al., "A propos de «stûpa miniatures» votifs," 95. On page 100 the same authors state that the corresponding seated figure on the Cheng Duan'er stupa wears Indian dress, but in fact there is nothing to suggest that the badly damaged figure is not also garbed in Han Chinese apparel (see fig. 3.18).

98. For background on the trigrams, see Feng Yu-lan, *A History of Chinese Philosophy* (Princeton: Princeton University Press, 1983), 2: 102–5; and Joseph Needham and Wang Ling, *Science and Civilisation in China,* vol. 2, *History of Scientific Thought* (Cambridge: Cambridge University Press, 1956), 304–13, especially table 13; for the Earlier Heaven and Later Heaven sequences, see W. A. Sherrill and W. K. Chu, *An Anthology of I Ching* (London: Routledge & Kegan Paul, 1977), 16–18.

99. For the early use of *bagua,* see Zhang Yachu and Liu Yu, "Some Observations about Milfoil Divination Based on Shang and Zhou *bagua* Numerical Symbols," *Early China* 7 (1981–82): 46–55. For the Eastern Han cosmic board, see Harada Yoshito, *Lo-lang* (Tokyo: The Tōkō-shoin, 1930), pl. CXII, also discussed in Marc Kalinowski, "Les Instruments astro-calendériques des Han et la méthode *liu ren,*" *Bulletin de l'École française d'Extrême-Orient* 72 (1983): 363–65.

100. First noted by Wang Yi, "Bei-Liang shita," 179.

101. The role of the Dipper on the cosmic board is discussed in Donald Harper, "The Han Cosmic Board," *Early China* 4 (1979): 1–10; and Kalinowski, "Les Instruments astro-calendériques," 343–47. For an example from a nearby tomb of the first century C.E., see Gansu sheng bowuguan, "Wuwei Mojuzi sanzuo Han mu fajue jianbao," 12: 15, fig. 8, and pl. 5, 1. For references to the Big Dipper in a late sixth-century text on divination, see Xiao Ji, *Cosmologie et divination dans la Chine ancienne: Le Compendium des cinq agents (Wuxing dayi, VIᵉ siècle)* (Paris: École française d'Extrême-Orient, 1991), 68–69 and 338–39.

102. The image of the incised Dipper is difficult to discern in illustrations, but see Eugene Wang, "What Do Trigrams Have to Do with Buddhas? The Northern Liang Stupas and Problems of the Sinicization Narrative," *Res* 35 (spring 1999): 77, fig. 5. The northern orientation of the Dipper handle is confirmed by Yin Guangming, "Bei-Liang shita shang de *Yijing* bagua yu qifo yi mile zaoxiang" (The *Yijing* trigrams and seven Buddha/one Maitryea on the Northern Liang stone pagodas), *Dunhuang yanjiu* 1997, 1: 84.

103. For correcting my translation, thanks to Stephen Bokenkamp, who adds that it "is quite possible, though not explicit here, that the living means to express the wish that their deceased ancestors will 'remember' them and continue to shower blessings on them, as in usual Chinese mortuary practice. 思 is frequently employed in such contexts."

104. See Durt et al., "A propos de «stûpa miniatures» votifs," 97, fig. 11; Zhongguo meishu quanji bianji weiyuanhui, ed., *Wei Jin Nanbeichao diaosu,* (Wei Jin Northern and Southern Dynasties sculpture) (Beijing: Renmin meishu chubanshe, 1988), pl. 33.

105. Jue Ming, "Ji Dunhuang chu liuchao Poluomizi yinyuanjing jingchuang canshi" (A Brāhmī inscription of the Pratītyasamutpādasūtra on a fragmentary Dhvaja-pillar at Tun-huang), *Xiandai foxue* 1963, 10. The report and rubbing were noted in Durt et al., "A propos de «stûpa miniatures» votifs," 100.

106. Published as the Sanweishan stupa by Yin Guangming, "Dunhuang shi bowuguan cang sanjian Bei-Liang shita" (Three Northern Liang stone pagodas in the collection of the Dunhuang city museum), *Wenwu* 1991, 11: 79–80. For the rubbing of the text of the dedication, see Yin Guangming, "Meiguo Kelinfulan yishu bowuguan suocang Bei-Liang shita ji youguan wenti" (Cleveland Museum of Art collection Northern Liang stone pagoda and some related issues), *Wenwu* 1997, 4: 44.

107. Wang Yi, "Bei-Liang shita," 183; reiterated in Yin Guangming, "Shilun Bei-Liang shita jizuoxiang yu shenwang" (The Spirit Kings and the images on the bases of the Northern Liang stone pagoda), *Dunhuang yanjiu* 1996, 4: 8–9. For a chart of the trigram names in King Wen order and the two sets of colophons, see Wang, "What Do Trigrams," 80, table 1. The character *shi* may have been preceded by one such as *yi* 邑 to form a title such as *yishi,* a monk-teacher in a lay religious organization (discussed in chapter 4).

108. Yin Guangming, "Dunhuang shi bowuguan cang," 76–79.

109. Ibid., 80–82.

110. Ibid., 83. The text is the *Qifo bapusa suoshuo datuo luonishen zhoujing,* T.1332, translator unknown, dated to the Eastern Jin (317–420) in the text's colophon.

111. Yin Guangming, "Dunhuang shi bowuguan cang," 81, fig. 16.

112. Ibid., 80–81, fig. 12.

113. Härtel, *Along the Ancient Silk Routes,* 64, figs. 7 and 8.

114. Museum für Indische Kunst MIK III 6838, collected by von Lecoq from Khocho in 1904–1905. See Albert von Le Coq, *Chotscho* (Berlin: D. Reimer, 1913), pl. 60.

115. Soper, "Northern Liang," 132–33.

116. Ibid., 146.

117. MIK III 610. According to private communication from Dr. Marianne Yaldiz, director of the Museum für Indische Kunst, Berlin, this work had no original accession number but belongs with other works, including the Song Qing votive stupa, gathered in Central Asia by the German expeditions of 1902–1914.

118. The sixteen-character exegesis, which restates the chain of causation central to the sutra text, appears to be original—that is, not copied from any known sutra text or repeated on other votive stupa. For a transcription, see Durt et al., "A propos de «stupa miniatures» votifs," 103.

119. The double set of eight image niches is very unusual and is found on only one other work of early Chinese sculpture, the stone pillar (MA. 1175) in the Musée Guimet, Paris, illustrated in Matsubara Saburō, *Chūgoku bukkyō chōkokushi ron* (Historical discussion of Chinese Buddhist sculpture) (Tokyo: Yoshikawa kōbunkan, 1995), pl. 50a-d.

120. The possibility that the cross-legged figure was not part of the original design of the Bai votive stupa raises problems for those

who would see the cross-ankled and cross-legged bodhisattvas as contemporary representations of Maitreya and Sakyamuni respectively. See, for example, Asai Kazuharu, "Bosatsu hankazō, Kanshō-in" (Bodhisattva in leg-over pose, Kanshō temple), *Kokka* 1116 (1988): 29–30.

121. Translation follows Satō Chisui, "The Character of Yün-kang Buddhism," *Memoirs of the Research Department of the Toyo Bunko* 36 (1978): 69, where the full text, as far as it can be read, is translated.

122. V. V. Gokhale, "A Brāhmī Stone Inscription from Tun-huang," *Sino-Indian Studies* 1, 1 (1945): 19.

123. Durt et al., "A propos de «stûpa miniatures» votifs," 101.

124. V. V. Gokhale, "A Brāhmī Stone Inscription from Tun-huang," 21–22. Also see Jue Ming, "Ji Dunhuang," 8–12, 42–43.

125. Wilson, "Miniature Votive Stupa," 319, footnote 6. Special thanks to Keith Wilson for showing and discussing the work with me at the Cleveland Museum on a Sunday (!) in 1992.

126. According to Sherman Lee (private communication), who recalls seeing the work in a dealer's showroom in Paris in the 1950s.

127. For *jingta,* see Shi Yan, "Jiuquan Wenshushan de shiku siyuan yiji," 7: 53–59; and Satō Chisui, "Character of Yün-kang Buddhism," 69. For *jingchuang,* see Jue Ming, "Ji Dunhuang," 8–12, 42–43; also see Soper, who uses sutra pillar without an explanation in "Northern Liang," 131–64. The term miniature stupa is adopted in Durt et al., "A propos de «stûpa miniatures» votifs," 92–106.

128. For the *jingchuan,* see Liu Shufen, "Foding zunsheng tuoluoni jing yu Tang dai zunsheng jingchuan de jianli" (Dhāraṇī Sutra and the growth of Dhāraṇī pillars in T'ang China), *Zhongyang yanjiuyuan lishi yuyan yanjiusuo jikan* 67, 1 (1996): 145–93.

129. Durt et al., "A propos de «stûpa miniatures» votifs," 105 n. 3.

130. For the 466 pagoda, see Shi Shuqing, "Bei-Wei Cao Tiandu zao qianfo shita" (Thousand Buddha stone pagoda dedicated by Cao Tiandu of the Northern Wei), *Wenwu* 1980, 1: 68–71; Han Youfu, "Bei-Wei Cao Tiandu zuo qianfo shita tasha" (Finial of the Thousand Buddha stone pagoda dedicated by Cao Tiandu of the Northern Wei), *Wenwu* 1980, 7: 65; and Huang Yongchuan and Guoli lishi bowuguan, eds. *Fodiao zhi mei, Beichao fojiao shidiao yishu* (The splendour of Buddhist statuaries: Buddhist stone carvings in the Northern dynasties) (Taibei: Guoli lishi bowuguan, 1997), no. 004. For the Jiuquan work, see Chen Bingying, "Bei-Wei Cao Tianhu zao fangshita" (Square stone pagoda dedicated by Cao Tianhu of the Northern Wei), *Wenwu* 1988, 3: 83–85, 93.

131. Such a relationship is surmised in Xiao Mo, "Songyuesi ta yuanyuan kaobian" (Research on the origin of the pagoda of Songyue monastery), *Jianzhu xuebao* 1997, 4: 49–53. For the Song Shan pagoda, see Tokiwa Daijō and Sekino Tadashi, *Shina bukkyō shiseki hyōkai,* 6 vols. (Tokyo: Bukkyō shiseki kenkyūkai, 1926), 2: pls. 140–41; Alexander C. Soper, "Two Stelae and a Pagoda on the Central Peak, Mt. Sung," *Archives of the Chinese Art Society of America* 16 (1962): 41–48; Liu Dunzhen, *Zhongguo gudai jianzhu shi* (History of the ancient architecture of China) (Beijing: Zhongguo jianzhu gongye chubanshe, 1980), 84–86; Laurence G. Liu, *Chinese Architecture* (New York: Rizzoli, 1989), 56–58.

132. The chamber was 10½ inches square and 3 feet 8½ inches high. John Marshall, *Taxila,* 3 vols. (Cambridge: Cambridge University Press, 1951), 1: 373 and 3 (plates): plates 105 (a) and 110 (a).

133. Lucknow Museum B 116 in Joanna Williams, *The Art of Gupta India: Empire and Province* (Princeton: Princeton University Press, 1982), fig. 70. Special thanks to Joanna Williams for providing photographs of the work and to Frederick Asher and Ju-hyung Rhie for clarifying the contents of all four sides.

134. Another small-scale stupa from Mathura with four seated Buddhas in the register below the dome may have been a section of a similar work. John C. Huntington, "Mathura Evidence for the Early Teachings of Mahayana," in *Mathura: The Cultural Heritage,* ed. Doris Srinivasan (New Delhi: Manohar Publications for American Institute of Indian Studies, 1989), pl. 9.IV.

135. Katherine R. Tsiang, "Monumentalization of Buddhist Texts in the Northern Qi Dynasty: The Engraving of *Sutras* in Stone at the Xiangtangshan Caves and Other Sites in the Sixth Century," *Artibus Asiae* 56, 3/4 (1996): 255–56. The passage is found in the *Gaoseng Faxian zhuan,* T 2085.51.857.b5–6, and translated in Samuel Beal, *Si-Yu-Ki, Buddhist Records of the Western World,* two volumes in one (London: Kegan Paul, Trench, Trubner, 1884), xxiv.

136. Following the readings provided for the Cleveland work in Wilson, "Miniature Votive Stupa," 314.

137. Not surprisingly, none of the names are to be found in the dynastic histories covering this period: the *Weishu, Bei shi,* and *Song shu.*

138. This is in contrast to the monastic patronage central for early Indian votive images studied by Gregory Schopen. See "Two Problems in the History of Indian Buddhism: The Layman/Monk Distinction and the Doctrines of the Transference of Merit," *Studien zur Indologie und Iranistik* 10 (1985): 9–47; Gregory Schopen, "On Monks, Nuns and 'Vulgar' Practices: The Introduction of the Image Cult into Indian Buddhism," *Artibus Asiae* 49, 1/2 (1989): 153–68; Gregory Schopen, "Monks and the Relic Cult in the *Mahāparinibbānasutta:* An Old Misunderstanding in Regard to Monastic Buddhism," in *From Benares to Beijing: Essays on Buddhism and Chinese Religion in Honour of Prof. Jan Yun-Hua,* ed. Koichi Shinohara and Gregory Schopen (Oakville, Ont.: Mosaic Press, 1991), 187–202.

139. See Tonkō bunbutsu kenkyūjo, ed., *Tonkō Bakukokutsu* (Mogao Caves of Dunhuang), 5 vols. (Tokyo: Heibonsha, 1980)., 1: pls. 6 and 12. For a recent discussion of the Northern Liang dynasty Mogao caves, see Ning Qiang, "Patrons of the Earliest Dunhuang Caves," 496–512.

140. For a discussion of the relationship between prominent local families and the Mogao site, see Stanley Kenji Abe, "Mogao Cave 254: A Case Study in Early Chinese Buddhist Art" (Ph.D. diss., University of California, Berkeley, 1989), 91–101.

141. Two dedications on a single donation is an anomaly; because the longer dedication is the more conventional—it includes the date and some elaborate language of respect—and because the shorter dedication is in a slightly smaller script, I am inclined to regard the latter as a secondary addition as suggested in Durt et al., "A propos de «stûpa miniatures» votifs," 97.

142. Durt et al., "A propos de «stûpa miniatures» votifs," 103.

143. Jan Nattier, *Once Upon a Future Time* (Berkeley: Asian Humanities, 1991), 101 n. 106, and 109–10. The following discussion is based largely on pages 90–118 of this work.

144. The term *guan* 觀 can also mean "to visualize," which is part of a meditation practice. But because this is a technical procedure suit-

able for monastics, the generic notion of viewing seems more appropriate for this passage.

145. Yin Guangming, "Shilun mofa sixiang yu Bei-Liang fojiao ji qi yingxiang" (On *mofa* thought and Northern Liang Buddhism as well as its influence), *Dunhuang yanjiu* 1998, 2: 89–102.

146. Ibid., 91. The text is the *Nanyue si dachanshi lishi yuanwen, T.*1933. Nattier, *Once Upon,* 110–11; Erik Zürcher, "'Prince Moonlight,' Messianism and Eschatology in Early Medieval Chinese Buddhism," *T'oung Pao* 68 (1982): 18–19 n. 33. For Huisi, see Paul Magnin, *La vie et l'œuvre de Huisi* (Paris: École française d'Extrême-Orient, 1979).

147. Nattier, *Once Upon,* 117 n. 133.

148. A number of scholars have noted that the period in which the Northern Liang votive stupa were created was one lacking in social and political stability, which resulted in heightened eschatological concerns as found in both Buddhist and Daoist texts from the fifth century. See, for example, Anna Seidel, "Taoist Messianism," *Numen* 31, 2 (1984): 161–74; or Zürcher, "'Prince Moonlight,'" 1–75. Yet there is nothing in the votive stupa or any extant imagery from this period to suggest a parallel interest.

149. For an overview, see David J. Kalupahana, "Pratītya-samutpāda," in *Encyclopedia of Religion,* ed. Mircea Eliade (London: Macmillan, 1987), 11: 484–88.

150. *T.*2.776a–b. The first to identify the relationship to *T.*125 was Shi Pingting in Wang Yi, "Bei-Liang shita," 187–88. See the concordance of the votive stupa texts and *T.*125 in Durt et al., "A propos de «stûpa miniatures» votifs," figs. 18–21. Paul Harrison has kindly compared the texts for me and agrees that the passage on the votive stupa is almost certainly based on *T.*125, which is probably the Mahāsāṅghikā version of the *Ekottarāgama.* For a dissenting argument, see Yin Guangming, "Bei-Liang shita *Shi er yinyuan jing* ji youguan wenti" (The *Shi er yinyuan jing* of the Northern Liang Stone Pillars and some related problems), *Dunhuangxue jikan* 1996, 2: 61–71. There is also the issue of whether Gautama Saṅghadeva was in fact the translator of *T.*125. Jan Nattier in 1992 pointed out to me that Saṅghadeva is also credited with the translation of one other text, *T.*26, in 396–7 just prior to translating *T.*125. But the language used in the two texts is different: the former text is in the Sarvāstivādin tradition while the latter is Mahāsāṅghikā. This indicates that it was unlikely that the same translator was responsible for both works. The questionable reliability of the traditional identification of translators of Chinese Buddhist texts only compounds the problem. For a discussion, see Michel Strickmann, "The *Consecration Sūtra:* A Buddhist Book of Spells," in *Chinese Buddhist Apocrypha,* ed. Robert E. Buswell (Honolulu: University of Hawaii, 1990), 79.

151. Durt et al., "A propos de «stûpa miniatures» votifs," 104. My reading of Durt's commentary on the sutra text in the above ("Note sur le sûtra de l'Ekottarâgama gravé sur les «stûpa miniatures»") was greatly facilitated by the English translation produced in a seminar by Josh Lindquist.

152. Ibid.; Étienne Lamotte, "Un sûtra composite de l'*Ekottarāgama,*" *Bulletin of the School of Oriental and African Studies* 31, 1 (1967): 106. For the Pali version, see K. R. Norman, *Pali Literature* (Wiesbaden: O. Harrassowitz, 1983), 56–57. Special thanks to Paul Harrison for his personal communications that clarified so many important

aspects of the sutra. All infelicities of interpretation, of course, remain my own.

153. Giles, *Descriptive Catalogue,* 113, nos. 3972–3979. One undated manuscript in the Pelliot collection contains a part of the *Zeng yi a han jing.* See Bibliothèque nationale (France) Division des manuscrits orientaux, ed., *Catalogue des manuscrits Chinois de Touenhouang, fonds Pelliot chinois.* Vol. 1, N 2001–2500 (Paris: Bibliothèque nationale, 1970), 246–47, no. 2385.

154. Translated from the *Salistambasutra,* known in Chinese translations as early as the third century. Daniel Boucher, "The *Pratītyasamutpādagāthā* and Its Role in the Medieval Cult of the Relics," *Journal of the International Association of Buddhist Studies* 14, 1 (1991): 2.

155. See V. Natesa Aiyar, "An Inscribed Relic Casket from Kurram," *Epigraphia Indica* 18 (1925–26): 16–20; Sten Konow, "Remarks on a Kharoṣṭhī Inscription from the Kurram Valley," in *Indian Studies in Honor of Charles Rockwell Lanman* (Cambridge: Harvard University Press, 1929), 53–67.

156. Boucher, "*Pratītyasamutpādagāthā* and Its Role," 5.

157. For a recent review of some early deposits in Gandhara, see Elizabeth Errington, "Gandhara Stupa Deposits," *Arts of Asia* 28, 2 (March–April 1998): 80–87.

158. Richard Salomon, *Ancient Buddhist Scrolls from Gandhara* (Seattle: University of Washington Press, 1999) 85.

159. Jue Ming, "Ji Dunhuang," 10.

160. Paul Harrison suggested that the use of the *pratītyasamutpāda* text on the votive stupa was a turning inside-out of the Indian practice with the text now exposed and public rather than hidden inside a stupa.

161. Boucher, "*Pratītyasamutpādagāthā* and Its Role," 12–13.

162. Liu Shufen, "*Foding zunsheng tuoluoni,*" 145–93.

163. Salomon, *Ancient Buddhist Scrolls,* 86.

164. Durt et al., "A propos de «stûpa miniatures» votifs," 101. For a discussion of the *pratītyasamutpāda* verse and *dhāraṇī,* see Yael Bentor, "On the Indian Origins of the Tibetan Practice of Depositing Relics and *Dhâraṇîs* in Stûpas and Images," *Journal of the American Oriental Society* 115, 2 (April 1995): 248–61.

165. Robert F. Campany, "Notes on the Devotional Uses and Symbolic Functions of *Sūtra* Texts as Depicted in Early Chinese Buddhist Miracle Tales and Hagiographies," *Journal of the International Association of Buddhist Studies* 14, 1 (1991): 37–40 and 62, nn. 34–36.

166. Michel Strickmann, "The *Consecration Sūtra,*" 79–81.

167. Giles, *Descriptive Catalogue,* 109. The sutra is *T.*1339, *Dafangdeng tuoluoni jing,* translation attributed to Fazhong 法眾.

168. Giles, *Descriptive Catalogue,* 196, no. 6248.

169. Yin Guangming, "Shilun Bei-Liang shita," 9–10. The version of the sutra cited is *T.*374, the translation by Dharmakṣema completed in the years 414–21 under the Northern Liang.

170. Yin Guangming, "Shilun Bei-Liang shita," 21; also see Jin Shen, "Guanyu shenwang de tantao" (Inquiry regarding spirit kings), *Dunhuangxue jikan* 1995, 1: 55–62; and Zhao Xiurong, "Beichao shiku zhong de shenwang xiang" (Images of the Spirit Kings in Northern dynasty caves), *Dunhuangxue jikan* 1995, 1: 63–71.

171. Emmy C. Bunker, "The Spirit Kings in Sixth Century Chinese Buddhist Sculpture," *Archives of the Chinese Art Society of America* 18 (1964): 26–37.

172. Kuno Miki, "Hokuryō-tō kidan no sonzō ni tsuite" (Regarding

the images on the base of the Northern Liang stupa), in *Uehara Kazu hakushi koki kinen bijutsushi ronshū* (Festschrift for Professor Uehara Kazu's Seventieth Birthday), ed. Uehara Kazu hakushi koki kinen bijutsushi ronshū kankōkai (Tokyo: Uehara Kazu hakushi koki kinen bijutsushi ronshū kankōkai, 1995), 263–95.

173. For a discussion of the incorporation of the *devalokas* into the Buddhist art of the Dunhuang Mogao Caves about a century later, see Jao Tsung-i, "The Vedas and the Murals of Dunhuang," *Orientations* 20, 3 (March 1989): 71–76.

174. See Joe Cribb, "Shiva Images in Kushan and Kushano-Sasanian Coins," in *Studies in Silk Road Coins and Culture,* ed. Katsumi Tanabe, Joe Cribb, and Helen Wang (Kamakura: Institute of Silk Road Studies, 1997), 46, especially coins A8 and A9.

175. The following account is based on Gil Raz, "Ritual and Cosmology: Transformations of the Ritual for the Eight Archivists," M.A. thesis, Indiana University, 1996. Special thanks to Stephen Bokenkamp for introducing me to this work and to Gil Raz for his kind assistance.

176. Ge Hong and James Roland Ware, *Alchemy, Medicine, Religion in the China of A.D. 320: The Nei pien of Ko Hung (Pao-pu tzu)* (Cambridge: MIT Press, 1967), 255.

177. The versions in the Daoist Canon are *Bashitu, HY 767,* and *Wuchengfu, HY 671.*

178. Poul Andersen, "Talking to the Gods: Visionary Divination in Early Taoism (The Sanhuang Tradition)," *Taoist Resources* 5, 1 (August 1994): 20.

179. Raz, "Ritual and Cosmology," 24–25.

180. Ibid., 79–74. The Buddhist sutra is the *Foshuo pusa benyijing,* T.281.10.664c17–665a6, said to have been translated by Zhiqian, the noted monk of the Wu Kingdom mentioned in chapter 2.

181. Raz, "Ritual and Cosmology," 9–10.

182. Precept number 114 translated in Barbara Hendrischke and Benjamin Penny, "*The 180 Precepts Spoken by Lord Lao:* A Translation and Textual Study," *Taoist Resources* 6, 2 (August 1996): 25. For a discussion of the text, see Benjamin Penny, "Buddhism and Daoism in *The 180 Precepts Spoken by Lord Lao,*" *Taoist Resources* 6, 2 (August 1996): 1–16. The "Eight Spirits" here probably refer to divination using the trigrams. See Raz, "Ritual and Cosmology," 9 n. 15.

183. The use of images for Buddhist meditation and visualization practices is well attested to in this period. See Stanley K. Abe, "Art and Practice in a Fifth-Century Chinese Buddhist Cave Temple," *Ars Orientalis* 20 (1990): 1–31; and Nobuyoshi Yamabe, "*The Sūtra on the Ocean-Like Samādhi of the Visualization of the Buddha:* The Interfusion of the Chinese and Indian Cultures in Central Asia as Reflected in a Fifth Century Apocryphal Sūtra," Ph.D. diss., Yale University, 1999.

184. For example, Soper, "Northern Liang," 147; more recently, see Yin Guangming, "Bei-Liang shita fenqi shilun," 87.

185. For the seven Buddhas of the Past, see J. Ph. Vogel, "The Past Buddhas and Kāśyapa in Indian Art and Epigraphy," in *Asiatica,* ed. Johannes Schubert (Leipzig: O. Harrassowitz, 1954), 808–816; according to Nattier, *Once Upon,* 19–20, the "locus classicus" for the tradition of the seven Buddhas of the Past is the *Mahāpadānasuttanta,* which is included in the *Zeng yi a han jing, T.*125.

186. Only one example of the set of seated images with a cross-ankled bodhisattva (on the base of a Gandharan work) is known to me. See Islay Lyons and Harald Ingholt, *Gandharan Art in Pakistan* (New York: Pantheon, 1957), fig. 135. For examples of the set in different positions, see Vogel, "Past Buddhas," 809–811; and Kurita Isao, ed. *Gandara bijutsu* (Art of Gandhara), 2 vols. (Tokyo: Nigensha, 1988), 2: figs. 77 and 289.

187. For a review of the set of eight figures, see Yu-Min Lee, "The Maitreya Cult and Its Art in Early China," Ph.D. diss., Ohio State University, 1983, 169–70, 207–8, 248–49, 276–79.

188. For the inscription, see Rong Xinjiang, "'Juqu Anzhou bei' yu Gaochang Da-Liang zhengquan" (*The Juqu Anzhou stele* and the Great Liang regime in Gaochang), *Yanjing xuebao* 5 (1998): 65–92; Satō Chisui, "Character of Yün-kang Buddhism," 68; Soper, "Northern Liang," 143–44; Ōmura Seigai, *Shina bijutsu shi chōso hen* (History of Chinese art, sculpture volume), 3 vols. (Tokyo: Bussho kankōkai zuzōbu, 1915), 1: 177–78; and Otto Franke and Tsan Hsia-Hou, *Eine chinesische Tempelinschrift aus Idikutsahri bei Turfan (Turkistan)* (Berlin: Verlag der Königl, Akademie der Wissenschaften, 1907). The Maitreya text is *T.*452, *Guan Mile pusa shangsheng tushitian jing,* translated by Juqu Jingsheng in 455 under the Liu Song dynasty.

189. Satō Chisui, "Character of Yün-kang Buddhism," 68–71.

190. Gu Zhengmei, "Zaitan Su Bai de Liangzhou moshi" (Another discussion of Su Bai's Liangzhou style), in *Dunhuang shiku yanjiu guoji taolunhui wenji, shiku kaogu bian* (Collected works from the international conference on Dunhuang cave research, cave archaeology volume), ed. Duan Wenjie (Shenyang: Liaoning meishu chubanshe, 1990), 85–122; in addition, see Gu Zhengmei, *Guishuang fojiao zhengzhi chuantong yu dasheng fojiao* (Kushan Buddhist political tradition and Mahayana Buddhism) (Taibei: Yunchen wenhua shiye gufen youxian gongsi, 1993), 574–671. Her thesis is challenged in Yin Guangming, "Guanyu Bei-Liang shita de jige wenti" (Several questions related to Northern Liang stone pillars), *Dunhuangxue jikan* 1993, 1: 64–70, 76.

191. The multivalence of viewing Buddhist art has been most extensively discussed in Vidya Dehejia, "Aniconism and the Multivalence of Emblems," *Ars Orientalis* 21 (1991): 45–66; Susan L. Huntington, "Aniconism and the Multivalence of Emblems: Another Look," *Ars Orientalis* 22 (1992): 111–56.

192. Yin Guangming, "Bei-Liang shita shang de Yijing bagua," 81–85.

193. The parallel between Indian and Chinese understandings of causality in the *pratītyasamutpāda* sutra and the *Book of Changes* is, of course, not new. See, for one example, Whalen Lai, "Some Notes on Perceptions of *Pratītya-samutpāda* in China from Kumārajīva to Fa-yao," *Journal of Chinese Philosophy* 8 (1981): 433.

194. Wang, "What Do Trigrams," 74–75; Soper, "Northern Liang," 133–34 and 147–48.

195. Wang, "Trigrams," 74.

196. Ibid., 87.

197. See the summary of Han dynasty cosmic boards in Michael Loewe, *Ways to Paradise,* 204–8. For the seventh example referred to by Loewe on page 203, see Anhui sheng wenwu gongzuodui, Fuyang diqu bowuguan, and Fuyang xian wenhuaju, "Fuyang shuang gudui Xi-Han Anyin hou mu fajue jianbao" (Report on the

excavation of a pair of ancient Western Han tombs of the marquis of Anyang at Fuyang), *Wenwu* 1978, 8: 12–31; and Liu Haichao, "Fuyang bowuguan zangpin jianjie" (Brief introduction to the collection of the Fuyang Museum), *Wenwu tiandi* 2000, 1: 32–36.

198. Harada Yoshito, *Lo-lang,* 61. The single discernible trigram is desribed by Chen Mengjia, "Han jian nianli biaoxu" (Overview of the calendar system observed on Han bamboo and wooden slips), *Kaogu xuebao* 1965, 2: 141; also see Kalinowski, "Les Instruments astro-calendériques," 363–65. For Tang dynasty and later mirrors with trigrams, see Kong Xiangxing, *Zhongguo tongjing,* 664, 758–66.

199. The Dipper is shown inverted compared to other examples from extant cosmic boards. See Harper, "Han Cosmic Board," 4 and 6, figs. 3 and 4.

200. For examples of the dissemination of the reconstructed drawing, see Yan Dunjie, "Ba liuren shipan" (Postscript on *liuren* divining boards), *Wenwu cankao ziliao* 1958, 7: 21; Joseph Needham and Wang Ling, *Science and Civilisation in China,* vol. 3, *Mathematics and the Sciences of the Heavens and the Earth* (Cambridge: Cambridge University Press, 1959) 3: 542, pl. LXXX; Loewe, *Ways to Paradise,* 80, fig. 12; Xu Xitai, "Kaogu faxian lidai qiwu shang kezhu bagua fangweitui ji qi yuanyuan tansuo" (Discussion of the archaeologically discovered historical implements with engraved and cast directional trigrams and their origin), *Wenbo* 1993, 5: 7, fig. 6.

201. Wang, "What Do Trigrams," 83–84. For a discussion of the Six Dynasties cosmic board, see Kalinowski, "Les Instruments astro-calendériques," 368–81.

202. Wang, "Trigrams," 90.

203. For the narrow definition, see Zürcher, *Buddhist Conquest,* 184; Tang Yongtong, *Han Wei liang Jin nanbeichao fojiao shi* (History of Buddhism during the Han, Wei, two Jin, and Northern-Southern periods) (Beijing: Zhonghua shuju, 1983), 168. For a review of the literature, see Takatoshi Itō, "The Formation of Chinese Buddhism and 'Matching the Meaning' (*geyi*)," *Memoirs of the Toyo Bunko* 54 (1996): 68–74.

204. Tsukamoto, *Early Chinese Buddhism,* 1: 284–310. For a fifth-century example of a failed attempt to utilize a kind of *geyi*, see Whalen Lai, "The Limits and Failure of K'o-i" (Concept Matching) Buddhism," *History of Religions* 18, 3 (1979): 238–57.

205. See, for example, Victor H. Mair, "Dunhuang as a Funnel for Central Asian Nomads into China," in *Ecology and Empire: Nomads in the Cultural Evolution of the Old World,* ed. Gary Seaman (Los Angeles: Center for Visual Anthropology, University of Southern California Press, 1989), 143–63.

CHAPTER FOUR

1. John Lee, "Conquest, Division, Unification: A Social and Political History of Sixth Century Northern China," Ph.D. diss., University of Toronto, 1986, 35. This chapter is dedicated to the memory of John, whose work was an inspiration.

2. Here I follow with modification the terminology developed in A. B. Griswold, "Prolegomena to the Study of the Buddha's Dress in Chinese Sculpture," *Artibus Asiae* 26, 2 (1963): 89–90. My "closed mode" corresponds to Griswold's "covering mode" with the chest draped. What I term the "open mode" is Griswold's "covering mode with 'opening' inflection." The modification is meant to simplify the terms in light of the fact that Griswold's open mode is rare in Chinese sculpture and not found in any works discussed in this book.

3. Okada Ken and Ishimatsu Hinako, "Chūgoku Nanbokuchō jidai no nyorai zō chakui no kenkyū (jō)" (A study of the robes of Buddha images in the period of the Northern and Southern dynasties, part 1), *Bijutsu kenkyū* 356 (March 1993): 3–5.

4. Laurence Sickman and Alexander Soper, *The Art and Architecture of China* (New York: Penguin, 1971), 90.

5. Sickman and Soper, *Art and Architecture,* 97.

6. Mizuno Seiichi and Nagahiro Toshio, *Yün-kang, the Buddhist Cave-Temples of the Fifth Century A.D. in North China,* 16 vols. (Kyoto: Jimbunkagaku Kenkyusho, Kyoto University, 1951–1956), 3, 1 (text): 98.

7. Ibid., 10, 2 (text): 62.

8. Ibid., 3, 1 (text): 99.

9. James O. Caswell, *Written and Unwritten* (Vancouver: University of British Columbia Press, 1988), 46–47.

10. James Caswell's studies of the Yungang Caves have been exemplary in differentiating mode of dress and visual style, although not always with equal clarity. In addition to *Written and Unwritten,* see James Oliver Caswell, "Cloud Hill and the Glory of the Law," Ph.D. diss., University of Michigan, 1970.

11. Alexander C. Soper, "South Chinese Influence on the Buddhist Art of the Six Dynasties Period," *Bulletin of the Museum of Far Eastern Antiquities* 32 (1960): 47–112.

12. Ibid., 57.

13. Soper only had two fifth-century images with Southern regnal dates to work with: the well-known sculpture from Maowen, Sichuan, dated to 483, and a piece in the Musuem of Fine Arts, Boston, dated to 494. The inscribed date on the latter sculpture is not considered reliable and it has not been published in recent decades. For the Maowen image, see Yuan Shuguang, "Chengdu Wanfosi chutu de Liang dai shike zaoxiang" (Liang dynasty stone sculptures unearthed at Wanfosi, Chengdu), *Sichuan Wenwu* 1991, 3: 27–32. For the Boston sculpture, see Osvald Sirén, *Chinese Sculpture from the Fifth to the Fourteenth Century,* 4 vols. (London: Ernest Benn, 1925), 2: pl. 16B. For recent discoveries in Sichuan of Buddhist images in Han-style robes dated to 490 and 504, see works H1:1 and H1:7 in Chengdu shi wenwu kaogu gongzuodui and Chengdu shi wenwu kaogu yanjiusuo, "Chengdu shi Xi'an lu Nanchao shike zaoxiang qingli jianbao (Report and inventory of the Southern dynasties stone images from Xi'an Road, Chengdu)," *Wenwu* 1998, 11: 4–20; and Luo Shiping, "Sichuan Nanchao fojiao zaoxiang de chubu yanjiu" (Preliminary study of Buddhist images of the Southern dynasties in Sichuan), in *Han Tang zhi jian de zongjiao yishu yu kaogu* (Religious art and archaeology of the Han to Tang period), ed. Wu Hong (Beijing: Wenwu chubanshe, 2000), 401–402, figs. 4 and 5.

14. Soper, "South Chinese Influence," 53.

15. Ibid., 57–58.

16. A. B. Griswold, "Prolegomena," 85–131.

17. See the translator's introduction in Su Bai, "Xianbei Remains in

Manchuria and Inner Mongolia," trans. David Fridley, *Chinese Studies in Archaeology* 1, 2 (fall 1979): 3; Victor H. Mair, "Review of *Written and Unwritten: A New History of the Buddhist Caves at Yungang,*" *Harvard Journal of Asiatic Studies* 52 (June 1992): 358. For the early history of the Xianbei and Tuoba, see Jennifer Holmgren, *Annals of Tai, Early To'pa History According to the First Chapter of the Wei-shu* (Canberra: Australian National University Press, 1982).

18. For "compatriot" as a translation of *guoren,* see Kenneth Douglas Klein, *Contribution,* 95–96; Lee, "Conquest, Division, Unification," 8–10.

19. Lee, "Conquest, Division, Unification," 9–10 and n. 52. I will follow Lee and modify his translation of *beiren,* "northmen," to "northerner" as a term to be used when referring to the original steppe people in general or as a whole.

20. Le Kang, "An Empire For a City," Ph.D. diss., Yale University, 1983, 97.

21. Soper, "South Chinese Influence," 72.

22. Ibid., 66.

23. Since the Jin dynastic history (*Jinshu* 晉書), covering the years 265–419, was compiled in 644 under the Tang dynasty, it might be more accurate to say that the positive viewpoint was that of the seventh-century Tang court.

24. Soper, "South Chinese Influence," 69.

25. The discussion closely follows Jennifer Holmgren, "Social Mobility in the Northern Dynasties: A Case Study of the Feng of Northern Yen," *Monumenta Serica* 35 (1981): 19–32.

26. Soper, "South Chinese Influence," 69.

27. Su Bai, "Dongbei, Neimenggu diqu de Xianbei yiji" (Xianbei remains in northeastern China and Inner Mongolia) *Wenwu* 1977, 5: 44–46; translated in Su Bai, "Xianbei Remains," 10–15.

28. Jennifer Holmgren, "The Harem in Northern Wei Politics; 398–498: A Study of To'pa Attitudes Towards the Institution of Empress, Empress-Dowager and Regency Governments in the Chinese Dynastic System During Early Northern Wei," *Journal of the Economic and Social History of the Orient* 26, 1 (1983): 83–85; Holmgren, "Social Mobility," 28–29.

29. Kang, "Empire," 70–72, 92–95; and also Lee, "Conquest, Division, Unification," 47–48.

30. Holmgren, "Harem," 89–92.

31. Holmgren, "Social Mobility," 22–26.

32. Lee, "Conquest, Division, Unification," 49, based on Wei Shou, *Weishu* (History of the Northern Wei) (Beijing: Zhonghua Shuju, 1974), 738.

33. Kang, "Empire," 149–50.

34. W. J. F. Jenner, *Memories of Loyang (493–534)* (Oxford: Clarendon Press, 1981), 60–61, based on Wei Shou, *Weishu,* 494, 588–89, 738, and 1754.

35. Kang, "Empire," 162–63; Sun Tongxun, *Tuoba shi de Han hua* (Sinicization of the Tuoba) (Taibei: Guoli Taiwan daxue wenxueyuan, 1962), 132, based on Wei Shou, *Weishu,* 536.

36. Jennifer Holmgren, "Empress Dowager Ling of the Northern Wei and the To'pa Sinicization Question," *Papers on Far Eastern History* 18 (1978): 158.

37. Jennifer Holmgren, "Race and Class in Fifth Century China," *Early Medieval China* 2 (1996): 91.

38. Holmgren, "Empress Dowager Ling." 155–56, based on Wei Shou, *Weishu,* 408.

39. For a singular attempt to confront the issue, see Jennifer Holmgren, "Northern Wei as a Conquest Dynasty: Current Perceptions, Past Scholarship," *Papers on Far Eastern History* 40 (1989): 1–50.

40. For example, see Kang, "Empire," 161–62; also Jenner, *Memories of Loyang,* 50.

41. Albert E. Dien, "Elite Lineages and the To'pa Accommodation: A Study of the Edict of 495," *Journal of the Economic and Social History of the Orient* 19, 1 (1976): 61–78; Lee, "Conquest, Division, Unification," 53.

42. Holmgren, "Race and Class in Fifth Century China," 115.

43. In relation to the Guyang Cave, Soper argued that the "strongly Chinese flavor" of work after 508 should be understood as a "wholesale appropriation of artistic ideas from the Southern Chi'i." See "South Chinese Influence," 79. It should be noted that others have argued even more broadly for the role of Southern influence. See Yoshimura Rei, "Ryūmon yōshiki nanchō kigen ron" (Origin of the Longmen style lies in the Southern dynasties), *Kokka* 1121 (1989): 7–18; and most recently in "Ryūmon Koyōdo butsugan mi mirareru shōgon ishō no igi" (Significance of the decorative designs in the niches for Buddhas in the Longmen Guyang Cave), *Bukkyō geijutsu* 250 (May 2000): 13–52. Also see Su Bai, "Origins and Trends in the Depiction of Human Figures in China of the Fifth and Sixth Centuries," in *China, 5000 Years: Innovation and Transformation in the Arts,* ed. Sherman E. Lee, Solomon R. Guggenheim Museum and Museo Guggenheim Bilbao (New York: Solomon R. Guggenheim Museum, 1998), 132–43.

44. See photo of the site taken in 1910 when Charles Freer visited Longmen. Thomas Lawton, *Freer: A Legacy of Art* (Washington, D.C.: Freer Gallery of Art, Smithsonian Institution, 1993), fig. 63.

45. Also known as the Laojun 老君 Cave. For a complete description of the cave and a discussion of key issues, see Wen Yucheng, "Longmen Guyang dong yanjiu" (Research on the Longmen Guyang Cave), *Zhongyuan wenwu* 1985 (Special Issue): 114–47. For recent discussions, see Ishimatsu Hinako, "Ryūmon sekkutsu Koyōdō zōzō kō" (Sculpture in the Longmen Guyang Cave), *Bukkyō geijutsu* 248 (January 2000): 13–51; and Katherine R. Tsiang, "Disjunctures of Time, Text, and Imagery in Reconstructions of the Guyang Cave at Longmen," in *Between Han and Tang,* ed. Wu Hung (Beijing: Wenwu chubanshe, 2000), 313–48. My understanding of the Guyang Cave has been greatly assisted by discussions with Ishimatsu Hinako, Amy McNair, and Katherine Tsiang.

46. Wen Yucheng, "Longmen Guyang dong," 139.

47. The total height of image and base is 6.12 m; the base alone is 4.80 m. Wen Yucheng, "Longmen Guyang dong," 115.

48. This follows Mizuno Seiichi and Nagahiro Toshio, *Kanan Rakuyō Ryūmon sekkutsu no kenkyū* (Research on Longmen Caves, Luoyang, Henan) (Tokyo: Zauhō kankōkai, 1941); and Ryūmon bunbutsu hokanjo and Peking daigaku kōkokei, eds., *Ryūmon sekkutsu,* 2 vols. (Tokyo: Heibonsha, 1987). In Wen Yucheng, "Longmen Guyang dong," 114–47, the rows and niches are num-

49. All of the dated inscriptions at Longmen up to the beginning of the Zhengshi 正始 (504) regnal era are found in the Guyang Cave. One possibly earlier image is an undated cross-ankled bodhisattva with attendants in a niche carved against the cliff face near the Weizi Cave. Although some have suggested that this work predates the Guyang Cave, stylistically this seems unlikely. For a recent discussion that suggests a dating of c. 495, see Sofukawa Hiroshi, "Ryūmon sekkutsu ni okeru hokuchō zōzō no sho mondai" (Several issues related to Northern dynasties images from Longmen), in Chūgoku chūsei no bunbutsu, ed. Tonami Mamoru (Kyoto: Kyoto daigaku jinbun kagaku kenkyūjo, 1993), 182–90.

50. A natural cave opening has been documented at this level. Wen Yucheng, "Longmen Guyang dong," 114.

51. Wen Yucheng, "Ryūmon hokuchōki shōgan no ruikei to bunki oyobi hokuchōki sekkutsu no hennen (Typological and periodic classification of small Longmen Northern dynasty niches and the chronology of the Northern dynasty grottoes as a whole)," in Ryūmon sekkutsu, ed. Ryūmon bunbutsu hokanjo and Peking daigaku kōkokei (Tokyo: Heibonsha, 1987), 1: 170–215.

52. See Amy McNair, "The Engraved Model-Letters Compendia of the Song Dynasty," Journal of the American Oriental Society 114, 2 (April 1994): 209–25; Amy McNair, "Engraved Calligraphy in China: Recension and Reception," Art Bulletin 77, 1 (March 1995): 106–14.

53. For the relationship of the pre-Buddhist stele to the Buddhist stele form, see Wong, "Beginnings," 157–271.

54. This five-month trip included stops in Beijing, Kaifeng, Luoyang, Xi'an, Guangyuan (Sichuan), Chengdu, Chongqing, Wuhan, and Shanghai. Afterward, he lectured on Chinese art in Japan; and in a lecture of Feb. 17, 1894, Okakura showed a slide of the Binyang Cave and related the style of the statues to the Tori-style sculpture of the Suiko-period (early seventh century) in the main hall of the Hōryū-ji temple. The above based on personal communication from Okada Ken.

55. Mizuno Seiichi and Nagahiro Toshio, Kanan Rakuyō Ryūmon sekkutsu, 1.

56. Édouard Chavannes, Mission archéologique dans la Chine septentrionale, 2 vols. (Paris: Ernest Leroux, 1909).

57. For Freer, see Lawton, Freer: A Legacy, 87–97. Freer's photographs and notes are archived in the Freer Gallery Library. Sirén published a report on the Longmen Caves in Osvald Sirén, Chinese Sculpture, 1: 20.

58. Mizuno Seiichi and Nagahiro Toshio, Kanan Rakuyō Ryūmon sekkutsu.

59. Longmen wenwu baoguansuo, Longmen shiku (Longmen Caves) (Beijing: Wenwu chubanshe, 1981), 1.

60. Sirén, Chinese Sculpture, 1: 20.

61. For the C. T. Loo head, see Chen Zhejing, Wen Yucheng, and Wang Zhenguo, Longmen liusan diaoxiang ji (A collection of dispersed sculpture from the Longmen Caves) (Shanghai: Shanghai renmin meishu chubanshe, 1993), fig. 16; for additional discussion of the sculpture taken from Longmen, see Higashiyama Kengo, "Ōbei Nihon e ryūshutsu shita Ryūmon sekkutsu no sekicho sonzō" (Stone sacred images from the Longmen Caves that flowed to Europe, the United States, and Japan)," in Ryūmon bunbutsu hokanjo and Peking daigaku kōkokei, ed., Ryūmon sekkutsu, 2 vols. (Tokyo: Heibonsha, 1987) 2: 263–69.

62. C.T. Loo & Co., An Exhibition of Chinese Stone Sculptures (New York: C.T. Loo & Co., 1940), preface.

63. For example, see Langdon Warner's report of French dealers marking photographs of sculpture at Longmen for removal in Warren I. Cohen, East Asian Art and American Culture (New York: Columbia University Press, 1992), 89.

64. Sotheby's (London), Fine Chinese Ceramics, Bronzes and Works of Art, London, December 7, 1993, no. 32, refers to Osvald Sirén, Chinesische Skulpturen der Sammlung Eduard von der Heydt (Zurich: Museum Rietberg, 1959), no. 11; and Asian Art Museum of San Francisco, Chinese, Korean, and Japanese Sculpture, no. 38.

65. Osvald Sirén, Kinas konst under tre årtusenden, 2 vols. (Stockholm: Natur och kultur, 1942–43), 1: fig. 234.

66. Wen Yucheng, "Longmen beichao xiaokan de leixing, fenqi yu tongku painian" (The typology, stages, and chronology of the Longmen Northern dynasties small niches), in Longmen shiku (Longmen Caves), ed. Longmen wenwu baoguansuo and Beijing daxue kaoguxi (Beijing: Wenwu chubanshe, 1991), 1: 190–91, no. 11. Liu Jinglong and Li Yukun, eds., Longmen shiku beike tiji (Record of stele inscriptions from the Longmen Caves) (Beijing: Zhongguo dabai kequanshu chubanshe, 1998), 2: 420, no. 1840; Mizuno and Nagahiro, Kanan Rakuyō Ryūmon sekkutsu, 298, inscription no. 577. Translated in Chavannes, Mission 1, pt. 2: 473–74, no. 373.

67. For a discussion of Mu Liang and his wife, see Wen Yucheng, "Guyang dong," 143. For the favored position of the Mu lineage, see Holmgren, "Race and Class," 86–87. For Mu Liang and the new capital, see Yang Xuanzhi, Luoyang qielanji jiaoshi (Record of the monasteries of Luoyang, critical edition), ed. Zhou Zumo (Beijing: Zhonghua shuchu, 1963), 8; Yang, Record, 7; Jenner, Memories, 143; Tsukamoto Zenryū, Shina bukkyō shi kenkyū, Hokugi hen (Research on the history of Chinese Buddhism, Northern Wei volume) (Tokyo: Kōbundō shobō, 1942), 430–33.

68. Holmgren, "Wei-shu Records," 69.

69. Chavannes transcribes Yuchi's name as Wei-tch'e (Weichi); Wong transcribes it as Weici. I follow Acker, who states that Yü (Yu) is often spelled Wei in Western scholarship but that the correct reading is Yu. William Reynolds Beal Acker, Some T'ang and Pre-T'ang Texts on Chinese Painting, Translated and Annotated, 2 vols. (Leiden: E. J. Brill, 1954 and 1974), 2, 1: 205 n. 2. Yuchi is followed in Liu Jinglong, Longmen ershipin (Twenty Longmen works) (Beijing: Zhongguo shijieyu chubanshe, 1995), 34. Chavannes suggests that Mu Liang married Yuchi after the death of the royal princess and that she was connected to the royal family of Khotan; see Chavannes, Mission 1, 2: 474, note. 1. Wong follows Yao Weiyuan in considering Yuchi to be of northerner background. See Wong, "Beginnings," 308.

70. Weishu, 736; translation after Jenner, Memories, 51.

71. Summarized in Jenner, Memories, 52–57.

72. Wen Yucheng, "Longmen Beichao xiaokan," 1: 190–91, nos. 14 (Yifu) and 50 (Gao Hui); Liu Jinglong and Li Yukun, eds., Long-

men shiku beike, 2: 431, no 1841 (Yifu) and 507, no. 2297 (Gao Hui); Mizuno and Nagahiro, *Kanan Rakuyō Ryūmon sekkutsu*, 298, no. 578 (Yifu), and 345, no. 836 (Gao Hui); Chavannes, *Mission* 1, 2: 473–74, no. 375 (Yifu).

73. Gao Hui's niche is 50 cm in height; Yifu's is 26 cm See Wen Yucheng, "Longmen Beichao xiaokan," 1: 190.

74. Wen Yucheng, "Longmen Beichao xiaokan," 1: 190–91, no. 15, Liu Jinglong and Li Yukun, eds., *Longmen shiku beike*, 2: 431–32, no. 1842; Mizuno and Nagahiro, *Kanan Rakuyō Ryūmon sekkutsu*, 299, inscription no. 579.

75. Translated in part in Soper, *Literary Evidence*, 135–36; and completely in Chavannes, *Mission* 1, pt. 2: 475–76, no. 376.

76. Amy McNair, "Engraved Calligraphy," 110. Interestingly, in Nakata Yujiro, ed., *Chinese Calligraphy* (New York: Weatherhill/Tankosha, 1983), 172, the names and titles (朱義章書孟達文) are translated as "expert passages of brilliant truths and beautiful calligraphy." A similar passage in the Sun Qiusheng inscription to be discussed below names the calligrapher as Meng Guangda 孟廣達, possibly the same person named here.

77. The 498 date is followed in the publications of the Longmen Research Institute—for example, Ryūmon bunbutsu hokanjo and Peking daigaku kōkokei, eds., *Ryūmon sekkutsu*. For 493 as well as a review of some less likely possibilities, see Wen Yucheng, "Longmen Guyang dong," 141–42. For 488, see Gong Dazhong, *Longmen shiku yishu* (Art of the Longmen Caves) (Shanghai: Shanghai renmin chubanshe, 1981), 212; Zhang Naizhu, "Longmen shiku Shiping gong xiangkan zaoxiang niandai guankui" (Focus on the date of the sculpture in the duke of Shiping image niche, Longmen Caves) *Zhongyuan wenwu* 1983, 3: 91–93; and Yan Wenru and Chang Qing, *Longmen shiku yanjiu* (Longmen Cave-temple research) (Beijing: Shumu wenxian chubanshe, 1993), 20–21. Caswell follows Gong in *Written and Unwritten*, 122 and 190 n. 13.

78. For a review of previous scholarship on the identity of the duke of Shiping, see Wen Yucheng, "Guyang dong," 143–44.

79. For example, Tsukamoto Zenryū, *Shina bukkyō shi*, 473–82; Caswell, *Written and Unwritten*, 122–23.

80. Wen Yucheng, "Longmen Beichao xiaokan," 1: 190–91, no. 9; Liu Jinglong and Li Yukun, eds., *Longmen shiku beike*, 2: 432, no. 1843; Mizuno and Nagahiro, *Kanan Rakuyō Ryūmon sekkutsu*, 299, inscription no. 580; Chavannes, *Mission* 1: 2:477–78.

81. The date—twelfth month, eleventh day of the eighteenth year of *taihe*—corresponds to January 22, 495. See Dong Zuobin, *Zhongguo nianli zongpu* (Chronological tables of Chinese history) (Xianggang: Xianggang daxue chubanshe, 1960), 2: 62.

82. Both men were favorites of the emperor Xiaowen but I have not been able to uncover any other special relationship between them. See Jennifer Holmgren, "Princes and Favourites at the Court of Emperor Shih-tsung of Northern Wei, c. 500–510," *Journal of Oriental Studies* 20, 2 (1982): 95–127.

83. For a comparison of the two styles, Western and Han, at the Yungang and the Guyang Cave, see Ishimatsu Hinako, "Ryūmon Koyōdō shoki zōzō ni okeru chūgokuka no mondai" (Questions related to the sinicization of sculpture in the Longmen Guyang Cave in the early period), *Bukkyō geijutsu* 184 (May 1989): 49–69.

84. Wen Yucheng, "Longmen Beichao xiaokan," 1: 190–91, no.16; Liu Jinglong and Li Yukun, eds. *Longmen shiku beike*, 2: 432, no. 1844; Mizuno and Nagahiro, *Kanan Rakuyō ryūmon sekkutsu*, 299, inscription no. 581. Chavannes, *Mission* 1, 2: 478, no. 378. The full titles are 都綰關口遊邀校尉司馬 Duwanguankou Youjixiaowei Sima. Chavannes indicates that the "guankou" refers to the Longmen gorge (Chavannes, *Mission* 1: 2, 478 n. 4); Hucker defines "xiaowei" as a military commandant. See Hucker, *A Dictionary of Official Titles*, entry no. 2456.

85. Chavannes, *Mission* 1: 2, 478 n. 5.

86. Liu Jinglong, *Longmen ershipin*, no. 6.

87. Most recently, for example, see Wong, "Beginnings," 315.

88. The above follows the detailed comparison of Yungang and the Guyang Cave in Ishimatsu Hinako, "Ryūmon Koyōdō," 49–69.

89. See, for example, Unkō sekkutsu bunbutsu hokanjo, ed., *Unkō sekkutsu* (Yungang Caves) (Tokyo: Heibonsha, 1989), 1: pl. 117.

90. Ishimatsu, "Ryūmon Koyōdō," 60. Neither of the works, however, may have been made prior to the end of the fifth century. The regnal date of the first example, dated to the second year of *heping* 和平 or 461 by Ishimatsu (also Matsubara Saburō, *Chūgoku bukkyō chōkokushi ron*, pl. 28a) is now read as second year of *yongping* 永平 or 509 by others. See Jin Shen, *Zhongguo lidai jinian fojiao tudian* (Illustrated dictionary of dated Chinese Buddhist images) (Beijing: Wenwu chubanshe, 1994), 121, no. 80. The second work is not dated. See Matsubara Saburō, *Chōgoku bukkyō chōkokushi kenkyū* (Research on Chinese Buddhist sculpture) (Tokyo: Yoshikawa kōbunkan, 1966), pl. 27b.

91. Mizuno and Nagahiro, *Yün-kang*, 15, 1 (text): 126.

92. For northern Henan, see Ishimatsu Hinako, "Hokugi Kanan no ikkō sansonzō" (A study of Buddhist trinities of the Henan area in the Northern Wei period), *Tōhō gakuhō* 69 (March 1997): 247–86. For Hebei, see Li Yumin, "Hebei zaoqi de fojiao zaoxiang, shiliuguo he Bei-Wei shiqi" (Buddhist images of the early period in Hebei: Sixteen Kingdoms and Northern Wei periods), *Gugong xueshu jikan* 11, 4 (Summer 1994): 1–80.

93. Jennifer Holmgren, "Princes and Favourites," 95–113.

94. Wen Yucheng, "Longmen Beichao xiaokan," 1: 190–91, no. 49; Liu Jinglong and Li Yukun, eds., *Longmen shiku beike*, 2: 507–8, no. 2298; Mizuno and Nagahiro, *Kanan Rakuyō Ryūmon sekkutsu*, 365, no. 8.

95. Read as the first year of Jingming 景明 (500) in Mizuno and Nagahiro, *Kanan Rakuyō Ryūmon sekkutsu*, 345, no. 837; Fusinian Library, Institute of History and Philology, Academia Sinica, Nangang, Taiwan, rubbing no. 21021; undated in Liu Jinglong and Li Yukun, eds., *Longmen shiku beike*, 2: 503, no. 2282.

96. Also referred to as *heyi* 合邑 or *fayi* 法義. See Kyoko Tokuno, "A Case Study of Chinese Buddhist Apocrypha: The *Hsiang-Fa Chueh-I Ching*," M.A. thesis, University of California, Berkeley, 1983, 33–36. Tokuno bases her discussion on the inscriptions recorded in Ōmura Seigai, *Shina bijutsu shi choso hen* (Tokyo: Bussho kankōkai zuzōbu, 1915), 187–244, which lists nineteen examples of inscriptions by such associations. For other discussions of inscriptions by *yiyi*, see Tsukamoto Zenryū, *Shina bukkyō shi*, 489–504; and Satō Chisui, "Hokuchō zōzō mei kō" (A consideration of Northern period image inscriptions), *Shigaku zasshi*

86 (1977): 1–47. For a broader discussion of *yi* and *she* type Buddhist associations, see Gernet, *Buddhism in Chinese Society,* 259–77.

97. For a detailed discussion, see Wong, "Beginnings," chapter 3.

98. See the quotation from the biography of the monk Pu'an in Gernet, *Buddhism in Chinese Society,* 261.

99. Beijing tushuguan, *Beijing tushuguancang Zhongguo lidai shike taben huibian,* 100 vols. (Beijing: Zhongzhou guji chubanshe, 1989–1991), 3: 6.

100. Ibid., 3: 12 and 13.

101. Ōmura Seigai, *Shina bijutsu shi,* 187–88. Also in rubbings nos. 00408 and 16445 in the collection of the Fusinian Library, Institute of History and Philology, Academia Sinica, Nangang, Taiwan.

102. The titles include that of *biejia* 別駕, an administrative aide to the heads of regions and commanderies. See Hucker, *Official Titles,* entry no. 4623.

103. Inscription number 14 in "Yün-kang Epigraphy," Mizuno and Nagahiro, *Yün-kang* 2 (text): 4–5; Caswell, *Written and Unwritten,* 85.

104. Mizuno and Nagahiro, *Yün-kang,* 8, pt. 2 (plates): pl. 29.

105. Adapted from Mizuno and Nagahiro, *Yün-kang,* 8–9 (text): 115.

106. See the chart in Satō Chisui, "Hokuchō zōzō mei kō," 19.

107. Caswell, *Written and Unwritten,* 37–38.

108. Wei Shou, *Treatise on Buddhism,* 76 (edict no. 84) and n. 4, 79 (no. 93), and 85 (no. 103) respectively.

109. Liu Jinglong and Li Yukun, eds., *Longmen shiku beike,* 2: 432, no. 1845; Mizuno and Nagahiro, *Kanan Rakuyō Ryūmon sekkutsu,* 345, no. 838; Lu Weiting, "Longmen zaoxiang mulu," *Wenwu* 1961, 4–5: 89.

110. Other occurrences of such a self-centered practice do exist, for example a colophon to a Dunhuang manuscript in the Stein collection (S.1329), number 1774 in Giles, *Descriptive Catalogue,* 47–48.

111. Practical versions of Buddhism in apocryphal Buddhist texts such as the *Diwei Boli jing,* although aimed at a lay audience, still emphasize fundamental and conventional Buddhist principles. See Kyoko Tokuno, "Byways in Chinese Buddhism: The Book of Trapusa and Indigenous Scriptures," Ph.D. diss., University of California, Berkeley, 1994.

112. Wen Yucheng, "Longmen Beichao xiaokan," 1: 190–91, no. 62; Mizuno and Nagahiro, *Kanan Rakuyō Ryūmon sekkutsu,* 299, no. 582. Chavannes, *Mission* 1: 2, 478–79. For a discussion of Zheng, see Wen Yucheng, "Longmen Guyang dong," 143; Zheng's biography is found in Wei Shou, *Weishu,* 1232.

113. Recorded in the *Luoyang Qielanji* by Yang Xuanzhi. See Yang Hsüan-chi, *A Record of Buddhist Monasteries in Lo-yang,* trans. Wang Yi-t'ung (Princeton, N.J.: Princeton University Press, 1984), 124 and 145. For the Zhuishengsi, also see Jenner, *Memories,* 216–17 and n. 28.

114. Yang Hsüan-chi, *Record of Buddhist Monasteries,* 90–91. For Cui Guang, see ibid., 84 n. 110, and 196; Jenner, *Memories,* 41 and 66.

115. Shizong's edict is translated in Wei Shou, *Treatise on Buddhism,* 91. For a discussion of the emperor's commission, see Alexander C. Soper, "Imperial Cave-Chapels of the Northern Dynasties: Donors, Beneficiaries, Dates," *Artibus Asiae* 28, 4 (1966): 246–47.

116. Soper, *Literary Evidence,* 103, citing Wei Shou, *Weishu,* 198. The text records a visit to Yique 伊闕 (Yi Gate Tower) as the Longmen site was referred to.

117. Wen Yucheng, "Longmen Beichao xiaokan," 1: 190–91, no. 52; Liu Jinglong and Li Yukun, eds., *Longmen shiku beike,* 2: 506, no. 2296; Mizuno and Nagahiro, *Kanan Rakuyō Ryūmon sekkutsu,* 299, inscription no. 583; translated in Chavanees, *Mission,* 1: 479–80.

118. For *taishou,* see Hucker, *Official Titles,* entry no. 6221. For *zhongsan dafu,* see ibid., entry no. 1591. The inscription is discussed and translated in Wong, "Beginnings," 309–11.

119. According to Hucker, *Dictionary of Official Titles,* entry no. 3489, a *gongcao* was responsible for preparing and processing the merit ratings of subordinate officials and monitoring all government activities in their jurisdiction. Xincheng lies just south of the Longmen site along the Yi River. See Tan Qixiang, ed., *Zhongguo lishi dituji* (Historical atlas of China) (Shanghai: Ditu chubanshe, 1982), map 46–47, insert.

120. For an analysis of the carving of the halos, see Jiang Renhe, "Zaoqi foxiang huoyan shiwen shenguang zhi yanbian ji Guyang dong qiyuan de yixie tanxiang" (Some thoughts on the origin of the Guyang Cave and the evolution of flame patterns in early Buddhist mandorlas), in *Longmen shiku yiqian wubai zhounian guoji xueshu taolunhui lunwenji* (Collected works from the 1500th year anniversary international scholarly conference on the Longmen Caves), ed. Longmen shiku yanjiusuo (Beijing: Wenwu chubanshe, 1996), 211.

121. Procrastination also had the potential to produce negative effects as in the story of the merchant in Luoyang's western suburb who deferred the gilding of a bronze Buddha image; after two years, the image told his wife in a dream that it was taking their son as compensation for their failure. At dawn the son suddenly died and the image transformed itself into a golden form. Yang Hsüan-chi, *Record of Buddhist Monasteries,* 189–90. Also see Whalen Lai, "Society and the Sacred in the Secular City: Temple Legends of the *Lo-yang Chi'ieh-lan-chi,*" in *State and Society in Early Medieval China,* ed. Albert E. Dien (Stanford: Stanford University, 1991), 252–53.

122. Tsukamoto Zenryū, *Shina bukkyō shi,* 385–86; Wen Yucheng, "Longmen Guyang dong," 139–40; Li Yukun, "Longmen beike de yanjiu" (Research on Longmen stele inscriptions), *Zhongyuan wenwu* 1985 (special issue): 178; followed by Yen Chuan-ying, "The Compelling Images: Ku-yang Buddhist Cave at Lungmen," *Chinese Pen* 19, 4 (1991): 64.

123. Wen Yucheng, "Longmen Beichao xiaokan," 1: 190–91, no. 18; Liu Jinglong and Li Yukun, eds., *Longmen shiku beike* 2: 433, no. 1846; Mizuno and Nagahiro, *Kanan Rakuyō Ryūmon sekkutsu,* 300, inscription no. 584; Chavannes, *Mission* 1: 2, 479, no. 380.

124. Wen Yucheng, "Longmen Beichao xiaokan," 1: 190–91, no. 13; Liu Jinglong and Li Yukun, eds., *Longmen shiku beike,* 2: 433–34, no. 1847; Mizuno and Nagahiro, *Kanan Rakuyō Ryūmon sekkutsu,* 300, inscription no. 585. Xie Bodu may be related to the earlier donor Xie Boda. See Chavannes, *Mission* 1: 2, 481 n. 4.

125. Liu Jinglong, *Longmen ershipin,* 83

126. For the common phrases, see Tsukamoto Zenryū, *Shina bukkyō shi,* 481–82.

127. Chen Zhejing, Wen Yucheng and Wang Zhenguo, *Longmen liusan,* figs. 1–6.

128. Wen Yucheng, "Longmen Beichao xiaokan," 1: 190–91, no. 44; Liu Jinglong and Li Yukun, eds. *Longmen shiku beike*, 2: 434, no. 1848; Mizuno and Nagahiro, *Kanan Rakuyō Ryūmon sekkutsu*, 300, inscription, 300, no. 586.

129. Suggested by Chavannes; mentioned in Wen Yucheng, "Longmen Guyang dong,"

130. Wen Yucheng, "Longmen Beichao xiaokan," 1: 192–93, no. 2; Liu Jinglong and Li Yukun, eds., *Longmen shiku beike*, 2: 501, no. 2271; Mizuno and Nagahiro, *Kanan Rakuyō Ryūmon sekkutsu*, 300, inscription no. 587.

131. Wen Yucheng, "Longmen Beichao xiaokan," 1: 192–93, no. 1; Liu Jinglong and Li Yukun, eds., *Longmen shiku beike*, 2: 501, no. 2272; Mizuno and Nagahiro, *Kanan Rakuyō Ryūmon sekkutsu*, 301, inscription no. 588.

132. For the prince of Guangchuan, see Wei Shou, *Weishu*, 516–18; Chavannes, *Mission*, 1, 2: 482 n. 2, where Yuan Xie's year of death is incorrectly given as 498; Wen, "Longmen Guyang dong," 141; Liu Jinglong, *Longmen ershipin*, no 10.

133. Wen Yucheng, "Longmen Beichao xiaokan," 1: 192–93, no. 3; Liu Jinglong and Li Yukun, eds., *Longmen shiku beike*, 2: 501–502, no. 2273; Mizuno and Nagahiro, *Kanan Rakuyō Ryūmon sekkutsu*, 301, inscription no. 590; Chavannes, *Mission*, 1, 2: 482, no. 384.

134. Both short texts are transcribed in Wen Yucheng, "Longmen Guyang dong," 128. The first, by a Wang Shenxiu 王神秀, is published in Liu Jinglong and Li Yukun, eds., *Longmen shiku beike*, 2: 502, no. 2274; the second, by a Ping Qianhu 平乾虎, is published in ibid., 2: 503, no. 2281. For the location of the Ping Qianhu niche, see Liu Jinglong, *Ryūmon nijuppin* (Twenty Longmen works) (Tokyo: Chūkyō shuppan, 1997), 174–75.

135. The arrangement of the small niches also suggests something of earlier forms of patron-client relationships. See Patricia Ebrey, "Patron-client relations in the Later Han," *Journal of the American Oriental Society* 103 (July/September 1983): 533–42.

136. Liu Jinglong and Li Yukun, eds., *Longmen shiku beike*, 2:505, no. 2288; Mizuno and Nagahiro, *Kanan Rakuyō Ryūmon sekkutsu*, 311, inscription no. 680; Chavannes, *Mission* 1, 2: 474–75, no. 374; Tsukamoto Zenryū, *Shina bukkyō shi*, 435; Wen Yucheng, "Longmen Guyang dong," 142.

137. Holmgren, "Princes and Favourites," 110–13.

138. Wen Yucheng, "Longmen Beichao xiaokan," 1: 192–93, no. 17; Liu Jinglong and Li Yukun, eds., *Longmen shiku beike*, 2: 434, no. 1849; Mizuno and Nagahiro, *Kanan Rakuyō Ryūmon sekkutsu*, 366, no. 20.

139. Some two months before the second niche of Lady Hou. Wen Yucheng, "Longmen Beichao xiaokan," 1: 192–93, no. 7; Liu Jinglong and Li Yukun, eds., *Longmen shiku beike*, 2: 544–45, no. 2521; Mizuno and Nagahiro, *Kanan Rakuyō Ryūmon sekkutsu*, 301, inscription no. 589.

140. The former is the conclusion in Liu Jinglong, *Longmen ershipin*, no. 11; the latter is stated in Wen, "Longmen Guyang dong," 126.

141. B60 S499. Asian Art Museum of San Francisco, *Chinese, Korean, and Japanese Sculpture*, no. 30.

142. 景明四年十二月一日 is usually dated to 503—for example, in Mizuno and Nagahiro, *Kanan Rakuyō Ryūmon sekkutsu*, 301, inscription no. 591; or Wen Yucheng, "Longmen Beichao xiaokan," 1:

192–93, no. 8. But the corresponding date in the Julian calendar is January 3, 504. See Chavannes, *Mission*, 484. This is confirmed in Dong Zuobin, *Zhongguo nianli zongpu*, 2: 63.

143. Liu Jinglong and Li Yukun, eds., *Longmen shiku beike*, 2: 434–35, no. 1850; Mizuno and Nagahiro, *Kanan Rakuyō Ryūmon sekkutsu*, 366, no. 22.; Wen Yucheng, "Ryūmon hokuchōki," 1: 184, fig. 56.

144. Wen Yucheng, "Longmen Beichao xiaokan," 1: 192–93, no. 53; Liu Jinglong and Li Yukun, eds., *Longmen shiku beike*, 2: 508, no. 2299; Mizuno and Nagahiro, *Kanan Rakuyō Ryūmon sekkutsu*, 301, inscription no. 591; translated in Chavannes, *Mission*, 1, 2: 483–84, no. 385.

145. For the imperial processions, one in the Nelson-Atkins Museum of Art, Kansas City, and the other in the Metropolitan Museum of Art, New York, see Chen Zhejing, Wen Yucheng, and Wang Zhenguo, *Longmen liusan*, 29–33.

146. For a rubbing with the names, see Liu Jinlong, *Longmen ershipin*, no. 13; the names are transcribed in Liu Jinglong and Li Yukun, eds., *Longmen shiku beike*, 2: 508, no. 2299.

147. Liu Jinglong and Li Yukun, eds., *Longmen shiku beike*, 2: 469, no. 2024; Mizuno and Nagahiro, *Kanan Rakuyō Ryūmon sekkutsu*, 311, no. 678; Chavannes, *Mission*, 1, 2: 487–89, no. 392.

148. A *gongcao* was responsible for the preparations of merit ratings for local officials and the monitoring of government operations. See Hucker, *Official Titles*, no. 3489. Luhun was located in what is now Song xian 嵩縣.

149. Liu Jinglong and Li Yukun, eds., *Longmen shiku beike*, 2: 468, no. 2023; Mizuno and Nagahiro, *Kanan Rakuyō Ryūmon sekkutsu*, 310, no. 677; Chavannes, *Mission*, 1, 2: 486–87, no. 391.

150. For 500, see Ōmura Seigai, *Shina bijutsu shi*, 197; for 500–503, see Tsukamoto Zenryū, *Shina bukkyō shi*, 458–60; for 504 or 506, see Chavannes, *Mission*, 1, 2: 486 n. 2; for 504, see Wen Yucheng, "Longmen Guyang dong," 142.

151. Wong, "Beginnings," 308. The possibility that the Guyang Cave functioned as a repository for memorial dedications was also suggested to me by Amy McNair in 1997.

152. Soper, *Literary Evidence*, 103.

153. Ishimatsu Hinako, "Ryūmon Koyōdō," 56–57.

154. See her essay written under her Chinese name: Jiang Renhe, "Zaoqi foxiang," 216.

155. Wen Yucheng, "Longmen Guyang dong," 142. Special thanks to Amy McNair for emphasizing Wen's argument and the importance of this quote in personal communication.

156. For the Mogao Caves, see Abe, "Mogao Cave 254"; Abe, "Art and Practice," 1–31.

157. Thanks to Amy McNair for this suggestion.

CHAPTER FIVE

1. Erik Zürcher, "Buddhist Influence on Early Taoism: A Survey of Scriptural Evidence," *T'oung Pao* 66 (1980): 146.

2. Zürcher's observation, as quoted above, has been reproduced in Jean M. James, "Some Iconographic Problems in Early Daoist-Buddhist Sculptures in China," *Archives of Asian Art* 42 (1989): 71–72; and Liu Yang, "Manifestation of the Dao: A Study in Daoist Art from the Northern Dynasty to the Tang (5th–9th Centuries)," Ph.D. diss., School of Oriental and African Studies, Uni-

versity of London, 1997, 146. A corrective was suggested in Stephen R. Bokenkamp, "The Yao Boduo Stele as Evidence for the 'Dao-Buddhism' of the Early Lingbao Scriptures," *Cahiers d'extreme-asie* 9 (1996–1997): 57–58.

3. There is, however, a paucity of historical references to Buddhist activities in Chang'an in the latter part of the fifth and early sixth centuries. The issue of ethnic conflict and the proscription of Buddhism in the early fifth century are discussed in Liu Shufen, "Cong minzushi de jiaodu kan Taiwu miefo (Considering the suppression of Buddhism by Taiwu from the perspective of the history of ethnic minorities)," *Zhongyang yanjiuyuan lishi yuyan yanjiusuo jikan* 72, 1 (2001): 1–48. For a study of non-Han peoples in the region based on extant inscriptions, see Ma Changshou, *Beiming suojian Qian–Qin zhi Sui chu de Guanzhong buzu* (Clans of the central plains from the Qin to the Sui periods as seen in northern inscriptions) (Beijing: Zhonghua shuju, 1985).

4. For a detailed study, see Kleeman, *Great Perfection.*

5. Richard B. Mather, "K'ou Ch'ien-chih and the Taoist Theocracy," in *Facets of Taoism,* ed. Holmes Welch and Anna Seidel (New Haven: Yale University Press, 1979), 106.

6. The earliest historical documentation for the site as a Daoist institution, however, dates from the Tang dynasty. See David C. Yu, *History of Chinese Daoism* (Lanham, Md.: University Press of America, 2000), 374–84, and Livia Kohn, "Yin Xi: The Master at the Beginning of the Scripture," *Journal of Chinese Religions* 25 (1997): 83–139. Kohn draws extensively on Zhang Weiling, "Guanling Yin Xi shenhua yanjiu" (Research on the deification of the Guardian of the Pass Yin Xi), *Daojiao xue tansuo* 3 (1990): 21–74; and Zhang Weiling, "Beichao zhi qian Guan daojiao xiuxingfa de lishi kaocha" (Historical investigation of Guan Daoist practices during the Northern dynasties and earlier), *Daojiao xue tansuo* 4 (1991): 67–117.

7. For a discussion of early work from Shaanxi, see Sirén, *Chinese Sculpture,* 1: l–liv.

8. For the study of subregional Shaanxi styles, see the two essays by Matsubara Saburō: "Hoku-Gi no Fuken yoshiki sekichō" (Fuxian style stone carving in the Northern Wei), in Matsubara Saburō, *Chūgoku bukkyō chōkokushi kenkyū,* 19–41; and "Hoku-Gi Seiansho ha sekichō no ikkeifu" (Genealogy of Northern Wei Shaanxi stone carving), in Matsubara Saburō, *Chūgoku bukkyō chōkokushi ron,* 1: 35–52.

9. In the collection of the Beilin Museum, Xi'an; Matsubara Saburō, *Chūgoku bukkyō chōkokushi ron,* 1: pl. 43. A work in the Museum of Fine Arts, Boston, very similar in style and likely from Chang'an, is a seated Buddha dated by inscription to 476. See Matsubara Saburō, *Chūgoku bukkyō chōkokushi ron,* 1: pl. 51.

10. Excavated in 1955 from Xi'an Nanjiao Wahutong cun 西安南郊瓦胡同村, presently in the Beilin Museum. Xi'an. See Matsubara Saburō, *Chūgoku bukkyō chōkokushi ron,* 1: pl. 102.

11. Sherman E. Lee, Solomon R. Guggenheim Museum, and Museo Guggenheim Bilbao, *China, 5000 years: Innovation and Transformation in the Arts* (New York: Solomon R. Guggenheim Museum, 1998), no. 148.

12. Matsubara Saburō, *Chūgoku bukkyō chōkokushi ron,* 1: pl. 128; Zhongguo meishu quanji bianji weiyuanhui, *Wei Jin Nanbeichao*

diaosu, pl. 71. Thanks to Kathy Mino for first alerting me to the same donor's name on both works.

13. Li Yuzheng, Zhao Minsheng, and Lei Bing, *Xi'an beilin shufa yishu* (Calligraphic arts of the Xi'an forest of stele) (Xi'an: Shaanxi renmin meishu chubanshe, 1992), 404, no. 15.

14. Excavated in 1949 from Zhajiazhai 查家寨, presently in the Beilin Museum, Xi'an. See Matsubara Saburō, *Chūgoku bukkyō chōkokushi ron,* 1: pls. 103–4.

15. For non-Han Liu lineages, see Yao Weiyuan, *Bei chao huxing kao* (Beijing: Kexue chubanshe, 1958), 38–52.

16. Field Museum of Natural History FMNH 121396; Sirén, *Chinese Sculpture,* 2: pl. 123b; Matsubara Saburō, *Chūgoku bukkyō chōkokushi ron,* 2: pl. 101.

17. Matsubara Saburō, *Chūgoku bukkyō chōkokushi ron,* 1: 256.

18. *For nanguan* as a priest, see Jan Fontein, "Inscriptions on Taoist Statues," in *Proceedings of the International Conference on Sinology: Section of History of Arts* (Taipei: Chung yang yen chiu yuan, 1981), 7: 95; and Kamitsuka Yoshiko, "Nanbokuchō jidai no dōkyō zōzō" (Daoist images of the Northern-Southern dynasties), in *Chūgoku chūsei no bunbutsu,* ed. Tonami Mamoru (Kyoto: Kyoto daigaku jinbun kagaku kenkyūjo, 1993), 246. The latter is followed in Livia Kohn's abbreviated English version of the same essay: Yoshiko Kamitsuka, "Lao-tzu in Six Dynasties Taoist Sculpture," in *Lao-tzu and the Tao-te-ching,* ed. Livia Kohn and Michael LaFargue (Albany, N.Y.: State University of New York Press, 1998), 71–72. The female equivalent, *nüguan* 女官, is also known and was combined with *daomin* 女官道民 in a Daoist work dated to 528. See Anna Seidel, "Le sūtra merveilleux du Ling-pao suprême, traitant de Lao Tseu qui convertit les barbares (le manuscrit S. 2081)," in *Contributions aux études de Touen-houang,* ed. Michel Soymié (Paris: École française d'Extrême-Orient, 1984), 333 n. 118, and pls. LV and LVI. Although *daomin* identifies a lay follower, Seidel identifies *nüguan* as a priestess. An alternative reading is that the term identifies lay initiates. See Kristofer M. Schipper, "Taoist Ordination Ranks in the Tunhuang Manuscripts," in *Religion und Philosophie in Ostasien: Festschrift für Hans Steininger zum 65. Geburtstag,* ed. Gert Naundorf, Karl-Heinz Pohl, and Hans-Hermann Schmidt (Würzburg: Königshausen and Neumann, 1985), 132 n. 31.

19. Annette L. Juliano, *Teng-hsien: An Important Six Dynasties Tomb* (Ascona: Artibus Asiae, 1980), figs. 54–55. Juliano dates the Dengxian tomb to the late fifth century. Ibid., 68. For a discussion of the costume of Daoist deities and the relationship to contemporary Daoist dress, see Liu, "Manifestation," 158–60.

20. See, for example, Sirén, *Chinese Sculpture* 1: li.

21. Five Northern Wei examples are housed in the Lintong Museum. See Lintong xian bowuguan and Zhao Kangmin, "Shaanxi Lintong de beichao zaoxiangbei (Northern dynasty image stele from Lintong, Shaanxi)," *Wenwu* 1985, 4: 15–26.

22. Wong, "Beginnings," 245–46. For a variety of examples, see Liu Shufen, "Wu zhi liu shiji huabei xiangcun de fojiao xinyang" (Buddhist practice in rural north China during the fifth and sixth centuries), *Zhongyang yanjiuyuan lishi yuyan yanjiusuo jikan* 63, 3 (1993): 497–544.

23. Liu, "Manifestation," 117.

24. Lintong and Zhao Kangmin, "Shaanxi Lintong," 15–20, figs. 1–5. Discovered in 1798. See Zhang Yan and Zhao Chao, *Beichao fodao zaoxiangbei jingxuan* (Selected Northern dynasties Buddhist and Daoist stele) (Tianjin: Tianjin chubanshe, 1996), 127.

25. Transcription of the text and names on the stele from Zhang Yan and Zhao Chao, *Beichao fodao*, 127–28.

26. For Niyang, see Wang Zhongluo, *Bei-Zhou dili zhi* (Geographical records of the Northern Zhou), 2 vols. (Beijing: Zhonghua shuju, 1980), 1: 67. The location of Pingding is not clear; see Wang, *Bei-Zhou* 2: 1022.

27. Kamitsuka Yoshiko, "Nanbokuchō," 248–49, 286 n. 27. Special thanks to Koizumi Yoshihide and Matsumoto Nobuyuki of the Tokyo National Museum for the reference to Kamitsuka. Alternatively, Schipper, "Taoist Ordination Ranks," 129–32, translates the term as a youthful "novice of the register."

28. Schipper, "Taoist Ordination Ranks," 135; Bokenkamp, "Yao Boduo Stele," 65.

29. The object held by Daoist deities has been identified as a *zhuwei* 麈尾 by some, but the form of the object varies and the accuracy of this identification needs further study. See Liu, "Manifestation," 160–62.

30. Stanley K. Abe, "Northern Wei Daoist Sculpture from Shaanxi Province," *Cahiers d'extrême-asie* 9 (1996–1997): 80.

31. Shi Zhangru, "Shaanxi Yaoxian de beilin yu shiku" (Cave temples and the forest of stele at Yaoxian, Shaanxi), *Zhongyang yanjiuyuan lishi yuyan yanjiusuo jikan* 14 (1953): 145–72; Hamasaki Michiko, "Sensei-shō Yō-ken Yakusan Yō-ken hirin" (Shaanxi Yaoxian Yaowangshan, Yaoxian forest of stele), *Sumi* 86 (September–October 1990): 98–112 [special thanks to Ishimatsu Hinako for this reference]; Yao Sheng, "Yaoxian shike wenxue luezhi" (Notes on the carved stone inscriptions of Yaoxian), *Kaogu* 1965, 3: 134–51; Han Wei and Yin Zhiyi, "Yaoxian Yaowangshan de daojiao zaoxiangbei" (Daoist stele from Yaoxian Yaowangshan), *Kaogu yu wenwu* 1987, 3: 18–26; Li Song, "Shaanxi beichao daojiao diaoke" (Northern dynasty Daoist statues in Shaanxi), *Yishuxue* 6 (September 1991): 7–32; Shaanxi sheng wenwu puchadui, "Yaoxian xinfaxian de yipi zaoxiangbei" (Stele newly discovered in Yaoxian), *Kaogu yu wenwu* 1994, 2: 45–63. For the most complete overview of the Yaoxian stele, see Zhang Yan, "Chūgoku Sensei shō Yō-ken no hirin" (A group of stone monuments located at Yaoxian in Shaanxi Province, China), Parts I and II," *Bukkyō geijutsu* 205 (December 1992): 77–89; and 211 (December 1993): 101–23.

32. 137 cm in height. See Zhang Yan, "Chūgoku Sensei shō (Part 2)," 101–7; and Zhang Yan and Zhao Chao, *Beichao fodao*, 9–38 and 125–26.

33. Bokenkamp, "Yao Boduo Stele," 65.

34. For the Qiang, see Zhang Yan, "Chūgoku Sensei shō (Part 2)," 105.

35. Kamitsuka, "Lao-tzu," 75.

36. Bokenkamp, "Yao Boduo Stele," 60–65.

37. Stephen R. Bokenkamp, "The Salvation of Laozi: Images of the Sage in the Lingbao Scriptures, the Ge Xuan Preface, and the 'Yao Boduo Stele' of 496 c.e.," forthcoming in the *festschrift* for Professor Liu Ts'un-yan, edited by Chen Man Sing (Hong Kong: University of Hong Kong Press).

38. Stephen R. Bokenkamp, "Sources of the Ling-pao Scriptures," *Mélanges Chinois et Bouddhiques* 21 (1983): 435.

39. Liu, "Manifestation," 114–16; Liu Zhaorui, "Bei-Wei Yao Boduo daojiao zaoxiangbei kaolun" (Discussion of the Northern Wei Daoist stele of Yao Boduo), in *Daojia wenhua yanjiu*, ed. Chen Guying (Shanghai: Shanghai guji chubanshe, 1996), 9: 311–15.

40. Mather, "K'ou Ch'ien-chih," 110–11.

41. As translated in Bokenkamp, "Yao Boduo Stele," 67, note 37. The passage can be found transcribed in Kamitsuka Yoshiko, "Nanbokuchō," 251.

42. This section begins in line eleven of the inscription on the front face, directly following the statement that the image is of *huang laojun*. Thanks to Stephen Bokenkamp for the translation.

43. Such problems are not new and scholars such as Soper were forced to repeatedly rationalize textual claims against extant visual imagery in works such as his still-impressive *Literary Evidence for Early Buddhist Art in China*.

44. 119 cm in height. Briefly noted in Yao Sheng, "Yaoxian shike wenzi luezhi," 3: 134. Identified as Buddhist in Zhang Yan, "Chūgoku Sensei shō (Part II)," 115.

45. For early summaries of the inscription, see Yao Sheng, "Yaoxian shike wenzi luezhi," 3: 134, followed by Li Song, "Bei-Wei Wei Wenlang zaoxiangbei kaobu" (Supplementary study of the Northern Wei Wei Wenlang stele), *Wenbo* 1994, 1: 52. For complete transcriptions, see Hamasaki Michiko, "Sensei-shō Yō-ken," 106, and Satō Chisui, "Senseishō Yō-ken no Hokugi zōzōhi ni tsuite (Regarding the Northern Wei image stele at Yaoxian, Shaanxi province)," in *Shiranshū, Yoshinami Takashi sensei taikan kinen ronshū*, ed. Shiranshū henshū i-inkai (Okayama: Shiranshū henshū i-inkai, 1999), 265–66. Special thanks to Satō Chisui and Ishimatsu Hinako for providing the latter essay to the author.

46. Abe, "Northern Wei Daoist Sculpture," 78.

47. 100 cm in height. Han Wei and Yin Zhiyi, "Yaoxian Yaowangshan de daojiao," 18, 26 and fig. 1: 6.

48. Transcribed in Zhang Yan and Zhao Chao, *Beichao Fodao*, 127.

49. Bokenkamp, "Yao Boduo Stele," 57 n. 36.

50. Lee, "Maitreya Cult," 58–59 and 126–29. For an overview, see Jan Nattier, "The Meanings of the Maitreya Myth," in *Maitreya, the Future Buddha*, ed. Alan Sponberg and Helen Hardacre (Cambridge: Cambridge University Press, 1988), 23–47.

51. 90 cm in height. Han Wei and Yin Zhiyi, "Yaoxian Yaowangshan de daojiao," 18, 26 and fig. 1: 5.

52. Both images are described as Daoist in ibid., 18.

53. For a Buddhist example, see the main image niche of Dunhuang Mogao Cave 259, probably of the 470s or 480s, in Tonkō bunbutsu kenkyūjo, ed., *Tonkō bakukokutsu*, 1: pl. 20. For the relationship to the *Lotus Sutra*, see J. Leroy Davidson, *The Lotus Sutra in Chinese Art* (New Haven: Yale University Press, 1954).

54. Bokenkamp, "Yao Boduo Stele," 66.

55. 68 cm in height. Zhang Yan, "Chūgoku Sensei shō (Part II)," 112.

56. Tokyo geijutsu daigaku (Tokyo University of Fine Arts and Music), ed., *Tokyo geijutsu daigaku zōhin zuroku: chōkoku* (Illustrated catalog of the Tokyo University of Fine Arts and Music collection: sculpture) (Tokyo: Tokyo geijutsu daigaku, 1977), no. 7.

57. See, for example, the work dated to 564 in the Field Museum of Natural History, Chicago, in Arthur Pontynen, "The Deification

of Laozi in Chinese History and Art," *Oriental Art* 26, 2 (summer 1980): 194, fig. 1.

58. Tellingly, the work was omitted from early Chinese publications of the Yaowangshan collection, but earlier doubts appear to have been lost on recent scholars and the work is published with the date of 499 in Zhang Yan and Zhao Chao, *Beichao fodao,* 39–43 and 126; Liu, "Manifestation," 141; Satō Chisui, "Senseishō Yō-ken," 267.

59. 124 cm in height. See Zhang, "Chūgoku Sensei shō (Part I)," 83–89.

60. For the *ta,* see Liu, "Manifestation," 163–64.

61. Identified as Tianzun by Zhang Yan in "Chūgoku Sensei shō (Part I)," 83.

62. Juliano, *Teng-hsien,* figs. 35 and 39. For an overview, see Liu Panxiu, "Wei Jin Nanbeicho shehui shangceng chengzuo niuche fengsu shulun" (A discussion of the fashion for riding in ox-drawn carriages among the upper classes in the Wei-Jin and Southern and Northern dynasties). *Zhongguo dianji yu wenhua* 1998, 4: 96–101.

63. The inscription and colophons have been transcribed by Zhang Yan and Zhao Chao, *Beichao fodao,* 124–26.

64. The above follows Wong, "Beginnings," 38–39.

65. For an example dated to 442, see Matsubara Saburō, *Chūgoku bukkyō chōkokushi kenkyū,* pl. 11a-b. The image, however, does not appear in the revised version (1995) of Matsubara's work, *Chūgoku bukkyō chōkokushi ron,* an indication that he no longer considers it to be a work of that date.

66. As suggested by Ning Qiang, "Buddhist-Daoist Conflict and Gender Transformation: Deciphering the Illustrations of the *Vimalakirti-nirdesha* in Mediaeval Chinese Art," *Orientations* 27, 10 (November 1996): 50–53.

67. Wong, "Beginnings," 39. An alternative interpretation, one linking these two figures as well as the two flanking the *boshanlu* to the Vimalakirti and Manjusri story, is offered in Ning Qiang, "Buddhist-Daoist Conflict," 50–53.

68. I am here in agreement with the iconographic reading of Zhang Yan, "Chūgoku Sensei shō Yō-ken (Part I)," 83–87. Kamitsuka Yoshiko appears, in this regard, to be in error. See "Nanboku-chō," 237–38.

69. Abe, "Northern Wei Daoist Sculpture," 73–76; Wong, "Beginnings," 12–33; Liu, "Manifestation," 121–26.

70. Li Song, "Bei-Wei Wei Wenlang," 52–53; Abe, "Northern Wei Daoist Sculpture"; Liu, "Manifestation," 124.

71. Bokenkamp, "Yao Boduo stele," 65–67, suggests that such a reading of the stele would be consistent with the interest of Ling-bao adherents to convert Buddhists.

72. Zhang Yan, "Chūgoku Sensei shō (Part I)," 88–89; followed by Wong, "Beginnings," 40–41; and Liu, "Manifestation," 138.

73. Livia Kohn, *Laughing at the Tao: Debates Among Buddhists and Daoists in Medieval China* (Princeton: Princeton University Press, 1995), 24.

74. Kristofer Schipper, "Purity and Strangers," 65–74. For a thorough discussion of the development of the story of Laozi's conversion of the barbarians, see Zürcher, *Buddhist Conquest,* 288–320.

75. Ishimatsu Hinako, "'Gibunrō zōzōhi' no nendai ni tsuite" (Regarding the date of the Wei Wenlang stele), *Bukkyō geijutsu* 240 (September 1998): 13–32.

76. The *Bei-Zhou dilizhi* also records the date of 446. See Wang Zhongluo, *Bei-Zhou,* 1: 28.

77. Han Wei and Yin Zhiyi, "Yaoxian Yaowangshan fojiao zaoxiang-bei" (Buddhist stele from Yaoxian Yaowangshan), *Kaogu yu wenwu* 1996, 2: 13–14.

78. The stele is in the collection of the Indiana University Art Museum. See Kenneth Ganza, "A Forged Buddhist Stele Inscription as a Case Study in Chinese Epigraphy," *Journal of the American Oriental Society* 111, 3 (July–September 1991): 512–22.

79. Ishimatsu Hinako, "'Gibunrō zōzōhi,'" 29.

80. The relationship of the two patrons is also discussed in Li Song, "Bei-Wei Wei Wenlang," 52–57, 108.

81. Both discovered in the Qi 漆 River according to Shi Zhangru, "Shaanxi Yaoxian de beilin," 147–49.

82. Liu, "Manifestation," 79 and 95.

83. Ibid., 147–51.

84. Bokenkamp, "Yao Boduo Stele," 66.

CONCLUSION

1. Wang Chong 王充, *Lunheng* 論衡 (Disquisitions), translated from Wang Chong and Huang Hui, *Lunheng jiaoshi* (Disquisitions, annotated) (Beijing: Zhonghua shuju, 1990), 1179, in Thompson, "Yi'nan Tomb," 273. Also see Wang Ch'ung, *Lun-heng,* trans. Alfred Forke (1907 and 1911; reprint, New York: Paragon Book Gallery, 1962), 1: 85.

2. Michael Baxandall, "Art, Society, and the Bouguer Principle," *Representations* 12 (1985): 32–43.

3. Mair, "Review of *Written and Unwritten,*" 358–60.

4. For extra-canonical beliefs, see Erik Zürcher, "Perspectives in the Study of Chinese Buddhism," *Journal of the Royal Asiatic Society* 1982, 2: 161–76; Zürcher, "Prince Moonlight"; Tokuno, "Case Study of Chinese Buddhist Apocrypha"; Strickmann, "Consecration Sutra"; Whalen Lai, "The Earliest Folk Buddhist Religion in China: *T'i-wei Po-li Ching* and Its Historical Significance," in *Buddhist and Taoist Practice in Medieval Chinese Society,* ed. David W. Chappell (Honolulu: University of Hawaii Press, 1987), 11–35; Robert Ford Campany, *Strange Writing: Anomaly Accounts in Early Medieval China* (Albany: State University of New York Press, 1995).

Bibliography

WORKS IN WESTERN LANGUAGES

Abe, Stanley K. "Art and Practice in a Fifth-Century Chinese Buddhist Cave Temple." *Ars Orientalis* 20 (1990): 1–31.

———. "Mogao Cave 254: A Case Study in Early Chinese Buddhist Art." Ph.D. diss., University of California, Berkeley, 1989.

———. "Northern Wei Daoist Sculpture from Shaanxi Province." *Cahiers d'extrême-asie* 9 (1996–1997): 69–83.

Acker, William Reynolds Beal. *Some T'ang and Pre-T'ang Texts on Chinese Painting, Translated and Annotated.* 2 vols. Leiden: E. J. Brill, 1954, 1974.

Aiyar, V. Natesa. "An Inscribed Relic Casket from Kurram." *Epigraphia Indica* 18 (1925–26): 16–20.

Andersen, Poul. "Talking to the Gods: Visionary Divination in Early Taoism (The Sanhuang Tradition)." *Taoist Resources* 5, 1 (August 1994): 1–24.

Asian Art Museum of San Francisco. *Chinese, Korean, and Japanese Sculpture: The Avery Brundage Collection, Asian Art Museum of San Francisco.* Tokyo: Kodansha International, 1974.

Asian Art Museum of San Francisco and He Li. *Chinese Ceramics.* New York: Rizzoli, 1996.

Baxandall, Michael. "Art, Society, and the Bouguer Principle." *Representations* 12 (1985): 32–43.

Beal, Samuel. *Si-Yu-Ki, Buddhist Records of the Western World.* Two vols. in one. London: Kegan Paul, Trench, Trubner, 1884.

Belting, Hans. *Likeness and Presence: A History of the Image before the Era of Art.* Translated by Edmund Jephcott. Chicago: University of Chicago Press, 1994.

Bentor, Yael. "On the Indian Origins of the Tibetan Practice of Depositing Relics and *Dhâraṇîs* in Stûpas and Images." *Journal of the American Oriental Society* 115, 2 (April 1995): 248–61.

Bibliothèque nationale (France), Division des manuscrits orientaux, ed. *Catalogue des manuscrits Chinois de Touen-houang, fonds Pelliot chinois. Volume I, N 2001–2500.* Paris: Bibliothèque nationale, 1970.

Bielenstein, Hans. "The Six Dynasties, Vol. 1." *Bulletin of the Museum of Far Eastern Antiquities* 68 (1996): 5–324.

Bodde, Derk. *Festivals in Classical China.* Princeton: Princeton University Press, 1975.

Bokenkamp, Stephen R. *Early Daoist Scriptures.* Berkeley and Los Angeles: University of California Press, 1997.

———. "The Salvation of Laozi: Images of the Sage in the Lingbao Scriptures, the Ge Xuan Preface, and the 'Yao Boduo Stele' of 496 C.E." In the *festschrift* for Professor Liu Ts'un-yan, ed. Chen Man Sing. Hong Kong: University of Hong Kong Press, forthcoming.

———. "Sources of the Ling-pao Scriptures." *Mélanges Chinois et Bouddhiques* 21 (1983): 434–76.

———. "The Yao Boduo Stele as Evidence for the 'Dao-Buddhism' of the Early Lingbao Scriptures." *Cahiers d'extrême-asie* 9 (1996–1997): 55–68.

Boltz, William G. "Chou li." In *Early Chinese Texts, A Bibliographical Guide,* edited by Michael Loewe, 24–32. Berkeley: Society for the Study of Early China, 1993.

Boucher, Daniel J. "Buddhist Translation Procedures in Third-Century China: A Study of Dharmarakṣa and His Translation Idiom." Ph.D. diss., University of Pennsylvania, 1996.

———. "The *Pratītyasamutpādagāthā* and Its Role in the Me-

dieval Cult of the Relics." *Journal of the International Association of Buddhist Studies* 14, 1 (1991): 1–27.

Brashier, K. E. "Longevity Like Metal and Stone: The Role of the Mirror in Han Burials." *T'oung Pao* 81, 4–5 (1995): 201–29.

———. "Han Thanatology and the Division of 'Souls.'" *Early China* 21 (1996): 125–58.

Bunker, Emmy C. "The Spirit Kings in Sixth Century Chinese Buddhist Sculpture." *Archives of the Chinese Art Society of America* 18 (1964): 26–37.

Cahill, Suzanne. *Transcendence and Divine Passion: the Queen Mother of the West in Medieval China.* Stanford: Stanford University Press, 1993.

Campany, Robert F. "Notes on the Devotional Uses and Symbolic Functions of *Sūtra* Texts as Depicted in Early Chinese Buddhist Miracle Tales and Hagiographies." *Journal of the International Association of Buddhist Studies* 14, 1 (1991): 28–72.

———. *Strange Writing: Anomaly Accounts in Early Medieval China.* Albany: State University of New York Press, 1995.

Caswell, James Oliver. "Cloud Hill and the Glory of the Law." Ph.D. diss., University of Michigan, 1970.

———. *Written and Unwritten.* Vancouver: University of British Columbia Press, 1988.

Chang, Kwang-chih. *Art, Myth, and Ritual.* Cambridge: Harvard University Press, 1983.

Chavannes, Édouard. *Dix inscriptions Chinoises de l'Asie centrale d'après les estampages de M. Ch.-E. Bonin.* Paris: Librarie C. Klincksieck, 1902.

———. *Mission archéologique dans la Chine septentrionale.* 2 vols. Paris: Ernest Leroux, 1909.

Chen Xiandan. "On the Designation 'Money Tree.'" *Orientations* 28, 8 (September 1997): 67–71.

Christie's South Kensington, Ltd. *Fine Chinese Ceramics, Paintings and Works of Art.* New York, March 22, 1999.

Cohen, Warren I. *East Asian Art and American Culture.* New York: Columbia University Press, 1992.

Cohn, William. "The Deities of the Four Cardinal Points in Chinese Art." *Transactions of the Oriental Ceramic Society* 18 (1940–41): 61–75.

Connery, Christopher Leigh. *The Empire of the Text: Writing and Authority in Early Imperial China.* Lanham: Rowman & Littlefield Publishers, 1998.

Craven, Roy C. *Indian Art.* New York: Thames and Hudson, 1976.

Cribb, Joe. "The Origin of the Buddha Image: the Numismatic Evidence." In *South Asian Archaeology 1981,* edited by Bridget Allchin, 231–44. Cambridge: Cambridge University Press, 1984.

———. "Shiva Images in Kushan and Kushano-Sasanian Coins." In *Studies in Silk Road Coins and Culture,* edited by Katsumi Tanabe, Joe Cribb, and Helen Wang, 11–66. Kamakura: Institute of Silk Road Studies, 1997.

Csikszentmihalyi, Mark. "Emulating the Yellow Emperor: The Theory and Practice of Huanglao, 180–141 B.C.E." Ph.D. diss., Stanford University, 1994.

Czuma, Stanislaw J. *Kushan Sculpture: Images from Early India.* Cleveland: Cleveland Museum of Art, 1985.

Davidson, J. Leroy. *The Lotus Sutra in Chinese Art.* New Haven: Yale University Press, 1954.

de Crespigny, Rafe. *Generals of the South: The Foundation and Early History of the Three Kingdoms State of Wu.* Canberra: Australian National University, Faculty of Asian Studies, 1990.

———. "The Three Kingdoms and Western Jin: A History of China in the 3rd Century AD: I." *East Asian History* 1 (June 1991): 1–36.

———. "The Three Kingdoms and Western Jin: A History of China in the 3rd Century AD: II." *East Asian History* 2 (December 1991): 143–65.

de Groot, J. J. M. *The Religious System of China.* 6 vols. Leiden: E. J. Brill, 1892–1910.

Dehejia, Vidya. "Aniconism and the Multivalence of Emblems." *Ars Orientalis* 21 (1991): 45–66.

Demiéville, Paul. "La *Yogācārabhūmi* de Saṅgharakṣa." *Bulletin de l'École française d'Extrême-Orient* 44, 2 (1954): 339–436.

DeWoskin, Kenneth J., and J. I. Crump, Jr. *In Search of the Supernatural.* Stanford: Stanford University Press, 1996.

Dien, Albert E. "Elite Lineages and the To'pa Accommodation: A Study of the Edict of 495." *Journal of the Economic and Social History of the Orient* 19, 1 (1976): 61–78.

———. "Instructions for the Grave: The Case of Yan Zhitui." *Cahiers d'extrême-asie* 8 (1995): 41–58.

Dubs, Homer H. *History of the Former Han Dynasty,* 3 vols. Baltimore: Waverly Press, 1938.

Dunhuang Institute for Cultural Relics, ed. *The Art Treasures of Dunhuang.* Hong Kong: Joint Publishing Co., 1981.

Durt, Hubert, Krishna Riboud, and Lai Tung-Hung. "A propos de «stûpa miniatures» votifs du Ve siècle découverts à Tourfan et au Gansu." *Arts Asiatiques* 40 (1985): 92–106.

Eberhard, Wolfram. "The Leading Families of Ancient Tunhuang." *Sinologica* 4, 4 (1955): 209–32.

———. "The Origin of the Commoners in Ancient Tunhuang." *Sinologica* 4, 3 (1955): 141–55.

Ebrey, Patricia Buckley. *The Aristocratic Families of Early Imperial China.* Cambridge Studies in Chinese History, Literature, and Institutions. Cambridge: Cambridge University Press, 1978.

———. "Patron-Client Relations in the Later Han." *Journal of the American Oriental Society* 103 (July/September 1983): 533–42.

Edwards, Richard. "The Cave Reliefs at Ma Hao (Part 1)." *Artibus Asiae* 17, 1 (1954): 5–25.

———. "The Cave Reliefs at Ma Hao (Part 2)." *Artibus Asiae* 17, 2 (1954): 103–29.

Elvin, Mark. *The Pattern of the Chinese Past* (Stanford: Stanford University Press, 1973).

Erickson, Susan N. "Money Trees of the Eastern Han Dynasty." *Bulletin of the Museum of Far Eastern Antiquities* 66 (1994): 5–115.

Errington, Elizabeth. "Gandhara Stupa Deposits." *Arts of Asia* 28, 2 (March–April 1998): 80–87.

Errington, Elizabeth, and Joe Cribb with Maggie Claringbull, eds. *The Crossroads of Asia: Transformation in Image and Symbol in the Art of Ancient Afghanistan and Pakistan.* Cambridge: Ancient India and Iran Trust, 1992.

Faccenna, Domenico. *Sculptures from the Sacred Area of Butkara I (Swat, W. Pakistan).* Roma: Istituto poligrafico dello Stato, Libreria dello Stato, 1962.

Feng Yu-lan. *A History of Chinese Philosophy.* 2 vols. Princeton: Princeton University Press, 1983.

Field Museum of Natural History. *Catalogue of Chinese Rubbings from Field Museum.* Chicago: Field Museum of Natural History, 1981.

Finsterbusch, Käte. *Verzeichnis und Motivindex der Hans-Darstellungen.* 2 vols. Wiesbaden: O. Harrassowitz, 1966.

Fontein, Jan. "Inscriptions on Taoist Statues." In *Proceedings of the International Conference on Sinology: Section of History of Arts,* 7: 95–100. Taipei: Chung yang yen chiu yuan, 1981.

Fracasso, Riccardo. "Holy Mothers of Ancient China: A New Approach to the Hsi-wang-mu Problem." *T'oung Pao* 74 (1988): 1–46.

Franke, Otto, and Tsan Hsia-Hou. *Eine chinesische Tempelinschrift aus Idikutsahri bei Turfan (Turkistan).* Berlin: Verlag der Königl, Akademie der Wissenschaften, 1907.

Franke, Wolfgang. "Die Han-zeitlichen Felsengraber bei Chia-Ting (West Ssuchuan)." *Studia Serica* 7 (1948): 19–39.

Ganza, Kenneth. "A Forged Buddhist Stele Inscription as a Case Study in Chinese Epigraphy." *Journal of the American Oriental Society* 111, 3 (July–September 1991): 512–22.

Ge Hong and James Roland Ware. *Alchemy, Medicine, Religion in the China of A.D. 320: The Nei pien of Ko Hung (Pao-pu tzu).* Cambridge: MIT Press, 1967.

Gernet, Jacques. *Buddhism in Chinese Society: An Economic History from the Fifth to the Tenth Centuries.* New York: Columbia University Press, 1995.

Giles, Lionel. *Descriptive Catalogue of the Chinese Manuscripts from Tun-huang in the British Museum.* London: British Museum, 1957.

———. "Tun-huang Lu: Notes on the District of Tun-huang." *Journal of the Royal Asiatic Society,* July 1914, 703–28.

Gokhale, V. V. "A Brāhmī Stone Inscription from Tunhuang." *Sino-Indian Studies* 1, 1 (1945): 17–22.

Griswold, A. B. "Prolegomena to the Study of the Buddha's Dress in Chinese Sculpture." *Artibus Asiae* 26, 2 (1963): 85–131.

Guo Po and Hao Yixing. *Shan Hai Ching: Legendary Geography and Wonders of Ancient China.* Translated by Hsiao-chieh Cheng, Pai Hui-Chen Cheng, and Kenneth Lawrence Thern. Taipei: Committee for Compilation and Examination of the Series of Chinese Classics, National Institute for Compilation and Translation, Republic of China, 1985.

Harper, Donald. "The Han Cosmic Board." *Early China* 4 (1979): 1–10.

———. "The Han Cosmic Board: A Response to Christopher Cullen." *Early China* 6 (1980–81): 47–56.

Harrison, Paul. "Commemoration and Identification in *Buddhanusmrti.*" In *In the Mirror of Memory,* edited by Janet Gyatso, 215–38. Albany: State University of New York Press, 1992.

Härtel, Herbert. *Along the Ancient Silk Routes.* New York: Harry N. Abrams, 1982.

Hendrischke, Barbara, and Benjamin Penny. "*The 180 Precepts Spoken by Lord Lao:* A Translation and Textual Study." *Taoist Resources* 6, 2 (August 1996): 17–29.

Ho Peng-yoke. *The Astronomical Chapters of the Chin Shu.* Paris, The Hague: Mouton & Co., 1966.

Ho, Wai-kam. "Hun-p'ing: The Urn of the Soul." *Bulletin of the Cleveland Museum of Art* 48, 2 (February 1961): 26–34.

Holmgren, Jennifer. *Annals of Tai, Early To'pa History According to the First Chapter of the Wei-shu.* Canberra: Australian National University Press, 1982.

———. "Empress Dowager Ling of the Northern Wei and the To'pa Sinicization Question." *Papers on Far Eastern History* 18 (1978): 123–70.

———. "The Harem in Northern Wei Politics; 398–498: A Study of To'pa Attitudes Towards the Institution of Empress, Empress-Dowager and Regency Governments in the Chinese Dynastic System During Early Northern Wei." *Journal of the Economic and Social History of the Orient* 26, 1 (1983): 71–96.

———. "Lineage Falsification in the Northern Dynasties: Wei Shou's Ancestry." *Papers on Far Eastern History* 21 (1980): 1–16.

———. "Northern Wei as a Conquest Dynasty: Current Perceptions, Past Scholarship." *Papers on Far Eastern History* 40 (1989): 1–50.

———. "Princes and Favourites at the Court of Emperor Shih-tsung of Northern Wei, c. 500–510." *Journal of Oriental Studies* 20, 2 (1982): 95–127.

———. "Race and Class in Fifth Century China." *Early Medieval China* 2 (1996): 86–117.

———. "Social Mobility in the Northern Dynasties: A Case Study of the Feng of Northern Yen." *Monumenta Serica* 35 (1981): 19–32.

———. "*Wei-shu* Records on the Bestowal of Imperial Princesses during the Northern Wei Dynasty." *Papers on Far Eastern History* 27 (1983): 21–97.

Hucker, Charles O. *A Dictionary of Official Titles in Imperial China.* Stanford: Stanford University Press, 1985.

Hulsewé, A. F. P. *China in Central Asia.* Sinica Leidensia 14. Leiden: E. J. Brill, 1979.

Huntington, John C. "Mathura Evidence for the Early Teachings of Mahayana." In *Mathura: The Cultural Heritage,* edited by Doris Srinivasan, 85–92. New Delhi: Manohar Publications for American Institute of Indian Studies, 1989.

Huntington, Susan L. "Aniconism and the Multivalence of Emblems: Another Look." *Ars Orientalis* 22 (1992): 111–56.

Itō, Takatoshi. "The Formation of Chinese Buddhism and 'Matching the Meaning' (*geyi*)." *Memoirs of the Toyo Bunko* 54 (1996): 65–91.

James, Jean M. "An Iconographic Study of Xiwangmu during the Han Dynasty." *Artibus Asiae* 55, 1/2 (1995): 17–41.

———. "Some Iconographic Problems in Early Daoist-Buddhist Sculptures in China." *Archives of Asian Art* 42 (1989): 71–76.

Jao Tsung-i. "The Vedas and the Murals of Dunhuang." *Orientations* 20, 3 (March 1989): 71–76.

Jenner, W. J. F. *Memories of Loyang (493–534).* Oxford: Clarendon Press, 1981.

Johnson, David G. *The Medieval Chinese Oligarchy.* Boulder: Westview Press, 1977.

Juliano, Annette L. *Teng-hsien: An Important Six Dynasties Tomb.* Ascona: Artibus Asiae, 1980.

Kalinowski, Marc. "Les Instruments astro-calendériques des Han et la méthode *liu ren.*" *Bulletin de l'École française d'Extrême-Orient* 72 (1983): 309–420.

Kalupahana, David J. "Pratītya-samutpāda." In *Encylopedia of Religion,* edited by Mircea Eliade, 11: 484–88. London: Macmillan, 1987.

Kamitsuka, Yoshiko. "Lao-tzu in Six Dynasties Taoist Sculpture." In *Lao-tzu and the Tao-te-ching,* edited by Livia Kohn and Michael LaFargue, 63–75. Albany, N.Y.: State University of New York Press, 1998.

Kang, Le. "An Empire for a City." Ph.D. diss., Yale University, 1983.

Karlgern, Bernhard. "Early Chinese Mirror Inscriptions." *Bulletin of the Museum of Far Eastern Antiquities* 6 (1934): 9–79.

Kawakatsu, Yoshio. "L'aristocratie et la société féodale au début des Six Dynasties." *Zinbun* 17 (1981): 107–60.

Kieser, Annette. "Northern Influence in Tombs in Southern China after 317 CE? A Reevaluation." Paper presented at the conference "Between Han and Tang: Cultural and Artistic Interaction in a Transformative Period," Beijing University, July 8, 2000.

Kleeman, Terry F. *Great Perfection: Religion and Ethnicity in a Chinese Millennial Kingdom.* Honolulu: University of Hawaii Press, 1998.

———. "Land Contracts and Related Documents." In *Chūgoku no shūkyō shisō to kagaku: Makio Ryōkai hakushi shōju kinen ronshū* (Religion, thought and science in China: a festschrift in honor of Professor Ryōkai Makio on his seventieth birthday), edited by Makio Ryōkai hakushi shōju kinen ronshū kankōkai, 1–34. Tokyo: Kokusho kankōkai, 1984.

Klein, Kenneth Douglas. "The Contributions of the Fourth-Century Xianbei States to the Reunification of the Chinese Empire." Ph.D. diss., University of California, Los Angeles, 1980.

Kohn, Livia. *Laughing at the Tao: Debates Among Buddhists and Daoists in Medieval China.* Princeton: Princeton University Press, 1995.

———. "Yin Xi: The Master at the Beginning of the Scripture." *Journal of Chinese Religions* 25 (1997): 83–139.

Konow, Sten. "Remarks on a Kharoṣṭhī Inscription from the Kurram Valley." In *Indian Studies in Honor of Charles Rockwell Lanman,* 53–67. Cambridge: Harvard University Press, 1929.

Kuo Li-ying. "Autour du *Fojiao chuchuan nanfang zhi lu wenwu tulu.*" *Arts Asiatiques* 53 (1998): 102–11.

Lai, Whalen. "The Earliest Folk Buddhist Religion in China: *T'i-wei Po-li Ching* and Its Historical Significance." In *Buddhist and Taoist Practice in Medieval Chinese Society,* edited by David W. Chappell, 11–35. Honolulu: University of Hawaii Press, 1987.

———. "The Limits and Failure of K'o-i (Concept Matching) Buddhism." *History of Religions* 18, 3 (1979): 238–57.

———. "Society and the Sacred in the Secular City: Temple Legends of the *Lo-yang Chi'ieh-lan-chi.*" In *State and Society in Early Medieval China,* edited by Albert E. Dien, 229–68. Stanford: Stanford University Press, 1991.

———. "Some Notes on Perceptions of *Pratītya-samutpāda* in China from Kumārajīva to Fa-yao." *Journal of Chinese Philosophy* 8 (1981): 427–35.

Lamotte, Étienne. "Un sūtra composite de l'*Ekottārāgama.*" *Bulletin of the School of Oriental and African Studies* 31, 1 (1967): 105–116.

Lancaster, Lewis R. "An Early Mahayana Sermon about the Body of the Buddha and the Making of Images," *Artibus Asiae* 36, 4 (1976): 287–91.

Lao Kan. "Population and Geography in the Two Han Dynasties." In *Chinese Social History,* edited by E-tu Zen Sun and John deFrancis, 83–102. 1956. Reprint, New York: Octagon Books, 1966.

Lawton, Thomas. *Freer: A Legacy of Art.* Washington, D.C.: Freer Gallery of Art, Smithsonian Institution, 1993.

Le Coq, Albert von. *Chotscho.* Berlin: D. Reimer, 1913.

Lee, John. "Conquest, Division, Unification: A Social and Political History of Sixth Century Northern China." Ph.D. diss., University of Toronto, 1986.

Lee, Sherman E., Solomon R. Guggenheim Museum, and Museo Guggenheim Bilbao. *China, 5000 Years: Innovation and Transformation in the Arts.* New York: Solomon R. Guggenheim Museum, 1998.

Lee, Yu-Min. "The Maitreya Cult and Its Art in Early China." Ph.D. diss., Ohio State University, 1983.

Liang Ssu-ch'eng. *A Pictorial History of Chinese Architecture.* Cambridge, Mass.: MIT Press, 1984.

Li Houbo. "Han Dynasty Tomb Murals from the Luoyang Museum of Ancient Tomb Relics." *Orientations* 25, 5 (May 1994): 40–50.

Lim, Lucy, ed. *Stories from China's Past.* San Francisco: Chinese Culture Foundation of San Francisco, 1987.

Lin, Fu-shih. "Chinese shamans and shamanism in the Chiangnan area during the Six Dynasties period (3rd–6th century A.D.)." Ph.D. diss., Princeton University, 1994.

Little, Stephen, ed. *Taoism and the Arts of China.* Berkeley and Los Angeles: University of California Press, 2000.

Liu, Laurence G. *Chinese Architecture.* New York: Rizzoli, 1989.

Liu Yang. "Manifestation of the Dao: A Study in Daoist Art from the Northern Dynasty to the Tang (5th–9th centuries)." Ph.D. diss., School of Oriental and African Studies, University of London, 1997.

Loewe, Michael. *Ways to Paradise: The Chinese Quest for Immortality.* London: Allen & Unwin, 1979.

———, ed. *Early Chinese Texts: A Bibliographical Guide.* Berkeley: Society for the Study of Early China, 1993.

Lohuizen-de Leeuw, Johanna Engelberta van. "New Evidence with Regard to the Origin of the Buddha Image." In *South Asian Archaeology 1979,* ed. Herbert Härtel, 377–400. Berlin: D. Reimer Verlag, 1981.

C.T. Loo & Co. *An Exhibition of Chinese Stone Sculptures.* New York City: C.T. Loo & Co., 1940.

Lopez, Donald S., Jr., ed. *Religions of China in Practice.* Princeton: Princeton University Press, 1996.

Lyons, Islay, and Harald Ingholt. *Gandharan Art in Pakistan.* New York: Pantheon, 1957.

Magnin, Paul. *La vie et l'œuvre de Huisi.* Paris: École française d'Extrême-Orient, 1979.

Mair, Victor H. "Buddhism and the Rise of the Written Vernacular in East Asia: The Making of National Languages." *Journal of Asian Studies* 53, 3 (August 1994): 707–51.

———. "Dunhuang as a Funnel for Central Asian Nomads into China." In *Ecology and Empire: Nomads in the Cultural Evolution of the Old World,* edited by Gary Seaman, 143–63. Los Angeles: Center for Visual Anthropology, University of Southern California Press, 1989.

———. "Review of *Written and Unwritten: A New History of the Buddhist Caves at Yungang.*" *Harvard Journal of Asiatic Studies* 52 (June 1992): 345–61.

Marshall, John. *Taxila.* 3 vols. Cambridge: Cambridge University Press, 1951.

Mather, Richard B. *A New Account of Tale of the World.* Translated by Richard B. Mather. Minneapolis: University of Minnesota Press, 1976.

———. "K'ou Ch'ien-chih and the Taoist Theocracy." In *Facets of Taoism,* ed. Holmes Welch and Anna Seidel, 103–22. New Haven: Yale University Press, 1979.

McNair, Amy. "Engraved Calligraphy in China: Recension and Reception." *Art Bulletin* 77, 1 (March 1995): 106–14.

———. "The Engraved Model-Letters Compendia of the Song Dynasty." *Journal of the American Oriental Society* 114, 2 (April 1994): 209–25.

Meng Jun and Gao Guopei. *A Chinese-English Glossary and Illustrations of Antique.* Hong Kong: Woods Publishing Co., Liangmu chubanshe; Daye gongsi faxing, 1991.

Mino, Yutaka, and Katherine R. Tsiang. *Ice and Green Clouds.* Bloomington: Indianapolis Museum of Art, 1986.

Mino, Yutaka, and Patricia Wilson. *An Index to Chinese Ceramic Kiln Sites from the Six Dynasties to the Present.* Toronto: Royal Ontario Museum, 1973.

Mizuno Seiichi and Nagahiro Toshio. *Yün-kang, the Buddhist Cave-Temples of the Fifth Century A.D. in North China.* 16 vols. Kyoto: Jimbunkagaku Kenkyusho, Kyoto University, 1951–1956.

Nakata, Yujiro, ed. *Chinese Calligraphy.* New York: Weatherhill/Tankosha, 1983.

Nattier, Jan. "The Meanings of the Maitreya Myth." In *Maitreya, the Future Buddha,* edited by Alan Sponberg and Helen Hardacre, 23–47. Cambridge: Cambridge University Press, 1988.

———. *Once Upon a Future Time.* Berkeley: Asian Humanities, 1991.

Needham, Joseph, and Wang Ling. *Science and Civilisation in China.* Volume 2: *History of Scientific Thought.* Cambridge: Cambridge University Press, 1956.

———. *Science and Civilisation in China.* Volume 3: *Mathematics and the Sciences of the Heavens and the Earth.* Cambridge: Cambridge University Press, 1959.

Nickerson, Peter. "Taoism, Death, and Bureaucracy in Early

Medieval China." Ph.D. diss., University of California, Berkeley, 1996.

Ning Qiang. "Buddhist-Daoist Conflict and Gender Transformation: Deciphering the Illustrations of the *Vimalakirtinirdesha* in Mediaeval Chinese Art." *Orientations* 27, 10 (November 1996): 50–59.

———. "Patrons of the Earliest Dunhuang Caves: A Historical Investigation." In *Between Han and Tang,* ed. Wu Hung, 489–529. Beijing: Wenwu chubanshe, 2000.

Norman, K. R. *Pali Literature.* Wiesbaden: O. Harrassowitz, 1983.

Nylan, Michael. "Feng su t'ung i." In *Early Chinese Texts, A Bibliographical Guide,* edited by Michael Loewe, 105–12. Berkeley: Society for the Study of Early China, 1993.

Penny, Benjamin. "Buddhism and Daoism in *The 180 Precepts Spoken by Lord Lao.*" *Taoist Resources* 6, 2 (August 1996): 1–16.

Pirazzoli-t'Serstevens, Michele. "De l'efficacité plastique à la productivité: les grès porcelaineux du Jiangnan aux IIIe-IVe siècles de notre ère." *T'oung Pao* 84, 1–3 (1998): 20–61.

Pontynen, Arthur. "The Deification of Laozi in Chinese History and Art." *Oriental Art* 26, 2 (summer 1980): 192–200.

Poo, Mu-chou. "Ideas concerning Death and Burial in Pre-Han and Han China." *Asia Major* (3rd series), 3, 2 (1990): 25–62.

———. *In Search of Personal Welfare: A View of Ancient Chinese Religion.* Albany: State University of New York Press, 1998.

Powers, Martin. *Art and Political Expression in Early China.* New Haven: Yale University Press, 1991.

Rainey, Lee. "The Queen Mother of the West: An Ancient Chinese Mother Goddess?" In *Sages and Filial Sons,* edited by Julia Ching and R. W. L. Guisso, 81–100. Hong Kong: Chinese University Press, 1991.

Rawski, Evelyn Sakakida. *Education and Popular Literacy in Ch'ing China.* Ann Arbor: University of Michigan Press, 1979.

Rawson, Jessica. *Chinese Ornament: The Lotus and the Dragon.* London: Holmes & Meier, 1984.

———. *Mysteries of Ancient China: New Discoveries from the Early Dynasties.* New York: G. Braziller, 1996.

Raz, Gil. "Ritual and Cosmology: Transformations of the Ritual for the Eight Archivists." M.A. thesis, Indiana University, 1996.

Rhi, Ju-hyung. "From Bodhisattva to Buddha: The Beginning of Iconic Representation in Buddhist Art." *Artibus Asiae* 54, 3/4 (1994): 207–25.

Rhie, Marylin M. "The Earliest Chinese Bronze Bodhisattva Sculptures." *Arts of Asia* 25, 2 (March-April 1995): 86–98.

———. *Early Buddhist Art of China and Central Asia.* Leiden: Brill, 1999.

Rudolph, Richard C. *Han Tomb Art of West China: A Collection of First- and Second-Century Reliefs.* Berkeley and Los Angeles: University of California Press, 1951.

Salomon, Richard. *Ancient Buddhist Scrolls from Gandhara.* Seattle: University of Washington Press, 1999.

Satō Chisui. "The Character of Yün-kang Buddhism." *Memoirs of the Research Department of the Toyo Bunko* 36 (1978): 39–73.

Schipper, Kristofer M. "Taoist Ordination Ranks in the Tunhuang Manuscripts." In *Religion und Philosophie in Ostasien: Festschrift für Hans Steininger zum 65. Geburtstag,* ed. Gert Naundorf, Karl-Heinz Pohl, and Hans-Hermann Schmidt, 127–48. Würzburg: Königshausen and Neumann, 1985.

Schopen, Gregory. *Bones, Stones, and Buddhist Monks: Collected Papers on the Archaeology, Epigraphy, and Texts of Monastic Buddhism in India.* Honolulu: University of Hawaii Press, 1997.

———. "Monks and the Relic Cult in the *Mahāparinibbānasutta:* An Old Misunderstanding in Regard to Monastic Buddhism." In *From Benares to Beijing: Essays on Buddhism and Chinese Religion in Honour of Prof. Jan Yun-Hua,* edited by Koichi Shinohara and Gregory Schopen, 187–202. Oakville, Ont.: Mosaic Press, 1991.

———. "On Monks, Nuns and 'Vulgar' Practices: The Introduction of the Image Cult into Indian Buddhism." *Artibus Asiae* 49, 1/2 (1989): 153–68.

———. "Two Problems in the History of Indian Buddhism: The Layman/Monk Distinction and the Doctrines of the Transference of Merit." *Studien zur Indologie und Iranistik* 10 (1985): 9–47.

Seidel, Anna. "Chronicle of Taoist Studies in the West, 1950–1990." *Cahiers d'extrême-asie* 5 (1989–90): 223–347.

———. "Le sūtra merveilleux du Ling-pao suprême, traitant de Lao Tseu qui convertit les barbares (le manuscrit S. 2081). In *Contributions aux études de Touen-houang,* edited by Michel Soymié, 305–52. Paris: École française d'Extrême-Orient, 1984.

———. "Taoist Messianism." *Numen* 31, 2 (1984): 161–174.

———. "Tokens of Immortality in Han Graves." *Numen* 29, 1 (1982): 79–122.

———. "Traces of Han Religion." In *Taoism and Religious Culture,* edited by Akizuki Kan'ei, 21–57. Tokyo: Hirakawa shuppan, 1987.

Sharf, Robert H. "The Scripture in Forty-two Sections." In *Religions of China in Practice,* edited by Donald S. Lopez, Jr., 360–71. Princeton: Princeton University Press, 1996.

Sherrill, W. A., and W. K. Chu. *An Anthology of I Ching.* London: Routledge & Kegan Paul, 1977.

Shih, Robert. *Biographies des moines éminents (Kao seng tchouan) de Houei-kiao.* Louvain: Institut Orientaliste, 1968.

Sickman, Laurence, and Alexander Soper. *The Art and Architecture of China.* New York: Penguin, 1971.

Sirén, Osvald. *Chinese Sculpture from the Fifth to the Fourteenth Century.* 4 vols. London: Ernest Benn, 1925.

———. *Chinesische Skulpturen der Sammlung Eduard von der Heydt.* Zurich: Museum Rietberg, 1959.

———. *Kinas konst under tre årtusenden.* 2 vols. Stockholm: Natur och kultur, 1942–43.

Soper, Alexander C. "Imperial Cave Chapels of the Northern Dynasties: Donors, Beneficiaries, Dates." *Artibus Asiae* 28, 4 (1966): 241–70.

———. *Literary Evidence for Early Buddhist Art in China.* Ascona: Artibus Asiae, 1959.

———. "Northern Liang and Northern Wei in Kansu." *Artibus Asiae* 21, 2 (1958): 131–64.

———. "South Chinese Influence on the Buddhist Art of the Six Dynasties Period." *Bulletin of the Museum of Far Eastern Antiquities* 32 (1960): 47–112.

———. "Two Stelae and a Pagoda on the Central Peak, Mt. Sung." *Archives of the Chinese Art Society of America* 16 (1962): 41–48.

Sotheby's London. *Fine Chinese Ceramics, Bronzes, and Works of Art.* December 7, 1993.

Soymié, Michel. "Biographie de Chan Tao-k'ai." *Mélanges publiés par l'Institut des hautes études Chinoises* 1 (1957): 415–22.

Spiro, Audrey. "Shaping the Wind: Taste and Tradition in Fifth-Century South China." *Ars Orientalis* 21 (1991): 95–117.

Stein, Rolf A. "Religious Taoism and Popular Religion from the Second to Seventh Centuries." In *Facets of Taoism,* edited by Holmes Welch and Anna Seidel, 53–82. New Haven: Yale University Press, 1979.

Strickmann, Michel. "The *Consecration Sutra:* A Buddhist Book of Spells." In *Chinese Buddhist Apocrypha,* edited by Robert E. Buswell, 75–118. Honolulu: University of Hawaii Press, 1990.

———. "India in the Chinese Looking-Glass." In *The Silk Road and the Diamond Path,* ed. Deborah E. Klimburg-Salter, 52–63. Los Angeles: UCLA Art Council, 1982.

Su Bai. "Origins and Trends in the Depiction of Human Figures in China of the Fifth and Sixth Centuries." In *China, 5000 Years: Innovation and Transformation in the Arts,* ed. Sherman E. Lee, Solomon R. Guggenheim Museum, and Museo Guggenheim Bilbao, 132–43. New York: Solomon R. Guggenheim Museum, 1998.

———. "Xianbei Remains in Manchuria and Inner Mongolia." Translated by David Fridley. *Chinese Studies in Archaeology* 1, 2 (fall 1979): 3–43.

Tang Changshou. "Shiziwan Cliff Tomb no. 1." *Orientations* 28, 8 (September 1997): 72–77.

T'ao Ch'ien and James Robert Hightower. *The Poetry of T'ao Ch'ien.* Oxford: Clarendon, 1970.

Teiser, Stephen. "The Spirits of Chinese Religion." In *Religions of China in Practice,* edited by Donald S. Lopez, Jr., 3–37. Princeton: Princeton University Press, 1996.

Thompson, Lydia Dupont. "The Yi'nan Tomb: Narrative and Ritual in Pictorial Art of the Eastern Han (25–220 C.E.)." Ph.D. diss., New York University, 1998.

Tokuno, Kyoko. "Byways in Chinese Buddhism: The Book of Trapusa and Indigenous Scriptures." Ph.D. diss., University of California, Berkeley, 1994.

———. "A Case Study of Chinese Buddhist Apocrypha: The *Hsiang-Fa Chueh-I Ching.*" M.A. thesis, University of California, Berkeley, 1983.

———. "The Evaluation of Indigenous Scriptures in Chinese Buddhist Bibliographical Catalogues." In *Chinese Buddhist Apocrypha,* edited by Robert E. Buswell, 31–74. Honolulu: University of Hawaii Press, 1990.

Trentelman, Karen, Leon Stodulski, Ray Lints, and Chongmin Kim. "A Comparative Study of the Composition and Corrosion of Branches from Eastern Han Dynasty Money Trees." *Studies in Conservation* 44, 3 (1999): 170–73.

Tsiang, Katherine R. "Monumentalization of Buddhist Texts in the Northern Qi Dynasty: The Engraving of *Sutras* in Stone at the Xiangtangshan Caves and Other Sites in the Sixth Century." *Artibus Asiae* 56, 3/4 (1996): 233–61.

——— "Disjunctures of Time, Text, and Imagery in Reconstructions of the Guyang Cave at Longmen." In *Between Han and Tang,* ed. Wu Hung, 313–48. Beijing: Wenwu chubanshe, 2000.

Tsukamoto Zenryū. *A History of Early Chinese Buddhism.* Translated by Leon Hurvitz. 2 vols. Tokyo: Kodansha International, 1985.

Twitchett, D. C. "The Monasteries and China's Economy in Medieval Times." *Bulletin of the School of Oriental and African Studies* 19, 3 (1957): 526–49.

Twitchett, Denis. "The Composition of the T'ang Ruling Class: New Evidence from Tun-huang." In *Perspectives on the T'ang,* edited by Arthur F. Wright and Denis Twitchett, 47–75. New Haven: Yale University Press, 1973.

Vogel, J. Ph. "The Past Buddhas and Kāśyapa in Indian Art and Epigraphy." In *Asiatica,* edited by Johannes Schubert, 808–816. Leipzig: O. Harrassowitz, 1954.

Wang Ch'ung. *Lun-heng.* Translated by Alfred Forke. 2 vols. 1907 and 1911; reprint New York: Paragon Book Gallery, 1962.

Wang, Eugene. "What Do Trigrams Have to Do with Buddhas? The Northern Liang Stupas and Problems of the Sinicization Narrative." *Res* 35 (spring 1999): 70–91.

Wang Zhongshu. *Han Civilization.* Translated by K. C. Chang. New Haven: Yale University Press, 1982.

Wei Shou. *Treatise on Buddhism and Taoism.* Translated by Leon Hurvitz. Japanese annotation by Tsukamoto Zenryū. Kyoto: Jimbunkagaku Kenkyusho, 1956.

Williams, Joanna G. *The Art of Gupta India: Empire and Province.* Princeton: Princeton University Press, 1982.

———. "The Case of Omitted Hundreds: Stylistic Development in Mathura Sculpture of the Kusana Period." In *Mathura: The Cultural Heritage,* edited by Doris Srinivasan,

325–31. New Delhi: Manohar Publications for American Institute of Indian Studies, 1989.

Wilson, J. Keith. "Miniature Votive Stupa *(Shita)* and Stele with Sakyamuni and Maitreya." *Bulletin of the Cleveland Museum of Art* 81, 8 (October 1994): 313–20.

Wong, Dorothy C. "The Beginnings of the Buddhist Stele Tradition in China." Ph.D. diss., Harvard University, 1995.

Wright, Arthur F. "Biography and Hagiography: Hui-chiao's *Lives of Eminent Monks.*" In *Silver Jubilee Volume of the Zinbun-Kagaku-Kenkyusyo, Kyoto University,* edited by Zinbun Kagaku Kenkyujo Kyoto Daigaku, 2: 383–432. Kyoto: Kyoto Daigaku Jinbun Kagaku Kenkyujo, 1954.

Wu Hung. "Buddhist Elements in Early Chinese Art (2nd and 3rd Centuries A.D.)" *Artibus Asiae* 47, 3/4 (1986): 263–352.

———. "Mapping Early Taoist Art: The Visual Culture of Wudoumi Dao." In *Taoism and the Arts of China,* edited by Stephen Little, 77–93. Berkeley: University of California Press, 2000.

———. *Monumentality in Early Chinese Art and Architecture.* Stanford: Stanford University Press, 1995.

——— "Myths and Legends in Han Funerary Art: Their Pictorial Structure and Symbolic Meanings as Reflected in Carvings on Sichuan Sarcophagi." In *Stories from China's Past,* edited by Lucy Lim, 72–81. San Francisco: Chinese Culture Foundation of San Francisco, 1987.

———. *The Wu Liang Shrine.* Palo Alto: Stanford University Press, 1989.

———. "Xiwangmu: The Queen Mother of the West." *Orientations* 18, 4 (1987): 24–33.

Xiao Ji. *Cosmologie et divination dans la Chine ancienne: Le Compendium des cinq agents (Wuxing dayi, VIᵉ siècle).* Translated by Marc Kalinowski. Paris: École française d'Extrême-Orient, 1991.

Yamabe, Nobuyoshi. "*The Sūtra on the Ocean-Like Samādhi of the Visualization of the Buddha:* The Interfusion of the Chinese and Indian Cultures in Central Asia as Reflected in a Fifth Century Apocryphal Sūtra." Ph.D. diss., Yale University, 1999.

Yang Hsüan-chi. *A Record of Buddhist Monasteries in Lo-yang.* Translated by Wang Yi-t'ung. Princeton, N.J.: Princeton University Press, 1984.

Yang Lien-sheng. "Notes on the Economic History of the Chin Dynasty." *Harvard Journal of Asiatic Studies* 9, 2 (June 1946): 107–85.

Yang, Xiaoneng, ed. *The Golden Age of Chinese Archaeology.* New Haven: Yale University Press, 1999.

Yen Chuan-ying. "The Compelling Images: Ku-yang Buddhist Cave at Lung-men." *Chinese Pen* 19, 4 (1991): 58–69.

Yu, David C., trans. *History of Chinese Daoism.* Lanham, Md.: University Press of America, 2000.

Yu, Ying-shih. "'O Soul, Come Back!' A Study in the Changing Conceptions of the Soul and Afterlife in Pre-Buddhist China." *Harvard Journal of Asiatic Studies* 47 (December 1987): 363–95.

———. *Trade and Expansion in Han China: A Study in the Structure of Sino-Barbarian Relations.* Berkeley and Los Angeles: University of California Press, 1967.

Zhang Yachu and Liu Yu. "Some Observations about Milfoil Divination Based on Shang and Zhou *bagua* Numerical Symbols." *Early China* 7 (1981–82): 46–55.

Zürcher, Erik. *The Buddhist Conquest of China.* Leiden: E. J. Brill, 1972.

———. "Buddhist Influence on Early Taoism: A Survey of Scriptural Evidence." *T'oung Pao* 66 (1980): 84–147.

———. "Han Buddhism and the Western Region." In *Thought and Law in Qin and Han China,* edited by W. L. Idema and E. Zürcher, 158–72. Leiden: E. J. Brill, 1990.

———. "Late Han Vernacular Elements in the Earliest Buddhist Translations." *Journal of the Chinese Language Teachers' Association* 12 (1977): 177–203.

———. "A New Look at the Earliest Chinese Buddhist Texts." In *From Benares to Beijing: Essays on Buddhism and Chinese Religion in Honour of Prof. Jan Yun-Hua,* edited by Koichi Shinohara and Gregory Schopen, 277–304. Oakville, Ont.: Mosaic Press, 1991.

———. "Perspectives in the Study of Chinese Buddhism." *Journal of the Royal Asiatic Society* 1982, 2: 161–76.

———. "'Prince Moonlight,' Messianism and Eschatology in Early Medieval Chinese Buddhism." *T'oung Pao* 68 (1982): 1–75.

WORKS IN CHINESE AND JAPANESE

Anhui sheng wenwu gongzuodui 安徽省文物工作隊, Fuyang diqu bowuguan 阜陽地區博物館, and Fuyang xian wenhuaju 阜陽縣文化局. "Fuyang shuang gudui Xi-Han Anyin hou mu fajue jianbao 阜陽雙古堆西漢汝陰侯墓發掘簡報" (Report on the excavation of a pair of ancient Western Han tombs of the marquis of Anyin at Fuyang). *Wenwu* 文物 1978, 8: 12–31.

Anhui sheng wenwu kaogu yanjiusuo 安徽省文物考古研究所 and Ma'anshan shi wenhuaju 馬鞍山市文化局. "Anhui Ma'anshan Dong-Wu Zhu Ran mu fajue jianbao 安徽馬鞍山東吳朱然墓發掘簡報" (Report on the excavation of the Eastern Wu tomb of Zhu Ran at Ma'anshan, Anhui). *Wenwu* 文物 1986, 3: 1–15.

Asai Kazuharu 浅井和春. "Bosatsu hankazō, Kanshō-in 菩薩半跏像，觀松院" (Bodhisattva in leg-over pose, Kanshō temple). *Kokka* 国華 1116 (1988): 21–31.

Ban Gu 班固. *Hanshu* 漢書 (History of the Former Han). Beijing 北京: Zhonghua shuju 中華書局, 1962.

Bao Chang 寶唱. *Mingsengzhuan chao* 名僧傳抄 (Biographies of famous monks, copy). Taibei 臺北: Xinwenfeng chuban gongsi 新文豐出版公司, 1975.

Beijing tushuguan 北京圖書館. *Beijing tushuguancang Zhongguo lidai shike taben huibian* 北京圖書館藏中國歷代石刻拓本匯編 (Corpus of stone rubbings of the past dynasties in the Beijing Library Collection). 100 vols. Beijing 北京: Zhongzhou guji chubanshe 中州古籍出版社, 1989–1991.

Cao Shibang 曹仕邦. "Lun liang Han qi nanbeichao Hexi zhi kaifa yu ruxue shijiao zhi jinzhan 論兩漢迄南北朝河西之開發與儒學釋教之進展" (Discussion of the development of Hexi from the Han-Wei to Northern and Southern dynasties and the advancement of Confucianism and Buddhism). *Xinya xuebao* 新亞學報 5, 1 (1960): 49–177.

Chai Zhongqing 柴中慶. "Nanyang Han huaxiang shimu muzhu ren shenfen chutan 南陽漢畫像石墓墓主人身份初探" (A preliminary study of the social status of tomb occupants in decorated stone tombs at Nanyang). In *Handai huaxiang shi yanjiu* 漢代畫像石研究 (Studies of Han dynasty decorated stones), ed. Nanyang Handai huaxiang shi xueshu taolunhui 南陽漢代畫像石學術討論會, 45–52. Beijing 北京: Wenwu chubanshe 文物出版社, 1987.

Chen Bingying 陳炳應. "Bei-Wei Cao Tianhu zao fangshita 北魏曹天護造方石塔" (Square stone pagoda dedicated by Cao Tianhu of the Northern Wei). *Wenwu* 文物 1988, 3: 83–85, 93.

Chen Mengjia 陳夢家. "Han jian nianli biaoxu 漢簡年曆表敘" (Overview of the calendar system observed on Han bamboo and wooden slips). *Kaogu xuebao* 考古學報 1965, 2: 103–49.

Chen Shou 陳壽. *Sanguozhi* 三國志 (Record of the Three Kingdoms). Beijing 北京: Zhonghua shuju 中華書局, 1959.

Chen Wanli 陳万里. *Zhongguo qingci shilüe* 中國青瓷史略 (Historical outline of Chinese greenware). Shanghai 上海: Shanghai renmin chubanshe 上海人民出版社, 1957.

Chen Zhejing 陳哲敬, Wen Yucheng 溫玉成, and Wang Zhenguo 王振國. *Longmen liusan diaoxiang ji* 龍門流散雕像集 (A collection of dispersed sculpture from the Longmen Caves). Shanghai 上海: Shanghai renmin meishu chubanshe 上海人民美術出版社, 1993.

Cheng Xinren 程欣人. "Woguo xiancun gudai fojiao zhong zuizao de yizun zaoxiang 我國現存古代佛教最早的一尊造像" (The earliest Buddhist image extant in our country to date). *Xiandai foxue* 現代佛學 1964, 11–12.

———. "Wuhan chutu de liangkuai Dong-Wu qianquan shiwen 武漢出土的兩塊東吳鉛券釋文" (Two Eastern Wu dynasty inscribed lead title deeds excavated at Wuhan). *Kaogu* 考古 1965, 10: 529–30.

Chengdu shi wenwu kaogu gongzuodui 成都市文物考古工作隊 and Chengdu shi wenwu kaogu yanjiusuo 成都市文物考古研究所. "Chengdu shi Xi'an lu Nanchao shike zaoxiang qingli jianbao 成都市西安路南朝石刻造像清理簡報" (Report and inventory of the Southern dynasties stone images from Xi'an Road, Chengdu). *Wenwu* 文物 1998, 11: 4–20.

Chengdu shi wenwu kaogu gongzuodui 成都市文物考古工作隊 and Qingbaijiang qu wenwu guanlisuo 青白江區文物管理所. "Chengdu shi Qingbaijiang qu Yuejin cun Han mu fajue jianbao 成都市青白江區躍進村漢墓發掘簡報" (Report on the excavation of Han dynasty tombs at Yuejin village, Qingbaijiang district, Chengdu city). *Wenwu* 文物 1999, 8: 19–37.

Dai Chunyang 戴春陽 and Gansu sheng wenwu kaogu yanjiusuo 甘肅省文物考古研究所, ed. *Dunhuang Foyemiaowan Xi-Jin huaxiangzhuan mu* 敦煌佛爺廟灣西晉畫像磚墓 (Western Jin pictorial brick tombs at Foyemiaowan, Dunhuang). Beijing 北京: Wenwu chubanshe 文物出版社, 1998.

Dai Chunyang 戴春陽, Zhang Long 張瓏, and Gansu sheng wenwu kaogu yanjiusuo 甘肅省文物考古研究所. *Dunhuang Qijiawan, Xi-Jin Shiliuguo muzang fajue baogao* 敦煌祁家灣西晉十六國墓葬發掘報告 (Dunhuang Qijiawan, Report on the excavation of the tombs of the Western Jin dynasty and Sixteen Kingdoms period). Beijing 北京: Wenwu chubanshe 文物出版社, 1994.

Dong Zuobin 董作賓. *Zhongguo nianli zongpu* 中國年曆總譜 (Chronological tables of Chinese history). Xianggang 香港: Xianggang daxue chubanshe 香港大學出版社, 1960.

Dunhuang wenwu yanjiusuo kaoguzu 敦煌文物研究所考古組. "Dunhuang Jin mu 敦煌晉墓" (Jin tombs at Dunhuang). *Kaogu* 考古 1974, 3: 191–99.

Dunhuang yanjiuyuan 敦煌研究院. *Dunhuang* 敦煌. Nanjing 南京; Lanzhou 蘭州: Jiangsu meishu chubanshe 江蘇美術出版社; Gansu renmin chubanshe 甘肅人民出版社, 1990.

———, ed. *Dunhuang Mogaoku gongyangren tiji* 敦煌莫高窟供養人題記 (Dunhuang Mogao grotto donor inscriptions). Beijing 北京: Wenwu chubanshe 文物出版社, 1986.

Echeng xian bowuguan 鄂城縣博物館. "Echeng Dong-Wu Sun jiangjun mu 鄂城東吳孫將軍墓" (Tomb of a General Sun of the Eastern Wu at Echeng). *Kaogu* 考古 1978, 3: 164–67, 163.

———. "Hubei Echeng sizuo Wu mu fajue baogao 湖北鄂城四座吳墓發掘報告" (Report on the excavation of four Wu tombs at Echeng, Hubei). *Kaogu* 考古 1982, 3: 257–69.

Enoki Kazuo 榎一雄. "Kan Gi jidai no Tonkō 漢魏時代の敦煌" (Dunhuang in the Han and Wei periods). In *Tonkō no rekishi* 敦煌の歴史, ed. Enoki Kazuo 榎一雄, 1–37. Tokyo 東京: Daitō shuppansha 大東出版社, 1980.

Ezhou bowuguan 鄂州博物館 and Hubei sheng wenwu kaogu yanjiusuo 湖北省文物考古研究所. "Hubei Ezhou Egang yinliaochang yi hao mu fajue baogao 湖北鄂州鄂鋼飲料廠一號墓發掘報告" (Report on the excavation of tomb no. 1 in the drink factory of the Ezhou municipal steel mill). *Kaogu xuebao* 考古學報 1998, 1: 103–32.

Ezhou shi bowuguan 鄂州市博物館. "Hubei Echeng Wu Jin mu fajue baogao 湖北鄂城吳晉墓發掘報告" (Report on the exca-

vation of Wu and Jin tombs at Echeng, Hubei). *Kaogu* 考古 1991, 7: 608–13.

Fan Ye 范曄. *Hou Hanshu* 後漢書 (History of the Later Han). Beijing 北京: Zhonghua shuju 中華書局, 1965.

Fang Xuanling 房玄齡. *Jinshu* 晉書 (History of the Jin). Beijing 北京: Zhonghua shuju 中華書局, 1974.

Feng Xianming 馮先銘 and Zhongguo guisuan yanxuehui 中國硅酸鹽學會, eds. *Zhongguo taoci shi* 中國陶瓷史 (History of Chinese ceramics). Beijing 北京: Wenwu chubanshe 文物出版社, 1982.

Fu Juyou 傅舉有. *Mawangdui Han mu wenwu* 馬王堆漢墓文物 (Han tomb cultural relics from Mawangdui). Changsha 長沙: Hunan chubanshe 湖南出版社, 1992.

Gan Bao 干寶. *Soushenji* 搜神記 (In search of the supernatural, the written record). Beijing 北京: Zhonghua shuju 中華書局, 1979.

Gansu sheng bowuguan 甘肅省博物館. "Wuwei Mojuzi sanzuo Han mu fajue jianbao 武威磨咀子三座漢墓發掘簡報" (Report on the excavation of three Han dynasty tombs from Mojuzi, Wuwei). *Wenwu* 文物 1972, 12: 9–21.

Gansu sheng Dunhuang xian bowuguan 甘肅省敦煌縣博物館. "Dunhuang Foyemiaowan Wu-Liang shiqi muzang fajue jianbao 敦煌佛爺廟灣五涼時期墓葬發掘簡報" (Report on the excavation of Five Liang period tomb groups at Foyemiaowan, Dunhuang). *Wenwu* 文物 1983, 10: 51–60.

Gansu sheng wenwu guanli weiyuanhui 甘肅省文物管理委員會. "Lanxin tielu Wuwei—Yongchang yanxian gongdi gumu qingli gaikuang 蘭新鐵路武威——永昌沿線工地古墓清理概況" (General survey of the ancient tombs at the Yongchang Yanxian construction site, on the new Lanzhou to Wuwei railway). *Wenwu cankao ziliao* 文物參考資料 1956, 6: 39–44.

Gansu sheng wenwu kaogu yanjiusuo 甘肅省文物考古研究所. "Gansu Jiuquan Xigoucun Wei Jin mu fajue baogao 甘肅酒泉西溝村魏晉墓發掘報告" (Report on the excavation of the Wei and Jin tombs at Xigou, Jiuquan, Gansu). *Wenwu* 文物 1996, 7: 4–38.

———, ed. *Jiuquan shiliuguo mu bihua* 酒泉十六國墓壁畫 (Wall painting of the Sixteen Kingdoms tomb at Jiuquan) Beijing 北京: Wenwu chubanshe 文物出版社, 1989.

Gansu sheng wenwudui 甘肅省文物隊, Gansu sheng bowuguan 甘肅省博物館, and Jiayuguan shi wenwu guanlisuo 嘉峪關市文物管理所. *Jiayuguan bihuamu fajue baogao* 嘉峪關壁畫墓發掘報告 (Report on the excavation of the Jiayuguan wall painting tombs). Beijing 北京: Wenwu chubanshe 文物出版社, 1985.

Gao Dalun 高大論. "Guanyu 'Nanfang sichou zhi lu' de jidian sikao 關於 '南方絲綢之路' 的幾點思考" (Some reflections on the southern Silk Road). *Zhongguoshi yanjiu* 中國史研究 1995, 2: 131–38.

Gong Dazhong 宮大中. *Longmen shiku yishu* 龍門石窟藝術 (Art of the Longmen Caves). Shanghai 上海: Shanghai renmin chubanshe 上海人民出版社, 1981.

Gu Xuejia 顧學稼. "Nanfang sichou zhi lu zhiyi 南方絲綢之路質疑" (Questioning the validity of the Silk Road in South China). *Shixue yuekan* 史學月刊 1993, 3: 27–30.

Gu Zhengmei 古正美. *Guishuang fojiao zhengzhi chuantong yu dasheng fojiao* 貴霜佛教政治傳統與大乘佛教 (Kushan Buddhist political tradition and Mahayana Buddhism). Taibei 臺北: Yunchen wenhua shiye gufen youxian gongsi 允晨文化實業股份有限公司, 1993.

———. "Zaitan Su Bai de Liangzhou moshi 再談宿白的涼州模式" (Another discussion of Su Bai's Liangzhou style). In *Dunhuang shiku yanjiu guoji taolunhui wenji, shiku kaogu bian* 敦煌石窟研究國際討論會文集, 石窟考古編 (Collected works from the international conference on Dunhuang cave research, cave archaeology volume), ed. Duan Wenjie 段文杰, 85–122. Shenyang 沈陽: Liaoning meishu chubanshe 遼寧美術出版社, 1990.

Guizhou sheng bowuguan 貴州省博物館. "Guizhou Qingzhen Pingba Han mu fajue baogao 貴州清鎮平壩漢墓發掘報告" (Report on the excavation of a Han tomb at Pingba, Qingzhen, Guizhou). *Kaogu xuebao* 考古學報 1959, 1: 85–103.

Hamasaki Michiko 濱崎道子. "Sensei-shō Yō-ken Yakusan Yō-ken hirin 陝西省耀縣藥王山耀縣碑林" (Shaanxi Yaoxian Yaowangshan Yaoxian forest of stele). *Sumi* 墨 86 (September/October 1990): 98–112.

Han Wei 韓偉 and Yin Zhiyi 陰志毅. "Yaoxian Yaowangshan de daojiao zaoxiangbei 耀縣藥王山的道教造像碑" (Daoist stele from Yaoxian Yaowangshan). *Kaogu yu wenwu* 考古與文物 1987, 3: 18–26.

———. "Yaoxian Yaowangshan fojiao zaoxiangbei 耀縣藥王山佛教造像碑" (Buddhist stele from Yaoxian Yaowangshan). *Kaogu yu wenwu* 考古與文物 1996, 2: 13–21.

Han Youfu 韓有富. "Bei-Wei Cao Tiandu zao qianfo shita tasha 北魏曹天度造千佛石塔塔剎" (Finial of the Thousand Buddha stone pagoda dedicated by Cao Tiandu of the Northern Wei). *Wenwu* 文物 1980, 7: 65.

Hanzhong shi bowuguan 漢中市博物館 and He Xincheng 何新成. "Shaanxi Hanzhong shi Puzhen zhuanchang Han mu qingli jianbao 陝西漢中市鋪鎮磚廠漢墓清理簡報" (Inventory report on the Han tombs at the Puzhen brick factory, Hanzhong city, Shaanxi). *Kaogu yu wenwu* 考古與文物 1989, 6: 35–46, 77.

Harada Yoshito 原田淑人. *Lo-lang* 樂浪. Tokyo 東京: The Tōkō-shoin 刀江書院, 1930.

Hayashi Minao 林巳奈夫. "Jūkan hoshu no jakkan o megutte 獸鐶鋪首の若干をめぐって" (Demon mask with ring from Eastern Zhou to Tang Period). *Tōhō gakuhō* 東方学報 57 (March 1985): 1–74.

He Changqun 賀昌群. *Han-Tang jian fengjian tudi suoyouzhi xingshi*

yanjiu 漢唐間封建土地所有制形式研究 (Research on the forms taken by feudal land tenure systems from Han to Tang times). Shanghai 上海: Shanghai renmin chubanshe 上海人民出版社, 1964.

He Jiying 何繼英. "Xifang yishu dui Wei Jin Nanbeichao Sui Tang taociqi de yingxiang 西方藝術對魏晉南北朝隋唐陶瓷的影響" (Western artistic impact on the ceramics of the Wei, Jin, Northern-Southern, Sui and Tang dynasties). *Shanghai bowuguan jikan* 上海博物館集刊 7 (1996): 158–74.

He Shizhe 賀世哲. "Cong gongyangren tiji kan Mogaoku bufen tongku de yingjian niandai 從供養人題記看莫高窟部分洞窟的營建年代" (Examining the construction dates of the Mogao Grottoes from donor inscriptions). In *Dunhuang Mogaoku gongyangren tiji* 敦煌莫高窟供養人題記, ed. Dunhuang yanjiuyuan 敦煌研究院, 194–236. Beijing 北京: Wenwu chubanshe 文物出版社, 1986.

He Xilin 賀西林. "Dong-Han qianshu de tuxiang ji yiyi 東漢錢樹的圖像及意義" (The imagery and meaning of Eastern Han money trees). *Gugong bowuyuan yuankan* 故宮博物院院刊 1998, 3: 20–31.

He Yun'ao 賀雲翱, ed. *Fojiao chuchuan nanfang zhi lu* 佛教初傳南方之路. (The southern route of the early Buddhist tradition). Beijing 北京: Wenwu chubanshe 文物出版社, 1993.

He Zhiguo 何志國. "Sichuan Mianyang Hebian Dong-Han yamu 四川綿陽河邊東漢崖墓" (Eastern Han cliff tombs at Hebian, Mianyang, Sichuan). *Kaogu* 考古 1988, 3: 219–26, 233.

———. "'Zaoqi fojiao zaoxiang nanchuan xitong Zhong-Ri xueshu yantaohui' shuping '早期佛教造像南傳系統中日學術研討會' 述評" (Review of the "Joint Chinese-Japanese scholarly research conference on the southern system of early Buddhist imagery"). *Dongnan wenhua* 東南文化 1991, 6: 61–66.

———. "Zhongguo zuida de yaoqianshu ji qi neihan 中國最大的搖錢樹及其內涵" (Largest money tree in China and its significance). *Wenwu tiandi* 文物天地 1998, 2: 45–48.

Henan sheng wenhuaju wenwu gongzuodui 河南省文化局文物工作隊, *Dengxian caise huaxiangzhuan mu* 鄧縣彩色畫像磚墓 (Tomb with painted bricks at Dengxian). Beijing 北京: Wenwu chubanshe 文物出版社, 1958.

Higashiyama Kengo 東山健吾. "Ōbei Nihon e ryūshutsu shita Ryūmon sekkutsu no sekicho sonzō 欧米・日本へ流出した龍門石窟の石彫尊像" (Stone sacred images from the Longmen Caves that flowed to Europe, the United States, and Japan). In *Ryūmon sekkutsu* 龍門石窟, ed. Ryūmon bunbutsu hokanjo 龍門文物保管所 and Peking daigaku kōkokei 北京大学考古系, 2: 263–69. Tokyo 東京: Heibonsha 平凡社, 198m7.

Hou Can 侯燦 "Xi-Jin zhi beichao qianqi Gaochang diqu fengxing nianhao zhi tantao 西晉至北朝前期高昌地區奉行年號之探討" (Notes on the regnal titles employed in the Gaochang area before and during the Western Jin to Northern dynasties periods). *Kaogu yu wenwu* 考古與文物 1982, 2: 92–102, 75.

Hou Xudong 侯旭東. *Wu, liu shiji beifang minzhong fojiao xinyang* 五、六世紀北方民眾佛教信仰 (Common people's Buddhist beliefs in northern China during the fifth and sixth centuries). Beijing 北京: Zhongguo shehui kexue chubanshe 中國社會科學出版社, 1998.

Hua Guorong 華國榮. "Jiangsu Nanjing shi Jiangning xian Xiafang cun faxian Dong-Wu qingciqi 江蘇南京市江寧縣下坊村發現東吳青瓷器" (Eastern Wu greenware discovered at Xiafang Jiangning Nanjing, Jiangsu). *Kaogu* 考古 1998, 8: 92–93.

Huang Yongchuan 黃永川 and Guoli lishi bowuguan 國立歷史博物館, ed. *Fodiao zhi mei, Beichao fojiao shidiao yishu* 佛雕之美、北朝佛教石雕藝術 (The splendour of Buddhist statuaries: Buddhist stone carvings in the Northern dynasties). Taibei 臺北: Guoli lishi bowuguan 國立歷史博物館, 1997.

Hubei sheng bowuguan 湖北省博物館 and Ezhou shi bowuguan 鄂州市博物館, ed. *Echeng Han Sanguo Liuchao tongjing* 鄂城漢三國六朝銅鏡 (Han, Three Kingdoms, and Six Dynasties bronze mirrors from Echeng). Beijing 北京: Wenwu chubanshe 文物出版社, 1986.

Hubei sheng wenwu guanli weiyuanhui 湖北省文物管理委員會. "Wuchang Lianxisi Dong-Wu mu qingli jianbao 武昌蓮溪寺東吳墓清理簡報" (Report and inventory of the Eastern Wu tomb at Lianxisi, Wuchang). *Kaogu* 考古 1959, 4: 189–90.

Hubei sheng wenwu kaogu yanjiusuo 湖北省文物考古研究所 and Ezhou shi bowuguan 鄂州市博物館. "Hubei Ezhou shi Tangjiaotou liuchao mu 湖北鄂州市塘角頭六朝墓" (Tombs of the Six Dynasties period at Tangjiaotou, Ezhou, Hubei). *Kaogu* 考古 1996, 11: 1–27.

Ikeda On 池田温. *Chūgoku kodai shahon shikigo shūroku* 中国古代写本識語集録 (Collected colophons of ancient Chinese manuscripts). Tokyo 東京: Tokyo daigaku tōyō bunka kenkyūjo 東京大学東洋文化研究所, 1990.

———. "Chūgoku rekidai boken ryakkō 中国歴代墓券略考" (A brief study of Chinese tomb documents of the past dynasties). *Tōyō bunka kenkyūjo kiyō* 東洋文化研究所紀要 86 (1981): 193–278.

———. "Tonkō Han shi kaden zankan ni tsuite 敦煌氾氏家伝残巻について" (On an inherited family history of the Fan lineage of Dunhuang). *Tōhōgaku* 東方学 24 (1962): 14–29.

Irisawa Takashi 入澤崇. "Yōsenju butsuzō kō 搖銭樹仏像考" (A consideration of Buddha images on a bronze "money tree"). *Mikkyō zuzō* 密教圖像 12 (December 1993): 44–60.

———. "Butsu to rei, Kōnan shutsudo busshoku konbin kō 仏と霊、江南出土仏師魂瓶考" (Buddhas and spirits, a study of soul vases decorated with Buddha images from Jiangnan). *Ryūkoku daigaku ronshū* 龍谷大学論叢 444 (1994): 233–71.

Ishimatsu Hinako 石松日奈子. "'Gibunrō zōzōhi' no nendai ni tsuite 魏文朗造像碑の年代について" (Regarding the date of

the Wei Wenlang stele). *Bukkyō geijutsu* 仏教藝術 240 (September 1998): 13–32.

———. "Hokugi Kanan no ikkō sansonzō 北魏河南の一光三尊像" (A study of Buddhist trinities of the Henan area in the Northern Wei period). *Tōhō gakuhō* 東方学報 69 (March 1997): 247–86.

———. "Ryūmon Koyōdō shoki zōzō ni okeru chūgokuka no mondai 龍門古陽洞初期造像における中国化の問題" (Questions related to the sinicization of sculpture in the Longmen Guyang Cave in the early period). *Bukkyō geijutsu* 仏教藝術 184 (May 1989): 49–69.

———. "Ryūmon sekkutsu Koyōdō zōzō kō 龍門石窟古陽洞造像考" (Sculpture in the Longmen Guyang Cave). *Bukkyō geijutsu* 仏教藝術 248 (January 2000): 13–51.

Jiang Renhe 蔣人和. "Zaoqi foxiang huoyan shiwen shenguang zhi yanbian ji Guyang dong qiyuan de yixie tanxiang 早期佛像火焰式紋身光之演變及古陽洞起源的一些探想" (Some thoughts on the origin of the Guyang Cave and the evolution of flame patterns in early Buddhist mandorlas). In *Longmen shiku yiqian wubai zhounian guoji xueshu taolunhui lunwenji* 龍門石窟一千五百周年國際學朮討論會論文集 (Collected works from the 1500th year anniversary international scholarly conference on the Longmen Caves), ed. Longmen shiku yanjiusuo 龍門石窟研究所, 220–51. Beijing 北京: Wenwu chubanshe 文物出版社, 1996.

Jiang Xuanyi 蔣玄佁 and Qin Tingyu 秦廷棫. *Zhongguo ciqi de faming* (The invention of porcelain in China) 中國瓷器的發明. Shanghai 上海: Yiyuan zhenshangshe 藝苑眞賞社, 1956.

Jiang Yuxiang 江玉祥. "Shilun zaoqi daojiao zai Ba-Shu fasheng de wenhua beijing 試論早期道教在巴蜀發生的文化背景" (A preliminary discussion of the cultural background to the occurrence of early Daoism in Ba-Shu). In *Daojia wenhua yanjiu* 道家文化研究, ed. Chen Guying 陳鼓應, Shanghai 上海: Shanghai guji chubanshe 上海古籍出版社, 1995, 7: 323–37.

Jiangsu sheng wenwu guanli weiyuanhui 江蘇省文物管理委員會. "Nanjing jinjiao liuchaomu de qingli 南京近郊六朝墓的清理" (Inventory of the Six Dynasties tombs in the suburbs of Nanjing). *Kaogu xuebao* 考古學報 1957, 1: 187–91.

Jiayuguan shi wenwu guanlisuo 嘉峪關市文物管理所. "Jiayuguan xincheng shi'er, shisan hao huaxiang zhuanmu fajue jianbao 嘉峪關新城十二, 十三號畫像磚墓發掘簡報" (Report on the excavation of pictorial brick tombs numbers 12 and 13 at Xincheng, Jiayuguan). *Wenwu* 文物 1982, 8: 7–15.

Jin Qi 金琦. "Nanjing Ganjiaxiang he Tongjiashan liuchao mu 南京甘家巷和童家山六朝墓" (Six Dynasties tombs at Ganjiaxiang and Tongjiashan, Nanjing). *Kaogu* 考古 1963, 6: 303–307, 318.

Jin Sha 金沙. "Sichuan Yibin chutu Xiwangmu taoyong 四川宜賓出土西王母陶俑" (Pottery tomb-figure of Xiwangmu excavated from Yibin, Sichuan). *Wenwu* 文物 1981, 9: 43.

Jin Shen 金申. "Guanyu shenwang de tantao 關於神王的探討" (Inquiry regarding spirit kings). *Dunhuangxue jikan* 敦煌學集刊 1995, 1: 55–62.

———. *Zhongguo lidai jinian fojiao tudian* 中國歷代紀年佛教圖典 (Illustrated dictionary of dated Chinese Buddhist images). Beijing 北京: Wenwu chubanshe 文物出版社, 1994.

Jin Weinuo 金維諾. *Zhongguo zongjiao meishu shi* 中國宗教美術史 (China's religious fine arts history). Nanchang 南昌: Jiangxi meishu chubanshe 江西美術出版社, 1995.

Jinhua diqu wenguanhui 金華地區文管會 and Wuyi xian wenguanhui 武義縣文管會. "Zhejiang Wuyi taoqichang Sanguo mu 浙江武義陶器廠三國墓" (Three Kingdoms tomb at the Wuyi pottery factory, Zhejiang). *Kaogu* 考古 1981, 4: 376–79.

Jue Ming 覺明. "Ji Dunhuang chu liuchao Poluomizi yinyuanjing jingchuang canshi 記敦煌出六朝婆羅謎字因緣經經幢殘石" (A Brāhmī inscription of the Pratītyasamutpādasūtra on a fragmentary Dhvaja-pillar at Tun-huang). *Xiandai foxue* 現代佛學 1963, 8–12, 42–43.

Kamitsuka Yoshiko 神塚淑子. "Nanbokuchō jidai no dōkyō zōzō 南北朝時代の道教造像" (Daoist images of the Northern-Southern dynasties). In *Chūgoku chūsei no bunbutsu* 中国中世の文物, ed. Tonami Mamoru 礪波護, 225–89. Kyoto 京都: Kyoto daigaku jinbun kagaku kenkyūjo 京都大学人文科学研究所, 1993.

Kang Liushuo 康柳碩. "Beichao sichou zhi lu huobi gaishu 北朝絲綢之路貨幣概述" (Summary outline of the currency used along the Silk Road in the Northern dynasties). *Zhongguo qianbi* 中國錢幣 1998, 32–35.

Kawanishi Hiroyuki 川西宏幸. "Sankakubuchi butsujūkyō 三角緣仏獸鏡" (Triangular rimmed Buddha–mythical animal mirrors). *Kōkogaku foramu* 考古学フォーラム 5 (September 1994): 1–20.

Kominami Ichirō 小南一郎. "Shinteiko to Tōgo no bunka 神亭壺と東呉の文化" (Spirit bottles and Eastern Wu culture). *Tōhō gakuhō* 東方学報 65 (1993): 223–312.

Kong Xiangxing 孔祥星. *Zhongguo tongjing tudian* 中國銅鏡圖典 (Illustrated dictionary of Chinese bronze mirrors). Beijing 北京: Wenwu chubanshe 文物出版社, 1992.

Kuno Miki 久野美樹. "Hokuryō-tō kidan no sonzō ni tsuite 北涼塔基壇の尊像について" (Regarding the images on the base of the Northern Liang stupa). In *Uehara Kazu hakushi koki kinen bijutsushi ronshū* 上原和博士古稀記念美術史論集 (Festschrift for Professor Uehara Kazu's Seventieth Birthday), ed. Uehara Kazu hakushi koki kinen bijutsushi ronshū kankōkai, 263–95. Tokyo 東京: Uehara Kazu hakushi koki kinen bijutsushi ronshū kankōkai 上原和博士古稀記念美術史論集刊行会, 1995.

Kurita Isao 栗田功, ed. *Gandara bijutsu* ガンダーラ美術 (Art of Gandhara). 2 vols. Tokyo 東京: Nigensha 二玄社, 1988.

Leshan shi wenhuaju 樂山市文化局. "Sichuan Leshan Mahao

yihao yamu 四川樂山麻浩一號崖墓 (Mahao Tomb 1, Leshan, Sichuan). *Kaogu* 考古 1990, 2: 111–15, 122.

Leshan shi yamu bowuguan 樂山市崖墓博物館. "Sichuan Leshan shi Tuogouzui Dong-Han yamu qingli jianbao 四川樂山市沱溝嘴東漢崖墓清理簡報" (Report and inventory on the cliff tomb of the Eastern Han dynasty at Tuogouzui, Leshan City, Sichuan). *Wenwu* 文物 1993, 1: 40–50, 16.

Li Song 李淞. "Bei-Wei Wei Wenlang zaoxiangbei kaobu 北魏魏文朗造像碑考補" (Supplementary study of the Northern Wei Wei Wenlang stele). *Wenbo* 文博 1994, 1: 52–57, 108.

———. "Shaanxi beichao daojiao diaoke 陝西北朝道教雕刻" (Northern dynasty Daoist statues in Shaanxi). *Yishuxue* 藝術學 6 (September 1991): 7–32.

Li Yukun 李玉昆. "Longmen beike de yanjiu 龍門碑刻的研究" (Research on Longmen stele inscriptions). *Zhongyuan wenwu* 中原文物 1985 (special issue): 173–89.

Li Yumin 李玉珉. "Hebei zaoqi de fojiao zaoxiang, shiliuguo he Bei-Wei shiqi 河北早期的佛教造像，十六國和北魏時期" (Buddhist images of the early period in Hebei: Sixteen Kingdoms and Northern Wei periods). *Gugong xueshu jikan* 故宮學術季刊 11, 4 (Summer 1994): 1–80.

Li Yuzheng 李域錚, Zhao Minsheng 趙敏生, and Lei Bing 雷冰. *Xi'an beilin shufa yishu* 西安碑林書法藝術 (Calligraphic arts of the Xi'an forest of stele). Xi'an 西安: Shaanxi renmin meishu chubanshe 陝西人民美術出版社, 1992.

Lianyungang shi bowuguan 連雲港市博物館. "Lianyungang Kongwangshan moya zaoxiang diaocha baogao 連雲港孔望山摩崖造像調查報告" (Report on the investigation of the cliff images at Lianyungang, Kongwangshan). *Wenwu* 文物 1981, 7: 1–7.

Lintong xian bowuguan 臨潼縣博物館 and Zhao Kangmin 趙康民. "Shaanxi Lintong de beichao zaoxiangbei 陝西臨潼的北朝造像碑" (Northern dynasty image stele from Lintong, Shaanxi). *Wenwu* 文物 1985, 4: 15–26.

Liu Dunzhen 劉敦楨. *Zhongguo gudai jianzhu shi* 中國古代建築史 (History of the ancient architecture of China). Beijing 北京: Zhongguo jianzhu gongye chubanshe 中國建築工業出版社, 1980.

Liu Haichao 劉海超. "Fuyang bowuguan cangpin jianjie 阜陽博物館藏品簡介" (Brief introduction to the collection of the Fuyang Museum). *Wenwu tiandi* 文物天地 2000, 1: 32–36.

Liu Jinglong 劉景龍. *Longmen ershipin* 龍門二十品 (Twenty Longmen works). Beijing 北京: Zhongguo shijieyu chubanshe 中國世界語出版社, 1995.

———. *Ryūmon nijuppin* 龍門二十品 (Twenty Longmen works). Tokyo 東京: Chūkyō shuppan 中教出版, 1997.

Liu Jinglong 劉景龍 and Li Yukun 李玉昆, eds. *Longmen shiku beike tiji* 龍門石窟碑刻題記. (Record of stele inscriptions from the Longmen Caves). 2 vols. Beijing 北京: Zhongguo dabai kequanshu chubanshe 中國大百科全書出版社, 1998.

Liu Panxiu 劉磐修. "Wei Jin Nanbeicho shehui shangceng chengzuo niuche fengsu shulun 魏晉南北朝社會上層乘坐牛車風俗述論" (A discussion of the fashion for riding in ox-drawn carriages among the upper classes in the Wei-Jin and Southern and Northern dynasties). *Zhongguo dianji yu wenhua* 中國典籍與文化 1998, 4: 96–101.

Liu Shixu 劉世旭. "Sichuan Xichang Gaocao chutu Han dai 'yao qian shu' canpian 四川西昌高草出土漢代'搖錢樹'殘片" (Fragment of a Han dynasty "money tree" discovered at Gaocao, Xichang, Sichuan). *Kaogu* 考古 1987, 3: 279–80.

Liu Shufen 劉淑芬. "Cong minzushi de jiaodu kan Taiwu miefo 從民族史的角度看太武滅佛" (Considering the suppression of Buddhism by Taiwu from the perspective of the history of ethnic minorities). *Zhongyang yanjiuyuan lishi yuyan yanjiusuo jikan* 中央研究院歷史語言研究所集刊 72, 1 (2001): 1–48.

———. "*Foding zunsheng tuoluoni jing* yu Tang dai zunsheng jingchuang de jianli 《佛頂尊勝陀羅尼經》 與唐代尊勝經幢的建立" (Dhāraṇī Sutra and the growth of Dhāraṇī pillars in T'ang China). *Zhongyang yanjiuyuan lishi yuyan yanjiusuo jikan* 中央研究院歷史語言研究所集刊 67, 1 (1996): 145–93.

———. "San zhi liu shiji Zhedong diqu jingji de fazhan 三至六世紀浙東地區經濟的發展" (The economic development of the Zhe-Dong area from the third to the sixth centuries). *Zhongyang yanjiuyuan lishi yuyan yanjiusuo jikan* 中央研究院歷史語言研究所集刊 58, 3 (1987): 485–524.

———. "Wu zhi liu shiji huabei xiangcun de fojiao xinyang 五至六世紀華北鄉村的佛教信仰" (Buddhist practice in rural north China during the fifth and sixth centuries). *Zhongyang yanjiuyuan lishi yuyan yanjiusuo jikan* 中央研究院歷史語言研究所集刊 63, 3 (1993): 497–544.

Liu Zhaorui 劉昭瑞. "Bei-Wei Yao Boduo daojiao zaoxiangbei kaolun 北魏姚伯多道教造像碑考論" (Discussion of the Northern Wei Daoist stele of Yao Boduo). In *Daojia wenhua yanjiu* 道家文化研究, ed. Chen Guying 陳鼓應, 9: 302–18. Shanghai 上海: Shanghai guji chubanshe 上海古籍出版社, 1996.

Longmen wenwu baoguansuo 龍門文物保管所. *Longmen shiku* 龍門石窟 (Longmen Caves). Beijing 北京: Wenwu chubanshe 文物出版社, 1981.

Longmen wenwu baoguansuo 龍門文物保管所 and Beijing daxue kaoguxi 北京大學考古系, eds. *Longmen shiku* 龍門石窟 (Longmen Caves). 2 vols. Zhongguo shiku 中國石窟, Beijing 北京: Wenwu chubanshe 文物出版社, 1991.

Lu Weiting 陸蔚庭. "Longmen zaoxiang mulu 龍門造像目錄" (Catalog of Longmen images). *Wenwu* 文物 1961, 4–5: 88–108.

Luo Erhu 羅二虎. "Han dai huaxiang shiguan yanjiu 漢代畫像石棺研究" (A study of Han period pictorial stone coffins). *Kaogu xuebao* 考古學報 2000, 1: 31–62.

———. "Shaanxi Chenggu chutu de qianshu foxiang jiqi yu Sichuan diqu de guanxi 陝西城固出土的錢樹佛像及其與四

川地區的關係" (A money tree Buddha image excavated at Chenggu Shaanxi and its relationship to those of the Sichuan region). *Wenwu* 文物 1998, 12: 63–70.

———. "Sichuan yamu de chubu yanjiu 四川崖墓的初步研究" (A preliminary study of the cliff tombs in Sichuan and adjacent areas). *Kaogu xuebao* 考古學報 1988, 2: 133–67.

Luo Shiping 羅世平. "Sichuan Nanchao fojiao zaoxiang de chubu yanjiu 四川南朝佛教造像的初步研究" (Preliminary study of Buddhist images of the Southern dynasties in Sichuan). In *Han Tang zhi jian de zongjiao yishu yu kaogu* 漢唐之間的宗教藝術與考古 (Religious art and archaeology of the Han to Tang period), ed. Wu Hong 巫鴻, 397–428. Beijing 北京: Wenwu chubanshe 文物出版社, 2000.

Luo Zongzhen 羅宗眞. "Jiangsu Yixing Jin mu fajue baogao 江蘇宜興晉墓發掘報告" (Report on the excavation of Jin tombs at Yixing, Jiangsu). *Kaogu xuebao* 考古學報 1957, 4: 83–106.

Ma Changshou 馬長壽. *Beiming suojian Qian-Qin zhi Sui chu de Guanzhong buzu* 北銘所見前秦至隋初的關中部族 (Clans of the central plains from the Qin to the Sui periods as seen in northern inscriptions). Beijing 北京: Zhonghua shu 中華書局, 1985.

Machida Ryūkichi 町田隆吉. "Tonkō shutsudo shi, go seiki tōkan tō meibun ni tsuite 敦煌出土四・五世紀陶罐等銘文について" (Regarding the inscriptions on the fourth and fifth century bottles excavated at Dunhuang). *Kenkyū kiyō, Tokyo gakugeidai fukō, Ōizumi kōsha* 研究記要, 東京学芸大附高, 大泉校舎 10 (1986): 101–18.

Matsubara Saburō 松原三郎. *Chūgoku bukkyō chōkokushi kenkyū* 中国仏教彫刻史研究 (Research on Chinese Buddhist sculpture). Tokyo 東京: Yoshikawa kōbunkan 吉川弘文館, 1966.

———. *Chūgoku bukkyō chōkokushi ron* 中国仏教彫刻史論 (Historical discussion of Chinese Buddhist sculpture). Tokyo 東京: Yoshikawa kōbunkan 吉川弘文館, 1995.

Mianyang bowuguan 綿陽博物館 and He Zhiguo 何志國. "Sichuan Mianyang Hejiashan yihao Dong-Han yamu qingli jianbao 四川綿陽何家山一號東漢崖墓清理簡報" (Report and inventory of the Eastern Han cliff tomb Hejiashan No. 1, Mianyang, Sichuan). *Wenwu* 文物 1991: 3: 1–8.

———. "Sichuan Mianyang Hejiashan erhao Dong-Han yamu qingli jianbao 四川綿陽何家山二號東漢崖墓清理簡報" (Brief report and inventory of the Eastern Han cliff tomb Hejiashan No. 2, Mianyang, Sichuan). *Wenwu* 文物 1991: 3: 9–19.

Mizuno Seiichi 水野清一. *Chūgoku no chōkoko: sekibutsu, kondōbutsu* 中国の彫刻: 石仏, 金銅仏 (Bronze and stone Buddhist sculpture of China). Tokyo 東京: Nihon keizai shinbunsha 日本経済新聞社, 1960.

Mizuno Seiichi 水野清一 and Nagahiro Toshio 長廣敏雄. *Kanan Rakuyō Ryūmon sekkutsu no kenkyū* 河南洛陽龍門石窟の研究 (Research on the Longmen Caves, Luoyang, Henan). Tokyo 東京: Zauhō kankōkai 座右宝刊行会, 1941.

Nakamura Keiji 中村圭爾. "Kōnan rikuchōbo shutsudo tōji no

ichikōsatsu 江南六朝墓出土陶瓷の一考察" (An inquiry into ceramics excavated from Six Dynasties tombs in Jiangnan). In *Chūgoku chūsei no bunbutsu* 中国中世の文物 (Culture of the Chinese middle-ages), ed. Tonami Mamoru 礪波護, 83–135. Kyoto 京都: Kyoto daigaku jinbun kagaku kenkyūjo 京都大学人文科学研究所, 1993.

Nan Bo 南波. "Nanjing Xigang Xi-Jin mu 南京西崗西晉墓" (Western Jin tomb at Xigang, Nanjing). *Wenwu* 文物 1976, 3: 55–60.

Nanjing bowuyuan 南京博物院. "Jiangsu Jiangning xian Zhangjiashan Xi-Jin mu 江蘇江寧縣張家山西晉墓" (Western Jin tomb at Zhangjiashan, Jiangning, Jiangsu). *Kaogu* 考古 1985, 10: 908–14.

———. *Nanjing bowuyuan zang baolu* 南京博物院藏寶錄 (Catalogue of the treasures of the Nanjing Museum). Xianggang 香港; Shanghai 上海: Sanlian shudian 三聯書店; Shanghai wenyi chubanshe 上海文藝出版社, 1992.

———. *Nanjing fujin kaogu baogao* 南京附近考古報告 (Archaeological report on the environs of Nanjing). Shanghai 上海: Shanghai chuban gongsi 上海出版公司, 1952.

———. *Sichuan Pengshan Han dai yamu* 四川彭山漢代崖墓 (Han dynasty cliff tombs at Pengshan, Sichuan). Beijing 北京: Wenwu chubanshe 文物出版社, 1991.

Nanjing shi bowuguan 南京市博物館. "Nanjing jiaoxian sizuo Wu mu fajue jianbao 南京郊縣四座吳墓發掘簡報" (Report on the excavation of four Wu Kingdom tombs from the outskirts of Nanjing). *Wenwu ziliao congkan* 文物資料叢刊 8 (1983): 1–15.

———. "Nanjing shi Yinxi cun Xi-Jin mu 南京市尹西村西晉墓" (A Western Jin tomb in Yinxi village, Nanjing). *Huaxia kaogu* 華夏考古 1998, 2: 29–34.

———. "Nanjing Shizishan, Jiangning Suoshu Xi-Jin mu 南京獅子山, 江寧索墅西晉墓" (Western Jin tombs at Nanjing Shizishan, Jiangning Suoshu). *Kaogu* 考古 1987, 7: 611–18.

Nanjing shi bowuguan 南京市博物館 and Jiangning xian bowuguan 江寧縣博物館. "Nanjing shi Dongshanqiao 'Fenghuang san nian' Dong-Wu mu 南京市東善橋 '風凰三年' 東吳墓" (Eastern Wu tomb dated "Fenghuang third year" at Dongshanqiao, Nanjing). *Wenwu* 文物 1999, 4: 32–37.

Nankin hakubutsuin 南京博物院. *Nankin hakubutsuin ten* 南京博物院展 (Exhibition from the Nanjing Museum collection). Nagoya 名古屋: Nagoya-shi hakubutsukan 名古屋市博物館, 1981.

Nara kokuritsu hakubutsukan 奈良国立博物館, ed. *Higashi Ajia no hotoketachi* 東アジアの仏たち (Buddhist images of East Asia). Nara 奈良: Nara kokuritsu hakubutsukan 奈良国立博物館, 1996.

Ni Run'an 倪潤安. "Lun liang Han siling de yuanliu 論兩漢四靈的源流" (A discussion of the origin and development of the four directional animals in the two Han dynasties). *Zhongyuan wenwu* 中原文物 1999, 1: 83–91.

Okada Ken 岡田健 and Ishimatsu Hinako 石松日奈子. "Chūgoku Nanbokuchō jidai no nyorai zō chakui no kenkyū (jō) 中国南北朝時代の如来像着衣の研究 (上)" (A study of the robes of Buddha images in the period of the Northern and Southern dynasties, part I). *Bijutsu kenkyū* 美術研究 356 (March 1993): 1–23.

Okauchi Mitsuzane 岡内三眞. "Gorenkan to sōshoku tsuki tsubo 五連罐と装飾付壺" (Five linked pots and decorated votive jars). In *Kodai tansō II, Waseda daigaku kōko gakkai sōritsu 35-shūnen kinen kōkogaku ronshū* 古代探叢 II, 早稲田大学考古学会創立 35 周年記念考古学論集, ed. Takiguchi Hiroshi 滝口宏, 669–706. Tokyo 東京: Waseda daigaku shuppanbu 早稲田大学出版部, 1985.

Okazaki Takashi 岡崎敬. "Shichū no michi to Tonkō Bakukokutsu 絲綢之路と敦煌莫高窟" (The Silk Road and the Mogao Grottoes of Dunhuang). In *Tonkō Bakukokutsu* 敦煌莫高窟, ed. Tonkō bunbutsu kenkyūjo 敦煌文物研究所, 1: 216–27. Tokyo 東京: Heibonsha 平凡社, 1980.

Ōmura Seigai 大村西崖. *Shina bijutsu shi chōso hen* 支那美樹史彫塑篇 (History of Chinese art, sculpture volume). 3 vols. Tokyo 東京: Bussho kankōkai zuzōbu 仏書刊行会図像部, 1915.

Rong Xinjiang 榮新江. "'Juqu Anzhou bei' yu Gaochang Da-Liang zhengquan 《且渠安周碑》與高昌大凉政權" (The Juqu Anzhou stele and the Great Liang regime in Gaochang). *Yanjing xuebao* 燕京學報 5 (1998): 65–92.

Ruan Rongchun 阮栄春. *Bukkyō denrai no michi: nanpō rūto* 仏教伝来の道: 南方ルート (The path of Buddhist transmission: southern route). Kyoto 京都: Yūkonsha 雄渾社, 1996.

Ryūmon bunbutsu hokanjo 龍門文物保管所 and Peking daigaku kōkokei 北京大学考古系, eds. *Ryūmon sekkutsu* 龍門石窟 (Longmen Caves). 2 volumes. Tokyo 東京: Heibonsha 平凡社, 1987–88.

Santai xian wenhuaguan 三台縣文化館. "Sichuan Santai xian faxian Dong-Han mu 四川三台縣發現東漢墓" (Eastern Han tomb discovered at Santai, Sichuan). *Kaogu* 考古 1976, 6: 395.

Satō Chisui 佐藤智水. "Goko jūroku koku kara nanbokuchō jidai 五胡十六国から南北朝時代" (From the Sixteen Kingdoms to the Northern and Southern dynasties period). In *Tonkō no rekishi* 敦煌の歴史, ed. Enoki Kazuo 榎一雄, 39–98. Tokyo 東京: Heibonsha 平凡社, 1980.

———. "Hokuchō zōzō mei kō 北朝造像銘考" (A consideration of Northern period image inscriptions). *Shigaku zasshi* 史学雑誌 86 (1977): 1–47.

———. "Senseishō Yō-ken no Hokugi zōzōhi ni tsuite 陝西省耀縣の北魏造像碑について" (Regarding the Northern Wei image stele at Yaoxian, Shaanxi province). In *Shiranshū, Yoshinami Takashi sensei taikan kinen ronshū* 芝蘭集, 好並隆司先生退官記念論集 ed. Shiranshū henshū i-inkai 芝蘭集編集委員会, 254–83. Okayama 岡山: Shiranshū henshū i-inkai 芝蘭集編集委員会, 1999.

Shaanxi sheng wenwu puchadui 陝西省文物普查隊. "Yaoxian xinfaxian de yipi zaoxiangbei 耀縣新發現的一批造像碑" (Stele newly discovered in Yaoxian). *Kaogu yu wenwu* 考古與文物 1994, 2: 45–63.

Shang Chunfang 商春芳. "Ji Luoyang chutu de Dong-Han shiqi fojiao wenwu ji qi xiangguan wenti 記洛陽出土的東漢時期佛教文物及其相關問題" (Notes on the Eastern Han Buddhist cultural relics unearthed in Luoyang and related issues). *Wenwu chunqiu* 文物春秋 1998, 71–72.

Shangyu xian wenwu guanlisuo 上虞縣文物管理所. "Zhejiang Shangyu Jiangshan Sanguo Wu mu fajue jianbao 浙江上虞江山三國吳墓發掘簡報" (Report on the excavation of a Three Kingdoms Wu tomb discovered at Jiangshan, Shangyu, Zhejiang). *Dongnan wenhua* 東南文化 1989, 2: 135–37.

Shen Zhongchang 沈仲常 and Li Xianwen 李顯文. "Dong-Han tongzhi taozuo yaoqianshu 東漢銅枝陶座搖錢樹" (Money trees with bronze branches and pottery bases of the Eastern Han period). *Renmin zhongguo* 人民中國 1980, 12: 37–38.

———. "Ji Pengshan chutu de Dong-Han tong yaoqianshu 記彭山出土的東漢銅搖錢樹" (On the Eastern Han bronze money tree excavated from Pengshan). *Chengdu wenwu* 成都文物 1986, 1: 17–19.

Shen Zuolin 沈作霖. "Zhejiang Shaoxing Fenghuangshan Xi-Jin Yongjia qinian mu 浙江紹興風凰山西晉永嘉七年墓" (Western Jin Yongjia year-seven tomb at Fenghuangshan, Shaoxing, Zhejiang). *Wenwu* 文物 1991, 6: 59–63.

Shengxian wenguanhui 嵊縣文管會. "Zhejiang Shengxian liuchaomu 浙江嵊縣六朝墓" (Six Dynasties tombs from Shengxian, Zhejiang). *Kaogu* 考古 1988, 9: 800–813.

———. "Zhejiang Shengxian Datangling Dong-Wu mu 浙江嵊縣大塘嶺東吳墓" (Tombs of the Eastern Wu State at Datangling, Sheng County, Zhejiang). *Kaogu* 考古 1991, 3: 206–16.

Shi Shuqing 史樹青. "Bei-Wei Cao Tiandu zao qianfo shita 北魏曹天度造千佛石塔" (Thousand Buddha stone pagoda dedicated by Cao Tiandu of the Northern Wei). *Wenwu* 文物 1980, 1: 68–71.

Shi Weixiang 史葦湘. "Bakukokutsu kankei nenpyō 莫高窟関係年表" (Chronology related to the Mogao Caves), in Tonkō bunbutsu kenkyūjo 敦煌文物研究所, ed. *Tonkō Bakukokutsu* 敦煌莫高窟 (Mogao Caves of Dunhuang), 1: 262–65. Tokyo 東京: Heibonsha 平凡社, 1980.

Shi Yan 史岩. "Jiuquan Wenshushan de shiku siyuan yiji 酒泉文殊山的石窟寺院遺跡" (Historical remains of the Jiuquan Wenshushan stone cave temples). *Wenwu cankao ziliao* 文物參考資料 1956, 7: 53–59.

Shi Zhangru 石璋如. "Shaanxi Yaoxian de beilin yu shiku 陝西耀縣的碑林與石窟" (Cave temples and the forest of stele at Yaoxian, Shaanxi). *Zhongyang yanjiuyuan lishi yuyan yanjiusuo jikan* 中央研究院歷史言研究所集刊 14 (1953): 145–72.

Shirasu Jōshin 白須淨真. "Zaichi gōzoku, meizoku shakai 在地

豪族, 名族社会" (Society of powerful and famous provincial families). In *Tonkō no shakai* 敦煌の社会, ed. Ikeda On 池田温, 3–49. Tokyo 東京: Daitō shuppansha 大東出版社, 1980.

Sichuan sheng bowuguan 四川省博物館. *Sichuan sheng bowuguan* 四川省博物館 (Sichuan provincial museum). Beijing 北京: Wenwu chubanshe 文物出版社, 1988.

Sichuan sheng bowuguan 四川省博物館 and Xinduxian wenguansuo 新都縣文管所. "Xinduxian Majiashan yamu fajue jianbao 新都縣馬家山崖墓發掘簡報" (Report on the excavation of cliff tombs at Xinduxian, Majiashan). *Wenwu ziliao congkan* 文物資料叢刊 9 (1985): 93–106.

Sichuan sheng bowuguan 四川省博物館 and Yibinshi wenguansuo 宜賓市文管所. "Yibinshi Shanguci Handai yamu qingli jianbao 宜賓市山谷祠漢代崖墓清理簡報" (Report and inventory of the Han dynasty cliff tombs at Yibin, Shanguci). *Wenwu ziliao congkan* 9 文物資料叢刊 (1985): 133–37.

Sichuan sheng wenwu guanli weiyuanhui 四川省文物管理委員會. "Sichuan Zhongxian Tujing Shu-Han yamu 四川忠縣涂井蜀漢崖墓" (Shu-Han cliff tombs at Tujing, Zhongxian, Sichuan). *Wenwu* 文物 1985, 7: 49–95.

Sichuan sheng wenwu guanli weiyuanhui 四川省文物管理委員會 and Baoxing xian wenhuaguan 寶興縣文化館. "Sichuan Baoxing Longdong Dong-Han muqun 四川寶興隴東東漢墓群" (A group of Eastern Han tombs at Baoxing Longdong, Sichuan). *Wenwu* 文物 1987, 10: 34–53.

Sofukawa Hiroshi 曽布川寬. "Ryūmon sekkutsu ni okeru hoku-chō zōzō no sho mondai 龍門石窟における北朝造像の諸問題" (Several issues related to Northern dynasties images from Longmen). In *Chūgoku chūsei no bunbutsu* 中国中世の文物, ed. Tonami Mamoru 礪波護, 181–223. Kyoto 京都: Kyoto daigaku jinbun kagaku kenkyūjo 京都大学人文科学研究所, 1993.

Su Bai 宿白. "Dongbei, Neimenggu diqu de Xianbei yiji 東北, 內蒙古地區的鮮卑遺跡" (Xianbei remains in northeastern China and Inner Mongolia). *Wenwu* 文物 1977, 5: 42–54.

———. "Liang Han Wei Jin Nanbeichao shiqi de Dunhuang 兩漢魏晉南北朝時期的敦煌" (Dunhuang in the Han, Wei, Jin, Northern and Southern dynasties period). In *Silu fanggu* 絲路訪古 (Visiting archaeological sites of the Silk Road), ed. Sichou zhi lu kaochadui 絲綢之路考察隊, 15–38. Lanzhou 蘭州: Gansu renmin chubanshe 甘肅人民出版社, 1983.

———. "'Mogaoku ji' ba '莫高窟記' 跋" (Postscript on the "Record of the Mogao Grottoes"). *Wenwu cankao ziliao* 文物參考資料 1955, 2: 113–119.

Sun Tongxun 孫同勛. *Tuoba shi de Han hua* 拓拔氏的漢化 (Sinicization of the Tuoba). Taibei 臺北: Guoli Taiwan daxue wen-xueyuan 國立臺灣大學文學院, 1962.

Tan Qixiang 譚其驤, ed. *Zhongguo lishi dituji* 中國歷史地圖集 (Historical atlas of China). Shanghai 上海: Ditu chubanshe 地圖出版社, 1982.

Tang Changshou 唐長壽. "Leshan Mahao, Shiziwan yamu foxiang niandai xintan 樂山麻浩, 柿子灣崖墓佛像年代新探" (New inquiry into the date of the cliff-tomb Buddha images at Leshan Mahao and Shiziwan). *Dongnan wenhua* 東南文化 1989, 2: 69–74.

Tang Jinyu 唐金裕 and Guo Qinghua 郭清華. "Shaanxi Mianxian Hongmiao Dong-Han mu qingli jianbao 陝西勉縣紅廟東漢墓清理簡報" (Report and inventory of a Eastern Han tomb at Hongmiao, Mianxian, Shaanxi). *Kaogu yu wenwu* 考古與文物 1983, 4: 30–34.

Tang Yongtong 湯用彤. *Han Wei liang Jin nanbeichao fojiao shi* 漢魏兩晉南北朝佛教史 (History of Buddhism during the Han, Wei, two Jin, and Northern-Southern periods). 2 volumes. Beijing 北京: Zhonghua shuju 中華書局, 1983.

Tokiwa Daijō 常盤大定 and Sekino Tadashi 関野貞. *Shina bukkyō shiseki hyōkai* 支那仏教史蹟評解 (Buddhist monuments in China). 6 volumes. Tokyo 東京: Bukkyō shiseki kenkyūkai 仏教史蹟研究会, 1926–31.

Tokyo geijutsu daigaku 東京藝術大學, ed. *Tokyo geijutsu daigaku zōhin zuroku: chōkoku* 東京藝術大學藏品圖録: 彫刻 (Illustrated catalog of the Tokyo University of Fine Arts collection: sculpture). Tokyo 東京: Tokyo geijutsu daigaku 東京藝術大學, 1977.

Tong Enzheng 童恩正. "Gudai Zhongguo nanfang yu Indu jiao-tong de kaoguxue yanjiu 古代中國南方与印度交通的考古學研究" (An archaeological study of communication between ancient southern China and India). *Kaogu* 考古 1999, 4: 79–87.

Tonkō bunbutsu kenkyūjo 敦煌文物研究所, ed. *Tonkō Baku-kokutsu* 敦煌莫高窟 (Mogao Caves of Dunhuang). 5 volumes. Tokyo 東京: Heibonsha 平凡社, 1980.

Tsukamoto Zenryū 塚本善隆. *Shina bukkyō shi kenkyū, Hokugi hen* 支那仏教史研究, 北魏篇 (Research on the history of Chinese Buddhism, Northern Wei volume). Tokyo 東京: Kōbundō shobō 弘文堂書房, 1942.

Unkō sekkutsu bunbutsu hokanjo 雲岡石窟文物保管所, ed. *Unkō sekkutsu* 雲岡石窟 (Yungang Caves). 2 volumes. Tokyo 東京: Heibonsha 平凡社, 1989–90.

Wan Gengyu 万庚育. "Zhengui de lishi ziliao, Mogaoku gong-yangren huaxiang tiji 珍貴的歷史資料, 莫高窟供養人畫像題記" (Precious historical materials, Mogao Grotto donor por-trayal inscriptions). In *Dunhuang Mogaoku gongyangren tiji* 敦煌莫高窟供養人題記 (Dunhuang Mogao grotto donor inscrip-tions), ed. Dunhuang yanjiuyuan 敦煌研究院, 179–93. Beijing 北京: Wenwu chubanshe 文物出版社, 1986.

Wang Chong 王充 and Huang Hui 黃暉. *Lunheng jiaoshi* 論衡校釋 (Disquisitions, annotated). Beijing 北京: Zhonghua shuju 中華書局, 1990.

Wang Chunwu 王純五. *Tianshi Dao ershisizhi kao* 天師道二十四治考 (A study of the twenty-four centers of Tianshi Dao). Cheng-du 成都: Sichuan daxue chubanshe 四川大學出版社, 1996.

Wang Shouzhi 王壽芝. "Chenggu chutu de Handai taodu 城固

出土的漢代桃都" (Han dynasty *taodu* excavated from Cheng-gu)." *Wenbo* 文博 1987, 6: 91–92.

Wang Yi 王毅. "Bei-Liang shita 北涼石塔" (Stone pagodas of the Northern Liang). *Wenwu ziliao congkan* 文物資料叢刊 1977, 1: 179–88.

Wang Yonghong 王永紅. "Handai 'yaoqianshu' de xingzhuang ji neihan 漢代 '搖錢樹' 的形狀及內涵" (Form and significance of Han dynasty "money trees"). *Zhongguo lishi bowuguan guan-kan* 中國歷史博物館館刊 1996, 2: 42–49.

Wang Zhimin 王志敏. "1955 nian Nanjing fujin chutu de Sun Wu liang Jin qingciqi 1955 年南京附近出土的孫吳兩晉青瓷器" (Celadon wares of the Wu and two Jin dynasties excavated in 1955 from the vicinity of Nanjing). *Wenwu cankao ziliao* 文物參考資料 1956, 11: 8–14.

Wang Zhongluo 王仲犖. *Bei-Zhou dili zhi* 北周地理志 (Geographical records of the Northern Zhou). 2 volumes. Beijing 北京: Zhonghua shuju 中華書局, 1980.

Wang Zhongshu 王仲殊. "Guanyu Riben de sanjiaoyuan fo-shoujing 關於日本的三角緣佛獸鏡" (Regarding the Japanese triangular-edged Buddha and mythical animals mirrors). *Kaogu* 考古 1982, 6: 630–39.

———. "Lun Riben 'fangzhi sanjiao yuan shenshou jing' de xingzhi jiqi yu suowei 'bozai sanjiao yuan shenshou jing' de guanxi 論日本 '仿制三角緣神獸鏡' 的性質及其与所謂 '舶載三角緣神獸鏡' 的關係" (On the character of "imitative triangular rimmed bronze mirrors with deities and mythical animal designs" in Japan and their relationship with so-called "imported" ones). *Kaogu* 考古 2000, 1: 78–88.

———. "Lun Wu Jin shiqi de fojiao kuifeng jing 論吳晉時期的佛像夔鳳鏡" (On the Buddhist phoenix mirrors of the Wu and Jin periods). In *Zhongguo kaoguxue yanjiu: Xia Nai xian-sheng kaogu wushi nian jinian lunwenji* 中國考古學研究：夏鼐先生考古五十年紀念論文集 (Archaeological research in China: A collection of papers in commemoration of the fiftieth year of Prof. Xia Nai's work in archaeology), ed. Zhongguo kaogu-xue yanjiu bianweihui 中國考古學研究編委會, 254–67. Beijing 北京: Wenwu chubanshe 文物出版社, 1986.

Wei Shou 魏收. *Weishu* 魏書 (History of the Northern Wei). Beijing 北京: Zhonghua shuji 中華書局, 1974.

Wei Wenbin 魏文斌 and Tang Xiaojun 唐曉軍. "Guanyu shiliu-guo beichao qifo zaoxiang zhu wenti 關於十六國北朝七佛造像諸問題" (Various questions regarding images of the seven Buddhas in the Sixteen Kingdoms and Northern dynasties). *Beichao yanjiu* 北朝研究 1993, 4: 31–49.

Wen Yucheng 溫玉成. "Gongyuan yi zhi san shiji zhongguo de xianfo moshi 公元 1至 3 世記中國的仙佛模式" (The Immortal-Buddha type in first to third century China). *Dunhuang yanjiu* 敦煌研究 1999, 159–70.

———. "Longmen beichao xiaokan de leixing, fenqi yu tongku painian 龍門北朝小龕的類型, 分期与洞窟排年" (The typol-
ogy, stages and chronology of the Longmen Northern dynasties small niches). In *Longmen shiku* 龍門石窟 (Longmen Caves), ed. Longmen wenwu baoguansuo 龍門文物保管所 and Bei-jing daxue kaoguxi 北京大學考古系, 1: 170–224. Beijing 北京: Wenwu chubanshe 文物出版社, 1991.

———. "Longmen Guyang dong yanjiu 龍門古陽洞研究" (Research on the Longmen Guyang Cave). *Zhongyuan wenwu* 中原文物 1985 (Special Issue): 114–47.

———. "Ryūmon hokuchōki shōgan no ruikei to bunki oyobi hokuchōki sekkutsu no hennen 龍門北朝期小龕の類型と分期および北朝期石窟の編年" (Typological and periodic classi-fication of small Longmen Northern dynasty niches and the chronology of the Northern dynasty grottoes as a whole). In *Ryūmon sekkutsu* 龍門石窟, ed. Ryūmon bunbutsu hokanjo 龍門文物保管所 and Peking daigaku kōkokei 北京大学考古系, 1: 170–215. Tokyo 東京: Heibonsha 平凡社, 1987.

Wu Hong 巫鴻. "Diyu kaogu yudui 'Wudoumi dao' meishu chuantong de chonggou 地域考古與對 '五斗米道' 美術傳統的重構" (Regional archaeology and the reconstruction of the artistic tradition of Wudoumi Daoism). In *Han Tang zhi jian de zongjiao yishu yu kaogu* 漢唐之間的宗教藝術與考古 (Reli-gious art and archaeology of the Han to Tang period), ed. Wu Hong 巫鴻, 431–60. Beijing 北京: Wenwu chubanshe 文物出版社, 2000.

Wu Jialun 伍加倫 and Jiang Yuxiang 江玉祥. *Gudai xinan sichou zhi lu yanjiu* 古代西南絲綢之路研究 (Research on the ancient southwestern Silk Road). Chengdu 成都: Sichuan daxue chu-banshe 四川大學出版社, 1990.

Wu Rongceng 吳榮曾. "Zhenmuwen zhong suojiandao de Dong-Han dao wu guanxi 鎮墓文中所見到的東漢道巫關係" (The relationship of Eastern Han Daoism and shamanism seen among grave-quelling texts). *Wenwu* 文物 1981, 3: 56–63.

Wu Tingqiu 吳廷璆 and Zheng Pengnian 鄭彭年. "Fojiao hai-shang chuanru Zhongguo de yanjiu 佛教海上傳入中國的研究" (Research on the entry of Buddhism into China via the sea route). *Lishi yanjiu* 歷史研究 1995, 20–39.

Wu Wenxin 吳文信. "Jiangsu Jiangning chutu yipi Xi-Jin qingci 江蘇江寧出土一批西晉青瓷" (A group of Western Jin ceram-ics uncovered at Jiangning, Jiangsu). *Wenwu* 文物 1975, 2: 92–94.

Wu Yuxian 吳玉賢. "Zhejiang Shangyu Haoba Dong-Han Yong-chu sannian mu 浙江上虞蒿壩東漢永初三年墓" (Eastern Han Yongchu third year tomb at Zhejiang Shangyu Haoba). *Wen-wu* 文物 1983, 6: 40–44.

Wuxian wenwu guanli weiyuanhui 吳縣文物管理委員會. "Jiangsu Wuxian Shizishan sihao Xi-Jin mu 江蘇吳縣獅子山四號西晉墓" (Western Jin tomb 4 at Shizishan, Wuxian, Jiangsu). *Kaogu* 考古 1983, 8: 707–713.

Wuxian wenwu guanli weiyuanhui 吳縣文物管理委員會 and Zhang Zhixin 張志新. "Jiangsu Wuxian Shizishan Xi-Jin mu

qingli jianbao 江蘇吳縣獅子山西晉墓清理簡報" (Report and inventory of the Western Jin tombs at Shizishan, Wuxian, Jiangsu). *Wenwu ziliao congkan* 文物資料叢刊 3 (1980): 130–38.

Xia Nai 夏鼐. "Dunhuang kaogu manji 敦煌考古漫記" (Notes on archaeology at Dunhuang). *Kaogu tongxun* 考古通訊 1955, 1: 2–8.

Xian Ming 鮮明. "Lun zaoqi daojiao yiwu yaoqianshu 論早期道教遺物淺錢樹" (Discussion of money trees as early Daoist votive objects)" *Sichuan wenwu* 四川文物 1995, 5: 8–12.

———. "Zai lun zaoqi daojiao yiwu yaoqianshu 再論早期道教遺物淺錢樹" (A further discussion of money trees as early Daoist votive objects). *Sichuan wenwu* 四川文物 1998, 4: 29–33.

Xiao Mo 蕭默. "Songyuesi ta yuanyuan kaobian 嵩岳寺塔淵源考辨" (Research on the origin of the pagoda of Songyue monastery). *Jianzhu xuebao* 建築學報 1997, 4: 49–53.

Xie Mingliang 謝明良. "Liuchao gucangguan zongshu 六朝穀倉罐綜述" (Summary of Six Dynasties granary vessels). *Gugong wenwu yuekan* 故宮文物月刊 109 (April 1992): 44–63.

Xiong Shouchang 熊壽昌. "'Huawendai foshoujing' zhiyi, yu Wang Zhongshu xiansheng shangque '畫紋帶佛獸鏡' 質疑, 與王仲殊先生商榷" (Questioning "decorative-band *foshou* mirrors," and the deliberations of Wang Zhongshu). *Dongnan wenhua* 東南文化 1992, 3–4: 143–47.

Xu Xitai 徐錫台. "Kaogu faxian lidai qiwu shang kezhu bagua fangweitu ji qi yuanyuan de tansuo 考古發現歷代器物上刻鑄八卦方位圖及其淵源的探索" (Discussion of the archaeologically discovered historical implements with engraved and cast directional trigrams and their origin). *Wenbo* 文博 1993, 5: 3–12, 14.

Xupu liuchaomu fajuedui 胥蒲六朝墓發掘隊. "Yangzhou Xupu liuchaomu 揚州胥蒲六朝墓" (Six Dynasties tombs at Xupu, Yangzhou). *Kaogu xuebao* 考古學報 1988, 2: 233–56.

Yamada Meiji 山田明次, Kida Tomo-ō 木田知生, and Irisawa Takashi 入澤崇. "'Zaoqi fojiao zaoxiang nanchuan xitong' yanjiu gaikuang ji zhanwang '早期佛教造像南傳系統' 研究概況及展望" (Review and prospects for research on "the southern tradition of early Buddhist imagery"). *Dongnan wenhua* 東南文化 1991, 3: 50–56.

Yan Dunjie 嚴敦傑. "Ba liuren shipan 跋六壬式盤" (Postscript on *liuren* divining boards). *Wenwu cankao ziliao* 文物參考資料 1958, 7: 20–22.

Yan Wenru 閻文儒 and Chang Qing 常青. *Longmen shiku yanjiu* 龍門石窟研究 (Longmen Cave-temple research). Beijing 北京: Shumu wenxian chubanshe 書目文獻出版社, 1993.

Yang Hong 楊泓. "Ba Ezhou Sun-Wu mu chutu tao foxiang 跋鄂州孫吳墓出土陶佛像" (On the pottery Buddha image excavated from a Sun-Wu tomb in Ezhou City). *Kaogu* 考古 1996, 11: 28–30.

———. "Guonei xiancun zuigu de jizun fojiao zaoxiang shiwu 國內現存最古的幾尊佛教造像實物" (Earliest objects of Buddhist imagery preserved in China today). *Xiandai foxue* 現代佛學 1962, 4: 31–34, 49–50.

Yang Xiaowu 楊曉鄔. "Qiantan Guanghan shi chutu yaoqianshu de xiufu 淺談廣漢市出土搖錢樹的修復" (Brief discussion of the restoration of a "money tree" excavated from Guanghan). *Sichuan wenwu* 四川文物 1989, 6: 76–77, 49.

Yang Xuanzhi 楊衒之. *Luoyang qielanji jiaoshi* 洛陽伽藍記校釋 (Record of the monasteries of Luoyang, critical edition). Ed. Zhou Zumo 周祖謨. Beijing 北京: Zhonghua shuju 中華書局, 1963.

Yao Qian 姚遷 and Gu Bing 古兵, ed. *Liuchao yishu* 六朝藝術 (Art of the Six Dynasties). Beijing 北京: Wenwu chubanshe 文物出版社, 1981.

Yao Sheng 耀生. "Yaoxian shike wenzi luezhi 耀縣石刻文字略志" (Notes on the carved stone inscriptions of Yaoxian). *Kaogu* 考古 1965, 3: 134–51.

Yao Weiyuan 姚薇元. *Bei chao huxing kao* 北朝胡姓考 (Study of Northern dynasties non-Han surnames). Beijing 北京: Kexue chubanshe 科學出版社, 1958.

Yi Jiasheng 易家胜. "Nanjing chutu de liuchao zaoqi qingci youxiacai pankouhu 南京出土的六朝早期青瓷釉下彩盤口壺" (Early Six Dynasties celadon ewer with dish-shaped mouth in underglaze enamel excavated from Nanjing). *Wenwu* 文物 1988, 6: 72–75.

———. "Wu mo Jin chu qingci youxiacai hua yishu chuyi 吳末晉初青瓷釉下彩畫藝術芻儀" (An opinion on the underglaze painting art on the greenware dated to the end of the Wu, beginning of the Jin dynasties). *Dongnan wenhua* 東南文化 1989, 2: 176–79.

Yi Wen 一聞. "Daojiao gushi yanjiu de zhongda tupo 道教古史研究的重大突破" (Major breakthrough in the study of Daoist ancient history). *Sichuan wenwu* 四川文物 1997, 2: 21.

Yin Guangming 殷光明. "Bei-Liang shita fenqi shilun 北涼石塔分期試論" (On the periodization of the Northern Liang stone pagodas). *Dunhuang yanjiu* 敦煌研究 1997, 3: 84–94.

———. "Bei-Liang shita shang de Yijing bagua yu qifo yi mile zaoxiang 北涼石塔上的易經八卦与七佛一彌勒造像" (The *Yijing* trigrams and seven Buddha/one Maitryea on the Northern Liang stone pagodas). *Dunhuang yanjiu* 敦煌研究 1997, 1: 81–89.

———. "Bei-Liang shita *Shi er yinyuan jing* ji youguan wenti 北涼石塔《十二因緣經》及有關問題" (The *Shi er yinyuan jing* of the Northern Liang stone pillars and some related problems). *Dunhuangxue jikan* 敦煌學集刊 1996, 2: 61–71.

———. "Dunhuang shi bowuguan cang sanjian Bei-Liang shita 敦煌市博物館藏三件北涼石塔" (Three Northern Liang stone pagodas in the collection of the Dunhuang city museum). *Wenwu* 文物 1991, 11: 76–83, 64.

———. "Guanyu Bei-Liang shita de jige wenti 關於北涼石塔的幾個問題" (Several questions related to Northern Liang stone pillars). *Dunhuangxue jikan* 敦煌學集刊 1993, 1: 64–70, 76.

———. "Meiguo Kelinfulan yishu bowuguan suocang Bei-Liang shita ji youguan wenti 美國克林富蘭藝術博物館所藏北涼石塔及有關問題" (Cleveland Museum of Art collection Northern Liang stone pagoda and some related issues). *Wenwu* 文物 1997, 4: 42–45.

———. "Shilun Bei-Liang shita jizuoxiang yu shenwang 試論北涼石塔基座像与神王" (The Spirit Kings and the images on the bases of the Northern Liang stone pagoda). *Dunhuang yanjiu* 敦煌研究 1996, 4: 8–21.

———. "Shilun mofa sixiang yu Bei-Liang fojiao ji qi yingxiang 試論末法思想與北涼佛教及其影響" (On *mofa* thought and Northern Liang Buddhism as well as its influence). *Dunhuang yanjiu* 敦煌研究 1998, 2: 89–102.

Yoshimura Rei 吉村怜. "Ryūmon Koyōdo butsugan ni mirareru shōgon ishō no igi 龍門古陽洞仏龕にみられる莊嚴意匠の意義" (Significance of the decorative designs in the niches for Buddhas in the Longmen Guyang cave). *Bukkyō geijutsu* 仏教藝術 250 (May 2000): 13–52.

———. "Ryūmon yōshiki nanchō kigen ron 龍門樣式南朝起源論" (Origin of the Longmen style lies in the Southern dynasties). *Kokka* 国華 1121 (1989): 7–18.

Yu Haoliang 于豪亮. "'Qianshu,' 'qianshuzuo' he yulong manyan zhi xi '錢樹,' '錢樹座' 和魚龍漫衍之戲" ("Money trees," "money tree bases," and the performance known as the fish-dragon transformation). *Wenwu* 文物 1961, 11: 43–45.

Yu Weichao 俞偉超. "Dong-Han fojiao tuxiangkao 東漢佛教圖像考" (A study of Eastern Han dynasty Buddhist imagery). *Wenwu* 文物 1980, 5: 68–77.

Yuan Shuguang 袁曙光. "Chengdu Wanfosi chutu de Liang dai shike zaoxiang 成都万佛寺出土的梁代石刻造像" (Liang dynasty stone sculptures unearthed at Wanfosi, Chengdu). *Sichuan wenwu* 四川文物 1991, 3: 27–32.

Yunnan sheng wenwu gongzuodui 雲南省文物工作隊. "Yunnan Zhaotong Guijiayuanzi Dong-Han mu fajue 雲南昭通桂家院子東漢墓發掘" (Excavation of Eastern Han tombs at Guijiayuanzi, Zhaotong, Yunnan). *Kaogu* 考古 1962, 8: 395–99.

Zeng Zhaoyu 曾昭燏. *Yi'nan guhuaxiang shimu fajue baogao* 沂南古畫像石墓發掘報告 (Report of the excavation of ancient stone engravings in a tomb near Yi'nan). Beijing 北京: Wenhuabu wenwu guanliju 文化部文物管理局, 1956.

Zhang Heng 張恆. "Zhejiang Shengxian faxian de zaoqi fojiao yishupin ji xiangguan wenti zhi yanjiu 浙江嵊縣發現的早期佛教藝術品及相關問題之研究" (Research and related questions on early Buddhist works discovered at Shengxian, Zhejiang). *Dongnan wenhua* 東南文化 1992, 2: 21–25, 144.

Zhang Naizhu 張乃翥. "Longmen shiku Shiping gong xiangkan zaoxiang niandai guankui 龍門石窟始平公像龕造像年代管窺" (Focus on the date of the sculpture in the duke of Shiping image niche, Longmen Caves). *Zhongyuan wenwu* 中原文物 1983, 3: 91–93.

Zhang Weiling 張煒玲. "Beichao zhi qian Guan daojiao xiuxingfa de lishi kaocha 北朝之前觀道教修行法的歷史考察" (Historical investigation of Guan Daoist practices during the Northern dynasties and earlier). *Daojiao xue tansuo* 道教學探索 4 (1991): 67–117.

———. "Guanling Yin Xi shenhua yanjiu 關令尹喜神化研究" (Research on the deification of the Guardian of the Pass Yin Xi). *Daojiao xue tansuo* 道教學探索 3 (1990): 21–74.

Zhang Yan 張硯. "Chūgoku Sensei shō Yō-ken no hirin 中国陝西省耀県の碑林 (Part I)" (A group of stone monuments located at Yaoxian in Shaanxi province, China, Part I). *Bukkyō geijutsu* 仏教藝術 205 (December 1992): 77–89.

———. "Chūgoku Sensei shō Yō-ken no hirin 中国陝西省耀県の碑林 (Part II)" (A group of stone monuments located at Yaoxian in Shaanxi province, China, Part II). *Bukkyō geijutsu* 仏教藝術 211 (December 1993): 101–23.

Zhang Yan 張燕 and Zhao Chao 趙超. *Beichao fodao zaoxiangbei jingxuan* 北朝佛道造像碑精選 (Selected Northern dynasties Buddhist and Daoist stele). Tianjin 天津: Tianjin chubanshe 天津出版社, 1996.

Zhangye diqu wenwu guanli bangongshi 張掖地區文物管理辦公室 and Gaotaixian bowuguan 高台縣博物館. "Gansu Gaotai Luotuocheng huaxiang zhuanmu diaocha 甘肅高台駱駝城畫像磚墓調查" (Investigation of the pictorial brick tomb at Luotuocheng, Gaotai, Gansu). *Wenwu* 文物 1997, 12: 44–51.

Zhao Dianzeng 趙殿增 and Yuan Shuguang 袁曙光. "Sichuan Zhongxian Sanguo tongfoxiang ji yanjiu 四川忠縣三國銅佛像及研究" (Research on the bronze Buddha images of the Three Kingdoms period from Zhongxian, Sichuan). *Dongnan wenhua* 東南文化 1991, 5: 55–61.

———. "'Tianmen' kao '天門'考" (Considering the gate of heaven). *Sichuan wenwu* 四川文物 1990, 6: 3–11.

Zhao Xiurong 趙秀榮. "Beichao shiku zhong de shenwang xiang 北朝石窟中的神王像" (Images of the Spirit Kings in Northern dynasty caves). *Dunhuangxue jikan* 敦煌學集刊 1995, 1: 63–71.

Zhejiang sheng bowuguan 浙江省博物館. *Zhejiang qiqian nian* 浙江七千年 (7000 years in Zhejiang). Hangzhou 杭州: Zhejiang renmin meishu chubanshe 浙江人民美術出版社, 1994.

Zhejiang sheng wenwu kaogu yanjiusuo 浙江省文物考古研究所. "Hangzhou diqu Han, Liuchao mu fajue jianbao 杭州地區漢, 六朝墓發掘簡報" (Report on the excavation of Han and Six Dynasties tombs in the Hangzhou area). *Dongnan wenhua* 東南文化 1989, 111–28.

Zheng Yan 鄭岩. "Jiuquan Dingjiazha shiliuguo mu sheshu bihua kao 酒泉丁家閘十六國墓社樹壁畫考" (Investigation of the land god tree in the Sixteen Kingdoms tomb at Dingjiazha, Jiuquan). *Gugong wenwu yuekan* 故宮文物月刊 143 (February 1995): 44–52.

Zhong Jian 鐘堅. "Shitan Handai yaoqianshu de fuxing yu neihan 試談漢代搖錢樹的賦形与內涵" (Discussion of the significance

and form of Han dynasty money trees). *Sichuan wenwu* 四川文物 1989, 1: 18–22.

Zhong Zhi 鍾治. "Santai Hujiabian yaoqianshu chukao 三台胡家堰搖錢樹初考" (Initial study of the money tree from Santai Hujiabian). *Gugong wenwu yuekan* 故宮文物月刊 188 (November 1998): 120–27.

Zhongguo meishu quanji bianji weiyuanhui 中國美術全集編輯委員會, ed. *Qin Han diaosu* 秦漢雕塑 (Qin and Han dynasty sculpture). Zhongguo meishu quanji, diaosu bian 2 中國美術全集, 雕塑編 2. Beijing 北京: Renmin meishu chubanshe 人民美術出版社, 1985.

———, ed. *Taoci* 陶瓷 (Ceramics). Zhongguo meishu quanji, gongyi meishu bian 1 中國美術全集, 工藝美術編 1. Shanghai 上海: Shanghai renmin meishu chubanshe 上海人民美術出版社, 1988.

———, ed. *Wei Jin Nanbeichao diaosu* 魏晉南北朝雕塑 (Wei Jin Northern and Southern dynasties sculpture). Zhongguo mei-
shu quanji, diaosu bian 3 中國美術全集, 雕塑編 3. Beijing 北京: Renmin meishu chubanshe 人民美術出版社, 1988.

Zhongguo wenwu jinghua bianji weiyuanhui 中國文物精華編輯委員會. *Zhongguo wenwu jinghua* 中國文物精華 (Gems of China's cultural relics). Beijing 北京: Wenwu chubanshe 文物出版社, 1997.

Zhou Junqi 周俊麒. "Lun Leshan shi Dong-Han yamu de yanjiu 論樂山市東漢崖墓的研究" (Research on the Eastern Han dynasty cliff tombs at Leshan). *Sichuan wenwu* 四川文物 1997, 6: 10–17.

Zhou Kelin 周克林. "Yaoqianshu wei zaoqi daojiao yiwu shuo zhiyi 搖錢樹爲早期道教遺物說質疑" (Doubts concerning the hypothesis that "money trees" were early Daoist votive objects). *Sichuan wenwu* 四川文物 1998, 4: 15–22.

Zhu Boqian 朱伯謙, ed. *Yueyao* 越窯 (Yue ware). Zhongguo taoci quanji, 中國陶瓷全集, vol. 4. Shanghai 上海: Shanghai renmin meishu chubanshe 上海人民美術出版社, 1983.

Index

Boldface numerals indicate page numbers of illustrations.